THE PELICAN HISTORY OF ART

Founding Editor: Nikolaus Pevsner

Joint Editors: Peter Lasko and Judy Nairn

Fritz Novotny

PAINTING AND SCULPTURE IN EUROPE 1780–1880

Fritz Novotny was born in Vienna in 1903, and studied history of art at Vienna University under Josef Strzygowski. He was an Assistant Keeper at the Institute of Art History at Vienna University from 1928 to 1939. He then became a lecturer at the University and curator of the Österreichische Galerie, of which in 1960 he was made Director. His books include: *Romanische Bauplastik in Österreich* (1930), *Adalbert Stifter als Maler* (1941), *Wilhelm Busch als Zeichner und Maler* (1949), *Die grossen französischen Impressionisten: Ihre Vorläufer und ihre Nachfolge* (1952), *Der Maler Anton Romako* (1954), *Toulouse-Lautrec* (1969), and works on Cézanne and van Gogh.

Fritz Novotny

PAINTING AND SCULPTURE

IN EUROPE 1780-1880

Penguin Books

PENGUIN BOOKS

Published by the Penguin Group
27 Wrights Lane, London w8 5TZ, England
Viking Penguin Inc., 40 West 23rd Street, New York, New York 10010, USA
Penguin Books Australia Ltd, Ringwood, Victoria, Australia
Penguin Books Canada Ltd, 2801 John Street, Markham, Ontario, Canada L3R 1B4
Penguin Books (NZ) Ltd, 182–190 Wairau Road, Auckland 10, New Zealand

Penguin Books Ltd, Registered Offices: Harmondsworth, Middlesex, England

Written for the Pelican History of Art
Translated from the German by R. H. Boothroyd

First integrated edition, equivalent to the second hardback edition, 1971
Reprinted with minor revisions and updated bibliography, 1978
Reprinted 1980, 1985, 1988, 1990

Library of Congress Catalog Card Number: 74–149800

ISBN 0 14 0561.20 X

Set in Monophoto Ehrhardt
Printed and bound in Great Britain by
Richard Clay Ltd, Bungay, Suffolk

Designed by Gerald Cinamon

CONTENTS

PART TWO: SCULPTURE

PAINTING AND SCULPTURE

IN EUROPE 1780-1880

FOREWORD

Every compiler of a book such as this is inclined to grumble and ask for indulgence because of the limitations within which he must work: the inevitable renunciation of the advantages of precision, the problems of selection. But here, if it be permitted to worry the reader at all with such preliminary remarks, we must obviously confine ourselves to matters specifically relevant to the present volume.

It will be generally admitted that the greatest difficulty facing the historian of nineteenth-century art is due to the growth of individualism; also, obviously, the nearer we come to our own times, the more known artists there are among whom many appeal to us almost as contemporaries. This being the case, how are we to choose? How resolve the contradiction between an 'art history without names' and a period in which there are so many names? Perhaps the worst of it is the horrible and inhuman 'Also ran . . .'. But, having uttered my complaint, I must leave the matter at that.

Perhaps, however, I may be allowed to say that I have deliberately paid more attention to general, international features in the development of methods and forms of conception than I have to the task of attempting to interpret national differences.

I should also add that British artists are mentioned only occasionally and marginally because there is going to be, in a few years' time, a special volume on British painting in the nineteenth century.

There are so many people I have to thank for help that I cannot mention them all individually. My colleagues in museums and galleries have obtained photographs and information for me, especially Dr Heinrich Brauer of the Ehem.

Staatliche Museen and Dr Vera Ruthenberg of the Staatliche Museen in Berlin, and M. Albert Châtelet of the Louvre. Professor Otto Benesch, Director of the Albertina Print Room in Vienna, Dr Franz Glück, Director of the Historisches Museum der Stadt Wien, and Professor Siegfried Freiberg, Director of the Print Room of the Akademie der bildenden Künste in Vienna, kindly permitted the making of reproductions from originals in their collections. Photographs were also obtained for me by Professor Klaus Berger in Kansas City, my friend Dr John Rewald in New York, and Dr Zdrawka Ebenstein of the Österreichische Galerie. At the beginning of my work on this book, my friend the late Ludwig Münz gave me much valued advice.

Other friends and colleagues provided me with bibliographical details and corrections. They are Dr Selma Krasa-Florian, who did prodigiously much for me, Miss Mimi Mihaliuk of the Österreichische Nationalbibliothek, Dr Fritz Grossmann, Dr Bruno Fürst, Dr Herta Hanatschek, Dr Viktor Griessmaier, Director of the Österreichisches Museum für angewandte Kunst, and Dr Gustav Künstler.

All these and many others, including those who have kindly permitted reproduction of pictures in their possession, I wish to assure of my profound gratitude.

FRITZ NOVOTNY

For the 1976 reprint, one or two minor improvements have been made to text and illustrations, and the bibliography has been brought up to date, with over 200 new entries.

The major museum or gallery in each town is mentioned in the text by the name of the town only: thus, Lyon, Musée des Beaux-Arts, is referred to as Lyon. Smaller galleries in the same town are quoted in full. In the specific cases of Berlin, Munich, and Vienna, the abbreviations have the following meanings:

West Berlin	Staatliche Museen, West Berlin
East Berlin	Staatliche Museen, East Berlin
Formerly Berlin	Refers to works of art formerly in the Berlin gallery but now lost
Munich	Bayerische Staatsgemäldesammlungen, Munich
Vienna	Österreichische Galerie, Vienna

INTRODUCTION

In the year 1780 Immanuel Kant finished his *Critique of Pure Reason*, and about 1880 Cézanne painted the first of his pictures to reveal his definitive style – these two events can be adduced as justification of the two dates on the title-page of the present book. It is doubtful whether, during the intervening period, there were any other turning-points of such general significance and so pregnant with consequences. One of these events occurred in the field of thought at the end of the Baroque period, the other in the field of pictorial representation of the world at the beginning of modern painting; yet they are basically related because of their profoundly revolutionary character and because they both represented a kind of 'Copernican turning-point'. Both stand for a trend away from the objective world of things towards new perceptive possibilities, towards a new kind of investigation of the premises and constructional laws of the objective world.

It is certainly tempting to ask the reason for such a similarity between two changes of spirit, one of which took place a hundred years later than the other. Does it mean merely that there was an essential relationship between the achievements of two geniuses which, welling up from unfathomable sources, determined future developments for a long time? Are we to consider it as just another proof of the fact that comparable developments in different fields of creative activity do not always take place contemporaneously? Can we, because the difference between the two fields excludes a complete parallelism between their own laws, define as a *necessity* the fact that an event in the history of thought finds its analogy in the history of painting only much later? These questions cannot

receive detailed answers here, but they cannot be disregarded altogether, in so far as they concern laws which seem to govern the development of art. For an attempt to give a condensed account of a century of European painting and sculpture must in part consist in an attempt to define the prevailing lines of development.

The nineteenth century has been and still is decried – though perhaps less than our own – on account of the lack of uniformity in its art, on account of its fragmentary nature and many-sidedness, and on account of the increasing rapidity of its changes in the treatment of form. Other reproaches are also levelled against it, above all the increase of individualism, which is regarded as an essential cause of these disturbing features. Nevertheless there is a fundamental tendency underlying the multitude of variations between the end of Baroque art and the last days of Impressionism about 1900. It can be defined as the study of the external appearance of nature. We are not doing an injustice to the nineteenth century if we call it the century of Naturalism. This is certainly true if Naturalism is taken without any more exact limitations. Never before had there been such a degree of Naturalism in painting, not even in Holland in the seventeenth century. To use 'closeness to nature' rather than Naturalism may be a little less precise, but it is a more fitting description of the basic trend of nineteenth-century art. For the painting of this century was 'naturalistic' only now and again – for example during the Biedermeier period in the Germanic countries and during Impressionism everywhere in Europe; but it kept close to nature even when it pursued programmes in opposition to Naturalism, such as those of Classicism and Romanti-

cism. The element logically opposed to Naturalism, to the representation of the visible, was Idealism, that painting of ideas which occurs in many forms in the art of the nineteenth century. This Idealism, however, when it appeared in direct opposition to Naturalism, hardly ever had the same artistic strength.

Here another characteristic of nineteenth-century art makes its appearance. It is precisely that opposition, the lack of equilibrium between the two fundamental tendencies, the failure, save for rare exceptions, to achieve a synthesis. The struggle to achieve such a synthesis permeates the whole century and took a large number of forms. In France it was the aim of Ingres as well as that of Delacroix, in Germany of a Romanticist of the calibre of Runge as well as of Feuerbach. It also underlies nineteenth-century historicism, that strange and characteristic phenomenon which was a sign of the century's weakness.

In this ambition to achieve a synthesis of superficial closeness to nature and Idealism, another factor makes its appearance – the desire for uniformity of style such as could be found in the art of the past down to the end of the Baroque. This uniformity, however, had never been a simple matter, as is shown by comparing for example the younger Holbein with Grünewald, Velázquez with his immediate predecessor El Greco, and Rembrandt with his great contemporaries. But in the centuries before the nineteenth there had still existed a sufficiently strong coherence of style and never the rigid compartmentation which is found everywhere in nineteenth-century art.

The causes of this change which lay outside art itself have been often and amply explained: the radical changes in the structure of society; the disturbance of secular and ecclesiastical power on the Continent as a result of the French Revolution, an event which affected the history of the whole world; the subsequent beginnings of a democratic society and a new form of individualism; the consequent fundamental change in the relationship of the artist to society, both as his patron and his milieu. The significance of this new situation, involving the destruction of all links with the past and the emergence of a new freedom for art and the individual artist, is in part obvious: it opened the way for a new view of the world.

Elsewhere, however, only obscure reasons for the creative activity of artists are discernible – reasons which have always existed because they are part of its nature, but which now led to hitherto unknown problems. For the artist of the nineteenth century lack of restrictions was often synonymous with being left to fend for himself, not only in the material sense, in dealing with competition, but also in a deeper spiritual sense. Forms of consciousness and of artistic self-consciousness appeared which had not been so widespread in earlier periods. Both the external and the internal situation of the individual forced to rely on himself resulted in the emergence, more frequently than in the past, of the unrecognized artist – a lonely man, an outsider. It certainly does not redound to the credit of the nineteenth century that in extreme cases this loneliness assumed a tragic and heroic form, for example in Blake, van Gogh, and Marées. Nevertheless, if we want to do justice to the much despised nineteenth century, we must also admit that the new and difficult position of the artist gave rise to an absolutely new conception of art. This is not to be understood in the sense of a complacent determinism, according to which things happen because they are bound to happen; it is surely evident that there is a connexion between the marked individualism in the world and lives of artists during the nineteenth century and certain matters of subject and content in art to which this period was the first to gain access.

There are two themes which determined, in a most striking manner, the art of the last century – landscape and the inner man – and both

were the result of an experience of reality in conformity with the century's fundamental attitude towards realism in art. During our period landscape-painting made particularly rapid progress. In the second half of the century it was in a certain sense the central theme. It is true that before the nineteenth century there had already been a period of definitely realistic landscape-painting – in Holland during the seventeenth century. It was therefore only to be expected that this great model from the past should exercise a decisive influence. In actual subject-matter, there was little possibility of going beyond what the Dutch masters had achieved by admitting the spontaneous motif of homely, everyday landscape as an adequate subject for pictures. Nevertheless, these classic masters of realistic landscape had left aside several things which provided material for a more naturalistic rendering of reality, in particular the phenomena of light and atmosphere. The link with the past and the foundations of a new art of landscape-painting are found in their clearest and most significant form in Constable. Light and atmosphere gradually became the domain of landscape-painting almost exactly during the hundred years from 1800 to 1900, beginning with Romanticism and ending with Impressionism. One might therefore suggest, as a concise definition of the art of the nineteenth century, that it was a century of great landscape-painting.

By the time the art of landscape reached the exclusiveness of strict Impressionism, of extreme painting of light, the dualism in the painting of the entire century had become extremely acute. After all, if the painted picture of reality was placed single-mindedly on a par with the reproduction of the *optical* impression, this represented a threat to another reality as a subject for pictures: the image of man, the portrait in the wider sense. It is for this reason that there are so few important portraits by the great Impressionists. This, however, applied only in the late phase of Realism. During the century as a whole man as a subject was of considerable importance. In this field the peculiarities in selecting themes were an inevitable consequence of the decline of the old social hierarchy and of the spiritual domination of the Church. Although interest in official portraits, in the exceptional human being, the hero of any kind, persisted long after the end of the eighteenth century, an important role was assigned from the very beginning of the period to the depicting of man for his own sake. This opened the way to a more intimate representation. It is true that ever since the late Middle Ages there have always been important examples of such a representation of mankind, but they invariably produce the effect of being an exceptional achievement by a great individual. By the end of the Baroque, however, the way was clear for a general change of conception, and shortly after 1800 the shift from a super-personal idea of man to an interest in his individual destiny had already taken place in all the arts. This denotes the assignation of an increasingly important role to the psychological factor of portraiture, to the rendering of mood and the analysis of the soul. Here, as compared with painting, poetry had the advantage of direct speech and an almost unlimited range of subject-matter; and music to a certain extent had the same advantage. The greatest and most striking productions in these fields – the literature of Russia from Pushkin to Chekhov, the 'Lied', since its creation by Schubert, and dramatic music – had an effectiveness which could not be equalled in painting. All this is in the nature of things. Painting, with its plain images of people without the help of 'narrative', was bound to be at a disadvantage. It would be unnecessary to refer to this self-evident factor if it were not that in the most important representations of human beings during the first half of the nineteenth century, and even after the middle of the century – in the works of Goya, Géricault, Daumier – the literary element

penetrated into painting. As soon as the principle of representation of the visible, of 'autonomous' painting, became prevalent, the representation of human beings became a difficult matter. Towards the end of the century, however, there was a new intensification and spiritualization in the portrayal of mankind, in particular in the early forms of Expressionism in the art of van Gogh, Gauguin, Ensor, and Munch. This was in opposition to the Impressionistic rendering of nature, and did not occur until after 1880, the date which marks the end of our period. It was not, however, merely the result of opposition; for the means of expressing this new and more profound psychological portrayal of mankind had their easily recognizable premises in the achievements of the preceding 'pure' painting. In the years round about 1880 many things contributed to the birth of 'modern' painting. There were instances of 'precipitation', similar to the appearance of crystals at a certain point during the saturation of a liquid. During the later phase of Impressionism an extremely free use of colour and a new structure of the pictorial plane had already been developed; they were used, however, for purposes of naturalistic illusion, and naturalistic illusion was an impediment to penetration into the spiritual field, to the attainment of psychological depth in portraiture and the representation of human beings. One solitary, mighty breach of the illusionistic principle – and a new image of mankind of a frightening strength and directness had already been accomplished: the portraits painted by van Gogh, the most profound and most moving of all nineteenth-century portraits. Their directness and vigour are due to a considerable extent to the freeing of the colour and to the 'open' structure of the picture, the credit for which must be given to Impressionistic painting. Nevertheless, these very qualities showed that Impressionism had already been left behind, and this finds a parallel in the fact that such portraiture of significance

as existed *before* Impressionism – that of Goya and Ingres and many of the German Romantics, especially Runge, and also the caricatures of Daumier – remained more or less aloof from Realism.

The nearer we draw to the end of the period we are considering the more obvious become the new trends: structure now tends to consist of small parts having a marked life of their own; many and bright colours are used with increasing confidence and independence; and form contains new elements, in particular a more expressive line. Indeed the picture as a formal image acquired a new value, and this brings us to the beginning of modern painting. This development, which took place over several decades, includes yet another general characteristic of nineteenth-century painting – the increasing prevalence of 'open' form. It makes its first appearance as a sharp contrast to everything naturalistic. The independence and sovereignty of forms, colours, and lines obviously constituted a threat to the objective representation of the visible material world. Indeed, after a time it was felt that the naturalistic subservience to objective forms was a coercion of art striking at its very roots. This was one of the essential problems with which the art of the nineteenth century had to cope.

It is difficult to form a just historical appreciation of Naturalism, since we have here to do with a kind of art in which, more than in any other, the artist's main task was invariably mastery of the material elements. What had this art to set against the boundless abundance of reality? In principle, of course, the same as any other less realistic manner of representation, namely mastery of the subject by means of well-organized composition and colour and fine draughtsmanship. Since in naturalistic works the importance of all these elements is actually or apparently reduced, or at all events relegated to an obscure position, their effectiveness can only consist in mysterious relationships be-

tween the material and its spiritualization. For spiritualization is bound to play a part even in naturalistic art. Admittedly the predominance of reality over spiritualization often leads to a loss of genuinely artistic content, but where a work of art of undeniable worth is concerned, the relationships between material and spiritualization are of the most enigmatic kind possible. That the naturalistic painting of the last century can show a few works such as Wilhelm Leibl's portraits, the art of Menzel and Degas, Rudolf Alt's landscapes, and others of the same kind must be considered a triumph. This must be remembered when making a general survey of the period, even if one has to admit that later generations were right in much of their criticism and condemnation of Naturalism. The position is the same as it is with individualism, the other characteristic of the century, with its *splendeurs et misères*.

Much of what has just been said is not applicable to art at the beginning of the period, to Early Classicism and Romanticism. The interest in natural phenomena was then only beginning and was subordinated to the painting of ideas, which in many respects had been inherited from the Baroque. The path of painting from 1780 to 1880 thus begins with concentration on the invisible idea, leads into ever vaster fields of portrayal of the visible, and ends in an apotheosis of the optical image of nature. The latter represented a radical one-sidedness which was bound to evoke a violent reaction. It was clearly something final, and even today many of those who study it consider that it was the end of painting. The radiant charm of this great painting over many decades, which is acknowledged to be the least controversial achievement of nineteenth-century art, can easily mislead us into formulating an unjust opinion of this kind. In pure painting – and also in the manual skill of *peinture* – the nineteenth century, under the leadership of France, carried on a tradition which had originated with the great Venetian painters in the sixteenth century, and which the great Impressionists brought to a brilliant conclusion. The link with the great past was partly avowed openly – by Delacroix and Manet, to mention only the greatest names – but partly it showed itself in a strictly logical expansion into new fields, especially that of colour. The result here was the establishment of a new chromatism. The richness of painting during the latter half of the nineteenth century and its close relationship to the painting of the great periods of the past tend to make us overlook the extent to which it was a preparation for the events of after 1880. The change began with surprising renunciations – for instance, in a case such as van Gogh's, of the complicated stratification of traditional painting – and with simplifications and innovations; unknown depths were plumbed, at the cost of an ever greater abandonment of realistic representation.

Nowadays we are a long way from the first shocks of the beginnings of modern painting, and we think we can understand, not only to what extent the old is linked with the new in that 'about-turn' towards a new conception of the function and construction of a picture, but also what the older illustrative rendering of reality still signifies for the art of our own century. On the other hand, the change of 1880 is still so close to us and so vivid that it is permissible to look back from our own vantage-point and evaluate accordingly. The art of our century is deeply indebted to the Realism of the nineteenth in so far as our art still makes the starting-point of all representation the visual image of the actual material world. No ideology, old or new, religious or otherwise, is involved; the inherent idea – if one can speak of any one such idea – however metaphysical it may be, rests on the idea of nature.

Quite apart from such a retrospective valuation, it must be admitted that the historical value of Realism and Naturalism in nineteenth-century art lies in the idea of nature as the world

of visible phenomena. This dominating idea is what the nineteenth century could set against the ideologies of earlier times. Since it was obliged, at all events if it was to keep to its programme, to limit itself to the visible, it could not be universal (as it could become after 1880, when painters began to study the significance of the inner structure of natural things). The isolation of painting as a branch of art was closely connected with this limitation to the rendering of the visible. In the art of the nineteenth century hardly any *Gesamtkunstwerk* is to be found in which architecture, painting, and sculpture were fused to form a unified whole, despite the fact that attempts to achieve this were made at every stage of the period, since it was after all a kind of timeless ideal. At the same time, however, this limitation and isolation, this obedience to a strict principle, gave rise to a remarkable strength of self-restraint. The principle referred to was that of painting for painting's sake. Devoting itself for a few decades, with a hitherto unknown exclusiveness, to the study of visible nature, European painting accomplished a task which theoretically had been awaiting accomplishment ever since the Renaissance. In this way the painting of the nineteenth century, always threatened by the danger of falling into trite materialism, succeeded in its happiest moments in achieving a degree of spiritualization by means of form which makes it worthy to be ranked with the great examples of painterly painting of the past.

PART ONE

PAINTING

CHAPTER 2

CLASSICISM IN FRANCE

JACQUES-LOUIS DAVID (1748-1825)

Jacques-Louis David is one of those artists in whose work everything that is peculiar to a given trend of art is found concentrated and displayed with admirable clarity. He is almost unanimously regarded as the embodiment of Classicism in painting. (Opposition to this statement could only be founded on a point of principle, namely in the question how far we - conversely - tend to deduce the general characteristics of a whole movement from a dominating personality.) This impression is so strong that it is easy to forget to what a great extent his Classicism took a peculiarly French form.

The beginnings of David's artistic career exemplify the relationship between the vanishing Baroque art and the new movement. His earliest works still contain much that is Baroque, but also a leaning towards a general, undated Classicism. Themes derived from Antiquity are found in their old pictorial form in the paintings which he submitted during the early 1770s in the hope of obtaining a scholarship at the French Academy in Rome: *The Struggle between Minerva and Mars* (1771, Louvre), *Apollo and Diana piercing the Children of Niobe with their Arrows* (1772, Collection of Madame La Mise d'Hérou-

ville), *The Death of Seneca* (1773, Paris, Petit Palais), *Antiochus the son of Seleucus, King of Syria, sick with love for his mother-in-law Stratonice. The Physician Erasistratus discovers the cause of his illness* (1774, Paris, École des Beaux-Arts). In the last-named picture we still find the typically Baroque peculiarity of the chief figure being immersed in deep shadow. The great equestrian portrait of Count Potocki (Wilanow, Poland) of 1781 clings to the type of courtly Baroque portraits. In 1775 David went to Rome with his teacher, Joseph-Marie Vien (1716-1809), when the latter assumed the direction of the French Academy in that city. During the following decade, the second half of which David spent again in Paris (1779-84), he evolved a new manner of constructing pictures. It is found fully developed in *The Oath of the Horatii* [1], which can be described as the most important programmatic work of Early Classicism. David finished it in Rome in 1784, while Louis XVI was still on the throne; from every point of view it is Classicism at its purest. The least novel thing about it is the subject, since the stories of ancient heroes and mythology were important sources for Baroque painting as well; the novelty lies rather in the moralizing pathos permeating the whole picture. The groups of

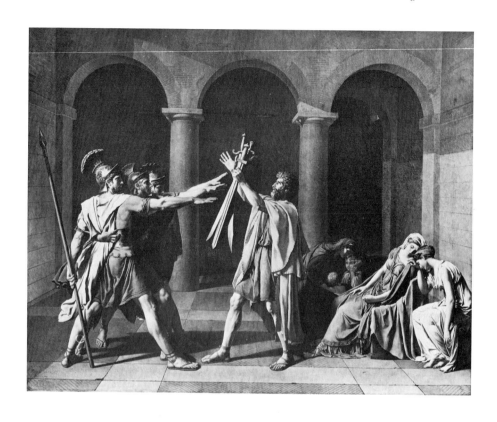

1. Jacques-Louis David: The Oath of the Horatii, 1784. *Paris, Louvre*

figures are 'posed' as they were in the *tableaux vivants* which were so popular at that time, but since everything else in the representation is deliberate composition carried to the extreme, the theatricality and the heavy weight of ideas do not burst the whole of the picture. Where artificiality is as consistent and as much the result of deliberate stylization as it is here, we are ready to accept it as convincing. In two respects especially the conflict with Baroque composition is noticeable – in the relief-like arrangement of the setting and of the rows of parallel figures, and in the excessively harsh, cold lighting used to produce an effect of hard, metallic solidity. Every trace of twilight vagueness is excluded. The problem this radically new method of composition had to solve was how art could still remain painting when it was governed by ideas, and by such strict self-consciousness. Its solution was the new significance of line and of sculptural modelling. With its extreme use of the latter, Classicism provided painting with a problem around which controversy raged until well into the nineteenth century. With regard to line, as the principal agent of 'great' compositions and of a form of expression the possibilities of which were inexhaustible, no such problem existed. Modelling of statuesque sharpness, on the other hand, could easily endanger the cohesion of the pictorial plane. Moreover, there was always the risk of a materialistic ponderousness which it would be difficult to bring into harmony with the idealistic linear construction. These difficulties began with Classicism and lasted throughout the first half of the nineteenth century, and they gave Courbet and even Degas a great deal of trouble. The rejection of the painterly Baroque method of construction by the Classicists brought about a repetition of the relationship between Idealism and Naturalism as it existed in Renaissance art, and so the Renaissance became the model. Antique art, on the other hand, provided models in abundance for sculpture, but hardly any for painting. But the carefully conceived combination of idealistic composition and sculptural solidity which the High Renaissance achieved so successfully could not possibly be attained by Classicism – if for no other reason, because of its ideology. Whenever, during the Age of Reason, the desire to render ideas arose in Classicist painting, the demand for closeness to reality was always too strong to allow harmony in the Renaissance sense to be achieved. Clarity, dignity, and grandeur, in terms of the idealized human figure, were the fundamental postulates of Classicism, but the belief in reason also demanded, often unconsciously, a certain degree of faithfulness to reality. This was the cause of a frequent inner struggle. The limitations imposed by a primarily religious ideology and accepted as a matter of course down to the end of the Baroque had vanished, but the new conception of mankind did not at once produce a similar, generally accepted ideal in painting. This became possible only when the more universal idea of nature began to prevail in painting too, when the visible world became as important as the world of ideas. It was for this reason that during the Classicist period painting had to resort to borrowing from the Baroque, the very art against which, according to its programme, it was fighting.

Even David, the greatest and most vigorous painter of Classicism, could not entirely avoid this discrepancy, at all events not in those great compositions of his which, in the programmatic sense, are held to be the very embodiment of Classicism: *The Oath of the Horatii* [1], *The Oath at the Jeu de Paume* (1791, Louvre; unfinished), *The Sabine Women* (1799, Louvre), and even the later *Leonidas at Thermopylae* (1814, Louvre). For the painter himself, who believed in political action, these pictures were more than just works of art; he meant them to be rousing manifestos – protests, incitements, or

glorifications – and he succeeded in his aim. In addition, they were conceived as authoritative manifestations of the new tendency in art, which identified the 'beautiful' with the 'true' and the 'lucid'. On the other hand, the glorification of the heroic element in art comes very close to one aspect of the Baroque. The most violent reaction was indeed directed against other qualities of the Baroque: the playfulness and voluptuousness of the immediately preceding Rococo.

In the pursuit of his aim David suppressed in his historical paintings one of the most outstanding of his talents: the sense of the painterly. But since some trace of this always remains in his pictures, they are preserved from the coldness of purely moralizing and intellectual painting. It also gives a vital strength to the stereotyped supermen of such historical scenes and mitigates the dangerous contrast between idealizing linear composition and the stiffness of excessively naturalistic modelling. In achieving this David was helped by the works of Nicolas Poussin, the greatest French Baroque painter, the master of Baroque Classicism. The most balanced of David's historical pictures in this sense is at the same time the most moving of his 'topical' works – in fact the only one of them which can be called moving – the picture of the murdered Marat in his bath (1793) [10]. The gruesome scene is presented as brutally as in a waxworks-show and the harsh light – reminiscent of Caravaggio – accentuates the stirring drama of the picture. At the same time, however, this light and the composition in strict parallels have something of the solemnity and delicacy of Chardin's still-lifes; even the bare wall in the background, that pitiless void round the lonely corpse, has something of this painterly charm. Two extremes, a hypnotically fascinating *verismo* and a very carefully thought-out construction, are here combined to produce an impression which cannot but be persuasive. David's *Marat* created a whole genus of paintings of topical subjects, the artistic value of

which steadily declined as the realism in the details became more pronounced and the old compositional recipes feebler and more impersonal. In a picture painted ten years before the *Marat*, *Andromache with the Body of Hector* (1783, Paris, École des Beaux-Arts), the essential elements of the later work are already foreshadowed in the composition, lighting, and tragic atmosphere, but it still lacks the simplification and synthesis of the *Marat*. David did not achieve this admirable vigour in his later historical pictures dedicated to the glorification of Napoleon; for in these the mind is disturbed either by a cold and bloodless doctrinarianism, as in the equestrian portrait of *Napoleon crossing the Great St Bernard Pass* (1800, four

2. Jacques-Louis David:
Napoleon crossing the Great St Bernard Pass, 1800.
Vienna, Kunsthistorisches Museum

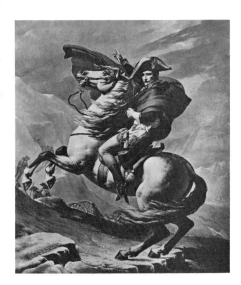

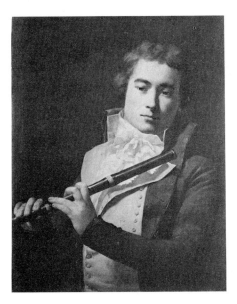

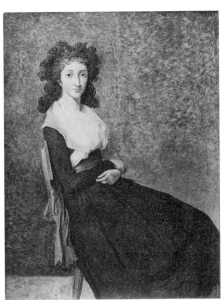

versions) [2], or the overwhelming ceremonial pomp of enormous canvases full of figures such as the *Coronation of Napoleon* (1805-7, Louvre) or *The Distribution of the Eagles on the 5th December 1804* (1810, Versailles). The *Leonidas* in the Louvre, finished in 1814, likewise reveals a notable decline into theatricality.

In one category of pictures, however, David was free from all preoccupation with the imitation of Antiquity or the rendering of modern history: in the portrait. His portraits reveal his supreme ability in the field of pure painting and at the same time throw a clear light on his indebtedness to eighteenth-century traditions. The portrait of the flute-player François Devienne (1792) [3] again reminds us of Chardin, and the portrait of Madame Chalgrin, wife of the architect of the Arc de Triomphe (1793) [4], has a similar delicacy and tranquillity. The picture of the *Woman selling Vegetables* ('La Maraîchère', 1795, Lyon) is a feat of psychological concentration on a single figure which

3 *(above left)*. Jacques-Louis David: François Devienne, Virtuoso on the Flute, 1792. *Brussels, Musées Royaux des Beaux-Arts*

4 *(above)*. Jacques-Louis David: Madame Emilie Chalgrin, 1793. *Paris, Louvre*

could not be attained in historical paintings with numerous figures. In all these works of David, among which we must also include the well-known portrait of Madame Récamier (1800, Louvre), those of M. and Mme Seriziat painted in 1795 (Louvre), and that of Cathérine-Marie-Jeanne Tallard dating from the same year (Louvre), the colour is laid on thinly and loosely, producing an effect at least as strong as that of the simple and monumental silhouettes of the figures. In other portraits, however, especially in the *Gérard Family* (c. 1800) [5], the

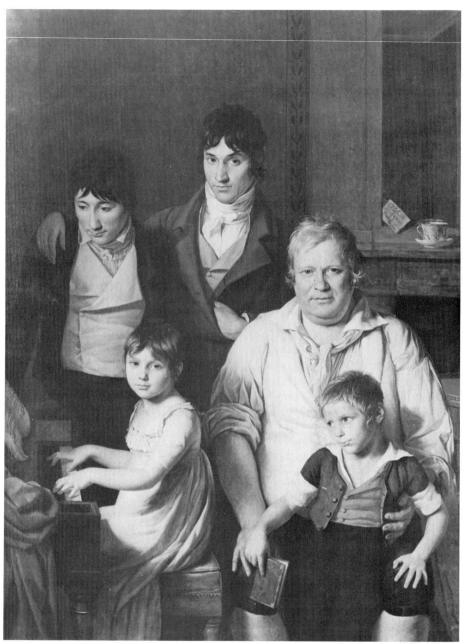

5. Jacques-Louis David: Michel Gérard and his Children, *c.* 1800. *Le Mans, Musée Tessé*

most striking effect is produced by the severity of the cubic structure of the group.[1] Although the painterly element remains nevertheless of great importance, it is more concealed than in the *Marat* [10]. However, if we stress the painterly element as being of such importance in David's art, we must bear in mind the essentially restricted meaning to be attributed to the term in his case. In David's works only the use of chiaroscuro and the detailed structure of the brushwork can be called painterly; he was not a colourist in the true sense of the word. His continuation of Baroque traditions did not include their chromatic elements; for in his

conception of art there was no room for colour as an element of imagination and composition. On the contrary, he either subordinated the chromatic element entirely to the figure composition and limited himself to the clear and cool isolation of strong local colours, or chose a subdued system of tones bordering on monochrome. These were the two possibilities left to orthodox Classicism in its attitude to colour.

In David's only landscape, *The Garden of the Luxembourg* (1794) [6], an almost timeless ingenuousness and freshness in the observation of nature are at work. This is one of the few pictures painted in any European country during

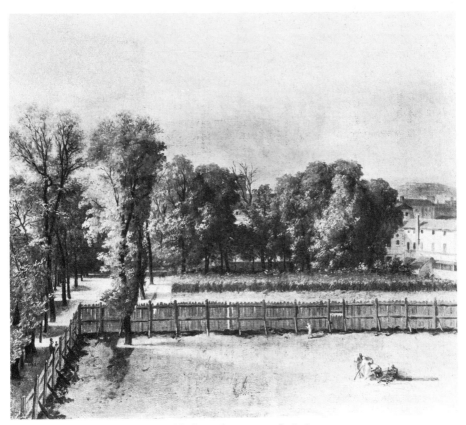

6. Jacques-Louis David: The Garden of the Luxembourg, 1794. *Paris, Louvre*

the last decades of the eighteenth century in which we find evidence of directness in the approach to nature. In such pictures an undercurrent becomes perceptible that links the great landscape-paintings of the seventeenth century with the new feeling for nature of the early nineteenth. Owing to its lack of all idealizing notions, this landscape of David's seems at first astonishing when compared with his other works; yet it is not really so astonishing, since it springs from the same source of strength in his art as the celebrated fleeting sketch of Marie-Antoinette on her way to the guillotine [7]. Indeed, when we survey the whole range of David's artistic achievement, we may well ask ourselves whether we are justified in considering him as the Classicist *par excellence*.

7. Jacques-Louis David:
Marie-Antoinette on the way to the Guillotine, 1793.
Pen-drawing.
Paris, Louvre, Edmond de Rothschild Collection

DAVID'S PUPILS AND FOLLOWERS

After the fall of Napoleon in 1815, David went into exile at Brussels. In the meantime, however, the overwhelming, almost despotic influence of his personality and art had created a considerable school. Among those on whom his influence was direct, the outstanding names, in the order of their dates of birth, are Regnault, Prud'hon, Gérard, Gros, Guérin, Ingres. In the works of each of these most important pupils of David, Classicism naturally has not only an individual character, but, equally naturally, it recedes to a greater or lesser degree under the impact of the new programmes of the younger generation, in particular those of growing Realism and Romanticism.

The artist who remained closest to David was François-Pascal Gérard (1770-1837). Judged by the standard of David's grandiose pathos, Gérard's art represents a softening towards the delicate and the intellectual. In his portraits as well as in his historical pictures he was what one might call a courtly Classicist. Like his teacher, who placed his art at the disposal first of the Revolution and then of Napoleon, Gérard came unscathed through a political upheaval – in his case the transition from the rule of Napoleon to that of Louis XVIII. In the gallery of fame founded by the latter at Versailles, there are two colossal paintings by Gérard, *Henri IV in Paris* and *Austerlitz*.[2] In these historical pictures the grandiose style of monumental mural painting is as unsuccessful as it is in the ceilings in the Panthéon (after 1830). Gérard's temperament found its purest fulfilment in a series of notable portraits. That of Mme Récamier in the Louvre (1802) is by no means inferior to David's, but the tendency of Gérard's gentler, more feminine talent towards the intimate and the pleasing is clearly visible. Quite as masterly and exemplary as specimens of Classicist portraiture are the *Family of Reichsgraf Moriz Christian Fries*, the Viennese patron of the arts (1800) [8], and that

8. François-Pascal Gérard: The Family of Reichsgraf Moriz Christian Fries, 1800.
Vienna, Kunsthistorisches Museum

of the painter *Jean-Baptiste Isabey and his little Daughter* (1795, Louvre). Isabey (1767-1855) was also one of the circle of busy portraitists of the school of David. His portraits, especially his miniatures, display the rather shallow complaisance of skilful formal portraiture. Another member of the same circle is Elisabeth Vigée-Lebrun (1755-1842). She kept away from ideologies and from all artistic problems of the period, and specialized in an ideal of feminine grace in portraiture which pleased everybody. This and a competent routine of painting made her a great success in several European courts, first that of Marie-Antoinette, and then, after the French Revolution, those of Rome and Naples, Vienna, St Petersburg, Dresden, and London.

The same tendency towards complacency and preciosity is evident in the field of historical and mythological scenes in the Antique manner, as can be seen in the paintings of Jean-Baptiste Regnault (1754-1829) and Pierre-Narcisse Guérin (1774-1833). In the compositions of these minor followers of David we occasionally find romantic lighting effects, revealing the influence of Prud'hon; for example in Guérin's *Return of Marcus Sextus* (1799, Louvre) or in the works of Anne-Louis Girodet-Trioson (Girodet de Roussy, 1767-1824) like the *Endymion* (1792, Louvre) and the *Burial of Atala* (1808, Louvre). Such pictures are as remote from the hard and vigorous rhetoric of David's great works as they are from the genuine lyricism of Prud'hon, though they strive to equal both. In them there is a remnant – and sometimes rather more than a remnant – of that mawkish theatricality into which David occasionally lapsed.

A special place in the circle of David's pupils was occupied by Antoine-Jean Baron Gros (1771-1835), who began working with the master when he was only fourteen. One of his best-known monumental pictures is *Napoleon at Eylau* (1808) [9], an important example of the genre of battle-paintings, which he made his speciality. There had been no lack of battles before his time, but during the Napoleonic wars they acquired a new and greater importance for painting, not only because the period was a particularly warlike one with armies and battles bigger than ever before, but also for other reasons. One of these was the important role played by the cult of Napoleon in French Classicist painting. Another was the fact that for artists who sought for everything unusual and supernormal in reality, war had a peculiar fascination. It was a reality which, more than any other, brought the superhuman before the spectator's eyes with a terrifying directness. That this superhuman element was at the same time inhuman was something that most of the artists attracted by it contrived to conceal. To do this was easy, since the trend in art was towards the ideological. Patriotism and the cult of heroes were the ingredients of this ideology, so that contemporary events could without difficulty be substituted for stories of ancient heroes and the representation of war be simplified into the representation of victory. Only a few profound spirits, like Goya and Daumier, refused to give artistic form to these pious lies. It is true that, even when judging battle-pictures, the ethical and artistic aspects have to be kept separate, but whenever art deliberately follows didactic purposes this is not entirely possible. Thus we cannot avoid non-artistic valuations when we study works from the golden age of battle-painting at the beginning of the century; in fact such works invite them, since they are meant to be illustrations of an idea. But it was no longer a matter of similes expressed in pictures, as in the case of the transposition of ideas into the stories of ancient heroes. The subject-matter now was, or could be, experienced in its crudest form. The glorification of heroes within the narrow framework of the new nationalism was obviously too petty an idea to be able to cope with the vastness of the reality

of modern war, and the demand for realistic conception already too strong to be compatible with Classicist stylization. The old, well-tried formulas for concentrating the turmoil of battle into the drama of only a few figures now seemed atavistic. The painted representations of war consequently lagged far behind the literary descriptions written during the same century – Stendhal's *La Chartreuse de Parme* (1839), Stifter's *Witiko* (1865), Tolstoy's *War and Peace* (1865). In fact, it is once more a question of the 'limits of the arts'. It is significant of the path followed by painting during the first half of the century that a rendering of war as convincing as that of the writers was achieved only in individual works by the greatest masters – for example the soldiers and battle-scenes of Géricault and Delacroix – because in them the dramatic element in the action is conveyed in the

dynamics of painting. The old ideal of formal equilibrium was denied by them, though it was an ideal which, however concealed, still remained valid for a long time among other artists.

Even the most important examples from the best days of the genre inevitably confirm these conclusions. In Gros's *Battle of Eylau* [9] it is typical that the single figure, with its heroic pathos, is the keynote of the whole drama. A few figures may be set side by side or otherwise combined to form well-articulated masses. We do not yet find the anonymous masses of men engaged in a chaotic struggle as they appear for the first time in Géricault's works and later in the novelists' descriptions of war. At the most such masses are allowed to appear as accessories in the landscape background. The individualistic principle of Classicism thus asserts itself even when, as in Gros's battle-picture, the concen-

9. Antoine-Jean Gros:
Napoleon at Eylau, 1808. *Paris, Louvre*

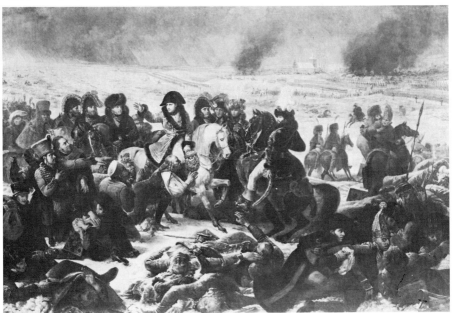

trated violence of the groups is duly oppressive
and sinister, and the realism of the colossal
figures in the foreground is truly amazing. The
realism of David's *Marat* [10] has everywhere
more than individual dimensions: the naked
wall becomes the very expression of a vacuum,
the harsh light on the corpse suggests all the
coldness of death. The presentation of such
super-individual values could have made it pos-
sible to depict the horrors of war without giving
a realistic rendering of the details. The possi-
bility of doing this has been proved in our own
day in Picasso's *Guernica*. By keeping to the
middle path between the raising of a scene to the
plane of elementary grandeur and its rendering
in terms of crude realism, the battle-painters of
the nineteenth century remained aloof in the
face of death and destruction, subjects of which
it is always difficult to give an artistically valid
rendering.

Within these limits, and within the frame-
work of the heroic and patriotic representation
of battles and important historical events, the
production during the Napoleonic period and
its lengthy aftermath remained for the most part
academic, and the difference between the few
great painters – Gros, Géricault, Delacroix – and
the numerous minor 'official' artists is con-
siderable. A closer study would probably reveal
the common course of development to be valid
in this category of pictures too, for example the
after-effects of the Baroque type of picture with
masses of small figures – as they are still visible,
e.g., in Étienne-Barthélemy Garnier's (1759–
1849) *Entry of Napoleon and Marie-Louise into
the Tuileries after their Wedding* (1846, Ver-
sailles) – and the various trends resulting from
the mixture of Baroque tradition, Classicist
hero-worship, and the growing Naturalism.
Naturalism in representations of soldiers is
specially notable in the meticulous portraits of
André Du Tertre (1753-1842).

In the works of a whole group of pupils and
followers of Gros the events of the Napoleonic

10. Jacques-Louis David:
The murdered Marat in his Bath, 1793.
Brussels, Musées Royaux des Beaux-Arts

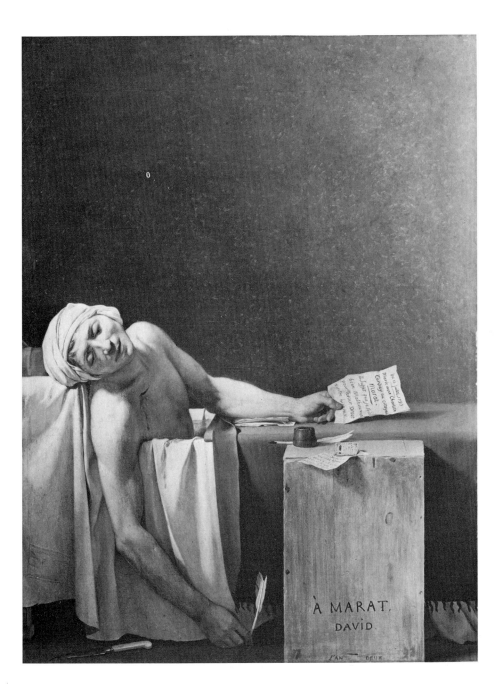

era, in some cases personally experienced, are already depicted with the nostalgic Romanticism of the later generation. To this group belong Nicolas-Toussaint Charlet (1792–1845), Auguste Raffet (1804–60), Paul (properly Hippolyte) Delaroche (1797–1856), and Eugène Isabey (1803–86), who studied under his father Jean-Baptiste. Charlet and Raffet used the new medium of lithography for their illustrations of heroic legends. In these illustrations the character of the pictorial narrative becomes more intimate and modest, and a new type, in contrast to the accepted monumental one, was thus created which was subsequently much used: episodes of war and military life, in which heroic figures appear only occasionally. Raffet's series of lithographs for the *Vie de Napoléon* (1826–7) [11] inspired Horace Vernet's (1789–

1863) illustrations for the *Histoire de l'Empereur Napoléon* by Laurent de l'Ardèche, published in 1839 [12], and Charlet's woodcuts for the *Mémorial de Sainte-Hélène, etc.* (1842; first edition published by the Comte de Las Cases in 1821–3). In 1839 a further series of illustrations of the life of Napoleon by Raffet was published, the 351 woodcut vignettes to Jacques de Norvin's *Histoire de Napoléon*. These small-scale pictorial narratives are full of realistic details, and occasionally rise to moments of drama, for example in Raffet's single sheet *La Revue nocturne* (1837, 1848) with the ghostly glimmering of the weapons (after the ballad *Die nächtliche Heerschau* by Josef Christian von Zedlitz), or the lithograph *Vive l'Empereur!!!* (1834) showing Napoleon at the battle of Lützen (1813), with the blurred outlines of the em-

11. Auguste Raffet:
Napoleon at a Camp Fire, 1831. Lithograph

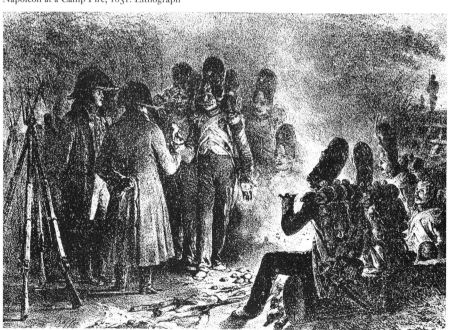

12. Horace Vernet: Wood-engraving from de l'Ardèche,
Histoire de l'Empereur Napoléon, 1839

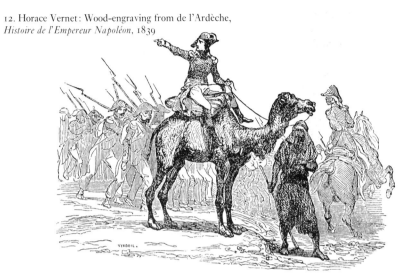

peror's figure as he dashes past. This effect would have been unthinkable without Goya's demonic visions. The only connexion of such works with Classicism is the subject-matter. Even so, however, occasionally these late works still show soldiers attitudinizing in classical *contrapposto* [11]. On the other hand, Delaroche's shallow historical scenes, with their combination of theatrical idealization and almost photographic naturalism, bear witness to the decline of Classicism and academic art. We must not overlook the fact, however, that this naturalism in historical paintings was deeply rooted in French Classicism. Nearly all its questionable elements are already found in a surprisingly early work of historical painting, the picture of *President Molé attacked by Frondists* (1779, Paris, Palais Bourbon), the best-known work of Vien's pupil François-André Vincent (1746–1816), and one which at the time it appeared attracted a good deal of attention.

Gros's *Napoleon at the Battle of Eylau* is only one of a series of colossal paintings glorifying his patron. Gros had been introduced to Napoleon at Milan by Josephine Beauharnais. Later on he depicted the emperor at the battle near the Pyramids (1810), at the taking of Madrid (1809, Versailles), after the battle of Austerlitz (1812, Versailles), and among the plague-stricken populace of Jaffa (1804, Louvre). Together with these crowded historical pictures, among which *Homage to France* in the dome of the Panthéon in Paris (1811–24), which was conceived as a monumental mural, should be included, Gros also painted official portraits, finding in these better opportunities to display his skill in the handling of colour, which constitutes the most valuable side of his talent. To David's pathos and Classicist composition he added a painterly buoyancy. This combination was especially successful in details of these battle-pictures and also in the whole of a few other works. *The young Napoleon on the Bridge at Arcole* (1796, Ver-

13. Antoine-Jean Gros:
Napoleon at Arcole, 1796.
Paris, Louvre

sailles; the reproduction of illustration 13 is from a study for the painting in the Louvre) is, with the magnificent fortissimo of abrupt counter-movements and the agitated and loose brush-work, an outstanding example of this genre. In the portrait of Lieutenant-General Count Fournier-Sarlovèze (exhibited in 1812; Louvre) the theatrical pose is disturbing in its contrast with the magnificence of the uniform against the background obscured by gun-powder-smoke. Such effects, both in their good qualities and in their weaknesses, were eagerly imitated; they impressed Delacroix and formed much of the basis of his dramatic handling of colour. A work by Gros such as the *Woman bathing* in the museum at Besançon seems like an anticipation of Courbet. Gros's life ended in tragedy - quarrels during his last years and lack of confidence in himself drove him to suicide.

It is impossible to give here a detailed list of all the painters who produced weaker Classicist versions of David's historical style, for example Guillaume Lethière (1760-1832) with his *Brutus sentencing his Sons to Death* (c. 1810) and *The Death of Virginia* (finished 1828), both in the Louvre. One group of artists combined a milder, genre-like manner with the melodramatic Classicism of David's school. They shared with him a more or less clearly expressed didactic aim, and they cultivated a kind of bourgeois Classicism in genre pictures which forms a counterpart to the Biedermeier realism of Central and Northern Europe. This tendency towards a sober representation of reality and a delight in details is also found occasionally in historical paintings such as the *Triumph of Marat* (c. 1794, Lille) by Louis-Léopold Boilly (1761-1845), who has been called the 'petit-maître of the Revolution'. Apart from portraiture, his real domain, however, was the genre picture. The best-known of his innumerable genre-paintings, *The Arrival of the Stage-Coach* (1803, Louvre), is a scene of everyday life full of picturesque charm and narrative anecdote. Dutch painters

like Pieter de Hooch, van der Heyden, and Berckheyde played an important part as models for this intimate genre of the Empire period - at least in a general sense. In the narrower sense the genre-painting of the Rococo provided the direct link. We find side by side a cool, glassy sharpness in the representation of the bodies and of light and a painterly freedom in which the spirit of Rococo painting is gradually transformed into the new conception of everyday reality. An example of this realism in Late Rococo art is the sketches of Jean-Michel Moreau (Moreau le Jeune, 1741-1814) [14], who worked as an illustrator and a graphic artist in general. In the delicacy of refined small-

14. Jean-Michel Moreau: Seated Woman, early 1760s. Pencil-drawing. *Paris, Louvre, Print Room*

scale painting the connexion with Greuze is often discernible, and this is particularly clear in the genre pictures of Martin Drolling (properly Drölling; 1752–1817), who was born in Alsace and worked also for the porcelain factory in Sèvres during the first decade of the nineteenth century. Carle Vernet (1758–1836), the father of Horace Vernet, specialized in the painting of horses. The lithograph plays an important role in his work. Indeed, the intimate nature of printed illustration was bound to appeal to these petits-maîtres. Jean-Louis Marne (Demarne; 1754–1829) also used etching for his landscapes and genre scenes of Dutch inspiration, while Louis-Philibert Debucourt (1755–1832), like David a pupil of Joseph Vien,

devoted himself after 1785 to the production of coloured engravings.

François-Marius Granet (1775–1849), born at Aix-en-Provence (where the museum possesses a masterly portrait of him by Ingres [18]), was for some time a pupil of David and then spent several years in Italy, until in 1826 he became curator of the museum at Versailles. He achieved success with a number of interiors of churches and monasteries with small genre-like figures, but it was not until our own century that he became famous as the painter of a large number of sketch-like landscapes full of Impressionistic bravura [15]. These sketches are in oil or water-colour. They follow in the footsteps of Claude Lorrain's wash studies in the *Liber*

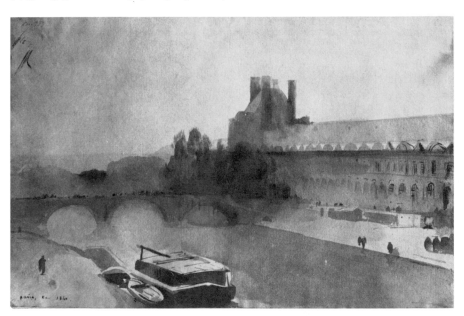

15 *(above)*. François-Marius Granet: Quay on the Bank of the Seine near the Louvre, 1848. Water-colour. *Aix-en-Provence, Musée Granet*

16 *(opposite)*. Pierre-Paul Prud'hon: Crime pursued by Vengeance and Justice, 1808. *Paris, Louvre*

Veritatis. It was this dependence on a tradition established by a classic that kept Granet's landscapes in close touch with Classicism, in spite of the fact that they contain no deliberately propounded ideas, but are the children of observation and the fleeting moment. The difference between Granet's and the 'Early Impressionist' landscapes of Constable, Corot, Blechen, and Menzel lies in the never-abandoned connexion of Granet with the summary masses of light and shade and the sublime pathos of the great French Classicists of the seventeenth century.

As a rare example in French landscape-painting of sober Classicism keeping close to reality, the delightful *View of the Boulevard des Capucines about 1810* in the museum at Chartres

(*c*. 1815) by Léon-Mathieu Cochereau (1793–1817) stands quite alone. He, too, was a pupil of David and is better-known for his *Interior of David's Studio* (1814, Louvre), a piece of virtuosity in the painting of light in keeping with the ideas of his teacher.

PIERRE-PAUL PRUD'HON (1758–1823)

Prud'hon is discussed in this chapter only because he was a contemporary of the Classicists, not because he was a Classicist. In many traits of his character and his art he was, indeed, the very reverse. It is true that he studied classical models, but the decisive influence for him was Correggio, whose art he absorbed in an instinc-

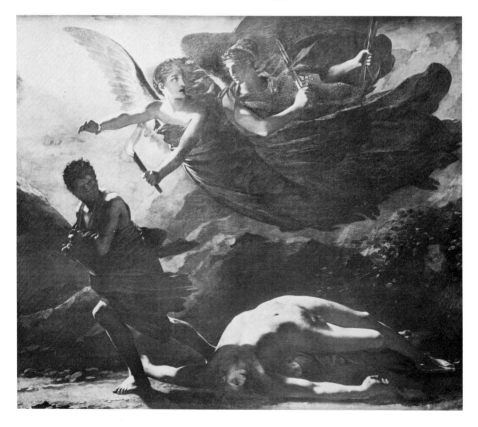

tive, more profound way than the orthodox Classicists were wont to absorb their models. Prud'hon's art has no trace of the programmatic aims, the dogmatism, and the deliberate austerity of pure Classicism. It is true that the world of his pictures is also an ideal world, even more than that of his contemporaries, because he did not feel the rationally determined obligation towards the topical which they felt, but it is a world of dreaminess and gentle melancholy: in short a world of Romanticism. For this reason Prud'hon has been classified as a 'Romantic', a term which is otherwise only sparingly used when speaking of French art. In one of his best-known works (for which Napoleon conferred on him the Cross of the Legion of Honour), *Crime pursued by Vengeance and Justice*, painted in 1808 for the court-room of the Palais de Justice in Paris [16], the allegorical figures, whose actions are inspired with sublime feeling, are illuminated by a full moon behind driving clouds; this is not merely a dramatic heightening of the scene but also a kind of magical transfiguration. The *Rape of Psyche* (Louvre), painted in the same year, is also a nocturnal scene, and here a soft gleam of light plays over the sleeping girl, surrounding her with an aura of poetically tender sensuality. Light plays an important role in every branch of his versatile work, not merely as a means of stressing the modelling of the bodies, but also as a sort of mysterious, delicate veil. In this respect, Prud'hon transported an element of Baroque painting through Classicism into the nineteenth century; Corot with the silvery light on his arcadian landscapes is his direct successor. In many of his chalk drawings Prud'hon develops a play of forms of the utmost delicacy, especially in the rendering of light [17]. An example of this is the portrait of Constance Mayer de la Martinière (1775-1821), who was his pupil and with whom he lived. Her suicide was one of the most tragic events in his life, a life of continual poverty and lack of recognition. Another masterpiece of this

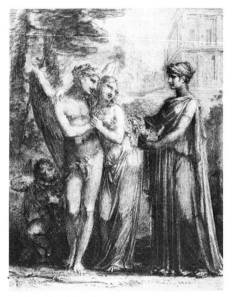

17. Pierre-Paul Prud'hon: Innocence prefers Love to Wealth, c. 1800-10. Drawing. *Chantilly, Musée Condé*

kind is the study for the portrait of the Empress Josephine painted in 1805. All the graceful draughtsmanship of the masters of French Rococo and the *sfumato* of Leonardo da Vinci and Correggio are recaptured in these drawings in a completely personal manner. The many echoes from the art of the old masters are never eclectic imitation, but the expression of a spiritually kindred nature. In Prud'hon's paintings, the actual *peinture* is of the highest importance, higher even than it is in the works of the leading representatives of French Classicism. (For this reason David's brusque rejection of Prud'hon's art was quite unjustified; for those portraits by David in which the pictorial tradition of the eighteenth century still persists, e.g. illustrations 3 and 4, are very close to some of Prud'hon's portraits, such as those of M. and Mme Anthony of 1796 at Dijon and Lyon.)

When Napoleon honoured Prud'hon with his recognition, this implied that the painter was under an obligation to produce official paintings in accordance with the spirit of the time. The studies for a never executed *Triumph of Napoleon*, which was also called *Peace* (1801, Chantilly), or the studies for paintings at the Hôtel-Dieu are in their very nature contrary to his temperament and thus among his weaker works. But even in them the gracefulness and the feminine softness of his temperament were not obscured, and the same is true of some of his compositions in which the influence of Canova, whom he met during his stay in Rome (1785–8), is discernible. His remoteness from topical events, even where it was raised to a heroic level, freed Prud'hon from the handicaps which his French confrères so rarely succeeded in quite overcoming when they painted Greek and Roman figures in the dress and uniforms of their own days.

With his dreamy lyricism, his veiled, melancholy charm, and his sensitive eroticism Prud'hon stood apart from doctrinaire Classicism, but the tranquillity, coolness, and purity with which these traits of his personality are displayed show how remote he was from the conceptions of Baroque, and to what an extent he was in fact bound up with Classicism. In his best works, especially his drawings with their richness and clarity, he makes us forget, as Ingres does, his links with his own time, with what went before it and what came after. Within the narrow limits of the esotericism of an immaculate 'World of Beauty' there lives a naturalness, a degree of gracefulness, which remind us of Mozart, who was almost exactly his contemporary.

JEAN-AUGUSTE-DOMINIQUE INGRES (1780–1867)

Ingres, the last of the great French Classicist painters, lived to be eighty-seven. In his native city, Montauban, he received an elementary training in painting and music from his father, who was a painter, sculptor, and architect. He then went to the academy in the neighbouring city of Toulouse, and at the age of seventeen became a pupil of David. His first mature pictures were painted just after 1800; nearly sixty years later, in his eightieth year, he produced one of his masterpieces, *The Turkish Bath* [24]. Throughout this long period, which began with Classicism and ended with fully-fledged Impressionism, his style, that is his treatment of form, remained practically unaltered. This phenomenon might be interpreted either as a rigid, narrow-minded adherence to a once-formed style, or else as proof of the conviction that it was possible to achieve the 'absolute' by means of a formative process continued through the whole of a long life. In the case of Ingres the second interpretation is true. Already the doctrines of Early Classicism comprised a claim to be absolute, valid for all time, proved by conclusions deduced from the classical art of Antiquity and the Renaissance. Ingres's art is in this special sense 'timeless'. The Classicist doctrines which David bequeathed to his pupils are applicable to the art of Ingres, but they do not explain its essence. There are two factors which have to be added, one of them clear and precise, the other, despite the powerful impression it produces, difficult to define and mysterious: the first is drawing as a basic element of form; the second is the element of nature in Ingres's pictures, the realism of the details of bodies and fabrics, and also the psychological truth of his portraits [18–20]. The predominance of drawing is the idealistic element in the art of Ingres, and on account of this alone he can be called a Classicist. The regulating, constructive power of drawing is even more important in his work than it is in David's, although David strove in principle to achieve the same aim. The close relationship between David and Ingres becomes particularly clear if we compare David's portrait of the Gérard family dating from the end of the cen-

tury [5] with Ingres's portrait of Madame de Senonnes painted in 1814 [19]. More important, even if often only slightly so, is the part played in the works of Ingres by that which his drawing renders, namely the reality he sees. Ingres was one of those virtuosi of idealistic form who continually stressed the necessity of close contact with nature. In this, despite everything else, he belongs, both in theory and practice, to the nineteenth century. There was even less of the

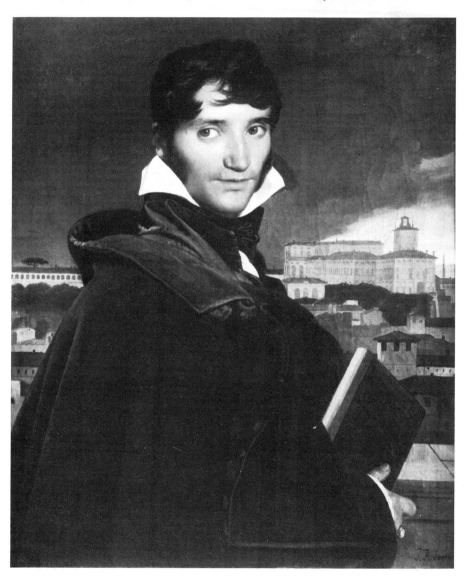

18 *(opposite)*. Jean-Auguste-Dominique Ingres: The Painter Granet, 1807. *Aix-en-Provence, Musée Granet*

19 *(below)*. Jean-Auguste-Dominique Ingres: Madame de Senonnes, 1814. *Nantes, Musée des Beaux-Arts*

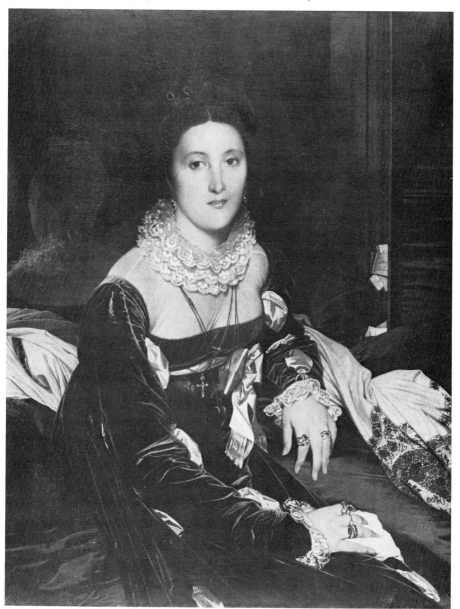

spirit of Baroque in his painting than there was in that of the older Classicists. The painting of the High Renaissance, or to be more precise, Raphael, provided the model for the architectonic and harmonious qualities in his art. He studied the Renaissance masters during the years he spent in Rome (1806-20), in Florence (1820-4), and – after an interval – again in Rome, as director of the French Academy (1834-40). It is true that, in addition to his numerous portraits, Ingres painted mythological, religious, and his-

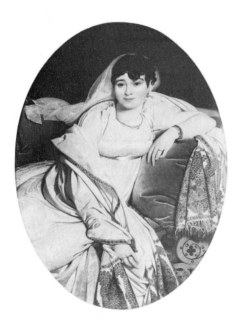

20. Jean-Auguste-Dominique Ingres:
Madame Rivière, 1805.
Paris, Louvre

21 *(opposite)*. Jean-Auguste-Dominique Ingres:
The Stamaty Family, 1818.
Pencil-drawing. *Paris, Louvre*

torical figure compositions (*Oedipus and the Sphinx*, 1808, Louvre; *Jupiter and Thetis*, 1811, Aix; *Roger and Angelica*, 1819, Louvre; *The Vow of Louis XIII*, painted as an altar-piece for the cathedral of Montauban and finished in 1824; *The Apotheosis of Homer*, 1827, Louvre, a kind of modern *Disputa*, painted as a ceiling picture for the Louvre; *The Martyrdom of St Symphorion* in the cathedral at Autun, finished in 1834), and also a large mural painting in the château of Dampierre, *The Golden Age* (1841-9; a smaller version in the Fogg Art Museum, Cambridge, Massachusetts); but it is significant that these figure compositions, which are part of the Classicist programme, rank even further below his portraits and single figures than is the case with David. Only rarely does he depict dramatic events – *Roger and Angelica* is the most noteworthy instance – his choice of subject-matter being normally restricted to the tranquillity of existence. This is typical of painters of ideas, but this limitation also made it possible for Ingres to achieve the harmonious calm of dispassionate contemplation, and so his pictures, not only his portraits, for all their idealization, create the impression of being products of direct vision.

Ingres's ideal of perfection demanded, in addition to a perfectly finished linear composition, an exact three-dimensional rendering down to the last detail, and as if to stress this he occasionally chose a round or oval shape for his pictures (*The Turkish Bath*, 1859-63 [24]; *Madame Rivière*, 1805 [20]; *M. Bochet*, 1811, Louvre). A deliberately sketchy structure never had any charm for him – with one characteristic exception. In black-and-white drawings – pure drawing being the only means of expression in a large number of portraits – Ingres placed softly and delicately modelled heads in settings which were often only indicated [21, 22]. This is an old recipe – one of the best-known examples is Holbein's portrait-drawings – and it could unite a play of lines with a masterly drawing of the

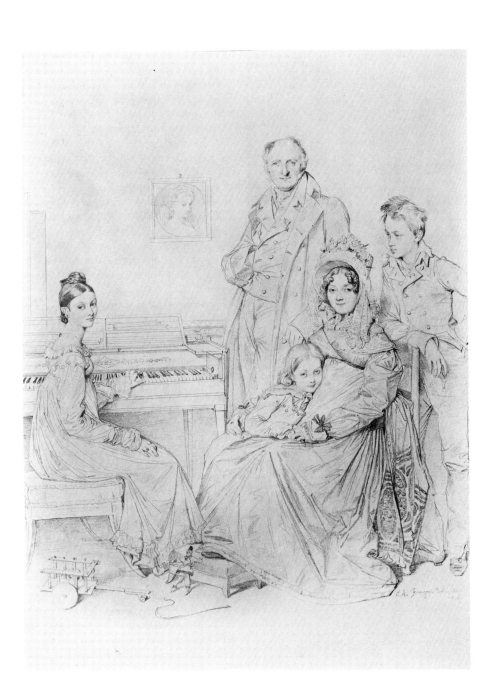

22. Jean-Auguste-Dominique Ingres:
Madame Destouches, 1816.
Pencil-drawing. *Paris, Louvre*

23 *(opposite)*. Jean-Auguste-Dominique Ingres:
Woman Bathing ('La Baigneuse de Valpinçon'),
1808. *Paris, Louvre*

form. Ingres's many drawings from the nude, for all their precision, are likewise for the most part freely executed and often soft and loose,[3] but in his paintings he accomplished the unusual feat of keeping his lines, which everywhere appear only as contours of the bodies, full of vitality and musical movement.

There was yet another factor in Ingres's striving for perfection – colour. However much the draughtsmanship may dominate the construction of his pictures, this never means that he neglected colour, but only that he assigned to it a subordinate role; and even then, it is felt as subordinate only in his pictures of imaginary figures. In the portraits, in the *Bathers* and *Odalisques* [23], the colour is exactly what the special character of his drawing required; the powerful and tranquil local colours have the same stamp of clarity as the drawing. The high degree of deliberateness which is an essential part of the art of Ingres finds expression in this relationship between draughtsmanship and colour, concerning which the painter himself said: 'There is no case of a great draughtsman not having found the exact colour to suit the character of his drawing.'[4] This, of course, is a claim rather than a statement, and the quotation is as characteristic of Ingres's striving after totality as the well-known words of Cézanne which are the converse of it: 'As one paints, one draws; the more harmonious the colour becomes, the more precise is the drawing.'[5] It would in fact seem that in the art of these two universal geniuses of painting something of the strength of the one primary element of form – in the case of Ingres the drawing, in Cézanne's the colour – has been communicated to the other. In spite of this, Ingres possessed a considerable natural talent for colour. He never turned to monochrome as a last resort. It is true that he cannot be called a master of colour in the way that Titian and Delacroix are, but his colour is of the same significance as that of Raphael, Holbein, Giorgione, and Vermeer. It is strange

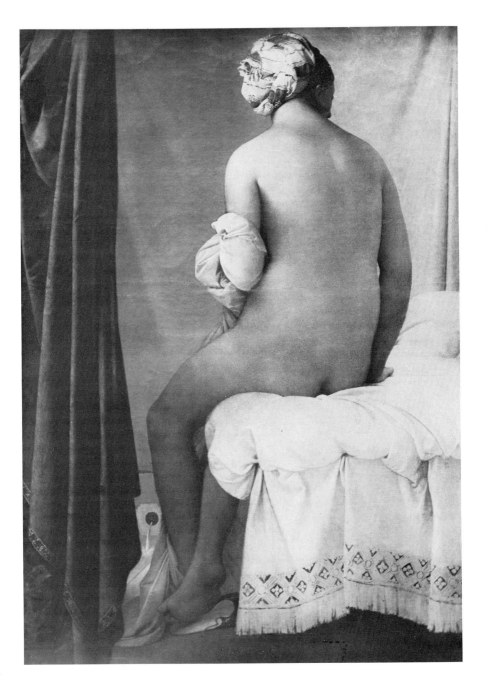

that the austerity and coolness of Ingres do not result in lifeless construction, but on the contrary are full of vitality; the solution of this mystery probably lies in the fact that in his case a vigorous temperament imposed order and discipline upon itself. This strength bound up with clarity of form is seldom directly perceptible in his pictures, and, curiously enough, it is most clearly discernible in a work of his old age, *The Turkish Bath* [24]. In the concise curves of the nude bodies there circulates a scarcely controlled energy, and the result is the often-remarked effect of a throng of crawling animals. Elsewhere this element is found only in the wholly sublimated form of monumental single figures. For all their lifelikeness, these are figures from an imaginary world, like those of Goethe's later poems or Stifter's *Nachsommer*. What in these literary works signifies the dignity of the typical and moral is expressed in the pictures of Ingres by the clarity and discipline of the forms. In this way Classicism becomes Classic.

In so far as the impression of 'perfection' in the art of Ingres lends itself to analysis, it rests,

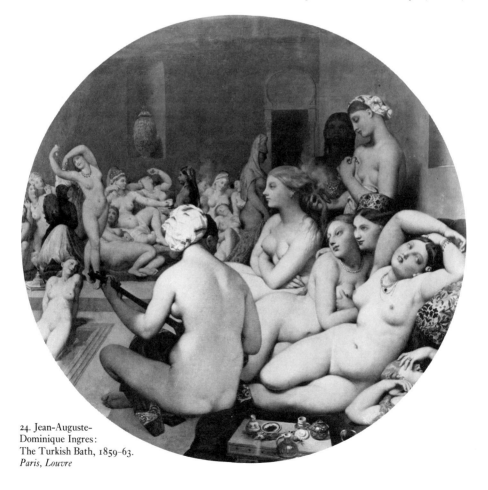

24. Jean-Auguste-
Dominique Ingres:
The Turkish Bath, 1859-63.
Paris, Louvre

or at least appears to rest, on the equilibrium of line, modelling, and colour – and, on a higher plane, on the equal values assigned to material reality and regulating form. It is understandable that subsequent artists were continually attracted by this kind of synthesis, not only those who, like Puvis de Chavannes, returned to the classical repose of Ingres's world, but even artists so different from each other as Degas, Renoir, and Picasso. For them the principle of synthesis was important; moreover each could find in the works of Ingres models for what he considered of the highest value in his own art. Ingres was thus the only painter of his century to bequeath to posterity an *œuvre* to which it could refer as to an original, elementary statement, just as he himself had shaped his *œuvre* according to the 'eternal laws' of classical art.

His art as a whole, and in particular the austerity of his draughtsmanship, is a direct antithesis to what became increasingly important in the course of the nineteenth century. Seldom, however, has an antithesis been so fruitful and of such convincing inner urgency.

CLASSICISM IN GERMANY AND AUSTRIA

At the beginning of German Classicism we find two painters in the contrasting essence of whose art the typical features, not only of German Classicism, but of Classicism in general, stand out with exemplary forcefulness – Anton Raphael Mengs and Asmus Jakob Carstens. The whole of their lives belongs to the eighteenth century, so that in reality a study of Classicist art should start with them, and not with the French representatives of the new style. Mengs and Carstens were by no means just forerunners and mediators of the transition from dying Baroque to the new idea of art; on the contrary, they already give the latter clear expression. But the works of both lack that degree of perfection and fulfilment, that completeness, and above all that overwhelming persuasiveness which make David the representative of the new style and the most influential artist of his age. For this reason we have given the first place to the French Classicists, who brought Classicism abruptly to the fore in their works, leaving the German Classicists for subsequent consideration. It is true that the latter, building on spiritual foundations, evolved a new method of creation at an early period; but since they remained for a long time without the balance which the French achieved immediately, there is some justification for leaving a discussion of them until now. The immediate influence of Mengs was unusually strong, but it evaporated very quickly after his death and seems today to be merely a typical example of an influence deriving from the intellect, from an artistic doctrine of a theoretical kind. Carstens, on the other hand, stood alone, and his influence, beginning only after he achieved success in the last years of his life, was more enduring because, though it was less wide, it was based on the uncompromising austerity of a profound temperament, on the strength of a conception of art pursued with fanatical unity of purpose.

THE BEGINNINGS IN THE EIGHTEENTH CENTURY: MENGS AND CARSTENS

Anton Raphael Mengs (1728–79) was not only Germany's first Classicist painter, but also the one in whose art Classicism is best exemplified in its superficial, literal aspect, as a Classical Revival. That is equivalent to saying that he was essentially eclectic, and that original, independent creation was, to a certain extent, excluded from his art. Winckelmann's claim that the 'brush the artist wields must be dipped in intellect'[1] might be placed as a motto above the work of any Classicist. As the most concise formulation of a tendency, it is also applicable in cases when a vigorous creative personality refuses to let itself be hampered by ideological dictates. But Mengs was not a vigorous personality, and the formula of Winckelmann, with whom he was closely connected, acquires in his case the negative meaning of a preponderance of the intellectual over the artistic element. He was, in fact, himself a theoretician, his most important work in this field being his *Considerations on Beauty and Taste in Painting* (1762), and the events which determined the change in the way of thinking outside the visual arts, in the field of the philosophy of art and the discovery of Roman antiquities, had a decisive effect on him, though with somewhat discordant results.

Soon after the middle of the century there appeared in Germany the works which established the new theory of art – Johann Joachim Winckelmann's *Reflections concerning the Imitation of the Grecian Artists in Painting and Sculpture*, 1755 (from which the celebrated maxim we have just quoted is taken); his *History of Antique Art*, 1764; the *Monumenti antichi inediti*, 1767; Gotthold Ephraim Lessing's *Laocoon, or the Limitations of Painting and Poetry*, 1763; while before the middle of the century the excavation of the ancient ruined cities had begun – at Herculaneum in 1736 and at Pompeii in 1748.

Germany and Rome were the decisive backgrounds of Mengs's life until his last years, the greater part of which he spent in Spain. From childhood he was trained to be a painter by his father, the Dresden Court painter Ismael Mengs (1688–1764); he visited Rome for the first time in 1741–4, and in 1745 himself became painter to the Saxon Court in Dresden. In 1754 he became director of the Roman Academy on the Capitoline hill in Rome. In 1761 he was summoned to Madrid as director of the royal tapestry manufactory.

Traditional Baroque and the new Classicist element are discernible in his art to the end, but clearly separated from each other. In this case that denotes an incapacity either to achieve a synthesis or to make a decision. The new element becomes positive only in so far as it concerns composition, the still calculable, or apparently calculable, element in painting. In Mengs's few figure paintings, which must be called Classicist, works of mythological or religious content, the composition is static, and the scene is acted on a shallow stage and arranged in accordance with the rules laid down by the High Renaissance. The most characteristic example of this is his *Parnassus*, the ceiling painting in the Villa Albani at Rome, completed in 1761 [25]. The composition here is put together by formula and produces the effect of a worked-out sum, in accordance with Mengs's principle of adding part to part, of deriving a general canon of construction from the stylistic

25. Anton Raphael Mengs: Parnassus, 1761.
Ceiling painting. *Rome, Villa Albani*

elements of the Classical masters, in particular Raphael, Correggio, and Titian. One of the chief reasons for the feebleness of this composition is the lack of a positive quality of line. Mengs's draughtsmanship has none of the Baroque liveliness and ease, and has not yet achieved the dominating force found in fully-developed, orthodox Classicism. In the monumental paintings of his later years, the large frescoes in the royal palaces at Madrid and Aranjuez, Mengs returns to the tenets of Baroque mural painting. In them he inserts his academism and eclecticism into a Baroque setting with fantastic expanses of sky. This hopeless attempt to compete with Giovanni Battista Tiepolo could produce only a tardy, strident, superficial, and sterile kind of Baroque.

So far Mengs's art might appear to be only of historical interest, but his numerous portraits are in a completely different category. To a certain extent they still belong to the Late Baroque court portraits of rulers and noblemen. Examples are the portrait of the Elector August II of Saxony (Dresden), which dates from the second half of the 1740s, and also several later portraits, which both in detail and essence reveal a painterly treatment of form. Something of these painterly qualities remains even in the colder and stiffer late portraits. All things considered, Mengs's portraits fulfil a function of portraiture valid even today, which preserved many elements of Baroque painting long after the turn of the century.

The life of Asmus Jakob Carstens (1754–98) has often been described as the first of those tragedies of artists of the new epoch, those cases of rebellion and isolation which were to occur time and again. Rarely, however, were the causes of the tragedy so exclusively due to personal human temperament. Carstens was proud, defiant, and aggressive. The son of a miller in a village near Schleswig, he spent his first years amidst poverty and gloom. For five years he worked as an apprentice cooper at

Eckernförde, and from this period date his first attempts to draw and his study of works on the theory of art. From 1776 to 1783 he studied at the academy in Copenhagen, and during the succeeding years in Lübeck. In 1783 he set out on a journey to Rome, which he had long desired to see, but owing to lack of funds he only got as far as Milan and Mantua, where Giulio Romano's frescoes in the Palazzo del Tè made a deep impression on him. The years from 1788 to 1792 he spent in Berlin, where he became a teacher at the academy. In 1792 he received a Prussian scholarship to go to Rome for two years. At the end of the two years he failed to return and made a violent attack on the academy, describing it as a tyrannical and materialistic institution. Thereupon he was dismissed. He stayed on in Rome and died there as early as 1798. The gist of his attack on the academy was a rejection of all that can be learned by routine work, and this rejection had a deep influence on his own art, which in his last years grew ever more intense and profound. There is hardly any other instance of a working artist carrying faith in the supremacy of ideas to such an extreme and with such consequences. If we compare Carstens's life-work with the standards of his Classicist contemporaries, we perceive that it differs fundamentally from theirs. His is creation clearly governed by strict internal laws, theirs are hybrid products of reason on the one hand, technical skill on the other. If, in referring to Carstens's contemporaries, we think in particular of the standard academic Classicism of Mengs, the contrast becomes a clash between mere rhetoric and spirit, between rationalistic frigidity and shallowness and urgent, almost oppressively profound feeling. If, however, we consider Carstens's work by itself, it appears problematical and contradictory. His *œuvre* is in many respects a fragment. He left many unfinished works, and several of those he completed have not been preserved and are known to us only through sketches of his or drawings made

after them. Such was the fate of his ceiling frieze in the queen's bedroom in the royal palace at Berlin, and the murals in the saloon of the Dorville house in Berlin, the former residence of the Prussian Minister of Education, Karl Friedrich von Heinitz, who was a patron of Carstens. Both these cycles were painted about 1790, and are thus still remote from Carstens's final style, which he developed during his stay in Rome. A model for a monument to Frederick the Great, which was to have been a joint work by Carstens and the architect Hans Christian Genelli (1763-1823), was destroyed in 1806. His only surviving sculptural work is a figure of *Atropos* preserved in the form of plaster casts (1794) [315]; see below, p. 390).

But Carstens's work also remained unfulfilled and fragmentary in a wider sense, in that his

26. Asmus Jakob Carstens:
Ganymede, *c.* 1795.
Pencil-drawing. *Weimar, Schlossmuseum*

27 *(opposite)*. Asmus Jakob Carstens:
Night with her Children Sleep and Death, 1795.
Pencil-drawing. *Weimar, Schlossmuseum*

most important compositions during his stay in Rome were almost invariably designs for monumental mural paintings of Greek mythological subjects, which all remained unexecuted. 'His soul lives only in wars of the gods, in battles of Titans, in Hesiod and Homer. He desires nothing more ardently than a wall seventy ells high, like that of Michelangelo's *Last Judgement*, on which he can work himself to death and become immortal.'[2] Such were the words which his most intimate friend and biographer, the art critic Carl Ludwig Fernow, wrote from Rome in 1795. Carstens lived in the shadow of Michelangelo, especially during his last years, when he had the great works of his idol all around him [26, 27].

Finally, Carstens's works appear fragmentary because they seem always to have left something unsolved, as a result of his rejection of routine training and the study of nature and of his indifference to colour, which he nevertheless would not renounce entirely. For example, in his few oil and tempera paintings and coloured drawings he used only a schematic, pale colouring as a timid and humble accessory to the dominating figure-drawing, a method which tends to disturb the effect rather than to help it. (More than a century later, there was a similar, more consciously speculative exclusion of colour in the first phase of Cubism.) But such problematical limitations and obvious deficiencies can become moving features if they are counterbalanced by an adequate strength of expression and mastery of form in other respects. This is the case with Carstens. Only in the works of his followers, in the mere outline drawings of Bonaventura Genelli [28] and even in the works of Cornelius, did this renunciation of colour and of many other means of expressing life lead to the bloodless rigidity of doctrinarianism. In spite of his ascetic self-restriction to mere draughtsmanship and modelling, Carstens managed to preserve in his more important figure pictures the organic vigour of a primitive world. It is as if he

had dreamed of something similar to 'abstract' music without instrumentation, the directest possible method of transforming spirit and idea into figures. In the reality of his work this endeavour was made entirely in terms of the stereotyped human figure of Antique stamp. He was wholly convinced that that was as it ought to be. It is this that proves the Classicist basis of his art. The importance of the *story* in the picture, of thought and poetry, was for him a matter of course. With the two elements of form – clear drawing and its rhythm and an undramatic, soft modelling – he contrived to create the fundamental tone of an elegiac, tragic atmosphere. In this he bore an occasional resemblance to Michelangelo. He exceeded the possibilities of his painting of ideas when he tried to personify Kant's categories of time and space (in a distich

The Latest from Rome, Schiller censured this attempt as soon as he heard of it), but he created one of his profoundest works with another allegory of supernatural powers, *Night with her Children Sleep and Death* [27] after the *Theogony* of Hesiod (1795). The composition has a classical equilibrium in so far as the figures in the foreground – Night and her children and Nemesis (the latter closely related to the Delphic Sibyl in Michelangelo's ceiling in the Sistine Chapel) – are concerned, but the crowded Parcae with the figure of Fate in the cave in the background weigh heavily on this harmonious texture of lines and three-dimensional forms. This oppressive element, the dim light, and the veil of sombre melancholy, which here form part of the content of the picture, are more generally speaking a Romantic trait in all Carstens's art.

Whether we interpret this as an expression of his Northern origin – he himself stressed this by often using the signature 'Asmus Jacobus Carstens ex Chersonesu Cimbrica' – or else as an imitation of the dramas of feeling in Michelangelo's gigantic figures, the fact remains that in this Carstens was furthest from the essence of Classicism. This oppressive, brooding solemnity, the tragedy of the sublime, is a counterpart to the melancholy of Prud'hon which underlies his immaterial grace [17]. For this reason the art of both Carstens and Prud'hon, taken as a whole, is not exclusively Classicist. One certainly cannot call Carstens a Romantic, but his art does contain the foundations of a later Romanticism. This anticipation of things to come is at its most mysterious in the similarities between Carstens and the most profound thinker among the German Romantics, Philipp Otto Runge [64, 65]. For Runge knew nothing of Carstens's works. On the other hand, unlike Blake and Fuseli, 'outsiders' so close to him in many ways, Carstens was a Classicist in that even the most Promethean among his Greek figures were always kept under control, and pain and agitation were subdued and fettered. Carstens stopped short of Michelangelo's Baroque *terribilità*. In the work of no other painter of his time is Winckelmann's conception of Greek Antiquity as an ideal of 'noble simplicity and tranquil greatness' given such pure and profound expression as in the drawings of Carstens.

In his extravagant and self-willed striving to achieve the absolute, to express the inexpressible, which was also the aim of the contemporary poets of 'Sturm und Drang', Carstens never faltered, not even during the exhaustion caused by his protracted illness; but there still remained a gap between the will and the way. As Kant, whom he revered, would have put it, there was something of an antinomy in his work, something unattainable in the translation of ethical ideas into visual art. Yet Carstens remains one of the great examples of the striving personality.

THE SPREAD OF CLASSICISM

The contrast in the fields of ethics and aesthetics between Mengs and Carstens shows at once that the picture of Classicism and of painting in general in Germany during the second half of the eighteenth century is far less uniform than in France. The cult of the super-real and the representation of visible surroundings were here far more sharply separated. (In this connexion it is characteristic that in the work of Carstens as against that of Mengs the portrait played a very subordinate role; Carstens was so convinced that contemplation was the only source of creative art that he drew portraits only against his will, in order to earn his daily bread, and with results of no consequence. The only exception is the self-portrait of about 1785 in the Kunsthalle at Hamburg, a coloured chalk drawing of a gently modelled face seen straight from the front, with anxiously staring eyes.)

In the German art of these decades one can feel everywhere that there had been no Revolution such as there had been in France. This saved German painting from the superficialities of French patriotic or propagandistic art, but at the same time it deprived it of the vigour of dramatic excitement. The speculative and sentimental side of the Classicist conception of art became more and more evident, and forerunners and pioneers of Romanticism began to reveal themselves in various ways, barely distinguishable from those of Classicism. The brooding spirit of Carstens, however, did not for the moment inspire his followers to take this romantic, sentimental direction; at first it was his idealization, hero-worship, and reduction to types that exercised the strongest influence. Carstens had no real pupils. When we speak of his direct influence, however, four artists are generally meant: the painters Wächter, Koch, and Schick, and the sculptor Thorvaldsen.

When Eberhard Wächter (1762–1852) arrived in Rome in 1794, he had already received train-

ing, first in Stuttgart and then in Paris under Jean-Baptiste Regnault and Jean-François-Pierre Peyron (1744-1814), a forerunner of David. In his chief work, *Job* (1807, not completed until 1824; Stuttgart), one can see that the impression produced by the works of Carstens had been strong enough to supplant the triumphant pathos of David's school. Despite all the weaknesses of Wächter's painting, the tranquillity and apathetic grief of the four men, and above all the naive expression of a fundamentally genuine feeling, are quite in the spirit of Carstens.

The connexion with Carstens of the most important landscape-painter of Classicism, Joseph Anton Koch (1768-1839), became very close after his arrival in Rome in 1795, owing to the deep impression made upon him by Carstens's exhibition in the former studio of Batoni. The result of Koch's study of the eleven compositions was a more intense interest in the rendering of the figure. It is true that the figure played only a secondary role in Koch's work [36, 37]; but precisely because he was a *Classicist* landscape-painter the human figure as an accessory to landscape had a certain significance, and to the end of his career the treatment of figures was to him an important matter [35]. Koch, during the years of his first stay in Rome, also became friendly with Wächter and Thorvaldsen, but Carstens remained his principal source of inspiration. When Carstens died he had left incomplete his designs for the *Voyage of the Argonauts* (Copenhagen, Print Room). Koch added to them and in 1799 converted them into a cycle of etchings. Of these he wrote in 1810 in his *Reflections of an Artist living in Rome*: 'That I etched these sketches was a token of my esteem and love for Carstens. By frequenting him I learned to shake off the dust of academic stupidity.'[3] Considerably later Koch copied other works by Carstens, such as his cartoon for *The Golden Age* (1811, Karlsruhe, Freiherr von Marschall Collection), and the water-colour

Dante and Virgil with the Pairs of Lovers (1823, Copenhagen, Thorvaldsens Museum). A long series of figure compositions by Koch, in particular his illustrations to Ossian (in the years just before and after 1800) and Dante, must be added to these copies after Carstens. Where they consist of drawings, the technique is far more impulsive, loose, and vivacious than Carstens's solemn, elegiac lines. This in itself marks the difference which separated the two artists. Despite all Koch's desire to imitate and especially his dependence on the layout of Carstens's composition, a drawing by Koch is, like the man himself, more cheerful, more 'earthy' than one by Carstens. In a late work, the frescoes in the Dante Room in the Casino Massimo in Rome (1825-8), Koch used the many studies he had made for monumental mural paintings since the beginning of the century of scenes from the *Divina Commedia*. In their feeling and method of presentation, however, they are already closer to the new age, especially to the Nazarenes, than they are to Classicism. Koch was a Classicist in his landscapes; he was a born landscape-painter, and in landscape his greatness and his historical importance lie. For this reason he belongs properly to another chapter.

In the figure drawings of Bonaventura Genelli (1798-1868) the influence of Carstens is even more evident than in the works of Koch which, after all, are mostly landscapes. Carstens, needless to say, had no use for landscape. Bonaventura was the son of the Berlin landscape-painter Janus Genelli (1761-1813) and nephew of the architect Hans Christian Genelli, who helped Carstens during the latter's Berlin period. Bonaventura thus already belongs to the generation after Carstens. With his cold and clear outline drawing, the real domain of his art, he represents a development of Carstens's style in the rendering of figures, with its complete renunciation of any attempt to achieve solidity by means of modelling. But this strict logic was not accom-

28. Bonaventura Genelli: Indolence.
Engraving illustrating Dante's *Purgatorio*, c. 1844

panied by an increased intensity. Carstens's draughtsmanship can be called ascetic; in it the term has its full, even its moral, significance. Thematically, Genelli's outline drawings embrace a far wider range. In addition to his illustrations for the *Divine Comedy* (c. 1844) [28] and for Homer (published as engravings in 1866), he also made drawings for *The Life of a Rake* (1840; two versions) and its counterpart, *The Life of a Witch* (1841–3), and an autobiographical cycle, *The Life of an Artist* (1850s; published as engravings in 1868). They are likewise richer in their vivaciousness and range of expression as compared with the one-sidedness of Carstens, but in many places they also reveal glibness and empty mannerism. This was a danger present in outline drawing as such – and also in outline engraving. Carstens was not

Genelli's only model for this kind of drawing, since it had already been presented in its most consistent form by John Flaxman (1755–1826). As happens so often in cases of extreme innovation, outline drawing proved very alluring, and its attraction lasted well into the nineteenth century, as the example of Genelli shows. At the end of the century it was revived once again in a new form (Beardsley), and there is a version of it in our own day (Picasso, Klee, Matisse, Modigliani, etc.), to a certain extent with a deliberate return to its Classicist beginnings. The reasons for this re-appearance in the art of the twentieth century are evident: it is a question not so much of Neo-Classicism as of radical faith in pure surface. The outline drawing is the extreme of formalism reached by Classicist painting. It is the furthest exaggeration of the Antique prin-

ciple of composition in bas-relief. Flaxman returned to that type of art in which Greece herself had created her extreme - the painting of vases. This offered a very tempting field for experiments in the effectiveness of the unbroken pictorial plane, and for attempting to solve the many problems of the relationship between surface and line. Flaxman did not exploit the possibilities of this kind of art to the full, since the demand for realism in his day was too strong and the consciousness of the purely formal significance of the surface too weak. (This situation did not change until the advent of the radical formalism of our own century.) Perspective, too, which he was unwilling to renounce completely, represented an obstacle.

For Classicism, and in particular for German Classicism, outline drawing was important not so much on account of the possibilities it offered in the evolution of pure form, but for the sake of 'purity' itself. Since in Classicist drawing - and drawing is the primary medium of the art of painting ideas during this epoch - expression and the illustrative, narrative value of line held a pre-eminent place, the tendency towards linear melody and the arabesque, which is also inherent in the outline style, could rarely find unrestrained scope. The result is, as has already been mentioned, a vacuous and doctrinaire proficiency. In this lies yet another difference between French and German Classicism. It is especially clearly perceptible in the way they fell prey to the different dangers inherent in the Classicist dogma, as in every dogma in art. Where French Classicism reached its artistic limits, the admixture of realism resulted in theatricality or, in the worst examples, in something resembling waxworks. In declining German Classicism, on the other hand, the composition was liable to become bloodless and artificial, and artists succumbed to the temptation to indulge in mere virtuosity in the pleasing arrangement of line. This is what the belated Classicism of a latecomer like Genelli demon-

strates. About the middle of the nineteenth century the original ideas of Classicism had ceased to be sufficiently genuine and alive, and moreover they were already permeated by the spirit of Romanticism and Realism. For this reason they were an obstacle to Genelli's undoubted talent as a draughtsman and to his unusual wealth of inventive fantasy. An artist like Ingres could remain a timeless Classicist, because his work was not subject to any literary idea; but in Genelli's drawings the charm of a melodious linear rhythm and the occasional unaffectedness of genuine arabesque were continually spoilt by hybrid effects.

A far more robust and unequivocal figure was Genelli's rather older contemporary and fellow-worker in the same field, Peter Cornelius (1783-1867), in whom the spirit of Carstens likewise survived. His soul too 'lived only in wars of the gods, in battles of Titans'. As, however, his art was not merely an echo, and as in the second quarter of the nineteenth century he became the leader of German monumental painting, we shall speak of him later.

The third of the painters mentioned above in connexion with Carstens, Gottlieb Schick (1776-1812), like his fellow-countryman the Swabian Wächter studied for a few years in Paris before going to Rome, where he arrived in 1802. Between 1787 and 1794 he had been a student at the Karlsschule in Stuttgart under Hetsch and the sculptor Dannecker, and from 1798 to 1802 he worked in David's studio. Already while working under Philipp Friedrich von Hetsch (1758-1838) he had come into indirect contact with French Classicism; for Hetsch had worked under Vien and David during the early 1780s, and in Rome and afterwards in Stuttgart had evolved a correct but arid Classicism in historical pictures and portraiture. Under the direct influence of David, Schick's art found its true scope, which can be concisely described as a combination of the painterly element in the French tradition and the essential

29. Gottlieb Schick: Wilhelmine von Cotta, 1802. *Stuttgart, Staatsgalerie*

characteristics of German Classicism. This combination was wholly successful only in some of his portraits, for example those of Dannecker's wife (1802, West Berlin), of Frau Cotta (1802) [29], and the double portrait of Adelheid and Gabriele, the children of the painter's friend Wilhelm von Humboldt[4] (1809, formerly Schloss Tegel near Berlin). In these works the German characteristics are so strongly marked that they are as representative of German Classicist portraiture as David's masterpieces of portraiture are of French Classicism. The difference is that Schick's portraits contain one degree more of 'narrative', that the landscape has more to say, and that – especially in the metallically hard and statuesque monumental portrait of Frau Cotta – the drawing has a greater independence than in David's portraits. To the figures of his mythological and biblical compositions – and this is especially clear in his chief work, *Apollo with the Shepherds* (1808, Stuttgart) – Schick gave something of the solidity of his portraits, and also a sensuous gracefulness; he set them in that clear, cool light which makes of gods and genii living earthly beings. Nevertheless, these figures, not only as creatures of fantasy, but also from the artistic point of view, obviously come from another world – the world of Carstens's austere draughtsmanship. In Rome, in 1804, a few years before he painted the double portrait of Humboldt's daughters, Schick had portrayed the mother of the two girls, Karoline von Humboldt, and her four children (formerly Schloss Tegel near Berlin) as half-naked figures in the antique style, in a drawing heightened with white in the style of Carstens. These two works are opposite poles. In other works, and with less cramped tension and more naturalness, Schick achieved something more like a balance between the two elements than is found in those of his contemporaries. When August Wilhelm von Schlegel gave a philosophical interpretation of Schick's *Sacrifice of Noah* (1805, Stuttgart) and spoke of the 'dignity and symbolical abundance of the subject', which the artist had successfully presented, his remarks were rationalistically exaggerated in a way typical of the spirit of the times, but they were at least linked to a painting which was not unworthy of them.

With his portraits Heinrich Christoph Kolbe (1771–1836) of Düsseldorf also belongs to the school of David – in the first years of the century he worked under Gérard and Vincent – but he used its doctrines, not to obtain formality or decorative idealization, but to achieve a matter-of-fact, slightly pedantic characterization.

Alongside these few outstanding personalities of German Classicism – Mengs, Carstens, Schick, Koch – who established the new programme in art and gave it individual expression in their works, the great majority of painters remained 'between the styles'. They are typical artists of a period of transition; the innovations either remain more or less unexpressed or mingled with the old forms of expression, or else they are grafted on to the surviving remains of conventional Baroque form with occasional strange discrepancies. This, in many gradations, was no more than a repetition of the intermingling in the art of Mengs of the Late Baroque painterly vision with the demand for new subject-matter and new principles of form. As in the works of Mengs, in those of many painters of his nearer or wider following the Baroque traditions survived longest in portraiture. Considered as an anonymous whole, late eighteenth-century portraiture in Germany often presents, in comparison with that of Baroque, only a progressive cooling off. Just as in architectural decoration and in ornament of this period, well-tried formulas, single bits of *rocaille*, are arranged in a new, more tranquil, but also less vigorous and more discrepant manner, so in portraiture the new is expressed in the old language. The rather paradoxical term 'Baroque Classicism' is justifiable when one is speaking of this genre.

It is difficult to pick out the few individual portrait-painters who rose above the level of the dying court portraiture with its craftsman's routine. The first place belongs to Johann Friedrich August Tischbein (the 'Leipzig' Tischbein; 1750–1812). He was one of the younger generation of a numerous Hessian family of painters, and was first a pupil of his father, Johann Valentin Tischbein (1715–68), and later of his uncle, the Hessian court painter Johann Heinrich Tischbein the Elder (1722–89). Only towards the end of his career do we see in the works of the latter the first feeble signs of a quenching and weakening of Rococo agitation and painterly bravura pointing the way towards Classicism. The mixture is as characteristic of Johann Heinrich Tischbein as it is of Johann Georg Ziesenis (1716–76), who worked for several German courts. Johann Heinrich Tischbein worked for a time abroad, in Paris under Carle van Loo and in Italy under Giovanni Battista Piazzetta, but without any discernible effect on his portrait-painting as a whole. Very different is the position of his nephew Friedrich August, in whose work we can recognize immediately the fruits of his sojourns in foreign countries, in Holland and Rome, where he came into contact with David, Mengs, Füger, and English portraitists. English portraiture in particular gave a freedom and lightness to his work which is rarely found in German portraiture of the time. The virtuosity of Romney and Raeburn is mitigated in some of the best of his late portraits, in order not to disturb the soft atmosphere of a somewhat languid charm; for example in the family portraits of the Hereditary Prince of Weimar (Weimar, Schlossmuseum) and the Hereditary Princess Christiane Amalie of Anhalt-Dessau (1798, Dessau) and the portraits of Duke Karl August of Sachsen-Weimar (1795, Weimar, Schlossmuseum) and Countess Theresia Fries (1801, Hamburg). Another aspect of his painting is a certain *soigné*, tasteful character – but tasteful-

ness was a quality which could *per se* have very little importance for Classicism.

Johann Heinrich Wilhelm Tischbein (the 'Goethe' Tischbein; 1751–1829), another nephew of Johann Heinrich Tischbein the Elder, was of a more robust nature. His best-known and also his best achievement, the portrait of Goethe in the Campagna (1786–7, Frankfurt am Main), owes its popularity not only to the fame of the subject, but also to the fact that in it, by a lucky inspiration, a type is created within the narrow limits of eclecticism: the type of the portrait of a celebrated contemporary in an antique attitude and with rather theatrical draperies. Far removed from the pompous formality of this picture is another well-known portrait of Goethe by Tischbein, a pen drawing, showing the young poet, seen from the back, at a window (1787). This has all the freshness of a fleeting impression.

Anton Graff (1736–1813), who was born in Switzerland but worked for most of his life at Dresden, avoided the use of pose or fancy dress in his portraits – and indeed any other form of idealization, with the exception of a competent calm and composure in the construction of bodies and setting. There are still Rococo elements in his pictures, but the trend towards objectivity is strong, and they represent a kind of objective Classicism, containing an idea only in so far as every portrait must express an idea of the sitter. Many celebrities sat to Graff, and although he did not turn them into heroes, they are by no means made to look 'middle-class' [30]. Most of them are representatives of an unpretending upper middle-class cosmopolitanism which was a new, far-reaching ideal of the time.

While speaking of objectivity, lack of pretension, and bourgeois elements in portraiture at the end of the eighteenth century, mention must be made of Daniel Nikolaus Chodowiecki (1726–1801), an artist whose work, to an almost greater extent than that of any other at that time, belongs to this secular side of the new style.

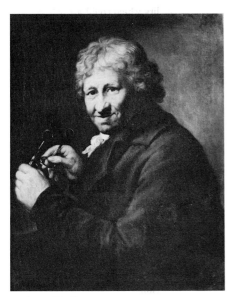

30. Anton Graff:
The Painter Daniel Chodowiecki, *c.* 1800.
Munich, Bayerische Staatsgemäldesammlungen

31. Daniel Chodowiecki:
Ladies in a Studio, *c.* 1760.
Pencil-drawing.
(West) Berlin, Staatliche Museen, Print Room

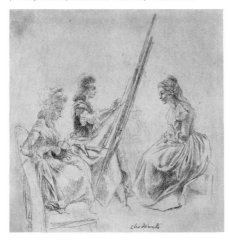

Attention to little things, to the beauties of everyday objects, was rare in those days of ideological exaggeration and of an aestheticism which took grandeur and sublimity as its ideals [31]. The painters who appreciated the value of ordinary things remained isolated, both in the portrayal of landscape and in that of human beings. In both types they could express themselves with unobstructed ease only in sketches. In their finished works, which alone were looked upon as being valid, they could include only occasional passages. To a certain extent this is true of Chodowiecki too, for he produced his most valuable work in sketches of Berlin life – not that of the upper classes, who attached importance to theatrical effects and formality in the Baroque or the new Classicist sense, but the bourgeois and lower middle-class milieu of his own circle. Chodowiecki, who was born in Danzig, moved to Berlin in 1743 and stayed there to his death. In 1797 he was appointed Director of the Academy. In his etchings, the naturalness and unaffectedness of the sketches – which are counterparts to those of Moreau le Jeune in France [14] – had to be adapted to the formulas of the current style of illustration, but they are nevertheless very much alive. For the most part they are illustrations to contemporary works of literature which appeared in very small format in almanacs such as the Berlin, Göttingen, and Gotha Almanacs. Among other works Chodowiecki illustrated Lessing's *Minna von Barnhelm*, Goldsmith's *Vicar of Wakefield*, Sterne's *Sentimental Journey*, Voss's *Luise*, Schiller's *Die Räuber* and *Kabale und Liebe*, Goethe's *Hermann und Dorothea*, *Götz von Berlichingen*, and *Die Leiden des jungen Werther*, Lavater's *Physiognomische Fragmente*, Klopstock, and Gellert. In this side of his art, the portrayal of manners, Hogarth and Greuze can be recognized as his models, the latter especially in *Calas taking Leave of his Family* (1767, West Berlin), which he painted before his extensive activity as an etcher.[5] From Chodowiecki's

beginnings as a craftsman drawing for the decoration of boxes and painting of enamels many elements survive in his *œuvre*, for example a Rococo trend towards prettiness and playful wit. This, however, is combined with objectivity in a highly personal manner, and the result is a sober, rigid charm. This was undoubtedly partly due to inspiration from the realism of the Berlin painter Christian Rode (1725-97), who for a time was Chodowiecki's teacher.

In the portraits of the Austrian Joseph Georg Edlinger (1741-1819) - who was born at Graz, worked first in that city and afterwards in Vienna and Hungary, and from 1770 on lived in Munich - and especially in those painted after 1800, there is a very personal, free manner of painting with delicate, warm tones, closely related to the Baroque (i.e. the last stages of the Rococo, 'Kremser-Schmidt's' chiaroscuro, and Dutch seventeenth-century painting), but in his simple models human beings are observed in their characteristic commonplaceness, and this again reveals the spirit of the new century.

Angelica Kauffmann (1741-1807) was born at Chur in Switzerland and spent most of her successful life in Italy, with a stay of a few years in London. She too aimed at retaining the effects of the painterly Late Baroque methods of expression, but on the whole succeeded in doing so only in her portraits, for example those of ladies depicted as Vestal Virgins or Sibyls (Dresden, *c.* 1782). In her Classicist mythological and biblical scenes little trace of Baroque remains, and what takes its place is no more than an unctuous softness and tediousness. The painters who followed this trend were for the most part at a loss to decide between these two tendencies and unable to combine them. The ideal which hovered before their eyes was fundamentally the principle of Late Renaissance and Early Baroque, but at that time painting had developed in the opposite direction and possessed the organic strength of an era of great art.

The ideal was of the kind expressed in the works of Dosso Dossi or of the later Titian. Titian, Raphael, and Correggio formed the trinity worshipped by Mengs, and the distance separating the early from the late, the Renaissance Titian from the 'baroque' Titian, did not constitute an obstacle to this. It is characteristic of the eclecticism of Classicist art that, apart from the Antique, room was found for such a wide range of models, from Raphael to Michelangelo. The painters of the last decades of the eighteenth century were only doing what artists have always done with their models: they took from them what they found useful. In doing so they often laid hold of the essentials, but at the same time they often turned them in the direction best suited to their own needs. In individual Classicists this procedure is merely part of a natural creative process, but taking Classicism as a whole, and remembering its normative tendencies, it reveals a significant contradiction.

As regards the principle of combining painterly Late Baroque with Classicist subjects and the Classicist spirit, Friedrich Heinrich Füger (1751-1818) is very close to Angelica Kauffmann. But he was an incomparably more independent and greater artist, and the leading figure in Austrian painting. Füger was by birth a Swabian. After his first studies in Stuttgart, Dresden, Halle, and under Adam Friedrich Oeser in Leipzig, he went in 1774 to Vienna. After residing from 1776 to 1783 in Italy, where he came into contact with David, Mengs, and the Austrian sculptor Franz Anton Zauner, he returned to Vienna for good and became Director of the academy and eventually of the imperial picture-gallery. In his portraits, many of them masterly miniatures, he reveals both the influence of English portraiture and the after-effects of Austrian Late Baroque. This legacy of Baroque painting had a decisive influence on the whole of Austrian art at the end of the eighteenth century. From its still living traditions Füger

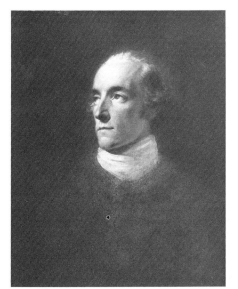

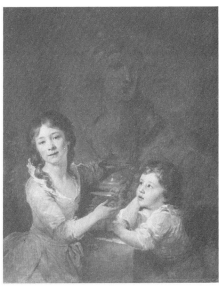

32. Friedrich Heinrich Füger:
Count Franz Joseph Saurau, c. 1797.
Vienna, Österreichische Galerie

33. Johann Baptist von Lampi the Elder:
Two Children of Count Thomatis, c. 1790.
Vienna, Österreichische Galerie

was able to derive not only the charm of a culti-vated use of colour, but also, in sketch-like historical scenes and in certain portraits (such as that of Count Franz Joseph Saurau of about 1797 [32][6]), a harmonious golden-brown *sfu-mato* in the manner of Johann Martin Schmidt ('Kremser-Schmidt'; 1718-1801). In both these elements the vigour and mysticism of Baroque are converted into a gentle refinement.[7] Into his late figure compositions, of a clearly Classicist trend, Füger was unable to put anything of equal value to the aristocratic culture of his portraits.

Johann Baptist von Lampi the Elder (1751-1830) and his son J. B. Lampi the Younger (1775-1837) also showed themselves at their best in portraiture [33]. Their masterly and charming portraits also owe something to the court portraiture of the last years of Baroque, the after-effects of which are so clearly visible in

the works of Füger. This is also true of Anton von Maron (1733-1808), a pupil of the Viennese academy and of Mengs, his brother-in-law, in Rome, who in his portraits reveals a dazzling mastery of the painting of materials (portraits of Winckelmann, 1768, Weimar, Schlossmuseum).

The first and at the same time the most im-portant Austrian painter who can be called a Classicist completely emancipated from Ba-roque was Peter Krafft (1780-1856). He brought the foundations of his Classicism with him from Paris, where he had been a pupil of David from 1801 to 1804. He was not Austrian-born, but came from Hanau on the Main and arrived in Vienna in 1799, where he worked in the academy under Füger until 1801. Except for short inter-ruptions he remained in Vienna until his death. His chief works in the field of monumental painting are the three large murals in the

34. Peter Krafft: Return of the Emperor Francis
after the Conclusion of Peace at Pressburg in 1809,
1825-30. Wall-painting. *Vienna, Hofburg*

imperial chancellery wing of the Hofburg [34].[8] The interval in time between these pictures of 1825-30 and David's comparable works dating from the first decade of the century (*The Corona- tion of Napoleon, The Distribution of the Eagles*) finds exact expression: as monumental, pathetic- ally heightened illustrations of the history of the period Krafft's murals are a continuation of what had evolved in France at the beginning of the century. The fine gestures of individual figures in the foreground among the group of spectators, the vigorous, clear light, and the very deliberate, skilful composition of the groups are Classicist traits, but the liveliness and closeness to nature of the three gay scenes are not merely the expression of the positivist side of French Classicism. To the tendency towards the grandiose and the impetus of festive rejoicing and solemnity permeating scenes of this kind is now added the charm of intimacy. For this reason Krafft's three wall-paintings, apart from being examples of monumental Classicism, can at the same time be called leading works of 'Alt- Wiener' genre-painting. Within the framework of the monumental painting of the nineteenth century, they represent the rarely achieved pos- sibility of enhancing realism into monumentality without any loss of power. In the field of monu- mental painting David had never been so genuinely followed. In earlier large works Krafft was still striving towards his goal. This applies to the two battle-pictures for the Inva- lidenhaus in Vienna, representing the battles of Leipzig and Aspern, painted respectively in 1817 and 1819,[9] which are rather too obviously compiled according to recipe; in *Departure* (1813) and *Return of the Landwehr Soldier* (1820, Vienna, Museum of Military History), which form a pair, the posing and the desire to edify are also too obvious.

In Austrian painting at the turn of the century there is no real intermediate position between Füger and Krafft. Only in portraiture did Martin Ferdinand Quadal (1736-1808) and Josef Kreutzinger (1757-1829) strike a mean between the past aristocratic and the coming bourgeois conception. A personality of outstanding individuality was Barbara Krafft (1764-1825). She saw people with a psychological intuition still rare in the portraiture of her time, and this involved a restlessness which expressed itself in a flickering vivacity in the brushwork, in a colouring freed from all trace of the academic, and in a peculiar rendering of light. All this leads to an almost demonic effect, which inevitably reminds one distantly of Goya, though it cannot be supposed that there was any direct connexion.

Significantly enough, in the Austrian painting of these years there is a lack of noteworthy examples of that trend in Classicism which kept aloof from reality and close to the Antique. The interest in reality, in nature as represented first in human beings and then in landscape, was stronger than the trend towards the ideological. When Austrian painting could not altogether ignore the spirit of the times, it concentrated either on reflection and the super-terrestrial in pictures springing from religious contemplation – I am here referring to the works of the Nazarenes painted when Classicism was already on the decline – or else on a peculiar kind of landscape-painting in which a latent form of spiritualization of natural phenomena is revealed. The earliest examples of this are the Classicist landscapes of Joseph Anton Koch.

LANDSCAPE-PAINTING DURING THE CLASSICAL REVIVAL

Classicist landscape-painting is a phenomenon whose very existence is surprising, for it is really a contradiction in terms. However, a mighty impulse made light of the contradiction and what has turned out to be the last great period of European landscape art began in the middle of the Classical Revival, and not primarily in opposition to it. It is true that in the Classicist conception of the world and art there was no place for landscape. In so far as they paid any attention to it at all, the theoreticians assigned to landscape the lowest place in the hierarchy of the arts. The ethical requirements of Classicism, the demand that the fine arts should give pictorial form to the humanistic ideas of Enlightenment and show 'beauty and sublimity' as being tantamount to truth and goodness – this task could be directly fulfilled only by pictorial narratives or, in a less literary form, by the human figure.

Despite all this, several approaches to landscape remained open. For the most relentless Classicist ideologists, landscape was not even a matter worthy of attention, either in theory or in practice. The more profoundly sensitive of them felt that landscape, i.e. undisciplined, formless nature, was a hostile element. On the other hand, many theoreticians of art during the period of Enlightenment found a justification for landscape in the accidental figures or scenes that could be inserted as a means of providing moral edification. For example, the aesthetician Johann Georg Sulzer, father-in-law of Anton Graff, wrote in his *General Theory of the Fine Arts* (1771–4): 'Just as every historical painting is good in its own way, if it represents a scene from the world of morals which vividly arouses salutary impressions and evokes, or revives, moral ideas, so, too, landscape is good in its own way when it represents similar scenes in inanimate nature; especially when these are heightened by concordant objects from the moral world.'[1] It must be noted that in this highly dignified justification of landscape, Sulzer at least mentions inanimate nature. That point of view, of course, was not far removed from the belief that non-human nature, as something not reduced to order, must be subjected to an ethical idea or an aesthetic discipline. In the case of landscape, however, this was less easy to formulate than the canonical order of the proportions of the human body as the expression and symbol of ideal values seen in the art of Antiquity and the Renaissance. In each case order denoted something different, and the principle common to both could not at once – that is at the same moment in history – be grasped. For this reason Classicist attempts to paint landscape as an *idea* necessarily remained far behind the much simpler representation of ideas by means of the human figure. Only at a somewhat later stage did such attempts appear, backed by the power of individual talents, above all Koch's. On the other hand, as *form*, Classicism could be applied to landscape once the latter refused to let itself be completely repressed by the negative pronouncements of the theoreticians. Ever since the sixteenth century landscape had been in the artist's consciousness, and thus it was not possible suddenly to decide to shut one's eyes to it. Regardless of the programmes and ideas, there ran through the eighteenth century an undercurrent of landscape-painting which found a ready public among lovers of the genre. What was depicted was certainly in many cases a very artificial

nature, but on the whole the landscape-painting of the latter half of the eighteenth century was pregnant with possibilities [43, 45, 47]. Based on the patient development of glorious traditions, and venturing boldly into new fields of conception, involving contradictions and paradoxes but also remaining consistent, landscape-painting did indeed begin to free itself from the restrictions of a specialist's genre, to explore new regions and depths, and to assume the leading role in a century destined to become pre-eminently that of the natural sciences.

The art of Joseph Anton Koch is not the beginning of Classicist landscape, but its fulfilment [35-7]. In the origins of Koch his artistic destiny is foreshadowed; for this first great painter of high mountains was the son of a poor peasant in a mountainous region, born in the Tyrolese village of Obergiblern near Elbigenalp in the valley of the Lech. Young shepherds who become famous artists are a favourite theme in books dealing with the lives of artists, and here was an actual case. At the age of sixteen Koch began his studies at Augsburg, and in the following year, 1785, he became a pupil of Hetsch and of the landscape-painter Adolf Friedrich Harper (1725–1806) at the Hohe Karlsschule in Stuttgart. In 1791 he threw off the bonds of academic training, and, during the following years, he lived in Basel and in the Bernese Alps. A walking-tour in Italy in 1794-5 brought him to Rome, where he remained until the end of his life, except for a period of residence in Vienna from 1812 to 1815. The impressions derived from the Alps remained a decisive element in his landscape-painting; indeed most of his Italian landscapes are of mountain scenery. In his diary for the year 1791, that is to say before his visit to Switzerland, he described the view from Tuttlingen on the Lake of Constance as follows: 'From east to west, as far as the eye can see, one beholds the whole southern sky veiled in mist, as if traversed by a thousand gleaming bodies often separated from the earth, whose crown-like summits seem to be a part of the distant sky. What stranger could imagine that beneath this there is such a boundless range of mountains? He could only wonder and guess in vain. Yes, there are immeasurably high and far-stretching Alps, numbed with eternal frost, laden with masses of ice, supported by rocks piercing the sky. Separated from the earth by a sea of clouds, they seem to be the masters of the sky.'[2] This description is not only evidence of Koch's literary talent, of which we have many proofs in his letters and writings;[3] it has also a significant figurative meaning. Just as, in this passage, the poetical description of one artist's emotions precedes his first attempts at a corresponding pictorial rendering, so in Europe at that time literary descriptions of high mountains preceded the painted representations of the mountain world which, in the form of 'heroic' landscape, finally became true Classicist landscape. Albrecht von Haller's epic poem *Die Alpen* was written as early as 1729, Salomon Gessner's *Idyllen* appeared in 1756, Goethe's descriptions of the Swiss Alps date from 1775, 1779, and 1797. These are only a few outstanding examples of the moralizing or descriptive landscape poetry which in Germany went before the creation of a landscape-painting inspired with the same spirit and of comparable quality. The priority of thought and literature over painting is clearer in landscape than in the field of the human figure.

In all Classicist landscape-painting the relationship between the human figure and the landscape is of prime importance. In Koch's works, to look first of all at quantitative ratios, sometimes one dominates, sometimes the other. In one group of pictures, which he himself described as 'historical and poetical landscapes', the two elements are kept in balance, and it is difficult to decide which is the more important. An early work like the scene from Ossian painted in 1796-7, *Fingal struggling with the*

35. Joseph Anton Koch:
Macbeth and the Witches, 1835.
Innsbruck, Landesmuseum Ferdinandeum

spirit Loda (Private Collection), or the late
Macbeth and the Witches [35],[4] shows the artist
obviously attempting to correlate a dramatically
constructed, imaginary landscape with the
dramatic conflict, giving to the two forces,
figure and landscape, approximately the same
space in the picture. As a general rule, however,
in this kind of picture Koch's figures are small,
even if they illustrate important events, and the
landscape is the dominating element.[5] This is an
old pattern, to be found from the beginnings of
landscape-painting in the early sixteenth cen-
tury, in the works of Patinir and his circle, down
to Elsheimer and finally to Poussin and Claude.
When, as in these landscapes, figures are
thematically important but of small size, one
can be certain that the landscape has not risen
to the dignity of art and is not a completely inde-
pendent genre. However, this curious relation-
ship clearly denotes the way in which landscape
was striving with all its strength to achieve inde-
pendence. At the same time these cases reveal
the prevalence of an idea, the idea of the
'universal landscape', that is to say the belief
that painting in this genre, instead of being an
excerpt from nature, ought to be a compendium
of landscape forms and of human habitations
and activities in a natural setting. The most im-
portant and characteristic of Koch's landscapes
are designed according to this principle, most of
them being imaginary landscapes made up of a
multitude of layers, zones, and details, each of
which has a high degree of independence. In the
paintings of the *Bernese Oberland* (three versions
painted between 1815 and 1817) [36][6] Koch re-
produces the wooded valley and the flat plain of

36 *(below)*. Joseph Anton Koch:
The Bernese Oberland, 1815.
Vienna, Österreichische Galerie

37 *(opposite)*. Joseph Anton Koch:
The Schmadribach Waterfall, 1821-2.
Munich, Bayerische Staatsgemäldesammlungen

the opposite corner. Even when he reduces the accessory figures to a minimum, as in his views of the *Schmadribach Fall* (two versions painted between 1805 and 1822) [37],[7] he retains this division into zones, the principle of the addition of part to part being carried to such a pitch that the picture offers no single uniform focal point. This method of construction, naive and artificial as it is, conveys almost better than any other an impression of the immensity of the world of high mountains. Koch's landscapes become epics of nature, in which the individual com-

the river, the foothills, crags, and glaciers, and includes a fragment of untouched nature in the right corner of the foreground, with a scene depicting the life of the mountain dwellers in

ponents produce effects like those of the stanzas of a poetical narrative. In this rendering of the grandeur and sublimity of nature there is an almost complete exclusion of mood. The lighting

of such pictures is generally cold, clear, neutral, and factual – exactly the same as in those early forms of European landscape-painting at the end of the Middle Ages, but very different from the moving landscapes of Jakob van Ruisdael or Allaert van Everdingen (to whom Koch nevertheless owes a great deal). If Koch's 'universal landscapes' thus repeat a situation as it had

existed in European landscape-painting three hundred years before, they were bound to suffer from the disadvantages of such a repetition, even if in his case these disadvantages were reduced by the saving grace of his naivety. On the other hand it need hardly be said that there were also differences between Koch's day and the early days of landscape-painting. One of these was the new significance of ideas in landscape, since, about 1800, the clearly ordered world was considered not so much as a divine creation, but rather in the secular sense as the expression of an ethical principle in the Law of the Universe. In the second place, a higher degree of direct observation of nature is discernible in pictures of this period than in the landscapes of the early sixteenth century, even though they are essentially derived from memory and literature. The strength of the instinct to arrange compositions is shown in Koch's many landscapes with Italian motifs – especially from the neighbourhood of Rome and Olevano – in which an orthogonal and crystal-clear cubic construction predominates. We feel that we are in the presence of a rebellious, fiery genius breaking away from Baroque rhetoric and submitting to a strict discipline – this is why Koch's landscapes have such a powerful effect, and this also makes them an unequivocal declaration of the Classicist idea of the world.

It has not yet been expressly mentioned that during the Classicist period the important centres of landscape-painting were Italy, Germany, and the Alpine countries, and that this revival of European landscape had its origins mainly in the works of artists from the German-speaking countries. The Latin countries, France and Italy, made no noteworthy contribution. As for England, though her contribution was considerable, it was from the very beginning directed more towards a closer approach to nature than to 'ideal' landscape. That Italy, the Classicists' promised land, played an important role as a source of motifs, need hardly be men-

tioned. Quite as important, however, is the fact that mountains had taken the place of the plains as the chief motifs. During the Baroque period the plains had predominated both in life and in art; it was there that the aristocracy lived, and it was there that country houses and gardens were built. The exploration of the mountains was only just beginning. This set significant limits to Baroque landscape-painting in so far as it was concerned with the rendering of reality. In addition there was the influential position of Dutch landscape-painting, where flat countryside was nearly always portrayed. It might at first, therefore, seem puzzling that, when a new independent landscape-painting arose with Classicism, plains did not continue as a favourite motif; for pathos and sublimity, the two principal items in the Classicist conception of nature, were as inherent in the boundlessness of space in flat country and on the seashore as in the mountains. The pathos of emptiness, however, was not apprehended until the advent of Romanticism, the next stage in the development of landscape art. For Classicism the basic idea which dominated all art, and hence landscape-painting as well, was not the pictorial but the architectural and sculptural aspects of nature: in other words mountains. This was the way in which landscape-painting could manifest the relationship between idea and figure in which Classicism believed, and this determined the limits of classical landscape.

These limits appear entirely self-imposed when a personality of the calibre of Koch works within them, but in the landscapes of painters of lesser stature they seem to cramp the immensity of nature. In their work, too, the supremacy of draughtsmanship, which is such a prominent characteristic of Classicism, was in itself a limitation. Koch is closely related to them in his tendency to confine himself to idyllic and 'heroic' landscape, although those minor masters who were older than he was contributed hardly anything to his development. His sources were

the same as theirs, the great landscape-painters of the sixteenth-century and the idealistic land-scape-painters of the seventeenth (Poussin, Claude Lorrain, Rubens, Elsheimer, Salvator Rosa), but he surpassed them all in the forceful-ness and independence of his vision of nature.

Gottlieb Schick also painted a number of 'historical landscapes', but they were only a side-line in his work. Koch could recognize in him an artist striving to achieve the same aims as himself. But when it came to the far more celebrated Jakob Philipp Hackert (1737-1807) the position was different, since for Koch Hackert represented the outmoded style of the preceding generation. Hackert studied at the Berlin Academy; during the 1760s he lived at Stralsund and on the island of Rügen; from 1765 to 1768 in Paris; and from 1768 onwards in

Italy. His landscapes are derived from the *vedute*, and he remained faithful to them to the end [38]. Ten years of very prolific output, in collabora-tion with his brother Johann Gottlieb Hackert (1744-73), reduced the construction of his land-scapes to a mere formula. His best works, however, reveal a sober objectivity and a feeling for spaciousness and clarity which seems super-ficially obscured in his usual compositions by the schematic use of scenic wings, as it were, and by many-coloured multitudes of little pieces of ground and buildings with neatly trimmed trees and pretty little accessory figures. In many respects his landscape-painting is the opposite of the pathos and the heroic exaggera-tion in which Koch and his followers believed. They therefore rejected it vigorously, but it was equally vigorously attacked by the increasingly

38. Jakob Philipp Hackert:
Lago d'Averno, 1794. Gouache.
Munich, Bayerische Staatsgemäldesammlungen

numerous adherents of Naturalism. Hackert's art is indeed frequently too complaisant and has a kind of courtly formality – he was, in fact, court painter to the king of Naples from 1782 to 1799 – but on the other hand we must not overlook the fact that its artificiality and coolness and the cleanness and sharpness of the drawing are merely another expression of that idealization of landscape equally typical of the Classicists.

Poetic ideas appear in a more obvious and conscious form in the landscapes of the Swiss painter Salomon Gessner (1730-88), the author of the *Idyllen*. Some of them are illustrations to his own poems (*Schriften*, 1770-2 and 1777-8); indeed one might say that the works of this dilettantist turning late to the visual arts, most of them etchings (in all about 400) and some of them gouaches, are themselves painted poems [39]. In them we see secluded nooks and

Arcadian fields, embellished with solitary, for the most part Antique, buildings, and sparsely populated with small Antique figures – ideal landscapes of an imaginary, 'innocent' nature. They are filled with an elegiac, dreamy tenderness, but despite their fundamentally lyric tone they are distinguished from Romantic art by a trace of rationalism, which shows itself in a multitude of small sharply drawn forms as fine as filigree. Gessner, like Koch, was a theoretician as well as a landscape-painter. His *Brief über Landschaftsmalerey an Herrn Fuesslin*[8] was published in 1770. His colours, though pallid, are better suited to landscape composition than the tepidly hesitant or vitreously hard colour-schemes of many of the other painters in this genre. For most of them colour was merely what it was for all Classicists – a necessary evil and a cause of embarrassment.

39. Salomon Gessner: Bathers in a Stream, *c.* 1767-8. Etching

40 (*opposite*). Johann Christian Reinhart: Italian Landscape with Hunter, 1835. *Copenhagen, Thorvaldsens Museum*

The landscapes of Johann Christian Reinhart (1761–1847) cover a wide range, from the idyllic to the heroic, from fresh, unaffected observation of nature to the artificial construction of ideal scenery [40]. He drew upon many sources, beginning with his teachers Adam Friedrich Oeser (1717–99) in Leipzig and Johann Christian Klengel (1751–1824) in Dresden, then Philipp Hackert and Salomon Gessner, and, in the years he spent in Rome from 1789 to his death, Joseph Anton Koch; and, of course, beyond all these he was constantly aware of the classical painters of landscape: Poussin and Claude Lorrain, Gaspard Dughet and the Dutch Italianists. The great doctrine of the Dutch masters was transmitted to him in particular through Klengel; it was a fruitful source for him to the end of his career, and to it he owes his series of etchings of animals, which can be counted among the earliest and best works of this kind.[9] In his landscape etchings, the finest of which were published as a collection in 1799 – one of them, *Stormy Landscape*, is dedicated to his friend Friedrich Schiller – the firm construction of the landscape and the conciseness of the treatment of light are impressive and result in a monumental plasticity. Reinhart's personality was sufficiently vigorous to maintain itself against all the numerous influences to which he submitted himself. In his best works, for example in the late, grandly conceived rocky landscapes for the Villa Massimi in Rome (1825–9) and the four views of the Eternal City from the Villa Malta (painted for King Ludwig I of Bavaria, 1829–35; now at Munich), he can be considered inferior in importance only to Koch.

The heroic landscape with its alluring emotionalism lingered on for a long time, since the

41. Carl Rottmann: Taormina and Etna, 1828.
Munich, Bayerische Staatsgemäldesammlungen

conception it expressed was not tied to the style of any moment. It developed in a completely unbroken line from the German artists working in Italy at the beginning of the century to later 'German Romans', i.e. to the landscapes of Böcklin and Feuerbach. Carl Rottmann (1797–1850) [41] and Friedrich Preller the Elder (1804–78) were the leading practitioners. Their landscapes, however, lack the naivety which had balanced the reflective element in the early days of the heroic landscape, but which was no longer accessible to a later generation. Hence in their works emotion is always in danger of degenerating into theatricality. It became more and more difficult to bring idea and vision, literature and painting, into accord, and the inability to bridge the gap was to be characteristic of the century's painting. Both Preller and Rottmann favoured landscapes of monumental format, to master

which an exceptional talent for stylization would have been necessary. Rottmann's frescoes for the Hofarkaden in Munich (1830–3; now in the Munich galleries) and Preller's Odyssey cycle (executed in 1832–4 for the former 'Roman House' in Leipzig; a second cycle dates from 1865–8) are in this monumental style. Preller and Rottmann failed, however, to establish the landscape as mural painting, and no satisfactory solution of this bold task was ever found during the nineteenth century. In Rottmann's best works, though not in Preller's, a remarkable talent for colour can be discerned. Its development owed much to the early influence of the Scottish landscape painter George Augustus Wallis (1770–1847), who during his stay in Rome about the turn of the century became friendly with Carstens and after 1812 spent a few years in Heidelberg. The more intimate side

of Rottmann's art, both in the colouring and in the general approach, is reminiscent of the manner of Blechen [159] and Bonington [114]. Spiritually akin to them and comparable also for their pictorial quality are the landscapes of Johann Wilhelm Schirmer (1807-63). In those of the architect Karl Friedrich Schinkel (1781-1841), despite the genuineness of conception and talent, the romantic lighting and fantastic buildings produce something of the effect of stage scenery, which was in fact one of Schinkel's fields of activity.

In the work of all these painters, who already belong wholly to the nineteenth century, there is a more or less noticeable degree of Romanticism, especially in the rendering of light. Nevertheless, their landscapes, even those of Rottmann, are far from being truly Romantic landscapes. In their essence they are still close to Classicism.

This is as good a point as any other at which to make brief mention of the activity as a draughtsman of a great dilettante, the greatest in an age when drawing as a polite accomplishment was the fashion, Johann Wolfgang von Goethe (1749-1832). Goethe was one of those poets who, like Adalbert Stifter and Gottfried Keller, for a time believed that painting was their real vocation. During his stay in Leipzig (1765-8), he received his first serious training from Oeser, who since 1764 had been the director of the academy in that city. Oeser had studied under Georg Raphael Donner in Pressburg, under Daniel Gran, and under the Empress Maria Theresa's court painter Martin van Meytens in Vienna. Oeser's own productions, revealing a somewhat frigid post-Baroque Classicism, perhaps influenced by Donner, are far less important than his activity as a teacher and his influence on Winckelmann and Goethe. For Goethe, Oeser's theoretical ideas meant more than the training he received in drawing and etching. What Goethe learned from Wilhelm Tischbein, Johann Conrad Seekatz (1719-

42. Johann Wolfgang von Goethe: Gretchen appearing to Faust and Mephistopheles on the Blocksberg, *c.* 1812. Wash-drawing. *Weimar, Goethe-Nationalmuseum*

68), and Hackert (whose autobiography he edited in 1810) was likewise of no great value to him. Of the lessons in workshop practice and professional skill Goethe absorbed very little, and his extensive work as a draughtsman was thus hardly influenced at all by the artists he knew. As the production of a dilettante, his *œuvre* would hardly be worth mentioning were it not for occasional flashes of emotion in the presence of nature which are quite isolated in the period. The landscape drawings made during his journey through Switzerland in 1775 (*Waterfall on the Reuss, Parting Glimpse of Italy from the St Gotthard Pass*, both in the Goethe-Nationalmuseum at Weimar) and during the Italian journey in 1786-8 are, in their primitive strength, as remote from the standard form of intellectualizing Classicism as they are from the narrowness of naturalistic landscape at the end of the eighteenth century. They have no significance as tokens of development, and they are neither more nor less than the isolated expressions of a genius; but as such they make us aware once again of the boundaries between the two great categories of landscape art during the Classicist period. Some of Goethe's drawings – and in this respect he shows himself to be a Classicist – reproduce dramatic and wildly fantastic scenes [42] and events of nature. But whereas in Koch's drawings similar effects are achieved by a revival of old graphic forms (the landscape drawings of Titian, Campagnola, and Bruegel), Goethe's drawings remain improvisations of a bold yet unpretentious sketchiness. Sometimes, in his early drawings, we find a certain anticipation of the feeling for landscape of the German Romantics, for example Caspar David Friedrich and Carus, whose art Goethe esteemed highly in his old age.

Mention has already been made several times of a second tendency in Classicist landscape-painting, which forms a contrast to the heroic, Arcadian, or idyllic tendency. Its original creative impulse was not the idea, poetical

imagination, or the ethical conception of an ideal nature harmonizing with human standards, but the observation of real landscape. For the sake of brevity and intelligibility, these two types can be called idealistic and realistic landscape. The gap between them is, at all events logically, so great that one is tempted to describe the realistic type simply as landscape-painting during the Classicist period rather than as Classicist landscape-painting; yet it is in a certain sense a complement to the idealistic type. The position corresponds to that in figure-painting where enough naturalistic elements were also added to the strictly idealistic ones to distinguish Classicist figure-painting clearly from any earlier remoteness from nature.

The moment when the new realistic landscape-painting began is more difficult to determine than that of the beginnings of the new style in the representation of figures, since the transitions from the illustrative landscape of the Late Baroque are often imperceptible. This is partly due to the close relationship with the landscape-painting of the great Dutch masters. Something of this relationship remained after landscape had in the main emancipated itself; for it was still considered a matter of course that a painter ought always to rely on some model from the past. Neither is it easy to pick out the leading figures among the numerous German landscape-painters of the second half of the eighteenth century, since individual pictures, the results of solitary meditation and reverent observation of nature, are more characteristic of the situation than individual painters, though the abundance of painters is in itself a clear sign of the new interest in realistic landscape.

The chief painters to cultivate the intimate Dutch tradition were Christian Georg Schütz the Elder (1718-91) and his nephew and pupil Christian Georg Schütz the Younger (1758-1823), both of Frankfurt, Johann Christian Klengel of Dresden, and Ferdinand Kobell (1740-99), active in Mannheim and Munich,

and his brother Franz Kobell (1749-1822). Dutch intimate landscape was not their only model, however; there was also the pathos of Ruisdael and Everdingen, whose influence is most apparent in Ferdinand Kobell. The seven upright panels in the 'Cold Bath' in the grounds of the Schwetzingen Palace (1772) are characteristic of Ferdinand Kobell's early style. In conformity with their purpose, they still contain traces of the tapestry-like Baroque landscape with its scenic wings. In his later works Kobell freed himself, to a greater extent than did the other minor masters of landscape during this period of transition, from the Dutch conventions of stylization, and viewed nature more independently, though still in the spirit of the Dutch masters. Two of his landscapes are particularly well known, and each is typical of one

of two categories: the landscape in the museum at Schwerin, full of spatial impulse, with a view over a sunlit plain behind a steeply rising rock, and the tranquil view of the Goldbach valley [43], one of a series of views of the district round Aschaffenburg painted in 1785-7 for the Elector of Mainz, Friedrich Carl Joseph von Erthal. Common to both these is the treatment of light, which is quite unusual, and heightened to an extraordinary degree of delicacy; it is translucent and full of contrasts in the mountain landscape, of a veiled indistinctness in the modest view of Goldbach. With these 'portraits' of the Aschaffenburg landscape Ferdinand Kobell – who remained ostentatiously aloof from Italian landscape – made an important stride in the history of intimate landscape. In this respect one can rank him with the Saxon painter

43. Ferdinand Kobell: View of Goldbach, 1785-7.
Munich, Bayerische Staatsgemäldesammlungen

Christoph Nathe (1753–1806) with his astonishing studies of villages, or with Johann Jakob Dorner the Younger (1775–1852) and Max Joseph Wagenbauer (1774–1829) among the group of early Munich landscape-painters.

Wilhelm von Kobell (1766–1855), who spent the greater part of his life in Munich (from 1792 when he became painter to the court), continued the manner of his father and master Ferdinand Kobell not only in his borrowings from the Dutch, in particular the painters of animals,[10] but also, and still more significantly, in his interest in the rendering of light. He became a specialist in the painting of light during the early years of the nineteenth century, like his contemporary Hummel in Berlin, the slightly later Waldmüller in Vienna, and the Danish landscape-painters. In Kobell we find a cool,

clear sunlight with long shadows, which gives the figures a hard, metallic solidity. There are motifs reminiscent of Berchem and Cuijp – horsemen on the flat banks of lakes or in the plains of Lower Bavaria near Munich – and they are set in that cold light which must have been at least partly inspired by the French Classicists whom Kobell studied during his stay in Paris in 1809–10. In the broad panorama of his *First Horse-Races in Munich during the October Festival in 1810* (painted in 1811; Munich, Städtisches Historisches Museum), this influence is equally clear. Kobell also painted huge, panoramic landscapes, containing highly original battle-scenes (*The Siege of Kosel*, 1808 [44], *The Battle of Wagram*, 1811, both Munich; *The Encounter at Bar-sur-Aube*, Munich, Armeemuseum, etc.). In these the armies are

44. Wilhelm von Kobell:
The Siege of Kosel, 1808.
Munich, Bayerische Staatsgemäldesammlungen

represented by tiny, stiff figures resembling toy soldiers. They remain completely aloof and have no other connexion with the events depicted than that provided by the landscape in which they are set, and this despite the fact that they were commissioned as patriotic historical pictures by the Crown Prince Ludwig. Landscape sensations – slanting sunlight, driving rain, morning mist, or transparent background haze – achieve greater importance in the picture than military sensations. In this they are similar to Baroque battle-panoramas, where landscape also predominates, and the masses of tiny human figures are subordinated to the dynamic elements in nature as expressed in the conformation of the terrain. Such a conception has little to do with Classicism; it is much nearer to the objectivity of Biedermeier realism, and is in fact a slightly mannered Realism. Yet the striking orthogonal composition, emphasized by the frequent long strips of shadow, and the crystalline sharpness of the modelling have a curious relationship to Classicism. They remind one of the formal construction of the views of buildings and towns painted by Bernardo Bellotto. In itself orthogonality is not a Classicist principle – one knows that, for instance, from Chardin; it is much rather the expression of an artist's personality; but it must nevertheless have some connexion with Classicism, since it appears so obviously at the beginning and end of the Classicist period. We may interpret it as an emphasis on the static, architectonic elements in nature, and architecture was after all the art in which Classicism rose to its highest, and certainly least problematic, achievements. This superiority of architecture is understandable, for it was only in architecture that Classicism could move in the sphere of pure proportions and forms, freed from any problem of representing ideas. This interpretation of orthogonality, however, cannot be applied to painting, for it occurs far too exceptionally. The only field in which it found

general application was the engravings of *vedute*. These, however, are only on the outskirts of art, since in them the determining factor was the subject as such, and wherever that is the case stylistic characteristics appear in a vulgar and coarsened form. However tempting it may be to follow such by-paths, it is impossible in a book such as this to select even a few outstanding figures for closer consideration from among the great multitude of producers of *vedute* in all countries.

In Austria, just as historical painting was of minor importance as compared with portraiture, so the heroically conceived landscape played a smaller part than the realistic. In the agitated High Baroque landscapes of the Tyrolese artist Anton Faistenberger (1663–1708) there might have been the foundations of a grandiose Classicist landscape art similar to that found in Germany, for example in the landscapes of the Saxon painter Johann Thiele (1685–1752). But in actual fact towards the end of Austrian Baroque the realistic landscape took the lead, in particular in the works of the Viennese Johann Christian Brand (1722–95). His apprenticeship under his father Christian Hilfgott Brand (1693–1756) had shown him the way to the schematically limited landscape idyll in the Dutch manner, and out of this he evolved beautifully constructed pictures of flat country, full of chromatic delicacy, in which there are still many traces of Rococo artificiality and finesse.[11] In a few of his late pictures, however, especially in his *Danube near Vienna with the Leopoldsberg* at Vienna [45], he is far in advance of his time in his tendency towards naturalistic landscape in certain definite moods. Compared with such freedom, the landscapes of Michael Wutky (1739–1823), a painter from Lower Austria, appear to be completely tied down by current fashions. Wutky is the Italianist among the Austrian landscape-painters about 1800. When, in some of his works, he manages to get beyond

45 *(below)*. Johann Christian Brand: The Danube near Vienna, *c.* 1790. *Vienna, Österreichische Galerie*

46 *(opposite)*. Johann Jakob Biedermann: The Pissevache Waterfall, 1815. *Winterthur, Kunstmuseum*

the narrow limits of eclecticism, the impulse of Baroque perspective seems stronger than the charms of intimate observation.

After Koch, who was Austrian in origin, the most significant figure in Austrian non-romantic and essentially still pre-romantic landscape-painting in the early years of the nineteenth century was Josef Rebell (1787–1828), a pupil of Wutky. His bright landscapes, with their mainly Italian motifs, have a certain Arcadian serenity which manages to dispense with all Antique stage properties. Its essence is a combination of a transparently clear, tranquil composition with a delightful treatment of sunlight. Though of a different school, Waldmüller is close to Rebell's landscapes in spirit.

This serene ideal landscape with its roots in Classicism survived until after the middle of the century in Austria as well as in Germany. One

of its best representatives was the Hungarian Karl Markó the Elder (1791–1860), who, however, had only a brief connexion with Vienna and after 1832 lived in Italy. He bequeathed his self-confident, cultured style of landscape-painting and his themes to his son Karl Markó the Younger (1822–91).

In Switzerland, none of the painters contemporary with Salomon Gessner can be called Classicists in the same sense. If they were not painters of *vedute* – which in a tourist country like Switzerland was only natural – they were creators of idylls of a more schematic kind. Compared with Gessner's poetical absorption with a 'golden age' of nature [39], the landscapes of Johann Heinrich Wüest (1741–1821) of Zürich, Ludwig Hess (1760–1800), Salomon Gessner's son Konrad Gessner (1764–1826), the Winterthur artists Ludwig Aberli (1723–86)

and Heinrich Rieter (1751-1818), and Peter Birmann of Basel (1758-1844), a pupil of Aberli, are far more prosaic in the way in which they idealize motifs derived from Dutch seventeenth-century art. It is curious and significant that they followed Dutch models even when painting the mountains of their own country – yet another proof of the preference given to art rather than to nature as a source of inspiration. It is only occasionally that anything of the mightiness and grandeur of high mountains finds its way into their pictures. Examples are Wüest's view of the Rhône glacier (Zürich), certain landscapes by Caspar Wolf (1735-98), and the *Pissevache Waterfall* (1815, Winterthur, Kunstmuseum) [46] by Johann Jakob Biedermann of Winterthur (1763-1830). The reverse procedure is more characteristic. The view of the *Lower Reichenbach Fall* (Neuchâtel) painted in 1818 by Maximilien de Meuron (1785-1868) shows Swiss mountains rendered with the gentleness and care of the Dutch Italianists and the 'German Romans' with whom Meuron came into contact when he went to Italy after 1810. The same contrast exists in English landscape-painting of the period, between the monumental and silent mountain scenery of Francis Towne's water-colours and that of the other water-colourists. In general, one can say that these Swiss landscape-painters tended towards the typical, and not yet towards the characteristic. In the idyllic elements of works by the younger generation of these artists there is occasionally an anticipation of the Biedermeier painting of moods, for example in the painting by Ludwig Hess of a woodland glade called *Des Malers Lust* ('The Painter's Joy', Basel, private collection), which reminds one of Spitzweg.

47. Louis-Gabriel Moreau: The Château de Vincennes, seen from Montreuil, *c.* 1770–80. *Paris, Louvre*

48 *(opposite)*. Théodore Caruelle d'Aligny: Landscape with Prometheus, 1837. *Paris, Louvre*

In so far as the dictatorship of David permitted any landscape-painting at all in France, it followed in the footsteps of the great French classics of landscape, Poussin and Claude Lorrain. Compared with the Germanic countries and England, there was no opposition to this academic and eclectic manner, which would have made the rise of the new landscape possible. For a long time after the Revolution French painting knew practically nothing of the heroic landscape of the type painted by Koch or the forerunners of Naturalism, just as later, in the landscape-painting of Early Romanticism, it had only a few isolated works of equal quality to place beside them. Such isolated examples are the landscapes of Louis-Gabriel Moreau (Moreau l'aîné, 1740–1806) [47], Jean-Laurent Houel (1735–1813), and the equally personal, brilliant landscapes of Hubert Robert (1733–1808); his landscapes really belong to the eighteenth century and have no direct link with the future. Not until much later did France again have a voice in European landscape-painting. The French landscape-painters working in the academic manner are today forgotten, though a few of them still live in the history of art as the teachers of Corot: Achille-Etna Michallon (1796–1822), Jean-Victor Bertin (1775–1842), and Théodore Caruelle d'Aligny (1798–1871) [48]. They, and in addition Jean-Joseph-Xavier Bidault (1758–1846), with his Italian landscapes echoing those of the elder Joseph Vernet (1714–89), and Pierre-Henri de Valenciennes (1750–1819), began as pupils of the leading Classicists – Michallon counted David among his teachers, Bertin was a pupil of Girodet-Trioson, d'Aligny of Jean-Baptiste Regnault – and studied Italian landscape. As

they grew older they occasionally made a closer study of nature. Some of d'Aligny's landscapes, with imposing, excessively large scenic wings in the foreground, may have influenced Corot. Something of the early naturalistic studies of Corot is foreshadowed, moreover, in a few landscapes by Lancelot-Théodore Comte de Turpin de Crissé (1782–1859). The French landscape-painters, like the Germans and Austrians, modelled themselves on the Dutch; proof of this are the landscapes of Jean-Louis Marne (see above, p. 36), who in his early days painted historical and genre pictures, and Jean-Jacques de Boissieu (1736–1810). It was not until this imitative art had come to an end that French nineteenth-century landscape-painting could really begin, though it must certainly be admitted that the Barbizon school was indebted to it for its beginnings.

The position of landscape-painting in the other countries – Italy, Belgium, Holland – was identical; everywhere we find the same general predominance of eclectics and minor talents. Only in Denmark and the Scandinavian countries did the situation about the turn of the century differ. In the landscapes which Denmark's leading portraitist, Jens Juel (see below, p. 89 f.), occasionally painted after his stay in Switzerland (1777–9) we seem to be able already to trace, amidst the coolness, delicacy, and decorativeness of the usual Classicist idyllicism, a kind of local character [49]. In any case, the excessive sharpness of the minute forms and the clear and tender light remained typical of Danish landscape-painting when, soon afterwards, it achieved full maturity. In Sweden, this kind of Classicism in landscape had no followers. In the paintings, and especially the

49. Jens Juel:
The Little Belt, seen from a height near Middlefart,
c. 1800. *Copenhagen, Thorvaldsens Museum*

water-colours, of the foremost Swedish land-
scape-painter of that time, Elias Martin (1739–
1818), the heroic tradition is sometimes found
side by side with an astonishingly direct render-
ing of data, that is to say Baroque side by side
with the new feeling for reality. The years he
spent in London, from 1768 to 1780, doubtless
encouraged him to follow this trend.

The position of landscape-painting within
Classicism, the style which forms the subject of
this chapter, is so strange that it must be sum-
marized and once again emphasized. In the
progress step by step of closeness to nature, a
general fact about Naturalism in painting be-
comes evident with exceptional force – the fact
that Naturalism can link up with all kinds of
conceptions of art, even those apparently
utterly alien to it. Early proof is the way in
which in Netherlandish painting of the late
Middle Ages extreme naturalism as a secular
element was accepted in sacred, spiritual,
transcendental representations. The case of
Naturalism within so spiritual and intelligent a
movement as Classicism is similar.

CLASSICISM IN OTHER COUNTRIES

THE NETHERLANDS – ITALY – SWITZERLAND – SCANDINAVIA

Generally speaking, Classicist painting was created by French and German artists, and no other Continental country substantially enriched or modified it. Not only was there a lack of outstanding personalities, but also, owing to the marked dependence of these areas on the achievements of the two centres, there was little chance for national idiosyncrasies to develop. Such idiosyncrasies as there were can be judged according to their relationship to the two fundamental manners of Classicism, the vital, heroic pose of the French, and the speculative attitude of the Germans, the latter from the very beginning impregnated with Romanticism. The Romantic version of Classicism was confined to Germany, and it was French Classicism that the outlying regions strove to rival. However, while they retained the heroic pose, they did not possess the vital strength.

In Belgium the only outstanding artist was François-Joseph Navez (1787-1869), who studied under David from 1813 to 1816 and spent the following four years in Rome. In some of his portraits, especially in the best-known of them, *The de Hemptinne Family* (1816, Brussels), he came very close to his model David. Mathieu-Ignace van Bree (1773-1839) was also a portraitist and history-painter; he was a pupil of Vincent in Paris and the teacher of Gustaaf Wappers (1803-74), Ferdinand de Braekeleer (1792-1883), Nicaise de Keyser (1813-87), and Antoine Wiertz (1806-65). Through him the loud pathos and the dangerous mixture of declamation and naturalism in the historical paintings of Vincent (see above, p. 33) were

handed down to this group of painters of Belgium's national history, which, after 1830, the year in which Belgium became independent, formed a distinct school. This school, whose leader was Wappers, has nothing to do with Classicism in the proper sense.

Holland during most of the eighteenth century was one of those countries that had sunk into exhaustion after a glorious past, and from the end of the century Italy was in the same position. Here Pompeo Batoni (1708-87), who both in his dazzling society portraits and in his pseudo-Classicist religious pictures is a kind of Italian counterpart to Mengs, was followed by the tired Davidism of Andrea Appiani (1754-1817), whom Napoleon appointed Italian court painter, by the routine art of Vincenzo Camuccini (1771-1844), the official Italian representative of the spirit of Mengs, especially in his portraits, and by Francesco Hayez (1791-1881), who in his historical paintings and portraits already reveals the influence of Romanticism. The portraits of Giuseppe de Albertis (1763-1845) are modest, and for that very reason original. Léopold Robert (1794-1835), a pupil of David and Gros, lived in Italy from 1818 and, especially with his best-known work, *The Return of the Harvesters from the Pontine Marshes* (1830, Paris, Louvre), founded the Classicizing Italian genre-painting of the first half of the century. This soon became a very questionable speciality, but some of Robert's own works, single figures of Italian women, still have the nobility and clarity of genuine Classicist portraiture. Robert was born in western Switzerland and is consequently

50. Jacques-Laurent Agasse: Westminster Bridge, 1818. *Winterthur, Oskar Reinhart Foundation*

claimed by Swiss historians to be a Swiss artist, with the same amount of justification as in the case of Graff. Several other Swiss painters about the turn of the century received their training in Paris. The versatile Jacques-Laurent Agasse (1767–1849) [50] studied under David and Carle Vernet and lived from 1800 on in London, where his elegant landscapes with horses and dogs suited the local taste for animal and sporting painting; Johann Jakob Oeri (1782–1868) and his friend David Sulzer (1784–1864) worked under David; Wolfgang Adam Toepffer (1766–1847), the father of Rodolphe Toepffer, belonged to the circle of French genre painters during the Empire – Debucourt, Boilly, and J.-L. Marne. These Swiss painters formed a group of 'minor masters' who produced portraits (Sulzer, Oeri) and pictures of everyday life (Agasse, Oeri, Toepffer) of a classical coolness

and at the same time a 'Biedermeier' cosiness. Quite apart from this neat, but for the most part rather artificial and mannered, rendering of a friendly world, there blazed a sombre and uncanny flame: the art of Fuseli with its nightmares and visions of horror. It, too, contains much that is artificial, a wild gracefulness coupled with a feverish demonic energy which is the very opposite of the idea of Classicism. Johann Heinrich Füssli the Younger (Fuseli; 1741–1825) was born in Zürich and studied under his father, the Zürich painter and writer on art Caspar Füssli the Elder (1706–82). In 1763, together with a schoolfellow, the physiognomist Lavater, he went to Berlin, where he studied under the philosopher J. G. Sulzer (see p. 67). Throughout his life he was interested in the theory of art, and he translated Winckelmann's *Reflections concerning the Imitation of the*

Grecian Artists in Painting and Sculpture into English, as well as several of Lavater's writings. In 1764 he went to England, and there, except for a stay in Italy, where he met David and Winckelmann, and a visit to Paris in 1802, he spent the rest of his life. For this reason his art is not dealt with here, but in the volume devoted to the English painting of the period.

In the northern countries the most unmistakable Classicist was a sculptor: the Dane Bertel Thorvaldsen. In his works his contemporaries saw the complete realization of the ideal of a Renaissance of Antiquity. Another Danish artist, however, almost a generation older, who deserves to be placed on the same level as Thorvaldsen, is Nicolai Abraham Abilgaard (1743–1809), whose Classicism was of a very personal kind. In one of his most characteristic works, the cycle of four scenes from Terence's *Andria* (painted shortly after 1800, now at Copenhagen) [51], his sources can be recognized clearly

enough – Poussin, Michelangelo, and the Italian Quattrocento – but the all-embracing geometry of the composition, setting, and lighting, which dominates the figures, are entirely Abilgaard's.[1] This is Classicism at its very roots. It was helped by the fact that the painter was also an architect and a sculptor. Within the dryness of the construction there is, in the figures, something of the primitive, gross humour of Abilgaard's painted illustrations to Holberg's *Niels Kym's Subterranean Journey* (Copenhagen), engraved in 1789 by Johann Frederik Clemens (1749–1831), something which forms a kind of harmless counterpart to the fantastic dreams of Goya and Fuseli.

Of almost the same age was the second leading Classicist at the Copenhagen academy: Jens Juel (1745–1802). His Classicism was of a very different kind – more superficial and in the main limited to the soigné beauty of formal portraits. His beginnings go back to Rococo, and the calm

51. Nicolai Abraham Abilgaard:
Scene from Terence's *Andria*, after 1800.
Copenhagen, Statens Museum for Kunst

of a masterly portrait like that of Ahron Jacobson (1767, Copenhagen) is not yet real Classicism. It reveals merely the first, chilling breath of the Classicist spirit, as do so many European portraits at that time: for example in neighbouring Sweden the delicately nervous, cultured, and very English portraits of Carl Fredrik von Breda (1759–1818). Juel had a look at everything in Europe; he began his studies in Hamburg, and then went to Paris, Rome, and Switzerland; from 1780 on he taught at the Copenhagen academy, and became court painter. In his late portraits (e.g. that of Marcus Pauli Karenus Holst von Schmidten [52]) the reflections of David's portraiture are unmistakable.

In closer master-pupil relationship to David stood Christoffer Wilhelm Eckersberg (1783–1853), who was born in Schleswig and was Juel's son-in-law. From 1803 to 1809 he worked at the academy in Copenhagen; he was in Paris from 1810 to 1813 and in Rome during the three following years [54], after which he settled permanently in Copenhagen. Of his studies under Abilgaard no trace remains in his art, which turns decisively and unconditionally towards reality in portraiture and landscape. This absence of the problematic factor in his portrayal of human beings and the friendly serenity of his landscapes determine the extent and the limits to which he idealized. His paint-

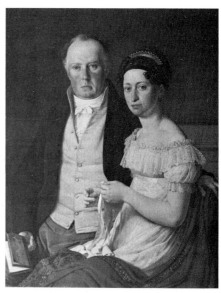

52. Jens Juel:
Marcus Pauli Karenus Holst von Schmidten, 1802.
Copenhagen, Statens Museum for Kunst

53. Wilhelm Eckersberg:
Graf Preben Bille-Brahe and his second Wife, 1817.
Copenhagen, Ny Carlsberg Glyptotek

ing is not an 'art of ideas' in any other respect, and it is therefore no longer Classicist. In most of Eckersberg's portraits the Ingres ideal of clarity in modelling, line, and colour is displayed through the medium of modest, *petit bourgeois* types of people [53], and in this respect is already Biedermeier. Even when, in his famous portrait of Thorvaldsen (painted in Rome in 1814; Copenhagen, Royal Danish Academy of Fine Arts), his sitter was a celebrity, his fidelity to the external appearance remained stronger than the urge to idealize. In his landscapes, his desire to bring clarity of form into harmony with nature is still more patent, at first in views of Italy [54] and later in motifs drawn from his

54. Wilhelm Eckersberg:
S. Maria in Aracoeli, Rome, *c.* 1813-16.
Copenhagen, Statens Museum for Kunst

Danish homeland, especially in numerous sea-scapes often painted with a glassy precision [55]. With these pictures Eckersberg laid the foundations of his country's landscape-painting, which until about the middle of the century represented the zenith of Danish art.

Mention must also be made of an extremely curious work of late Danish Classicism, the frieze by Jørgen Valentin Sonne (1801-90) on the external walls of Thorvaldsens Museum in Copenhagen [56].[2] This work (1846-50) was the result of the commission given to Sonne to represent on the walls of the austere building designed by Michael Gottlieb Bindesbøll (1800-56) the triumphal return of Thorvaldsen from Rome in 1838 and the removal of his sculptures to the museum. Most mural painting during the nineteenth century achieved only approximate

solutions, because it could not come to terms with the necessary illusionism of space and failed to recognize the importance of the surface. This is for instance the defect of the second important large-scale Late Classicist work in Copenhagen, the mythological murals by Constantin Hansen in the atrium of the University building (1844-53). Sonne was wholly successful, because he knew how to create something completely personal. He took as his models Attic red-figure vases, the mural paintings of Pompeii, and Quattrocento frescoes, and by borrowing from them succeeded in producing at a very late moment an example of Classicism in which the timeless monumental element adopts some of the Biedermeier conventions almost like a disguise, to make sure that theatricality would be avoided.

55 *(opposite)*. Wilhelm Eckersberg: View from the Trekroners Batteri towards Copenhagen, 1836. *Copenhagen, Hirschsprung Collection*

56 *(below)*. Jørgen Sonne: Unloading Sculpture (detail), *c*. 1846–50. *Copenhagen, Thorvaldsens Museum, frieze*

GERMAN ROMANTICISM AND THE NAZARENES

'Romanticism' is one of those terms used in the history of art of which it is particularly difficult to define the limits. This is not only because here, as is so often the case, the meaning of a stylistic concept is expanded until it becomes imprecise, but also because elements of Romanticism appear in many experiments and anticipations, before it assumed the concentration and definiteness of a true stylistic tendency. If we define Romanticism purely historically as that which followed Classicism and was the reaction to it, then it cannot be disputed that its chief distinction was the predominance of feeling over reasoning, whereas in Classicism reason had prevailed over feeling. Caspar David Friedrich's remark that 'the artists's feeling is his law'[1] is an epitome of this, but Rousseau had already said that 'sentiment counts for more than reason'.[2] These ideas are implicit in the works of many a painter during the last years of the eighteenth century, especially in those of the landscape-painters. In view of all the vagueness inherent in its nature and in the historical situation of a spiritual upheaval, the real essence of Romanticism can probably best be grasped by studying one of its extreme manifestations, the art of Caspar David Friedrich, the greatest Romantic landscape-painter in Germany. That he was a landscape-painter and that he was a German are facts of equal significance.

CASPAR DAVID FRIEDRICH (1774-1840)

The element of Romantic landscape-painting which a close study makes increasingly apparent is the infinite, the immeasurable. This is either explicit in the reflections of theoreticians, including poets and painters, or implicit in the paintings themselves. That, of course, does not mean that the landscape-painters of the period immediately before Romanticism were unaware of the boundlessness of landscape and did not try to give expression to it; but in Classicism this feeling and this aim were always disciplined and limited. Often enough the concentration on the individual detail left no room for the perception of breadth and greatness. It is true that the abundance of particulars can also be an expression of the infinite, a more ingenuous and more indirect expression, and indeed this was for Classicism the most suitable way of contemplating it. By means of order and arrangement, an image of the grandeur of nature could undoubtedly be given. This was the method followed by Koch, a method which Friedrich, from his point of view, was bound to reject as an 'unnatural, boastful striving after wealth and abundance'.[3] If, however, before Romanticism the sense of distance and expanse, which in reality means infinity, had not provided a motive for the portrayal of nature, there would have been no widespread art of landscape during the Classicist period. To this extent, therefore, Romantic landscape-painting was only the continuation and fulfilment of Classicist landscape, since, as has been rightly said, the very idea of landscape is in itself romantic. That which in Romantic landscape is fundamentally different from Classicist is the attempt to render expanse and greatness in a more direct and simpler way, to express by means of this simplicity the monotony and immensity of the elements found in nature, of the empty or clouded heavens, of the sea and the plain. Another basic difference from Classicism is the new attitude of mankind towards nature. This difference is nothing less

than the contrast between an active and a passive attitude to spiritual things. So long as the desire for order in the representation of landscape was as strong, as obvious, and as matter-of-fact as it was in Classicist landscape-painting, nature itself, that is to say the non-human element, could find no proper expression. In such art the grandeur and sublimity of nature, of space, mountains, and gorges, is fundamentally, however paradoxical it may seem, a reflection of the grandeur of the human being confronted with it. In this lies the deeper and more precise meaning of 'heroic' landscape. In it human moral concepts are projected on to amoral nature. Only when Romantic landscape relegated human beings to a purely contemplative role could the voice of nature and, above all, the silence of nature, become perceptible at all. This was the

chief element in the art of Friedrich, and it is expressed with a purity and an exclusiveness almost incomparable in his own and after his time. Hardly ever do we find a painter who contemplated nature in this way – as if he were holding his breath.

The art of Friedrich, so far as one can trace its development, underwent little change. Even if we consider it solely from the point of view of its content, its novel and characteristic elements stand out. His subjects are bound up with the various stages of his career and the places where he lived. He was born in the Baltic seaport of Greifswald in Pomerania, and from 1794 to 1798 attended the academy in Copenhagen. With frequent interruptions in the form of journeys to his home at Greifswald, to Rügen, the Riesengebirge of Silesia, and the Harz

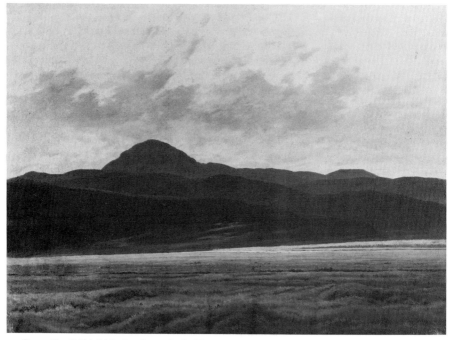

57. Caspar David Friedrich: Landscape in the Harz Mountains, *c.* 1820. *Hamburg, Kunsthalle*

Mountains, he then lived in Dresden, which in those years, at the beginning of the new century, was a centre of Romanticism. He died there in poverty and in a state of profound melancholy. The chief motifs of his pictures are from the shores of the Baltic, the harbour of Greifswald and the ruins of the Gothic monastery of Eldena, from Dresden and its environs, and from the Harz Mountains [57, 61]. There are, it is true, a number of imaginary landscapes among his works, but it is significant that he usually managed to convey phenomena of the most general nature by tying them to real local scenery, of which even the details can often be identified. This combination was just as novel as most of the more essential phenomena of his landscapes. These are in the main phenomena or moods of nature which had meant little or nothing to the landscape-painters who preceded him: fog on the seashore or over ploughed fields, banks of clouds in an evening sky, illuminated by the dying glow of the setting sun or interspersed with narrow, shining gaps, twilight on wooded mountains, a wintry haze above freshly fallen snow [58, 59]. Common to all these representations of mood is that they are steeped in sadness. Even a clear evening sky above dark chains of mountains is of a purity which one is tempted to call oppressive, and it is always the drama of the stillness of nature that burdens the soul. After visiting Friedrich's studio in 1834, the French sculptor David d'Angers wrote of him: 'Here is a man who has discovered the tragedy of landscape' and 'Friedrich's soul is sombre; he has understood perfectly that one can use landscape to paint the great crises of nature'.[4] This interpretation – and in this respect it is characteristically French – fails to stress the fact that these 'tragedies' and 'crises' of landscape are expressed mainly by means of an anxious, oppressive silence. It was a matter of course for Friedrich that infinity, the unapproachable and incomprehensible in landscape,

58. Caspar David Friedrich: Early Snow, 1813-14. *Hamburg, Kunsthalle*

could affect man only in terms of poignant or gentle sadness, just as it was a matter of course for Schubert that there is no gaiety in music. Many of Friedrich's landscapes in fact remind one of the contemporary 'Winterreise' of Schubert, the most profound of Romantic musicians. A unique characteristic of Friedrich's art is that he expresses the dedication of mankind to infinity by frequently representing the figure from the back, gazing into the landscape and thus vicariously expressing our own experience of the fragment of nature before which the figure stands. The difference between these figures and the busy little accessory figures in Classicist landscapes is as great as that between the sadness of Friedrich's landscapes and the optimism pervading the dramatic and heroic mountain scenery of the Classicists. Moreover, these dark figures seen from the back, set

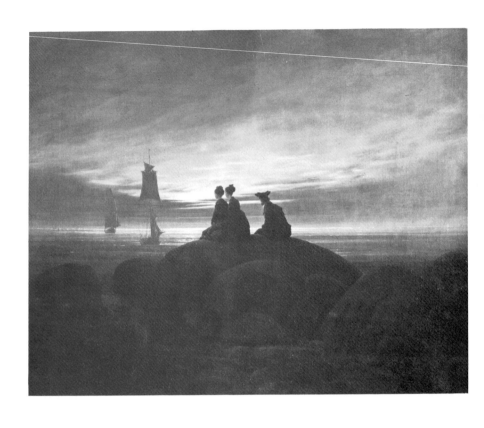

59 *(above)*. Caspar David Friedrich: Moonrise over the Sea, 1823. *(West) Berlin, Staatliche Museen*

60 *(opposite)*. Caspar David Friedrich: Capuchin Friar by the Sea, 1808–9. *(West) Berlin, Staatliche Museen*

in a moonlit landscape [59] or at a window, are also the expression of that Romantic yearning to embrace the universe which Novalis voiced when he said that 'the individual soul must

their sensuous materiality; this is also true of Carstens's drawings. It is seen again in the way in which Friedrich in some of his most important works, for instance the *Capuchin Friar*

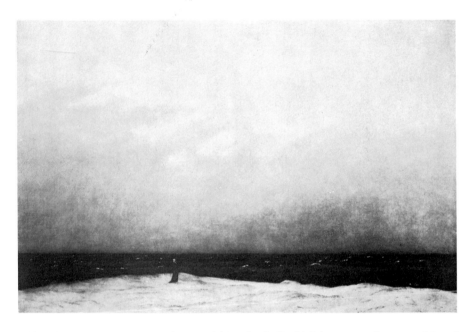

achieve harmony with the soul of the world'.[5] Viewed from this standpoint, many things in Classicist landscape-painting seem petty and commonplace; with Friedrich the small dimensions of the figures in the landscape for the first time assume a deeper significance, and his links with the landscape-painting of Classicism seem far more tenuous than those with that German Classicist for whom landscape did not exist – Asmus Jakob Carstens – who, like Friedrich, came from the extreme north of Germany. In Friedrich's works it is as if the mood of Carstens's gloomy figures [26, 27] had been translated into the sphere of landscape. In Friedrich's manner of painting there is, in addition, a trend towards asceticism which, despite all his faithfulness to reality, deprives the things he paints of much of

by the Sea [60], by means of a composition of the simplest kind gives the most monotonous elements of landscape an unsurpassed intensity of loneliness, making them images of the transitoriness of human life and the premonition of death.

Even in the presence of such a grandiose concentration, which seems to be worlds apart from the constructional principles of Classicism, it is impossible to overlook the fact that in this very contrast there is a connecting link between the two. There is a great deal of deliberate rationalism behind Friedrich's landscapes. Symbolical elements, as in the painting of the *Ages of Life* in a private collection at Greifswald, and patriotic ideas, as in his numerous pictures of 'heroes' tombs'[6] and his designs for funerary

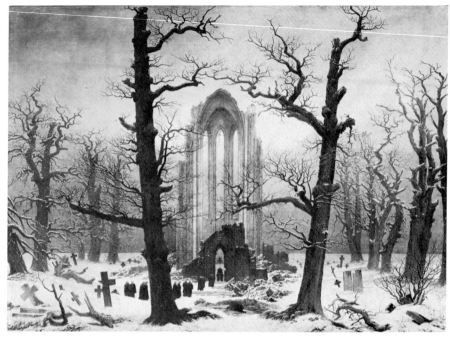

61. Caspar David Friedrich:
The Abbey Graveyard under Snow, 1819.
Formerly Berlin, Staatliche Museen, Nationalgalerie

monuments to those who fell in the War of Liberation of 1813 (Hamburg) reveal his affinity with the Classicist painting of ideas. Even a detail like the improbable burial of a monk in a ruined Gothic church [61] proclaims the predominance of an idea and of narrative. The attempt to link mankind and the cosmic powers remains a Romantic dream, that is to say the expression of a dualism. The appreciation of Friedrich's art is a relatively recent phenomenon, and its similarity to the landscape-painting of the great Chinese masters of water-colour painting is now freely recognized; but Chinese painting does not contain the dualism which is expressed in the earthliness of Friedrich's details. Nevertheless, in terms of European art and

of the subjective attitude towards nature which is the hallmark of Romanticism, Friedrich achieved an absorption in landscape akin to the Chinese painters' religion of nature, and this, too, can be called religious. It would be useless to insist further on the difference and thereby attempt to establish values; to prefer, for example, the harmonious tranquillity of Chinese landscapes to the melancholy silence of Friedrich's, or the incorporeal representations of the Chinese to the dualistic tension in the works of the North German Romantics.

On the other hand, a comparison between the compositional intentions of the Classicists and those of Friedrich is both justifiable and important, in order to demonstrate as clearly as

possible the contrast between landscape based on human elements and landscape concerned with the non-human. Yet we should not rate one higher than the other. It is not that 'thinking makes it so'; it is a true valuation based on emotional qualities. The historian can do no more than recognize two fundamentally different conceptions of nature. But if we limit ourselves to considering these landscapes as landscapes, there is no doubt that we must assign the first place to Friedrich's, because they are landscapes in a deeper, purer sense, and this for two reasons: firstly because Friedrich was the first to realize that the superhuman elements in nature can be painted; and secondly because he discovered an adequate method of painting them. In 1810, when Friedrich's *Capuchin Friar by the Sea* [60] was exhibited in Berlin, Heinrich von Kleist characterized it with a famous simile in his wild and breathless style: 'With its two or three mysterious subjects the picture stretches before us like the Apocalypse, as if it contained Young's "Night Thoughts", and since, in its uniformity and boundlessness, it has no other foreground than the frame, when one looks at it it is as if one's eyelids had been cut away.'[7] With these words Kleist defined something entirely new in Friedrich's painting, the ability to reproduce in the construction of a landscape the most elementary phenomena – geological, spatial, and atmospheric. Such things he could learn only from the greatest among the Dutch landscape-painters of the seventeenth century. He might even have learned much from Bruegel; but it is certain that he knew none of his works.

It is above all in this power that the art of Friedrich proves itself to be the great beginning of nineteenth-century landscape-painting. At first, Friedrich's entry into a new world had only a short-lived success, confined to a small circle of followers. Towards the end of the century, however, the appreciation of the non-human forces in landscape, initiated by Friedrich, reached a new climax in the works of Cézanne, who overcame Romantic dualism by confining his landscapes to nature alone, to the tectonic forces which go to make up landscape in human experience, and virtually excluding man himself with his visionary distress and enthusiasm in the presence of nature, his longings and his sense of desolation.

FRIEDRICH'S CIRCLE (CARUS, DAHL, KERSTING, AND OTHERS)

The art of Caspar David Friedrich, since it was quickly forgotten, was not cheapened and coarsened by imitators, a fate to which its philosophical, religious, and poetic aspects might have rendered it liable. On the other hand, those painters who had been in direct contact with Friedrich and realized that his art could show them the way to a development of their own, utilized, without imitating Friedrich's universality and singleness of vision, some of the numerous elements contained in it. This is the case with Carl Gustav Carus and August Heinrich. Others, e.g. Dahl, combined it with new points of view.

In his conception of nature, Carl Gustav Carus (1789-1869), who was a physician, naturalist, and philosopher, is particularly close to Friedrich. For the self-taught Carus, painting was merely a sideline, but that it was of great importance to him is shown by his *Nine Letters on Landscape-Painting*, written between 1815 and 1824 and published in 1831, and his *Twelve Letters on the Life of the Earth* of 1841, which entitle him to be considered the foremost theoretician of Romantic landscape-painting. In these books, however, the pantheistic doctrine of the unity of nature and the ego ('Thy identity vanishes, thou art nothing, God is all,'[8] he writes in the second of his 'Letters' with reference to a distant view of mountains) is set side by side with the necessity for a study of the organic construction of landscape. In this partly artistic, partly scientific method of perception

one sees the influence of Goethe, and it explains the reciprocal interest that Goethe took in Carus. This point of view is clearly expressed in one concept: 'the art of earth-life' ('Erdleben-bildkunst'), which Carus suggested should be substituted for 'the art of landscape'. His own painting lags a long way behind these lofty requirements. In its motifs it remains for the most part in the realm of Friedrich – in his memoirs published in 1865-6 Carus mentions the 'dark, misty pictures, churchyards deep in snow' which he painted 'in order to purge the inner-most recesses of the soul of deep gloom'[9] – and on the whole his work is indeed that of an amateur, in which Romantic pathos is relieved by a not unpleasing awkwardness. Occasionally he achieves independence, for example in the bold idea of representing an artist's studio with nobody in it (*Easel by Moonlight*, Karlsruhe). Otherwise, to explain the difference in level between his painting and Friedrich's, one must remember above all the quality and significance of colours in Friedrich's work. They convey, in a manner and to a degree of perfection unusual at that time, a feeling for chromatic relationships, and reveal a very deliberate use of the symbolic values of individual tones. There are in Fried-rich's paintings sorrowful and tired, anxious and hopeful colours. This symbolic role remains the chief function of Friedrich's colours, in an archaic sense, although a sense which in those days had been given a theoretical basis in Goethe's meditations on the 'sensuo-moral' effect of colours (in his *Farbenlehre*, published in 1810) and in Runge's treatises on colour. Friedrich's colours retain this symbolic role despite the accuracy of his rendering of atmos-phere, wherein he conforms with the new Naturalism which was beginning to develop during the second quarter of the century.

August Heinrich (1794-1822), who was also quickly forgotten, came from Dresden, where he worked for some time in the circle of Fried-rich and Dahl. From 1812 to 1818 and after 1820

he lived in Austria, at Vienna and Salzburg and at Innsbruck, where he died. In Vienna the Classicist landscape-painters Joseph Mössmer (1780-1845) and Joseph Fischer (1769-1822) were his academic teachers – academic in both senses of the word. With Friedrich, whose most important pupil he was, Heinrich had in com-mon an absorption in the small details of land-scape, and gentleness, purity, and tranquillity as the vital elements in painting. In the few works by him that have been preserved, mainly drawings, there is nothing of the huge, im-petuous masses and movement of Friedrich's landscapes, but for Heinrich the small elements such as the foliage in the interior of a wood or the strata of rocks in a quarry are also repre-sentative of the pervading grandeur of nature. Here there is a link too with the reverent con-templation of nature of the Nazarene landscape-painters (particularly the Olivier brothers and the two Schnorr von Carolsfeld), with whom Heinrich came into contact in Austria (p. 128).

More closely dependent on Friedrich, and not only as regards motifs, were Ernst Ferdinand Oehme (1797-1855) of Dresden and Gottlieb Christian Johannes Giese (1787-1838) of Greifs-wald, the latter active mainly as an architect of neo-Gothic churches.

Johann Christian Clausen Dahl (1788-1857) was by birth a Norwegian, but he spent a con-siderable part of his life, from 1818 on, in Dresden, after having studied at the academy in Copenhagen. He is not only the first and most important Norwegian landscape-painter, but also belongs to the Dresden circle of North German Romantics, even if only in a limited sense. For despite the powerful impression made upon his art by Friedrich he cannot be considered a Romantic landscape-painter in the same way as Friedrich, Carus, and Heinrich were. The difference is perceptible at first glance: in his mature phase, Dahl was too pure a painter to be a Romantic; in other words, his main interest was directed towards the pheno-

mena of light and atmosphere. It is true that these were also of great importance to Friedrich, but in his case the reason was that they were an expression of something invisible, of the soul of the landscape and of his own soul. For Dahl, on the other hand, these phenomena were important for their own sake, and he thus became one of the founders of naturalistic landscape-painting. Dahl's sources of inspiration were of many kinds; in addition to Friedrich, they included, in his early period, the Dutch painters, and in particular of course Allaert van Everdingen with his Scandinavian motifs. They also included the Danish landscape-painter Eckersberg [55], and the landscape of his own country and of Italy, which he got to know during a journey in 1820-1. So far as is known, however, he had no direct contact with Constable, the artist whose manner he approaches most closely in his studies from nature [62]. As far as his connexion with Friedrich goes, Dahl is a Romantic in the same sense as Friedrich in many

62. Johann Christian Clausen Dahl: Study of Clouds, c. 1825. *(West) Berlin, Staatliche Museen*

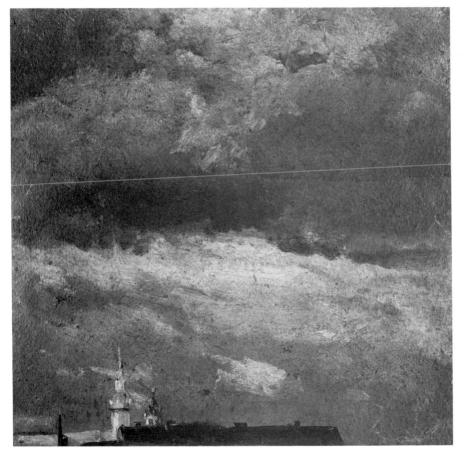

of his moonlight scenes, in his pictures of valleys with rising mists and of mountain torrents; without Friedrich's epoch-making renderings of the vastness of landscape, Dahl's studies of sky and clouds would be unthinkable. In these, however, the way in which a very narrow strip of ground, a church spire, or a few treetops are just included in the picture is something essentially new. Friedrich, in a fragment of real landscape, makes infinity perceptible, an other-worldly infinity, and this is in direct contrast to Classicism, because by means of fragmentary compositions the space in the picture points to something beyond itself. Dahl's studies of the sky go one step further, the step towards the profane, his method being what has often been called the 'casualness' of the framing. This alone, apart from the renunciation of all those elements of drawing which were so indispensable to Romantic landscape, represents a departure from Romanticism. Studies of clouds in Dahl's time formed a special category of their own, in which painting problems were combined with scientific observation, just as landscape-painting and geology were combined in the theories of Carus. Goethe's study of the discoveries of the English meteorologist Luke Howard and his poems on them, the cloud studies of Constable and Blechen, and those of Dahl, are striking evidence of this new semi-pictorial, semi-scientific interest in the phenomena of the sky. Immediately afterwards came Adalbert Stifter [137], Menzel with his early Impressionistic studies [218], and the cloud studies of a whole series of minor painters of the Biedermeier period.

The art of Dahl found a direct continuation in that of two of his pupils, the Norwegian Thomas Fearnley (1802–42) and the German Christian Friedrich Gille (1805–99). Echoes of Romanticism, Biedermeier-like genre features, and a lively naturalism in the spirit of Dahl are combined in the art of Fearnley, who worked mainly in Dresden, Munich, and Rome. In Gille's landscapes the only element that can be called Romantic is the marked prevalence of mood in what is otherwise a pictorial Early Impressionism.

Although he was not altogether a Romantic, and not even a landscape-painter, Georg Friedrich Kersting (1785–1847) must nevertheless be mentioned at this point. Not only was he one of the few intimate friends of the lonely Friedrich (he painted in 1811 and 1819 two well-known portraits of him at his easel in a monastically cold studio[10]), but there is something of Friedrich's profundity in his art, conferring an air of solemnity upon some of his best works. Kersting was a North German, born at Güstrow in Mecklenburg; from 1805 to 1808 he studied at the academy in Copenhagen and from 1808 to 1818 he lived at Dresden. From 1818 he was director of the painting department in the famous china factory at Meissen. His best work is in some of his indoor portraits, painted more for the sake of the interiors than for that of the sitters. The intimacy of these modest living-rooms and the artist's joy in the delicacy of light and materials are essentially Biedermeier, but the perceptible silence, the detachment and coolness of these rooms are a Romantic element. In the picture in the Oskar Reinhart Foundation at Winterthur (1814) [63] there is more than the magical effect of the light of the reading-lamp in a lofty room. Here, expressed in the small framework of an interior, we find a mood of loneliness, the mournful consolation of a solitary light surrounded by mysterious, indefinite dusk – in fact feelings such as Friedrich expressed in the boundless distances of his landscapes. With pictures of this kind German Romantic painting conferred totality upon the pantheistic conception of space.

63. Georg Friedrich Kersting:
Man reading by Lamplight, 1814.
Winterthur, Oskar Reinhart Foundation

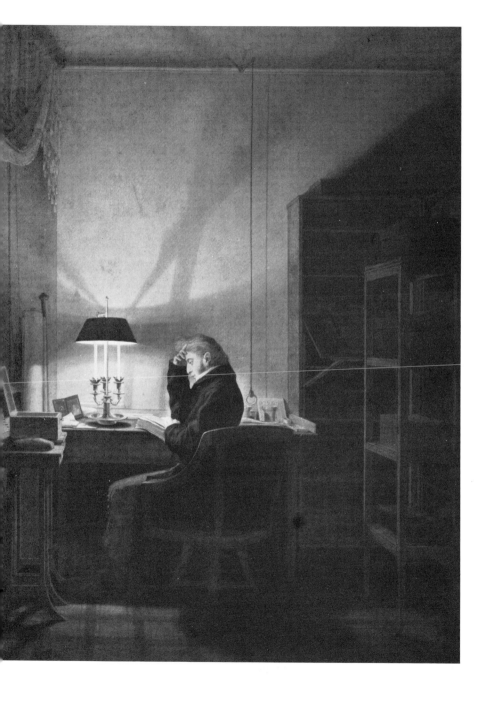

PHILIPP OTTO RUNGE (1777–1810)

The art of Runge is held to be the most patent embodiment of Romanticism in German figure-painting, just as Friedrich's is unquestionably its purest embodiment in landscape-painting. Nevertheless, this confrontation shows at once how much more simply and clearly the idea of Romanticism expressed itself in the rendering of landscape than it did in that of figures. If the representation of the infinite, of the immeasurable, to which mankind abandons itself with enthusiastic contemplation and absorption, is a hallmark of Romantic art – and this was our starting-point when considering Friedrich's landscape-painting – then we must now study how this infinity, this 'universal soul' of the Romantics, found expression in Runge's world of figures. In this connexion it must be made clear from the start that even for Runge infinity, both generally speaking and in special connexion with those works which were his chief concern and which cost him so much trouble in the last years of his life, meant infinity *in nature* and only secondarily infinity in the individual, in the human soul. The latter was for him, in conformity with Romantic ideas, contained in the soul of nature, in the cosmos. Whereas Friedrich, in harmony with this principle, depicted human figures as contemplators of infinity, i.e. merely as accessories, the pantheistic late works of Runge are peopled exclusively with genii [64, 65]. In these pictures the figures carry the whole pictorial content, and they are invariably allegories and personifications of the forces and phenomena of nature. These late works, culminating in the representations, conceived as gigantic murals for some sacred building, of the four phases of the day, and preserved only in the form of designs for several versions and in fragments, are nothing but poetic ideas translated into pictures. It is obvious that this is a kind of Romanticism which in its fundamental attitude is still closely linked to Classicist ideology. Here

there was obviously a critical and discordant situation, which is also revealed by the fact that Runge, who never painted a pure landscape, declared that 'everything tends towards land-scape'.[11]

He himself evidently believed that the use of allegories offered enhanced possibilities of rendering abstractions (such as the phases of the day) in pictorial form. We are reminded of the only slightly older attempts of Carstens to personify space and time (see p. 53). The profound spiritual relationship betwen the two painters becomes just as clear when Carstens, the Classicist, anticipates Romanticism, as it does when Runge, the Romantic, remains tied to Classicism. Runge's spirits of the forests, flowers, and clouds replace the ancient heroes and allegories of the Classicists; most of them are his own inventions, though some are taken from the works of Romantic poets. The change is thus only one of ideological subject, from the moralizing ideas of the age of enlightenment to the Romantic ideas of a religion of nature. Faith in the validity of poetical and philosophical thought as the real subject-matter of painting remains. Runge endeavoured to give a detailed annotation of his *Four Phases of the Day* [64, 65], and they certainly required explanation. The crucial passage from this runs: 'Morning is the boundless illumination of the Universe. Day is the boundless figuration of the creatures which fill the Universe. Evening is the boundless annihilation of existence into the origin of the Universe. Night is the boundless depth of the knowledge of the indestructible existence in God. These are the four dimensions of the created spirit. But God accomplishes all in all; who will represent how He touches the created?'[12] This is not just Romanticism; it is mysticism. Runge indeed made a constant study not only of the esoteric Romanticism of such contemporary poets as Wackenroder, Novalis, Hölderlin, and in particular his friend Tieck, but also of the writings of the seventeenth-century mystic Jakob Böhme.

64 *(left)*. Philipp Otto Runge: Night, 1803.
Pen-drawing. *Hamburg, Kunsthalle*

65 *(below)*. Philipp Otto Runge: Morning, 1808-9.
Second version (detail). *Hamburg, Kunsthalle*

A veritable treasure-house of original notes and letters shows how deliberately he strove to achieve the ultimates. Such deliberateness, in such an extreme form, was something new, and it went considerably beyond the art doctrines of the past and the traditional aesthetic theories. Although, or even partly because, it was practised by one man in isolation, it is characteristic of the spirit of the new century.

This peculiar link between Classicism and Romanticism throws a new light on the ethical trends which characterize the art of the whole epoch. A few months after Runge's death, Sulpiz Boisserée visited Goethe and was surprised to find the etchings of the *Phases of the Day* in his music-room. When he mentioned Beethoven in connexion with them, his chance remark perhaps involved even more than he imagined; he intended to refer to the fascination

of the infinite simply to please Goethe, but the comparison is also applicable to the absoluteness of the ethical imperative and the belief in a moral order in the cosmos, which the music of Beethoven seems to have in common with Runge's faith and thought.

What creative ability and means of expression were at Runge's disposal in realizing such a lofty ideal, and to how great a degree did he succeed? On the one hand we have the frequent use of pure outline drawing.[13] This is the logical result of the trend towards the abstract and is the appropriate means of expressing it, but it was not invented by Runge; it had already made a deep impression on him in the drawings of Flaxman. He, however, extended its original scope by reducing to a minimum the hybrid effects of space seen in perspective, and his outline drawing thus became more than a puristic

aid to philosophical painting. The drawn composition of the *Phases of the Day* has an absolute symmetry of the surface in which there is hardly any placing of one element behind another, but only a placing above and below, a rise and fall, a culmination and decline. The genii are enthroned, they hover and move in spaces which have only a vague relation to real space. The preoccupation with mural painting likewise plays its part, and also, from the very beginnings of Runge's art, a lively, musical, decorative play of foliage and trophies and silhouettes of plants, in which the spirit of late medieval book-illustration and of the marginal sketches which Dürer made for the Emperor Maximilian's prayer-book is re-created.[14]

The counterpart to this limitation, however, is the intense endeavour to achieve the opposite, to achieve three-dimensionality, colour, and the representation of light. This is a clear expression of Runge's desire for totality, which formed part of his programme and at the same time runs parallel with the tendency of Classicism about the turn of the century. We find it in the various attempts to achieve syntheses of line-drawing and three-dimensionality, and also in Koch's idea of the 'universal landscape' and in the general trend towards microcosmic abundance in every single picture. Runge, too, wanted to produce pictures which were not merely fragments; his later programmatic works aimed at being images achieving totality, and possessing an abundance of symphonic components. Everything that colour and light can contribute to the elaboration of the ideological structure is depicted. It was for this reason that Runge studied the elementary effects of colours, and even more their symbolical values. These he formulated in his theoretical work *Farbkugel* and in a *Farbenlehre*, which he left unfinished. In this way he broke through the narrow limits that Classicism had assigned to colour. He investigated the properties and laws of chromatic relationships by means of scientific, psycho-logical, and mystical speculations, and thus can be called a forerunner of the theoreticians and painters of the post-Impressionist period, who studied the infinite possibilities of non-representational colouring. Yet it is again a characteristic limitation of Runge that he, who was so attracted by the irrationality of colours, nevertheless used them ideologically, i.e. he added them to the primary structure of composition and lines, and did not start from colour in the conception of his pictures, as later painters did. Even here, however, this 'addition' of colour is the outcome of an intensive study of the artistic and technical problems of colouring (in contrast to Carstens's arrogant contempt for everything technical) which was to have the most helpful consequences. This is perhaps yet another reason why Runge succeeded in coming nearer to his ideal than Carstens, despite the fact that it was so much more sweeping and almost by definition unattainable.

Lastly, we must mention light. Runge rendered some of its more complicated phenomena, for example the reddish light of sunrise on the landscape and flower-genii in *Morning* [65], with such subtlety and such magical reality that, when he was 'rediscovered' fifty years ago, he was proclaimed as a forerunner of plein-air painting. This, it is true, is a misunderstanding of the characteristics of his rendering of light and its significance in the whole range of his art. These characteristics are more similar to those of Altdorfer and Grünewald than to any later renderings of light. Runge's light is not present for its own sake, but as a sign of mysterious natural phenomena. But if we judge it by the standard of the neutral or superficially picturesque rendering of light in the works of his contemporaries, it is a bold venture into unknown depths and heights. In his portraits, too, Runge occasionally made use of a mysterious light coming from below and of wide, magical reflections [66]. By this means he brought the portrait nearer to poetic painting.

66. Philipp Otto Runge: Self-portrait, 1799. Drawing. *Formerly Stettin, Provinzialmuseum*

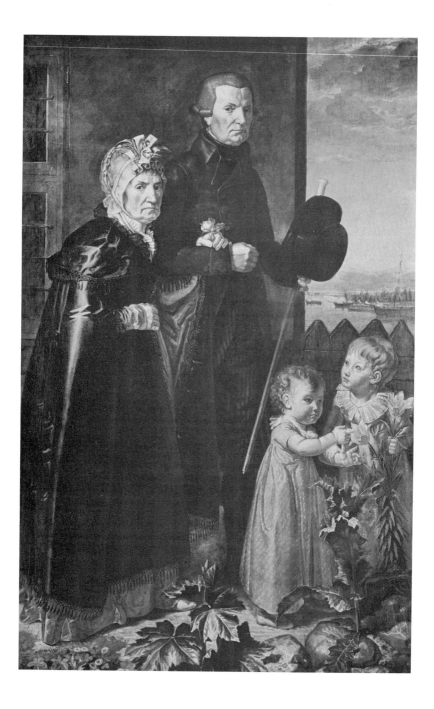

67. Philipp Otto Runge:
The Artist's Parents and Children, 1806.
Hamburg, Kunsthalle

For the rest, in his likenesses, especially in his portraits of himself and of his relatives and friends, objectivity and Romanticism are held in balance. They may be ranked with the best portraits anywhere of the early part of the nineteenth century. Consider, for example, the way in which, in the monumental painting of his parents with their grandchildren (1806) [67], the numbness of old age and the semi-animality of the children are characterized. In several portraits of children, e.g. *The Hülsenbeck Children* of 1805-6 and the *Portrait of his Eldest Son* of 1805-6 (both at Hamburg), Runge has caught the very essence of childhood, above and beyond mere charm, and has even exaggerated ugliness.

What has been said so far is merely an enumeration of the chief features in the wealth of Runge's *œuvre*, which was produced in barely a dozen years of activity. For Runge, who was born in 1777 at Wolgast in what was then Swedish Pomerania, was destined for the career of a merchant, and it was not until he was over twenty, when he was in Hamburg, that he turned to painting. From 1799 to 1801 he studied at the academy in Copenhagen under the Classicists Abilgaard and Jens Juel, and during the next two years under Graff in Dresden. There he came into contact with the circle of Romantic painters and poets: Caspar David Friedrich – whom he had visited at Greifswald in 1801 – Tieck, the poet and amateur painter August von Klinkowström (1778-1835), etc. In 1803 he paid a visit to Goethe in Weimar, and from then on corresponded with him, especially on problems of colour, sending him several of his graphic works and silhouettes of flowers. His last years, from 1803 to 1810, he spent in Hamburg, lovingly cared for by his brother Daniel until the end. In a letter to Daniel Runge,

written after the painter's death, Goethe wrote: 'The path which he followed was not his alone, but that of the century, on whose stream his contemporaries, willingly or unwillingly, are borne along.'[15] Goethe himself, at the time, was rather on the side of the 'unwilling', as is shown by his outburst on the occasion of Boisserée's visit, which, however, also shows, far more clearly than this cool letter to Daniel Runge, how much he was moved by the experience of this strange art: 'It is enough to drive one mad, beautiful and at the same time nonsensical . . . it tries to embrace everything and in doing so always loses itself in the elementary, but yet with infinite beauties in details. Here you see what sort of devilries, and there what charm and splendour the fellow has produced; but the poor devil couldn't stand the pace, he's gone already; there is no other solution: anyone who stands on the brink like that must either die or go mad; there is no salvation.'[16]

It was not only his premature death that made Runge's work fragmentary. Even a many-sided talent like his could not include the whole range of human thought in pictures. The dream of the *Gesamtkunstwerk*, the dream of all the great epochs of the past which succeeded in producing such works, the dream which hovered vaguely before the eyes of the Middle Ages and the Gothic period, was destined to remain unfulfilled. How could an 'abstract, pictorial, fantastic musical poem with choruses', as Runge himself called his *Phases of the Day*, become a pure work of visual art? Methods of presentation like those of the early and late Middle Ages could give adequate expression to religious ideas, but a painter of about 1800 could not sever himself completely from his own times. There are thus discrepancies in the art of Runge, a rather cramped tension side by side with an astringent gracefulness. These discrepancies were bound to remain, since the whole breadth of thought could not possibly be represented. *Depth*, however, was the dimension to which no

limits were set. Runge's depth is expressed more clearly and more harmoniously in the details than in the whole, and above all it is expressed in the draughtsmanship of his pictures, which in every line is the expression of the pure and the simple, of an instinct which checked its exuberant intellect. We perceive this purity in all its symbolical fervour in the fragment of *Morning*, in the translucent figure of the little child in the field damp with early-morning mist [65]. The little fragment of this vision of the resurrection of the day is like a picture of the rebirth of the art of landscape and like an illustration to the hymn-like passage in Runge's letter of 9 March 1802 to his brother Daniel: 'When the sky above me teems with countless stars, when the wind sweeps through the wide spaces, when the billows break with a roar in the far night, when the ether reddens above the forest and the sun illuminates the world; when the mist rises in the valley and I throw myself down in the grass among the glittering drops of dew, every leaf and every blade of grass teeming with life, the earth living and stirring beneath me, and when everything is tuned to one chord, then my soul cries aloud with joy and flies in the immeasurable space around me, there is no longer any below or above, no time, no beginning, no end, I hear and feel the living breath of God, who holds and bears the world, in whom everything lives and works: here is the highest that we can divine – God!'[17]

THE NAZARENES

Landscape and the Romantic representation of figures are separated in the art of the two foremost German Romantics, Friedrich and Runge, though in the case of Runge one ought to add, only just separated; for in his *Morning* [65] pure landscape is on the point of asserting itself. But in the case of Friedrich, except for a few studies for accessory figures, we have only some un-

important portraits and three sketched self-portraits, the latest of which (*c.* 1820, East Berlin) shows us the sorrowful, bearded face of a fanatic with terrifying, staring eyes – a striking example of Romantic portraiture.

Landscape and the representation of figures can no longer be separated, however, in the art of some of the outstanding Romantics of the next generation, who formed the group of the Nazarenes. The programme which this name denotes was the revival of Christian art with a more or less clearly expressed retrospective trend towards the religious painting of the Late Middle Ages in Germany and the Italian Quattrocento. But to them landscape formed part of religion (an obvious inheritance from Runge and Friedrich), while their avowed intention of forming a co-operative group with a uniform programme was a reminiscence of the medieval guilds. Such a group was formed on 10 July 1809 in Vienna. Vienna was the city in which at that time the preacher Clemens Maria Hofbauer was working, who in 1820 created the first settlement of the Order of Redemptionists in the German-speaking countries,[18] in close contact with the Romantics who had come to Austria from Germany, especially the Schlegel family. Johann Friedrich Overbeck, Franz Pforr, Josef Wintergerst (1783–1867), Joseph Sutter of Linz (1781–1866), and the Swiss Georg Ludwig Vogel (1788–1879) and Johann Konrad Hottinger (1788–1828) were the first members of the group, which they called the 'Lucas-Bund' or Guild of St Luke. They were united in their opposition to the academic teachings of Füger. Before the end of 1809 the Lucas-Bund moved to Rome, and in 1810 they established themselves in the monastery of S. Isidoro, which had been dissolved by Napoleon. They put into practice Wilhelm Heinrich Wackenroder's *Outpourings of the Heart of an Art-Loving Monk* ('Herzensergiessungen eines kunstliebenden Klosterbruders'), which had been published in

1797, and became monks in a monastery of art. During the following years the group was joined by the German painters Peter Cornelius, Julius Schnorr von Carolsfeld, Friedrich Olivier, the brothers Johannes and Philipp Veit, Wilhelm von Schadow, the Viennese Johann Evangelist Scheffer von Leonhardshoff, and Josef Führich from Bohemia.

The ideal of primitive art which guided the Nazarenes in their revival of religious paintings was as heterogeneous as that of the Classicists. For them 'ancient German art' meant Gothic art, i.e. in reality only Dürer and his circle, and their Italian models in painting included not only the masters of the Quattrocento but also Raphael, who had been the great model of the Classicists. This in itself does not imply that there was an identity of aims between the Classicists and the Nazarenes, since there were many different facets to the art of Raphael. More significant is the fact that Rome was once more the centre of things, both geographically and spiritually. Thus a curious contradiction appears at once in the Nazarene attitude: the Eternal City, the seat of the Roman Catholic religion, which nearly all the painters of the group embraced, but at the same time the sacred soil of ancient Roman art, became the scene of the activities of artists who were deliberate followers of 'ancient German' painting.

Moreover, the Nazarenes continued to develop the didactic, edifying tendency of programmatic Classicism. They could do this in a simplified manner, since the fundamental ethical intention of Classicism was predetermined by the Christian subject-matter. The doctrinaire element thus appeared in an even more pronounced form than in Classicism, namely in a restriction to one particular dogma. Definite bounds were thus set to inventive imagination. In view of all these links with Classicism, we have to ask ourselves what, in the art of the Nazarenes, was Romantic, for there is no doubt that on the whole they must be considered as belonging to Romanticism.

The answer is easy: it was precisely the religious subject-matter. Often this subject-matter is the only reason for calling a Nazarene painting Romantic. The irrational element, the torrent of yearning and the exuberance of feeling and spirit could have manifested themselves in all kinds of subjects, but Nazarene painting had no surplus of Romanticism for anything else; it confined itself for long periods to the spiritual content of religious narrative pictures, to which, however, unlike medieval painting, it could not do justice. When, in isolated cases, Nazarene art penetrated more deeply beneath the surface, it was usually in landscape and portraiture, i.e. away from the set biblical subjects. A return to medieval ingenuousness, at all events in the field of religious figure-painting, was merely wishful thinking at the beginning of the secular nineteenth century.

For Runge and Friedrich this wishful thinking was a minor consideration. Though their work was also clearly determined by Christianity, and included certain definitely Christian themes, these were few in number. Friedrich painted only one altarpiece, the sacred landscape for the chapel at Tetschen (1808, Dresden), while of Runge's paintings only two are of biblical subjects, *The Flight into Egypt* (1805-6, unfinished; Hamburg), one of his richest pictures, and *Jesus walking upon the Water* (1806-7, unfinished; intended for a chapel near Arcona on the island of Rügen, now also Hamburg), one of his least harmonious works. Equally enlightening is the attitude of the two great Romantic painters towards the Gothic style: Friedrich depicted Gothic ruins [61], like Schinkel in some of his Romantic imaginary landscapes, and Runge made a first design for a tomb on Gothic lines, but then decided instead to use a fantastic architecture derived from vegetation; he was always reserved

in his attitude towards the Gothic style, as is shown by his remark: 'In the end I shall invent a new architecture, but it will certainly be a continuation of the Gothic rather than of the Greek.'[19]

The piety of the Nazarenes was certainly no deeper than that of Runge and Friedrich, and their ability to express it was on the whole far weaker; for this reason, even when it is perfectly sincere, it seems in their pictures to be ostentatious and derivative, just as their art is derivative. The religiousness of Runge and Friedrich stands in the same relationship to that of the Nazarenes as primitive Christianity does to average religious belief. Runge dreamt of figures which could become symbols of the superhuman; Friedrich, more modestly, tried to render the non-human element alone in the phenomenon of landscape; but the Nazarenes withdrew into the shelter of a standard doctrine. If in their case the old, and yet ever new artist's dream of a community in the service of an idea took the form of an 'Order of Artists', this was the expression of a desire for security, for the mitigation of inner struggles, for a means to overcome the loneliness of the individual and to secure recognition. Since individual genius had been proclaimed for the past forty years, individualism had become inescapable and the appeal for a community life seemed very ostentatious. This dream of a brotherhood was, however, of short duration, as is always the case.

The vital element in the eclectic art of the Nazarenes is most difficult to discover when they set themselves the highest aim, namely in their monumental mural paintings. Nevertheless, historically speaking, it is to their credit that they never lost sight of this aim, as the Classicists had tacitly done when they failed to produce any new programme comparable with the last great creations in this field, those of the Baroque. Ancient Roman art did not offer them any adequate model for such works; Raphael could have been such a model in the highest sense but the Classicists did not possess the ability to create a revival of mural painting from what they admired in existing works. The Nazarenes did not possess this ability either, but their attitude towards their models was in two respects different: in the first place, owing to their religious frame of mind, they were not so exposed as the Classicists of the school of David to the allurements of Naturalism, especially dangerous in the case of mural painting; and secondly, for the same reason, they had another copious supply of models at their disposal, among the Italian monumental painters from Fra Angelico and Masaccio to Pinturicchio.

On two occasions patrons in Rome provided the Nazarenes with opportunities to execute mural paintings on a large scale. In 1816-17 the Prussian Consul-General, Jakob Salomon Bartholdy, had a room in the Palazzo Zuccari decorated with scenes from the Old-Testament story of Joseph [68], and a few years later the Marchese Carlo Massimo commissioned paintings in three rooms of his villa near St John Lateran. The frescoes in the Casa Bartholdy (transferred in 1888 to the Nationalgalerie, now East Berlin) were executed by Cornelius, Johann Friedrich Overbeck of Lübeck (1789-1869), and the Berlin painters Philipp Veit (1793-1877) and Wilhelm Schadow (1788-1862), those in the Casino Massimo (1822-32) by Cornelius, Koch, and Veit (Dante Room), Julius Schnorr von Carolsfeld (1794-1872; Ariosto Room), and Overbeck and Führich (Tasso Room). The result is a hybrid: the number of sources and borrowings can hardly be calculated; they range from Masaccio, Fra Angelico, and Gozzoli to Signorelli, Perugino, Carpaccio, Raphael, Pinturicchio, and Sodoma. The artists' own originality was no match for such an inheritance. Above all, they were incapable of achieving real architectural articulation. This being so, it is only natural that, des-

68. Johann Friedrich Overbeck:
Joseph sold by his Brethren, 1816-17.
(East) Berlin, Staatliche Museen

pite the striving after uniformity, the decisive element was the talent of the individual, and for this reason the two foremost talents, Koch and Cornelius, who, moreover, were similar to each other in more than one way, stand out above the rest. The abundance of models and the burden of acquired knowledge were also an obstacle to achieving that solitary grandeur of a single outstanding figure which is characteristic of Carstens's designs and which constitutes one of the most important means to success in monumental painting [26, 27]. One cannot help being reminded of Carstens in looking at some of the

work of Cornelius [70], and in fact there could have been a direct link through Eberhard Wächter, from whom the brethren of the Guild of St Luke had learned much during his stay in Vienna (1798-1808). The dramatic energy in the murals by Koch and Cornelius makes it possible to overlook many of the weaknesses of history-minded imitation. In the end this energy was bound to be their only way of achieving success, even if they did not attain a fully independent language of form. In respect of independence of form some of the gentler temperaments among the Nazarenes were more

successful. The panel-paintings by Franz Pforr (1788–1812), *Rudolf of Habsburg and the Priest* (*c.* 1809) [69] and *The Entry of the Emperor Rudolf into Basel in the year 1273* (1809–10, Frankfurt am Main), as well as individual works by Overbeck and by Franz Horny (*Rome at the time of the Renaissance*, 1821, Heidelberg), Johann Anton Ramboux, and Johann Evangelist Scheffer von Leonhardshoff (1795–1822), are examples. Originality of form is most clearly visible in the work of Pforr, in his figures and the shapes of objects rendered with a minimum of modelling, isolated like silhouettes, crowded

into settings which are shallow or divided into simple zones without being enlivened by perspective. This is a deliberate primitiveness, which yet produces the effect of being genuine; for although it is for the most part derived from the German primitives and the Quattrocento painters, and although it has certainly artificial folklore elements, it creates a true fairy-tale atmosphere. There was thus, inside the Nazarene movement, in addition to the religious dogmatism, a playful, unaffected Romanticism, which later became the point of departure for Schwind and Richter.

69. Franz Pforr:
Rudolf of Habsburg and the Priest, *c.* 1809.
Frankfurt am Main, Städelsches Kunstinstitut

Two early works by Peter Cornelius (1783–1867) stand quite alone – twelve drawings illustrating Goethe's *Faust*, published in 1816 after years of work, and seven drawings for the *Nibelungenlied* (1812–17, Frankfurt am Main). In them there is little that is soft, though they were certainly modelled on the smooth calligraphy of the outline drawings made by the brothers Riepenhausen of Göttingen. Franz (1786–1831) and Johannes Riepenhausen (1788–1860), with their Genevieve cycle published as a joint work in 1806, were in a certain sense forerunners of the Nazarenes, though, using graphic forms derived from Flaxman, they were to an even greater extent Classicists. These early drawings of Cornelius, on the other hand, have for the most part a vigour contrasting with the smoothness of the lines; from his models in a wider sense, Dürer's graphic works and the Dürer period in general, Cornelius selected the Mannerist, 'Baroque' elements, and these drawings, which on the whole are still immature, contain much that is bizarre and a demonic element – faintly reminiscent of Blake – which subsequently appears again and again as a fundamental quality of Cornelius's art. Of the frescoes in the Casa Bartholdy (completed in 1817) in Rome two are by his hand. His work for the Dante Room in the Casino Massimo never got beyond the stage of designs; for in 1819 King Ludwig I summoned him to Munich to decorate with frescoes the rooms in the Glyptothek begun by Leo von Klenze in 1816. This resulted in a turning towards classical themes (Hesiod and Homer) and thus to Classicism, to which Cornelius remained faithful throughout the rest of his career. More completely than any other artist he made Schlegel's maxim his own: 'All beauty is allegory. Because they are inexpressible, the highest things can only be said allegorically.'[20] In this attitude the affinity with Carstens is at once obvious. For Cornelius, too, great ideas could find expression only in terms of figures, and in 1825, when the new landscape-painting had already created a wide field of activity and achieved notable results, he declared that landscape-painting was 'nothing but a kind of lichenous growth on the great tree-trunk of art'.[21] All his efforts were now directed towards the formulation of a new monumental painting and of an artistic synthesis of Greek Antiquity and Christianity. The rigid exclusiveness of this attempt, the radical rejection of all the more sensuous means of representation in favour of a linear art as the only road to salvation, exposed him to all the dangers of intellectualism and eclecticism. Cornelius's colossal mural painting of the *Last Judgement* (1836–9) in the choir of Friedrich von Gärtner's Ludwigskirche in Munich is an example of this. But this fanatical, bitter struggle found its reward in one significant final work, the cartoons for mural paintings in a projected 'Campo Santo' for Berlin, on which Cornelius worked from 1843 on, mostly in Rome. *The four Horsemen of the Apocalypse*, the best-known and the most forceful of these drawings (exhibited in 1859 at Berlin) [70], is full of a dramatic power which makes it worthy to rank among the few great creations of the nineteenth century in the field of monumental painting and justifies Cornelius's European reputation.[22] What makes such drawings of Cornelius live for all time is something that had become rare since the days of Baroque art: the genuineness of great gestures.

In cases where dramatic passions were excluded from the composition and the supernatural gentleness of the figures of saints set the tone, as for example in the frescoes by Josef von Führich (1800–76) in St John Nepomuk (1844–6) and the Altlerchenfelder-Kirche in Vienna[23] and in similar works dating from the late phase of the Nazarene movement, the monumental effect is still more questionable and unsatisfactory. It would be possible to conceive of mural paintings in which linear harmony and a suitable colour-scheme would produce an effect like that

70. Peter Cornelius: The four Horsemen of the Apocalypse, *c.* 1850. Drawing. *(East) Berlin, Staatliche Museen*

71. Josef von Führich: The Virgin Mary crossing
the Mountains, 1841. *Vienna, Österreichische Galerie*

of hymns sung in churches, and this was prob-
ably the dream of those pious artists before
whose eyes Fra Angelico's Kingdom of Heaven
must have been continually hovering; but we
know of no monumental painting produced by
the Nazarenes in which this dream came true.
Only in a few smaller works by Führich, such as
The Virgin Mary crossing the Mountains (1841)
[71] or the drawings in the biblical cycles dating
from the last decades of his life (*The Road to
Bethlehem* at Prague, and *The Life of the Virgin*
and *The Prodigal Son*, both in Vienna, Akademie
der bildenden Künste, etc.) do the linear flow of
transparent drawing and the harmony of the
composition produce, in the whole as well as in
the parts, an impression of all-pervading grace.

This religious art, as the product of a 'gentle
law' (Adalbert Stifter), might have been a
worthy counterpart to the dramaticism and
dynamism of Cornelius's best works. In reality,
however, it lags a long way behind them, for the
edifying nature of these legends tempted artists
into stale clichés of gesture and composition, and
the invention, in comparison with Cornelius,
remained inadequate. This is also true of
Edward von Steinle (1810–86), a native of
Vienna, who studied under Kupelwieser in that
city and after a sojourn in Rome came back to
Vienna for a short time; from 1839 on he lived
in Frankfurt am Main and painted murals in a
number of Rhineland churches (St Mary in
Capitol, Cologne; St Mary, Aachen; St Ägidien,

Münster, etc.). His drawings have the gentle, melodious linearism of Führich's graphic works. In his many religious pictures and representations of fairy-tales, mural paintings, and designs for stained-glass windows, however, little of this charm has been preserved. They are devoid of feeling, stiff, schematic, and full of stereotyped repetitions. From such works it was only a step to the 'Beuron School' of ecclesiastical painting,[24] and thus not only to the extreme limit of Nazarene painting, but to the limit also of what can be considered aesthetic.

A unique late case of Nazarene art is Franz Stecher (1814–53), also a pupil of Kupelwieser, who has only recently become known once again. In the strange mixture of styles pervading his painting of saints there appear a kind of return to the beginnings of Nazarene and Romantic principles and a breaking down of the narrow confines of academic Nazarenism reminiscent even of Blake.

Cornelius's painted heroic epics were a stirring example for a number of painters at a time when the creative impulse of Nazarene religiousness was on the decline, an example which induced them to take the history and legends of their country, classical mythology, and allegories as subjects for mural paintings. Instances are the pictures painted by Julius Schnorr von Carolsfeld after his return from Rome in 1827, and by Bonaventura Genelli. But even here no fulfilment was found. Schnorr's frescoes of the legend of the Nibelungs, of episodes from the lives of Charlemagne, Frederick Barbarossa, and Rudolf of Habsburg in the royal palace at Munich (1831–42), like his murals in the Casino Massimo, are lacking in inner cohesion with the architecture – Cornelius felt the need for such cohesion more than any other painter in the group – while in Genelli's late Classicist allegories (designs for the garden room in the 'Roman House' built for Dr Härtel at Leipzig; 1832, Kiel) we find nothing more of architectural sense than the broad decorative frames schematically taken over from Late Renaissance painting. The general effect is one of a very forced, half-hearted gaiety. Only Late Romantics of the type of Schwind managed to recapture something of the serenity of the only valid classical model for the whole genre, Raphael's system of decorations in the *logge* of the Vatican.

The on the whole rather unfortunate predilection of German Romanticism for the 'grand form', for monumental painting, was counterbalanced by an absorption in intimate details. The only branch of art in which this absorption came to fruition was portraiture. The important role played by the portrait, with its new and profound interest in the human countenance, is part of the story of German Romanticism. It is completely in accord with the Romantic conception of landscape, and is only another aspect of one and the same attitude towards the world. In an art which wanted to give pictorial form to the soul of landscape, to the 'universal soul', there was naturally also a place for the soul of the human individual. To what an extent and in what manner the Romantic idea of landscape and that of the portrait coincide can easily be seen in the art of Runge. In portraits, the ideological elements tend to be subsidiary, to the benefit of the aesthetic elements; or at least they are more concealed than in the 'grand' themes with their obtrusive intellectualism. Something similar had already happened in Classicism. Nevertheless the difference between the Classicist and the Romantic conception of the portrait remains clear. The outstanding characteristic of Classicist portraiture is a striving after formality, and with this went a tendency to create types, in so far as they were compatible with portraiture. As against this, the portraits painted by Romantic artists are more contemplative, but they were prevented from achieving complete individualism by what yet survived in them of the ideological element. A curious detail exemplifies this situation: the most characteristic and

72. Julius Schnorr von Carolsfeld:
The Painter Carl Mosler, 1819. Pen-drawing.
Vienna, Akademie der bildenden Künste, Print Room

73. Carl Philipp Fohr:
The Painter Joseph Sutter, *c.* 1817-18. Pencil-drawing.
Heidelberg, Kurpfälzisches Museum

at the same time the profoundest portraits painted by the Romantics of those years were the series of likenesses of their friends and patrons in Rome drawn by Julius Schnorr [72] and Carl Philipp Fohr of Heidelberg (1795-1818) [73]. The latter, a man of outstanding talent, was drowned in the Tiber when he was only twenty-three. Despite all their crispness and definition in the reproduction of the anatomical structure and the meticulous execution of the details, Fohr's portrait-drawings retain something of the character of improvisations. Schnorr's, on the other hand, although both in the psychological conception and the graphic interpretation of the essence of the face on the same level as Fohr's, are in the main derived from the portraits engraved by Dürer and his contemporaries. A sign of Schnorr's dependence on these is the inscriptions beneath each of them. That may seem a superficial similarity, but it reveals not only reverence for the primitives, but also a desire for formality. Essentially intimate portraits of friends, which were documents of a personal human relationship, either remained, like Fohr's, purely private, or else, like Schnorr's, had to be enhanced by would-be historical accessories. The same thing happened in the *painted* portraits of the Romantics, in which historical costumes and schemes of German and Italian Renaissance portraits were frequently used (the eyes looking slantwise out of the pictorial field are a striking peculiarity borrowed from that classic epoch).

The portraits of the Romantics did not therefore play a role corresponding to their intrinsic worth, and even today they can still be called a hidden treasure. To the likenesses drawn by Fohr and Schnorr must be added numerous

74. Johann Ev. Scheffer von Leonhardshoff:
Young Man, *c.* 1820. Charcoal drawing.
Vienna, Albertina

portraits (mostly representing German artists in Rome) by painters such as Overbeck, Scheffer von Leonhardshoff [74], Theodor Rehbenitz (1791–1861), a native of Holstein, Friedrich Olivier, Johann Anton Ramboux (1790–1866) of Trier, etc.[25] Common to all these portraits is an ideal of clarity in line and modelling. This, it is true, had already been a Classicist ideal, but there are differences. The Romantic portraits are simpler, more lifelike, and 'more human', not only from the point of view of portrayal, but because the exaggerated tenderness and nervous delicacy of their outlines made it possible to achieve a more refined characterization and even more because the often ethereally delicate web of lines and the firm modelling directly express the whole ethos and sensibility of Romanticism. This is true of the best portraits in the same sense in which it is true of Runge's outline drawings for his *Phases of the Day* [64].[26]

The limitation to outline gives a quality of abstract coolness to the likenesses, and their peculiar charm is due to the various embellishments added to the outline structure, either compact layers of hatching as found in the engravings of the primitives, or pale, vague tones like those of Late Gothic or Holbein drawings. This produces, for example in the works of Schnorr von Carolsfeld, a steely hardness or, as a result of the suggestion conveyed by the washes, the highest degree of three-dimensionality. In this respect some of the best of the Nazarene portrait-drawings come very close to those of Ingres [21, 22].

If their special characteristics are translated into painting, as in many of the portraits by Heinrich Maria von Hess (1798–1863) – e.g. that of Thorvaldsen dating from 1823 at Munich – and those by Scheffer von Leonhardshoff or Overbeck, the result in the majority of cases was less successful; for where colour played an essential part the Nazarenes – just like the Classicists – were generally incapable of achieving much.

In three respects the Nazarenes contributed to the development of painting in an unequivocal, clearly positive and effective way – and by Nazarenes are meant here not only the professed adherents of the movement but also the mature German Romantics with leanings towards religious art. The first of these is a simplicity of form which was no longer a mere matter of imitation; this we have already mentioned in connexion with Pforr [69], and it also appears in portraits by many other painters [74], for example in some of Fohr's after his arrival in Rome in 1816. The second is introspection, an investigation of the inner soul, peculiar to the Nazarene conception of the portrait. The third is a specific, again more intimate, interpretation of landscape. This eventually signified a turning away from everything heroic. It is true that Koch, the master of heroic landscape, had a particularly strong influence on the landscape-

painting of the Nazarenes, but, as in portraiture, the Nazarenes expressed themselves most successfully in drawings and water-colours, and in Koch's case many of his drawings were not simply heroic.

It is no accident that the landscapes of two of the 'German Romans' who both died when they were still very young, Fohr and Horny, give the strongest impression of a painter's rapture on beholding the much extolled Italian landscape. Their drawings are full of a youthful freshness, despite the fact that the sacrosanct rules for the construction of foreground, middle distance, and background are still followed, and drawing, now as before, remains the dominating means of expression. Even when light and shade are rendered only in the conventional schematic way, these studies are often filled with the sunny brightness of the south.

The noteworthy element in the water-colours and drawings which Fohr produced just before his journey through the Alps, during his stay there (especially in Salzburg in 1815), and later in Italy, is the profuse variety in the interplay of drawing and colour, a clear, spirited *ductus* of strokes, and an abundant use of washes. In the works of the Nazarenes proper, who were timid in their use of colour, washes are rarely found. In the only two large landscape compositions which Fohr is known to have made – a view of Tivoli at Frankfurt am Main (1817) and a mountain landscape near Subiaco at Darmstadt (1818) – we find mountain scenery, constructed in principle completely on the lines of Koch's imaginary landscapes, but converted by Fohr from epic into lyric. Here, in a style of astonishing sketchiness, the rhythm in the rise and fall of the zones of ground acquires a new melodiousness. For decades this remained the determining factor in idealistic landscape, down to the last days of the Late Romantic period, the days of Schirmer, Lessing, Dreber, Richter, and Schwind, and still surviving in – or revived by – Hans Thoma and Karl Haider.

Franz Horny (1798–1824) of Weimar went to Italy in 1816 with the art critic and patron Carl Freiherr von Rumohr, and spent most of his time in the idyllic Olevano. He also had a share in the execution of the murals in the Casino Massimo, since he designed the floral decorations for Cornelius's ceiling paintings. In his studies of landscape the drawing is slightly more timid than Fohr's. He expressed the whole trend in the rendering of landscape among the early 'German Romans' when he wrote to his mother that he was trying 'to conceive Nature with austerity and a sense of modelling, as the painters of the fifteenth century did'.[27] A respect for reality and a pious serenity are the characteristics of Fohr's and Horny's landscapes. They and the Italian landscapes of Julius Schnorr, Scheffer von Leonhardshoff, and Ludwig Richter form a separate group within the framework of landscape-painting during the first half of the nineteenth century. Its source was partly the art of Ferdinand Olivier, who endowed this conception of landscape with a special gravity, and even profundity.

THE OLIVIER BROTHERS

It is a noteworthy fact that Ferdinand Olivier (1785–1841), one of the leading Nazarenes and the most important landscape-painter in the group, never set foot on Italian soil. He came from Dessau, where together with his brother Heinrich (1783–1848) he was in contact with the court of Prince Leopold Friedrich Franz of Anhalt-Dessau, who took a keen interest in art. The chief meeting-place of this circle was the prince's country house at Wörlitz, one of the finest works by Friedrich Wilhelm von Erdmannsdorff (1736–1800). Wörlitz, with its park and its collections, was a nursery of Classicism. The first teacher of the two older Olivier brothers was Carl Wilhelm Kolbe. He gave his pupils the foundation of a confident draughtsmanship together with something of his own

graphic virtuosity. It is easy to see how much they owed to his careful observation of nature and his self-willed, passionate Early Romanticism. At Dresden between 1804 and 1806 the brothers frequented the circle of the Romantics. Afterwards, during a stay of two and a half years in Paris, they painted in collaboration two religious pictures, a *Baptism of Christ* and a *Last Supper*, for the chapel at Wörlitz[28] (it is significant that – under English influence – a 'Gothic house' had been built in the grounds of Wörlitz as early as 1773). These two paintings are hesitant early works of Nazarene art, chockfull of motifs and forms borrwed from Late Gothic painting. But it was only during his long stay in Vienna (1811–30) that Ferdinand Olivier's art achieved full maturity. When he arrived there with his younger brother Friedrich (1791–1859), of the 'brethren of the Guild of

St Luke' only Sutter was still there, but Koch, Julius and Ludwig Ferdinand Schnorr von Carolsfeld, the Reinhold brothers, Theodor Rehbenitz, Philipp Veit, and G. W. Issel, and in addition the poets Eichendorff, Brentano, Tieck, Körner, Klinckowström, Werner, the Humboldt brothers, and the Schlegel brothers were all living in Vienna.

Some of Ferdinand Olivier's landscapes with religious figures painted during his first years in Vienna (*Legend of St Hubert, Rudolf of Habsburg and the Priest, Salzburg Landscape with Abraham and Isaac*)[29] are in the same category as the two pictures for Wörlitz, except that elements from Koch are added. But about the same time Olivier drew a number of views of Vienna [75], which in every respect are the opposite of the painted landscapes just mentioned. In contrast to these artificial landscapes with their scenic

75. Ferdinand Olivier:
Quarry near the church of Matzleinsdorf,
c. 1814–16. Pen-drawing. *Vienna, Albertina*

wings – typical Nazarene work, full of echoes of Dürer and the Danube School – the pen-drawings are evidence of Olivier's intimate knowledge of the little world of landscape motifs in the environs of a large town. Olivier lived in the suburb adjoining the Belvedere and the Schönburg Palace, then still not much more than a village, and this is the neighbourhood which appears in these strange drawings. Occasionally, the two palaces and Baroque churches appear in them, but never with any stress laid on their importance; on the contrary, they are either disfigured by mean houses, or are mere distant motifs behind little gardens, quarries, and country roads. The smallest details are recorded with extreme precision, yet the whole has the supernatural stillness of a somewhat melancholy landscape seen in a dream. Silent little figures stand among the cubic blocks and bare walls of the houses, lonely and filled with grief for the inexorable passage of time. The fundamental affinity of this conception of landscape with that of Caspar David Friedrich is obvious, and there exist two drawings by Olivier of *Cliffs on the Brocken* (1810, Dessau), made during a journey to the Harz Mountains before his visit to Vienna, which clearly reveal the influence of Friedrich, even in the subject, though at the same time they are in atmosphere anticipations of the Vienna drawings. Even Friedrich never succeeded in showing in this way, by means of things small and insignificant in themselves, the might of the invisible forces of nature, the infinity and silence of space. If it is possible to express in a landscape something of Christian humility in the presence both of living beings and of natural things, then it has been achieved in these drawings by Olivier. Unlike

76. Ferdinand Olivier:
The Cemetery of St Peter in Salzburg ('Saturday'),
c. 1818–22. Lithograph

the works of Friedrich, they lack the funda-
mentally dramatic quality of sublimity. They
realize, in a way that no other artist could
approach, the Nazarene ideal of medieval sim-
plicity. In their piety they remind us of the
landscapes in the pictures of saints by Nether-
landish painters of the fifteenth century, but
they are not historicism in the sense of an imita-
tion of the past. Moreover, so far as we can see,
the painting of the Netherlandish primitives
was of only minor importance for the Nazarenes
compared with the art of the German primitives.
It is exceptional when Friedrich Schlegel, on
seeing the triptych by Dirk Bouts in Munich,
speaks of 'sacred landscapes, surpassing every-
thing that can be seen in landscape-painting'.
Olivier's sketches of odd corners in the suburbs
of Vienna, sketches of what seems observed, as
it were, through a veil of tears, are also 'sacred
landscapes', and so are the views of Salzburg
painted or drawn after two visits in 1815 and
1817. Of his many studies, seven, which he drew
between 1818 and 1822 for reproduction as
lithographs, form a series [76]. The figures
which people them – figures such as we find in
the calendar pages of medieval Books of Hours –
make it clear that they represent the days of the
week, and lives pleasing to God. In 1823 Olivier
made another series of similar drawings in
Vienna and the neighbouring Mödling. They
were the last of the kind.

With their silvery web of delicate threads,
these drawings achieve a spiritualization which
surpasses all other Romantic landscape-draw-
ings, even those of Friedrich. Their ascetic,
cubic austerity and nakedness remind us of the
pictures of buildings by that 'outsider' Pieter
Saenredam (1597–1665), who had managed to
convey in paint the mysterious charms of spatial
geometry, and of the emptiness and bareness of
Dutch churches. In no other works does
Romantic landscape free itself so completely
from dependence upon the past. They are the
most notable counterpoise to the naturalistic

landscape art of the nineteenth century. Only in
the best of his painted landscapes did Olivier
approach their purity and grandeur: the *Garden
of the Capuchin Monastery in Salzburg* (1826,
Leipzig), the *View of the Castle of Weikersdorf*
(1826, destroyed by fire in Munich in 1931), and
the *Imaginary Salzburg Landscape* (1829, Des-
sau). In 1830 Olivier went to Munich. The
works he produced during the last ten years of
his life, most of them Italian landscapes, some
of them showing a trend towards the heroic
landscape which is not in harmony with his
character, are a feeble petering out of his art
into mediocre Romanticism.

Friedrich Olivier emulated his brother in
many respects, but except in isolated land-
scapes – such as the solemn *Italian Landscape
with Horseman* at Leipzig – he remained a long
way behind him. It was his ambition to be more

77. Friedrich Olivier:
Withered Leaves, 1817. Pen-drawing.
Vienna, Albertina

versatile, and he did in fact succeed in producing a few magnificent portraits. In some meticulous pen-drawings of withered leaves (1816–17) [77], he followed Dürer, Schongauer, and other German Late Gothic artists, showing an equally intense absorption in their art and in nature.

Ferdinand Olivier's landscape-drawings were recognized as outstanding by his painter-friends, and they created a school. Many of Julius Schnorr von Carolsfeld's drawings, for example *The Castle of Wetzlas in Lower Austria* of 1815 in the Albertina, might easily be mistaken for drawings by Olivier. In the intimate little etched *vedute* of Thomas Benedetti (1796–1863) and Franz Barbarini (1804–73), two later artists who worked in Vienna, there still lingers something of the gentle music of Olivier's glowing landscapes. But where, in Romantic pictures and drawings, the severe orthogonality and the angular hardness are not mysteriously veiled as they are in Ferdinand Olivier's art, we need not consider him as the source, but are well advised to look for other models such as, for example, Koch with his series of Italian landscape studies, and the landscape backgrounds of those Early and High Renaissance Italian artists and German primitives which had likewise had a decisive influence on the formation of Olivier's own Romantic landscapes. Finally, there was one foundation which was common to all, a kind of graphic lingua franca, namely engraving – at that time the only technique for art publishing and one which imposed its style on countless reproductions.

ROMANTIC LANDSCAPE-PAINTING
IN SALZBURG AND MUNICH

Ferdinand Olivier has been described as the founder of the Salzburg school of landscape-painting which flourished in the first half of the nineteenth century. This he was, in so far as he was the first outstanding landscape-painter of Romanticism to be fascinated by that city, and

was followed by a whole colony of artists. In this way a new school of native German landscape-painting grew up, side by side with the North German school centred on Friedrich. Both were opposed to Italian landscape, which had not yet lost any of the esteem inherited from the days of Classicism. It still enjoyed what Fernow had described in an article in the *Neuer Deutscher Merkur* of 1803 as being the general opinion: 'In other countries, for all its beauty and grandeur, nature has a special, narrow, as it were provincial character ... The Italian landscape, on the other hand, has the universal character of beautiful nature.'[30] Moreover, we must not overlook the fact that the many southern aspects of the town of Salzburg, which reminded painters of Italy, contributed to the enthusiasm for the town.[31]

The actual zenith of Salzburg landscape-painting after Olivier, however, had been preceded by the activities of a number of painters and sketchers of *vedute* who roamed around Salzburg and its environs, the Austrian Salzkammergut, and the Berchtesgaden area. The landscape of this area, which according to Alexander von Humboldt can be reckoned among the 'most beautiful regions in the world', had thus attracted travellers and painters at a somewhat earlier date, just as the high mountains of Switzerland had attracted them earlier still. About 1800 two Swiss engravers of *vedute* – Wilhelm Friedrich Schlotterbeck (1777–1819) and Johann Jakob Strüdt (1773–1807) – made the countryside round Salzburg known to a wider public with their series of etchings and coloured aquatints. These sheets, and some views of Salzburg made in 1796–7 by Albert Christoph Dies (1755–1822) of Hanover, are neat *vedute* in the manner of Hackert and Aberli, with occasional Romantic arabesques. It was not until 1811, with the appearance of Schinkel's pen-drawings of places in the neighbourhood of Salzburg and Berchtesgaden (Berlin, Schinkel Museum), that this detached painting of views

was replaced by a livelier Romantic form. This, too, was at first only a suggestion of Romanticism, which is manifested almost exclusively in the agitated, crowded accumulation of small forms, in the filigree-like, glittering drawing of foliage and rocks; but this is just enough to distinguish them from Classicist drawings. (One is reminded of the etched studies of trees and herbs by Carl Wilhelm Kolbe, the teacher of the Olivier brothers.) Concern with small things remained a characteristic of the draughtsmanship of the brothers. Only in Ferdinand did it acquire religious significance, but it had a notable influence on some of the Salzburg landscapes of his friends, not only, as said above, on those of his brother Friedrich and Julius Schnorr von Carolsfeld, who later became his brother-in-law,[32] but also, for instance, on August Heinrich of Dresden (see above, p. 102), who was very close to Ferdinand Olivier, both as an artist and as a man, and made several landscape-drawings of Salzburg in 1820-1. What distinguishes his conception of nature from that of Ferdinand Olivier is the renunciation of every suggestion of religious meditation. Heinrich's landscapes, almost without exception, contain no human figures; they are more objective than Olivier's and are reverent portrayals of nature without the veiled intellectualism and symbolism of Olivier. A more objective, more worldly Romanticism also characterizes the Salzburg views of two Nuremberg artists, Johann Christoph Erhard (1795–1822) and Johann Adam Klein (1792-1875). The brothers Friedrich Philipp (1779-1840) and Heinrich Reinhold (1788-1825), who came to the academy in Vienna from Gera in Thuringia, also reveal a variety of intentions in their Salzburg landscapes, in contrast to Olivier's single-minded religious solemnity. Sometimes we find in their works a reproduction of lighting effects in the manner of Biedermeier realism; elsewhere a dramatization of high mountain scenery in the spirit of Koch, as for example in Heinrich Rein-

hold's *Watzmann* of 1818, with its sonorous contrast between a dark gorge and the snow-capped mountain behind it [78]. In the same

78. Heinrich Reinhold:
The Watzmann near Berchtesgaden, 1818.
Vienna, Österreichische Galerie

artist's view of the Mönchsberg by evening light (1819) in the Österreichische Galerie at Vienna there are echoes of the Arcadian landscapes of earlier times; paradoxically, the Romantic introversion gives it a more classical character than is found in many of the landscapes by orthodox Classicists. Similarly, in the landscapes which Friedrich Loos (1797-1890), the first Austrian-born artist in this group of landscape-painters, created during his stay in Salzburg from 1826 to 1835, we find Romantic transfiguration side by side with an objective rendering of reality. In one of his most beautiful works, the view of the Mönchsberg dated 1826 [79], this juxtaposition takes an almost symbolical form: the distant mountains, crisply drawn with a meticulous fidelity to detail reminiscent of the Nazarenes,

79. Friedrich Loos:
The Mönchsberg near Salzburg, 1826.
Vienna, Österreichische Galerie

stand in the neutral light of Romantic painting which is an expression of remoteness from the world, but in the middle distance the clear sunlight penetrates gently and irresistibly and creates a play of sparkling light and acute shadows over the park and meadows surrounding Schloss Leopoldskron. In views of Salzburg dating from a few years later, Loos made this play of light the chief content of his painting, in a manner which is already Early Impressionist. About the same time, from 1828 on, Rudolf von Alt (1812–1905) in his first water-colours abandoned the conventional *vedute* of his father, Jakob Alt (1789–1872), a native of Frankfurt am Main, and devoted himself to a purely pictorial, almost scientifically prosaic study of the infinite abundance of visible things. Soon afterwards,

in the Salzkammergut landscapes of Gauermann and Waldmüller, real Romanticism was abandoned.

Salzburg landscapes continued for a long time to influence the work of Ludwig Richter (1803–84). He went to Salzburg in 1823, remained there only a short time, and visited the neighbourhood, but the experience made a deep and lasting impression upon him. His picture of the Watzmann painted in 1824 (now in Munich) is still completely under the impression of Koch's *Schmadribachfall* [37], and is almost a paraphrase of it. In his six etchings made in 1830, 'Picturesque Views from the Environs of Salzburg and Berchtesgaden', which have hardly any affinity with the studies of 1823, the mountain world around Salzburg is transformed

into a pleasing idyll, with a clear return to the Dutch type of stylization of landscape current about 1800 [169]. In a strictly historical sense, this is no longer Romanticism, but a Post-Romanticism already merging into the comfortableness of Biedermeier art.

Late, too, are the Romantic landscapes of Ludwig Ferdinand Schnorr von Carolsfeld (1788–1853), who at an early stage came into contact with the Viennese Romantics and after 1835 resided permanently in Vienna. In the landscapes he painted in the thirties and forties the hand of the draughtsman and colourist is still guided by the idea of a pantheistic conception of nature, and this determines the clear outline drawing and the local colours juxtaposed in well-defined contrasts. A picture like the *Valley of Chamonix with Mont Blanc* (1848, Vienna), with the village in the twilight of the valley, the rosy alpine glow on the wildly soaring snow-capped summits, and the moon in the enamel-blue expanse of the sky, is an 'earth-life' in the spirit of Carus.

It is a well-known fact, historically confirmed several times since the days of Classicism, that an art devoted to nature can flourish quite easily side by side with a grand manner with 'grandiose themes' and ambitious intellectual programmes forcibly imposed by an ideology or a patron. As far as it concerns the patron this is understandable, since he can intervene in the programmes of intellectual painting, according to circumstances, by either encouraging or demanding certain themes. It is equally understandable that naturalism pleased the public at large, a public which at a time of ever-growing democratic ambitions also tended to grow and become more influential. These relationships between artist and customer are as banal as they are indisputable. It does not logically mean that there is anything to be said against the great patron or against the art which flourishes under him; yet, from a more general point of view,

dependence on the patron does seem in fact to result in a loss of artistic purity. An instructive example of this is the way in which art flourished at Munich, 'the Athens on the Isar', during the reign of King Ludwig I. Goodwill and understanding on the part of the royal patron were certainly present, and it is equally certain that even unexpressed compulsion did not amount to much. Nevertheless the ideal world of grandiose stories and allegories is frequently disturbed by a sturdy realism, and the result is a discrepancy that is often painful. On the other hand, the idealization of landscape or of the human figure seldom produced real cohesion and harmony. To what extent the inner necessity of the style of the period or the decline towards mediocrity, academism, and compromise which is an inevitable consequence of officially subsidized art contributed to this state of affairs – that is a question which can only be decided by a theoretician of history. The fact remains that throughout nineteenth-century painting, after the early stage of Romanticism, the idealists – with the one notable exception of Ingres – were unable to compete with the great anti-idealists in either strength or depth. And this remained the case even after the prejudice had been overcome which, from Impressionism down to our own days, belittled the values of idealization in painting and favoured painterly realism.

In landscape-painting in particular, any restrictions on the free representation of visible things seemed more and more like concessions to outworn conventions. In consequence, the overall picture of Munich landscape-painting at that time becomes a motley mixture of surviving Classicist clichés and increasing interest in the local landscape, of heroic and middle-class elements, of idealization and sober reproduction of reality. It is in marked contrast both to the gravity and melancholy of the North German Romantics and to the absorption of Nazarene landscape-painting. In the landscape-painting of Munich, Romanticism exists only in

the more superficial sense of the term, most clearly seen - in spite of their Classicism - in the melodramatic landscapes of Carl Rottmann. Painters like Peter von Hess, Bürkel, Adam, Fries, and Christian Morgenstern still follow the example of Wilhelm von Kobell, Johann Jakob Dorner the Younger, and Wagenbauer (see p. 79 f.), with their constrained forms derived from Classicist tradition. The only real landscape-painters in this group were Fries and Morgenstern. Ernst Fries (1801-33) was influenced by Rottmann but produced his best work in his more restrained landscapes of Salzburg and Tyrol, which date from the early 1820s and are very close to the Nazarenes and especially to Ferdinand Olivier. Christian Morgenstern (1805-67) was born in Hamburg and studied at the academy in Copenhagen, which partly explains the affinity between his landscapes and Dahl's *Stimmungslandschaft*. The landscapes of Peter von Hess (1792-1871) and Heinrich Bürkel (1802-69) are generally filled with numerous accessory figures, consisting in Bürkel's case of groups of shepherds in Campagna settings, and genre scenes of peasant life in Bavaria and Tyrol, while in the pictures of Hess the landscape is often a mere background to genre and battle scenes. Albrecht Adam (1786-1862) specialized in the painting of horses and soldiers. In the pictures of these minor masters, particularly in the way in which the figures are disposed in the setting, Dutch models can usually be discerned, as they can also in the town views of Domenico Quaglio (1786-1837), who, with Eckersberg in Denmark, Gärtner in Berlin, and Boilly in France, belongs to the category of painters in whose pictures a certain neatness is converted into Romanticism. The clarity and cubic simplification of their pictures of buildings and streets reveal an understanding

80. Georg Dillis: View with St Peter's, Rome, 1818. *Munich, Schackgalerie*

of architectural values, and also a very clearly defined mood – often both at the same time. The danger in such cases is that the great art of the representation of little things, in which the Dutch had been masters, can easily degenerate into a pedantic rendering of trifles.

In the pictures of all these Munich landscape-painters, whether they were minor masters or real 'professionals' ('Fachmaler'), there is nearly always an element of oppressive studio atmosphere. The artist who shows the least trace of this is Johann Georg Dillis (1759–1841). It is true that he began by painting landscapes in the Dutch manner or according to schemes of composition and lighting à la Claude Lorrain, but in the end his painting emerged from this blind-alley of eclecticism and found the road, or at all events a side-road, to a free and lively form of pictorial representation. In some of his studies from nature, such as the four views of Rome (1818, Munich, Schackgalerie) [80] or the view of Dietramzell (c. 1810, Munich, Bayerische Staatsgemäldesammlungen), he becomes one of the representatives of that painterly Romanticism which was practised by Blechen and Wasmann, i.e. of a Romanticism on the point of being replaced by a purely painterly point of view.

FRANCISCO DE GOYA

(1746-1828)

It is doubtful whether the vague superlative 'genius' can be applied to any painter of the real Classicist school. But it is certain that Goya, who was their contemporary, deserves it. Many painters of the period had flashes of genius – for example David, Blake, Fuseli, and Runge – but none of them can be called a genius as unreservedly as Goya can. His art is the direct antithesis of theirs, just as Rembrandt's was the opposite of that of the painters of his time. As one looks at a work by Goya one realizes the limitations of Classicism, limitations which, as so often happens in matters of art, have no logical foundation. In the case of Classicism the limitations are lack of originality and universality of spirit, although the latter emphatically formed part of the Classicist programme. Of another trait of genius in Goya, the demonic element, hardly anything is to be found in the Classicists, though it can be discerned in certain artists of that Late Baroque from which Goya derived, for example Magnasco, Maulbertsch, and Piranesi. The sharp contrast between Goya and almost all his contemporaries is certainly astonishing, though not in every respect. From the point of view of evolution, of course, Goya seems like an outsider, directing his gaze to something that found no place in the normal aesthetics of figurative art about the year 1800, something which the others did not see, or did not want to see. Nevertheless, if we deal first with the question of subjects, the moralizing element in Classicist art is also evident in Goya. It is obvious that he shared the basic humanistic ideas and valuations of the period of enlightenment. But he perceived the demonic forces underlying them with unusual clarity and reproduced them in his pictures without disguise and without embellishment. Other great minds of his day also knew these things and gave expression to them, for instance Goethe, Mozart, Beethoven, and Schubert – but, except for Goya, the painters and sculptors perceived them hardly at all. Goya's achievements may thus most fitly be compared with the achievements of the most universally valid contemporary music and poetry. The trend towards the demonic and the weird during a period which in reality wished and was able to propound the idea of morality in art solely by means of clarity and harmony is still, as it was at the time, disconcerting, and is bound to appear as a confusing irruption into the harmonious construction of Classicism. But viewed from the standpoint of the universality of the idea of mankind, Goya's art is seen to be a profoundly necessary complement to Classicism. In the monstrous world of his pictures he reveals all the capabilities of mankind, and that was thoroughly in the spirit of the age, though only of the age of extreme individualism which set in about the year 1800.

To this extent, therefore, Goya is not alien to his time but expresses its prevailing tendencies. Those who are dazzled by the strangeness of his art will not be able to grasp this immediately. The truth is that Goya did not introduce into his pictures extreme savagery and the powers of darkness, demons and lemurs, in such terrifying abundance and unrestrained frenzy merely in order to provide examples of evil and condemn them, but also because like other great moralists before him such as Bosch, Bruegel, and Shakes-

peare, he was attracted by the spectacle of the 'radical evil in human nature' (Kant). For him the demonic element was not comprised in the framework of ethical doctrine, it was not just an abstraction, nor was it a mere vision as it was for Blake and Fuseli; in addition to this, Goya saw it as a reality, clearly visible amidst the horrors of war [89], and also in everyday life, in the sinister gloom of madhouses, in the deliberately unleashed impulses of bullfights [81], and in many of the faces he had to portray [86].

The richest material for the study of Goya's attitude to the world around him, both visible and invisible, is offered by his cycles of etchings – the eighty sheets of the *Caprichos* (1796-8) [82], the *Disasters of War* (eighty-five sheets; 1810-13) [89], the *Tauromaquia* (forty sheets; 1815) [81], and the contemporary series of eighteen etchings first published in 1850 under the title *Proverbios*, but also known as the *Sueños*

('Dreams'), originally entitled *Disparates* ('Curiosities'). In the way they reveal this attitude, the cycles differ widely from one another. The *Tauromaquia* is an objective report of the bullfight, of the most important details of technique and rules, of certain outstanding episodes from its remote history and its more recent past. These thrilling scenes are observed and reproduced with an interest and practical knowledge natural to the Spaniard (in his youth Goya had himself taken part in bullfights), while the savagery and excitement are already in the subject and need no heightening. It is only as an artist that Goya stands above these things; as an individual he is in the midst of them. In the *Disasters*, on the other hand, scenes from the guerrilla warfare against the French from 1808 to 1814, showing bestial struggles, heroic deeds, massacres, rapes, executions, and profanations of corpses, the objectivity of the *Tauromaquia* becomes an accusa-

81. Francisco de Goya:
The Death of the Alcalde Torrejon, 1815. Etching

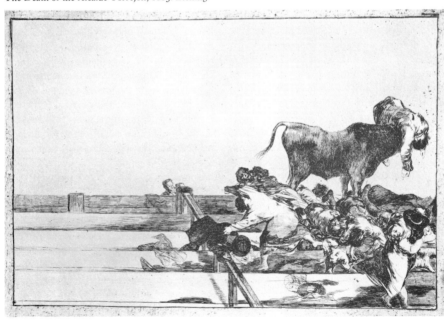

tion, even without Goya's original titles. Thanks to their artistic vigour, the *Disasters* become the strongest possible indictment of war. (Retrospectively, from the standpoint of art history, we can confidently extend Goya's accusation to the embellished renderings of war produced by his contemporaries and successors.) Goya's plea goes far beyond the opinions prevalent at the time, since it is directed against the whole idea of war, not only against the invading enemy. To quote an example, two sheets which follow one another, nos 22 and 23, shows heaps of dead belonging to both sides. This pacifism of Goya's is as isolated as that of Cervantes. The last sheets in the series are allegorical, and thus belong to the category of fantastic inventions which includes most of the *Caprichos* and *Proverbios*. In the *Caprichos*, the few critically observed scenes from life, reminiscent of Hogarth and with many now uninterpretable allusions to a corrupt society, become insignificant beside the oppressive multitude of spectral figures [82], of witches and ghosts, weirdly grinning forms, and fabulous animals, which intrude into everyday life or – in the *Sueños* – exist altogether in their own kingdom of nightmares and fantastically horrifying visions. In manifold gradations, they symbolize superstition and other pernicious powers, enemies of the world of reason, as can be seen clearly in Goya's own titles for his pictures and in his commentaries. To a certain extent, however, they are also the demons 'in one's own bosom'. Here there is still an echo of the old conception of sin. Traditional elements are fused with anticipations of the future: figures and scenes from Spanish popular belief are used to portray a pandemonium of human aberrations and distress. That might be held to come within the contemporary Early Romantic conception, but in actual fact these fantastic pictorial poems by Goya are, in their jeering acridness and coldness, and in the absence of all escapism, very different from genuine Romanticism. Except for the visionary figures of Blake and Fuseli, it is

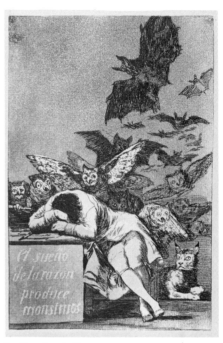

82. Francisco de Goya: Reason asleep, 1796–8. Etching

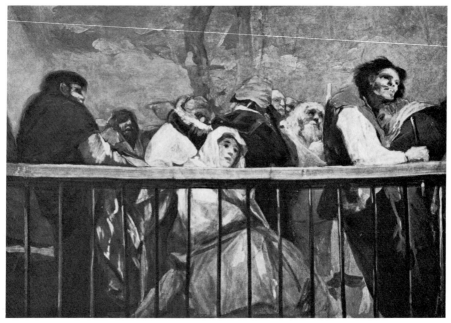

83. Francisco de Goya: Fresco in dome (detail),
1798. *Madrid, San Antonio de la Florida*

not until later that we find anything akin to this. At the other end of Europe, only a little later, Gogol in a similar way combined the weirdness of popular ghost-stories with a gloomy portrayal of the soul; it is not only the figure of the gigantic brazen ghost *Viy* (1834) that reminds one of Goya's figures, but also the spirit of the dead Akakiy Akakievich in *The Overcoat* (1835), which haunts the chief of police. Because his roots were in popular belief, Gogol, who already anticipates that great exorcizer of demons, Dostoievski, is closer to Goya than Romantic solitaries like E. Th. A. Hoffmann, Edgar Allan Poe, and other 'Satanists'. Yet it was due to their knowledge of Goya's etchings that the spirit of his works lived on in those of Grandville [209] and Daumier [191–204].

Although all that has been mentioned so far first appeared in Goya's art in the last thirty years of a life full of vicissitudes and continual unrest, one element in it can be discerned from the very beginning – a formal language in which painterly handwriting and colour are the alpha and omega. Here is yet another, absolute contrast with Classicism. Goya rescued the innermost essence of Baroque pictorial form and carried it into the nineteenth century, and thus became one of the founders of pure painting in that century. Three of the greatest Baroque painters were his models – Velázquez, Tiepolo, and Rembrandt – but not one of the Renaissance painters who were the idols of Classicism.

The artistic beginnings of Francisco José de Goya y Lucientes (such was his full name), who was born at Fuendetodos in Aragon in the year 1746, go back to his boyhood; for in 1760 he was already working in the studio of José Luzan y Martínez (1710–85) at Saragossa. From the

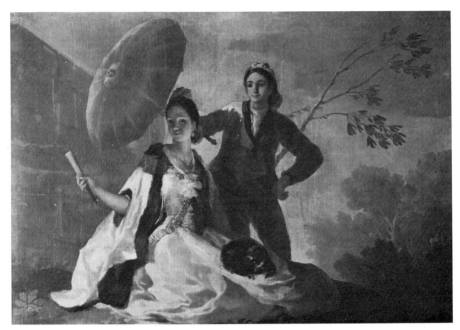

84. Francisco de Goya: The Sunshade, c. 1780–90.
Madrid, Prado

middle of the 1760s until 1771 he worked in Madrid under Francisco Bayeu y Subias (1734–95), whose sister he subsequently married. In 1771 he paid a short visit to Rome, and then went to Saragossa where in 1771–2 he painted his first religious frescoes in the cathedral of El Pilar, followed before 1774 by the frescoes in the Carthusian church of the Aula Dei near Saragossa. Many years later, in 1798, he executed another series of religious murals – his chief work in this category – for San Antonio de la Florida in Madrid [83]. Another branch of monumental painting is represented in his numerous designs for tapestries representing scenes from the life of the people and dating from the late 1770s and the period between 1786 and 1791 [84]. From 1780 on he was a member of the Academia de San Fernando, and from 1799 on painter to the court. He spent most of his life in Madrid, but in 1824, dissatisfied with political developments, he left his native country and went to Bordeaux. There he remained until his death, except for short visits to Paris and Madrid, compelled by increasing deafness to lead the existence of a hermit.

The mention of Tiepolo and Velázquez – works by whom Goya copied in 1778–9 in paintings and etchings – serves to characterize two of the main pillars in the gigantic structure of his art. One of these is monumental figure painting, in which he still belongs to the eighteenth century, since, working in a country which lay outside the borders of the real Europe, he remained practically unknown and had no influence on similar tendencies in the nineteenth century. In Goya's own works, however, it is of the greatest importance; for the trend towards large-scale dramatic painting full of Baroque dynamism

can be recognized in every single sheet of his cycles of etchings. It is present too in the fantastically weird murals from his country house, Huerta del Sordo (after 1814) [85], and in paintings such as the two scenes from the time of the Napoleonic invasion: *The Battle of 2 May 1808* (1814) and *The Execution of the Rebels on 3 May 1808* (1814) [88], both in the Prado, and even in the beauty of materials is rendered (portrait of Bayeu, 1796, Prado; portrait of the matador Pedro Romero, *c.* 1800, New York, Hispanic Society of America) and a hectic agitation reminiscent of marionettes (full-length portrait of the Duchess of Alba, 1795, Madrid, family of the Duke of Alba; and also the above-mentioned group of the royal family). One has to go back as

85. Francisco de Goya:
Two old People drinking Soup, after 1814.
Madrid, Prado

the portrait of the family of King Carlos IV (1799–1800) [86]. The other trend, towards Velázquez, is a striking proof of the uninterrupted survival of a great style through the centuries. A long series of portraits by Goya shows how two elements, elegance and delicacy, which, even if secondary, were of great significance in the portraits of Velázquez, can acquire new relationships through a psychological penetration carried sometimes to fantastic and grotesque extremes. There is an extraordinary range between the almost still-life sedateness with which far as Rembrandt in order to find a comparable depth in the representation of human beings. The last works of Titian, Tintoretto, and Frans Hals can also serve as comparisons, because in all these cases great masters of colour devoted the supreme wisdom of their old age to a reduction to almost monochrome simplicity, and this simplification was far more than a mere artistic trait. Their renunciation of the vital abundance of their previous colouring represented a concentration on the expression of the inner life of the persons portrayed. In Goya's works this

86. Francisco de Goya: King Carlos IV and his Family, 1799–1800. *Madrid, Prado*

vital abundance of colour was displayed for a long time with an ostentatious pleasure in the number of different bright colours, especially in his designs for tapestries and in his church frescoes [83, 84]. All the resources of a sonorous chromaticism are employed, from loud and sometimes rather clumsy contrasts of light to the refinement of the naturalistic rendering of materials – the silver-grey coat in the portrait of Bayeu, the flesh in the picture of the *Nude Maya* (*c.* 1800, Madrid, Prado) – and to the no longer naturalistic, mysterious flickering of glowing spots of colour in the midst of a dusky chiaroscuro, for example in the portrait of the family of Carlos IV, in the *Meeting of the Philippine Council* (1814–16)[1], or the portrait of Marshal Don Miguel de Lardizábal at Prague (1815) [87]. When Goya's painting rivals the highest achievements of the old masters, the question of what is new becomes unimportant; but many new compositional elements can easily be dis-

87. Francisco de Goya: Don Miguel de Lardizábal, 1815. *Prague, National Gallery*

cerned, for example in the painting of *The Execution of the Rebels on 3 May 1808* [88]. In his graphic works the novel element is even more obvious, despite the fact that these are still closely linked with Baroque draughtsmanship. Tiepolo's *Capricci* and *Scherzi di Fantasia*, Callot's war scenes, and Rembrandt's etchings are the most important foundations on which Goya's enormous graphic *œuvre* rests, and the many traces of their influence can hardly be enumerated. Here again the compositions, in spite of their dependence on the past, contribute something fundamentally new, with the aphoristic sharpness of his placing of the scene in the frame and the contrasting of masses with patches of chiaroscuro, which go far beyond the principles of Baroque graphic composition. The harshness of the contrasts between the tightly packed figures and the barren emptiness of dark or light backgrounds becomes a deliberate scheme and supplants the Baroque faith in unified, compact structure. Radically new details, such as the intrusion into the picture of projecting gun-barrels in two scenes of the *Disasters of War* (nos 15 and 26 [89]), are merely extreme applications of the new general principle. From the *Caprichos* onward, in order to achieve the greatest possible range of chiaroscuro, Goya made use of the aquatint technique invented at the end of the 1760s by Jean Le Prince (1734–81), developing it on a masterly scale, just as from 1819 he used the new invention of lithography in some of his most powerful drawings, especially in four bullfight scenes (*Los toros de Burdeos*, 1825).

The realism of his drawings is part and parcel of their vehemence, and this realism is carried to such a pitch that it also embraces the grotesque fabulous beings and spectres. Like the painters of the Middle Ages, Goya treated these abortions of his imagination, these personifications of evil and of fear, with the degree of realism used for creatures of flesh and blood [90]. Goya's realism, however complicated it may be, is one

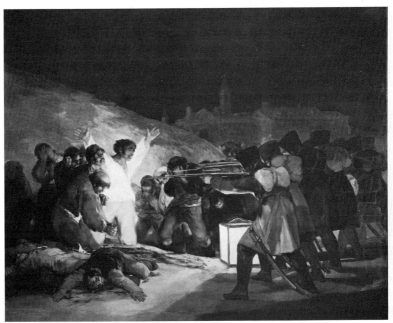

88. Francisco de Goya: The Execution of the Rebels on 3 May 1808, 1814. *Madrid, Prado*

89. Francisco de Goya: 'One can't watch it . . .', 1810-13. Etching

of the few constants in his art. Otherwise, this art is almost excessive in its duality, both in content and in form. A keen intellect and an impulsive fancy, excess of *verismo* and a trend towards the fantasy of a world of spectres, continually giving birth to something new, fill his works with a never-ceasing, overlapping movement. It begins with a somewhat overheated and distorted Spanish Rococo [84] and ends with altarpieces of an unequivocal religiousness (*Christ on the Mount of Olives*, 1819; *The Communion of St Joseph of Calasanz*, 1820; both in the Escuelas Pias de San Anton at Madrid), side by side with monumental representations of ordinary people (*The Blacksmiths*, c. 1818, New York, Frick Collection; *The Scissors-Grinder, The Female Water-Seller*, both at Budapest; *The Milkmaid of Bordeaux*, Madrid, Collection of Conde de Alto Barcillés). The figures of his court portraits and his other formal portraits are often depicted with objective aloofness, but at times also with concealed irony. Sarcasm à la Voltaire is found side by side with humanism in the spirit of Cervantes and mysticism in the manner of Zurbarán. One is certainly not wrong if one detects a Spanish element in this many-sidedness, but this is a rather too easy simplification. At all events, side by side with his particular form of realism, there is a second general characteristic of Goya's art, namely that he was always concerned with human beings, while landscape did not mean very much to him. This, once again, brings him nearer to the painters of the Classicist period. He did paint one grandiose, naturalistic landscape, the *Feast of San Isidro* (c. 1790, Madrid, Prado), but this is filled with a sparkling throng of people; two well-known etchings, dating from about 1810, are pure landscapes, but in both of them, as in two painted imaginary landscapes, there is a boulder which dominates the countryside like a primeval monster, in exactly the same way as does the crouching giant in the celebrated mez-

zotint from his late period [90]. In an art so exclusively devoted to mankind, the mystery of space, which is certainly not lacking in his pictures and drawings, is not depicted for its own sake, as it was in the works of the Romantics. In the last sheet of the *Disasters of War* a spirit bathed with light stands in such a setting and turns consolingly towards an exhausted, humble peasant. The drawing seems like an act of homage to Rembrandt, and his doctrine of compassion. It is certainly not a hymn *An die Freude* (Schiller-Beethoven), but a declaration of faith after the end of a terrible war, the admonition of a Faust-like character of the need for active life.

Goya was the last great painter in whose art thought and observation were balanced and combined to form a flawless unity. This makes him superior to the Classicists and links him with the great masters of the Baroque. But as so often happens in the development of art, it was not this fundamental attitude that determined his subsequent influence, but certain of his subsidiary qualities. When the example of Goya became effective in the painting of the nineteenth century, it was restricted to his mode of pictorial expression and to his drawings and etchings, admittedly two enormous realms. In Spain itself Goya had followers for a considerable time, firstly his favourite pupil, Ascensio Juliá (called 'El Pescadoret', 1771-1816), who collaborated with him on the frescoes for San Antonio de la Florida [83] and used his master's etching style with an abundance of aquatint effects in allegorical political satires. Subsequently, Eugenio Lucas the Elder (1824-70) and his son Eugenio Lucas y Villaamil (d. 1918) followed Goya's style and even imitated it.

90. Francisco de Goya:
The Colossus, c. 1820. Mezzotint

Vicente López y Portaña (1772–1850) avoided any imitation of Goya, though he borrowed much from his great contemporary – of whom he painted a notable portrait in 1827 (Madrid, Prado). He succeeded Goya as court painter and became the chief provider of official portraits in Spain. As such, as well as in his frescoes in the royal palace at Madrid (1828), he remained essentially on the lines of Mengs.

In the art of the leading Portuguese painter about 1800, Domingos António de Sequeira (1768–1837), much discrepant stylistic material is fused, for example an echo of the restlessness of Goya. His best qualities, however, come out in his Classicist portraits.

In a more profound sense, French painting derived much from the work of Goya. But considerable time elapsed before this was the case. In the meantime some of the leading French painters had already begun to study on their own account the problems posed by painterly painting.

THE FRENCH 'ROMANTIQUES'

THÉODORE GÉRICAULT (1791-1824)

The co-existence of Goya and Géricault – each independent of the other – is one of the most significant phenomena in the history of nineteenth-century painting, a striking and unequivocal proof of the need for a change of direction. This new trend might have found its triumphal beginning in Goya; in Géricault it actually did, at once, at least for French painting. When Géricault died in 1824 at the early age of thirty-two, David was still alive. In many respects Géricault's fragmentary but comprehensive *œuvre*, produced in the course of little

more than a dozen years, reveals his derivation from the school of David. He may indeed be said to belong to this school indirectly, as he was a pupil of Guérin, in whose studio he worked after studying under Carle Vernet from 1808 to 1810. If one judges Géricault by that of his chief works which in his own day and for a long time afterwards was considered *the* chief work, *The Raft of the 'Medusa'* (in the final version completed in 1819) [91], then his links with the programme of David's school and the manner in which he modified it are clearly visible: the enormous dimensions, the stirring actuality of a disaster which had occurred only a short time

91. Théodore Géricault: The Raft of the 'Medusa', 1819. *Paris, Louvre*

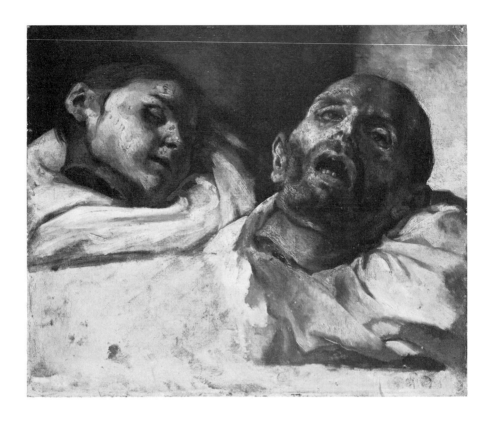

92. Théodore Géricault: Heads of executed Prisoners, 1818. *Stockholm, Nationalmuseum*

before, the culmination in a pathetically signi-
ficant 'fruitful moment', the sculptural sharp-
ness, achieved by means of a Caravaggesque
lighting – all this, both in conception and in
execution, is in the spirit of David and also owes
much to the epical extension which Gros gave to
that spirit. Nevertheless, instead of the restric-
tion to relief-like planes in accordance with the
Classicist rules of composition, the guiding
principle in Géricault's picture is comparatively
Baroque. Symbolizing the theme of 'salvation at
the moment of direst need', from the confusion
of dead bodies, of men exhausted or gone mad,
there soars a single movement, the diagonal
towards the top right corner. All the details are
most skilfully worked out, even to the counter-
poise provided by the restraining mass of mast
and sails. The criterion here is no longer
whether this extremely ingenious structure
preserves the necessary cohesion, or whether
the utilization of the compositional devices of
classical models such as Michelangelo, Raphael,
Correggio, Caravaggio, and Rubens is drawn
on with sufficient independence, but rather
whether in spite of all this Géricault's obvious
passion for realism has been able to assert itself.
This question can just be answered in the af-
firmative, but only just, which proves that this
only completed monumental picture by Géri-
cault is not his most important work. In view
of the intensity with which the painter devoted
himself to the study of corpses and portions of
corpses, of the anatomical dissection of limbs
and the heads of executed criminals [92], the
picture ought to have become a kind of assem-
bly of *Dead Marat*s [10]. In fact, however,
though Géricault made only comparatively
sparing use of the *verismo* of these studies, he in-
creased the impetus of the movement of masses
beyond the preliminary versions and composi-
tional studies, and he made his composition
taut; as a result, the picture became a program-
matic work for the future. It is also a program-
matic work within the framework of his own art,

in that it comprises a good many of its chief
elements.

A passion for reality and for the topical
appears in various forms in all his works, for
example in scenes from the immediate past: in
episodes of the Napoleonic campaigns, in the
last phase of which, during the 'Hundred Days',
he himself took part; in his design for a pictorial
account of *The Fualdès Story*, a murder which
had been committed in Rodez in 1817 (versions
in a private collection in the United States and
in the museum at Rouen, the painter's native
city); in his various pictures of horse-races
(*Riderless Horses at the Start in the Corso at
Rome*, 1817, and the *Epsom Derby*, 1821, both
Paris, Louvre, to mention the best known of
these); in the project for a large picture which
was to have been a protest against the slave
trade; in various street scenes and illustrations
of the life of workmen which he made during

93. Théodore Géricault:
The Piper, 1821. Lithograph

94. Théodore Géricault: Officer of the Chasseurs charging, 1812. *Paris, Louvre*

his stay in London from 1820 to 1822, most of them water-colours or lithographs (some of the latter with the collaboration of Charlet, who accompanied Géricault). In these London scenes, together with his own impressions, the influence of English genre painters and caricaturists like Wilkie, Rowlandson, and Cruikshank is visible in the settings, though not in the details. They are among the earliest examples of the interest of a great painter in the world of the Fourth Estate [93].

Lastly we must mention Géricault's partiality for oriental scenes and figures, and also for a special subject – horses. Horses played as big a role in his art as they did in his life (and even in his death, since he died as result of the aftereffects of two riding accidents). In his art Stubbs and other specialists in the field of sporting pictures evidently inspired him, but in his *œuvre* horses do not represent the favourite theme of a 'specialist'; they are the symbols of vital strength [94]. In portraying horses, too, he could fulfil his constant desire to reconcile the monumental element, the tranquillity and the balanced vivacity of classical art, with the rendering of reality. For this reason the true-to-life rendering of heavy draught horses (in lithographs and drawings dating from his London period) was for him just as important as the continual attempt to render the eternal beauty of horses in the silhouette form of antique reliefs (*Capture of a Wild Horse*, 1817, Rouen; the drawing of shepherds in the Campagna in the Fogg Art Museum at Cambridge, Massachusetts; and many others). At the same time the study of the nude human figure as found on antique monuments – and naturally also in later classical works, above all in Michelangelo and Raphael – remains typical [95], not only of his early period under Guérin, but also of his stay in Italy (1816–17), and even his later years.[1] The use of the nude as the starting-point in many of his designs for pictures is still part of the custom of the time, but nothing could be a

95. Théodore Géricault: Study of a Nude, 1818. Pen-drawing. *Vienna, Albertina*

more obvious proof of the curious relationship between Géricault's realism and his striving to attain a classical form than its almost invariable presence in his work, even in the sketches for the *Fualdès Story*.

It is not surprising that better knowledge of his art has made it more difficult to classify from a historical standpoint, and that, in particular, the label 'Romantic' is more and more disputed. For the trend which begins with Géricault and is continued especially in the work of Delacroix, the term 'Romantisme' has been coined to emphasize both its fundamental difference from German Romanticism, and the fact that it is the French form of Romanticism. It has even been denied that Géricault is a Romantic at all; but this is certainly just as wrong as the simple statement that he is a Romantic. The profound difference between German and French Romanticism is clearly visible and lies mainly in the fact that 'Romantisme' had no professed philosophy and no tendency towards the abstract. The peculiarity of Géricault's own art lies in its relationship to Classicism. Here, however strange the statement may seem, a remarkable affinity exists with the art of Runge. There

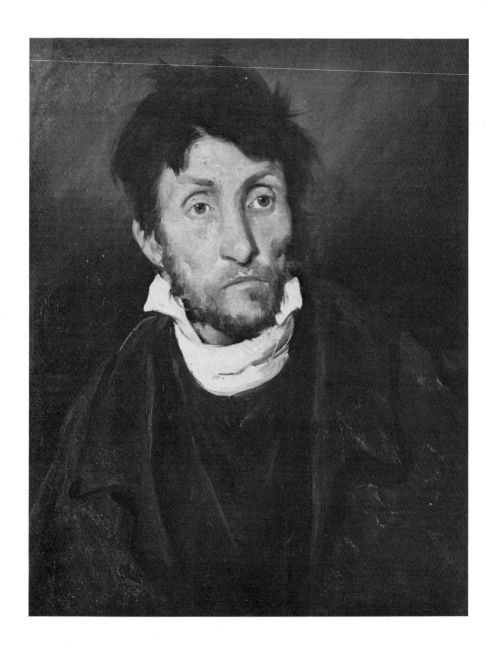

96. Théodore Géricault: Kleptomaniac, *c.* 1822–3. *Ghent, Musée des Beaux-Arts*

is in the work of both artists the urge to codify the boundless, to reduce human beings (and in Géricault's case animals too) to types. In the case of both, however, the hankering after the classic is a romantic dream; for the opposing forces were too strong. In Géricault they are expressed in a wild agitation of gesture, drawing, and dramatic light. All three can be traced back to direct study of phenomena, and this brings him nearer to Goya, to whom he is essentially most closely akin. The only thing he lacks is Goya's vision – but that Géricault's heightening of the reality of life to a point of soaring passion can be called Romantic, at least in the broader sense of the term, can hardly be doubted. Down to the very end his art is full of youthful fire and his style is declamatory. Towards the end, it is true, the Romantic element assumes a special, quieter, and deeper form in the series of portraits of mental patients which he painted in the clinic run by his friend the psychiatrist Dr Georget [96]. When we recall the superlative violence of an early work, the *Officer of the Chasseurs charging* [94], dating from 1812, we cannot but be astonished by the measure of a development achieved in so short a space of time. In the pictures of mental patients there is no longer any need for a stirring, dramatic story, and the faces of abnormal people become the sole theme. This offered the possibility of a Romanticism which could be brought into line with Géricault's fundamental realism. Moreover, it occurred at a time when he had fully mastered pictorial structure, and was thus equipped to venture into new fields. In a broader sense, of course, there was nothing absolutely new in the painterly aspects of his later works. They were the fruit of the teachings which Géricault had absorbed from the great painters of the Baroque, beginning with the late Venetians. Something comparable had also been present, to an almost imperceptible degree and in occasional sketchy passages, in the works of French Classicists such

as David, Prud'hon, and Girodet-Trioson; but in Géricault's later work this way of painting becomes the predominating element, possessing all the force of a revolutionary innovation. In this respect Géricault's study of the painting of Gros and of the landscapes of Constable during his stay in London played a special role. In almost all his works colour is confined to chiaroscuro effects; but this chiaroscuro, the abundance of greys and browns, gradually becomes colour on its own account. The moment had arrived for the most pregnant rediscovery made by nineteenth-century painting – the rediscovery of colour.

EUGÈNE DELACROIX (1798-1863)

Delacroix was only slightly younger than Géricault, and the way in which his work continues to develop Géricault's is one of the most striking examples of the organic growth of an artistic conception. At the same time the peculiarities which distinguish the one from the other are also differences between two generations. Géricault's work reflects much of his own experiences and milieu, and the passionateness and enthusiasm which pervade it make it a kind of chronicle of his inner life. An equally powerful passion permeates with never-flagging intensity the whole of Delacroix's enormous *œuvre*, but in him there is a curious aloofness of the creator from his creations, and the work does not reveal the man in the same way that Géricault's does. This, it is true, is due to a difference of personality which might occur anywhere, but in this particular case we may consider it also to be the difference between two epochs. The aloofness of Delacroix is not only a personal characteristic which cannot be further explained (and which, moreover, as we know from his contemporaries, was on a par with the coolness and reserve of his social behaviour), but is also the combined effect of two fundamental peculiarities of his art. One of these is the fact that by far the greater part of his

97. Eugène Delacroix: Medea, 1838.
Lille, Musée des Beaux-Arts

works represent events and scenes which are remote from the happenings of his own time and from reality, since they are historical and mythological pictures, or scenes from the Bible or from literary works [97, 99, 102, 107]. The other peculiarity is his insistence on exceptional, tense moments, even when he is dealing with non-historical subjects, as in his many pictures with an oriental background, in his portrayals of Arab horsemen or the hunting of beasts of prey [104], and in his numerous fights between animals [105, 106]. All this sounds like the purest Romanticism, and a Romanticism of the primitive kind, which rejects the ordinary things of everyday life, a Romanticism in the choice of subject-matter, a Romanticism of never-ceasing action. It is particularly evident

against the background of Realism, which had by then been everywhere at work for a long time in a variety of forms. Thus the content of Delacroix's work follows the lines of German, and indeed international, narrative idealism, of German Late Romanticism, that is of Cornelius, Rethel, and Kaulbach, and of the Belgian historical painters round Wappers before the middle of the century. It is significant also that Delacroix had a high esteem for the genre of David Wilkie.

However, the superabundance of literary and dramatic elements in the works of Delacroix, the gods, saints, and heroes, the frantic horses looking like bewitched heroes [98, 103], and the regal beasts of prey which are the very incarnation of animal ferocity – all these things are completely different from the Late Romantic interpretation of picturesque and significant events in the works of other painters. By this I do not mean only a difference of personal conception and means of expression, which is a matter of course, nor the difference in strength and intensity, but a profound difference of principle. It is as if the same fundamental material were suddenly transformed by some magical means and transported into another sphere. The means is colour. How does it come about that such a change in the meaning of the scene represented is achieved by the addition of a new system of colouring? How, indeed, is a colouring evolved which can produce such an effect? A closer consideration of this question brings us into contact with one of the most crucial events in the history of painting during the last centuries.

In a certain sense the answer is simple. The transformation is due to the fact that colour becomes the central force in creating a picture, which keeps the speculative thought of the painter constantly alert. Romanticism is storytelling by means of pictures, and in such storytelling line has at all times been given a certain predominance. The affinity between storytelling and drawing is a fact; idea and line are

98. Eugène Delacroix: Grey Horse in a Thunderstorm, 1824. *Budapest, Museum of Fine Arts*

closely interwoven. Colour could be an added factor, and there were numerous ways of adding it. Great colourists have existed even at times when line, and with it idea, were predominant: for example the mosaicists of the early Middle Ages, Giotto, the Flemish Primitives, Bruegel, and the Italians of the High Renaissance. In Romanticism, too, there was abundant scope for colour. Runge and Friedrich are the most important examples; Blake is an extreme instance. But at the same time these painters also demonstrate that on the whole the opportunities for colour remained of a theoretical, speculative kind. Colour remains an ancillary factor in their art. As soon as it appears with a more assertive independence, its essentially irrational and anti-ideal character becomes evident, despite its

possibilities for conveying a symbolical meaning. Liberated colour, freed from the service of illustrating reality, could harmonize with the irrational elements of Romanticism, but hardly with the intellectual and narrative ones.

All these things are theoretical simplifications, but the factual elements underlying them, the concealed and the patent problems and postulates of the relationship between line and colour, always aroused the keenest interest among painters, and, as is well known, frequently led to controversies between 'schools'. They were also the cause of the well-known antagonism between Ingres and Delacroix. For Delacroix the conflict between colour and drawing and the endeavour to synthesize was one of the most stimulating problems, and this same

group of problems also engaged and tormented the greatest painter of the second half of the century – Cézanne. Delacroix and Cézanne were the two painters who delved most deeply into the mysterious connexions between colour and line, and in the painting of Delacroix Cézanne found a realization of his own essential aims. (With the words of Cézanne quoted on page 44, one can compare the axiom which Delacroix wrote in his diary on 4 March 1847: 'When the tones are right, the lines draw themselves.'²) Both were haunted by the ideal of the Baroque painters who preceded them, Rubens and Veronese, with their apparently effortless harmony between drawing and colour. Delacroix, the greatest colourist of the first half of the century, achieved this harmony only after a hard struggle. He did not, of course, arrive at exactly the same result, since his study of the great Classics of Baroque painting was anything but eclectic. It was, rather, a re-creation based on the fundamental elements of the art of his predecessors. Here, in a new field, is enacted a process analogous to the reawakening of the formative principles of Antiquity in Classicism. The appreciation of the true essence of Greek Antiquity behind the façade of imitations, achieved only by a few outstanding personalities and in isolated, inspired moments in the works of Prud'hon, Ingres, Runge, and Géricault, has its counterpart in Delacroix in his study of those qualities which make the pictures of Rubens, Veronese, Titian, and Rembrandt emanations of a mysterious formative power, whereby they become 'great painting'. The more Delacroix evolved out of the art of the great colourists of the past an artistic chromatic doctrine of the most personal kind, the more individual became the Romanticism of his pictures. One might wonder why Romantic ideas should not find expression through colour; but in actual fact painting in which the dramatic contrasts and interplay between colours become ever more rich and important does not betray a heightened

Romanticism, but rather leaves Romanticism behind. If we still insist on calling it Romanticism, because of the retention of Romantic themes, we must qualify it as being quite different from the usual kinds. The painting of Delacroix contains the first hints of that painterly structure which dominated the art of the latter part of the nineteenth century, the first presage of the subjection of the illustrative element to the play of chromatic forms. For two of the great founders of modern painting, van Gogh and Cézanne, to whom Delacroix represented the highest that can be achieved in painting, these were more than hints or presages, and that in itself is significant. His inexhaustible invention, which always seems to be the outcome of an intense nervous excitement, ensured a continual, vital interplay between the events narrated and the forms, colours, and varying shades of lightness used. Moreover there is another regulating principle in Delacroix's work, the observation of colours in nature. He made an intensive study of the effects of complementary and contrasting colours as regards their value for the general effect of a picture, and he knew very well that the art of the past, even in its greatest manifestations, ought not to be his only source of inspiration for the establishment of a new colouring. In Delacroix analytical meditation and experimentation served as aids to the original thematic and chromatic conceit, but the latter always kept the upper hand. These first signs of a predominance of form (which in this case means colour) over subject-matter give all his pictures a touch of austerity and that aloofness which invariably appears in painting when form has achieved perceptible life of its own. This also explains the presence of a tragic undertone which, though often slight, always inheres in the works of Delacroix. It is of the kind so often found in music, the purest art of form, and an art which Delacroix loved passionately. This tragic note distinguishes his painting from that of the Baroque, in which, apart from Rembrandt,

it appears relatively seldom. The closest analogy is the melancholy of Watteau.

We have already said that Goya was the last painter to maintain a perfect balance between thought and observation. This statement remains valid despite Delacroix, though the situation and the degree of artistic perfection are very similar. But neither the term thought nor the term observation can, as they can in the case of Goya, be applied without hesitation to Delacroix. The pathos in so many of Delacroix's pictures can no longer, as it could in the works of the Classicists and Romantics, be explained as the outcome of moralistic ideas – except in just one of his historical scenes, *Liberty on the Barricades* (*The 28 July 1830*, painted in that year, Paris, Louvre). His attitude towards visible

reality, too, with the exception of a few landscapes and still-lifes, is less transparent. The reason in both cases is that the power of form has altered the ratios. The unanswerable, but not altogether meaningless question, to which world, that of idea or that of observation, do the figures in the pictures of the Classicists and Romantics, and to which do those of the Realists, belong, leads, when we are confronted with the work of Delacroix, to the conclusion that in his pictures the figures belong to a third, even more mysterious, fantastic realm of their own, a world which is also inhabited by the figures of El Greco.

In one of his early works, *The Bark of Dante* (1821–2) [99], the essence of his painting is already found *in nuce*. Of the teaching of Guérin,

99. Eugène Delacroix: The Bark of Dante, 1821–2. *Paris, Louvre*

whose studio he entered in 1815, there is no longer any trace, but there is a great deal of that of Géricault, largely impressions received from the *Raft of the 'Medusa'* [91]. Gros's history-painting in the grand manner [9] and his colour-ing also had a profound influence, as is shown especially in the huge painting of the *Massacre of Chios* (1821-4) [100]. Gros's criticism that this picture is 'le massacre de la peinture' probably contains a dissembled admiration of its novel

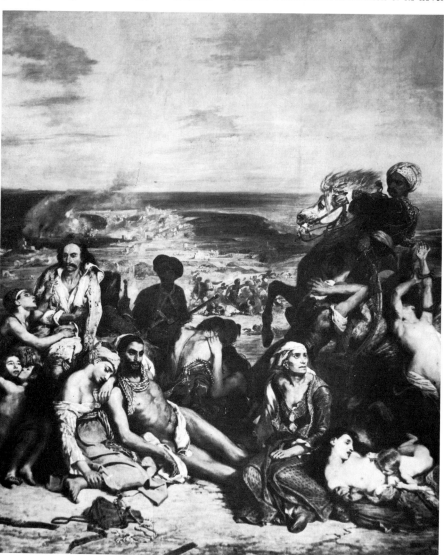

100. Eugène Delacroix: The Massacre of Chios, 1821-4. *Paris, Louvre*

101. Eugène Delacroix: Design for the ceiling painting in the Galerie d'Apollon at the Louvre, 1849-51.
Brussels, Musées Royaux des Beaux-Arts

elements. Some of these Delacroix owed to Constable's systematic analysis of colour, which he had been able to study in pictures exhibited in Paris in 1824 and which induced him to make alterations to his own painting immediately before it was shown to the public. A visit to London in 1825, on which he was accompanied by Bonington, enabled Delacroix to enlarge his knowledge of English painting, especially that of Constable, Turner, Wilkie, James Ward, and Lawrence. Mass scenes of huge dimensions remained his favourite domain – *The Death of Sardanapalus* (1827-8, Paris, Louvre); *The Murder of the Bishop of Liège* (1830, Lyon); *The Capture of Constantinople by the Crusaders* (1840, Paris, Louvre); *The Battle of Taillebourg* (1837, Rouen) – as well as monumental mural paintings, the long sequence of which began in 1833 and ended shortly before his death in 1861 with the completion of the murals in the Chapelle des Anges of the church of Saint-Sulpice in Paris [102]. These are his crowning achievement. Delacroix's large murals, painted partly in a wax technique, partly in oil on canvas, and partly in fresco, are those of the Salon du Roi in the Palais Bourbon (the Chambre des Députés), 1833-7; the library of the Palais Bourbon, 1838-47; the library of the Palais du Luxembourg, 1845-7; the ceiling of the Galerie d'Apollon in the Louvre, 1849-51 [101]; the Salle de la Paix in the old Hôtel de Ville (burned in 1871), 1849-53; and the Chapelle des Anges, 1849-61. In his murals for secular buildings Delacroix remained faithful in conception and composition to the traditions of Baroque mural painting. Single allegorical figures (especially in the Salon du Roi), larger allegorical groups and scenes from the history of civilization in ancient times, including several biblical scenes, down to the destruction of the ancient world by Attila (the five domes of the library of the Palais Bourbon), an apotheosis of the poets and philosophers of Antiquity based on Dante's *Divine Comedy*

(dome of the library of the Palais du Luxembourg), a glorification of Apollo in his battle with the Pythian serpent (ceiling of the Galerie d'Apollon in the Louvre, instead of a ceiling picture by Le Brun which was never executed) – all these formed parts of his programme. In principle, Delacroix never went beyond the framework of the Italian monumental style of the Late Renaissance and Baroque in his conceptions and he adopted the Baroque polyphony of representing space of unlimited depth illusionistically. This was as far as he could go, and it was also the extreme limit of all mural painting until the end of the nineteenth century, that is until Marées. On one occasion, in the ceiling picture for the Galerie d'Apollon, he exploited to the utmost the possibilities of his Baroque models, and on another, in the murals on the two side-walls of the Chapelle des Anges, *Heliodorus expelled from the Temple* [102] and *Jacob wrestling with the Angel*, he actually transcended these possibilities. His deviation from Baroque models takes the form of a spiritualization achieved by means of colouring. In his previous murals this had been limited to a large number of details, but here it comprises larger unities and pervades the whole. In the bright, strangely cool, subdued colours of these pictures, all the earlier theatrical effects are obliterated. In this respect they have little connexion with any of the great mural paintings of the past, but a good deal in common with the painting to come.

102. Eugène Delacroix:
Heliodorus expelled from the Temple, 1849-61.
Fresco. *Paris, Saint-Sulpice*

In 1832 Delacroix spent six months in Morocco, and this knowledge of Africa remained a decisive factor in his art. Scenes of African life, among them great works like the *Algerian Women* (1834, Paris, Louvre), the *Horses fighting in a Stable* (1860) [103], a number of pictures of Arabs hunting beasts of prey [104], and the grandiose series of pictures of lions and tigers [105, 106] were the fruits of this experience of exotic landscape, people, and animals. This 'romantic nature' and the unfading memory of it continually provided Delacroix with new material for his chromatic fantasies. The comprehension, so important for subsequent painting, of the chromatic possibilities of shadows, and the doctrine of the diffraction of colour in the interests of a colour-scheme which repro-

duces nature, but is at the same time a poetical vision, were also a continual source of theoretical meditations and fill the pages of his celebrated diary. I will quote one well-known sentence on the complementary colour as a necessary tone of shadow: 'To add black is not the addition of half-tint, it is a darkening of the tone of which the real half-tint is found in the opposite tone ... hence the green shadows in red.'[3]

The fundamentally painterly and colouristic conception of the works of Delacroix was no obstacle to his constantly vital, powerful draughtsmanship. As his colour and his chiaroscuro are full of drama, so his drawn line is full of quivering movement. Together with the picturesque element in the narrower sense it seems like another instrumentation for the expression

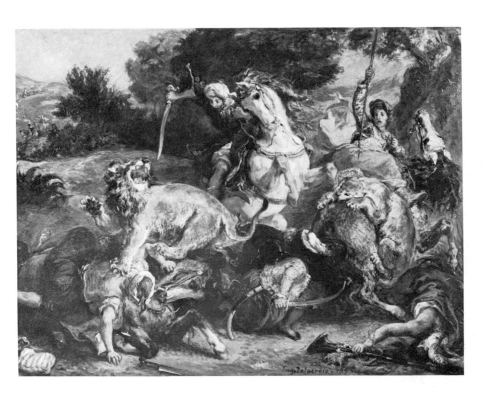

103 *(opposite)*. Eugène Delacroix: Horses fighting in a Stable, 1860. *Paris, Louvre*

104 *(above)*. Eugène Delacroix: Lion Hunt, 1855. *Lund, Professor Philip Sandblom*

105 *(below)*. Eugène Delacroix: Lion devouring a Hare, *c.* 1855. *Paris, Louvre*

106 *(opposite)*. Eugène Delacroix: Fight between a Lion and a Tiger, 1856. Pen-drawing

of picturesque, i.e. in a broader sense painterly, inspiration. The draughtsmanship of Delacroix is of the same kind as that of the great Baroque masters; even when it is pure linear art it remains very close to the painterly. Only in the later phases of his art is there a clash between colour and drawing, and even this was not un-fruitful. His creative instinct was scarcely affected by it. From the very beginning, how-ever, his contemporaries, with their narrower, academic conception of drawing, reproached him with a 'deficiency in drawing'. Drawing,

however, not merely as a means of making a sketch or design, but as an independent, valid means of expression, was for him of such importance that he produced a large number of lithographs. Outstanding among these are the illustrations for Goethe's *Faust* (nineteen sheets, 1827) [107] and *Götz von Berlichingen* (seven sheets, 1836-43), and for *Hamlet* (sixteen sheets, 1834-43); these are also a proof of the significance the Frenchman Delacroix attached to

107. Eugène Delacroix: Gretchen and Mephistopheles in the Cathedral (scene from *Faust*), 1827. Lithograph

the great English and German epic and dramatic poets (Shakespeare, Scott, Byron, Goethe). The scenes from *Faust* are full of theatrical demonism and grimacing exaggeration, conceived from a definitely Mephistophelian standpoint, and in their flickering vehemence they are not so unlike the *Faust* illustrations of Peter Cornelius as has sometimes been maintained, despite the fundamentally different style of drawing. In the two later cycles, as well as in individual lithographs, we find a masterly fusion of draughtsmanship and beautiful chiaroscuro effects. The latter may have been influenced by Goya's illustrations and drawings.[4]

Ever since his *Bark of Dante* [99] Delacroix had not lacked recognition, chiefly because of his rebellion against academism. He was admired by a critical spirit like Baudelaire, and he even received several commissions from the State, but he was also violently attacked – and even today, although he has long been recognized as a classic, his art is still in a certain sense the subject of controversy. This is understandable in the case of a painter who in the course of his search for an 'absolute' of pictorial form never lost touch with the achievements of the old masters and never renounced his allegiance to imagination and the idea. Such an attitude can easily give rise to misunderstandings and fluctuating valuations, since it is not always easy to distinguish between reminiscences and invention. Moreover, there is the problem of Delacroix's specific brand of Romanticism, which we must mention once again at this point. As a Romantic, he had to subordinate his art to emotion and to a striving after a vision of the 'infinite'. The former he achieved to a greater extent than perhaps any other painter of his time; contradictory though it may sound, he deliberately indulged in passionate emotion and at the same time subjected it to a strict critical control. As regards the conception of the 'infinite' in his 'Romantisme', it does not merely differ from German Romanticism in the same

way that the French conception differs from the German. When a German Romantic tried, in an individual picture, to create a microcosm as a symbol of the immeasurable, he did it by means of accumulation and multiplicity. Idea and feeling, narrative and symbol, were made subservient to this aim. Delacroix's method was simpler in that he utilized the impression of pure form in a more unequivocal way, in order to convert the microcosm of the individual work into an image of the universal.

ROMANTIC PAINTING AROUND DELACROIX

The chief characteristics of Delacroix may be summed up as follows: he was primarily a painter of important and unusual events and things, but he yet remained true to the maxim that a picture should be a 'feast for the eyes' (these words are at the beginning of the last entry in his diary); his impetuous invention is akin to poetical, and even more to musical, intuition – in his notes he talks as much about music as he does about painting; and if he was ultimately greater as a painter than as a draughtsman, the reason lies less in his systematic study of the chromatic laws governing pictorial construction than in the fact that he could keep in his paintings all the intensity of his drawing, and that in his day there was greater scope for discoveries in the field of colour than in that of drawing. All this entitles him to the epithet of genius. Several of his followers were able to profit by his example, and with some of them his discoveries were in good hands.

One of these followers was Alexandre-Gabriel Decamps (1803–60), who has gone down in history as the 'discoverer of the Orient'. He made a journey to Constantinople and Asia Minor in 1827, that is before Delacroix went to Morocco. Subject-matter contributed more to his success than form, the painterly qualities being restricted to isolated passages. This is the

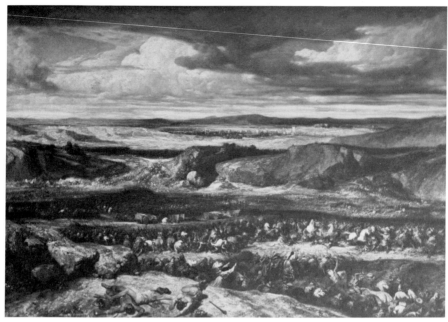

108. Alexandre-Gabriel Decamps: Marius vanquishing the Cimbri, 1833. *Paris, Louvre*

weakness of his large composition, *The Victory of Marius over the Cimbri near Aquae Sextiae* (1833) [108]; but with its dramatic harmony between the relief of an enormous panorama and the tumult of battle this picture is an impressive and significant document of the Romantic spirit. In principle at least it is akin to Géricault's grandiose sketch of the *Retreat of the Grande Armée from Russia (c.* 1815, New York, Germain Seligmann Collection). Decamps was more coherent in his picturesque drawings and book illustrations (mainly lithographs, though there are a few etchings). Unlike Delacroix, artists of his rank were on the whole unable to achieve unity between figures and landscape; in their works, Romantic figures and Romantic landscape seem like two specialized branches existing side by side.

Another specialist in 'Oriental painting' was Eugène Fromentin (1820-76). He was a writer, who turned to painting under the guidance of the landscape-painter Louis Cabat (1812-93) and under the influence of the 'Oriental' painter Prosper Marilhat (1811-47). His pictures, the fruit of three journeys to North Africa between 1846 and 1853, are mostly Oriental landscapes with subsidiary figures of ordinary people and horsemen. They are cultured paintings with a delicate tonality and a slightly exaggerated stress on mood. He achieved immortality, however, in two of his writings: his novel *Dominique,* and the essays on the art of the great Netherlandish masters of the fifteenth and seventeenth centuries, *Les maîtres d'autrefois* (published in 1876).[5] This was painting seen through the eyes of a painter, and it surpassed his own pictorial work.

One can now say of the art of the French Romantic Adolphe Monticelli (1824-86) of Marseilles that it was bound to come about as a

consequence of the painting of Delacroix. Delacroix's dynamic colouring, for a time through the mediation of Diaz, is heightened by Monticelli until it becomes an aim in itself, and hence to a certain extent petrified. The glittering, turbulent colour, presented with a dazzling and arbitrary impasto – dazzling in both senses of the word – has something strained about it. For the most part Monticelli depicts cheerful, festive groups in bewilderingly vague, romantic, parklike landscapes. These pictures contain a great deal of merely decorative play and romantic theatricality, but also show a great pictorial ability which is more clearly revealed in such portraits as that of Madame René at Lyon [109].

In so far as he was a landscape-painter, Narcisse (properly Virgilio Narcisso) Diaz de la Peña (1808–76) belongs to the Barbizon school, which he joined after 1840. In his figure-paintings many factors are combined. From Delacroix, the strongest determining influence, comes the magic of the colouring, and the light, which streams on to the Arcadian groups of figures and their gleaming shadows [110]. In the works of Diaz, as in those of Monticelli, the sombre glow and the dramatic gravity of Delacroix's pictures becomes playful, and the effects are produced by the charms of the delicate and the precious. On occasion there is a certain coquetterie, even in the pictorial presentation, and a harmless sultriness which is, in fact, typical of the art of the period. If a comparison with music is permissible – and comparisons with music are often very pertinent when dealing with French Romantic figure-painting – one might recall the virtuosity of Liszt. In the invention of themes and in many details of form there are also reminiscences of older art, of the 'fêtes galantes' of the eighteenth century and of

109. Adolphe Monticelli: Portrait of Madame René, 1871. *Lyon, Musée des Beaux-Arts*

110. Virgilio Narcisso Diaz: A Group of Girls, *c.* 1845. *Paris, Louvre*

all sorts of paintings of mythological and idyllic scenes. Nevertheless, the art of Diaz remains personal. This is due to a very slight extent to his Spanish origin (he was the son of a Spaniard who had emigrated to Bordeaux), something of which is revealed in the sombre restlessness of occasional landscapes. An example is the sinister seascape, reminiscent of Courbet, in the Kunsthistorisches Museum at Vienna.

Théodore Chassériau (1819–56) was, after Delacroix, the most important figure-painter of French 'Romantisme'. For the history of art he is a mediator between Ingres and Delacroix. The son of the French consul in San Domingo and of a Creole woman, he began his artistic career as a child of ten and until 1834 was a pupil of Ingres. In the following year he received a medal at the Salon. How important the teaching of Ingres was for his art, but also how independently he asserted himself by the side of his great teacher, is shown in his most celebrated portrait, that of two sisters in the Louvre (1843). The severity of doctrine is mitigated by a gentle softness, the clarity of drawing and plasticity by a stronger emphasis on the painterly element than in the works of Ingres. The deviations from the severity of Ingres, often hardly perceptible when taken alone, together amount to a departure from the latter's Classicism. What was occasionally a hidden Baroque effect in Ingres, in Chassériau becomes a determining factor. It appears partly in the more tranquil language of charm, and partly in a slightly exotic sensuality, in the agitated curves and gestures. Examples of this are the elegiac, restrained *Chaste Susanna* (1839, Paris, Louvre) and the *Toilet of Esther* (1842) [111], a group as compact as those in Greek metopes, and full of sweeping counter-movements. This picture demonstrates Chassériau's talent for monumental painting, to which he devoted himself between 1843 and 1854. From these years date the murals for the Parisian churches of Saint-Merri (1843), Saint-Roch (1854), and Saint-Philippe-du-Roule

(1854), and for the staircase of the former finance office in the Palais d'Orsay (1844–8) [112].[6] The models were undoubtedly Ingres's *Apotheosis of Homer* and *The Golden Age*, but Chassériau here surpassed his teacher.[7] He abandoned Ingres's Classicist symmetry, his orthogonality and parallelism, and displayed a greater profusion, but he also restrained any tendency towards the Baroque. In such a case, however, the art historian's classification into Classicism and neo-Baroque means little. Chassériau's figures have

111. Théodore Chassériau:
The Toilet of Esther, 1842.
Paris, Louvre

too much of the strength of simplicity to be forced into such categories. They are not just programmatic allegories of silence, meditation, and study, of war and peace, but in a deeper sense, thanks to their measured harmonies which do not disturb the integrity of the mural surface, personifications of simple great things, of majesty and sublimity, of dreaminess and melancholy. That some of Chassériau's murals are grisailles would seem to be the outcome of a

112. Théodore Chassériau: Peace (detail).
Fresco from the Palais d'Orsay, 1844–8.
Paris, Louvre

wise decision rather than the expression of a lack of ability. With these frescoes he takes his place among those rare artists who in the course of the century strove to achieve the highest in the sphere of the monumental picture. A spiritual kinsman of Carstens, Prud'hon, and Géricault, and of the Delacroix of the frescoes in Saint-Sulpice, he became the model for Puvis de Chavannes. The art of Hans von Marées is a mysterious re-emergence of Chassériau's.

On his path towards classical form, his stay in Italy in 1840 was an important stage. A journey to Algiers in 1846 strengthened the impression made upon him by the art of Delacroix, as can be seen in pictures like the *Mazeppa* (1853, A. Chassériau Collection), *Macbeth and the Witches*, or the unfinished *Interior of a Harem* (New York, Wildenstein Collection). With his equestrian portrait of the Caliph of Constantine (1845, Versailles), Chassériau was

already in competition with Delacroix's *Sultan of Morocco* (Paris, private collection) painted in the same year. In the fifteen etchings for *Othello* (1844), within the framework of his dependence on Delacroix's lithographs, he managed to retain the freedom of a personal form in the composition and in the graphically expressed chiaroscuro.

At this point, while we are discussing painters between Ingres and Delacroix, mention must be made of Victor-Louis Mottez (1809-97), who was a pupil of Ingres. The portrait of his wife in the Louvre reveals an unusual combination of pictorial realism and monumental effect, and in this it is slightly reminiscent of the murals by Peter Krafft in the Hofburg at Vienna (see p. 63 f.). Mottez began the portrait as a fresco during his stay in Rome (1835-42), but on the advice of Ingres it was detached from the wall. Mottez studied the technique of fresco systematically, and even translated Cennino Cen-

nini's *Treatise on Painting*. There are frescoes by him in the Parisian churches of Saint-Germain l'Auxerrois (1846), Saint-Séverin (1846), and Saint-Sulpice (1862).

In 1847 Thomas Couture (1815-79) exhibited his enormous picture *Romans of the Period of Decline* [113], a work which was greeted with more praise than almost any other single work of painting during the nineteenth century. Today it appears so remote from the monumental works of the artist's great contemporaries Delacroix, Ingres, and Chassériau as to belong to a completely different category, the outcome of learning rather than of direct experience. Indeed, Couture's picture is a monumental example of eclecticism, the chief models being Tiepolo and the older Venetians. The superficially seductive charm of his art, which Couture had taken over from Delaroche, and the skill that he owed to his other teacher, Antoine Gros, attracted a swarm of pupils from

113. Thomas Couture:
Romans of the Period of Decline, 1847.
Paris, Louvre

all over the world, though his own gift for teaching must have been a contributory factor. Among these pupils, Feuerbach is the artist in whose work the teaching of Couture left the clearest traces.

The counterpart to the academism of Couture in the field of religious monumental painting is the work of a pupil of Ingres, Hippolyte Flandrin (1809-64). His murals of the 1840s and 1850s in Paris (Saint-Séverin, 1840-1; Saint-Germain-des-Prés, 1842-6, 1856-61; Saint-Vincent-de-Paul, 1849-53) and in the provinces (Saint-Paul at Nîmes, 1847-9[8]; Saint-Martin-d'Ainay at Lyon, 1855) resemble in their frigid pomp many of the late works of the German Nazarene church painters. The art of Ary Scheffer (1795-1858), who was born in Holland, became a pupil of Guérin in 1812, and was active mainly in France, was a mawkishly pietistic offspring of this official religious painting.

ROMANTIC LANDSCAPE-PAINTING
IN FRANCE

During the first third of the nineteenth century landscape-painting in France remained curiously unbalanced and inarticulate, lagging a long way behind the landscape art of England and Germany, between which it was geographically situated. German landscape-painting left it untouched, though it drew fruitful inspiration from that of England. We have mentioned the persistent way in which, in addition, Classicist idealism lived on in French landscape-painting, though inextricably bound up with Romantic elements. Indeed, it could not have been otherwise. On a certain level any idealization of landscape is *per se* Romantic, though for the most part only in an academic and approximate way. Only when the philosophical penetration and interpretation of landscape has reached a certain depth, as it did in the case of Friedrich, the Oliviers, and others among the best artists of German Romanticism, does it constitute true Romanticism and stand in open conflict with Classicism. What English landscape-painting could teach France was a new objectivity in the sense of the coming development and the skill, solidity, and virtuosity of water-colour painting, an English speciality. The influence dates from before the exhibition of pictures by Constable in Paris in 1824. Chateaubriand's note on landscape-painting, written in 1795 during his stay in England (*Lettre sur l'art du dessin dans les paysages*),[9] the views of Paris which Thomas Girtin painted in 1801, the year before his death, the visits of English painters to France and their contributions to the exhibitions at the Paris Salon (Crome, John Glover, the Fieldings, Frederick Nash, the elder Cox, Cotman), and the journeys to England of French painters (the landscape-painter Jean Philippe de Loutherbourg, 1740-1812, Géricault, Delacroix, etc.) are a few examples of the reciprocal relations between France and England in the field of landscape-painting. In these relations a special role was played by Richard Parkes Bonington (1801-28), who was born in Nottingham, but went to Paris at the age of fourteen and spent most of his short life in France [114]. For a time he studied under Gros. Properly speaking, one should consider him as belonging to French art; but he also forms part of the history of English painting, since although he transmitted the landscape water-colour to France, he remained essentially English. The very fact that Delacroix had such a high esteem for his work is evidence of the importance of his role as an intermediary between English and French landscape-painting. In Granet's impulsive landscape sketches, the inspiration originating from Bonington bore its finest fruit [15]. Eugène Isabey also owes much to the English in his landscapes. He was one of the collaborators in the production of the *Voyages pittoresques et romantiques dans l'ancienne France*,[10] published between 1820 and 1878, the very title of which is an approximate defini-

114. Richard Parkes Bonington: The Park of Versailles, c. 1826. *Paris, Louvre*

tion of a certain category of romantically trans-figured *vedute*. It contains lithographs, most of them of great technical refinement, by French and English artists such as Carle and Horace Vernet, the architect Eugène Viollet-le-Duc (1814-79), Eugène Cicéri (1813-90) and Léon Sabatier (d. 1887), both masters in the representation of light, Paul Huet, Baron Isidore Taylor (1789-1879), Bonington, and Newton Fielding (1799-1856). In the sparkling Venetian views of Félix Ziem (1821-1911), Turner's light is imitated in a stereotyped fashion.

However fundamental the influence of English landscape-painting on that of France may have been, the change in France took place only slowly, and naturally not in the English direction alone. The excitement caused by the exhibition of Constable's three pictures, among them the celebrated *Haywain*, at the Paris Salon of 1824[11] found a quick reaction only in Delacroix, as shown by the landscape background of the *Massacre of Chios* [100], and by that of the monumental hunting still-life of 1826 with the mounted huntsmen (Paris, Louvre). In Delacroix Constable's method of differentiating colours encountered a kindred spirit. The other novel elements in the art of the great Englishman, however, his relationship to nature, the pictorial treatment of the phenomena of light and atmosphere – elements which have a parallel in German landscape art of the same period, in Blechen, Wasmann, and other artists – did not result in an immediate increase in realism in the works of French landscape-painters. The steadily growing precision in the observation of lighting and of the phenomena of the sky and

115. Victor Hugo: Morning in Vianden, 1871. Wash-drawing. *Paris, Maison de Victor Hugo*

weather remained within the framework of mitigated Romantic conventions, of a lyrical feeling for landscape, and of a certain subdued pathos, even where, as in the case of the Barbizon school, landscape-painters kept demonstratively away from both academism and Classicism.

There was, however, also an avowed pathos in the art of certain French landscape-painters about this time, for example in Paul Huet (1803–69). Dark, rocky gorges above which race lowering clouds, driven by the wind, and woods with mysterious patches of twilight and irruptions of harsh light are favourite motifs of Huet and the other painters of his group. Their works belong to the old category of 'heroic landscape', which, like 'historical landscape' with its significant settings and accessories, still existed. Their superiority in painterly profusion and delicacy

of colouring over the hardness and aridity of late heroic landscapes in Germany (Preller, Lessing) is greatly diminished by cheap theatrical effects. It is true that they are less naive than the comparable German landscapes, but on the whole they remained within the same very narrow limits. Occasionally these limits are overstepped by genuine poetical imagination. This is the case, for example, in the amateurish landscape-paintings of Victor Hugo (1802–85). His talent as a painter was sufficient to enable him to cope with the imaginativeness of the landscape elements described in his novels and poems – for the most part fantastic medieval buildings and towns [115]. The violent contrasts between black and white are not carefully brought into tone with one another, but recklessly noted down as expressions of passionate drama. The

first chiaroscuro visions which Odilon Redon created not long afterwards arc related in spirit to this Romanticism [264].

The most original and the most profound Romantic in French landscape-painting was a lonely invalid – Charles Meryon (1821–68). The illegitimate son of an English doctor and a Parisian ballet-dancer, he was pathologically over-sensitive, and so his illegitimacy was a source of torment to him throughout his life. He started by studying mathematics; in 1837 he entered a naval training school, and in 1841 became a midshipman, in which capacity he made ocean voyages lasting several years. Towards the end of the 1840s he turned to painting, but soon – on account of his colour-blindness – devoted himself exclusively to etching,[12] the technique of which he studied in 1849 and 1850 under Eugène Bléry (1805–87). To his deep melancholy was added persecution mania, and in 1858 he spent a short period in a mental hospital. The last two years of his life, from 1866 to 1868, were spent in the asylum at Charenton.[13] Many elements in his work reflect this external picture of a tormented life, starting with the choice of themes. Apart from a few reminiscences of his voyages in the South Seas, he has virtually only one theme – townscape, especially that of Paris. In his etchings, in a series of twenty-two 'Eaux-fortes sur Paris' (1850–4), and later in isolated sheets, the city appears under two aspects: firstly in famous buildings (Notre-Dame, the Palais de Justice, the church of Saint-Étienne-du-Mont), in old lanes and corners, and with a special predilection for the bridges over the Seine; and secondly as an urban monster, a labyrinth of houses and streets, swarming with insect-like human beings. Both these aspects are romantic, in the general, superficial sense as well as a deeper sense, and both reflect the Romanticism of the time in painting and literature. The renderings of historic buildings are stages on a 'Voyage pittoresque et

romantique', like the innumerable Romantic *vedute* of the period, and the more or less historically embellished general picture of the huge city [116] has its parallels in the written descriptions of Eugène Sue, Balzac, and Victor Hugo (who admired the 'souffle d'immensité' in Meryon). Occasionally in Meryon's etchings the bright, cloudy sky is filled with flights of sinister great birds, or a balloon (*Le Pont-au-Change*), or with demons and monsters in the manner of Bosch (illustration 117, *Tourelle Rue de l'École-de-Médecine, Le Ministère de la Marine*). Even the little accessory figures move with a mysterious agitation, and seem to act dramas reduced to microscopical dimensions, or only hint at dramas played out in the darkness of the lanes or in the broad daylight of the squares. These personifications of life's terrors, of melancholy and awe, remind us of the poetry of the period, of Baudelaire, Gérard de Nerval, and Poe – whose tales Meryon had read. Indeed, Meryon himself frequently wrote gloomy verse commentaries on his etchings.

The way in which these romantic subjects are drawn is as enigmatic as the subjects themselves. All the terror and menace of the lowering masses of houses and the sombre narrowness of the lanes are expressed, sometimes in a romantically veiled form, but more frequently in the harshness of a sharp lighting, in the clarity and starkness of block-like buildings and bare walls. The dim lighting and the veiled forms are in conformity with the taste of the time, but the excessive harshness is unusual and uncanny. The contrast between dazzling bright walls and dark, humid, canyon-like lanes and black window-openings is more than a dramatic contrast, since a dramatic contrast, a symbolical form of great moral gestures, has always something of a consoling element. In the sharpness of the meticulous forms in Meryon's works, however, lurks the uneasy fear of an imminent danger of being overwhelmed by an army of

116. Charles Meryon: The Morgue, 1854. Etching

small things, by the forces of decay and secret destruction. In one etching, the frighteningly precarious, dizzy bird's-eye view of the *Collège Henri IV* (1864) [117], the contrasts merge into but are yet irrevocably doomed to decay. It is the same spirit that lives in the etchings of James Ensor, and in the toying with the past of the Surrealists. Although this absorption has

117. Charles Meryon:
The Collège Henri IV, 1864. Etching

a confused grey mass. Elsewhere one can admire Meryon's pictures of buildings for their firmness and clarity. The effect, however, is often as if they were imploringly opposing the inexorable powers of dissolution. Demonic forces as expressed in landscape are more formidable than those that can be expressed in man. That is the difference between the demonism of Meryon and that of Goya, Meryon's predecessor in the art of etching. Meryon went further back into the past, however, and made copies of old portrait engravings and paraphrases of the landscape engravings of the seventeenth-century Dutch marine painter Reinier Zeeman. It was not the desire to imitate which stimulated his interest in earlier art, but something resembling the fascination of old buildings which defy the past, pathological features, it possesses something of the strength of Bruegel and Hercules Seghers, those two great draughtsmen of the past. To the art of Seghers, who, like Meryon, had visions of the power of small things and the monstrousness of numbers, Meryon's art is indeed very close. Owing to this spiritual affinity the normal conception of Romanticism is too narrow for his art. His Romanticism includes mysticism, but not only because of its ghosts and fabulous beings in the manner of Callot. It has a mystical flavour, just as the ugliness of amorphous masses of houses is the counterpart of the beauty and shapeliness of Gothic and Baroque buildings. In addition, in Meryon's incisive clarity and sharpness one can see an expression of the much quoted French 'clarté', even when it is

used to portray gloom and the oppressive fears of the soul.

In French landscape-painting, side by side with the 'wild' Romanticism which was the domain of a few gifted lone hands, there was also the 'soft' Romanticism of the familiar, popular kind. This conception of nature has already been referred to and was defined by contemporaries with the catch-phrase 'paysage intime'. In France as well as the rest of Europe it was indebted to the old Netherlandish artists, and it acknowledged this debt (see p. 85). The artificiality of the composition generally distracted their eyes from the factual elements of landscape – which were by no means a necessity, as the example of Joseph Anton Koch proves – and made them satisfied with re-interpreting memories of earlier art. Even the Montmartre scenes of so competent a painter as Georges Michel (1763-1843) are not so much renderings of an observed landscape as homage to the spirit of Ruisdael and Rembrandt.

There was, however, one last variety of landscape-painting, also based on Dutch examples, in which the relationship was different and more profound. This was the art of the Barbizon school, the most vigorous group of French landscape-painters of the mid century and the most fruitful for the future.

THE PAINTERS OF BARBIZON

The questions which must be posed in connexion with the so-called school of Barbizon – or Fontainebleau – are these: how much direct experience of nature could be expressed in the traditional language of the old masters without abandoning its consecrated laws? and could anything new be expressed through the medium of this language? The answer is that the possibility existed: but there was also another possibility, namely the exploration of the great traditional values down to their very roots in order to discover a common denominator in

history. This was the path that Delacroix followed. In the great painting of the past he sought to discover the fundamental principles of painting. In so doing he grasped the inexhaustible possibilities of Baroque, but he also realized that it was limited by its concentration on painterly painting. But the Baroque painting to which Delacroix turned was not the whole of Baroque painting, and in another sphere of it, namely the less open form of the painterly element in Dutch landscape-painting, the Barbizon school achieved something similar to Delacroix. In this respect they remained aloof from the tendencies of the last decades of the nineteenth century, and in particular from the problems of colour. Their analytic as well as their synthetic achievement was far more modest than his. After it had come to an end the school of Barbizon did not become the basis of a fashion or of a serious 'Renaissance', but it is nevertheless a striking example of the relativity of valuations. For the last few decades it has been regarded with that cool respect which amounts almost to disrespect. Viewed from the historical standpoint, it was the foundation of the realistic rendering of landscape and a harbinger of Impressionism; yet now, after Impressionism, the romantic, idealistic elements seem far stronger than the naturalistic. In exploring the constituent elements of the great Dutch landscape-painting, the masters of Barbizon were bound to perceive the guiding principle of a tranquil, harmonious cohesion. This and the concordance of the parts of individual bodies, of trees, rocks, and clouds and of the various masses of brightness and colour, which Fromentin had analysed so delicately, was the supreme law for the Barbizon school. The combination of all elements to give unity to the picture, in accordance with Fromentin's formula: 'All Dutch painting is concave',[14] was also one of their chief aims in the field of composition and the rendering of space. In addition, for these landscape-painters of the middle of the nineteenth century the static ele-

ment in the pictures of the classic masters of French landscape, Poussin and Claude Lorrain, was also obligatory. The basic requirement of harmony of the parts, and moreover of a melodramatic unison, was now, however, expanded on a greater scale than in the schemes of Baroque landscape. It was as if these schemes were warmed by a gentle glow, both in the literal and in the metaphorical sense. The demand for unity of tone, in which the grey of the cloudy sky, the brown of the soil, and numerous, but nevertheless determined, varieties of green are combined to form a whole, was retained, but everywhere there were signs of a freer use of colour, which, though still muted and subordinated to the prevailing tone, nevertheless played a steadily increasing role. These Fontainebleau painters discovered a definite, real, and native landscape for their pictures, and made it their only subject. That is an important historical factor; but it is significant that one has to force oneself to remember it. In no respect do their pictures produce the effect of being portraits of landscape, for it was the ambition of the Barbizon masters to achieve generalization, and they always viewed nature *sub specie aeternitatis*, like the classic landscape-painters of the Baroque. They laid stress on this element of the lasting and typical in their deliberate composition. (When the Forest of Fontainebleau, a landscape which had by then become historical, made its last appearance in some of Cézanne's later pictures, it did so once more under this superindividual aspect, though now in a completely new sense.) From this background, in which real greatness and academic rigidity are mingled, a certain individualism stands out, expressed in particular in an ever closer observation of the effects of light and atmosphere in forests and over flat country. Here the way opened from the restricted form of Romanticism to the prose of Impressionism.

The programmatic element in the landscape-painting of the Barbizon school is most evident in the art of Théodore Rousseau (1812–67), the actual leader of the group. While still very young he studied under the Classicist Lethière. His early *View of Le Puy* has the exaggerated pathos of Classicist 'universal landscape'. He remained an exponent of pathos until the end, despite the fact that he drew his subjects from real landscape – spacious plains and secluded woodland pools, the dark edges of woods [118], clumps of trees; in particular, he favoured the mighty forms of huge, isolated, individualized trees, which were capable of giving expression to the Romantic spirit of a pantheistic vision of nature. Occasionally, as in the picture of *Women gathering Wood* of 1837, the monumental effect of the view from below as found in Ruisdael's hill landscapes is exploited, but later the rectangular composition with scenic wings from the left and right prevails. Rousseau's own words, 'By composition I understand that which is within us, entering as far as possible into the external reality of things',[15] although they are very much of a generalization, can be considered to represent the guiding principle of the whole of this art. In this connexion it is worth noting that Rousseau admired and collected Japanese woodcuts. From 1833 on the Forest of Fontainebleau was the 'external reality' that became his favourite theme, and in 1836 he established himself permanently at Barbizon. Rousseau is held to be the real discoverer of this landscape, though Corot, Caruelle d'Aligny, François-Édouard Bertin (1797–1871), and others had previously worked there from time to time.[16] In Rousseau's work as a whole there are tiresome schematic elements, yet it is always given life by an unconstrained observation of nature, as for example in a little stormy landscape in the Louvre (*The Plain of Montmartre, c.* 1835), which reveals the influence of Constable. Rousseau rendered the complicated architectural structure of the edge of a wood in masterly drawings, and such a work as *The Valley of Saint-Vincent*, in the National Gallery [119], is far from schematic and has no

118. Théodore Rousseau: The Edge of the Woods, 1854. *New York, Metropolitan Museum of Art*

119. Théodore Rousseau: The Valley of Saint-Vincent, *c.* 1830. *London, National Gallery*

more than a touch of Romanticism. Of a completely different type, on the other hand, is a no less grandiose picture of high mountains in the Ny Carlsberg Glyptotek at Copenhagen, an Alpine panorama beneath a stormy sky.[17] Here the daring attempt – a very romantic attempt – has been made to make us feel the cosmic aspects of so ordinary an event as a storm in the mountains.

In an idealizing conception of nature such as is found in the landscapes of the Barbizon school, the 'noble' and the 'sublime' are not merely aesthetic but also ethical categories, and the aims of such an art are most completely fulfilled when these coincide. This is especially true of Rousseau. In the works of the other Barbizon painters, a superficial decorativeness and a leaning towards theatrical effects are more frequent. This is the case in the landscapes of Diaz and occasionally in those of Jules Dupré (1811–89), who was a friend of Rousseau and worked in close collaboration with him at Barbizon for a long time. A cardinal characteristic of Fontainebleau landscape-painting was the network of relationships among the strongly accented and richly detailed single motifs within the picture. This allowed plenty of room for personal variations, although their range was not very wide. Thus we find the gentler elegies of Dupré side by side with the virile, austere tonality of Rousseau and his pictorial poems of great high trees. The restrictions imposed by the school can be seen in one important detail, the treatment of the chief colour – green. Even in the numerous gradations from emerald green to greyish moss-green, the treatment of the forest remains in 'local' colour. Later, in the works of the Impressionists, there was a radical change, the green of nature being in the end considered as a 'dangerous' colour which was to be avoided; the Impressionists tried to prove that green was actually not green at all, but a combination of other colours. The importance of 'local' colour and the dominating role of

'valeurs' in the works of the Barbizon painters explain why so much of their art achieves full expression in etched reproductions, made either by themselves or by numerous routine engravers.[18] Occasionally the reproduction almost seems to convey a purer impression of the painter's intentions than the actual paintings.

While in the case of Rousseau and Dupré colour was limited only to a certain extent by the dictates of an ideal of form, it was completely subordinated in the work of Jean-François Millet (1814–75), the one member of the group who was a professed painter of ideas. In his pictures it has no more relationship to colour in reality than, for example, in those of the Nazarenes, and, as in their works, it tends towards the symbolical. This is very remarkable in a painter who has an undisputed place in history as the artist who opened up a new field of real life to painting, the life of the peasant. His many popular works are paraphrases of this basic theme; they show peasants working in the fields [120], sowing and harvesting, as herdsmen with their animals, doing housework, and – more rarely – resting after their work. All these pictures are more than objective, or even artistically heightened, renderings of real things; right from their very foundations they illustrate a particular view of this reality. All of them have the sole aim of producing an almost religiously transfigured picture of the gravity, hardship, and dignity of peasant life, a glorification of work. This was a new aim, based on a programme never before so clearly and so forcibly presented. The origin, childhood, and youth of Millet seem to have been a foundation and a preparation for his art. He was born in the little village of Gruchy near Gréville on the coast of Normandy, and not until he was twenty did he leave the peasant milieu of his home to become a painter. A particularly deep and lasting influence was that of his grandmother, a pious peasant woman. His first training he received in Cherbourg from the battle-painter Charles

120. Jean-François Millet:
Peasants digging, *c.* 1855. Etching

Langlois (1789-1870), a pupil of Gros. Later, in Paris, he studied under Delaroche and in the Atelier Suisse (1838). Despite his dislike of large cities he spent the next ten years in Paris, but in 1849 he moved to Barbizon – a return to nature and a partial return to the peasant world. As an artist, Millet in his relationship to the life of the peasants he depicted can have been only an outsider, yet his glorification of the peasants certainly had its roots in his own peasant origin. It is not true, as has often been said, that before his time peasants had been portrayed only as figures of fun. In the sixteenth and seventeenth centuries Netherlandish painters also knew a good deal of the real character of the peasant and the reality of peasant life. This is particularly true of Pieter Bruegel (who moreover

produced quite a number of scenes showing peasants at work). In the melancholy gravity of Millet's pictures of peasants three things meet: a sentimental aestheticism, a vigorous effort to achieve monumentality, and a humanity which turned towards the peasants because Millet was close to them, understood them, and felt an impulse to tell of their joys and sorrows. The discrepancy of these ideas and the questionableness of combining them subsequently induced a rejection of his portrayal of peasants as sentimental and as a deliberate glorification. Nevertheless, for several decades this simplification, and especially the feeling which speaks from these pictures, made a remarkably deep impression on the public and on many painters, on Israëls and Liebermann, on Segantini, and even – and to a

particularly high degree – on van Gogh. This fact alone justifies much that is in the art of Millet. Today we should try to keep the correct balance between overrating and underrating and to recognize in his paintings, side by side with the somewhat stereotyped simplification of form and the monotonous tonality, invariably in a minor key, the characteristics of a strange, gentle monumentality of the figures. The charms of the drawings and etchings can in any case be easily recognized. In them, as happens so often with artists who are greater as artists than as painters, Millet's talent speaks more immediately than in the paintings, especially in such popular works as *The Winnower* (1848, Paris, Louvre; the first of the series),[19] *The Gleaners* (1857, Louvre), *The Angelus*

(1858-9, Louvre), *The Man with the Rake, The Woodcutter and Death* (1859) [121], *The Shepherdess* (1864, Louvre). Only occasionally did Millet paint pure landscapes – one of the best examples is *Spring* in the Louvre (a late work, finished in 1873) – and the intention behind these is just as symbolical as that of the pictures of peasants [122].

Side by side with Millet, who for all his bias at least strove to achieve something universal, stand Constant Troyon (1810-65), Rosa Bonheur (1822-99), and Charles Jacque (1813-94) as specialists on a smaller scale; Troyon with his animal pictures à la Potter, in which the usually large dimensions are not accompanied by a corresponding monumentality, and Jacque with his village idylls. The large animal pictures of

Troyon and Rosa Bonheur contain too little real painting to place them on a level with the work of the leading masters of Barbizon, but their attempt to achieve an epic, 'heroic' rendering of animals had considerable influence, and pictures such as Troyon's *Oxen on the way to Work* (exhibited in 1855, Paris, Louvre) and Rosa Bonheur's *Oxen ploughing* became the ancestors of a very variegated type.

The direction in which the Barbizon landscape-painters tended was resolutely followed by Charles-François Daubigny (1817–78), after he had gone through a long period of training under his father Edmond-François Daubigny (1789–1843), Victor Bertin, Granet, and Delaroche. Daubigny fulfilled the promise which those landscape-painters had held out; that is,

121 *(opposite)*. Jean-François Millet:
The Woodcutter and Death, 1859.
Copenhagen, Ny Carlsberg Glyptotek

122. Jean-François Millet:
Shepherdess, *c.* 1855. Wood-engraving.
Vienna, Albertina

light and atmosphere took on a new function in his landscape. Even so, he did not succeed in eliminating the dualism between light and the thing lit, between the materialism of corporeal objects and the incorporeal atmosphere, as the Impressionists later did, and this links him still with the painters of Barbizon. But he did manage to give the two equal value, and this was something in which the artists of Barbizon had not succeeded. Their painting, however fervidly they devoted themselves to the experience and study of light, never leaves us in doubt as to which of the two separate entities – bodies or light – was 'there first'. So here was undoubtedly a new situation in the history of painting. However, Daubigny was not the first to achieve this equality. Constable had achieved it earlier, and some of the German Biedermeier painters of the middle of the century at the same time as Daubigny. In addition we have seen a number of examples of equilibrium of matter and light at a much earlier moment, between the days of Rococo and the last days of Romanticism. Even so, with the great exception of Corot, it was not until Daubigny that this tranquil balance became the cardinal feature of a painter's whole *œuvre*. The means of achieving it was systematic 'plein-air' painting, and this also begins with Daubigny. The painter in his houseboat, in which he travelled up and down the Oise, the Marne, and the Seine, in order to be amidst the peace and solitude of an unpretending landscape – that is something more than a mere accident. Eventually Daubigny settled at Auvers on the Oise, where he became the first of that series of major and minor French landscape-painters who found their subjects there: Dupré, Harpignies, Corot, Jacque, Karl Daubigny (1846–86), a son of Charles-François Daubigny, Pissarro, Berthe Morisot, Guillaumin, Cézanne, van Gogh, Vlaminck.[20]

Landscape-painting of this kind, although it contributed nothing fundamentally new to the conception of *nature*, was nevertheless on the

123. Charles-François Daubigny:
The Lock at Optevoz, 1859.
Paris, Louvre

way towards a new conception of the *picture*, in that it began the transition from local colour to a freer colouring determined by the atmosphere. Colour became the primary means of creating form. Despite this, however, Daubigny remains true to the conception of landscape of the great Dutch painters, down to the airiest impressions of his last years. It is from this conception that a picture like *The Lock at Optevoz* (1859) [123] draws its serene tranquillity and firmness; what is here framework and construction, however, is later, especially in the masterly play of lines and in the tender chiaroscuro of drawings [124] and etchings,[21] turned into a brilliantly paraphrased reminiscence of the works of the great predecessors.

The influence of the Barbizon masters was very considerable throughout Europe. Often foreign painters continued the study of nature

of the Barbizon school on the spot; for example the two Italian artists Nino Costa (1826–1903) and Serafino De Tivoli (1826–92), who was one of the *macchiaioli*, the Hungarian László Paál (1846–79), and the Roumanian Nicolae Jon Grigorescu (1838–1907).

CAMILLE COROT (1796–1875)

Even after the end of Classicism, the tranquillity of perfect harmony, an undramatic, effortless equilibrium, remained one of the ideals both of nineteenth-century painting and of the century as a whole. Indeed it is a timeless ideal, common to the enthusiastic though vague conception of a 'world of beauty', a better world of super-terrestrial perfection, and to the precise consciousness of individual artists who saw in the classical tranquillity of forms the self-evident

124. Charles-François Daubigny:
River Landscape, *c.* 1860. Chalk-drawing.
Vienna, Albertina

aim of art. No painter of the period realized this ideal to such an extent as Corot; moreover, he realized it while remaining remote from all the current doctrines of Classicism based on literature and philosophy, and at a time of great unrest and struggle.

A fundamental factor in the development of nineteenth-century painting is the dualism of thought and the contemplation of the visible world, their antagonism and co-operation. Such a statement is, of course, only an expedient generalization – rough-and-ready but indispensable. It shows itself to be inadequate when we try to apply it to Corot, and yet there can be no doubt that he too was aiming at perfection in the interpretation of the visible world. The dualism referred to, however, exists only in the beginnings of his art. Jean-Baptiste-Camille Corot was born in Paris in 1796, the son of a busi-

ness man. He did not turn to art until he was twenty-six, having previously been employed in a drapery business. He started as a pupil of the Classicist landscape-painters Michallon and Victor Bertin. During his first visit to Italy, in 1825 and 1826, he came into contact with other painters of Classicist tendencies, such as Léopold Robert, Caruelle d'Aligny, Édouard Bertin, and Johann Christian Reinhart. For a whole decade the influence of idealistic landscape painting is clearly discernible for instance in such typical works as the *Forest of Fontainebleau* (Washington),[22] exhibited in 1831, the approximately contemporary landscape at Zürich, and the *Hagar in the Wilderness* of 1835 in the Louvre. Ten years before the *Hagar*, however, at the beginning of his stay in Italy, Corot had already painted a view of the Colosseum (1826, Paris, Louvre) which was the starting-point of

125. Camille Corot:
The Farnese Garden in Rome, 1826
Washington, The Phillips Gallery

126. Camille Corot:
Ville d'Avray, *c.* 1835–8.
Paris, Louvre

a whole series of nature studies of Rome and its environs, in particular Città Castellana [125]. The type of small landscape which they herald recurred in Corot's work for several decades. It was not actually created by him; apart from its isolated predecessors at the end of the eighteenth century (p. 82 ff., illustrations 45, 47), even Classicists had painted renderings of reality unfettered by any idealistic doctrines,[23] and in the 1820s and 1830s examples of pre-Impressionist and Early Impressionist conceptions of light in sketchily painted pictures were frequent, from the England of Constable to Northern European and Austrian Biedermeier. These have already been mentioned in connexion with Daubigny, upon whom the early landscapes of Corot had a decisive influence. But Corot's influence extended further. His landscapes were the culmination of the type, and everything that is great in Late Impressionist landscape derives from them [125, 126]. Indeed Corot's classic landscapes are greater and purer than those of the Impressionists in so far as they lack the sometimes ominous characteristics of Late Impressionism. Moreover the clarity and precision that are their hallmark are not regulating factors, as they are in Classicist landscape, but qualities of the spirit of the landscape itself.

The method by which Corot achieves his results is not particularly mysterious, or at all events one of its mysteries is easily solved – the renunciation of drawing. This is an artistic device which has all the simplicity of genius, and its influence on subsequent landscape-painting is obvious. The way in which Corot applies his large and small patches of colour and combines them in the structure of a landscape implies that the essence of landscape, the indifferent tranquillity of nature, could not possibly be conveyed so intensively and unequivocally in any other way. The living surface of the picture becomes as convincingly the 'symbolic form' of the life of nature as in any great painting of any period of the past.

In his middle years Corot also cultivated another kind of landscape-painting, Arcadian landscapes in a silvery light, in which nymphs are dancing or playing or shepherds are performing on their pipes [127]. In such works, which brought him great success, he partly uses motifs drawn from the nature studies he made during his stays in Italy (1825-8, 1834, and 1843), but generally speaking the landscape is imaginary – happy visions of a timeless Antiquity. These pictures are no more narratives proper than those from his other phases; they are Romantic dream-poems in the language of painting, although even they remain closely bound to the visible world, however much their inner clarity may be veiled by gently gleaming tones. Owing to the enormous volume of Corot's production we sometimes find repetitions of decorative effects, but the painterly sovereignty is invariable.

Another category of paintings by Corot, which at the same time represents the highest level he reached, consists of his portraits and his late figure-paintings, almost all of them single figures of women in vague forest landscapes or in the diffuse light of a studio (*Woman with a Pearl*, 1868-70, Paris, Louvre; *Woman in front of an Easel examining a Picture*, in five versions dating from 1860-70, Paris, Louvre, Lyon, etc.; *La Zingara*, *c.* 1865-70, Paris, Jacques Laroche Collection; *Girl reading*, 1868; *Girl at the Well*, 1855-63, formerly Paris, Durand-Ruel Collec-

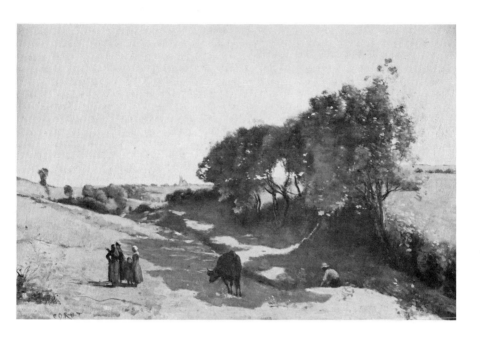

tion; *Lady in Blue*, 1874 [129]. Close to these pictures are mythological and religious figure compositions such as the *Nymph on the Seashore* (1865, New York), in motif and spirit a modern paraphrase of Giorgione's *Venus*, the *Bacchante with a Panther* (*c.* 1855-60, Bingham, N.Y., private collection), *Mary Magdalen reading* (1854, Paris, Louvre), *La Toilette* (1859, New York, Wildenstein Collection).

All these works are extremely simple in composition and the figures have a statuesque tranquillity. It might be called *portato* with a musical term, provided this does not conjure up any thought of heavy weight, either material or ideal. Indeed the compositional plan, the construction in horizontal and perpendicular axes and

outlines, are so simple and universal that they cannot be defined in any detail. How could anyone distinguish the differences in the orthogonal compositional schemes of Masaccio and Poussin, of Piero della Francesca and Chardin, of Raphael and Giorgione, without also taking into consideration the other elements of structure such as draughtsmanship and modelling, the treatment of space, and pictorial construction? In Corot there is one element which, above all others, seems to be peculiarly his own – light. One might be tempted to say that, if we think of light in the most strict and the most profound sense of painterly painting, no painter has ever been able to express more by means of light than Corot. But the temptation must be resisted. The

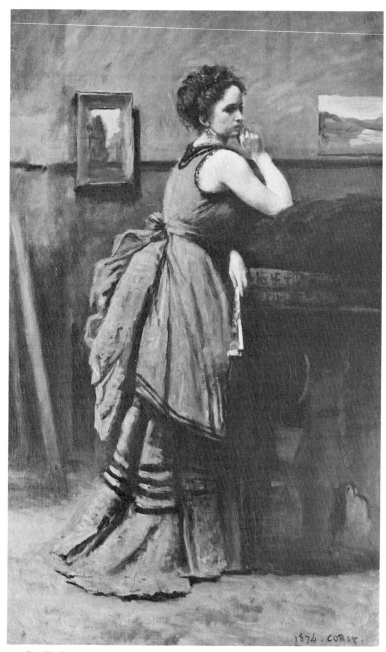

129. Camille Corot: Lady in Blue, 1874. *Paris, Louvre*

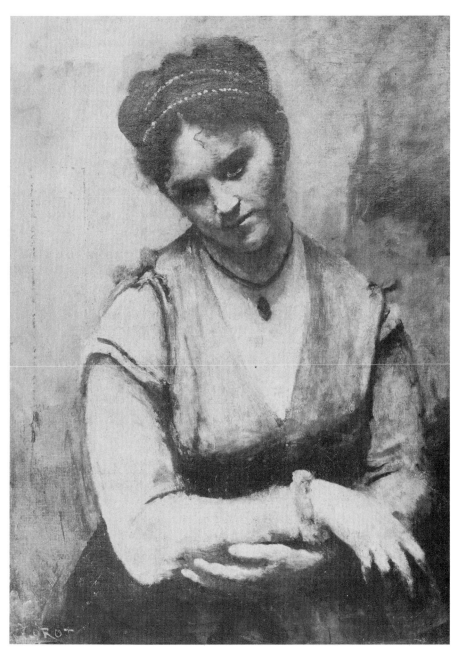

130. Camille Corot: Portrait of Mme Gambay, *c.* 1870. *Formerly Marczell von Nemes Collection*

pronouncement could be made only if there had never been a Rembrandt. Even so, of all Corot's abundance of pictorial means light is the richest. It has various meanings for Corot, corresponding more or less with the three main categories of his pictures to which reference has been made. In the studies from nature it appears as the counterpart of matter in the same way as it did in the mature painting of Daubigny. It could thus become the foundation of the painting of light in consistent Impressionism. The silver light of the Arcadian landscapes is the second, a playful variety of light. This offered the easiest method of eliminating any element of heaviness from Romanticism, both for Corot and for his successors. The most profound and mysterious kind, however, that of his late figure pictures [129, 130], remained for even longer unrecognized and without influence. Its profundity does not lie so much in its Romantic content, and in the fact that this light – which is also a silvery light – transports everything into a blissful dream-world, but rather in its more 'terrestrial' function of modelling figures and objects in such a way that they seem to be taking part in memorable events. The only analogy in the art of the latter part of the nineteenth century is the work of Cézanne and Marées, neither of whom was influenced in any provable way by Corot. Later still, this particular function of light, this sculptural power in painting, reappears in a cruder form – and here probably as a reminiscence of Corot – in the works of the Cubists and in certain 'Classicist' works of Picasso. With this rendering of light and a colouring which conforms with it, Corot achieved a mysticism of the real. Compared with this, the dance of the nymphs in the glimmering woodland glades beneath a mother-of-pearl sky seems rather theatrical, and the subdued sunshine of the little landscapes of Italy and France no more than a preliminary stage. From the sunlight on the ground or on the masonry of the Roman Forum

– those 'tablets of light', as Adalbert Stifter would have called them – to the twilight shadows of the late figure-paintings, amidst which gleams the curve of a forehead or of the back of a hand, stretches the domain of a painting of light which is among the most precious achievements of the whole century.

As Corot approached the end of his life the serenity of this *anima candida* was deepened by a melancholy sublimity, as if it were something inevitable and natural. Nor is there anything rhetorical in all this, or the least trace of the consciousness of anything revolutionary. Here appears something of the man Corot, who until the end of his life remained a kindly, childlike dreamer and – the greatest miracle of all – a modest genius. Yet he was a revolutionary, as is patent at once if one turns to his complete break with the tradition of the Dutch masters.[24] Despite this, in the field which we have shown to be peculiarly his own he is near to the two greatest Dutch masters, Rembrandt and Vermeer (of one of whom he can have known virtually nothing). The reason is that in some of the most significant portrayals of human beings from Corot's last period – in addition to the portraits of women already mentioned, the *St Sebastian* (*c.* 1850–5), the two pictures of a *Monk reading* (1855 and 1865), and the *Monk playing the Cello* (1874, Hamburg) – an unusual depth of contemplation is obtained through the means of painting, a depth which is no more akin to thought than music is.

Unquestionably Corot was a genius of a one-sided type, and his perennially youthful joy in living was his personal characteristic. However alluring this might be, it was something that could not be passed on. There was, however, in his work a great deal that could, and this was regarded as his doctrine and was bound to have influence. But in his more intimate circle, of his magic transformation of reality, the magic ele-

ment at first exercised an influence rather than the interpretation of the real, the lyrical rather than the pictorial vision. The latter became at last fruitful to a no longer exactly measurable extent in Impressionism, after having somewhat earlier inspired the landscapes of Stanislas Lépine (1835–92) and Félix-Hippolyte Lanoue (1812–72). In the works of another pupil, Antoine Chintreuil (1814–73), and in those of Louis-Nicolas Cabat, who belonged to the inner circle of Fontainebleau painters, and of Henri-Joseph Harpignies (1819–1916), the mood of Corot's native landscape and his dreams of Italy, the tempting side of his tonality and the refinements of his graphic art,[25] continued to manifest themselves.

EARLY NATURALISM (BIEDERMEIER PAINTING)

When one considers in how many gradations and variations naturalistic tendencies revealed themselves after the end of Classicism, and even contemporaneously with it, one is tempted to abandon the idea of 'Early Naturalism' as an independent movement. The trend towards a naturalistic contemplation of reality appeared not only side by side with the idealistic programmes, but in every conceivable sort of connexion with them, mingled with Classicism and mingled with Romanticism. It was – as has already been mentioned in the Introduction – the fundamental trend of nineteenth-century development, and practically everything was permeated with it. But it is precisely this that urges us to deal separately with the trend towards the naturalistic, whenever it appears in anything like a compact form. This can certainly be said of 'Biedermeier' art. The term Biedermeier, originally applied to the period in Austrian civilization between the Vienna Congress of 1815 and the revolution of 1848 and to the corresponding period in Germany, has for a long time been used in a wider sense.[1] We now talk of 'Biedermeier' in the painting of Scandinavia and Switzerland, and the genre-painting of Boilly is something of a French version of it. Nevertheless a certain narrowness of boundaries in Biedermeier art is not only a fact, but a characteristic fact. 'Biedermeier' painting is an art of 'minor masters'. Even when taken in its broadest sense, it is not of the same European importance as, for example, Romanticism. It is true that at certain fortunate moments the works of a Biedermeier painter can reveal breadth and depth, but that only poses the familiar question, whether on account of fortunate moments one ought to correct one's normal conception of a style and assign a broader and deeper meaning to it, or whether it is better to conclude that in such moments and in such works the limits of the style have been overstepped. The decision is no more than a matter of agreeing on terms, and this being so it will be better in the case of Biedermeier to accept the second interpretation. This at all events has the advantage of providing us with a definition of a style of marked limitations, in the sense both of deliberate and self-imposed and of involuntary restrictions. This definition does not do an injustice to Biedermeier, as long as one considers only its historical position and logic and does not overlook any further values for which room was found in it.

The painter whose art can be considered the prototype of the essence and spirit of Biedermeier was Waldmüller.

FERDINAND GEORG WALDMÜLLER (1793–1865)

Waldmüller must be given first place not only as the most typical painter of the circle, but also because, more than any other artist, he publicly proclaimed his conviction of the necessity of embarking upon new tasks.[2] Compared with the theoretical utterances of others, Waldmüller's declarations are admirably clear. Indeed, their uncompromising nature and polemical acrimony in the end brought him many unrelenting enemies and resulted in an open breach with the Viennese academy, in which Waldmüller had been a professor since 1830. What he maintained can be summed up in a few words: the study of nature is the one and only aim of painting. In itself, as one of the many references to 'nature as our teacher', this may not mean

131 *(above)*. Ferdinand Georg Waldmüller: Prater Landscape, 1830.
Formerly Berlin, Nationalgalerie

132 *(opposite)*. Ferdinand Georg Waldmüller: View of the Hallstättersee from the Hütteneckalm,
1838. *Vienna, Historisches Museum der Stadt Wien*

very much, but it is given weight by the explicit rejection of every 'idealistic' and Romantic tendency, and becomes of historical importance owing to Waldmüller's strict adherence to his own postulate in one portion of his art: landscape-painting. Waldmüller's landscapes are an extreme case, in fact a 'case' in every respect, because they deliberately bring problematic situations into the open and themselves stand on the verge of a problematic situation. The problem is precisely that of Naturalism. Looking at the *Prater Landscape* which was formerly in Berlin [131] no one would yet worry about this problem. The narrow flat strip of ground beneath the huge arch of the sky and the enormous complex of trees, the illuminated tree-trunk on the right and next to it the dark silhouette of the

shaded trunk, the abundantly differentiated masses of shadow and the patches of light of the houses in the distance – these are all painterly antitheses which hold promise of greatness. Superficially, the picture is reminiscent of Wilhelm von Kobell, but it lacks his mannerism. In spirit Waldmüller's landscape is close to the early landscapes of Corot, and like the latter it has greatness, naivety, and matter-of-factness, though these are achieved in a completely different way – not by means of a summary simplification of the details, but in spite of the details, which are all present. A picture such as the *View of the Hallstättersee from the Hütteneckalm* (1838) [132] has the same greatness. A part of the strength of both these pictures lies in the magnificence of the setting, in the former

the extensiveness of the flat water-meadow, in the latter the panorama of high mountains. The *Prater Landscape* was painted in 1830 and is the first of a long series of landscapes. The motifs are from the Wienerwald, the lakes and forests of the Salzkammergut, and famous sites in Sicily. They are all of a dazzling clarity, and are often filled with sparkling sunlight. Again and again the exuberance of reality is checked by large forms and contrasts as in the above two examples, or else by more or less concealed devices of composition. But again and again matter is also stressed down to the tiniest details. Moreover something of earthy heaviness is felt even in the sunlight. In Waldmüller's fanatical pursuit of reality, despite all the alluring charm, light as an important reality plays a singular role. In his painting of sunlight Waldmüller is the actual discoverer of a certain category of light in painting, and that is an achievement which cannot be valued too highly. His painting of light is presented with all the joy of discovery, with the youthful vigour and ostentation of a pioneer achievement, in the same way as, for example, the scientific central perspective of early Quattrocento painting and the still-lifes in Netherlandish painting towards the end of the Middle Ages. But of all forms of light this carefully

133. Ferdinand Georg Waldmüller:
The Public Auction,
1857. *Stuttgart, Staatsgalerie*

observed sunlight with its sharply defined shadows is the easiest to control, because it is the most palpable. Moreover, it was the most suitable for Waldmüller, in whose art corporeal solidity and the beauty of the surface are the dominating aims. Such art is continually endangered by materialism, even in other themes than landscape. In his still-lifes Waldmüller carried on the tradition of the classical still-life of the Baroque and produced brilliant show pieces; in the almost innumerable series of his portraits the fascinating glitter of the paraphernalia almost always outrivals the characterization of human beings, except in portraits such as those of Beethoven (1823, formerly Leipzig, Breitkopf & Härtel Collection); of Prince André Razumovsky (1835, Vienna, Razumovsky Collection); and of the engraver François Haury (1834, Vienna). In genre pieces the situation is reversed, but the result is the same, and Waldmüller's desire to achieve an exact rendering of the true and the real is very often accompanied by a striving after graceful harmonies and a pleasant grouping [133]. His portrayal of peasant life, like his portrayal of the pre-1848 Vienna bourgeoisie, is idealistically adjusted, and he reproduces truth only within very restricted limits. There is thus a fissure between the postulate and the form, a flight from reality despite the demand for faithfulness to nature. Waldmüller's versatility did not lead him to universality. Neither his realism of detail nor his permanent sunlight could achieve this. Nevertheless his ability as a painter, and in particular the confidence of his colouring, often make us forget all this, for example in the *Early Spring in the Wienerwald* ('The Violet-pickers'; several versions from 1858 on, of which the best-known is at Vienna) or the portrait of his second wife (1850) [134], which in its monumentality and supremely simple tonality comes very close to the sphere of Ingres. In the *Window surrounded by Vines* looking out over a mountain

134. Ferdinand Georg Waldmüller: Anna, second Wife of the Artist, 1850. *Vienna, Österreichische Galerie*

135. Ferdinand Georg Waldmüller: Window surrounded by Vines, 1841. *Vienna, Österreichische Galerie*

landscape, with the sun shining through the grapes (1841) [135], a unique idea combined with masterly painting produces what is almost a paradigm of Biedermeier optimism and voluptuous contemplation.

Waldmüller began as a painter of portrait miniatures and stage scenery for theatres in the Austrian provinces between 1814 and 1817. He then worked for a short time with the Viennese actor and amateur painter Josef Lange (1751–1831) and with the landscape and genre painter Johann Nepomuk Schödlberger (1779–1853). Finally, when he was a man of mature age, and despite all the hostility he had aroused, he received invitations to go abroad: one in 1847 to St Petersburg – which he declined – and another

in 1856 to Philadelphia. This he accepted, but he never actually went. After a short stay in London he returned to Vienna by way of Paris, having achieved a great success, from the material point of view as well,[3] in the British capital. However there is no trace in his work of any direct influence of his stay in London, in particular of Constable's method of plein-air painting, or of his visit to Paris on the way home. In genre pictures and landscapes painted during his last years Waldmüller certainly used on occasion a looser, flaky technique, but this remained a relatively superficial phenomenon and made no fundamental difference to his treatment of light. The gap between this and Impressionism could not be bridged. Only in

136. Matthias Rudolf Toma: Garden of a House on the Cobenzl, 1832. *Formerly Vienna, Josef Siller*

two of his last landscapes, the *View of Kloster-neuburg from the Kahlenberg* (1863, formerly Historisches Museum der Stadt Wien, missing since the last war) and a probably contemporary picture of the same area, the *View of the Cobenzl* (Bielefeld, R. A. Oetker Collection), are there signs of a change: in the midst of a gently veiling, pale tonality individual objects recede as they had never done before in his painting. The spirit of a new way of seeing nature has touched these landscapes and pervades them with a moving, dreamy tranquillity.

THE 'OLD VIENNA' SCHOOL

Waldmüller had many pupils, but only a few of them were of any lasting importance, and in

spite of his forceful personality he had no true successors. Many of the Alpine landscapes of Franz Steinfeld (1787-1868) and his son Wilhelm Steinfeld (1816-54) are closely related to his work, and Matthias Rudolf Toma (1792-1869) is so close to Waldmüller that many of his Prater landscapes have been attributed to him. His art was, however, of a slightly more delicate, weaker nature. In one of his finest pictures, showing a *Garden of a House on the Cobenzl near Vienna* on a sunny day in early summer (1832, formerly Siller Collection, Vienna, destroyed during the war) [136], a last delicate echo of the Classicist conception of landscape gives a special charm to the Biedermeier faithfulness to nature.

The landscapes of Erasmus von Engert (1796–1871), who from 1843 was curator and later director of the Imperial Picture Gallery in Vienna, belong to an era before Waldmüller's discovery of sunlight, and some of them are also chronologically earlier. Not only Engert's miniature type of painting, but also a certain aridity and stiffness, a kind of shyness, can be regarded as positive expressions of Biedermeier feeling.

In the landscapes painted by Friedrich Loos after his return from Salzburg, the study of atmosphere, as has been mentioned (p. 128 f.), plays a more and more important part. This study he pursued quite independently of Waldmüller, as is revealed by an astonishingly Impressionist view of Graz dating from 1839 (Private Collection). In 1846 Loos left Vienna for a visit to Rome. The last decades of his life were spent in Kiel, where the art of his early period, which even today is not sufficiently appreciated, deteriorated into meaninglessness.

The landscape-painting of Friedrich Gauermann (1807–62) was likewise hardly affected by Waldmüller. He was born at Miesenbach amidst the foothills of Lower Austria, the son of the landscape-painter and engraver of *vedute* Jakob Gauermann (1773–1843), who originally came from Württemberg. He studied first under his father and then at the academy in Vienna. The neighbourhood of his native place, where he settled, and the Salzkammergut were his favourite sources of inspiration. In his unusually extensive *œuvre* one can find side by side a careful study of nature, a masterly sketch-like manner with echoes of the Dutch painters, and a complaisant, spurious Romanticism, the latter chiefly in innumerable pictures of animals and hunting scenes. He is at his best in pictures like the unpretending *Landscape near Miesenbach* (*c.* 1830) at Vienna. It is precisely this lack of pretension that is the real virtue of his painting; it is genuinely Biedermeier in its vision of landscape, and forms a tranquil counterpart to the more festive art of Waldmüller.

Behind the comfortable contemplation of Biedermeier art lies the idea of the greatness of little things. This idea is fully developed and probed to its uttermost depths in the works of the greatest Austrian prose poet, Adalbert Stifter.[4] The painting of the period remained on the periphery. In Biedermeier painting we do not find the demonic, oppressive, blind force of small things to be seen in the works of Meryon; as a rule the affirmative, serene, harmonious, kindly aspect dominates, and Stifter's belief in the 'gentle law' of nature appears restricted to a narrow intimacy and to the appreciative rendering of the beauty of surface and textures. This is a limitation of Biedermeier which even Stifter as a painter rarely succeeded in overcoming, though he did so as a writer. As a painter, Adalbert Stifter (1805–68) was self-taught. In the late 1830s, during his stay in Vienna (1826–48), he achieved within the framework of 'Old Vienna' painting an astonishingly independent and progressive pictorial manner, full of impressionistic directness. Some of the works he painted in those years (*View of the Beatrixgasse, Vienna*, 1839 [137]; *Motif from Neuwaldegg*, 1840–1; and various studies of clouds, all in the Adalbert Stifter-Museum in Vienna) can be compared with the early impressionistic sketches of Blechen, Wasmann, and Menzel. Completely different from these, however, is a series of landscapes which he produced during his last years in Linz, symbolizing basic concepts such as 'Movement', 'Rest', 'Solemnity', 'Melancholy' (all in the Stifter-Museum), etc. In this peculiar painting of ideas, which expresses the old dream of a union of painting and poetry, the Biedermeier element, as in Stifter's later writings, is no more than a husk. In their brooding essence these pictures are like a testimony to a profound timeless Romanticism in the spirit of Caspar David Friedrich.

Another case of an artist remaining unaffected by the changes in development is that of Rudolf von Alt. His work covered almost a whole

137. Adalbert Stifter:
View of the Beatrixgasse, Vienna, 1839.
Vienna, Adalbert Stifter-Museum

century and underwent hardly any essential change. In his early works, beginning with his views of Salzburg dating from the late 1820s (see p. 129), there is something of the crystalline sharpness of Biedermeier rendering of details. This, however, is merely the consequence of meticulous draughtsmanship, and at the end of his life, round about the year 1900, Alt was painting water-colours showing a flickering restlessness of brushwork with which he immediately surpasses Impressionism without ever having himself practised it previously. This difference between his first and last works is certainly great, but during the many intervening decades Alt painted hundreds of water-colours –

and comparatively few oil-paintings – in which, with an unchanging uniformity, he raised the old category of *vedute* to a new artistic level. His subjects are almost invariably famous views and monuments in the former Austro-Hungarian Empire [138], Italy, South Germany, and also the Crimea, which he visited in 1863. From the technical standpoint, as the leading virtuoso of landscape water-colours on the European Continent, he can be ranked with the English masters of water-colour of the classical period about and after 1800. In his love of detail and his simple joy in the visible world, he can be considered an heir to Biedermeier realism. Nevertheless, his objectivity is more comprehensive,

138. Rudolf von Alt: The Graben, Vienna, 1848. Water-colour. *Vienna, Albertina*

and his accuracy in the rendering of things and light goes so far that one wonders how the constructive element can assert itself in the midst of such a profusion of exact details. In reality Alt's naturalism, intentionally devoid of all mystery, contains many gems of painting, but these are reduced to minute size. This sparkle lends life to the exact illustrativeness of the forms and the perspectival lines, and, moreover, in many of his water-colours and drawings, Alt accentuated the main lines of the composition by leaving parts of the surface empty or treating them very cursorily. One has to admire the way in which he never loses the thread of the composition even when he occasionally indulges in a surfeit of illustrative details.

The naturalism of Rudolf Alt's landscapes soon became an axiom and was imitated for many years to come. Its influence is clearly dis-cernible in the later works of his father Jakob and in the art of his brother Franz Alt (1821–1914). The most independent among the Austrian landscape-painters working within this realistic tendency was Thomas Ender (1793–1875). He too progressed from a Bieder-meier realism impregnated with a delicate Romanticism – especially in the hundreds of water-colours and drawings made while taking part in the Austrian expedition to Brazil in 1817[5] – to a definitely naturalistic objectivity in the manner of Rudolf Alt.

Genre-painting as part of Austrian Bieder-meier is the last flowering of genre-painting altogether, at least on a scale worth considering. Later there are no more than occasional groups or schools of genre-painters, such as the school of Düsseldorf and the Italian Macchiaioli. Thematically it added hardly anything, or at the

most only an occasional emphasis on social conditions such as was in accord with the spirit of the times. This is found here and there in the genre-paintings of Waldmüller, in pictures such as *The Public Auction* (1857) [133], *The Distraint* (1847, Historisches Museum der Stadt Wien), and *Strength Exhausted* (1854, Vienna), a gloomy nocturne. But on the whole this kind of portrayal of customs remained within narrow limits, usually confining itself to what Waldmüller demanded, a generalized 'pointing to the moral' of a story, and this after all forms part of the essence of the genre. Stronger was the tendency towards prettifying and the rendering of petit-bourgeois life with a kindly humour. If we judge this pre-1848 portrayal of customs according to its content – which was, after all, an important factor, especially for Waldmüller – then we have to consider it as an attempt to conceal the un-

pleasant and achieve lukewarm compromises, a far too tidy idyll in the style of Christoph Schmidt's edifying stories. Its remoteness from truth is not directed by any creative fancy or fairy-tale spirit, as it is in the contemporary fairy plays of Ferdinand Raimund. But one can do justice to this 'Old Vienna' genre-painting only if one acknowledges that its outstanding tendency was an endeavour to achieve stylization (which the following genre-painters cannot claim). This gave its best results in the works of Peter Fendi (1796-1842) and Carl Schindler (known as 'Soldatenschindler'; 1821-42), both Viennese and both masters of the water-colour. Many of Fendi's genre scenes and of Schindler's pictures of soldiers [139] – counterparts of the 'intimate' renderings of soldiers by Raffet and Charlet – are beautiful cabinet pieces in water-colour with their gently rounded

139. Carl Schindler: The last Salute to the Flag, *c.* 1838-9. Water-colour. *Vienna, Albertina*

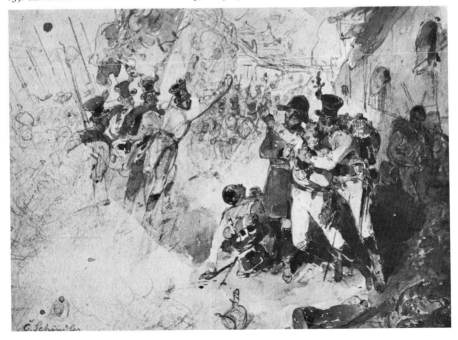

curves and their 'pointed' colour effects, which often form a kind of chromatic arabesque. Attention has often been drawn to the fact that the tradition of the great Austrian Baroque painting remained alive in this 'Old Vienna' painting, and indeed the water-colours of Fendi and Schindler frequently remind us of the fantastic gay colours of Baroque ceiling paintings. Despite this, the masterly abridgement of the distant landscape in Fendi's large oil-painting of the *Mass by the Outer Burgtor* (1826) [140] – a view of the western suburbs of Vienna – shows how genuine was his feeling for nature. Genre pictures of city life were the favourite theme of Josef Danhauser (1805-45), scenes of peasant life in the environs of the city that of Michael Neder (1807-82), whose painting is a rare example of genuine popular primitivism.

Fendi, Danhauser, and Neder also painted portraits. Franz Eybl (1806-80) was almost exclusively a portrait-painter, and his likeness

of the painter Franz Wipplinger at Vienna (1833) is one of the finest in Austrian Biedermeier. Formal society portraiture is brilliantly represented in the works of Friedrich von Amerling (1803-87). He studied first at the academy in Vienna and afterwards at that in Prague, and in 1827 worked in London under Lawrence and in Paris under Horace Vernet. The fashionable element in his painting, in which the after-effects of English portraiture are visible, shows signs of superficiality and a routine elegance. In one of his chief works, however, the large *Rudolf von Arthaber and his Children* (1837) [141], the familiar effects in the rendering of still-life and light and the well-tried form of composition are balanced by a genuine sense of humane and patriarchal middle-class honesty. The portraits of Moritz Michael Daffinger (1790-1849), almost all of them miniatures, likewise continued in a Biedermeier way the tradition of English portraiture and of

140 (*above*). Peter Fendi: Mass by the Outer Burgtor, 1826. *Vienna, Österreichische Galerie*

141. Friedrich von Amerling: Rudolf von Arthaber and his Children, 1837. *Vienna, Österreichische Galerie*

European portraiture in general round about 1800, in particular that of Füger and Lawrence, who visited Vienna in 1819. Between 1841 and 1846 his virtuosity found an outlet in the production of a large number of water-colours of flowers, of which about five hundred have been preserved.[6] These represent the extreme of Biedermeier naturalism in a special field, which elsewhere, in the flower-pieces of the Viennese artists Josef Nigg (1782–1863), Sebastian Wegmayr (1776–1857), Franz Xaver Petter (1791–1866), and Anton Hartinger (1806–90), remained much closer to the traditions of the Baroque flower-piece. Vienna formed a specially active centre of this genre. But what one observes here can also be observed in the work of the flower specialists in other countries. Thus the Belgian Gerard van Spaëndonck (1746–1822) represents extreme naturalism, the Parisian Pierre-Joseph Redouté (1759–1840) a more conventional style. His flower-pieces (and

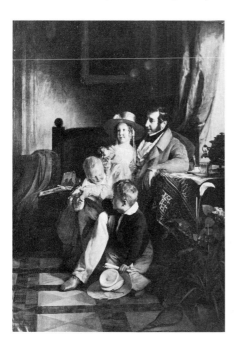

those of many others) come close to botanical illustrations.

The innumerable portraits of Josef Kriehuber (1800–76) are a kind of counterpart in water-colour and lithography to Daffinger's miniature portraits. The simpler, more humane and less formal side of Biedermeier portraiture is exemplified by the portraits of Leopold Kupelwieser.

The various national and local versions of Biedermeier are certainly revealing, but more from the point of view of the history of thought and civilization than from that of art. They are, however, of less importance than the relationships of the Biedermeier attitude to Classicism and Romanticism. These relationships are very close. Where Biedermeier painting is really at home, that is to say in the Germanic countries, we find a number of outstanding painters whose art, taken as a whole, is either Classicist or Romantic, but in addition – as we have already had occasion to note – shows clear traces of Biedermeier. Examples of this are Kersting with his interiors, Wilhelm von Kobell, especially in his later works, and Peter Krafft in pictures such as the twin pieces entitled *The Farewell* and *The Return of the Landwehrmann*, which in a way are the pattern for all genre-painting that came immediately afterwards. In all such paintings one feels that a great ideal has given way to a smaller ideal. Many historians interpret this incursion of the small-scale element as an indication that the great universal ideals, the harmony and tranquillity of the classical in Classicism and the boundlessness and inscrutability of Romanticism, had shrunk to petit-bourgeois idealization of the man in the street and of everyday life, on account of the pressure exercised by the authoritative political regimes. Such submission, leading to a virtue being made of necessity, undoubtedly existed as a negative factor, but the interpretation is insufficient. It is necessary to recognize as the positive impulse the steadily growing urge to make the repre-

sentation of visible reality the one and only aim of painting. The most fruitful field was landscape, in which Biedermeier appears without effort when heroic pathos or transcendental Romanticism is on the decline and the devout contemplation of small things – which had already existed before – remains as the only decisive factor. This phase, however, was relatively brief, and it was in landscape-painting that Biedermeier most quickly outgrew itself. The feeling for real phenomena soon passed from the contemplation of small things to the consideration of space, atmosphere, and light. A clearly defined stage, at which the painter believed light to fulfil its foremost purpose in the representation of nature if it was the means of giving the greatest possible splendour to bodies and materials and the most striking effects to

volume and outlines – this stage was the happiest moment in the history of Biedermeier landscape-painting. It was the stage of a naive realism, distinguished, as compared with the later softness and vagueness, by all the charm of a youthful astringency. Of this Waldmüller's landscapes of the early 1830s are an outstanding example. Their equivalents in Northern Europe are the works of the Danish realists.

DANISH BIEDERMEIER

In Danish painting during the first half of the nineteenth century, Biedermeier is purer and more exclusive than anywhere else. It followed immediately after Classicism and was not accompanied by any Romanticism. This is very significant, for it was at the academy in Copen-

142. Christen Købke: The Castle of Frederiksborg, 1835. *Copenhagen, Hirschsprung Collection*

hagen – founded in 1754 and round about 1800 the artistic centre for both Scandinavia and Northern Germany – that some of the most important German Romantics, for example Runge, Friedrich, and Kersting, began their careers. The intellectual side of Classicism found expression there in the art of Abilgaard, but Danish painting eschewed Romantic transcendentalism. Since it devoted itself strictly to the contemplation of reality, its themes were naturally portraiture and landscape. It was in landscape-painting that it found its fulfilment, and the decades preceding the middle of the century mark the 'great period' in Denmark's brief art history. This period has also been called the 'age of Købke', for it reached its zenith in the art of Christen Købke, who died at the age of thirty-eight (1810–48). To the

Naturalism already established in the landscapes of his teacher Eckersberg he added a differentiated rendering of light [142], thereby achieving, especially in some small pictures of Dosseringen near Copenhagen [143], a Corot-like fragrance and painterly freedom. This is the most progressive aspect of his painting, but the most characteristic is the way in which a delicate, hazy light, instead of dissolving the corporeal elements of things in the picture, adds to their filigree-like sharpness and firmness equally filigree-like patches of light (e.g. in *Østerbro by Morning Light*, 1836, Copenhagen). This reminds one of the 'pointillism' of Vermeer and of the rendering of light in the works of such a painter as Gerrit Berckheyde. The spiritual revival of Dutch seventeenth-century realistic painting in the landscapes of Købke and his

143. Christen Købke: Lakeside near Dosseringen, 1838. *Copenhagen, Statens Museum for Kunst*

144. Constantin Hansen: The Temple of Vesta, Rome, 1836. *Copenhagen, Hirschsprung Collection*

145. Johan Thomas Lundbye: Cows drinking near Brofelde, 1844. *Copenhagen, Statens Museum for Kunst*

211

group is almost without parallel. Compared with Biedermeier landscapes in the rest of Europe, with the North German Naturalism of Hummel and Gärtner or with Wilhelm von Kobell and Waldmüller in the South, these Danish landscapes appear as the gentlest, noblest variant of that uncomplicated, devout contemplation of reality which endeavoured to give a picture of the whole of nature through the sum-total of innumerable details. It comes very close to the point where universality and greatness begin to express themselves in an extreme singleness of vision. But it never goes beyond that point. The most profound component of this landscape art is a tranquillity free from melancholy (although in many of Købke's pictures one is tempted to think of some contact with the art of Friedrich). A peculiarity of Købke's is his predilection for delicate shades of green, especially apple-green, and for a greyish-violet. These colours are also found in the art of Jørgen Roed (1808-88), for example in his interior of the cathedral church at Ribe (1837, Copenhagen, Hirschsprung Collection), one of his finest works. Constantin Hansen (1804-80), who, like all the other landscape-painters of the group, worked for a time in Italy, produced his best work in the form of views of Rome [144]. With their definitely painterly form they follow the same direction that Købke took in his later works. The landscapes painted by Martinus Rørbye (1803-48) in Denmark, Norway, Italy, Greece, and Turkey, and those of his own country painted by Johan Thomas Lundbye (1818-48) [145] differ in the same way from the sculptural sharpness of the paintings of the earlier generation. Lundbye reproduced the same form and mood in numerous bright and delicate drawings, often very closely akin to the landscape drawings of the North German Romantics.[7] Dankvart Dreyer (1816-52) and Christian Skovgaard (1817-75) are the last members of the group. Their art shows an increasing observation of atmospheric moods, and gradually substitutes the free rhythm of a

146. Christen Købke:
The Landscape-Painter F. Sødring, 1832.
Copenhagen, Hirschsprung Collection

fragment from nature for landscape constructed on strictly architectonic lines.

In portraiture their ability as colourists induced the Danish painters of the period to indulge occasionally in virtuosity, which is absent from their landscapes. This is not the case in Købke's well-known portrait of the painter Frederick Sødring (1832) [146], where the sparkling over-brightness of a variegated coloured mosaic is permeated with a naive gaiety, just as the room in which the painter is placed is bathed in a subdued sunlight. But in many other portraits by Købke the tasteful colouring and refined, flaky brushwork become rather too superficially decorative. An equally dazzling pictorial ability – which incidentally influenced Købke – is handled with greater seriousness in the portraits of Christian Albrecht Jensen (1792-1870); these are fundamentally painterly, and in this respect they are in direct

147. Christian Albrecht Jensen: The Painter
J. C. Dahl, 1842. *Copenhagen, Hirschsprung Collection*

contrast with the Classicist system of Eckersberg's portraits [147]. In the delicacy of the colouring and surface some of Jensen's portraits remind one of the works of Leibl and his circle in the second half of the nineteenth century.

In the late 1820s a painter of lesser stature, Wilhelm Bendz (1804–32), succeeded in producing a picture which has always been considered the purest expression of the spirit of Danish Biedermeier painting: the *Interior in the Amaliegade with the Artist's Brothers* [148]. The 'Sunday-best' charm of ordinary life is to be

148 *(below)*. Wilhelm Bendz:
Interior in the Amaliegade, Copenhagen, *c.* 1830.
Copenhagen, Hirschsprung Collection

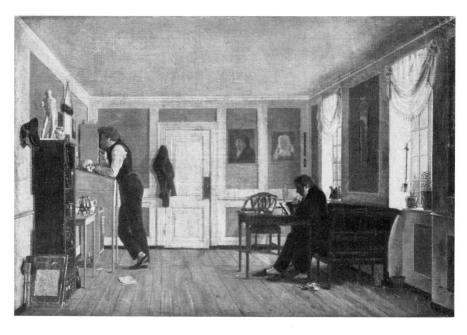

found in many pictures of that time and in fact forms part of the essence of Biedermeier, but seldom with such unaffectedness. One is naturally reminded of Kersting's interiors [63], but such a comparison at once brings out the hidden melancholy of the German artist. In the bright room in Bendz's picture with its light bluish-green wall one cannot forget the flat landscape outside beneath the great expanse of the sky. The picture is as Danish as Pieter de Hooch's interiors are Dutch. Something of the manner of Bendz survives in the genre-paintings of Wilhelm Marstrand (1810-73), but the tenderness is here shouted down by a bustling anecdotal element and later supplanted by too versatile an ability in the painterly presentation.

149. Eduard Gärtner:
The New Guardhouse in Berlin, 1833.
(West) Berlin, Staatliche Museen

BIEDERMEIER PAINTING IN GERMANY

The nearest approach to Scandinavian Biedermeier in German, or to be more exact, in North German landscape-painting is found in the works of two Berlin artists - Gärtner and Hummel. Eduard Gärtner (1801-77) began his apprenticeship in the Berlin porcelain factory and then entered the studio of Carl Wilhelm Gropius (1793-1870), painter of stage-sets for the royal theatre. It was a fitting sequel to these beginnings that, after studying in Paris under François-Édouard Bertin, Gärtner should have become a specialist in the painting of buildings, especially those of Berlin [149]. The sharpness and precision of his rendering of details and the mathematical exactitude of his perspective could hardly be surpassed, and are often carried to the extreme of an almost photographic Naturalism - for example in the six parts of the

panorama of Berlin from the Werder Church
(1834, Leningrad, Winter Palace) – which can
only just be called art. Analogies to this often
occur in the course of the nineteenth century,
for example in the flower-pieces of Daffinger
and in the works of Eckersberg, Rudolf Alt, and
Leibl. Such painting remains within the bounds
of art only when the fanatical striving after
objective exactitude produces the effect of being
itself a subjective spiritual force, or when certain
elements, such as colour and light, mitigate the
Naturalism. The latter is the case in many of
Gärtner's pictures, e.g. in the *View of the
Königsbrücke* (1832, two versions, Königsberg,
now called Kalinin, and Leningrad, Winter
Palace).

It is above all the rendering of light as a
stylizing element that is the saving grace in the
Naturalism of Johann Erdmann Hummel (1769–
1852). He obviously took a special and naive
delight in the representation of unusual pheno-
mena of light, such as the reflection on the
granite bowl in front of the Altes Museum in
Berlin, the construction and erection of which
Hummel depicted in four paintings which at the
time caused a sensation (1830–2, West Berlin),
and in the effects of artificial light (*The Game of
Chess in the House of Count Ingenheim*, 1818–19,
West Berlin). With their Naturalism these
Berlin Biedermeier landscapes moved further
away from the Dutch views of towns and build-
ings, to which they also looked back, than this
special category of landscape had ever done
before – further also than the Munich painting
of buildings under the leadership of Domenico
Quaglio, the Classicist aspects of which have
already been mentioned (p. 131). As an example
of the tendency towards the Dutch style in
Biedermeier renderings of buildings, one picture
may be mentioned, namely the *Churches near
the Panthéon in Paris* (1815, Heidelberg) by the
much-travelled Hessian landscape and court
painter Georg Wilhelm Issel (1785–1870).

In the field of portraiture, Franz Krüger

150. Franz Krüger: The Sculptor Friedrich Tieck,
c. 1840. Pencil-drawing.
(East) Berlin, Staatliche Museen

151 *(opposite).* Franz Krüger:
Parade on the Opernplatz, Berlin, in 1822 (detail),
1829. *Potsdam, Neues Palais*

Friedrich Tieck.

(1797-1857), with his paintings of the formal ceremonies of the time and in the portrayal of animals, occupied the same position as Gärtner and Hummel in the art of landscape. In both the same bourgeois spirit and the same soberness prevail. Aesthetically these are very doubtful qualities, but they combine with traits such as the sincerity of the factual approach, a restrained gracefulness, and a kind of cool gaiety. Thus the validity of the paintings as art is unquestionable, but the narrowness of the limits of artistic intensity in this kind of official Biedermeier painting is equally obvious. The official aspects occupied a great deal of space in Krüger's art. He was painter to the king in Berlin and in 1833, 1844, and 1850 Imperial painter at St Petersburg. As such he was called upon to portray a large number of rulers, members of the nobility, statesmen, high-ranking officers, and prominent figures in science and art [150]; to these works must be added his big pictures of military parades (*Parade on the Opernplatz, Berlin, 1822*, 1829, now in the Neues Palais at Potsdam [151]; *The Oath of Allegiance to Friedrich Wilhelm IV in the Lustgarten on 15 October 1840*, 1844, Potsdam, Sanssouci, Staatl. Schlösser und Gärten; *Parade at Potsdam*, 1849, Leningrad, Winter Palace, etc.). Officialdom, however, is in contradiction to the essence of Biedermeier – though the latter had a 'bourgeois' longing for the brilliant and aristocratic and a reverence for matters pertaining to the court – and for this reason the historical pictures of Peter Krafft [34], so clearly based on the pathos of David, are superior to those by Krüger. In his portrayal of masses Krüger followed the same path as Wilhelm von Kobell, and he too managed to combine into large units innumerable figures

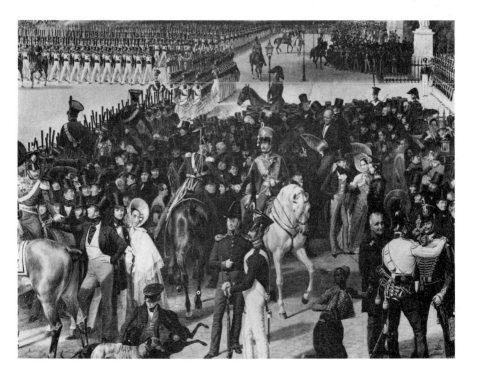

set in wide, brightly lit landscapes. He lacks Kobell's sense of landscape and consequently is unable to achieve the mysterious element of Kobell's panoramas [44], but his solution of the problem he set himself is both personally and generically characteristic. This is due to the fact that on closer examination, out of the neat and frequently rather affected arrangement of innumerable tiny figures there emerge skilfully painted individuals and scenes full of a fresh vivacity. In such details of his large pictures, and also in certain of the genre scenes and in his rendering of horses, Krüger found relief from his formal, official painting.

Karl Steffeck (1818-90), a pupil of Krüger, cultivated this side of his teacher's art as well as history-painting and the Biedermeier rendering of everyday life and of horses. Humorous genre pieces of this kind, interesting more as a pointer to contemporary interests than as works of art, were the speciality of Theodor Hosemann (1807-75), who was active for a short time in Düsseldorf and afterwards in Berlin as an illustrator and painter. In his drawings and lithographs[8] there is sometimes a reflection of the art of the great French illustrators, especially Gavarni. His counterpart as a genre-painter in Düsseldorf was Johann Peter Hasenclever (1810-53).

Krüger managed to preserve a certain freshness and freedom of form and expression in his portrayal of 'society', but as a rule, in his own day and after, this branch of portraiture remained tied to smooth routine and pompous academism. In general, the portraitists of the time had, to a greater or less degree, the ideal of Ingres before them. Some of the German portraitists of Krüger's time studied in France, for example Karl Begas the Elder (1794-1854), who worked in Paris under Gros from 1813 to 1821 and was active in Berlin from 1824 on, Eduard Magnus (1799-1872), also of Berlin, and Karl Stieler (1781-1858), a pupil of Gérard and Füger, celebrated for his portraits of Goethe.

Franz Xaver Winterhalter (1805-73) worked in Paris from 1835 to 1870; he was the famous portrayer of several European rulers; Napoleon III, the Empress Eugénie, Queen Victoria and the Prince Consort, and the Empress Elizabeth of Austria. The sequence of these names corresponds to a sequence from an objective, solid conception of portraiture, deliberately and somewhat pedantically limited, to dazzling display.

The works of some North German painters form the counterpart and the opposite of the superficially brilliant official portrait of Berlin. They are no more than likenesses of anonymous fellow beings, but they strive to express charac-

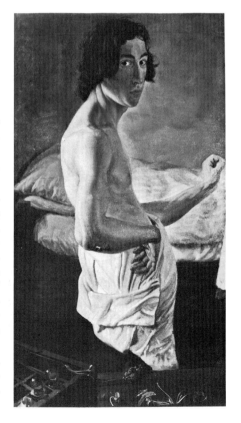

ter and in this succeed in being of more than local significance. Runge's fiery spirit and profundity is the magic circle in which the portraits of three painters in particular, Oldach, Janssen, and Wasmann, move. Julius Oldach (1804-30) died young, and of Emil Janssen (1807-45) only a few works are known. So little indeed were both of them recognized until a short time ago that a portrait by Johann August Krafft (1798-1829) of Altona, *The old Miller (Jakob Wilder)* (1819, Hamburg), was believed to be one of the chief works of Oldach, and Janssen's *Self-Portrait, semi-nude* (*c.* 1827) [152] was attributed to Wasmann. The three painters were friends and worked together in Munich from 1828 to 1830.

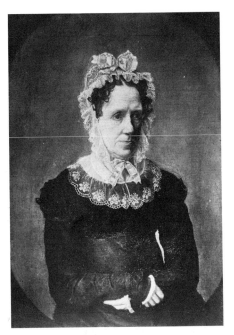

152 *(opposite)*. Victor Emil Janssen:
Self-portrait, semi-nude, *c.* 1827.
Hamburg, Kunsthalle

153 *(above)*. Julius Oldach:
The Artist's Aunt Elisabeth, 1824.
Formerly Hamburg, Kunsthalle (burnt in 1931)

Oldach died there just before a projected visit to Italy. The influence of the Romantic group in Dresden, where he lived from 1821 to 1823, and the circle of Cornelius in Munich were, together with the art of Runge, the decisive factors in his formation. In a picture like the portrait of *The Artist's Aunt Elisabeth* (1824, burned in the Munich Glaspalast in 1931) [153] an unaffected simplicity, the best aspect of the Biedermeier view of human beings, is most happily combined with the ascetic astringency of North German Romanticism. There are also reminiscences of the portraits of early German masters, for example in the pose and rendering of the old woman's hands. All this is likewise true of the self-portrait of Janssen, though in this there is more of Romantic restlessness in the peculiar *verismo* and in the harsh lighting. From Wasmann's autobiography we learn that both Oldach and Janssen were obsessed by constant doubts and torments, and this is certainly recognizable in their works.

To a certain extent one can say the same of the most important master of the Hamburg group, Friedrich Wasmann (1805-86). He himself speaks in his autobiography of a certain 'Zerrissenheit' in his early paintings. This autobiography is one of the best and most sincere confessions of an artist, worthy to be ranked with the memoirs of the painters Ludwig Richter and Wilhelm von Kügelgen (1802-67). Again and again in his paintings Wasmann disowned his effusive talent, often in an inexplicable way, and confined himself to conventional formulas. Finally, after his marriage in 1846, in the second half of his long life, though he still executed many commissions for portraits and occasionally religious pictures, he produced virtually nothing to which even the name of art can be applied. There is not only an enigmatic contradiction between his art and the inner obstacles and restrictions to creative work in his character, but there are also strange fluctuations within his production.

After a short, fruitless apprenticeship in Hamburg, Wasmann studied from 1824 to 1828 at the Dresden academy as a pupil of the Nazarene Gustav Heinrich Naeke (1786–1835), and while living in Munich in 1829–30 and 1835–9 and in Rome in 1832–5 he came into contact with other Nazarenes and became a friend of Overbeck. Nevertheless, and although the Roman Catholic religion, which he, like Janssen, embraced, played an important role in his life, the religious aspect of Nazarene painting remained a secondary factor in his art. It found expression only in the pictures of his decline. Many of his portraits, especially the drawings, are very similar to the best portraits produced by the Nazarenes and equal them in quality, but their characteristic humanity and austerity of draughtsmanship are already essentially present in Wasmann's earliest surviving portraits, two drawings and one painting of his sister Minna (1822, Hamburg). On the other hand some of his drawings compare in pictorial refinement

with Menzel's. In many of his portraits Wasmann penetrated more deeply into the human soul than Biedermeier painting generally contrived to do [154]. It is, in fact, only natural that we should look for figures in painting corresponding with those in contemporary fiction, such as Grillparzer's 'Armer Spielmann', figures from early Russian psychological novels, from the novels of Dickens and Stifter, Georg Büchner's *Wozzek*, or the protagonists of Hans Andersen's fairy-tales. The search would probably be a vain one, but the most likely place to find them would be in Wasmann's portraits, and it is food for thought that there are such figures in his 'primitive' phase, during which he made use of elements drawn from popular art. On the other hand it must be admitted that Wasmann in this respect is no more than one representative of a type of painting to which a number of others also belong, such as Michael Neder of Vienna, Johann Baptist Seele (1774–1814) from Swabia, and the Norwegian Mathias

154 *(right)*. Friedrich Wasmann:
Head of a dead Woman, *c.* 1842. Pencil-drawing.
Munich, Staatliche Graphische Sammlung

155 *(opposite)*. Friedrich Wasmann:
A Vineyard at Meran, Autumn, *c.* 1831.
Winterthur, Oskar Reinhart Foundation

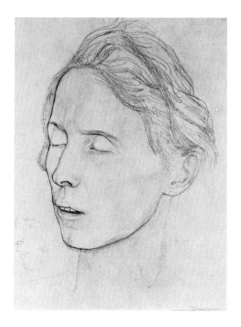

Stoltenberg (1799–1871). Without any support in popular primitivism, the presentation of simple people for their own sake was introduced only much later, by van Gogh, in his portraits.

Lastly, in sharp contrast to these paintings are the numerous landscape studies painted by Wasmann in South Tyrol [155]. On account of an affection of the lungs he lived in Meran from 1830 to 1832, and he lived mostly there and in Bozen from 1839 until his death. These nature studies made during the 1830s and the early 1840s are among the most astonishing incunabula of Impressionism. In them drawing is completely supplanted by painting, and in this, and also in other respects, they are a clear renunciation of Romantic landscape.

KARL BLECHEN (1798–1840)

The free, bold, and prophetic landscapes of Wasmann have every claim to be assessed by

European standards, but his art as a whole, with the profound cleavage running through it, left many things unsolved. It is for this reason often quoted as a typical example of the fate of German artists. Moreover Wasmann's art contained many provincial factors – though it redounds to the honour of such so-called provincialism that it can approach so near to profundity: that is to a human, over and above the artistic, profundity.

With Blechen, a fundamentally kindred painter, the position is different, despite the fact that his art contains plenty of evidence of transition, restlessness, and variety of expression. In 1822, after having worked as a bankclerk, Blechen became a pupil at the Berlin academy. In the following year he went to Dresden, and from 1824 to 1827, after attracting the attention of Schinkel, he painted scenery for the Königstädtisches Theater in Berlin. The termination of this activity also brought his Romantic period to an end, which in itself had

156. Karl Blechen: Mountain Gorge in Winter, 1825. *Formerly Berlin, Nationalgalerie*

157. Karl Blechen:
The Strada Consolare, Pompeii, 1829. Water-colour.
(East) Berlin, Staatliche Museen

been a varied one. At that time his work comprised many heroic landscapes, many romantic ruins with all kinds of literary connotations, especially in the often fantastic accessory figures, and showy effects like those of stage scenery. All this, however, is so restrained in a picture like the *Mountain Gorge in Winter* (1825) [156], that the result is a very independent paraphrase of the Romanticism of Friedrich.

A decisive turning-point in Blechen's painting was brought about by his visit to Italy. He began his pilgrimage to the South in the autumn of 1828 and stayed for thirteen months, first in Rome, and afterwards in Naples and Central Italy. Here his art turned from Romanticism to reality. Only Corot saw the Italian landscape in the same purely painterly way. Chronologically

Blechen's landscape studies follow immediately after Corot's first visit to Italy, and in manner and quality some of them are on the same level as Corot's. On the whole, light is a more prominent feature in Blechen's paintings, however [157]; while in Corot's landscapes it has a spring-like tenderness, Blechen often gives it all the strength of a summer's day. In the rendering of light, 'Italianists' like Josef Rebell, Johann Martin Rohden (1788-1868 [158] of Kassel, Christian Friedrich Nerly (1807-78) of Erfurt, and Franz Catel (1788-1856) of Berlin are to a certain extent forerunners of Blechen. In their landscapes, too, there is a great deal of light, but it shines on austerely drawn and for the most part harshly modelled objects, giving them form and stressing their volume and sub-

stance, without translating them into the language of painting. That is precisely the important step forward that Blechen took in German landscape-painting. In him, as in the paintings of Wasmann and in certain sketches by Dillis [155, 80], the bravura of pictorial abridgement is carried to an extreme pitch – which is the reason why Gottfried Schadow called his young fellow-countryman an 'incomparable sketcher' – but Blechen also had restraint and self-control at his disposal, in pictorial presentation as well as in colour. In Blechen colour as a medium for the visualization of reality, colour as a means of expression, and colour as an element in the composition reach the same historical stage as in Constable and Corot, the leading contemporary masters of colour in landscape.

From the profusion of his Italian studies Blechen drew the material for large pictures, which he painted immediately after his return. They again are slightly more romantic than the sketches. We should therefore amend our previous statement and say that the journey to Italy did not signify a radical caesura between Romanticism and realism in Blechen's art. That the tendency towards sketch-like abridgements, and the ability to make them, were present before 1828, doubtless as a result of the influence of Dahl in Dresden, is shown by studies such as the *Sunrise* (East Berlin). The trend towards Naturalism is revealed just as early and in a very curious way. When in 1828 Blechen exhibited his large composition *The Camp of the Semnones* (formerly Berlin), he gave it the title 'View from

158 *(opposite)*. Johann Martin Rohden: Ruins of Hadrian's Villa, near Rome, *c*. 1810. *Hamburg, Kunsthalle*

159 *(below)*. Karl Blechen: The Gulf of Spezia, *c*. 1829-30. *Berlin, Verwaltung der Schlösser und Gärten*

the Müggelberge looking south towards Köpenick; accessories: the Semnones preparing to repel the onrush of the Romans',[9] and he handled the details with a portrait-like fidelity. Conversely, the Romantic element did not entirely disappear from his works after his return from Italy. This is shown most clearly in his use of narrative, or even historical, accessory figures (*A Flash of Lightning*, *c*. 1833, burned in 1931 in the Glaspalast, Munich; *Women bathing in the Park at Terni*, 1830, Berlin, Frau Hilde Runge; *Garden of the Villa d'Este*, exhibited in 1832, East Berlin) and in his rendering of light. When in his *Shepherds near Narni* (1830, formerly Berlin) he painted spots of sunlight, he transformed the exultant rendering of light in the sketches into a lyricism filled with the

peace of evening. Shortly afterwards, Waldmüller also painted spots of sunlight, in one of his early small landscapes, *The Roman Ruins at Schönbrunn* (1832, Vienna), but he recorded this phenomenon in a completely unromantic way, with an admirably cool soberness. In his colouring, however, Blechen's Romanticism goes even deeper. An example of this is the dark gleam of the blackish-blue strip of water in the midst of bright sunlight in the *Gulf of Spezia* (*c*. 1829-30) [159]. Pictures of this kind are counterparts to the dramatic treatment of colour in the 'Romantisme' of Delacroix. At the end, shortly before Blechen became mentally deranged in 1839, a further heightening becomes noticeable in his work, which now consists of studies of Berlin backyards and gardens [160]. It is a

160. Karl Blechen:
View of Houses and Gardens in Berlin, *c.* 1838.
(West) Berlin, Staatliche Museen

heightening into extreme simplification, especially in the motifs, which are as unpretending as those which the Impressionists later made part of their programme. In the *Rolling-mill at Eberswalde* (1835, West Berlin), one of the first 'industrial landscapes', there is still a lot of Romanticism, but in these Berlin studies all the mastery of painting acquired during his year in Italy is employed by Blechen in the service of a tranquil objectivity. Here it is no longer a question of the double aspect of Romanticism and fidelity to nature, but of that other double aspect which determined the fundamental attitude of future painting: the image of the visible expressed in the special language of spots of colour forcing themselves into a living organism.

Blechen was quickly forgotten, and his work exercised no immediate influence. The same fate befell Ferdinand von Rayski (1806-90), a kindred artist, though there is no proof of any direct contact between the two. His work, too, is governed by 'open', painterly form. In some of his late works he reveals an astonishing boldness, and occasionally an unconcerned bravura, far beyond the Biedermeier of the greater part of his *œuvre*. Adopted and original elements are strangely mingled. Rayski spent most of his childhood in Dresden and then entered upon a military career, but as early as 1823 he was studying at the Dresden academy under the landscape-painter Karl Gottfried Traugott Faber (1786-1863), a pupil of Klengel. For

the rest of his life he lived mostly in Dresden. Of great importance for his development was his visit to Paris in 1834-5. Gros, Delacroix, Delaroche, and above all Géricault made a deep impression upon him, as is revealed in a number of pictures of soldiers and battles and in the passionately agitated sketches for a *Murder of Thomas à Becket* (*c.* 1835, Dresden, Print Room, and elsewhere). One of his special fields was portraiture, especially portraits of members of the nobility [161]. These are counterparts to Krüger's official portraits, above all in their free and sovereign treatment, which is reminiscent of the best portraits of Amerling. Rayski's work, however, also includes pictures like the strange *View of the Castle of Bieberstein* (*c.* 1849, formerly Berlin), in which the woods are seen with a Biedermeier naivety, gleaming in the harsh light of the morning sun.

In the 1870s Rayski stopped painting, and by then he was already a neglected survivor from another age. Like Blechen, Wasmann, Rohden, Oldach, and others, he remained forgotten until the Berlin Centennial Exhibition of 1906.

161. Ferdinand von Rayski: Graf Haubold von Einsiedel, 1855. *(West) Berlin, Staatliche Museen*

GERMAN BIEDERMEIER ROMANTICISM

SPITZWEG-SCHWIND-RICHTER-RETHEL, AND OTHERS

The tendency in late German Romanticism which can without hesitation be called Biedermeier Romanticism is largely represented by artists who were draughtsmen rather than painters. This is still part of the essence of Late Romanticism. One of them, however, Carl Spitzweg of Munich (1808–85), was very definitely a painter. Spitzweg did not start to paint until 1833 (having previously worked as a chemist). Throughout his work, as soon as he had achieved a form of his own after a period of self-education, the supremacy of the painterly

factor is evident. Nevertheless Spitzweg was in a certain sense a thwarted painter – thwarted by the claims made on him by his own excessive interest in anecdote and in the humorous and harmless aspects of small-town characters, of crotchety eccentrics and recluses (*The Cactus-lover*, 1858; *The Bookworm*, 1852; both, like many other works by Spitzweg, existing in several versions), of night-watchmen and street-musicians (*Serenade*, 1864, 1872, 1876, 1879). All these belong to an interregnum of mitigated Romanticism, to which Spitzweg adapted the

162. Carl Spitzweg: Village Parson with Pomeranian Dog, 1873. *Schweinfurt, Dr Schäfer*

magic of his lighting and colour. In this way he certainly achieved a uniformity of form and content, but there is something unreal about it. In Spitzweg's pictures there are camera-obscura effects, and sunshine and moonshine seem to be limelight. This is a type of unreality which invites comparison with real nature, especially in the landscape. Spitzweg's landscapes are painted in this same way even when, as in his last years, they only contain small accessory figures [162]. The problem of presenting through the medium of painting a pastoral remote from reality was solved only by Corot, and even by him only just solved.

It is not difficult to see that Spitzweg's painting was influenced by the Barbizon school, especially Diaz, and by Delacroix, though he did not get to know them until 1851, when he and his friend the landscape-painter Eduard Schleich the Elder (1812–74) went to Paris, Belgium, and London. Still later, about 1872, the two copied Isabey's *Women's Bathing-Place at Dieppe*,[1] and in this paraphrase Spitzweg produced one of his finest works. The best things in Spitzweg's art are two directly opposed virtues: the genuineness of the milieu he painted – as seen in many humorous drawings and illustrations (e.g. for the periodical *Fliegende Blätter*), or in pictures like the celebrated *Poor Poet* (1839) [163] – and the charms of the masterly, delicate tonality in his late landscapes. A 'Spitzweg problem' thus undoubtedly exists,

163. Carl Spitzweg: The poor Poet, 1839. *Munich, Bayerische Staatsgemäldesammlungen*

despite all the petit-bourgeois, 'old Munich' smugness and carefree idyllicism. In this light-heartedness and friendliness the world of Spitzweg comes very near to being a world of dreams, but in reality it is nothing of the sort. The typically Biedermeier intermediate position between realism and idealization, always more of a compromise than a synthesis, asserts itself in the field which is the most wilful and the most peculiarly his own, the field of colour. For all its profusion of bright colours Spitzweg's colouring never takes flight into the realm of fancy. In this respect he lags behind two other German Late Romantics – Moritz von Schwind and Ludwig Richter – to whom he was far superior in artistic ability.

The peculiar element in the talent of Moritz von Schwind (1804–71) is based on two cardinal qualities – an inventive imagination and a draughtsmanship full of genuine strength. These two qualities, springing from the same root, constantly help each other, and in the event produce a world of figures filled with the gay imagination of dreams, such as is hardly found again during the whole of the century [165]. The innumerable host of Schwind's figures, and also the settings in which they live, the forests and 'old German' small towns, the knights' castles and bowers, are remote from reality even when no fairy-tale or legend is being narrated. There is no clearer proof of the difference between this gay Late Romanticism and

164. Moritz von Schwind: The Morning Hour, 1858. *Munich, Schackgalerie*

the gravity of earlier German Romanticism than Schwind's *Morning Hour* (1858 [164]; second version, *c.* 1860, in a private collection at Darmstadt), one of his most beautiful works. Compared with the profound absorption and the mysteries of silence in the interiors of Kersting [63] and Friedrich, Schwind's picture has the lightness of a serene lyrical poem. Instead of confinement within an austere cubic room, it has a free spatial sweep which in itself is the expression of the optimistic atmosphere of early morning; here the bliss of the morning hour has really been captured. In the rendering of light the picture contains much of what became important in the portrayal of reality about the middle of the nineteenth century: flowering patches of sunlight and warm reflections in numerous gradations of tones. But all this – a very unusual thing – is displayed only as a kind of accompaniment to a narrative. The work belongs to the series of 'travel pictures' characteristic of Schwind's work during the 1850s and the early 1860s. Imagination and personal experience, present and past, are interwoven to produce pictures of a country of memories and dreams: *Farewell at Daybreak* (1859, West Berlin), *On the Journey* (*c.* 1860, burned in the Glaspalast at Munich in 1931), *Schwind and Bauernfeld on a Country Excursion* (*c.* 1860, Vienna, private collection), *The Honeymoon* (*c.* 1862, Munich, Schackgalerie), *Cornelius and Schwind in the Roman Campagna, On the Bridge over the Danube* (both *c.* 1860, Vienna, Historisches Museum), etc.[2]

Line is the means of bringing about the poetico-Romantic transfiguration. It removes the contrast between the 'travel pictures' and the scenes from fairy-tales such as the *Number Nip* (1851, several versions), the *Alder King* (*c.* 1850, several versions), '*Des Knaben Wunderhorn*' (after 1860) [165], *The Prisoner's Dream* (1836, Munich, Schackgalerie), *The Ride of Falkenstein* (1843-4, Leipzig). Schwind's draughtsmanship is one of the most striking examples of

165. Moritz von Schwind:
'Des Knaben Wunderhorn', after 1860.
Munich, Schackgalerie

the affinity between a certain kind of drawing and poetry and music. Right from the beginning music meant a great deal to him. He was one of the intimate friends of Schubert during the years he spent in Vienna, where he was born, and lived until he moved to Munich in 1827, and this friendship remained a powerful influence in his life and art until the end. Among his drawings dating from the Vienna period, rather thin and pedantic pen-sketches in the Nazarene style – one is reminded of the Riepenhausen brothers and of Cornelius's illustrations for *Faust* – a series of thirty illustrations for *The Marriage of Figaro* (1825) is outstanding, and in his old age Schwind made Mozart the only theme of his murals in the loggia of the Vienna Opera House (1865-7). The metaphor of 'linear music' evoked by Schwind's drawing must, however, be accepted with reserve. The 'musicality' of his lines does succeed in illustrating

a lavishly profuse narrative in a language entirely its own, but this conjuring-trick cannot vie with the forcefulness of great music, and it cannot be measured by the standard of the music of Schubert. Closer is the affinity to the narrowly circumscribed Romantic musician Weber and to contemporary poetry, to Eichendorff and Mörike, whose *Historie von der schönen Lau* Schwind illustrated in 1868.

Schwind could not resist the temptation to paint monumental murals as well. The result was most discordant when he had to depict historical scenes in the grand manner, as in the frescoes on the Wartburg (1853-5). When he tried to compete with pathos in the manner of Cornelius, Schwind was bound to fail. Even in his designs for smaller murals, such as the cycles for *Cinderella* (1852-4, private collection in Germany) and *The Seven Ravens* (1857, Weimar), as well as in the murals for the Vienna Opera House, all sorts of conventions hamper imagination and composition. Schwind breathes more freely in the water-colour of *The Fair Melusine* (1868-9, Vienna; designed as a frieze for a rotunda on the banks of the Starnberger

See), and when in a painted story, *The Symphony* (finished in 1852, Munich, Schackgalerie), he compressed an architecturally articulated mural into the small format of a picture, he achieved a happy combination of scenes in the spirit of the 'travel pictures' with the delicate gaiety of Renaissance ornamentation.

Schwind's failure in the field of monumental painting is also due to the weakness of his feeling for colour. Apart from one or two exceptions, like the magnificent portrait of his daughter Anna at Vienna (1860),[3] his colours are often dim to the point of being tedious; they seem like something accidental, and only because they are subordinated to the control of the drawing do they avoid being an embarrassment. Where there are no colours, in the drawings and woodcuts, the best sides of Schwind's art emerge in their purest form - forceful drawing and charm, linear melody and the spirit of a fairy-tale. If we want one work that is characteristic of this category, and of Schwind's art as a whole, the best choice is a figure which he himself invented, *Mr Winter* (1847) [166], striding alone through the magical moonlight of Christmas Eve.

166. Moritz von Schwind: Mr Winter on Christmas Eve. Wood-engraving from *Münchener Bilderbogen*, 1847

✣ᚦᚱ Hausmusik ᚱᚦ✣

167 *(above)*. Ludwig Richter:
Making Music at Home.
Wood-engraving from *Für's Haus*, 1858

168 *(right)*. Ludwig Richter:
Wood-engraving from von Horn, *Die Spinnstube*, 1860

169 *(opposite)*. Ludwig Richter: Two Shepherds
in German Landscape (Spring Evening), 1844.
Düsseldorf, Kunstmuseum

Compared with Adrian Ludwig Richter (1803–84), Schwind still seems to be relatively versatile. In the definitive form of Richter's art there is only one subject, the little world of peasant and petit-bourgeois idylls [167, 168]. To this all his illustrations of set subjects can ultimately be reduced – mostly German fairy-tales and stories for young people, beginning with Musäus's *Volksmärchen der Deutschen*, which appeared in 1842. Richter arrived at this definitive form only by a very roundabout route, after the already-mentioned attempt (see above, p. 129 f.) to vie with the landscape-painting of Koch, and to comprehend the pathos of Classicist and the intellectualism of Nazarene landscape. In his landscapes he eventually achieved a homely Romanticism, lying somewhere between Fohr and Schwind, inferior to both in the quality of painting and draughtsmanship, but revealing a genuine naivety and piety (*The old Harper*, 1825, *The Schreckenstein Ferry*, 1837, both in Dresden; *Spring Evening*, 1844 [169]).

In this Romanticism there is a primitive touch which is absent from his graphic works. Richter's style of drawing and wood-engraving is an established, very personal style, which only his unshakable simplicity preserves from having a flavour of mere routine. The intimacy of a world of old people and children, the 'contemplative and edifying' character of his drawn stories – *Beschauliches und Erbauliches* was the actual title of one of his independent series of woodcuts (1851–5) – is confined within limits too narrow to enable it to be called contemplation of the world, and is an extreme example of a turning away from reality, a Biedermeier escape to safety, to a happy hiding-place. It is trivial art, but it is full of delicate melodies. And, like the more spacious art of Schwind, it is superior to the general run of Biedermeier genre-painting in one by no means negligible quality: despite all the narrowness, it avoids the dangers of humdrum realism. To a large extent this is also applicable to its relationship to English and

French illustrative art after the beginning of the century, from which the drawings of Richter are derived and of which they are a late German counterpart.

The art of Alfred Rethel (1816-59), yet another master of drawing working in Germany about the same time, is as different from the placid serenity of Schwind and Richter as night from day. He was a tragic, isolated figure among the devotees of Arcadia. He certainly cannot be classified as a Biedermeier Romantic, but we mention him at this point because, at all events as a wood-engraver, his place is beside them. Rethel came from Diepenbend near Aachen, and studied at the Düsseldorf academy under Wilhelm von Schadow and under Johann Baptist Bastiné (1783-1844), who was born in Belgium and had studied under David. From 1836 to 1847 Rethel lived in Frankfurt. In 1844-5 he visited Italy and in 1848-9 was in Dresden. Six years before his death he lost his reason.

Most of Rethel's not very numerous works are of historical subjects [170, 171]. In this respect he was following what had already become a German tradition. Before him and in his own days there were Peter Cornelius, Julius Schnorr von Carolsfeld, Wilhelm von Kaulbach, and many others all occupied with idealistic renderings of history ranging from the genuine pathos of which only a forceful artistic temperament is capable, to empty theatricality. The first thing peculiar to Rethel is that on one occasion he depicted the history of his own time, in his series of six woodcuts showing scenes of the revolution and entitled *Another Dance of Death, in the year 1848* (1849), which with two other scenes from the Dance of Death, *Death as a Strangler* (1847) and *Death as a Friend* (1851), became his most popular works [172].[4] The realism in these scenes is of a kind that could keep in perfect accord with allegory. They give Rethel a position in German art corresponding

170 *(left)*. Alfred Rethel:
A Street Fight, 1848. Pencil-drawing.
Aachen, Suermondt Museum

171 *(above)*. Alfred Rethel:
A medieval Battle, *c.* 1850. Pen and water-colour.
Vienna, Albertina

172 *(opposite)*. Alfred Rethel: Death riding in the Fields. Wood-engraving from *Auch ein Totentanz*, 1849

to that of Daumier in France, despite the differences in trend and language of expression. Delacroix has also been mentioned in this connexion, especially his painting of *Liberty on the Barricades*. In a wider sense, the affinity lies in the fact that in his own field, the woodcut, Rethel strove with an energy comparable to Delacroix's to create something new out of his knowledge of older art, as represented in his case by the German woodcut of the Age of the Reformation. Illustrative woodcuts of Rethel's time, like those of Schwind, Spitzweg, Richter, and others, were to a far less extent stylistically derived than those of Rethel, but the latter's closeness to Dürer's woodcuts and to Holbein's *Dance of Death* does not imply any loss of independence. Rethel's woodcuts 'in the old style' represent a true renaissance, which is not a very frequent occurrence during the nineteenth century. Sometimes Rethel's use of colour was equally exceptional; once or twice in his few

paintings we find truly expressive colours, such as the heavy lead-grey and the pale clay colour in the profoundly serious portrait of his mother (before 1836, West Berlin).

In 1840 Rethel was commissioned to paint scenes from the life of Charlemagne in fresco in the Imperial Hall of the town hall in Aachen. After tedious negotiations and several changes of programme, work on the wall was eventually begun in 1847, after the artist's visit to Italy. By 1852 he himself had completed only four out of the eight compartments, and the remaining frescoes were executed after his designs, though considerably altered, by Josef Kehren (1817–80), a Düsseldorf painter of religious pictures.[5] The frescoes by Rethel's own hand, and even more the cartoons for them and a few other drawings representing biblical scenes and Hannibal crossing the Alps (1842–4), are among the most important dramatic scenes in German painting of that time. They are yet another proof

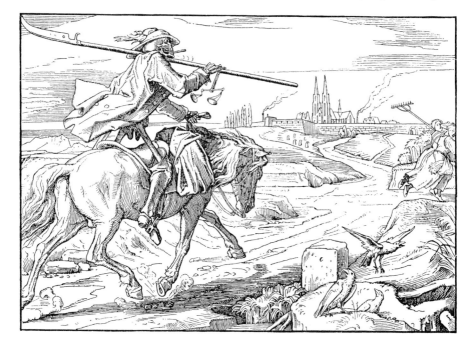

of the concentration on drawing in German art as compared with French. Only the best murals of Cornelius can be compared with them, and the intensity of expression is heightened by their freedom from the Classicist rigidity which Cornelius never completely abandoned. The accumulation of horrors in the Hannibal scenes becomes credible, and everywhere in these events of the past there is something ardently contemporary, the emotion and flickering restlessness of a fanatic. After half a century something of the poignant melancholy and the dignity of Carstens, and of his sinister and categorical qualities, is recaptured.

So long as Romanticism retains its essence, it is also bound to retain a touch of infinity. This is the case with Rethel, Schwind, and Richter, because the poetry of their inventions, whether their fantasies are sublime or homely, is a link between the general rhythm and the individual lines of their draughtsmanship. In the illustrative art of numerous minor talents, this poetry of draughtsmanship often deteriorates to a mere craftsman's routine. But even then occasionally, and especially in their book illustrations, they managed to achieve something both positive and characteristic of the time. Late Gothic marginal drawings, and in particular those by Dürer for the prayer-book of the Emperor Maximilian, which with its calligraphy, arabesques, and *drôleries* had inspired the imagination of the German Romantics ever since the days of Runge, still acted as a kind of godfather to illustrators about the middle of the century.[6] This can be seen in the 1840 edition of the *Nibelungenlied* in which Rethel collaborated, in the etchings of Adolf Schrödter (1805-75) for Chamisso's *Peter Schlemihl* (1836) and for *Don Quixote* (1844), and in his woodcuts for the *Lieder für deutsche Künstler* by Robert Reinick and Franz Kugler (1833). It influenced Eugen Napoleon Neureuther (1806-82) too in his fairy-tale illustrations and marginal drawings for Goethe's *Ballads and Romances* (forty-six

pen-lithographs, 1829-30), for Herder's *Cid* (1838), and for Goethe's *Götz von Berlichingen* (1846). Fantasy, in the conceit as well as in the form, wit, and humour find full scope in these combinations of illustration and decoration. This kind of draughtsmanship forms a counterbalance to the solemnity and pageantry of history-painting. On the whole it is no less artificial than the serious category, to which, incidentally, it owes a great deal. To quote a concrete example, Neureuther acted as assistant to Cornelius in the execution of the frescoes in the Munich Glyptothek. Later, the influence of Ludwig Richter asserted itself in his work. In the special field of fairy-tales and books for children the spirit of Richter's art, and to a considerable extent also his woodcut style [167, 168], were widely imitated.[7] Leading examples are the early works of Otto Speckter (1807-71) of Hamburg and Count Franz Pocci (1807-76) of Munich, who was also a poet and musician. In Speckter's illustrations to fairy-tales and

173. Otto Speckter: Farm Cart.
Wood-engraving from Klaus Groth,
Quickborn, 1856

children's books [173] (he also drew a large number of lithograph portraits),[8] and in the versatile work of Pocci, however, rather more of reality is introduced than the uniform childlike serenity of Richter permitted – in Speckter's case by means of a more precise study of objects, and in that of Pocci with the aid of an occasionally somewhat coarse burlesque.

In landscape-painting, where it was less easy to get away from nature, there existed during this period of moribund Biedermeier a special category lying halfway between the still surviving heroic landscape and the objective rendering of nature. In intention and plan these landscapes are heroic, or at all events Romantic in the wider sense of the term, but all their Romantic traits, whether of pathos, historical legend, or merely mood in general, took on a 'bourgeois' hue – to use a word which obtrudes itself again and again when we consider this class of painting. There is a lack of that naivety which gave impulse and depth to Romanticism, and of that humility which gave a timeless value to even the 'petit-bourgeois' element in Biedermeier Romanticism, and the didactic element is too obtrusive. It is for this reason that such landscapes with a historical bias today seem more outmoded than all others (except perhaps history-painting proper). The most pronounced and pretentious example is the later work of Carl Rottmann, that of Friedrich Preller the Elder, and that of Karl Friedrich Lessing (1808-80), Johann Wilhelm Schirmer (1807-63), and August Albert Zimmermann (1808-88). One of the centres of historical landscape-painting was Düsseldorf, where Lessing and his pupil Schirmer worked. In their choice of subjects the old ideal of Italian landscape continues to prevail down to the second half of the century. Very often in the nature studies of these painters, and

especially in those of Schirmer, one becomes aware of a talent for painterly improvisation and of a genuine feeling for the factual in an excerpt from nature. The distance between painting in the studio and the sketch made outdoors, between constraint and freedom, is particularly noticeable in the landscapes of the two Düsseldorf painters Andreas Achenbach (1815-1909) and his brother Oswald (1827-1905); some of the nature studies of the younger brother are brilliant impressions of the colour and light of Italian landscapes.

Heinrich Dreber of Dresden (known as Franz-Dreber; 1822-75) resided in Rome from 1843, and with his arcadian landscapes cultivated a tranquil and distinguished variety of historical landscape with hardly any striving for theatrical effect. Previously he had studied under Ludwig Richter at the Dresden Academy. A work like *On the way to the Well*, dating from 1843, anticipates the essentials of Richter's well-known *Bridal Procession in Spring* (1847, Dresden), but is closer to the art of August Heinrich, which in its form influenced Richter. This picture of Dreber's and his studies dating from the same period are late examples of the Nazarene reverence for nature. One can describe them as tardy, but they have a greater significance than those 'German-Roman' ideal landscapes which found a direct continuation in Böcklin. We can confidently regard them as symptomatic of the fate of Late Romantic landscape in Germany.

LATE ROMANTICISM AND EARLY REALISM IN OTHER COUNTRIES

The mild air of a temperate Late Romanticism spread quickly into the areas adjoining the main centres of art. Here we find numerous examples of ever more eclectic history-painting, of idealistic landscape stranded in academism, and of book illustration gaining in breadth rather than depth. In so far as one can speak of realism at all, it is usually a mere adjunct to a mitigated idealism. Individual talents with an unrestrained feeling for nature are found still less frequently than in the main centres, and if they do emerge, they remain without honour even in their own country. Rarely did national and popular idiosyncrasies assert themselves side by side with the more or less international dictates of fashion.

In Bohemia, one of the countries of the Austro-Hungarian monarchy, this situation was clearly reflected in the art of the Czech Josef Mánes (1820-71), with his interest in the past and present of his people. He began as a pupil of his father, the Prague landscape-painter Antonín Mánes (1784-1843), and worked mainly in his native city Prague, except for a stay in Munich from 1844 to 1846, where he was influenced by Cornelius and Genelli, Schwind, Richter, Rethel, and Schrödter. In his illustrations to the *Story of Dr Faust* (1858) he followed the wood-carving style of Richter; he also had a share in the illustrating of the 'Deutsche Volksbücher' published by Gustav Schwab at Stuttgart in 1859. He acquired a personal style of illustration only during the course of his work on Czech folksongs (1856-62). His personality is marked by an impulsive and sometimes effeminate neo-Baroque recognizable in his vigorous pen or pencil strokes and in the colouring of his genre-pictures and portraits. More unusual in his use of Baroque is Josef Navrátil

(1798-1865), who between the late 1830s and the end of the 1850s painted Baroque frescoes in several Bohemian castles (Ploschkowitz, Libĕchov, Jirna). Something of Spitzweg's humoresques and of the charm and spirited play of colour of Norbert Grund (1717-67), his fellow-countryman of the Rococo period, is found in his work. Nevertheless, the most surprising feature is the Early-Impressionist painterly profusion of his still-lifes [174]. The moonlight Romanticism

174. Josef Navrátil: The Pie, *c.* 1855-60.
Prague, Modern Gallery

of a number of small landscapes by the now forgotten Prague painter August Piepenhagen (1791-1868) is likewise full of intimate charm. Karel Purkyně (1834-68) on the other hand is the most important representative of early realism in Czech painting. His style, as the heaviness and the chiaroscuro of his portraits and still-lifes of the sixties prove, presupposes the realism of Courbet. Purkyně had seen paintings by Courbet when he visited Paris in 1856-8.

Just as in Bohemian painting at this time there were very few distinctly Slav idiosyncrasies, so in Hungarian painting there was little that can be called Magyar. In the main it is definitely 'western', and it is exceptional when Karl Markó the Elder (see p. 82), in the midst of his classical landscapes, depicts his Hungarian homeland, e.g. in the remarkable *View of Visegrád* (*c.* 1832, Budapest). It was a long time before the landscape of the Hungarian plains began to play a more important role in the painting of the country. Portraiture and genre-painting in Hungary were likewise only reflections of Viennese Biedermeier, as is shown by the works of József Borsos (1821–83), most of them actually painted in Vienna.

The situation was the same in what is now Yugoslavia, for here too the artists followed the lead of the outstanding personalities in the Austrian capital, painters like Peter Krafft, Waldmüller, and Friedrich Amerling in portraiture and genre-pictures, and Carl Rahl in history-painting. As an example one can mention Konstantin Danil (1798–1873). In portraiture, however, in the works of Djura Jakšić (1832–78), Dimitrije Avramović (1815–55), and several others, a popular element of simple characterization makes its appearance, akin, in its best manifestations, to that in the portraits of Wasmann and Neder.

The Polish painter Piotr Michalowski (1800 or 1801–55), active mainly in his native city Cracow and its neighbourhood, was the outstanding representative of his country's art during the first half of the century, despite the fact that in Paris he came under the influence of Géricault and Delacroix.[1] His pictures of soldiers [175] and animals, however, are very

175. Piotr Michalowski: Blue Hussars, *c.* 1836. *Vienna, Kunsthistorisches Museum*

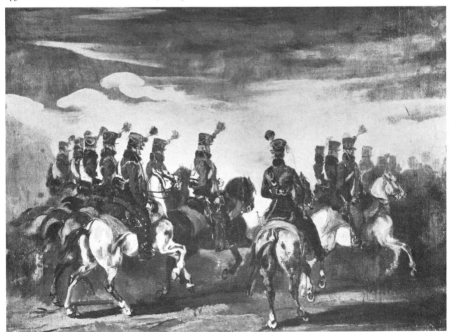

personal, especially in the colouring. The bravura of his impetuous brushwork, the silvery white of animals' bodies with patches of rusty brown and blue, and the colours of the uniforms create intimate little visions of horsemen dashing past on prancing horses, all set in the usual Romantic twilight. (A few years later, in Germany, Ferdinand von Rayski cultivated the same genre with very similar results.)

Polish art did not long retain this high level of purely painterly painting. Henryk Rodakowski (1823-94) in his portraits and Józef Chelmónski (1850-1914) in most of his landscapes and genre-pieces still treated painting as the chief thing. But the brilliant talents of the leading Polish artist of the second half of the century, the history-painter Jan Matejko (1838-93), suffered the fate common to the whole genre: it degenerated into the numbing pomp of episodes

from national history painted on a colossal scale (e.g. *The Arrest of the deputy Thaddäus Rejtan in the Diet of Warsaw in 1773*, 1866, *The Battle of Grünwald*, 1878, both at Warsaw).

One country in which painting showed a marked originality about the middle of the century was Switzerland. A general characteristic was that in the conflict between Late Romanticism and Early Realism it was the latter that everywhere gained the upper hand. In Switzerland there were no historical premises for Late Romanticism such as there were in Germany, and hence no predisposition towards it either. Even the Alps did not attract Swiss painters of the time as their emotive power and fantastic forms had attracted those of the older generation. This change of attitude was due to the influence of the Barbizon school and of Corot and their concentration on the phenomena

176. Barthélemy Menn: The Swamp, *c.* 1860. *Geneva, Musée d'Art et d'Histoire, Bodmer Bequest*

of light. When, notwithstanding this influence, the emotive power of mountains and rocks is deliberately exploited, as it is in many of the vigorous landscapes of Rudolph Koller (1828-1905), it is modified by such finesses as a silky gleam over the glaciers or a variegated play of light on snow-clad peaks and mountain forests. The relationship between the gigantic and the gentle is fundamentally not very different from that in the landscapes of the Late Classical Revival in Switzerland, in the works of Caspar Wolf, Biedermann [46], and Wüest (p. 82 f.). Under the supremacy of the new painterly form, for example in the works of Barthélemy Menn (1815-93) of Geneva [176], and the Vaudois Alexandre Calame (1810-64), the volumes and the primevalness of the shapes of the mountains are more thickly veiled by atmospheric tonality than in the older landscape-painters with their sharp outlines. This remained unchanged until the days of Ferdinand Hodler (1853-1918), that is to say until the dawn of a fundamentally new conception of painting. In the middle of the century there were even many Swiss landscape-painters (Menn, in particular; cf. illustration 176) who turned away from the representation of mountains, and discovered in the gentle, flat woodlands and meadows motifs which were more akin to the subjects chosen by the Barbizon school.

Although the painting of western Switzerland, which occupied the foremost place in the country's art from the beginning of the century, turned for inspiration mostly to France, German art was also appreciated. The Vaudois painter Charles Gleyre (1806-74) was for a short time influenced by the German painters in Rome, where he himself lived from 1828 to 1834. This influence set in even before his journey, as is shown by his austere self-portrait of 1827 at Lausanne. Despite such rare exceptions, however, Gleyre, who went to France when he was still a child, really belongs to French painting. With his scenes drawn from ancient history he

became a spiritual kinsman of Couture, and incidentally like Couture a popular teacher.

As a Romantic in the field of book illustration Martin Disteli (1802-44) is close to the German illustrators of the older generation, especially to Cornelius and Neureuther; the best examples of his crisp, biting style of caricature are his sixteen etchings for Bürger's *Adventures of the celebrated Baron Münchhausen* (1841). Munich Romanticism, especially the idealistic landscapes of Rottmann, also served as a model for Gottfried Keller (1819-90) when he took up painting during his stay in that city (1840-2). His experiments in the field of painting, however, unlike those of Stifter, are merely the by-products of a great writer's youth, and are of little more than psychological interest in connexion with his novel, *Der grüne Heinrich*.

A case of an ambivalent talent of a very curious kind was Rodolphe Toepffer (1799-1846), the son of Wolfgang Adam Toepffer (p. 88). He was a versatile writer and a teacher, studied ancient languages, and taught rhetoric and aesthetics in his native city of Geneva. From the end of the 1820s onwards he made pen-drawings illustrating satirical stories of his own invention which clearly reveal their derivation from the style of the English caricaturists, especially Rowlandson. From 1832 onward he reproduced these drawings by the simple technique of autography.[2] His decision to publish them was partly due to the praise they earned from Goethe, to whom the drawings for the *Histoire de M. Jabot* were shown in 1830 [177]. Toepffer's draughtsmanship is a good example of art being used to convey literary and pedagogical ideas. It is deliberately unpretending, and at the same time it has a sparkling calligraphical vivacity. His drawings have the qualities of dilettantism in the best sense of the term. Taken as a whole, Toepffer has a clearly defined position in the art of the nineteenth century. With his 'practical morality', his ridicule of vanity and snobbishness, he is a

177. Rodolphe Toepffer: Autograph (title page)
from *Histoire de M. Jabot*, 1833

satirist like Hogarth – whom he admired less as an artist than as a 'profound, practical, and popular moralist' – and like Rowlandson and Cruikshank. His pictorial narratives, with the smooth-flowing, running and bounding rhythm of their figures and many of their bizarre renderings of movement, influenced many French and German illustrators, for example Doré, Pocci, and Schroedter (in particular the latter's *Thaten und Meinungen des Herrn Piepmeyer*, 1848). Finally, in the mastery of the 'stories in pictures' of Wilhelm Busch, Toepffer's naive and capricious narrative drawing found a continuation and final fulfilment [247, 248].

In Belgium the group of history painters led by Gustaaf Wappers, Ferdinand de Braekeleer, and Nicaise de Keyser (p. 87) dominated the scene until after the middle of the century. One would like to call them Romantics, but they are Romantic only in the sense that they indulged in orgies of historical costume pieces. In their difficult task of mastering dramatic scenes with numerous figures, they made less use of the great art of the Flemish past than of the pseudo-art of the French history-paintings of, for example, Delaroche. The most independent among them is Wappers, with the brio of his *Episode during the Belgian Revolt of 1830* (1834,

Brussels). But on the whole there is too little drama in the formal qualities of these painters to give an adequate representation of great events of the past, and even too little true reality, in spite of the fact that the crude faithfulness to nature in details was widely imitated. Time has very quickly passed these paintings by. Works which in their own day were famous, like *The Brussels Guilds paying their last Tribute to Egmont and Hoorn* ('Les têtes coupées', 1851, Tournai) by Louis Gallait (1810–87) or *The Madness of Hugo van der Goes* (1872, Brussels) by Émile Wauters (1846–1933) are now nothing but show-pieces in art galleries, and the whole of this Belgian history-painting survives only as a warning against trying to achieve too much. As its declamatory pitch rises, its artistic level falls. Even Antoine Wiertz (1806–65), another Belgian painter of the period, who with his open avowal

of Romanticism produced fantastic and symbolical scenes of horror, could not achieve results of higher value. He overstepped himself in heroic Michelangelesque and Rubenesque poses (*The Struggle for the Body of Patroclus*, 1835–6; *The Revolt of Hell against Heaven*, c. 1840; both in the Musée Wiertz at Brussels). His wild-eyed hysteria is a mere caricature of real passion.

Belgium had no genuine Late Romanticism until artists became conscious of the true purpose of painting and until the influence of French Realism began to make itself felt. Then some of them recalled to mind the doctrines of the great Netherlandish artists of the seventeenth century. Such, for example, was the case of Charles de Groux (1825–70) with his pictures illustrating the lives of the poor and Henri de Braekeleer (1840–88) with his aristocratically tranquil,

178. Henri de Braekeleer: The Picture Restorer, 1878.
Antwerp, Koninklijke Museum voor schone Kunsten

delicately painted interiors [178] and landscapes. At about the same time the art of the two Stevens brothers reached its acme. Their guiding principles were realism in Courbet's sense, painting as an expression of the beauty of material things, but seasoned with a good deal of anecdote. Alfred Stevens (1823–1906), who began as a pupil of Navez in Brussels and then lived almost exclusively in Paris, chose as his theme ladies of a well-to-do, fashionable, but bourgeois milieu [179], Joseph Stevens (1819–92) specialized with equal competence in paintings of animals, particularly dogs. He preserved a good deal of Flemish vitality and thus kept closer to the painterly traditions of his country.

Dependence on a great national past characterizes the painting of Holland during the first half of the century. This did at least preserve it from the stridency and violence usual in Bel-

179. Alfred Stevens: Autumn Flowers, 1867.
Brussels, Musée Moderne

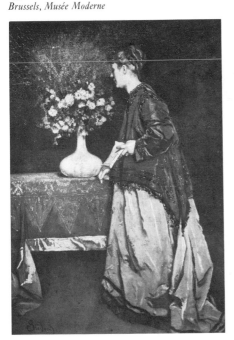

180 *(above)*. Wouter Johannes van Troostwijk: The Raampoort in Amsterdam in Winter, 1809. *Amsterdam, Rijksmuseum*

gium, but in landscape, in interiors, and in animal- and genre-pieces, Dutch painting remained extremely limited and eclectic. At the beginning of the century, in landscape-painters such as Wouter Johannes van Troostwijk (1782–1810) [180] and Pieter Gerardus van Os (1776–1839), and a little later in Andreas Schelfhout (1787–1870) and Barend Cornelis Koekkoek (1803–62), Biedermeier and Romanticism do appear, but only as slight modifying influences upon traditional forms. Actually, one can only talk of Romanticism in landscapes where mood predominates, for example in the townscapes of Wijnand van Nuyen (1813–39). The vast majority of the numerous Dutch landscape-painters of the time reveal only that special, extreme eclecticism in which the aim is not so much a genuine revival of a past style as a more or less

naive playing about with the charms of anti-
quated things, a kind of historicism for its own
sake. Yet there were here and there notable and
very original artists. The spirit of van der
Heyden and Berkheyde, the most intimate of
the major *petits maîtres* in Dutch seventeenth-
century landscape, is recaptured in the land-
scapes of Bartholomeus Johannes van Hove
(1790–1880), which belong to the family of
Danish, German, and Austrian Biedermeier
landscape. *In the Park of Saint-Cloud* (1809)
[181] by Pieter Rudolph Kleyn (1785–1816) can
also be included in this category. Its structure is
mathematically precise and achieves an effect of

cool monumentality, without sacrificing intim-
acy of detail; in this it resembles the best works
of Danish realism [53–5], of Wilhelm von
Kobell [44] or Waldmüller [131]. This picture
is easier to understand if we remember that its
author had studied under David a year before he
painted it.

Occasionally there is a reflection of the great
French 'Romantisme', for example in *The Battle
of Bautersem* (1832–8, Amsterdam, Royal Pa-
lace) by Cornelis Kruseman (1797–1857). But
Dutch painting did not achieve independence
until the last thirty years of the nineteenth
century, in the days of the 'Hague school'.

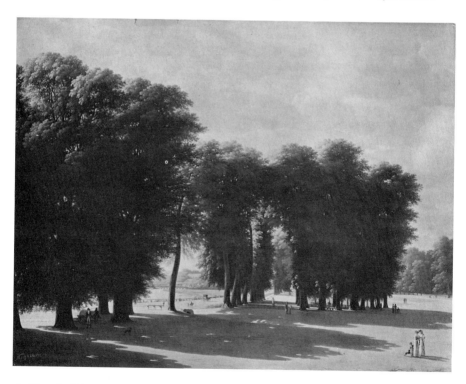

181. Pieter Rudolph Kleyn:
In the Park of Saint-Cloud, 1809.
Amsterdam, Rijksmuseum

REALISM IN FRANCE

GUSTAVE COURBET (1819-77)

In the work of Gustave Courbet, after all the widespread attempts and aspirations towards realism since the beginning of the nineteenth century, painting at last became in the very core of its being 'realistic'. According to the classification of art historians Courbet is the first great Realist among the painters of the nineteenth century, and we feel instinctively that this opinion is correct. Courbet and Realism are two concepts which will probably be considered synonymous for all time. Certain peculiarities may give us cause for hesitation, but they cannot change this view; they lead us rather to a better definition of Realism in painting. One of these peculiarities is Courbet's affinity to many of the great schools of the past, in particular to the Spanish school, to Velázquez and Zurbarán, and to that of the Netherlands, above all Frans Hals and Rembrandt. There is also the fact that Courbet's Realism is completely independent of the exact illustration of details. It is even true to say that for a long time Courbet did not bother much about 'correctness' and consistency in one great field of reality, that of the phenomena of light. Hundreds of painters before him had made a study of light in a far more differentiated way than he did, and the painters of the Barbizon school went on studying it in his day. But to the end of his life Courbet showed a predilection for the old system of starting from the dark and working towards the light. In his pictures the figures, the rocks, the fruits and flowers of his still-lifes are either set in a diffused light, so that the heavy volumes of the bodies do not seem to

have any special reference to the lighting [185-7], or else, when the lighting appears to be more open and independent, it is primarily there either for the sake of the bodies, as it is for example in Caravaggio and Zurbarán [182, 188], or, to go

182. Gustave Courbet: Self-portrait, *c.* 1853. *Copenhagen, Ny Carlsberg Glyptotek*

even further, to emphasize the aggressive mass and weight of material things. Only in some of the most powerful landscapes of his late period do light and matter have equal value and interpenetrate one another [184]. Thus a new unity is achieved, and in the resulting supreme painterly domination of everything material Courbet

is on a par with Corot, despite the profound differences in their characters. In Courbet the unity appears as the result of a display of strength. In fact he loved to brag about his physical strength, and this may help us to understand the arrogant animality of the living beings and the heavy power of all matter in his pic-

the most a tender charm which might be called Romantic. There is certainly no lack of tenderness in Courbet's wild braggadocio. And that is significant, although it is not uncommon in the field of definitely painterly painting. For a long time the public remained unaware of it, shocked by the 'ugliness' of his work, and overlooking

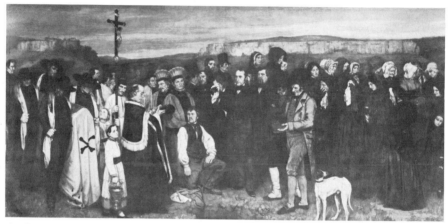

183. Gustave Courbet:
Funeral at Ornans, 1850.
Paris, Louvre

tures. These were what Courbet meant by 'reality'. In order to demonstrate them, he also needed the tranquillity of contemplation, and this he possessed from the very beginning. In an important early work, the huge *Funeral at Ornans* (1850) [183], the compact black mass of mourners has the tranquillity of a still-life, almost to the same extent as the barrier of rocks in the background. Here Courbet has already, in principle, gone just as far as he did when in the late *Puits Noir* landscapes dating from about 1865 he painted the soundless twilight of damp woods [184]. Drama and Romanticism are fundamentally alien to such painting. One notices this when both elements are inherent in a subject, as, for example, in the pictures of waves (several versions; *c.* 1869/70) and in the woodland scenes with deer or stags. These contain at

his occasional efforts to achieve a canonical beauty. An example of this is the relief-like, statuesque composition of the *Stone-breakers* (1849, Dresden). On occasions he also showed a fondness for beautiful gestures (*Self-Portrait with leather Girdle*, 1844, Paris, Louvre; *The wounded Man*, a self-portrait, in several versions, after 1844; *Bonjour, Monsieur Courbet!*, 1854, Montpellier; *Girls on the Banks of the Seine*, 1856, Paris, Petit Palais; *The Dream*, 1864; *La belle Irlandaise*, 1866, New York) and for movements of animals intensified to the point of becoming canonical (*Mountain Stream with Deer*, 1866; *Woodland Scene with Deer*, 1868; *Stags fighting in a Wood*, 1860–1; all in the Louvre). This can be interpreted as an idealistic trait in his art. After all, ideas and programmes played a considerable role in his life –

184. Gustave Courbet:
Woodland Scene at the Puits Noir, *c.* 1865.
Vienna, Kunsthistorisches Museum

the idea of a programmatic Realism, Socialism, and in particular, under the influence of his friend Pierre-Joseph Proudhon, the demand for a social aim in art. He conceived and expressed these ideas in a naively simplified form, but occasionally, in the midst of meaningless generalizations such as the slogan 'Faire de l'art vivant!', we find a statement of simple and fundamental force, such as the following: 'The art of painting consists only in the representation of objects which the artist can see and touch. No period should be reproduced except by its own artists, I mean by artists who have lived in it. I hold that the artists of a century are completely incapable of reproducing the things of a preceding or future century, in other words of painting the past or the future. It is for this reason that I reject history painting when

applied to the past. History painting is essentially contemporary . . . I also maintain that painting is essentially a *concrete* art and can only consist of the representation of *real* and *existing* things. It is a completely physical language, which is made up not of words, but of all visible objects. An *abstract* object, being invisible and non-existent, does not form part of the domain of painting.'[1] Yet the extent to which, in certain of his works, he seriously tried to convey a social idea through the medium of art is shown by the fact that he painted a huge picture of a country funeral, and considered the work of stone-breakers or of *Women winnowing Corn* (1853-4, Nantes) also worthy of a monumental format. Nevertheless, in his work as a whole – compared with that of Millet – this was a minor consideration, and the intellectual content of the work

remained subservient to the visual qualities. How could it be otherwise in the work of a painter who was continually proclaiming his rejection of the ideal? In him even the theorizing and oratory were due mainly to an exuberance of vitality.

Courbet was of peasant origin and was born at Ornans in the French Jura, which appears again and again in his landscapes. In 1837 he began his training at the Collège Royal in Besançon, and in 1839 he went to Paris. In 1847 he visited Holland – a visit of decisive importance – and from 1853 on he made several journeys to Germany – to Frankfurt, where he stayed six months, and Munich. The rebellious element in his nature showed itself for the first time in 1855 when, after the rejection by the jury of the International Exibition in Paris of two of his pictures, *The Funeral at Ornans* [183] and *The Studio* [188], he exhibited a total of forty-three works in a pavilion of his own under the title 'Le Réalisme'. Soon afterwards he started a private school. In 1871 he took an active part in the insurrection of the Commune and instigated the demolition of the column in the Place Vendôme. For this he had to pay a fine, and was subsequently called upon to pay for its re-erection. To avoid this he left France in 1873 and went to live in exile in Switzerland. He spent the last years of his life at La Tour-de-Peilz near Vevey.

In the development of Courbet, the unity and absence of any incisive break are noteworthy. His noisy display of self-confidence was obviously due to an early decision as to the path he intended to follow. His ideal of achieving the perfection of the old masters in works of craftsmanship is accounted for in the same way.[2] In this sense, the beauty of the painted surface in Courbet's work is just as much an effect of the paints used as it is the outcome of the desire to create a complete illusion, especially in the characteristic compact technique of his late landscapes. Such a method of painting was particularly suited to Courbet's specific Realism, the Realism of material things. If painterly Realism in the nineteenth century can be regarded from a certain moment onwards as a Realism whose concern is with the spirit of matter, then Courbet must be regarded as its initiator. This aspect of Realism, which was slightly obscured by the concentration on light in the works of the Late Impressionists, reappeared in the painting of Cézanne. If Cézanne's revolutionary achievement was the result of any preceding process, it was a result of Courbet's painting, even more than of Delacroix's and Manet's. Nothing approaches more closely to Cézanne than the conception of form in some of Courbet's woodland scenes or rocky landscapes [184, 185; cf. 302, 303]. This shows the revolutionary importance of Courbet. He was a revolutionary not only in that his whole personality led him to try to 'épater le bourgeois', but also in a more profound sense. The effect his painting soon began to produce was not only sensational but truly revolutionary, despite his ambition to vie with the old masters. The compelling force of his colouring is obvious, and it was no less effective than that of Delacroix. In his palette, in the heavy, saturated colours, in the organ-notes of this chromatic music, the same urge towards the colossal expresses itself that we have noticed elsewhere in his art. Here for once in the nineteenth century this urge produced no harmful effects. Courbet was extravagant and exuberant in the matter of scale, but in the crowded compositions of his still-lifes of flowers and animals [186, 187] he was blessed with a faculty for achieving great crescendos. Often he portrayed aggressively and statuesquely a single figure in a landscape, such as the *Dying Stag* (1861, Marseilles). Later van Gogh, another naive spirit, achieved something similar in still-lifes that were larger than life. When in Courbet's landscapes the structure of

185. Gustave Courbet: Rocky Landscape near Ornans, *c.* 1860. *Vienna, Kunsthistorisches Museum*

186. Gustave Courbet: Flower-piece, 1855. *Hamburg, Kunsthalle*

187. Gustave Courbet: Trout, 1871. *Zürich, Kunsthaus*

the edge of a wood emerges, when trees stand rigid in the snow or rocky walls arise out of inert folds in the ground, these things are painted so as at last to realize an old dream of landscape-painters. The things which they had until now conveyed indirectly are placed before us in their true mass and colour. Here too, as with Friedrich in German Romanticism, there are 'tragédies du paysage' (see above, p. 97), but Courbet managed in spite of them to remain true to his maxim: 'Le paysage est une affaire des tons.' In this way he would say things which could not be said through drawing. Perhaps he had in mind the landscapes of Rembrandt, with their torrents of dull gold and pale yellow-green. There is no danger of our missing the differences in the midst of the analogies. It was not until

Courbet that nature came to be regarded as a divinity.

Painters soon realized what Courbet had to offer them. His influence was so vast that a list of the painters in whom it is discernible would include practically all the leading figures. The gem-like surface of his early *After the Meal* (1849, Lille) had made a deep impression upon Delacroix. His effect on Cézanne has already been mentioned, and in the beginnings of Pissarro, Renoir, Bazille, and Manet the same model is clearly visible, and even more so in the German painters Leibl, Trübner and Schuch, Viktor Müller, and Hans Thoma.

In France the example of Courbet tempted a painter like Théodule Ribot (1823–91) to become a specialist. For Ribot the chiaroscuro of

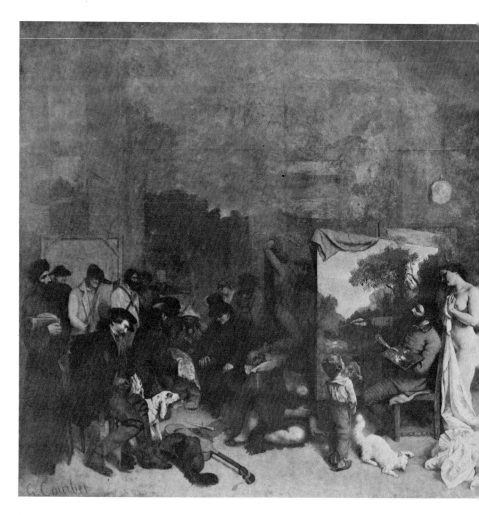

Spanish Baroque as seen in Ribera and Zur-
barán became a recipe, which, however, offered
great possibilities for fine effects in individual
works, especially in still-lifes.

The demonstrative way in which Courbet
denied problems was no guarantee against their
existence, and in the works of his followers they
emerged into the open in a variety of ways.
When Courbet gave to a huge composition like
The Studio [188] the sub-title: 'A real allegory,

the interior of my studio, which determined a
phase in my artistic life that lasted seven years',[3]
he was being very naive and vague. Neverthe-
less, the crude ideological intention to produce
a 'real allegory' does not spoil the purely artistic
effect. In fact, in a deeper sense, Courbet's
painting really *is* a personal manifesto, though
not quite in the way he thought. When he pro-
claimed by word and deed his concentration
on the visible and the actual he opened an enor-

188 *(left)*. Gustave Courbet: The Studio, 1855. *Paris, Louvre*

189 *(below)*. Michael von Munkácsy: Smoker, *c*. 1874. *Budapest, Museum of Fine Arts*

mously vast field to painting, but in the works of his followers, of the humbler temperaments and minor talents, this concentration was replaced by a merely voluptuous delight in the beauty of material things. As long as Realism did not confine itself to the visible but tried deliberately to reach the essence or totality of a phenomenon, it was faced with a very difficult task. Courbet himself was faced with this task, but he was able to master it thanks to the unfettered strength of his instinct. The position is different when a painter like Mihály (Michael) von Munkácsy (1844–1909) painted stories on a large scale and with chiaroscuro similar to Courbet's, such as *The last Day of the Prisoner condemned to Death* (1870),[4] *The Drunkard* (1878, Budapest), *The Lint-makers* (1872, Budapest), *At the Pawn-broker's* (1874, New York). In the presence of genre-pieces of this kind [189], one has to ask: does not this kind of painting, by its renuncia-

tion of stylization, symbolism, distortion, and imagery, render itself – precisely because it is so well done – incapable of conveying anything beyond the merely visible? It is up against its self-set limits as soon as it begins to tell stories and tries to render moving events in terms of a delicate treatment of surfaces. A prison cell in which a criminal sentenced to death is passing his last hours, represented with faithful realism and painterly refinement, might perhaps, just by means of this contrast, express the pitiless indifference of nature, but in actual fact there are hardly any examples of such pictures in nineteenth-century painting; on the contrary, in such cases a discrepancy becomes visible which runs through Realism for long periods. This discrepancy becomes even more obvious when it is a question of history-painting,

such as in Munkácsy's *The blind Milton dictating 'Paradise Lost'* (1878, New York) and *Christ before Pilate* (1881, Philadelphia, J. Wanamaker Collection). It is only his sketch-like technique that enables us to forget the discrepancy, and in this respect Munkácsy is an instructive instance of the sketch being better than the finished work, a state of affairs often to be met in the nineteenth century. (Characteristically, this was not so with Courbet.) In sketches, and in cases where the sketch-like element is preserved in the finished picture and to a certain extent translated into its larger scale, Munkácsy was able to show his talents. He was independent enough to be able to preserve his personality as a natural painter despite his dependence on Courbet. We are therefore justified in describing him as a very Hungarian painter,[5] although he received

190. Paul von Szinyei Merse: Picnic in May, 1873. *Budapest, Museum of Fine Arts*

his training in Vienna (under Carl Rahl), in Munich, Düsseldorf (under Knaus), and Paris, and after 1872 spent most of his time in Paris. Very similar, as regards both training and character, is his almost exactly contemporary fellow-countryman Pál (Paul) von Szinyei Merse (1845–1920), who came into close contact with the Leibl circle while he was in Munich. His best-known work, *Picnic in May* (exhibited at Munich in 1873) [190], lies, with its strident colours, between the rich dark tonality of Courbet and the brightness of Impressionism, but for all that it is still a Hungarian work. The influence of Courbet was the determining factor in the art of Djordje (George) Krstić (1851–1907), a Serb, and the best of the South Slav painters of the second half of the century. The influence reached him by way of the circle round Leibl in Munich, where Krstić worked during the seventies.

HONORÉ DAUMIER (1808–79)

Daumier caused many of his contemporaries to resort to superlatives. The best-known are Balzac's verdict: 'Ce gaillard-là a du Michel-Ange sous la peau', and Daubigny's cry of 'Daumier!' when he beheld the paintings of Michelangelo in the Sistine Chapel. Both, perhaps, were moved to this comparison merely by the violence of the forms, but they may have meant something more, namely the ability to create a whole world of figures. In this respect other great names could be introduced by way of comparison – for example Bruegel, Tintoretto, Rembrandt, and Goya. Daumier's world of figures is in essence the everyday world, the

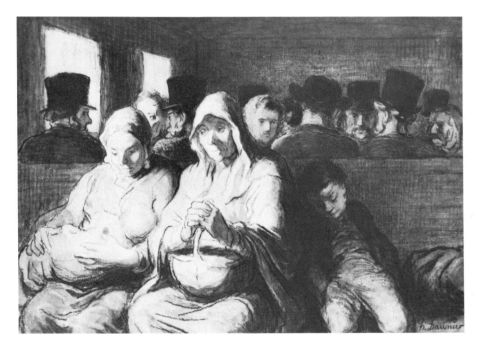

191. Honoré Daumier: In a Third-Class Railway Carriage, *c.* 1860–5. Water-colour. *Baltimore, Walters Art Gallery*

192 *(left)*. Honoré Daumier:
Blacksmith, *c.* 1855-60. Water-colour.
Whereabouts unknown

193 *(below)*. Honoré Daumier: Wood-engraving
from Balzac and Frémy, *Physiologie du Rentier*, 1841

194 *(right)*. Honoré Daumier:
Don Quixote capering in front of Sancho Panza,
c. 1865-8. Charcoal drawing.
Winterthur, Dr Oskar Reinhart

195 *(far right)*. Honoré Daumier:
Don Quixote and Sancho Panza, *c.* 1865.
London, Courtauld Institute Galleries

busy, noisy Parisian world, its streets, its trains [191], its law courts [199], and all the aspects of its proletarian and petit-bourgeois life [192,193, 199]. Daumier, to that extent, can be called a Realist, but he was something more. He was a satirist; and again for that reason a Realist to the extent to which a satirist is a Realist. At the same time he was a man of firm faith in an ideology to the extent which every satirist must have faith in an ideology. Moreover, to complicate the matter still further, he possessed more creative imagination than is necessary for a satirist and was more of a Romantic than a satirist need be. Because of this Romantic tendency he frequently overstepped the limits of visible reality even in his choice of subjects. He painted allegories, illustrations to Don Quixote [194, 195], and even religious pictures (*Christ with his Disciples*, Amsterdam; *Ecce Homo*, Essen, both *c.* 1850). Romantic, too, was his tendency towards the monumental in every single figure

and in his numerous crowd scenes. The pathos of form and the pathos of ideas were fused into a unity constructed with the firmness which in their own way both Classicists and Romantics had tried to achieve. This harmony of form and thought – the basic satirical thought – has a demonic character, and in this Daumier has only one equal during the whole century – Goya. But in comparison with Goya, Daumier's demonism lies more in the forms and the chiaroscuro than in the faces. He was certainly not sparing with the means of caricatural exaggeration; grotesquely exaggerated deformations of faces and bodies, wide-open staring eyes, gaping mouths, wild, unrestrained gestures, and bestial obtuseness are as much a part of his repertoire as they were of that of his predecessors in the field of caricature, Cruikshank, Rowlandson, and Toepffer, though Daumier's characterization of both physical and mental agitation is far more differentiated. But it is above all the ele-

 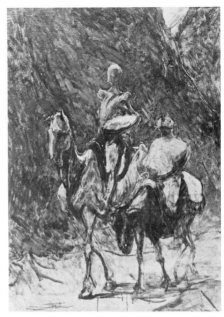

mentary violence of modelling and lighting that creates this demonism, leaving the mannerisms of the older caricaturists a long way behind. Daumier's creatures are 'driven' – driven by their wickedness and their passions, by stupidity and vanity, but also by poverty and need. So far Daumier interprets as any satirist would. But this driving element is expressed by means of draughtsmanship which seems to be in perpetually passionate movement, and by means of piled-up masses and dramatic effects of light. That is Daumier's personal form. It is personal despite the evident Baroque elements, which were just as important an artistic source for Daumier as for his contemporary Delacroix. His paintings are more reminiscent of Tintoretto than of Michelangelo. In Daumier, however, the dynamics of line, of volume and chiaroscuro, are no longer, as they are in the Baroque, embedded in a universal style, and this gives them a new individualism and alters

their meaning. (From here a straight path leads to Munch, and this glance into the future may serve to explain the meaning of the violence of forms, silhouettes, and masses in Daumier.) This demonism in Daumier's works – an element that is always vague and obscure – is the complement of an element directly opposed to it – the invariably clear, transparent morality of a great satirist. The sweeping gesture and the pathos of the gigantic, which especially at the beginning of the century so many artists strove to achieve or to which they forced themselves – we have just mentioned this when discussing Courbet – always remain genuine in Daumier, and seem like the expressions of an inner necessity. But in contrast to Courbet's ungainly naivety, Daumier's monumentality is always based on perception and intellectual keenness.

Daumier's predilection for Molière and Cervantes, for the classical simplicity of Molière's social criticism and for the sublime extrava-

gance of Don Quixote [194, 195],[6] in itself tells us a great deal about his ethical and critical attitude. Nevertheless, however keen a psychologist he may have been, it would be wrong to consider his psychological interest in mankind as the mainspring of his art. In his portrayal of human beings, side by side with malicious satire and indignation, there is a feeling for the tragic and the pitiful. It does not, however, make his work depressing, since even wretched beings like his *saltimbanques* are surrounded with a halo of pride, like characters in Greek tragedy [196]. Like that of Shakespeare or Rembrandt, his art is essentially optimistic, and despite all the bitterness betrays no fear of life. This is a manifestation of that classic element in his art which is also part of its ideal content.

Daumier's satire began with political caricatures, very soon after he had first started to

196. Honoré Daumier:
Mountebanks on the Move, *c.* 1865. Water-colour.
Hartford, Connecticut, Wadsworth Atheneum

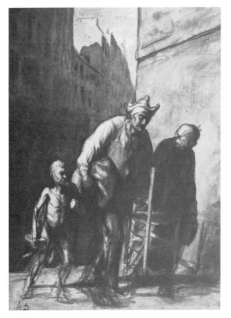

draw. He was born in Marseilles, the son of a glazier with poetical ambitions. In 1816 the family moved to Paris and Daumier stayed there for the rest of his life. After undistinguished beginnings in the style of Charlet, Traviès, Devéria, etc.,[7] he began in the early 1830s to work for the satirical journals of Charles Philipon, who in 1830 had founded *La Caricature* and in 1832 *Le Charivari*. Shortly after Daumier had been brought to the attention of Philipon, his drawing of 1832 representing the bourgeois king Louis-Philippe as a greedy Gargantua resulted in his being sent to prison for six months. Of the four monumental lithographs of 1834 – *Le Ventre Législatif* [197], *Rue Transnonain le 15 avril 1834* [198], *Enfoncé La Fayette, Ne vous y frottez pas!* – the first two may be reckoned among Daumier's most popular political drawings. Moreover they are two of his most important works, and show how early he matured. The row of ministers' busts is of an almost monstrous simplicity, but the fat colossus with the leonine head of hair below on the right converts it at one stroke into a caricature of such a monotonously arranged political assembly. (Several decades later Daumier used this principle of the juxtaposition of a single figure with an amorphous mass – or vacuum – in his horrifying *Dream of the Inventor of the Needle-Gun* of 1866 [202], and in his drawing entitled *In Naples*, 1851.) Very different are the artistic means employed in his representation of the room in the *Rue Transnonain* with four corpses [198]. Here he uses foreshortening and deliberate manipulation of light in the Baroque manner to obtain an effect of horror and deathly stillness, and by means of these 'classical' methods gives the scene something of the majesty of death. The difference between the two drawings exemplifies a typical feature of Daumier's work; the innumerable nuances between the extreme in witty and in tragic emphasis and a compromise usually achieved by means of chiaroscuro. Deliberate discordance

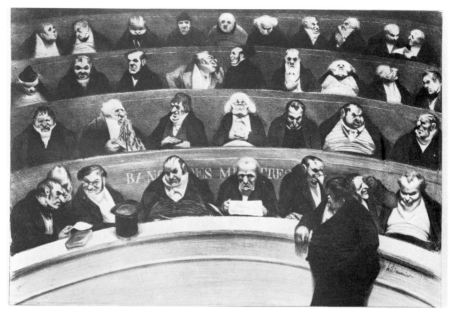

197. Honoré Daumier: Le Ventre Législatif, 1834. Lithograph

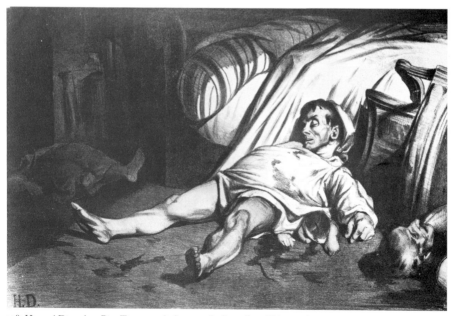

198. Honoré Daumier: Rue Transnonain le 15 avril 1834, 1834. Lithograph

199. Honoré Daumier: The Defence, *c.* 1855. Pen-drawing. *London, Courtauld Institute Galleries*

and deliberate harmony are placed in what for a satirical draughtsman must be a familiar contrast. In Daumier's particular synthesis the result is that a grandiose classical element is introduced into caricature.

The two drawings of 1834 contain other important traits. They are, in particular, Daumier's first attempts to reach the highest artistic level by exploiting all the possibilities of lithographical technique. A kind of chiaroscuro drawing as a specific form of chalk lithography had already been tried about 1830 by Charlet, Raffet, Traviès, Monnier, and Achille Devéria (1800–57). For Daumier this lithographic technique with its delicacy of line and at the same time its possibility of blurring was only the starting-point on his path towards that full-toned black-and-white which made him the greatest master of the lithograph in the nineteenth century. Even in the midst of the monumentality of his compositions he still found room for the most refined tonality, ranging from velvety black to silver-grey. This refinement remains effective even in the least significant among his nearly four thousand lithographs. From about 1860 Daumier reduced the rich scale of their chiaroscuro in order to let the drawing speak for itself. This change is one of the most instructive and fascinating examples of the recurrent tendency among great artists to economize in the means of expression. What spiritualization can mean in the rendering of figures can hardly be shown more clearly than in the late lithographs (and drawings) of Daumier [199] as compared with the earlier ones. In the flickering, palpitating lines of these drawings, the tone of which is a relatively even grey, the characterization of materials is no longer of importance, and even the lighting, which had been so dramatic, is reduced to a mere indication, but the forcefulness of the volumes remains unimpaired. Daumier's figures now have a kind of Michelangelesque emphasis on the nude even beneath their clothes, and in fact some of his drawings are very close to those of Michelangelo.

Daumier's brilliant personal style of draughtsmanship succeeded in permeating his wood-engraved illustrations, and what is more, he could get just as penetratingly to the core of what wood-engraving demands as he had done when he worked on the problems of lithography. There are about a thousand wood-engravings by him.[8] Many of his very small illustrations and vignettes have a kind of epigrammatical precision of drawing which is particularly delightful [193, 200].

200. Honoré Daumier:
Ulysses on the Journey. Wood-engraving from
Ulysse ou les porcs vengés, 1852

Daumier regarded his graphic work as journalism and often found it a drudgery and a hindrance, since it prevented him from pursuing the high art of painting. In an attempt to escape from drudgery, he terminated his contract with *Charivari* in 1860, but his freedom did not last long and three years later he went back. Despite his popularity he found himself in financial difficulties towards the end of his life, just as he had at the beginning. Increasing blindness made it impossible for him to work in his very last years, and at this time Corot gave a striking

proof of his friendship by placing a country house in Valmandois near Auvers-sur-Oise at Daumier's disposal. It was there that he died.

His painting received only tardy recognition, and its development and chronology are hard to establish even today.[9] Indeed, although it was more than a mere adjunct to his graphic work, it would be wrong to consider it as the culmination of his art, and the real essence of his artistic being. Naturally, just as in his few sculptural works (see below, p. 403 f., illustrations 323, 325), the change of medium is accompanied by an elaboration and heightening [195, 201]. Many of his paintings, e.g. the *Ecce Homo*, many of the *Don Quixote* pictures [195], the law-court scenes and scenes from the theatre [199, 203] such as *The Play* (Munich), are isolated in nineteenth-century painting, in their dramatic monumentality and polyphonic treatment of light. The monumental element and the chiaroscuro effect make us forget that colour plays only a subsidiary role and that all the essentials lie in the drawing.

As a result of the increased severity of the censorship regulations in 1835, politcal caricature became impossible for a considerable time. Throughout his life Daumier was a Republican, a partisan of the downtrodden classes from whose world he had sprung, and an opponent of all autocratic power, and in 1848 and in the difficult years of 1870-1 he returned to political satire. The ideas behind his famous political caricatures of the early 1830s, an artist's protest against the inadequacy and murderous excesses of a hated and corrupt regime [198], were re-animated. In his late lithographs, however, the idea of pacifism, with its appeal to a higher moral and emotional code of values, supersedes mere politics [202]. It is hardly necessary to say that for a satirist like Daumier political caricature was only a side-line. It included, however, the exposure of profiteers, swindlers, and desperadoes as exemplified in the types of *Robert Macaire* and *Ratapoil* [323]. The real targets of his satire, which he found everywhere in

201. Honoré Daumier:
Singing Couple, *c.* 1855-60.
Amsterdam, Rijksmuseum

202. Honoré Daumier: The Dream of the Inventor of the Needle-Gun, 1866. Lithograph

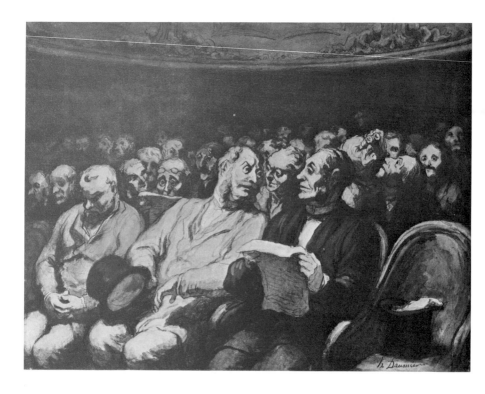

ordinary human nature, in its vanity and stupidity, vulgarity and hypocrisy, could be superficially classified according to profession and status – bachelors, married couples, blue-stockings, art collectors, visitors to exhibitions, theatre-goers, etc. [203, 204]. In establishing such categories the fashion of the time and the demands of publishers coincided with the natural desire of a satirist to create types. Such generalization and simplification are dangerous, but they need not stand in the way of truth and justice. Only with one particular class did Daumier go to extremes, and that was in his relentless and passionate hatred of the 'gens de justice' – judges, prosecutors, and defending counsel [199]. These masters of human destiny appear in his drawings, water-colours, and oil-paintings as personifications of hypocrisy and cunning, of ruthlessness and indifference. These men in black, lurking and grinning, shouting and gesticulating, are the counterparts of Goya's spectres and nightmares and they are more frightening because they are more real, more 'modern'. The arms raised in accusation or adjuration, the pathetic upturning of the eyes, even the undulations of the gowns are all as calculated and as false as the fulminating phrases, and sincerity appears only in the congratulatory smiles which the adversaries exchange when the case is over. This extreme acrimony in a satirist, who could find hardly anything amusing in such things, is justified by the fact that in them he saw a betrayal of the loftiest of ideals, the ideal of justice.

203 *(opposite)*. Honoré Daumier:
During the Interval, *c*. 1855-60. Water-colour.
Winterthur, Dr Oskar Reinhart

204 *(below)*. Honoré Daumier:
Rehearsing a Smile for the Electors,
1869. Lithograph

In his art Daumier became involved in life. The difficulties which that entailed could be overcome only with the aid of a genius in creating new form. Daumier's solution is only to the smallest possible degree an 'escape into form'. His almost immeasurable world of figures is, in fact, so full of carefully observed life that, quite apart from all artistic value, it is a historical document as enormous in its dimensions as the novels of Balzac or the comedies of the Viennese satirist Johann Nestroy, which are even nearer in spirit to Daumier. Even the background, the townscape of Paris, plays a part, though only as a carefully controlled, natural accessory. To characterize Daumier's gigantic *œuvre* in the words of Sophocles, whom he so sincerely revered: 'Nothing is mightier than man.'

GENRE-PAINTERS, CARICATURISTS,
AND ILLUSTRATORS OF DAUMIER'S TIME

The contrast between the realism of Courbet and that of Daumier, between realism based on observation of data and realism based on moral ideas, is very sharp. In this it seems to be a striking example of the multiform nature and the discrepancies of nineteenth-century art. Actually, however, it is not surprising that we should find realism applied to natural things side by side with realism applied to human life and its struggles. What makes the contrast so extreme is the forcefulness which we find on both sides. It almost disappears when we come to consider the minor masters of more meditative landscapes and the gentler forms of caricature. Indeed, compared with Daumier, all caricature seems gentle; outstanding genius inevitably renders one unjust to talents flourishing in its immediate neighbourhood, and so it is easy to overlook the fact that the work of the best draughtsmen around Daumier was both rich and varied. The very mention of Gavarni, Doré, and Grandville conjures up extreme variety, a range of subject-matter running from realistic rendering of everyday happenings to excesses of fantasy and symbolism. The work of these artists belongs only partially to Realism. For the most part it is pure Romanticism and poetry, even when it is not actually devoted to the illustration of poems. The prevailing influence of literature constitutes indeed the essential difference between the art of this group and that of Daumier. In Daumier everything literary, from a momentary thought to a dominating idea, is dissolved in form. In this respect all the other draughtsmen of the time are a long way behind him.

Nearest to him is Paul Gavarni (whose real name was Hippolyte-Guillaume-Sulpice Chevalier; 1804-66). But the personality which found a purely graphic expression in Gavarni's

205. Paul Gavarni: Lithograph from
Faits et gestes du propriétaire, 1846

206. Paul Gavarni: Wood-engraving from
Contes fantastiques de Hoffmann, 1843

lithographs and wood-engravings is so fundamentally different from that of Daumier that a comparison has hardly any point, although (or perhaps precisely because) the subject-matter of the two artists to a considerable extent overlaps. Paris, and in particular the life of the petits-bourgeois and artists, is Gavarni's theme too. But he preferred to dwell on the city's carefree and enjoyable side, its talent for graceful frivolity and playfulness. The celebrated series of lithographs which appeared in *Charivari* between 1837 and 1847[10] [205] portray it with a mastery rivalling that of Daumier. The supple strokes of his chalks and refined gradation of his tones are full of a gentle, sweet – but not sugary – elegance. Never has a particular side of French life and the French character been more melodiously celebrated than in Gavarni's lithographs of this period. The apprenticeship leading up to this artistic maturity began in 1824, when he studied engraving under Jean-Nicolas Adam (1786–1840) and when he drew fashion-plates.

Before that Gavarni had been apprenticed to an optician and a mechanical engineer. Like so many of his colleagues he made wood-engravings as well as lithographs, in the same routine yet spirited manner [206, 207]. It is especially evident in his tiny illustrations to *Masques et Visages* (1852–3) [207] and his contributions to

207. Paul Gavarni: Congé en partie double.
Wood-engraving from *Masques et Visages*, 1852–3

the *Vocabulaire des Enfants* (1839) and to *Les Français peints par eux-mêmes, La grande ville*, and the various *Physiologies*. Reference to the latter three books has already been made. In 1847 and from 1849 to 1851 he was in England, and his stay there, the immediate result of which

was the series of wood-engravings entitled *Gavarni in London*, represented a turning-point in his career, from the human rather than from the artistic point of view. In his later lithographs, as well as in his water-colours and drawings,[11] he passed, like Daumier, from black-and-white effects rich in contrast to a form more specifically based on line. Gavarni now concerns himself with social distress and the sufferings of old age, which are depicted with a sorrowful pessimism, but without resentment. Gavarni was not naturally inclined to acrimony, distortion, or harshness, and he did not even try to express the demonism of evil. His art, which had begun so gaily, ended with his ragged philosopher Thomas Vireloque (*Le propos de Thomas Vireloque*, 1852) [208], and with his old hags (*Les Lorettes vieillies*, 1852), querulously resigned to their fate; the melody is muted and brittle, but still beautiful.

There is a dark side too, though of a completely different kind, in the art of Grandville (pseudonym of Jean-Ignace-Isidore Gérard; 1803-47), but it is only a part of the inventive fantasy which is the basic element of his art. It appears in one of his early works in the shape of a Dance of Death (*Voyage pour l'Éternité*, 1829). With the pen-lithographs entitled *Métamorphoses du jour*, published in the same year, he created the device of showing animals in human clothing, a type of political and social caricature that brought him great success, but at the same time made him many enemies (e.g. Baudelaire). A good example is the *Scènes de la vie privée et publique des animaux* (1842), but Grandville also used this satirical method on occasions in his illustrations to books of other writers, e.g. Lafontaine's *Fables* (1838).[12] The limits of the real world are constantly overstepped by his exuberant fantasy, and the old satirical concept of a topsy-turvy world appears once again in his numerous wood-engravings, for example in Old Nick's *Petites misères de la vie humaine* (1843), *Un autre monde* (1844, with the sub-title: 'Trans-

208. Paul Gavarni: Lithograph from *Le propos de Thomas Vireloque*, 1852

formations, Incarnations, Visions, Locomotions, Explorations, Pérégrinations, Excursions, Stations, Cosmogonies, Fantasmagories, Rêveries, Folâtreries, Facéties, Lubies, Métamorphoses, Zoomorphoses, Métempsycoses, Apothéoses') [209], and *Cent proverbes* (1845). Grandville, however, also penetrated into exaggeratedly romantic realms of vision and dream. He belongs to the group of visionaries and symbolists who occur in the nineteenth century side by side with the realists, and he exercised considerable influence even outside France, on the illustrations of German Late Romantics like Schrödter, and in England on Lear's 'nonsense' books and on Tenniel's illustrations to Lewis Carroll.

Despite his facility as a draughtsman, Grandville was primarily interested in subject-matter. On the whole this is also true of Gustave Doré (1832–83), who was born in Strasbourg and was obviously influenced both by Grandville and by Toepffer. He is the last of the great French illustrators. Although he was exceptionally prolific as a draughtsman and although he had begun doing good work when he was only fifteen (*Les Travaux d'Hercule*, 1847), he could never have produced his gigantic *œuvre* without the help of assistants and the organization of what was almost a factory, and this naturally resulted in a great deal of hastiness, superficiality, and platitude. Amidst the multiplicity of elements in his graphic style, an expressive line introducing Baroque flourishes stands out (Balzac's *Contes drôlatiques*, 1855; *Les aventures du Baron Münchhausen*, 1862), stifled, however, by the typical Late Romantic profusion of naturalistic effects. We can nearly always detect a trace of calculation, of stage effect and half-expressed parody – which should be compared with the genuinely Romantic depth of Meryon. Nevertheless there is a close affinity to the Romanticism of Victor Hugo, both as a writer and as a painter [115]. For all this, Doré undoubtedly possessed a great deal of originality, in his predilection for the vast and for seething masses of human beings – e.g. the battle scenes in his illustrations to Rabelais (1854) and the contemporary *Histoire pittoresque, dramatique et caricaturale de la Sainte Russie* [210] – and for the effects of excessive foreshortening. But in the majority of cases the execution lags a long way behind the lively, exuberant conceits. This becomes particularly clear in some of the large pages of his impressive later works, such as the illustrations to Blanchard Jerrold's *London. A Pilgrimage* (1872). Here Doré tried to convey the frightening, monstrous aspect of a huge city with all its social misery, and he did it with considerable success. What might he not have achieved if the colossal perspective à la Piranesi in *Over London*

210. Gustave Doré: Wood-engraving from *Histoire de la Sainte Russie*, 1854

211. Gustave Doré: Newgate – the Exercise Yard, 1872. Wood-engraving

by Rail or in the nightmarish *Newgate – the Exercise Yard* [211] had been accompanied by an equal mastery of detail! We can see the result when van Gogh translated the Newgate scene into his own language. Even so, it must be admitted that van Gogh was only revealing the greatness of Doré's idea. Such grand, subtly accentuated settings and the profusion and truth to life of Doré's figures exercised a lasting influence on the art of illustration, for example on the commercial illustrators of the Utopian novels of Jules Verne with their curious panoramas and cosmic landscapes.

There were numerous French draughtsmen of lesser stature. Some of them devoted themselves to political caricature, in the beginnings of which Decamps also had a small share, and most of them were contributors to *Charivari*. As artists they are satellites of Daumier; for example Charles-Joseph Traviès (1804–59), who at the outset was ahead of Daumier, and Cham (whose real name was Amédée-Charles-Henry de Noë; 1819–79). A gentler irony in the portrayal of manners and the ridiculing of philistines was cultivated by Henri Monnier (1805–77), the inventor of the figure of 'Joseph Prudhomme',[13] and Eugène Lami (1800–90); the former occasionally approached Daumier, whereas Édouard de Beaumont (1821–88) was a follower of Gavarni. Lami, a pupil of Gros and Horace Vernet, was another French artist who paid frequent visits to England. The fruits of his visit in 1826 were the hand-coloured pen-lithographs entitled *Souvenirs de Londres* (1826) and, in collaboration with Monnier, the *Voyage en Angleterre* (published in 1829–30). These show that he owed a good deal to the English caricaturists and illustrators, just as in his water-colours he was indebted in particular to Bonington. The connexion between French and English book-illustration was a close one, both in general and as regards the technique of wood-engraving, since up to the middle of the century a number of English wood-engravers worked in France.[14]

English influence is also perceptible in some of the early standard works of French book-illustration such as Le Sage's *Gil Blas* (1835) with illustrations by Jean Gigoux (1806–94), the Molière edition of 1835, illustrated by Tony Johannot (1803–52), and Bernardin de Saint-Pierre's *Paul et Virginie*, on which Johannot collaborated with several other artists, among them Eugène Isabey, Paul Huet, and Ernest Meissonier (1815–91). Soon, however, wood-engraving, the foundations of which had been laid by Thomas Bewick in the last twenty years of the eighteenth century, began to develop in the direction of technical virtuosity at the expense of the artistic element. Doré's late illustrations, e.g. for Dante's *Divine Comedy* (1861, 1868) and the Bible (1866), are striking examples of this.

Very popular was the illustration of fairy-tales and books for children. The name of one of the best in this field, Vicomte Albert d'Arnoux, called Bertall (1820–83), may be mentioned here as typical [212]. He is also an example of the

212. Bertall: Wood-engraving from Feuillet, *Vie de Polichinelle*, 1846

interplay of international influences during the golden age of illustration. Like so many other French graphic artists, Bertall illustrated German fairy-tales and stories, e.g. Grimm's Fairy-

Tales (1855), Wilhelm Hauff's *Die Karawane* (1855), and E. Th. A. Hoffmann's *Nussknacker und Mäusekönig* (1845).[15] His work may serve to bring up the whole question of the mutual relationship between French and German book-illustration. It is probably hardly correct to say that German Romanticism had a definite influence on French art in this field, for the differences remain even when it is a question of illustrating fairy-tales. The French stay closer to reality, while the Germans are more poetic. The profundity and gravity of the great Early Romantics is still present in the linear draughts-manship of Schwind and Richter [166-8], but there is nothing like it in the work of French illustrators. The tone of their drawings is conversational, and the content almost always the humour either of the situation itself or of the presentation of it. In that lies the reason for the superiority of French artists in caricature and of Germans in the illustration of fairy-tales.

CONSTANTIN GUYS (1805-92)

Constantin Guys is often called the 'Chronicler of the Second Empire'. This is true, but it represents too narrow a view of his art. His contribution to the documentation of the period as recorded by the French caricaturists and illustrators is certainly noteworthy. However, it is of a very specific kind, and limited as regards subject-matter. For a long time his chief interest was life in the services, which in fact played a part in his life from the very beginning, since he was born in Flushing as the son of a chief purser in the French navy and had thus been familiar with naval life since childhood. The services, however, were something more to him than mere matter for observation. With Lord Byron he took part in the Greek war of liberation in 1824, and in 1827 he enlisted in a French regiment of dragoons; during the Crimean War in 1854 he acted as war artist for the *Illustrated London News*. Throughout his life his love of

adventure led him to travel. He went to Spain, several times to England, and to Turkey. He affected the nonchalant pose of a dandy, which fitted in with his obstinate preservation of anonymity. In his old age he became a crank, though he remained a man about town, always in the thick of things, both in society and in the demi-monde, always busily drawing, and he seems to have continued to draw even during his last years which, as a result of a street accident at the age of eighty, he had to spend in hospital. In his later work women became his favourite theme, from *grandes dames* to quayside prostitutes [213, 214].

Guys was a draughtsman of the highest quality and had a genius for improvisation. He never painted in oils, and he taught himself how

213. Constantin Guys: Two Ladies with Muffs, *c.* 1875-80. Wash-drawing.
London, Courtauld Institute Galleries

to draw and how to master the very personal technique of his water-colours. For all their refinement, his works often retain a touch of carelessness and naivety. The drawings of Callot, Rembrandt, and Goya must have inspired him, but there is hardly any trace of the influence of Daumier. Daumier, however, held him in great esteem, and a comparison between the two is instructive. As a great amoralist – and in this respect he was a forerunner of Toulouse-Lautrec – Guys was in direct opposition to him. What, in spite of this, makes the comparison so interesting is the fact that, in spite of their different premises, they possessed decidedly similar powers. For all his one-sidedness, Guys depicted a very variegated world, from the 'terrible poetry of battlefields'[16] to the dizzy

214. Constantin Guys: Woman standing, *c*. 1875–80. Wash-drawing. *Vienna, A.S. Collection*

whirl of the world of pleasure, of parades and promenades. It was the gay sparkle of this world that attracted him. In his method of presentation, however, in the jerky rhythms of his drawing and his refined grisaille with a few pale shades of water-colour, everything acquires a spectral touch, not because it is 'Romantic', but simply because this quality is implied by the very intensity of his vision of the turmoil of an ever-changing, rapidly passing life.

Superficially considered, the art of Guys is no more than a strange adjunct to the general picture of French painting. He was an eccentric, not only in life, but also in his art. Nevertheless his work fits in remarkably well with the marvellous structure of French painting. Guys kept to the surface of life and took little interest in psychological depth. The human face meant very little to him. In this respect, though it would be wrong to call him an Impressionist, he is fundamentally close to the Impressionist point of view. His art must therefore have been highly important for the painter who was to give the Impressionist conception a world-wide significance – for Manet.

NATURALISM IN GERMANY

In ordinary parlance Naturalism is taken to denote a more pronounced degree of Realism, and this elementary distinction has so far been adequate for our discussion. In the contrast between 'Realism in France' and 'Naturalism in Germany', however, something more precise is involved. Neither the art of Daumier nor even that of Courbet can be called naturalistic, but we can unhesitatingly apply the term to the painting of Menzel, and even go further by saying that Menzel is the Naturalist *par excellence*. The different attitudes of these three painters to reality reflects something of the general differences between French and German nineteenth-century painting. There is in fact no parallel in contemporary France to the extreme naturalism which existed in Germany and culminated in Menzel. But how can this be reconciled with the fact which we have already stressed, that in the art of illustration we find a more marked sense of reality in the French artists than in the Germans, who tend towards stylization, a Romanticism remote from reality?

Perhaps the answer is that a tendency towards extremes is a German national characteristic. German nineteenth-century painting, in fact, lacks compactness and organic cohesion, qualities much admired in contemporary French painting. Within the framework of the latter, even Ingres and Delacroix seem to be supplementary to each other, in spite of the radical contrasts between them.

Menzel is not simply an extreme case in German painting, however, for both his personality and his work embody contradictions and problems of fundamental importance, some of them resulting from his nationality, but others of a far more general kind. His work thus exemplifies with unusual clarity the problems inherent in Naturalism itself.

ADOLF VON MENZEL (1815–1905)

Menzel began his long career as an illustrator. In 1830 his father, a school-teacher, moved with his family from Breslau to Berlin, where he

215. Adolf von Menzel: Departure of Frederick the Great with the Army. Wood-engraving from Kugler, *Geschichte Friedrichs des Grossen*, 1840–2

founded a lithographer's business. When he died two years later, his seventeen-year-old son, finding himself compelled to support the family, did so by drawing upon what he had learned from his father and turning out diplomas and other such jobbing printer's work. In 1834 he published his first original work – illustrations (eleven pen-lithographs) to Goethe's poem *Künstlers Erdenwallen*, which at once found recognition. He thus started with subjects which could not help being romantic, in spite of the fact that he himself was an anti-Romantic. However, his austere Naturalism was accompanied by a no less deeply rooted inventiveness, and it is in the constantly changing relation between the two, the interplay of objectivity and imagination, that his specific character is most apparent. The earliest of his important works are the four hundred illustrations to Franz Kugler's *Geschichte Friedrichs des Grossen* (published in 1840-2) [215]. These are an expression of the gift for 'drôleries', for marginal decorations and vignettes, witty in conception and graceful in form, which had already been apparent in Menzel's previous works, though in these he still owed much to Schrödter, Neureuther, Hosemann, etc.[1] He continued to produce works of this kind, full of allusion and symbolism, down to his last great illustrations to Kleist's *Der zerbrochene Krug* (1877). But his fanciful varying and transposing of events, while specially telling in such marginal drawings and vignettes, can also be recognized as illustrations proper, especially those to Kugler's book, where, however, it is fused with realism. The past appears as a living present. This, of course, is the postulate of all naturalistic history-painting, but it was realized more successfully by Menzel than by almost any other artist. Like other Naturalists who painted history Menzel made a study of the period in terms of persons, as well as things, but he did it much more diligently than the others, devoting three years (1839-41),

for example, to preparation for Kugler's book. Moreover he did not confine himself to historical details, but studied nature, which is super-historical and permanent, with the same enthusiasm. His fanaticism for studying everything and, in principle, for drawing everything, without distinction, if for no other reason for the very purpose of study, which was already beginning to assert itself in the Kugler illustrations, distinguishes his art from the normal representation of history, even by Naturalists. The latter were more or less content with the vague ideal of the 'Zeitgeist'; but for a consistent naturalistic rendering of history there cannot be any 'Zeitgeist' such as there is in literature, and in Menzel's work it indeed either plays no role at all or else a rapidly diminishing one. By combining creative imagination with a devoted study of nature Menzel was able to depict the battles of the Seven Years' War and the life of Frederick II in war and peace as if he had been an eye-witness, with all the freshness of a momentary vision. This was the great, new thing in the Kugler illustrations.

In principle Menzel did exactly the same in his later history-paintings, yet the Kugler illustrations are approached in artistic intensity only by three of the famous Cycle of Frederick the Great: *Frederick's Speech to his Generals before the Battle of Leuthen* (c. 1858, formerly Berlin; unfinished), *Bonsoir, Messieurs!* (1858, Hamburg), and the ghostly nocturne of the *Battle of Hochkirch* (1856, formerly Berlin). It is, incidentally, characteristic of Menzel that, except for three little-known studies of fallen soldiers and a dying man, in which he catches something of the authentic horror of warfare, he did not paint the only war which he himself witnessed, the 1866 campaign in Bohemia with its 'horror, agony and stench'.[2] This Naturalist, who never transfigured war in the manner of the idealistic battle-painters, was thus discerning enough to recognize the limits of his possi-

bilities – limits partly dictated by linear as opposed to painterly form. The characteristics of Menzel's graphic, i.e. linear, art are most evident in the Kugler illustrations, which have passed into history as leading examples of how a painter copes with graphic art. Here alone, in these magnificent drawings which display the whole range of chiaroscuro, do we find a parallel to the epoch represented, that is, to the style of the masters of Late Baroque drawing and especially often to that of Chodowiecki [31]. It is true that this can be seen better in the pencil studies for the illustrations than in the illustrations themselves, but even in these the intended

transformation of painterly effects into linear art has succeeded. This was the result of the uncompromisingly strict training that Menzel gave his engravers.[3] In this respect too the Kugler illustrations represent the zenith of Menzel's work, which was not surpassed until the skill of wood-engravers had made facsimile reproductions on wood possible. Menzel could thus disregard the technical limitations of wood, though at the same time these limitations had been a formative element in his art. There is in addition another reason why the two hundred wood-engravings for the *Werke Friedrichs des Grossen* (1844-9) [216] no longer reveal the

216. Adolf von Menzel: Two young Officers in a Military College. Wood-engraving from *Werke Friedrichs des Grossen*, 1844-9

217. Adolf von Menzel:
The Artist's Sister with Candle, 1847.
*Munich, Bayerische
Staatsgemäldesammlungen*

same unalloyed purity – and that brings us to
the question of Menzel's Naturalism.

What Menzel deliberately tried to achieve,
and what inherent dangers there were in his art,
can easily be seen in these few examples. In
trying to present the past as a living reality, he
set himself a difficult and almost monstrous task.
This is very revealing; for it shows us something
of Menzel's character, his recognition of the
conventional standards, according to which 'the
greatest category in painting . . . is after all
history-painting',[4] and his consequent accept-
ance of an obligation to idealize. It is unnecessary
to stress how completely this is in contrast with
Menzel's opposite ideal, according to which a
representation of the visible is self-justificatory.
He came near to achieving this latter ideal in the
period immediately following his work on the
Kugler book, in a series of landscapes and
interiors which did not become famous until
shortly before his death but which since then
have been counted among the most brilliant
productions of painting during the nineteenth
century. These pictures (*Building-Site with
Willows*, 1846; *Garden of Prince Albrecht's
Palace in Berlin*, 1846[218]; *The Berlin-Potsdam
Railway*, 1847, West Berlin; *Room with Balcony*,
1845 [220]; *Evening Party*, *c.* 1848, West
Berlin; *The Anhalt Station in Berlin by Moon-
light*, *c.* 1847, *The Artist's Sister with Candle*,
1847 [217], both in Munich; and one or two
other Berlin landscapes and interiors) can be
considered as documents of an independent
early Impressionism, even if one admits that
they contain obvious inspiration from Blechen
[160], Dahl [62], and Constable.[5]

Menzel's own attitude to these pictures was
curious. Later on, when he rejected Impression-
ism as 'the art of laziness', he kept them hidden
away; but in his old age he made additions to one
of them, the *Garden of Prince Albrecht's Palace*
[218], as well as to a later work of the same
category, the *Memories of the Théâtre Gymnase*

(1856) [219], which shows that he regarded them as more than mere incidental studies. In actual fact, only a few of these pictures are studies in the ordinary sense; most of them are finished paintings – the *Garden of Prince Albrecht's Palace* to such an extent that all the wisdom of the old masters of landscape art seems to have been drawn upon. Then again, in other pictures from this group, for example the *Room with a Balcony*, the entire content of the picture is innovation [220]. In this picture that great achievement of nineteenth-century art,

the recognition of greatness in the unpretentious, finds one of its purest manifestations, and the art of seizing the pure joy of a moment one of its earliest examples. A comparison between this immortalization of the morning hour and Schwind's *Morning Hour* [164], painted more than ten years later, might make it possible to recognize the rules of a philosophy of nineteenth-century art. In some of the works in this group, such as the *Interior with the Artist's Sisters*, the *Evening Party*, and the *Théâtre Gymnase*, Menzel represented artificial light (as

218. Adolf von Menzel:
Garden of Prince Albrecht's Palace in Berlin, 1846.
(East) Berlin, Staatliche Museen

he was fond of doing later), and in such a way that one has a feeling that here for the first time artificial light is rendered in exactly the same way as daylight. On the other hand the artificially mysterious light of the footlights is truly mysterious in Menzel's rendering, and in this 'objective' manner the *Théâtre Gymnase* picture becomes a magical apotheosis of the Stage.

These pictures of the mid 1840s to the mid 1850s are the finest evidence of Menzel's genius as a painter, the counterpart in painting of the graphic art of the Kugler illustrations. They are the pure gold that in his later works was compounded into all sorts of alloys. In itself, of course, that need not have represented a depreciation in value, any more than did the extreme Naturalism in the details – of which there are hundreds of examples in the art of previous centuries. The Impressionist method of abridgement must not be taken as a standard, since in judging Menzel's later works it is far more important to note how much of their vigour and impulse remained even after the painter had committed himself to the maxim 'genius is diligence'. Indeed a great deal of it did remain a living force until the end. Again and again a foreshortening or a gesture proves his power of dynamic composition, for example in the picture showing a falcon and a pigeon

219. Adolf von Menzel:
Memories of the Théâtre Gymnase, 1856.
(West) Berlin, Staatliche Museen

220. Adolf von Menzel: Room with a Balcony, 1845. *(West) Berlin, Staatliche Museen*

221. Adolf von Menzel: Falcon and Pigeon, c. 1848.
(East) Berlin, Staatliche Museen

(dating from the late 1840s) [221]; in one of the large pictures of episodes from the life of Frederick the Great, *Bonsoir, Messieurs!* (in this case combined with a grandiose rendering of light and colour); in certain of the forty-three gouaches in the so-called 'Children's Album' (1861–83); and in many of the innumerable drawings dating from all periods of his life [222, 223]. On the other hand, these powers frequently disappear completely, for example in some of the popular later pictures of episodes from the king's life. It is obvious that even Menzel's striking command of colour could not cope with his own excessive Naturalism. A few years before the *Théâtre Gymnase* he produced the *Flute Recital at Sanssouci* (1852, West Berlin). In the former a brilliant sketch from

222. Adolf von Menzel:
At the Concert, 1848. Coloured chalk-drawing.
(East) Berlin, Staatliche Museen

memory of a festive moment becomes a veritable feast for the eyes, and the contrast between the sparkling blue of the dress on the left and the quiet glow of the warm tones surrounding it seems like the translation into painting of a passage of dramatic dialogue. In the *Flute Recital* there is a similar contrast, but in this case it is no longer a chromatic problem, posed and solved, but merely illustrates how the blue jacket of the king's uniform looks in the candle-light of a Baroque room.

In the course of his early training as a painter, Menzel modelled himself mainly on Berlin Biedermeier, especially that of Krüger, whose influence is clearly visible in the portrait of Friederike Arnold (1845, West Berlin), but also for a short time on Belgian history-painting. In

a few years he reached the zenith of his peculiar Early Impressionism, after which the subject, as opposed to the spirit, once more gained the upper hand. It is superfluous to add that such supreme skill in the use of colour and drawing would not allow itself to be stifled; and that the increasing importance of local colours was always held in check, at all events in certain parts of his pictures, by the unity of the chromatic conception, just as many of the sumptuous and brilliant drawings, drawn in chalk and worked over with stump, with their sometimes almost photographic tonality yet pulsate with graphic life. And again and again Menzel produced individual masterpieces such as the *Studio Wall* (1872, Hamburg), in which he returns to a theme of 1852 (West Berlin) –

223. Adolf von Menzel:
Study of a bearded Gentleman, 1889. Pencil-drawing.
Hamburg, Kunsthalle

224. Adolf von Menzel: Court Ball
in the White Room of the Imperial Palace, Berlin,
1888. *Schweinfurt, Dr Schäfer*

plaster casts on a wall seen at an angle in artificial light – or the *View from a Balcony of the Palace in Berlin* (1863, Munich). The former picture is painted in the style of the interiors of 1850, the latter in a later style.

In many of his later anecdotal pictures (*The Rolling-Mill*, 1875, East Berlin; *Supper after the Ball*, 1878, West Berlin; *The Piazza Erbe, Verona*, 1884, Dresden; *Court Ball in the White Room of the Imperial Palace, Berlin*, 1888 [224]), the disposition in compositional groups, designed to balance the exuberant profusion of detail, is upset by the effort to render the whole bustle and turmoil, the chaotic accumulation of movement and colour. This effort might appear

the expression of an artisitc principle, and it could in fact be regarded as a principle of composition, though of a special kind. In reality, however, the prevailing impression produced by these pictures is that of uncontrolled life. Yet even in this unresolved duality we cannot help admiring Menzel's demonic power. His fanatical search for reality often led him to overstep the bounds of art, but he sinned against the law of his own nature only when he followed conventional rules in an attempt to master reality and, even worse, when he resorted to compromises, because he thought that he *must* adhere to these rules, as he did in pictures like the *Round Table at Sanssouci* (1850, formerly

Berlin) and in some of the other late paintings from the life of Frederick the Great. In such cases the result was mere frigid showiness. But whenever the image of nature informed his work, greatness triumphed over all mistakes and failures.

Menzel's own contemporaries did not understand his tragic voyage from freedom to a self-imposed bondage, from confidence to lack of self-command. The public gazed in astonishment and naive admiration at his virtuosity. Among the painters on whom it was bound to make an impression was Meissonier, for whom Menzel in his turn had a great esteem. Meissonier's pictures of soldiers and the military and society pictures of his weaker German counterpart, Anton von Werner (1843-1915), show where unlimited naturalism in history-paintings executed by specialists can lead – to the costume piece and a ghostly, entirely unreal form of reportage. In Naturalism like that of Menzel in his old age it is a mystery how there can still be room for so much art; in the other Naturalists it is astonishing how devoid of all art art can be.

Specialists of other kinds were also bound to be attracted by the richness of Menzel's art, for example Carl Werner (1808-1904) in his watercolours. But Menzel's true followers were not these specialists. They were those who could understand his genius both as a painter and a draughtsman, in particular Max Liebermann and Max Slevogt. Outside Germany it is obvious that Degas also appreciated him. We know, in fact, that he admired Menzel's Kugler illustrations. None of Menzel's contemporaries approached him more closely than Degas, not only in his idiom of draughtsmanship and his faith in both painterly and graphic effects, but also in the conception of the human figure in movement, and, more fundamentally, in the attitude to Naturalism as a whole.

For a short time, during his early years in Rome (1858-9), the case of Franz von Lenbach (1836-94) appeared similar to Menzel's. In this period Lenbach painted a number of dark-toned pictures and studies, and in a moment of inspiration produced one of the finest works of German Naturalism, the *Shepherd Boy* in the Schackgalerie at Munich (1860). Soon afterwards he became a society portraitist in Munich, and his fame in this field was almost as great as Menzel's. Of the original colouring of his youthful works not a trace remained; it was replaced by a stereotyped chiaroscuro in 'gallery tones', with effects borrowed from Titian and Rembrandt, from Velázquez, van Dyck, and the English portraitists of the eighteenth century. With rare exceptions, such as the portrait of Prince Ludwig of Bavaria and his family (1882, Munich, Städtische Galerie and Lenbachgalerie), in which the influence of Marées is discernible,[6] Lenbach's portraits are superficial even when they are attempts to express the soul. In his art the popular mixture of literature, Naturalism, and rather primitive physiognomics loses all its mystery; this was also a continual menace to Menzel himself and the ruin of many a minor artist.

Menzel never confined himself to a deliberate and consistent reproduction of the visible, although the foundations of it were present in his art. Such a limitation became a principle of painting, however, towards the end of the 1860s in Germany, in the first mature works of Wilhelm Leibl, who soon assembled around him a group of artists of the same way of thinking. Their art was not founded on the great mid-century paintings of Menzel, however, since these were not yet known, but on French painting. Their master was Courbet.

WILHELM LEIBL AND THE LEIBL GROUP

Wilhelm Leibl (1844-1900) was born in Cologne and studied at the Munich academy under the history-painter Karl Theodor von Piloty (1826-86) and the genre-painter Arthur Ramberg (1819-75). When he first came into contact with

Courbet he was already a mature artist. This is proved by his picture entitled *The Critics*[7] (1868) and by the portrait of Frau Gedon, painted at the same time, which was exhibited at the Munich International Exhibition of 1869 (now in Munich). He won the approval of Courbet, who had pictures of his own in the exhibition and was in Munich at the time. At Courbet's suggestion Leibl went to Paris, where he exhibited the Gedon portrait and won a prize. He remained in Paris until the outbreak of the Franco-Prussian War in 1870, and produced there two of his best works, *Old Parisienne* [225] and *Cocotte* (both Cologne). In these Courbet's influence is far less evident than in the somewhat later, unfinished picture of the *Company at Table* (also in Cologne), which is very close to Courbet's *After the Meal* of 1849 in other ways besides the subject. The two Parisian pictures already contain the whole of Leibl in a nutshell, both in the ideal they share – which is that of a

225. Wilhelm Leibl: Old Parisienne, 1870. *Cologne, Wallraf-Richartz Museum*

perfection as accurate as that of any master of the past – and also in the difference between them. The *Old Parisienne* is a masterpiece of painterly form, while in the *Cocotte* the same open form is compressed to a delicate, enamelled smoothness, without any loss of freshness and directness either in the rendering of the model or in the life of the surface. For Leibl the two possibilities of open and of smooth technique were not mutually exclusive, and he tried them both, side by side and one after the other, which is a thing that distinguishes him from the other painters in his group. Painters like Schuch and Trübner used only the open form, while Munkácsy degenerated into academism when he exchanged it for what he intended to be compositional compactness. In fact it is only his closeness to Courbet that connects Munkácsy with the Leibl group, for as early as 1868 he left Munich for Düsseldorf, to study under Knaus. As for Leibl, not long after his return from Paris he decided to abandon Munich and retired to the seclusion of small villages in Upper Bavaria.

Leibl's art is filled with a tranquillity resembling that of nature, very different from the tranquillity of Courbet's painting, despite the fact that the aim of the two painters is identical: to make the image of material things the exclusive subject of the picture. There is no trace in Leibl of the drama and action which remain characteristic of Courbet, even where his aim is to demonstrate how they can be mastered by the strength of pictorial structure. Leibl's painting lacks this tension and its capacity is smaller, just as its range of subjects is more limited, consisting as it does of portraits and groups of figures with the landscape merely indicated. He sees everything exactly like a still-life, and his professed aim is technical perfection in the highest sense. The ultimate consequence of such painting can on the one hand be the chill of an over-refined artistry, but on the other a pictorial structure so compact and concentrated that it produces

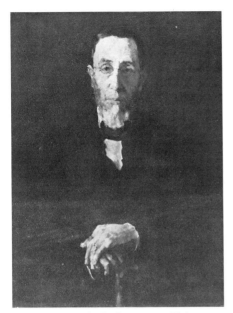

226. Wilhelm Leibl: The Burgomaster Klein, 1871. *(West) Berlin, Staatliche Museen*

227. Wilhelm Leibl: In the Kitchen (1), 1898. *Stuttgart, Staatsgalerie*

greatness. Both possibilities are found in Leibl's work, just as they are in Vermeer's, of whose pictures Leibl's own are frequently very reminiscent.

In constructing his paintings Leibl relies mainly on colour, both by itself and with a highly skilful exploitation of chiaroscuro [226]. Since Leibl was also a remarkable draughtsman (as is proved by his drawings and by nineteen masterly etchings dating from the first half of the 1870s), his pictures never lack firmness of linear structure, whether this is clearly displayed or concealed. Here the Ingres ideal of a synthesis of line and colour reappears, but in accordance with the trend of the times the proportions are now reversed, the chief stress being on the painterly, not on the linear side. For a time, from the middle of the 1870s to the beginning of the 1880s, Leibl strove to achieve a complete equilibrium between colour and draw-

ing. This was his 'Holbein period'. In this attempt to rival the gem-like technique of the old masters he certainly achieved the utmost possible, but the reverence of van Eyck or Holbein for all objects, whether religious or not, was something that could never be recaptured. Leibl never succeeded in getting over this difficulty, despite the fact that he felt to the highest degree the nineteenth-century painter's reverence for nature. Often in these pictures the artist's personal integrity in his relation to the subject, or to the old master whom he took as his model, appears imperilled, for example in the 'German Primitive' linework of the *Poachers* (1882–6, West Berlin). In the best-known work of this period, and the most famous of all Leibl's pictures, the *Three Women in Church*, painted at Berbling between 1878 and 1882 [228], he nevertheless fully justified the ideal of this passing phase. For Naturalism, carried to the utmost

228. Wilhelm Leibl: Three Women in Church, 1878–82. *Hamburg, Kunsthalle*

pitch – in the almost photographic optics of the near distance as well as in every detail of form and material – here becomes one with the skilful composition of curves and intersecting axes. It is a kind of union of the worlds of nature and the spirit, which was doomed not to last. It had been foreshadowed in the *Hunter* (the young Baron von Perfall, 1876, formerly Berlin), painted only a few years before, and Leibl tried to repeat it in the *Poachers*. When the attempt failed[8] he abandoned the idea, which for him had been a temptation in some ways similar to that which assailed Menzel. Leibl, having freed himself from it, returned to a definitely painterly form, and in the portraits and groups of the last decade of his life he achieved an increasingly high standard. This did not imply any deterioration in the modelling of the figures; they were merely veiled in the medium of an enchanting chiaroscuro. The monumental simplicity of the composition, a simplicity similar to that found in the later portraits of Corot [129, 130], seems a natural co-ordinate to this painting of tones. In some of the figure pieces of those years, for example in the two versions of *In the Kitchen* (Stuttgart [227] and Cologne) dating from 1898, this painterly treatment is even reconciled with the naturalistic near perspective of the *Women in Church*. Light plays the most important part in accomplishing this reconciliation. Many years before, in the portrait of the *Painter Sattler with a Hound* [229], Leibl had already shown how much light meant to him by constructing a whole picture as a bold impression of light. Leibl's light is not the same as the light of the Impressionists, but it is a curious parallel to it. In the moist glimmer of these late works [230] it is as muted as everything else, including space and matter. Unexpectedly, almost unintentionally, the souls of these people are revealed, in the hands every bit as much as in the faces, as indeed they nearly always had been, though in a less obvious way, in his earlier pictures. To the criticism that his

229. Wilhelm Leibl:
The Painter Sattler with a Hound, 1870.
Munich, Bayerische Staatsgemäldesammlungen

230. Wilhelm Leibl: Frau Rossner-Heine, 1900.
Formerly Bremen, Kunsthalle

painting was 'soulless' Leibl once retorted that one ought to paint human beings exactly as one sees them, in which case 'the soul would be there anyhow'. As a generalization these words may not tell us much, but they are very true of Leibl's art.

When Leibl left Munich in 1873, the circle of painters to which he had given his name lost its cohesion. Only his inseparable friend Johann Sperl (1840–1914) remained true to him to the end. Sperl was a minor master specializing in the landscape of the Upper Bavarian foothills. His civilized, intimate landscapes, in some of which Leibl painted the accessory figures, do not in actual fact really belong to the Leibl circle.

The painters of Leibl's group attempted to evolve a system founded on his works. They concentrated on the cohesion of tones and chiaroscuro values, or, as painters say, 'valeurs'. The chief slogan of the group was 'tonality', which means a colouring that includes, in addition to the local colours, the effects of light and atmosphere even in the smallest distances within the modelled surface of a head or a still-life. This, of course, was an old ideal, but it also became a new one. Leibl studied it mainly in the works of Frans Hals, who for him was the

231. Carl Schuch: Forest near Purkersdorf, 1872. *Vienna, Österreichische Galerie*

greatest of all painters, and in those of Courbet, which he regarded as a contemporary attempt to realize this ideal. By discovering it the Munich painters of Leibl's group opened up a new path for German painting. Ultimately, the skilful way in which Leibl built up his pictures and the objects in them out of oscillating tones was an anticipation of Cézanne's replacement of modelling by 'modulation'. Sometimes, however, the result was that the concentration on system ended in petrifaction. Of all the artists in the Leibl group only the Viennese Carl Schuch (1846-1903) achieved in some of his late still-lifes a perfection equal to Leibl's. He also seems to have had a clearer understanding than the others of the problems inherent in this method of painterly expression. For example, in a letter written to his friend and subsequent biographer, the landscape-painter Karl Hagemeister (1848-1933), he says '. . . the significance of tone is that it deprives things of their materiality and retains only the ethereal essence of their appearance'.[9] That, however, was but the extreme development of a category of painting in which it was precisely the material things that had the greatest importance. The idea was that the sensuousness of material things, the juiciness of the pulp of fruit, the downiness of a bird's plumage, the dull gleam of a pewter mug should be translated into painting by means of the free interplay of colours and planes in a delicate technique of spots. The art of this 'liberated form' with its very deliberate structure on the picture plane was for the most part, by its own confession, a painting of beautiful surfaces. Such a system, applied indifferently to diverse subjects, to still-lifes, landscapes, and the human countenance, could not possibly do equal justice to all of them, and Leibl's renunciation of landscape was a wise limitation. Schuch, on the other hand, did not renounce it. He began as a pupil of the Viennese landscape-painter Ludwig Halauska (1827-82), and as early as 1872 painted as

outstanding a picture as the beautifully constructed *Forest near Purkersdorf* [231], which was followed by others from the neighbourhood of Ferch an der Havel and the forests of the French Jura. Yet these only serve to show that his real domain was the still-life. Two kitchen still-lifes on an unusually large scale which he began to paint in Venice in 1879[10] prove that a sumptuous, painterly form need not imply an overcoming of the sensuous effects of materials. It was not until his late still-lifes – those painted during his stay in Paris between 1882 and 1894, after which he had a long mental illness – that Schuch demonstrated that a beautiful surface

232. Carl Schuch: Still-Life with White Bowl, *c*. 1885. *Vienna, Österreichische Galerie*

can in its own roundabout way achieve depth [232]. In the best of his late works the language of space and masses becomes more intelligible than that of the surface, and the objects stand before us 'in the ethereal essence of their appearance', as they do in the still-lifes of Chardin.

Wilhelm Trübner (1851-1917) was born at Heidelberg and studied at the School of Art in Karlsruhe before going to Munich in 1869. In his earliest works, which are also his best (e.g. *Portrait of Carl Schuch*, 1876, West Berlin; *In the Castle at Heidelberg*, 1873 [233]), he remains

very close to the essence of the art of Leibl and Schuch. They have not only the same coolness, softness, and delicacy of colouring, but also all that Leibl's method signifies in the conception

233. Wilhelm Trübner:
In the Castle at Heidelberg, 1873.
Darmstadt, Hessisches Landesmuseum

of the object. Trübner did not, however, possess either Leibl's outstanding naivety or that touching modesty which is so surprising in, and yet so typical of, such a physical giant as Leibl was. It shows the deep affinity between Leibl and Courbet. It very soon becomes evident that Trübner's paintings (and also Schuch's) are more intellectual than Leibl's and Courbet's. In Trübner, tranquillity often becomes rigidity, the secret life and movement expressed in the tonality and colouring of Leibl and Courbet becomes more superficial, and in the late works the luscious, broad strokes of the brush often become an end in themselves – inspired already by Impressionism. Nevertheless in many of his landscapes Trübner preserves a freshness and spontaneity which make them real 'symphonies

in emerald green', for example, his views of the Herreninsel and the Fraueninsel in the Chiemsee.

Leibl, Schuch, Trübner, and Munkácsy are four artists who reflect Courbet's attitude towards nature in the most direct and obvious way. However, a larger number of German painters, such as Theodor Alt (1846-1937) and Albert von Keller (1844-1920), two fellow-pupils of Leibl under Ramberg, were also influenced by Courbet or, indirectly, by the Leibl group on their course through the new system of painting and through Realism. They did not always remain faithful to the idea that everything must be conceived purely as a still-life, but used the principle of tonal painting in order to convey other pictorial notions – notions especially of a more or less romantic kind. This was the case with Viktor Müller of Frankfurt (1829-71), who for a time studied under Couture in Paris, and with Otto Scholderer (1834-1902), also of Frankfurt, who likewise spent some years in Paris. Müller's Romanticism lies more in the themes – stories or fairy-tales – whereas Scholderer's is of the restrained, lyrical kind. Scholderer's still-lifes are both simple and highly accomplished. Next to them, one of his best works is the *Violinist at a Window* at Frankfurt (1861), in which a Biedermeier intimacy is combined with the new painterly style. The third member of this Frankfurt group ('Viktor Müller-Kreis') was Louis Eysen (1843-99), whose best-known work is the interior with the portrait of his mother (West Berlin). The mood of this picture, however, is no longer Biedermeier, but more typical of the new objectivity, especially in the rendering of light, which belonged to the future.

For a considerable part of his life Hans Thoma (1839-1924) pursued the same aim, i.e. good true-to-nature painting. However, from the very start he found room for idylls, for contentment, and for the poetry of his native land. After studying at the Art School in Karlsruhe

234. Hans Thoma: Laufenburg, 1870. *(West) Berlin, Staatliche Museen*

under Schirmer and Canon and at Düsseldorf, he reached the height of his capabilities as a painter about 1870, while working in Munich with Viktor Müller, Scholderer, Leibl, Karl Haider, Rudolf Hirth du Frênes (1846-1916), and Eysen. With Scholderer he had visited Paris in 1868 and studied the art of Courbet. A dark tonality with a beautiful gleam like that of old silver in the light lends a personal note to his genre-pieces of peasant and petit-bourgeois life, his portraits, flower-pieces, and landscapes [234], the latter mostly of his native Black Forest. A personal note in these paintings (and in certain later landscapes) also appears in the care with which a nice balance is kept between a painterly rendering of what his eye saw and his inborn inclination to the telling of stories. On the whole, however, during the latter half of his life, Thoma felt less and less obliged to keep this balance, and used his talents for drawing more and more simply as a medium for narrative. The result was that, with his easily under-stood idyllicism and fairy-tale symbolism, he was revered by his fellow-countrymen as a very German poet-painter, whereas in fact he had succumbed to a fatal dualism. The 'joyful play of the spirit' ('das frohe geistige Spiel'), which was his own definition of art, often became ponderous and demonstratively naive, and frequently degenerated into a kind of self-conscious folk art. He thus became an epigone of Schwind and Ludwig Richter, just as in many of his religious pictures he was a neo-Nazarene.

Compared with Thoma, Karl Haider (1846-1912) is more of a dreamer than a poet, readier to brood than to communicate. Although he did not imitate them, Wasmann lives again in his figure-pieces and Friedrich in his landscapes. He is at his best in landscape, in which an archaic, sensitive, needle-sharp draughtsmanship is combined with the new decorative principles of about 1900 (e.g. in *Über allen Gipfeln ist Ruh*, several versions from 1896 on; Vienna, Kunsthistorisches Museum, Munich, etc.).

UNDER THE SIGN OF REALISM

Having discussed the French and German Realists who set the tone in the third quarter of the century, we have now to consider the minor painters in the various countries of Europe whose art stood under the sign of Realism. Generally speaking, these minor painters were not extreme Realists. Art for the most part kept to the middle of the road. In so far as there was any general trend at all, it was made up of widely different elements. In Biedermeier Realism before the middle of the century, the wish to keep to a pleasing harmony imposed limitations upon the study of reality which were sometimes very narrow indeed, and in the following years the position remained much the same. Reality was extolled, but without renouncing the old ideals of beauty. These ideals still occupied the first place, and Realism was sometimes added. The development – if one can apply the term development to the varied but seldom successful attempts to resolve this duality – can easily be followed in, for example, the painting of the Düsseldorf School. This school became an epitome of academism.

The leading painters of the first half of the century – Wilhelm von Schadow, Schirmer, and Lessing – have already been mentioned as being representatives of a melodramatic and academic Romanticism in history-painting and landscape, and we have also referred to the increasing naturalness and the increasing significance of the painterly element in their work and in the landscapes of the brothers Achenbach (see above, p. 237). In history-painting the new Naturalism can be found in the works of two Düsseldorf artists, Eduard Bendemann (1811–89) and Emanuel Leutze (1816–68). Leutze painted episodes of English and American his-tory and achieved fame with his picture of *Washington crossing the Delaware River* (1850, Bremen). In 1859 he went to live in Washington, where he was commissioned to decorate the assembly-rooms of the Capitol. These Düsseldorf painters cultivated a Naturalism in the manner of Delaroche and the Belgians, in which effects like velvetiness of draperies and the gleam of armour concealed the poverty of their imagination, at all events to the eyes of their many pupils and the public. In 1842, when works of Gallait and Édouard de Bièfve (1808–82), two other Antwerp history-painters, began to circulate in Germany, this category of pseudo-naturalistic history-painting created an open conflict with the heroic epics, remote from reality, of Peter Cornelius. The new style celebrated its last great triumph with the works of Karl von Piloty in Munich.

In the field of genre-painting in Düsseldorf the influence of Ludwig Knaus (1829-1910) was equally strong. In his work too there exists a fatal dualism, but the more modest themes and the more ambitious pictorial treatment mitigate it. For even these village episodes and scenes of petit-bourgeois life proclaim a realism of half-truths, more noticeable than in the genre-paintings of the Biedermeier period, in those of English painters about Wilkie's time, and even, in Düsseldorf itself, in those of Hasenclever, though all these suffer from the same prettifying sentimentality as Knaus's. Only in certain works of Knaus's most important pupil, Munkácsy, is there any turning towards an interest in form strong enough to hold the illustrative interest in check. That, however, was an isolated case. What determined the influence of Knaus in all the countries of Europe was the anecdotal ele-

ment. Previously this had had a moralizing or a humorous tinge; now, with the new painterly realism, it could keep this moralizing or humorous tinge, and, in addition, display new possibilities, though still not to such an extent as to make the subject a secondary matter. For example, one of the best-known exponents of genre-painting, the Tyrolese Franz von Defregger (1835-1921), who studied under Piloty in Munich and afterwards lived for many years in that city, showed in his landscape studies and cottage interiors that he fully understood what painting is, but in his popular pictures of Tyrol's fight for freedom in 1809 and his scenes of peasant life made the smallest possible use of this understanding. Benjamin Vautier (1829-98) shows no such understanding at all. Born in western Switzerland, he went to live in Düsseldorf in 1857 and became almost a twin-brother of Knaus's in painting the same old sentimental or comical stories.

The painters of genre – in the widest sense – during the second half of the nineteenth century largely neglected the possibilities of Realism. Yet in their works, despite all the abuses and triteness, we can perceive one genuine, deeply rooted tendency, namely the desire to render the underlying reality of human life in painting. This shows that they were dissatisfied with the idea that the function of painting was only to reproduce an image of the visible. This was indeed the conviction of many of the great painters of the nineteenth century, and they could proudly point to the fact that they had revealed to the world an incredible wealth of new possibilities, and moreover prepared the way for still more possibilities which arose after the close of the century. Yet even so great a programme could not silence the desire for realism in the accepted sense. To make the appearance so important that the subject would become a matter of indifference was after all only one of the possibilities of pictorial art. Could realism not go further and express a new conception of man-

kind, a new psychology and a new code of social ethics? Must a painterly realism, when combined with statements concerning the individual and humanity, inevitably lead to a contradiction in the sense that feeling and thought can never be completely absorbed into the pictorial form without leaving a remnant of 'literature'? These are the questions and problems the discussion of which could form an interesting, though ambiguous, chapter in the history of nineteenth-century painting, a chapter which could be headed: The rendering of total reality in painting. In fact history has proved that in these fields painting could never vie with poetry or music. When, after Realism in painting had accomplished its full development towards the end of the century, a new and compelling image of mankind emerged entire, it sprang from a field far removed from naturalism: the art of van Gogh and Munch. Once this had taken place, painting ceased to lag behind literature and music in strength of feeling and intensity of life.

Nevertheless, the art of the Dutch painter Jozef Israëls (1824-1911) shows how, within the limits laid down by Realism, much of the feeling for the human situation could find expression and yet still retain the language of painting. Israëls succeeded by accepting sincerely the limits of his own capabilities. This meant, among other things, the renunciation of colour. Israëls's pictorial medium was an almost monochrome grey-brown tonality of a fragile delicacy. In subject-matter, he was a direct descendant of the sentimental story-tellers of the Düsseldorf kind (*Passing his Mother's Grave*, 1857, Amsterdam, Stedelijk Museum; *The drowned Fisherman*, 1861, London, Tate Gallery). Of his relationship to Millet, Israëls himself said all that could be said in a very simple sentence: 'Except for Millet, there is no painter who knew as little about drawing and painting as I do, and at the same time produced such good pictures.'[1] For the first time in Dutch painting since the golden age of the seventeenth century there is an af-

235. Jozef Israëls:
A Son of the Chosen People, 1889.
Amsterdam, Stedelijk Museum

finity with Rembrandt, the solitary painter to whom alone the greatest and the rarest gift was given of instilling into pictures the depth of compassion. Compassion is also the fundamental trait of Israëls in his renderings of the wretched inhabitants of his little world of fishing villages and the Jewish quarter of Amsterdam (*A Son of the Chosen People*, 1889 [235]; *When we grow old*, 1883, The Hague, Gemeente Museum). With his hovering, melancholy chiaroscuro, which constitutes the special artistic element in his pictures, Israëls is very close to the painters of the school he founded, the 'Hague School', of which the leading artists were the Maris brothers, Mesdag, and Mauve.

What these painters have in common, in so far as they were landscape-painters, is an attitude towards nature which is basically similar to that of the landscape-painters of Barbizon. The schools of Barbizon and The Hague are akin as regards the proportion between Realism and Romanticism, between observation of nature and studio adaptations. They differ in that the Dutchmen have none of the oppressive pathos and hardly anything of the lively movement of the Barbizon painters – except perhaps for the seascapes of Henrik Willem Mesdag (1831–1915) – and that their mitigated Romanticism shows itself in the form of an oppressive stillness and a melancholy dreaminess. The difference in the motifs and their closer relationship to those of the classic landscape-painters of their native land are of secondary importance. Their job was naturally difficult when they had to deal with the same subjects as their great forerunners, Salomon van Ruysdael, van Goyen, and Vermeer, and the only way in which they could achieve independence was through a subtler rendering of the atmospheric elements. A sober objectivity in the rendering of light is the principal characteristic of Willem Maris (1844–1910), whereas what distinguishes the painting of Anton Mauve (1838–88) is an extreme refinement in the delicate use of tones. More vigorous

236. Jakob Maris: Harbour Scene, *c.* 1885.
Amsterdam, Rijksmuseum

are the chiaroscuro effects of Jakob Maris (1837-99) [236], and occasionally they reveal a muted sense of drama. In a deliberate attempt to achieve refinement, Matthijs Maris (1839-1917) introduces gentle, forever fading linear schemes into the vague twilight of his pictures, for example in his well-known *Souvenir of Amsterdam* (1871) [237]. (The same method was used by Johannes Bosboom, 1817-91, in his church interiors.) In his figure pieces Matthijs Maris assigned a far more considerable role to a sensitive and often decorative draughtsmanship, to bring out the symbolical or fairy-tale content. His study of French Symbolism, and even more of Pre-Raphaelitism, during his long stays in Paris and London, where he lived from 1877 on, was obviously fruitful.

Johann Barthold Jongkind (1819-91) is the most important among the artists who freed

Dutch painting from the idyllic eclecticism of the first half of the century and devoted themselves to the new Realism in landscape. But his lonely task as a pioneer of Impressionism was accomplished in Paris [279], and only his beginnings, as pupil of Schelfhout, lay in Holland, so that he belongs more properly to the history of French art.

In the Northern countries about this time there were one or two Danish landscape-painters whose way of seeing things can be compared with that of the Hague School. They are P.C. Skovgaard, who has already been mentioned, and Vilhelm Kyhn (1819-1903). Their pictures have none of the melancholy tone and the dim haze that we find in Dutch landscapes,

237. Matthijs Maris: Souvenir of Amsterdam, 1871. *Amsterdam, Rijksmuseum*

238. Marcus Larson:
The Sogne Fjord, 1861.
Stockholm, Nationalmuseum

but are full of a vernal and robust gaiety. In this, unlike their Dutch contemporaries, they were only continuing certain qualities of Biedermeier realism beyond the middle of the century. This Biedermeier realism was progressive enough to link up directly with Theodor Philipsen's (1840-1920) 'French' Impressionism.

'Classical' Danish Biedermeier, the diffusion of which was so important for the art of Northern Germany, had no influence worth mentioning on Swedish or Norwegian painting. This can probably be ascribed to differences in national character, since in both these countries the prevailing tone, in art as well as in life, was more serious and solemn. Moreover, neither Sweden nor Norway had the good for-

tune to produce a compact school of art such as existed in Denmark. In Norway the landscapes of Johann Fredrik Eckersberg (1822-70), Hans Fredrik Gude (1825-1903), and Herman August Cappelen (1827-52) continued the mountain Romanticism of Dahl and Fearnley. They remained tied to their native country for their motifs, but they received their training outside Norway and also spent a large part of their lives abroad. In this too they continued a pattern established by Dahl, who worked in Dresden and began paying fruitful visits to Norway only in 1836. By the middle of the century, however, Düsseldorf had taken the place of Dresden. Gude, in fact, even became a professor at the Düsseldorf academy. Adolph

239. Johan Fredrik Höckert: The Flight of
Charles XII and his Family from the burning Castle,
1866. *Stockholm, Nationalmuseum*

Tidemand (1814-76) also lived in Düsseldorf
(from 1845 on). He depicted Norwegian life in
the manner of the Düsseldorf genre-painters.

Düsseldorf too was the example which
Robert Wilhelm Ekman (1808-73) chose in his
endeavour to promote art in his native Finland.
Ekman was preceded by Alexander Lauréus
(1783-1823) and Gustav Wilhelm Finnberg
(1784-1833), both smaller men, but with more
elementary and more popular talents. Their
field was genre-painting. Ekman's pupil Werner
Homberg (1830-60) in his landscapes at first
followed the style of the Düsseldorf landscape-
painters. Later he became the leading artist in
the field of landscape in Finland. His mature
work is more independent and combines a civi-

lized handling with the new faith in plein-air
painting.

In Sweden, too, there were only isolated
talents. A brooding melancholy fills the Nordic
landscapes of Marcus Larson (1825-64), who as
late as 1861, in his large picture of the Sogne
Fjord [238], produced a nocturne full of the
tragic spirit of Ossian. Very close to this in spirit,
and despite its clumsy illusionism more genuine
in its Romanticism than the average productions
of the kind in Europe, is the gloomy picture of
*The Flight of Charles XII and his Family from
the burning Castle* (1866) [239] by the history-
painter Johan Fredrik Höckert (1826-66). His
art has a kind of counterpart in the grotesque
historical scenes of the Danish artist Kristian

Zahrtmann (1843-1917). The Swedish painter Ernst Josephson (1851-1906) is an elusive figure. In his work we find side by side a masterly Naturalism in portraiture and an emotional symbolism shot with irony in his figure-pieces,[2] a tonal chiaroscuro and a manner of painting completely dominated by the drawn line, for example in the portrait of Mrs Jeannette Rubenson (1883) [240]. Some of his portraits show a magnificent repose in the treatment but for the most part they are over-pointed and overdone. In 1888 Josephson went mad, but he still continued to draw and paint, producing fantastic and barbarous figures which are full of unbridled disproportion, a wild mixture of pathological and valid artistic expression [241]. There was another similar case in Sweden at the same time – Carl Fredrik Hill (1849-1911), who was

240 *(above)*. Ernst Josephson: Jeannette Rubenson, 1883. *Göteborgs Konstmuseum*

241. Ernst Josephson: King Charles X on the Belt, *c.* 1890-5. Drawing. *Stockholm, Nationalmuseum*

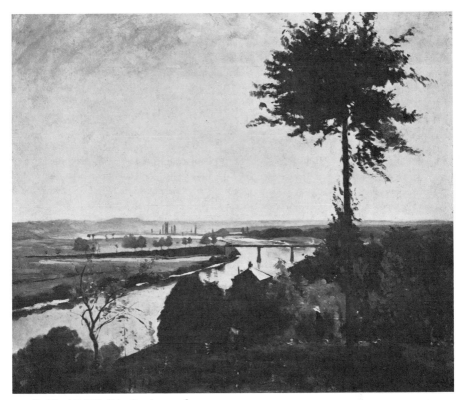

242. Carl Fredrik Hill: Seine Landscape, 1877.
Stockholm, Nationalmuseum

Sweden's outstanding landscape-painter dur-
ing the third quarter of the century. He unites a
feeling for mood which shows him to be a
genuine follower of Corot with characteristics
of the later plein-air painting and of the realistic
rendering of material things [242]. The many
landscapes, most of them in coloured chalk,
which he sketched after he went mad – in 1878,
during a stay of several years in Paris – reveal an
uncanny, pathological Expressionism. In the
works of these two painters it is not just ordinary
language reduced to a stammer, but a polished
language handled with the skill of the virtuoso.
Their creative power was not completely des-

troyed by mental disease, as Schuch's was, and
the lack of control due to the disease, while it
disintegrated a system of art, at the same time
revealed the power of elementary forms. When
we look at these pictures today, we cannot help
seeing in them, in addition to the tragic contrast
between artistic vitality and mental decay, a re-
volt of genuine forces against an over-civilized
artistry.

In these cases the break with convention took
place in the dark borderlands of the mind. In the
strange art of Anton Romako (1832–89), the
foremost Austrian painter of the second half of
the century, it occurs in broad daylight. His art

was based on a dangerously unstable foundation. To the very end it revealed a hesitation between various fundamentally different and equally mastered methods. His anecdotal style agrees with the taste of the time, but it is exaggerated in a peculiar way and on occasions spiced with irony against the very things he loved. At the academy in Vienna he studied under Rahl, and in Munich he became an enthusiastic disciple of Wilhelm von Kaulbach. From 1857 to 1876 he lived in Rome, where he was successful with mediocre genre-pieces. Towards the end of his stay in Italy his portraits assumed a new intensity by reason of an interest in psychology, and a restlessness of form, a tendency that increased steadily as time went on. In these efforts to grasp the totality of life, as it could not be grasped in pure painting, Romako was a forerunner of Kokoschka's early Expressionist portraits. He created tension by means

243. Anton Romako:
Admiral Tegetthoff at the Battle of Lissa (II),
c. 1880. *Vienna, Österreichische Galerie*

of a feverishly agitated brushwork which pervades the whole of his delicate colour schemes. In the last years of his life, which Romako spent mainly in Vienna, he produced a number of masterly landscapes, especially the views of the Gastein valley (1877, Vienna), and a battle picture entitled *Admiral Tegetthoff at the Battle of Lissa* (*c.* 1880) [243], of which he made several replicas. No other history-painter of the time produced such a direct vision of a moment of danger as Romako in this picture, with its silhouettes which are monumental and yet at the same time quivering with explosive force.

The background in Austria against which the phenomenon of Romako's art stands out was a very moderate Realism. Curiously enough, Waldmüller's painting of light found no direct followers. The most objective form of Realism was August von Pettenkofen's (1822–89). He adopted a light palette very early in his career and produced atmospheric moods in the manner of the later Barbizon painters [244]. His beginnings, as a pupil of Franz Eybl, were Biedermeier; in the 1840s he made lithographs in the style of Gavarni and the French military painters and at the same time developed his own style inspired by the eastern Hungarian Puszta and its inhabitants, which he had discovered during visits to Szolnok. Two other Viennese painters were also working there at the time – Johann Gualbert Raffalt (1836–65) and Leopold Carl Müller (1834–92). The native Hungarian painters, on the other hand, for the most part preferred to work outside their own country. Outstanding among them was the landscape-painter László Paál (1846–79), who, like his friend Munkácsy, lived in turn in Vienna, Munich, Düsseldorf, and Paris. Paál spent his last and most fruitful years at Barbizon, and in his pictures of the Forest of Fontainebleau, a personal, very lively plein-airism asserts itself side by side with the Barbizon tradition. In the field of landscape-painting his work is a counterpart of Munkácsy's.

244. August von Pettenkofen:
Austrian Infantry crossing a Ford, 1851.
Vienna, Österreichische Galerie

Bertalan Székely (1835–1910) was another artist who studied in the West, at Vienna, Munich, and Paris, but from 1862 on he worked in Budapest. He was one of the numerous pupils of Piloty, but fortunately he did not succumb, even in murals, to the allurements of Piloty's style so completely as his fellow-countryman Gyula Benczúr (1844–1920). In his self portrait of 1860 (Budapest), Székely managed to subdue his fiery natural talent to a tranquil simplicity and thus to produce one of the finest works in Hungarian painting.

In Pettenkofen's late works we already find an assimilation of many of the elements of French Impressionism, and the same can be said of other Austrian landscape-painters of the time, especially Eugen Jettel (1845–1901), Rudolf Ribarz (1848–1904), and Tina Blau-Lang (1845–1916), all of whom spent long periods in France. Nevertheless, in essence these Viennese landscapes are pre-Impressionist, bound by many threads to the Barbizon Realism and still tinged with Romanticism. Veiled, broken tones, not vigorous colours, are generally used, even by Pettenkofen, who, as he became more and more Impressionist, tended more and more towards monochrome. The real essence of this painting, as it was of the landscapes of the Hague School, is mood – a soft and gentle, slightly melancholic mood. Its most delicate gradations

245. Emil Jakob Schindler:
Landing-Stage on the Danube near Vienna, c. 1872.
Vienna, Österreichische Galerie

are found in the landscapes of Emil Jakob Schindler (1842–92), whose *Landing-Stage on the Danube near Vienna* dating from the early 1870s is a beautiful reminiscence of Corot [245].

Switzerland, within this art of limited horizons, exhibited national characteristics more clearly than she had done before. Albert Anker (1831–1910), who was his country's best genre-painter, differs notably from the genre-painters of the same type outside Switzerland. He shows the same things and relates the same trifling anecdotes as Knaus and his fellow-countryman Vautier, for example in his *At the Registrar's* (1887, Zürich), *At the Quack Doctor's* (1879, Basel), *The Country Funeral* (1863, Aarau), and his scenes in village schools and of children's life in general, but the mawkishness and the

gloomy studio light are redeemed by coolness and clarity. Whereas celebrities like Knaus, Vautier, and Defregger allowed their art to become more and more arid, Anker became increasingly free and easy in the execution of his pictures. He set himself specific problems in the rendering of light and thought about his colouring. His training in the studio of Gleyre and periodical visits to Paris bore fruit. From French Impressionism he eventually adopted the general lightness of colour, just as the Frenchman Jules Bastien-Lepage (1848–84) and his pupil the Russian Maria Konstantinowna Bashkirzew (1860–84) did about the same time in their genre scenes and pictures of workmen. Partly as a result of direct contacts with French plein-air painting, Swiss artists

like Robert Zünd (1827-1909), François Bocion (1828-90), and Ernst Stückelberg (1831-1903) followed in the footsteps of Barthélemy Menn, who had been the first to explore the possibilities of a strict adherence to reality in the rendering of light [176]. The artist who went furthest in this direction was Frank Buchser (1828-90), the most radical and versatile of Swiss nineteenth-century painters. His relationship to his Swiss colleagues reminds one of that of Anton Romako to his milieu, and in addition to this some of Buchser's early portraits are very close to Romako in their restless neo-Baroque. In his later works, in place of this romantic glow, Buchser showed his receptiveness to the new experiments in painting. He remains a Romantic in his restlessness and his love of travel, which took him all over Europe and even overseas: he paid many visits to Paris and England and also went to Spain, Holland, Belgium, Dalmatia,

and Montenegro; in Rome he joined Garibaldi in the fighting of 1849, he took part in a campaign against the Kabyles in Morocco, and from 1866 to 1871 he lived in North America [246]. In the radiant sunshine of the landscapes and portraits which he painted after his stay in the United States he comes very close indeed to the Impressionists, quite as close as the Italian Macchiaioli. In such works Ferdinand Hodler was able to find the foundations of his decorative form.

The work of a number of German painters of the same time is dominated by a Romanticism that became more and more permeated with Realism but was never completely transformed. When they had to deal with landscape they thought naturally in terms of mood, and they created the German variant of the 'paysage intime'. Their derivation from the Barbizon School is often clearly visible. This is true, for

246. Frank Buchser: Negro Hut in Charlottesville, c. 1870. *Basel, Kunstmuseum*

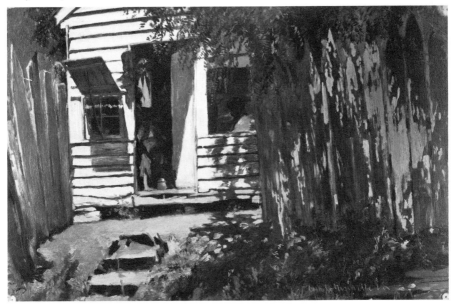

example, in Munich of artists still belonging to the older generation such as Eduard Schleich, a friend of Spitzweg, and Adolf Lier (1826–82) and in Frankfurt of Karl Peter Burnitz (1824–86). Only occasionally do we find a more independent painter like Karl Buchholz (1849–89) of Weimar. In the field of genre-like history painting, the most influential teachers at the Munich academy besides Piloty, Wilhelm von Lindenschmit (1829–95) and Wilhelm von Diez (1839–1907), managed to preserve so much naturalness and originality in their painting, despite their indebtedness to the French and Belgian history-painters, that they became important sources of inspiration for Leibl and other Realists at the outset of their careers.

This Munich training with its mixture of Realism and Idealism was also the background against which a curious outsider, Wilhelm Busch (1832–1908), developed. His stay in Munich, however, had been preceded by something even more decisive, a year at the academy in Antwerp (1852–3), where he acquired a knowledge of the great Dutch masters. These,

and in particular Frans Hals and Brouwer, remained a determining influence in his art, to such a degree that a large proportion of his paintings are paraphrases of Dutch pictures, both in the subjects – tavern scenes, portraits in Dutch costume, still-lifes – and in the delicately chromatic method of painting with rapid, sweeping brush-strokes, Busch himself realized that in his painting he would never be able to 'get out of his Netherlandish skin';[3] so he kept painting a secret. In any case he was fully aware of the superiority of his graphic work. His drawings, too, clearly show the influence of the Netherlands, especially that of Ostade, Brouwer, and the inexhaustible profusion of Rembrandt, but in this case it is not merely a matter of imitating. Busch's drawings are a counterpart in the field of graphic art to the revival of Dutch painting which was of such cardinal importance during almost the whole of the nineteenth century, but he shows far more independence than any of the landscape-painters. He was, at least in so far as he expressed himself in the medium of drawing, a real kinsman of the great Dutch

247 *(below)*. Wilhelm Busch: Fuga del Diavolo. Wood-engraving from *Ein Neujahrskonzert*, 1865

248 *(opposite)*. Wilhelm Busch: Wood-engraving from *Die fromme Helene*, 1872

painters of peasant life, starting right back from Bruegel. What he had in common with them was a particular kind of vitality, and an ability to express in the rhythm of a drawing the life and movement of the innumerable figures of the little village world [247, 248]. In this respect he was on the level of the most brilliant of nineteenth-century draughtsmen. In the vigour of satire, on the other hand, he was inferior to Daumier, Nestroy, or Gogol; for his view of mankind remained chained to the pessimism of Schopenhauer. The difference between this bitter scepticism and the tragic pathos of Daumier can however also be regarded as the difference between two generations, and, in addition, between two nations. For one of Busch's most profound characteristics, the fairy-tale atmosphere, the poetical fancy, are profoundly German. It is a contemplative element and it mitigates the rationalism of Busch's moral attitude. Mystery appears in his drawing side by side with rationalism, and everything is conveyed by drawing alone, to a greater extent than in any other German illustrator of the period.

Moreover, Busch succeeded in creating types valid for all time. The first of these types were the two rascals *Max und Moritz* (1865), who soon became famous all over the world, and they were followed by the other heroes of his 'Picture Stories', most of which he produced in his native village of Wiedensahl in Lower Saxony.[4] These picture stories, 'little curricula in abstracto' as Busch himself described them, are composite works of art of unique compactness, in which Busch's drawing and his rhymed comments, his imagery and language, the illustration of reality and a grotesque humour are perfectly balanced. With the precision of the inescapable they reveal the spirit of an age dedicated to Realism, and at the same time are a criticism of it – especially when the interplay of forms and ideas reaches up into the realm of fancy.

Adolf Oberländer (1845–1923) also worked for many years in Munich for the *Fliegende Blätter*, and he ranks with Busch as an artist who overcame the temptations of Realism by virtue of a spiritualized and humorous style of drawing. Yet this style was completely different from Busch's, because Oberländer's temperament was fundamentally different. His strokes, every bit as sure as Busch's, have a fragile delicacy, and the attitude to mankind which they express retains a certain ironical good-nature. In the inmost mind of Busch there were complications and contradictions, and his tenderness and sensitiveness often gave way to coarseness and, on occasion, an oppressive, demoniacally caustic sneer. In Oberländer everything is simpler and clearer, and even the slightly humorous idyllicism of his paintings forms a unity with his caricatures.

During the years when Realism began within Romanticism, Italian painting remained marginal and little noticed. Even the intensive production of the innumerable foreigners who came to Italy from beyond the Alps, and even from as far away as Scandinavia, had no influence worth

mentioning on the painting of the country. This is as true of landscape as it is of classical, idealistic figure-painting. From Carstens to Cornelius, and even to Ingres, foreign work bore no indigenous fruit.

One exception must, however, be noted: Giovanbattista Bassi (1784–1852), who worked in Rome, with his intimate landscapes full of an accurate observation of nature came close to the sunny, semi-Romantic Realism of Josef Rebell. The relationship between Italian painting and foreign painting on Italian soil can be clearly seen in the works that Thorvaldsen collected,[5] though he neglected one category of Italian painting, that which can, at least with some justification, be called Romantic and of which the best representative is the North Italian artist Giovanni Carnovali, called Piccio (1806–73). In reality, however, what Piccio inserts into his figure pieces is not so much Romanticism as a delicate neo-Baroque in the manner of Hayez, achieved by means of a sensitive, transparent *sfumato* (*Girl bathing*, 1868, Milan, Civiche Raccolte d'Arte). A generation later another North Italian, Tranquillo Cremona (1837–78), carried this manner to an astonishing degree of sultry haziness.

Naturalism made its first appearance in Italy towards the middle of the century in the genre-paintings of the brothers Domenico (1815–78) and Gerolamo Induno (1827–90), but in them nature is given no greater emphasis than in the works of Knaus and Vautier. There is the same combination of extreme realism in the details of material things and a conventional, complaisant idealization appears both in the types and in the composition.

One group only worked in opposition to this typical art of 'minor masters', which in Italy occupied more of the scene than in other countries. This, which represented a revolt of free, independent form against illustrative constraint, unimaginative eclecticism, and academism, was known as the Macchiaioli or 'pointil-listes'. Both as regards the open form and the new feeling for nature, the painting of Corot had prepared the way for them [125, 126, 128]. The pioneering years of the movement were the early sixties, the years of achievement the later sixties. The movement began with the early works of Giovanni (Nino) Costa (1826–1903) of Rome, in pictures such as his *Women of Anzio* (*c.* 1850, Rome, Guerrazzi-Lemon Collection) and *Women carrying Faggots at Porto d'Anzio* (1852, Rome, Galleria Nazionale d'Arte Moderna). After 1859 Costa lived for a long time in Florence, and in the 1860s he made journeys to Paris and Fontainebleau, where he came into personal contact with Corot and the painters of the Barbizon School. Florence was the home of the Macchiaioli movement, and the meeting-place of the leaders of this artistic revolution during the 1860s was the Caffè Michelangelo. Some of the painters of the group took part in the wars of the Italian Risorgimento in 1859–60 and 1866, thus demonstrating their desire for freedom in their lives as well as in their art. The urge towards simplification was a fundamental human and artistic feature. For them simplification meant a reduction of painting to clear contrasts of brightness and colour. This in no way represented a coarsening; for the Macchiaioli tried to instil into their bold silhouettes all the rich essence of light and mood. In many of their best works they succeeded; for example in *The Rotonda di Palmieri* (1866) [249] by Giovanni Fattori (1825–1908), the leading painter of the group, and in numerous works by Raffaello Sernesi (1838–66), Giuseppe Abbati (1836–67), and Vito D'Ancona (1825–84). The view here reproduced [250] shows the extreme form of Macchiaioli rendering of light, the ultimate consequence of the use of the 'point' or spot system.

This painting, as a first step towards Impressionism, was, like Impressionism itself, an attempt to represent purely objectively the optical phenomena of light. Nevertheless there

249. Giovanni Fattori: The Rotonda di Palmieri, 1866. *Florence, Galleria d'Arte Moderna*

is a great deal of Romanticism in the lighting effects of Macchiaioli pictures. In addition, something in all of them can be called specifically Italian, and that distinguishes their art from that of Swiss contemporaries such as Menn, Bocion, Stückelberg, and Buchser, who in other respects are most closely akin to them. This is the 'literary' quality which cannot be excluded from the achievement of simple, 'great' form. To quote an example, in Fattori's *Patrol* of *c.* 1885 [251], the faithfully rendered, homogeneous, empty surface of the brightly lit wall

250. Vito D'Ancona: Gateway, *c.* 1870-5. *Florence, Galleria d'Arte Moderna*

(whence the second title of the picture, *The White Wall*) has also a value as the expression, in a much more general way, of the heat of scorching sunlight, and the abandoned house in the middle of the landscape in *La Sardigna* (Florence, Terni Collection) is also an image of loneliness. The same attitude appears in the attempts of Telemaco Signorini (1835-1901), the theoretician of the Macchiaioli, and of Silvestro Lega (1826-95) to express inner processes in figure scenes by Macchiaioli means. In pictures like Lega's *The Visit* (1868) [252] and *The Last Sacrament* (1865, Florence, formerly Giustiniani Collection), the melancholy of old walls is every bit as eloquent as the solemnity of the groups of figures, which are reminiscent of those in Quattrocento pictures. Not only does a delicate undertone of genre appear, but a spiritual message is conveyed in the language of form, to a greater extent than anywhere else in nineteenth-century genre-painting during the vogue of Realism. Only in isolated works of the German Romantics, such as the drawings of

Ferdinand Olivier, is there a comparable unity of form and content [75, 76]. This, even more specifically than their great competence in painting, was the real achievement of the Macchiaioli.

The 'literary' element and the monumental simplicity of construction – which, incidentally, progressive as it is, hardly ever makes use of the 'Japanese' spatial obliqueness that had so much influence in other countries – are also found in the works of painters who did not belong to the Macchiaioli group, for example in the tranquil and cool interiors of Gioacchino Toma (1836-91) such as his *Luisa Sanfelice in Prison* (1877, Rome, Galleria Nazionale d'Arte Moderna). The next step is the work of Giovanni Segantini (1858-99), where symbolism is more obvious and the language of *peinture* completely different. After the end of the 1870s the painterly form of pointillism degenerated into multifariousness and virtuosity, even in the works of painters who for a long time had been very close to the Macchiaioli, such as the Venetian Gia-

251 *(opposite)*. Giovanni Fattori: The Patrol, *c.* 1885. *Rome, Marzotto Collection*

252 *(below)*. Silvestro Lega: The Visit, 1868. *Rome, Galleria Nazionale d'Arte Moderna*

como Favretto (1849–87), the Apulian Giuseppe De Nittis (1846–84), and Giovanni Boldini of Ferrara (1842–1931). Lively stories and glittering effects in the rendering of materials and light are characteristic of a few slightly older Southern Italian painters, for example Giacinto Gigante (1806–76), Filippo Palizzi (1818–99), and Domenico Morelli (1826–1901). Gigante became the leader of the School of Posillipo, to which Palizzi also belonged. They were a group of landscape-painters who preceded the Macchiaioli in the immediacy of their observation of nature but never reached the radicalism of Fattori, Lega, or Toma. The best landscapes of Gigante are, in their sketchy treatment, a late parallel to the sketches of Blechen and Granet.

Morelli's painting had a decisive influence on the Spaniard Mariano Fortuny y Carbó (1838–74), who made many visits to Rome. With his Moroccan scenes and his much imitated genre-pieces of Rococo subjects, Fortuny became one of the most popular and extreme representatives of a dazzling, gorgeous virtuosity. Spain's official portraitist at this time was the court painter Federico de Madrazo y Kuntz (1815–94).

Quite a number of Italian realistic painters strove to achieve direct contact with the painting of Western Europe and visited Paris (Nino Costa, Boldini, De Nittis, the Macchiaioli D'Ancona, Signorini, De Tivoli), but London also attracted them. This may at first sight seem strange, but we must remember that these Italian painters painted not only southern gaiety, but also melancholy natural and imaginary landscapes, impressions of grimy suburbs as well as of sunlight. Costa, De Nittis, Signorini, Boldini, and Serafino De Tivoli all lived for some time in London.

However close the connexion between these artists and the Macchiaioli and their followers, the fact remains that Macchiaiolism as a whole, with the boldness of its forms and its sensitiveness to the human element, remained a cul-de-sac in Italian nineteenth-century art, an 'Early Renaissance' that was not followed by any 'High Renaissance'.

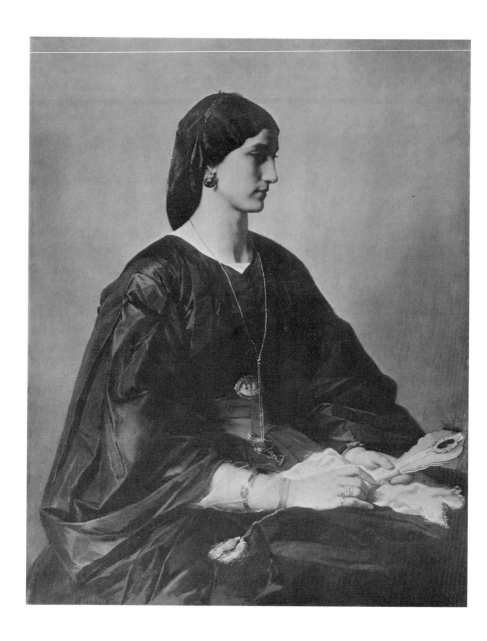

253. Anselm Feuerbach: Nanna, 1861. *Stuttgart, Staatsgalerie*

'INTELLECTUAL' PAINTING IN THE LATTER HALF

OF THE NINETEENTH CENTURY

Side by side with Realism, painting during the second half of the nineteenth century evolved a sharply defined Idealism. This sort of contrast had existed before, and in an age marked by individualism it need cause no surprise. What distinguishes it in different epochs is the relationship of the two elements to each other. In seventeenth-century Holland, for instance, Rembrandt's intellectual and transcendental genius succeeded in balancing the whole trend towards realism. In eighteenth-century painting on the other hand realism was without any doubt a sideline, however important its aims were to be for the future. In the first half of the nineteenth century it is hard to say which of the two elements predominated, but there is no doubt that during the latter half of the century it was realism. All the essential innovations were on its side, whereas the 'intellectual' tendency continued to follow old conventions and lacked a genius capable of presenting them with a validity powerful enough to break through the natural inclination of the moment.

In two cases we find 'intellectual' painting with a broader scope and a consistent programme: in the art of the English Pre-Raphaelites, and in that of the painters known as the 'German Romans',[1] whose leaders were the German Feuerbach and the Swiss-German Böcklin.

ANSELM FEUERBACH (1829-80)

Anselm Feuerbach was born at Speyer in 1829. He came of a highly cultured family, being the son of an archaeologist and the nephew of the philosopher Ludwig Feuerbach. He began his training as a painter at an early age, in 1845, at the Düsseldorf Academy under Wilhelm Schadow, Lessing, and Schirmer. From 1848 to 1850 he studied at the academy in Munich, where he was influenced by Carl Rahl (1812-65). This Viennese artist, who happened to live at Munich at that time, had many qualities which, to young students, must have seemed far more attractive than the cold bombast of his confrère Wilhelm Kaulbach (1805-74) with his crowded figure-pieces. Rahl possessed a genuine feeling for colour, which lends a touch of life and vigour to the conventional and eclectic elements in his work. Between 1851 and 1854 Feuerbach made two visits to Paris, which gave a definite direction to his work. Courbet and Couture were the two artists who exercised the strongest influence on his art, that of Couture being unfortunately the stronger. Two pictures from this period, *Hafiz outside the Tavern* (1852, Mannheim) and *The Death of Aretino* (1854, Basel), are the best proof of this, and at the same time the real starting-point of Feuerbach's art. In 1855 Feuerbach went to Italy with the poet Josef Viktor von Scheffel, first to Venice, where he studied Titian and Veronese, then via Florence to Rome. Here he produced all his most famous works: the long series of portraits of *Nanna* (his model Nanna Risi) [253], the *Medea* (1870) [254] and two preliminary versions of this work executed in 1866 and 1867 (Breslau, Städtische Sammlungen, and formerly Berlin),[2] the *Battle of the Amazons* (1873, Nuremberg, Künstlerhaus), and *Iphigenia* (1871, Stuttgart). From 1873 to 1876 Feuerbach taught at the academy in Vienna, where he painted *The Fall*

254. Anselm Feuerbach: Medea, 1870. *Munich, Bayerische Staatsgemäldesammlungen*

of the Titans on the ceiling of the main hall. His last years he spent in Venice.

After long failing to achieve recognition, Feuerbach finally became an object of veneration as one of the greatest German painters, the accent being more or less deliberately placed on the word German. On the other hand, his art has also long been admitted to be somewhat problematic. The indisputably high quality of many of his portraits is mainly due to their deliberately statuesque tranquillity and clarity – qualities which he considered necessary for the achievement of classic harmony. Referring to his portraits – and also to certain purely heroic landscapes – Feuerbach himself was right in speaking of a 'truly majestic, forbidding tranquillity'.[3] There is indeed an identity between the composition and the aristocratic super-humanity and immaculateness represented. In his figure compositions, however, Feuerbach hardly ever managed to get so far. If we wish to understand what is so problematic in them, we must compare them with the earlier German idealism in figure-pieces since Carstens [26, 27, 70]; for they share with Feuerbach the desire to represent a higher world of heroic humanity, and so both they and Feuerbach as a late Classicist suffer from the unavoidable cleavage between the wish to portray the sublime and the remote and the inability to fulfil it. But Feuerbach's failure has a further cause, a cause connected with his aestheticism. At all times aestheticism was fatal to the idea of Classicism. Carstens and Koch [35], Cornelius and Rethel [170-2], and even the Nazarenes with their naively melodramatic scenes [68, 69], were in this respect at an advantage over Feuerbach. With his over-refined palette based on muted greyish-violet and dull green, Feuerbach certainly endowed his figures with a melancholy gravity, in contrast to the clumsy brightness of the Nazarenes, but at the same time he gave them all the artificiality of stage characters. The almost tragic inner uncertainty concealed behind the composure of Feuerbach's figures is betrayed by the fact that in the composition of the *Fall of the Titans* in the Academy at Vienna he resorted to the scheme of Baroque ceiling-pictures – in complete contradiction to the imitation-antique architecture!

255. Arnold Böcklin: The Awakening of Spring, 1880. *Zürich, Kunsthaus*

ARNOLD BÖCKLIN (1827-1901)

Nobility and dignity were the spiritual foundations of Feuerbach's world, but its limits were relatively narrow, and this narrowness is almost an expression of self-conscious, aristocratic pride. When Feuerbach emerged from his ivory tower and tried to create dramas instead of elegies, the result was a failure. Böcklin's attitude on the other hand was almost at the opposite pole, despite the fact that, like Feuerbach, he tried to paint symbols. He started from the 'ideal' landscapes of Schirmer and the pathetic mountain landscapes of Calame and proceeded to a conception of landscape with lyrical, tonal colouring; that is, from obvious generalization to refinement. Most of his best-known works were painted in Italy. He went there for the first time in 1850, after studying in Düsseldorf, in Geneva under Calame, and for a short time in Paris, together with Rudolf Koller. Apart from numerous short visits to his native city of Basel, to Munich, Hanover, and Weimar, and a stay of several years in Zürich (1885-92), he resided in Rome and Florence.

With his change from the lofty aim of achieving a unity of form, mood, and poetry - in this Corot must have been his model - to the supposedly higher aim of a philosophy expressed in pictures, Böcklin's development becomes the paradigm of a typical nineteenth-century aberration. He had never paid much attention to historical subjects. His ambition was manifold invention. His landscapes, already full of symbols, with their rocks and trees, waters and seashores and ruins, were in addition peopled with woodland sprites and other fabulous beings, centaurs, nymphs, fauns, and tritons, battling heroes, and personifications of the ages of man and the forces of nature [255]. He did not, like Feuerbach, nourish an exclusive ambition for gravity, but loved humorous allusions and resounding laughter. Quite a number of his pictures are in fact genre-pieces in mythological costume. His eclecticism left him little scope for genuine invention. On the whole, however, with this literary side of his art and his cheerful indifference to formal values, he contrived to hand down to posterity one of the aspects of his own time, just as Richard Wagner did as a poet.

Böcklin presented ideals which were simple and crude enough to appeal to the taste of the artistically-minded upper-middle-class society of the so-called 'Gründerzeit' or boom period of the 1870s and 1880s. In other words, strictly artistic problems played a limited role in his work – a role certainly more limited than in Wagner's. It was this that was referred to in Germany as the 'Böcklin Case', the 'case' being that of the 'literary' painter, or the limits of the arts and of what can be accepted as artistic.[4] In his celebrated later works he makes us forget that he was a painter at all, for the clash of symbolically intended contrasts between colours became more important for him than the laws of chromatic harmony (*The Island of the Dead*, five versions from 1880 on, Leipzig, etc.; *Ruins by the Sea*, three versions after 1880; *Vita somnium breve*, 1888, Basel; *At the Mercy of the Waves*, 1883, Munich; *War*, 1896, *The Plague*, 1898, both Zürich, Gottfried-Keller Stiftung). The fact that his vitality was as vigorous as ever cannot be accepted as justification. Among these stridently coloured pictures we forget that the artist who painted them had in his earlier days thought not so much of poetry and symbolism, as of achieving good painting. He remains one of those artists who survive, not in their chief works, but in their by-products.

HANS VON MARÉES (1837–87)

Feuerbach and Böcklin followed the principle of using a vigorous Realism in order to bring to life supernatural and invisible forces, legendary heroes and imaginary beings. They were not satisfied with a mere imitation of the appearances of things, but the fictitious was to be endowed with the reality of flesh and blood. Many artists since the end of the Middle Ages had followed the same principle, though it is one of dubious logic. It certainly was a principle which fitted the end of the nineteenth century. But the results achieved by 'intellectual' painting on the lines of Feuerbach and Böcklin – and one is always entitled to judge art by results – showed that it was not the right one.

The case of Hans von Marées was diametrically opposite. Though he was a contemporary of Feuerbach and Böcklin and was also a 'German Roman', his connexion with them was only superficial. Marées's painting is 'intellectual' painting only as regards the choice of subject-matter. The form and even more the idea of his art have nothing to do with what Feuerbach and Böcklin understood by painting. A comparison between Marées and Böcklin is in any case almost useless: it can only serve to show up the incompatibility of art basking in the light of a past tradition and a profoundly serious pioneer achievement. It is true of course that in Marées's venture into unknown lands some traces of tradition still remain, but this shows rather the essential unity of all great figure art than a retrogressive attempt to be historical. In fact no nineteenth-century painter of monumental figure pieces with antique motifs has cared so little about 'historicizing' as Marées.

The greatest and the most important part of his life-work is formed by the theme of the human figure in landscape, but stories or legends are scarcely told, mythological events scarcely portrayed, symbols scarcely expounded, and no thought is ever 'illustrated'. So far as one can talk of thought at all in his work – and in actual fact there is a high degree of deliberateness in it – this must be taken in the sense of thought directly expressed through the medium of form. Such painting excludes all realism. Its fundamental principle is vision, the vision of a formal pictorial structure which in the course of its realization makes use of the human figure and of a carefully measured landscape setting. 'I long for nothing more than the moment in which conception and representation will flow together to form a unity',[5] Marées wrote on 10 April 1871 to his self-sacrificing friend, the art theorist Konrad Fiedler. The rigour with which a lofty

aim was pursued without any deviation and finally achieved, has few parallels throughout the whole of the century. The first indications of it date from the beginning of the 1860s. An example is the *Resting Cuirassiers* (1861-2, West Berlin), which thematically is still related to the early, insignificant pictures of soldiers and horses which he had painted during his apprenticeship to Steffeck in Berlin in 1853-4 and during the years round 1860 in Munich. In these early pictures there are still traces of Franz Krüger's cool, gay objectivity. Marées's stay in Munich helped him to achieve suppleness and pictorial freedom, as is proved by the portrait of

The Artist and his friend Lenbach painted in 1863 (Munich). In that year Marées also painted *The Bath of Diana* (in the same gallery). In this picture, in the *Rest on the Edge of a Wood* (present whereabouts unknown), also dating from 1863, and in the *Horse Pond* (Munich), painted a year later, we find for the first time the typical clarity of the pictorial structure, the Poussin-like element in Marées, the element which qualified him for mural painting. It was not until ten years later, however, while he was in Italy, that Marées in his frescoes in the Zoological Institute at Naples (1873) [256] was able to try his hand at monumental painting.[6] In 1864 he went

256. Hans von Marées: Friends of the Artist in a Pergola, 1873. Fresco.
Naples, Library of the Zoological Institute

257. Hans von Marées:
The Hesperides (II), 1884-5.
Munich, Bayerische Staatsgemäldesammlungen

258. Hans von Marées:
The Rape of Ganymede, 1886-7.
Munich, Bayerische Staatsgemäldesammlungen

with Lenbach to Italy, a country which he subsequently left for only one period of any length, when he lived in Berlin and Dresden from 1869 to 1873. Graf Schack helped the two painters, as he helped Feuerbach and Böcklin, by commissioning them to copy pictures for him (see Chapter 13, Note 6). A series of paintings containing groups of figures in landscapes[7] and a few important portraits[8] are the preliminary steps toward the frescoes in Naples. These were actually the only murals Marées painted, but from then on he devoted himself almost exclusively to monumental figure-pieces; in his four large triptychs with painted frames and pedestals he adhered to the form of mural paintings even in the dimensions. These triptychs, all now at Munich, are *The Hesperides* (two versions, 1879 ff. and 1884-5) [257], *The Judgement of Paris* (two versions, 1880-1 and *c.* 1884), *Three Saints on horseback: St Martin, St Hubert, and St George* (two versions), and *The Wooing* (1884-5). In addition Marées painted smaller figure-compositions of the same kind, such as his last work, *The Rape of Ganymede* (1886-7) [258], and various portraits.

Compared with the later monumental pictures, the frescoes in Naples, although among the most important examples of mural painting

in the nineteenth century, are works of transition, preliminary stages on the road towards a perfection which can be only dimly divined from them. Viewed from a broader historical standpoint, Marées's monumental figure-pieces are a return to the older ideals of architectural structure as they had been demonstrated in the figure-compositions of Mantegna, Signorelli, and Piero della Francesca, of Raphael, Michelangelo, and Poussin. In looking to them Marées turned away from the neo-Baroque or pseudo-Baroque ideal of monumental painting that had prevailed for many decades. Since in his figures the hallowed antique canon of balance and simplicity and of the secret geometry of the human body is clearly obeyed, his art can be called a kind of Classicism. One can easily see, however, that in this Classicism a completely new role is assigned to colour. Marées was the second great Classicist in the nineteenth century who was also a great painter. Ingres had been the first.

What distinguishes Marées from Ingres, however, is the role of colour in their work. In Marées, despite its ascetically limited range, colour is so powerfully used in the all-important endeavour to construct basic stereometric forms that it plays at least as great a part as the proportion and outlines, and indeed tends to obscure the latter. Rembrandt-like shadows surround the gleaming nude bodies, and a complicated tempera technique with a great deal of overpainting helps to give the groups of figures chromatic richness and at the same time to veil them in a haze of visionary spiritualization. Whereas idealistic painting since the beginning of the century had paid tribute to Realism and found, or thought it could find, strength and support in it, Marées's form is independent of realism. It is for this reason that in his art the relationship between composition and portrait is different from that in the works of other 'idealistic' painters from Mengs to Feuerbach. In their cases portraits had invariably been superior to imaginary compositions as regards

formal as well as painterly qualities. Marées's portraits too were for a time warmed by closer contacts with nature, for example the full-length portrait of Fiedler painted in 1869–71, which lies midway between Courbet and Manet. But a portrait like that of the writer Hans Marbach, dating from 1871 (Vienna, Kunsthistorisches Museum), is already covered by that veil of solemnity which indicates the increasing strength of the form – just as it is in Manet's portrait of Zola [268]. In the end Marées reached the point where his portraits, e.g. the self-portrait of 1883 [259], display the same visionary spirit as his figure-pieces, an exceedingly rare phenomenon in nineteenth-century art. Never-

259. Hans von Marées:
Self-portrait, 1883.
Munich, Bayerische Staatsgemäldesammlungen

theless Marées's ideas did not lead him to decorative patterns or to abstractions. We are here confronted with the same question as we are when we consider the art of Delacroix (whose late frescoes in Saint-Sulpice [102] have a close relationship with the late works of Marées), namely what kind of world is created by these figure-compositions? If it is a world of sublimity and harmony as conceived by the Classicists, then their Classicism is akin to Schubert's settings of Mayrhofer's antique poems, or, to take an example nearer to Marées's own time, to Hugo Wolf's *Lieder*. Like this music, Marées's art is full of nature, and the more monumental it is the more natural it becomes. Something of this mystery can be explained by Marées's imperturbable concentration on the most elementary bodily forms, and on relationships between body and space. This made it possible for him to remain true to nature without resorting to realism of the surface. Colour could prevent any petrifaction in the geometry of forms and in addition fulfil the important function of giving life to the monumental structure of the picture plane. To describe what the picture plane signifies in the painting of Marées would require a separate chapter. The new consciousness of its value in modern painting has here its beginning – here and in the art of Cézanne, who achieved the same aims at about the same time, partly, like Marées, in imaginary figure-pieces, but for the most part, and much more broadly, in the rendering of ordinary visible nature. Following the speculations of Konrad Fiedler, who had investigated the meaning of art along the lines laid down by Kant, Marées sought to discover, by creative means, the fundamental characteristics of painting as an art of the surface. The enigmatical relationships between the picture as an image on a surface and the objects in the pictorial space, which in all great painting of the painterly kind constitute the real life of the picture, had never been revealed before in this way in works of monumental

painting. The Naples frescoes [256] may not go beyond preceding achievements, but the triptychs certainly do [257]. Marées's final synthesis is the outcome of a new situation, and signifies an important moment in the history of painting. When, after much tribulation, this synthesis succeeds, the image made up of forms by the artist contains, despite the renunciations, all the vigour of nature, and 'conception and representation' really 'flow together to form a unity'. The spiritual element that Marées wished and was able to represent, is something like a modern version of Winckelmann's 'noble simplicity and tranquil grandeur'; it remains within the narrow bounds of vegetative tranquillity and melancholy, of dreaminess and absorption, but these spiritual qualities have become embodied in the form. The sublimity of this arcadian figure-world of Marées is a sublimity of forms and colours, which no longer needs the assistance of intellectual content but stands on an equal footing with it. In this sense, Marées's art is the very antithesis of Realism, and is completely different from Feuerbach's, Böcklin's, and the Pre-Raphaelites' 'intellectual' painting.

His art had little direct influence and was not properly understood until the twentieth century. Even Fiedler's appreciation did not grasp its full significance. Two direct pupils of Marées, the Austrians Karl von Pidoll (1847-1901) and Viktor zur Helle (1839-1904), were certainly unable to follow their teacher into the depths he explored. The nearest analogy as regards attitude towards art is to be found in the work of a sculptor, Adolf von Hildebrand (p. 413 f., illustration 329), who for a time was on terms of close friendship with Marées.

One would like to be able to say that the rest of the neo-Classicist and neo-Romantic painters, those who were not 'German Romans', can be accommodated in the great span between Böcklin and Marées as the two extremes, but that was not the case. Marées's path lay far from the beaten track, and in historical or allegorical

fresco painting taken as a whole we find only a Realism without any feeling for the laws of the mural, or nothing but efforts of epigones following the methods of the Renaissance or the Baroque. If anything good came out of this 'intellectual' painting, it was no longer, as had still been possible at the time of Schwind, in the fields of invention and draughtsmanship, but in the sphere of painterly and colouristic effects. This situation is clearly mirrored in the art of two Austrian painters, the Viennese Hans Canon (in reality Johann von Strašiřipka; 1829-85) and Hans Makart (1840-84), who was born in Salzburg. Both of them lived in the Vienna of the boom years, and the spirit of the time, and also of the city, is expressed in Canon's case in a distinguished and in Makart's in a somewhat obtrusive manner. In his figure-pieces Canon hardly got beyond paraphrases of Rubens, but he was more independent in many of his portraits, which are based on delicate, subdued colours in gallery tones. Makart was a faithful pupil of Piloty in that he cultivated pompous, historical costume-pieces on a gigantic scale (*The Entry of Charles V into Antwerp*, 1878, Hamburg; *The Plague in Florence, or The Seven Deadly Sins*, 1867-8), and allegorical compositions. What he added of his own was a decorative splendour of colours which derived from the great Venetians, Titian and Veronese. The hectic glitter of this painting, its hothouse atmosphere and its erotic perfume gained Makart an exaggerated admiration during his lifetime and left him completely rejected soon after his death. In the same way as the greater Munkácsy, he is typical of his age in the effect he produced on his own times and on posterity, as well as in a genuine gift for painting which appears in many details. He even produced a few masterpieces, like the early *Lady playing the Spinet* (1871, Vienna).

On the rest of the Continent, as we have already said, there was no 'intellectual' painting on the large scale, just as there had been no

Romanticism in the narrower sense. It was essentially alien to the French character. Gustave Moreau (1826-98) [260] thought he had found in symbolism and mysticism an alternative to realism, but on the whole the result was an

260. Gustave Moreau: St Sebastian, *c.* 1875. *Cambridge, Massachusetts, Fogg Art Museum*

unsatisfactory mixture of materialism and attempts to be fanciful. These paintings are very similar in principle to those of the Prague-born German artist Gabriel von Max (1840-1915), who wasted a solid talent for painting on pictures which in their arrangement seem rather like spiritualist séances. Of the genuinely Romantic experience of the exotic which one

261 *(below)*. Pierre Puvis de Chavannes: The Sacred Grove (detail), 1883-4. *Lyon, Musée des Beaux-Arts*
262 *(opposite)*. Henri Fantin-Latour: A Studio at Batignolles, 1870. *Paris, Musée de l'Impressionnisme*

would expect from a pupil of Chassériau something is echoed in Moreau's colourful sketches (which are reminiscent of Monticelli), but hardly anything in his finished pictures, and this despite the exotic draperies and the gleam of the numerous trinkets. This variety of 'intellectual' painting burdened with Realism is also characteristic of its time, and to understand its historical position one should compare its pseudo-decadence with the genuine decadence of the symbolistic painting of a later artist like the Belgian Fernand Khnopff (1858-1921).

PUVIS DE CHAVANNES, FANTIN-LATOUR, CARRIÈRE, AND OTHERS

Pierre Puvis de Chavannes (1824-98) - though with some reservation - can be regarded as the one great exception to the assertion that in France there was no serious 'intellectual' painting. He was certainly a serious artist, and there are traits in his art which place him almost on a level with Marées. Puvis, like Marées, was well aware of the demands made on the artist who wants to master large mural surfaces. For Marées they signified years of worry and hard work, and for this reason much of his painting remained fragmentary, though this is often exaggerated by critics. What Puvis wanted he seems to have achieved effortlessly - sometimes too effortlessly. His art lacks depth, but he never tried to achieve it. His own particular Arcadia was bright and transparent, free from melancholy and pervaded by the *serenitas* of the ancients. Harmony, however, is carried so far as to produce an academic frigidity, and both his

figures and his landscapes are anaemic. The world of gods and nature herself become a kind of 'neutral zone', and the impression we receive is that although this zone is detached from any real corporality in volume and colour, it still lacks the power and mystery of the visionary. The unproblematic and (despite the mythological, religious, and allegorical subject-matter) simple and essentially modest nature of his art saved Puvis from the fate of Marées and brought him fame and important official commissions. His best-known works are the murals (on canvas) of the life of St Geneviève in the Panthéon (1874-8, 1898), and those on the staircase of the museum at Lyon (Palais Saint-Pierre, 1883-4) [261][9] and in the Sorbonne (1887, Allegory of the Arts and Sciences). Puvis was an innovator in mural painting but not a revolutionary, since he always adapted his new ideas to tradition; his work is a sequel to that of Chassériau [112] and found an organic continuation in that of Maurice Denis (1870-1945). Something of his spirit lives on even in the work of one of the greatest French artists of our own time – in Maillol's rustic drawings for woodcuts.

In one portion of his work Henri Fantin-Latour (1836-1904) also belongs to the sphere of 'intellectual' painting, and in particular to its Romantic side. He was one of the French admirers of Richard Wagner and produced a number of rather dusky lithographs illustrating Wagner's operas, poetic visions in the spirit of Wagnerian music, and allegorical homage to other musicians (Berlioz, Schumann, Brahms). In his paintings, on the other hand, the Romanticism is for the most part only a kind of

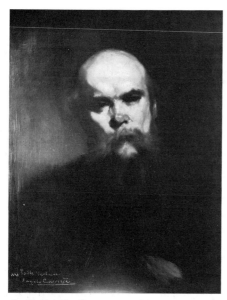

263. Eugène Carrière:
Paul Verlaine, c. 1890. *Paris, Louvre*

264. Odilon Redon:
Pegasus, after 1890. Lithograph. *Vienna, Albertina*

superficial charm, lending a gentle twilight dimness to things of which the conception is fundamentally realistic. It is clear that Courbet meant much to him, both in his flower-pieces and in his portraits. His subdued and silvery colours do not, however, fuse completely with the volume of the bodies, but merely 'tint' them. This is probably one of the reasons why Fantin-Latour's pictures seem so 'photographic', a thing which does not happen when, as in the case of Leibl, Naturalism is carried to a higher pitch. In the oldest of the three well-known group-portraits in the Louvre, *Hommage à Delacroix* (1864), the *Studio at Batignolles* (1870) [262],[10] and *Un Coin de Table* (1872), the figures and heads are arranged in rows as they are in the early Netherlandish groups of the sixteenth century. This is not a deliberate exploitation of the charm of the primitive, as it is in an offshoot of these pictures, the *Hommage à Cézanne* by Maurice Denis (1901), but seems more like a reminiscence of contemporary photographs.[11]

Eugène Carrière (1849-1906) went a step further towards Romanticism. His element is a cloudy chiaroscuro, out of which emerge dreamy, passive figures – his favourite motif being motherhood – but he also produced portrait heads of famous contemporaries (Verlaine [263], Daudet). A process already used by the painters of Barbizon, and especially by Millet, is thus refined and intensified, and at the same time subtly reduced to monochrome – brown on brown in the paintings, a velvety grey in the lithographs. Carrière's art thus leads to a piquant Romanticism, not to any real progress.

Odilon Redon (1840-1916) [264] for a number of years of his activity provides the second great exception to the denial of an 'intellectual' art on a major scale in French painting. The first of course had been Puvis de Chavannes. To do what he did was certainly a hazardous undertaking, since an art so completely dedicated to symbolism and the world of dream-visions as

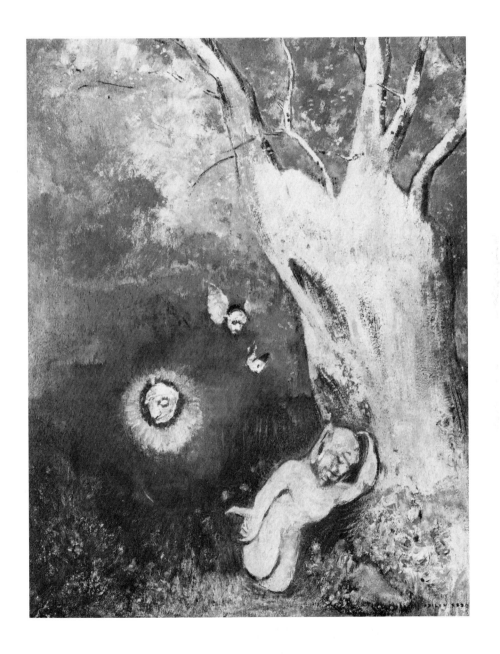

265. Odilon Redon: Caliban's Dream, *c.* 1880–5. *Paris, Ari Redon*

was Redon's from the beginning of the 1870s – before this he had been influenced mainly by Delacroix and Corot – ran the risk of becoming excessively literary. Obviously this danger could only be overcome if the mysterious ideas contained in the pictures found a counterpart in the mysteriousness of form, drawing, chiaroscuro, and colour. This is of course not a matter of an exact correspondence between mystical content and mystical form – as far as the spectator is concerned, he may be moved by the mystery of the formal elements without understanding the symbolic ideas and allusions. It need hardly be added that a residue of obscurity always remains in this kind of symbolic art – obscurity as a lower form of mystery, or rather a pseudo-mysticism. It must be said to Redon's credit that the interplay of vigorous and yet tender forms in most of his works more than compensates for any failure in the symbolical language to convey the secrets of life and death, of existence and the soul, of fear and change. Literature – the writings of Poe and Baudelaire, of Flaubert and Mallarmé, and Indian poetry – for a long time played an important role in his work [265]. The interpreters of the fantastic and the weird in painting were his ancestors and to a certain extent his models – Bosch, Bruegel, Blake, Fuseli, Goya, Meryon, Grandville, the French artist Rodolphe Bresdin (1825–85), a Romantic creator of fantastic visions under whom Redon studied etching,[12] and Moreau, whose pretence at hermetic secrets he converted into genuine mysteries. He also borrowed from Rembrandt. In other cases what seems to be borrowing is merely similarity of subject-matter. In the end, in his flower-pieces and landscapes, Redon achieved a lyrical mysticism, freed from all literary allusion and the burden of realism. He

thus became in his turn an ancestor of the Expressionists and Surrealists of our own days, of Chagall, Klee, and Miró. Since his unbroken artistic development extends beyond 1880, which is the limit of this volume, this is not the place to discuss it. It belongs to the beginnings of 'modern' painting.

In conclusion, it can be said that, viewed as a whole, 'intellectual' painting of the late nineteenth century is a medley, and its variety is not of the kind that is gratifying. Artistic truth, in the rare cases where it appears, stands out sharply against the falseness of the many shallow eclectics. The falseness of those who achieved official successes and throve on compromise forms a link between them and their opposite numbers in the camp of unimaginative, routine Naturalism. In France, painters like Alexandre Cabanel (1823–89) and Adolphe-William Bouguereau (1825–1905) were the highly acclaimed leaders of the first camp; Léon Bonnat (1833–1922) and Émile-Auguste Carolus-Duran (1838–1917) are two representatives of naturalistic society portraiture, though both also painted mythological and historical pictures.

While this confusion still prevailed, a new movement which was sure of its aim appeared upon the scene in France: Impressionism. At the beginning and for a long time afterwards it was received by the public with condemnation and scorn, but painters, even those of the more conservative kind, soon began to admire it – as Fantin-Latour's *Studio at Batignolles* demonstrates [262] – and finally, for the last time in the history of painting down to our own days, it produced something resembling a 'school' on a large scale. A proof is that its world-wide influence has not yet seen its end: there have already been 'Renaissances' of Impressionism.

FRENCH IMPRESSIONISM

The methods of Impressionism, generally speaking, did not appear for the first time in the 1860s. A distinction must be drawn between 'impressionistic' and 'Impressionism', just as we must distinguish between 'romantic' and 'Romanticism'. For centuries there has always been an impressionistic element in art,[1] and during the first half of the nineteenth century there was even more than that, namely real forerunners of consistent total Impressionism such as Constable, Corot, Blechen, and Menzel. When Impressionism ceased to be merely an astonishing, obscure form of expression in the achievements of certain outsiders and became a broad current in art, it naturally underwent many changes. In its fully-developed form, its system and doctrine of vision become more evident. It is advisable to separate the question of what was the aim of Impressionist representation from the other question of what was its formal principle. It is, in fact, indispensable to keep the two aspects separate, for unless this is done one cannot understand its characteristics. What was it, amidst the universal profusion of reality, that the Impressionists tried to grasp? And what was the proportion between their realism and their artistic form?

The answer to the first question is that for the Impressionists there was no theme but the visible. That, however, is a basic statement that tells us very little, since it is also applicable to older kinds of realism. The specific hallmark of Impressionist realism is a particular limitation, namely that, for the painter, the visible is fundamentally nothing more than a complex of spots of colour. Even this could still be considered as forming part of the subject-matter; for this very fabric of spots of colour can at the same time be conceived as essentially a repro-

duction of light and atmosphere, according to the doctrine that the pictorial rendering of the real is possible only through the medium of atmosphere filled with light. In the end atmosphere itself became the only real subject of art.

That answers one of the two questions. The principle of Impressionist painting is an extreme form of illusionism. There still remains the second question, that of the role assigned to artistic form. Here too we find the same sort of ambiguity. For while the fabric of spots of colour was certainly a means to achieve illusionism or, to go a little deeper, was concerned with the expression of a doctrine, the technique of colour-spots also opened the way to an independent colourism. Impressionism is a radically painterly form of painting, and therein lay its great possibilities. The question as to which of the two roots was more important for the genesis of Impressionism, the realistic doctrine of appearances or the urge towards a pure painting, the spot of colour as means to an end or as the end itself, cannot be answered. It should be noted that in France – that much is certain – illusionism and the painting of light progressed steadily towards ever greater achievements, once the Barbizon school had taken to the method of plein-air painting; yet the starting-point of the greatest creative personality in Impressionism, Édouard Manet, was the problem of form.

ÉDOUARD MANET (1832–83)

Manet began his career in the studio of Couture (1850–6). Like others, he eventually outgrew the academism of his celebrated teacher; nevertheless he learned one important thing from him, namely that to be a master one must listen to the teachings of the great masters of the past.

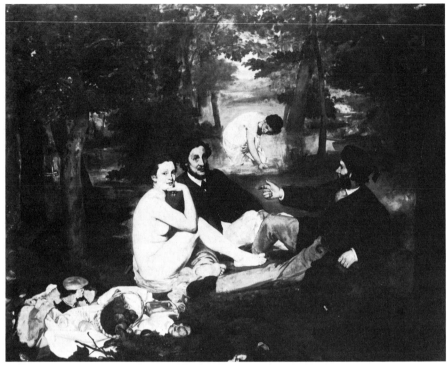

266. Édouard Manet: The Picnic Lunch, 1863.
Paris, Musée de l'Impressionnisme

His relationship to the old masters, however, soon assumed very strange forms. Manet for a long time used motifs and formal elements from old masters, but he used them in a manner which was irreconcilable with the current eclecticism and aroused violent protests. He really did nothing more than Delacroix had done – to mention only the closest analogy – namely look for the fundamental doctrines in the old masters; but the way in which he demonstrated these doctrines seemed very radical and provocative, all the more so because Manet frequently borrowed complete motifs [266].[2] He did this because he wanted to test the validity of his own form by imposing it on motifs and compositions that had become classic, and on the classic chiaroscuro of

'museum pieces', and at the beginning of the 1860s his form was already 'unclassic'. This group of works by Manet thus seems to be something of an experiment, even if that word refers in his case rather to a discovery than an endeavour. The most important and the purest of the results of these experiments was the *Olympia* of 1863, which is already a triumphant fulfilment [267]. The new 'unclassic' element in Manet's painting can easily be defined (in fact he himself defined it): it is the reduction of gradations of tones, and it went a step beyond Delacroix's doctrine of coloured shadows.[3] The succession of these two doctrines is one of the finest examples of the logic of development in French painting during the last century. The reduction

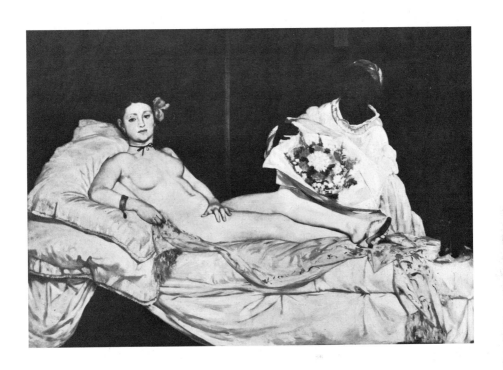

267. Édouard Manet: Olympia, 1863. *Paris, Musée de l'Impressionnisme*

268. Édouard Manet: Émile Zola, 1868. *Paris, Musée de l'Impressionnisme*

of gradations of tones means a subordination of the modelling to a stronger emphasis and cohesion of the picture plane. On the way towards this goal, Manet's two favourite models, Velázquez and Frans Hals, were just as helpful as Rubens and Rembrandt had been to Delacroix. One example will suffice to make this clear: the *Piper* (1866, Paris, Louvre) stands against a pearl-grey ground devoid of perspective in the same way as many of the portrait figures of Velázquez, e.g. the *Admiral Adrian Pulido Pareja* in London.[4] In addition Manet was inspired by the vigorous outline in the masters of the Japanese woodcut, who attracted the attention of artists in Paris from the beginning of the 1860s. Bold silhouette with a minimum of shadow, but with coloured contours, is most clearly noticeable in the *Olympia* [267]. No other painter of the time had seen as clearly as Manet the possibilities which the plane surface in Japanese woodcuts held for completely painterly painting. In his portrait of Émile Zola, Manet's friend and the champion of his art[5] (1868) [268], we see again how a great painter can extract what is essential for his own, very European purpose from an art which is entirely alien in spirit. It is an astonishing and fascinating spectacle. Incidentally, the same thing happened again, some twenty years later, in the work of van Gogh, and again a little later in that of Toulouse-Lautrec.

As regards Manet's painting 'à plat', however, it must also be pointed out that he adopted it not only as a formal principle, nor even for wholly artistic reasons, but also because he observed it in nature. He was in fact at that time producing pictures which were entirely the result of direct observation, such as the *Concert in the Tuileries Gardens* (1862) [269]. In it we find again an extremely sketchy modelling and a composition consisting of large patches of colour and bold silhouettes, with the shadows merely indicated.

269. Édouard Manet: Concert in the Tuileries Gardens, 1862. *London, National Gallery*

The gay whirl of women's dresses, which are simply gleaming masses, and the faces which are vague, hovering patches – notwithstanding the fact that they catch likenesses with uncanny accuracy – would not have seemed so strange to the critics of the time if they had remembered that there was a similar confusion of masses, in which single things and single beings are submerged, in the Romanticism of Géricault and Delacroix, and that the principle behind this is already to be found in Baroque painting. But at that time there was no understanding for such connexions, and moreover Manet's pictures, like those of all other artists, were judged according to the amount of realism they con-

tained. The realistic intention was, quite rightly, appreciated, but people were shocked by a realism in which not only objective clarity was lacking, but even any normal rendering of light. Here the light was neither conventional and non-committal, nor was it precise and naturalistic. In landscapes of a similar kind, the depths of woods and parks, daylight and even patches of sunlight had often been painted in the past.

The peculiar, confusing 'realism' of Manet during the first half of the 1860s is still remote from Impressionism. Also remote from Impressionism is the occasionally very strange spatial perspective. Even before his landscape *The World Exhibition in Paris 1867* (Oslo), we

270. Édouard Manet: The Roadstead at Boulogne, 1863.
Chicago, Art Institute

are reminded of the unusual cadences of the groups of figures in the *Petits Cavaliers*, a picture in the Louvre attributed at that time to Velázquez, which Manet had copied in 1856 (Oslo, Tryggve Sagen Collection) and which also provided inspiration for his *Spanish Ballet* painted in 1862 (Washington, The Phillips Gallery). One might be tempted to speak of a visionary method of pictorial composition [270], if it were not that the word 'visionary' seems high-flown in view of the aloof coolness that invariably characterizes Manet's art. Nevertheless it is 'visionary' in the sense that Manet always begins with the 'vision' of the picture as a picture, as a complex of forms, and above all as a

chromatic composition. This impression, however, is liable to be dispelled by the sovereign ease and elegance, and the lack of pathos, which also became characteristic of Manet very soon after his first experiments and in which his inner affinity to Velázquez is revealed.

About 1870 certain elements in Manet's painting changed. The invented themes disappeared from his work, and he painted almost exclusively subjects taken from the visible world – portraits, landscapes, and still-lifes. Light and spatial perspective, and also the material aspect of things, were henceforth rendered in a more naturalistic way. Another noteworthy change is increased brightness. This, taken with the other

271. Édouard Manet: Chez Père Lathuille, 1879.
Tournai, Musée des Beaux Arts

272. Édouard Manet: The Bar of the Folies Bergère, 1881–2. *London, Courtauld Institute Galleries*

273. Édouard Manet: Country House at Rueil, 1882.
(West) Berlin, Staatliche Museen

things, shows that Manet was approaching Impressionism. It is true that this brightness is a rather superficial characteristic, but it is nevertheless the most prominent and most easily recognizable thing about Impressionist painting. Brightness cannot by itself make a picture Impressionistic, but on the whole it can be said that at that moment a light painting was also a painting of light. Although in this respect Manet associated himself with the illusionism of his Impressionist friends, especially that of Monet, and on occasions even made use of the surprising 'casual' spatial fragmentation and oblique vision in figure-pieces and landscapes which are typical of Impressionism (*In a Sailing-Boat*, 1874, New York; the two versions of the *Rue*

Mosnier [Rue de Berne], 1878, formerly New York, Jakob Goldschmidt Collection, and collection of Lord Butler), he remained faithful until the end to certain decisive elements in his earlier style. Outstanding among these is a firm structure, the predilection for a right-angled framework in the composition of the picture. Almost all the chief works of his later years are proofs of this: the marvellously Spring-like *Chez Père Lathuille*, painted in 1879 [271], *In the Conservatory*, dating from the same year (West Berlin), *The Bar of the Folies Bergère* (1881-2, London, Courtauld Institute Galleries) [272] and the two variants of the picture of the garden of a country house at Rueil (1882, West Berlin and Melbourne) [273].[6] Even when,

towards the end of his career, at a time when his colour was becoming more and more free, light, and brilliant, he showed a liking for pastel in a series of female portraits [274], he retained traces of a statuesque monumentality, despite the tempting liberty offered by the crayon technique. One of his last major works, *The Bar of the Folies Bergère*, is a variant of the idea of the *Breakfast in the Studio* painted fifteen years before (1868, Munich). There is the same continuity in Manet's graphic work [275]. Many of the impulsive late sketches and of the few lithographs (twelve in all) remain closely akin to the monumental etchings which Manet had produced in the early 1860s, during that general revival of the art of etching pioneered above all by the excellent etcher and engraver Felix Brac-

quemond (1833–1914).[7] Equally characteristic of the consistency of Manet's work is the fact that in his early paintings the difference between those inspired by, or modelled on, old masters and those based on impressions of nature, such as the *Concert in the Tuileries Gardens* [269], is negligible. The difference between dark and light pictures, for a man who knew how to paint like Manet, was a minor matter, however important it may be from the standpoint of illusionism.

To what extent was Manet an Impressionist? The answer must be, to about the same extent as Rembrandt was a Baroque painter. He has certain fundamental elements in common with the Impressionists, but other things separate him from them. The Impressionists were vir-

274. Édouard Manet:
Lady with a Fur, *c.* 1881. Pastel-drawing.
Vienna, Kunsthistorisches Museum

275. Édouard Manet: Portrait of Baudelaire, 1862. Etching

276 *(opposite)*. Édouard Manet:
The Absinthe Drinker, 1859.
Copenhagen, Ny Carlsberg Glyptotek

tuosi in the representation of the body in movement. Manet dealt only occasionally with this problem, for example in certain pictures of horse-racing. The atmosphere of rigidity which lies over these pictures makes one remember at once that the painter usually portrayed things at rest.[8] If, on the other hand, movement is considered as the all-pervading movement of flickering light, the vibration of the atmosphere, the expression of the invisible active life of organic nature, then it can be said that movement is inherent equally in Impressionist painting and in that of Manet. In this respect he was not only an Impressionist, but one of the founders of Impressionism.

Taken as a whole, his Impressionism was one of form rather than of illusion. Nevertheless, it would be wrong to consider him as no more than a great constructor, for even in the essence of his form, which is his handling of colour, he never loses touch with nature and never relaxes his exclusive concentration on the visible. Herein lie the secret and the profundity of Manet's painting. The way in which Manet's form imposed limits upon the so-called 'spiritual' content can best be seen in his portrayal of human beings. The curiously passive, indifferent, mask-like faces [267, 268, 272, 274, 276] probably worried and repelled his public from the beginning. It is possible to interpret this shortcoming as the sign of a conception of the human figure in the manner of a still-life, but what makes this interpretation unconvincing is the fact that in Manet's works the figures pre-

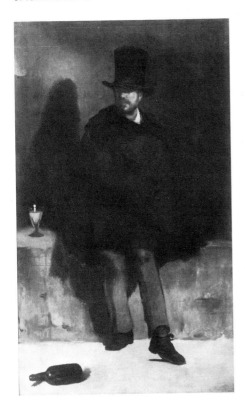

277. Édouard Manet: White Lilac in a Glass, 1880. *(West) Berlin, Staatliche Museen*

dominate, not the still-life and the landscape, as was the case in later, mature Impressionism. Perhaps we should attempt a different interpretation altogether. Manet's figures have their 'ancestors' and collaterals in the history of art. Archaic deities belong to the same family, and so do the figures of Vermeer and Velázquez, and chronologically closer to Manet, the human beings in many of the pictures of Corot [129, 130], Marées [259], and Cézanne. If we interpret the figures in such pictures as vegetative creatures, only slightly affected by feeling and thought, we come very close to the central idea of Manet's painting. Despite the supreme art that has gone into composition and colour, this central idea is nature. The few landscapes of his later period [273] and the series of his still-lifes [277] are only another aspect of nature. Painting of this kind is an autonomous equivalent to thought, and therein lies its greatest triumph. In the pages of this book we have encountered painting of this sort several times. The painters who come to mind are precisely those we have mentioned in connexion with Manet's special way of portraying human beings, namely Corot, Marées, and Cézanne. Manet, of all the members of this group, showed no aversion to painting ordinary life and the fleeting moment. Yet he was able to produce, just as they did, invariably and almost as if by coincidence, pictures of nature, the imperishable, the untouched, and the unmoved.

IMPRESSIONIST LANDSCAPE-PAINTING IN FRANCE (MONET, SISLEY, PISSARRO, AND OTHERS)

The fundamental trend or idea which determined the painting of the nineteenth century was the investigation of the secrets of nature through the medium of art. No matter how clear we are on this point, however, we have to keep on repeating it to ourselves, otherwise the many-sided variety of the century will confuse us.

278. Édouard Manet: The Execution of
the Emperor Maximilian of Mexico,
1867. *Mannheim, Städtische Kunsthalle*

Impressionist landscape-painting is a confirmation of our original tenet. Supposing now that this tenet is accepted, is there then one dominant painter in whose art the tendency was manifested as clearly as, say, the Renaissance is undoubtedly manifested in Raphael? If one had to choose such a painter, one ought most probably to name Manet, because in his painting the directness and the unhesitating restriction to the merely visible appear as profundity and mystery, a profundity without abysses and a mystery without darkness. (To be more precise, though Manet very seldom intended to render more than the merely visible, on one occasion

when he did the result was an important work, the *Execution of the Emperor Maximilian of Mexico* [278], which is great painting, but at the same time displays the limitations of a painter who was averse to historical subjects.[9]) Painting of this kind has its great moments when it makes us forget that the visible is only one aspect of nature. When we look at Manet's pictures we do not even notice how much there is of feeling and thought in nature that has not found expression. The painters of fully developed Impressionism do not entirely succeed in making us forget these things completely. Hence, all our admiration for the individual painting and for the sincerity

of the method cannot prevent us from feeling from time to time that something is lacking. These doubts are silenced, however, in the best Impressionist landscapes by their pantheistic delight in the contemplation of nature.

The gradual, more moderate trend in the development of Impressionist landscape – a trend in its essence descending in a straight line from realistic landscape – is particularly well demonstrated in the art of Jongkind and Boudin. In their landscapes there is a steadily increasing impressionistic element, despite the fact that they cannot be called true Impressionists, since they rely too much on tone and too little on colour. In this respect their works are a bridge between the plein-air art of the Barbizon land-

scape-painters and Impressionism. Nevertheless, in the painting of atmosphere many of Jongkind's river landscapes and seascapes are far in advance of the Barbizon painters [279]. Occasionally he even repeated the same landscape motif in various moods of lighting and weather – a typically Impressionist idea, which Monet later used as the basis of his celebrated series of views, the *Gare Saint-Lazare* (1877), *The Haystack* (1891), the façade of *Rouen Cathedral* (1894), and the *Bassin aux Nymphéas* (after 1900). The best-known examples of Jongkind's *œuvre* are the two views of the Seine showing the choir of Notre-Dame, in different lights (1863 and 1864, Paris, Claude Roger-Marx and Madame Ginette Cachin-Signac Collections).

279. Barthold Jongkind: The Barrière de Vanves, 1867. *Paris, Alfred Daber*

In the landscapes of Eugène Boudin (1824-98) small figures play a notable role. He felt most at home when in his pictures of beaches with accessory figures - his favourite subject - he scapes such as the *Breakfast in the Forest* (1866, Moscow, Pushkin Museum) and the *Ladies in a Garden* (1867) [281]. In these pictures Manet's grand forms are not simply imitated with great

280. Eugène Boudin: Seashore near Trouville, 1874.
Zürich, private collection

could bring the life of the landscape into relationship with human life [280]. This is a delightful old-fashioned trait in his paintings, which remind us of seventeenth-century Dutch pictures of the seashore, and something of it was preserved - underground, as it were - in the whole of Impressionism. The more obvious influence of Boudin on Impressionism, however, was due to his extraordinarily subtle nuances in the rendering of light. From this the greatest among the Impressionist landscape-painters of France - Claude Monet (1840-1926) - derived his first enduring notions.

Monet's first apprenticeship under Boudin at Le Havre was followed by a short interlude in the atelier of Gleyre in Paris. After this the influence of Manet's first great works began to exert itself with all its power. Monet now painted large pictures, pure figure-pieces such as the *Lady in a Green Dress* (*Camille*, 1866, Bremen), and groups of figures in sun-drenched land-

skill and sensibility, but they are fully absorbed and have become part of Monet's own personality. Despite this external similarity, however, a difference between Manet and Monet can at once be discerned. Creativeness of form and the illusionistic effect of the new method of vision have reversed their relationship: in Manet the creative element remains predominant to the end, and the illusionism is an addition, a heightening of the sensual beauty; in Monet the dominating factor from the very beginning is the striving to incorporate into a system the new mode of vision, especially the notion of the character of light, while the composition in large masses and surfaces serves only to obtain cohesion. Consequently it seems to be an addition, and even in comparison with Manet and also with Courbet, whose early style likewise influenced Monet, something extraneous. In fact Monet did not keep to this method of achieving cohesion for long. One can say already

281. Claude Monet: Ladies in a Garden, 1867. *Paris, Musée de l'Impressionnisme*

282. Claude Monet:
The Church of Saint-Germain l'Auxerrois, Paris,
1866. *(West) Berlin, Staatliche Museen*

of the landscapes of his large figure-pieces [281] that the decorative mosaic of patches of sunlight and luscious depths of shadow is too obtrusive, and that, in contrast to Manet, the landscape as a whole is already the main thing. Perfect equilibrium was achieved only in some of his best works, such as *The Church of Saint-Germain l'Auxerrois* (1866) [282]. In the following decades his painting passed through several stages, from this still compact Impressionism to a mastery in the use of fleeting clouds of colour that has never been surpassed [284, 285]. At the beginning stand the 'constructed' pictures, like the *Saint-Germain l'Auxerrois* or the approximately contemporary *Glade in the Forest of Fontainebleau* now in the Ordrupgaard Collection; at the end, striking ebullitions like the Fata morgana of his renderings of London fog dating from the years immediately after 1900 [284]. However wide his range may appear, it is merely a perfectly consistent progress within the possibilities of one constant, basic principle. His range enables one in fact to survey all the possibilities and all the principles of Impressionism. From the beginning Monet's theme is the real theme of Impressionist painting – light as the element of life, and the atmosphere as its medium. Many other factors of visible reality are barely touched

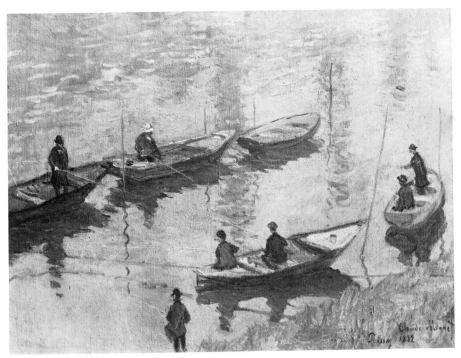

283. Claude Monet:
Anglers on the Seine near Poissy, 1882.
Vienna, Kunsthistorisches Museum

upon by him, in particular perspective; he was comparatively little interested in spatial relations. It is true that in many of his mature landscapes, e.g. the *Bridge at Argenteuil* (1874, Munich), we find a composition in vertical strata such as is characteristic of the static compositions of Manet; but other landscapes are built on the opposite spatial principle, and one generally characteristic of Impressionism, namely the oblique view from above with the horizon lying high up or even beyond the edge of the picture [283]. Monet used this 'Japanesque' angle with particular frequency, for example in his series of water-lilies [285]. It is

altogether characteristic of Impressionism that painters who made so intensive a study of aerial perspective should take linear perspective for granted. From the historical point of view, this is a very important and instructive fact: linear perspective this way is the sign of the final, naturalistic phase of the history of scientific perspective in European painting, a history that lasted nearly five hundred years.

In the rendering of materials, however, the artist's freedom in imposing his form is considerable. Here the restriction of Impressionist painting to what is naturalistically sanctioned shows itself on closer examination to be decep-

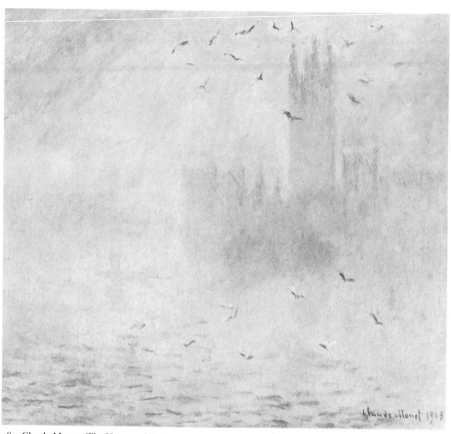

284. Claude Monet: The Houses of Parliament,
London, 1903. *New York, Mrs Vanderbilt Webb*

tive. It is precisely in the rendering of material things that spiritualization, if such a word can be used, in the sphere of Impressionism shows itself most clearly. In the way in which the Impressionists painted flesh and cloth, metal and wood, earth, stone, and foliage, they remained true to the tradition of Courbet, Leibl, and Schuch [184, 186, 225, 226, 229-32]. The transposition of materials and three-dimensional objects into the airy play of the effects of light is certainly also illusionism, but it is synonymous with the most extreme form of

freedom that the Impressionists allowed themselves – freedom of colour. We have already mentioned *light* colouring as an obvious characteristic of Impressionist painting, and to this we must now add *variegated* colouring. This, as is well known, soon found support in the theory of the spectrum,[10] but, as with other theories, its application was far more complicated than the theory itself.

There are manifold links between fully developed Impressionist painting and the near and distant past. Constable and Turner, for instance,

to go no further back, were its forerunners. But these links are for the most part matters of form. In other respects the freedom from conventions is carried to extremes, and the break with his-toricism is complete. Moreover, even when Impressionism merely continues what had gone before, it rises to a new level: never before had there been such a degree of illusionism of space, light, and atmosphere, or such light and varie-gated colours. To put it in a more general way, never before had individual objects and indi-vidual beings been so completely fused in the

painter. His aim was to demonstrate the uni-versality of the Impressionist conception in a variety of landscape subjects, in city scenes such as the *Gare Saint-Lazare*, and in seascapes, views of the seashore, etc. A list of his journeys gives an idea of the variety of his subjects: in 1887–8 he visited the Italian Riviera and Antibes, in 1895 he was in Norway, from 1900 to 1902 in London [284], in 1908 in Venice. During the last decades of his life he lived mainly in his country house at Giverny, where he painted garden scenes and his series of at least 100

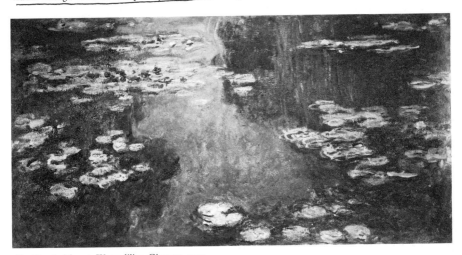

285. Claude Monet: Water-lilies, Giverny, 1919.
Paris, P. Durand-Ruel Collection

vibrating light, never had they become to such an extent patches of colour in a complex of impressions of light and colour. The watchword of Impressionism is that light is something higher than matter, that light is freedom, matter captivity.

All this, to say it again, is clearly expressed in the innumerable works of Monet. In its essentials it had already been developed by him when he took part in the memorable first exhibition held by the painters of the group in 1874.[11] At that time he was already exclusively a pure landscape-

pictures of water-lilies [285]. In the mural version of this subject in two oval rooms in the Orangerie in Paris, he tried, not very success-fully, to give decorative articulation to the nebulous swirl of colours.

Alfred Sisley (1840–99), the son of English parents, is very close to Monet in his art. He too began by painting landscapes in relatively dark tones, after which he produced for some time sunlit pictures in soft tones in a mosaic of broad surfaces, for example the *Little Square at Argenteuil* (1872, Paris, Louvre). Later he used

286. Alfred Sisley: Cornfield, 1873. Hamburg, Kunsthalle

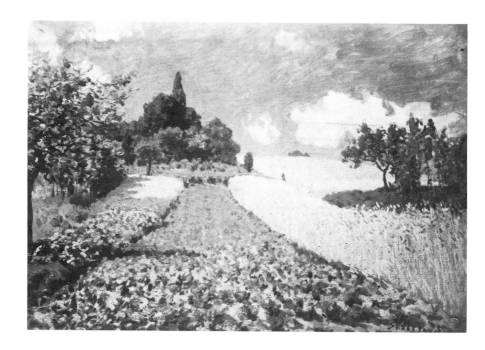

the sparkling network of tiny brush-strokes which at that time had just become the language of fully-developed Impressionism, and in this he resembles Monet so closely that their works can easily be confused [286, 287]. Sisley is often called the lyricist of French Impressionist landscape-painting. This is true if it is meant to refer to his delight in the splendours of nature, the streaming light and the gently flowing air. It is like a painted hymn of praise. There is an underlying Romanticism, full of poetry which is suggested rather than openly expressed, for the conventions of Impressionism have no place for pure poetry. If we glance back to German Romantic landscape at the beginning of the century, we can measure the distance traversed. When Friedrich and Sisley paint trees beneath freshly fallen snow, the result is very different

[58, 288]. In Friedrich we have a timeless silence and melancholy, with every clearly delineated thing weighed down by the fullness of eternity; in Sisley a moment of gay unconcern, with the individual objects veiled and sheltered in the weightless element, in snow and haze. Nevertheless, the two conceptions are also in some ways alike. They are the beginning and the end of the same road, and two aspects of the same thing: nature. The Romantics wanted to paint depth and distance, the loneliness and silence of nature, and where they succeeded in this they were conveying much of human nature as well. The Impressionists did not try to depict such mysterious things; they believed that the task of painting was to attempt to render nature from the optical standpoint alone. However, more than mere optical illusion was involved, since

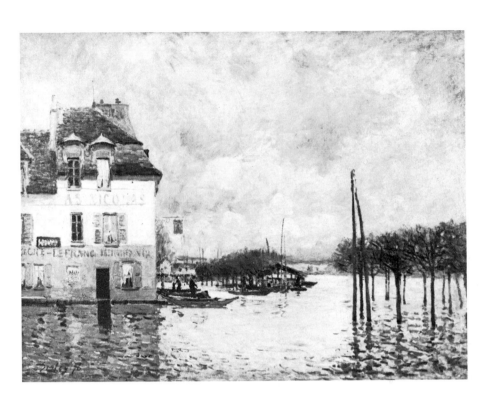

287. Alfred Sisley: Flood at Port Marly, 1876. *Paris, Musée de l'Impressionnisme*

288 *(below)*. Alfred Sisley: Fresh Snow, 1873. *Paris, P. Durand-Ruel Collection*

289 *(opposite)*. Camille Pissarro: Red Roofs, 1877. *Paris, Musée de l'Impressionnisme*

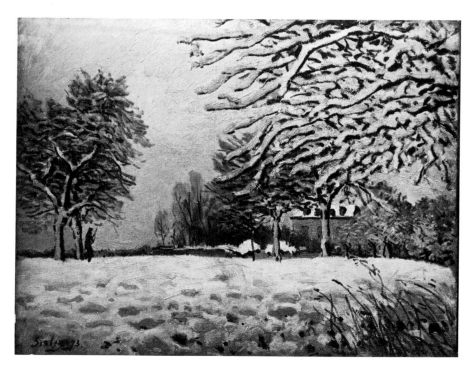

they also painted the movement and flow of light. Light is also a part of man's awareness of nature, and so nature as a human experience remained the theme, but it is a nature which is less dependent on mankind than the Romantic conception.

Camille Pissarro (1830-1903) had a gentle and sensitive temperament very similar to that of Sisley, but in addition a remarkable susceptibility to influences. Various manners and phases of Impressionism are reflected in his works: first a 'constructive Impressionism', formed on Corot and on Courbet's compact substance and gravity, then on Monet's joyous transparency, and after that on the systematization and many gay colours of Seurat's and

Signac's *pointillisme*. In all this the competence and the receptiveness of Pissarro were such that he is entitled to be considered, together with Monet and Sisley, as one of the trinity of leaders of French Impressionist landscape-painting.

The son of a French business man of St Thomas in the Danish West Indies, Pissarro was originally destined to become a merchant. In 1855 he went to Paris, having decided to devote himself to painting. We know little about his beginnings, because almost all his early works were destroyed during the Franco-Prussian war.[12] At that time, in 1870, Pissarro took refuge in London, where, together with Monet, he acquired a closer knowledge of the art of Constable and Turner. His most important

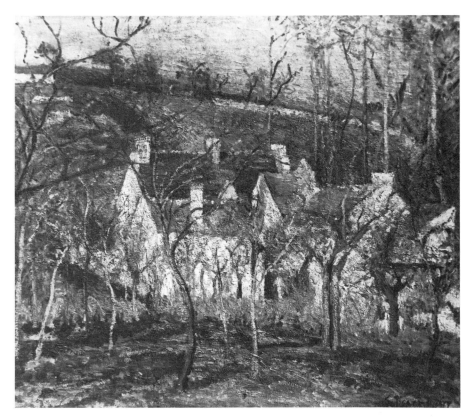

years were the 1870s, when he settled at Pont-oise. It was then that he had a share in the pioneering of Impressionist painting. In these years also his friendship with Cézanne began, and a little later that with Gauguin. The reverence which Cézanne preserved throughout his life for 'humble et colossal Pissarro'[13] is an eloquent testimony of what he owed to his older friend, but on the other hand Pissarro was undoubtedly influenced by the fanatical way in which Cézanne was seeking to achieve his own style. A picture like Pissarro's *Red Roofs* (1877) [289] is a striking example of that firmness and compactness of structure which he never completely renounced. Pissarro was attracted by the neo-Impressionist method, and was honest enough to accept for his own painting the chromatic doctrine and compositional methods of these younger painters [290]; undoubtedly the austere, rigid ornamentality of neo-Impressionist pictorial structure appealed to the desire for order and the distrust of the fascinating licence of colourism which make up one side of his nature. Eventually, however, he once more gave full rein to the fascinating freedom of pure colourism. His views of Paris dating from the 1890s, the series of pictures of the *Avenue de l'Opéra* and the *Boulevard Montmartre* by day and by night [291], with their whirl of strokes and dabs of delicate, broken colours are a masterly demonstration of the Impressionist principle of a chromatic tonality. In mature and late

290. Camille Pissarro: The Railway to Dieppe, 1886. *Gladwyne, Pennsylvania, Mrs Louis C. Madeira 4th*

Impressionism one colour dominates the picture, just as in the landscapes of the Dutch masters and of their many nineteenth-century followers, especially the Barbizon school, there was a definite, closely circumscribed scale of tones based on green and grey. Here, once more, a link between the revolutionary new style and tradition is evident. Impressionist innovations are greater independence in colours and in the choice of the pervading tone, which in the late landscapes of Pissarro is a greyish violet and in Monet's Thames landscapes [284] a smoky reddish-blue. This chromatic tonality – which in the hands of Whistler became a programme[14] – is used in conjunction with a robust polyphony of contrasting colours extending into depth. The minor talents specialized in chromatic tonality, in which they displayed many refinements – Berthe Morisot (1841-95), a sister-in-law of Manet, with her fragile network of muted emerald tones, Eva Gonzalès (1850-83) with landscapes in delicate grey and ochre tones, and Armand Guillaumin (1841-1927) with his Provençal landscapes in a stereotyped, violent lilac and orange. Gustave Caillebotte (1848-94), to whom the Musée du Luxembourg owed the famous bequest of Impressionist pictures (now in the Musée de l'Impressionnisme), remained essentially true to the methods established by Monet in his landscapes.

chromatic tonality of foreground

291. Camille Pissarro: Evening on the Boulevard Montmartre, 1897. *London, National Gallery*

EDGAR DEGAS (1834-1917)

In many respects Degas was an anti-Impressionist, a fact which it suited his misanthropic nature and attitude to emphasize. His guiding star was Ingres and his chief care accordingly was highly finished drawing. For this reason it was the human body that was his real theme, landscape being an occasionally unavoidable adjunct. For this and other reasons, Degas's relationship to Impressionism is curious. He was faithful to the Ingres ideal that the conception of an orthodox, harmonious perfection can be demonstrated by means of the human

bound to represent a new aesthetic theory. Degas, in order to demonstrate it, made use of a specific fragment of reality, a fragment taken from an artificial world – that of the ballet [292, 293]. Unusual, ingenious, sometimes bizarre poses and gestures now take the place of the noble though likewise ingenious attitudes of earlier times, and the real world of the theatre, rendered in full enjoyment of the illusions it offers and yet with a clear underlying consciousness that they are, after all, only illusions, takes the place of the imaginary world of the Classicists. The aim and the final effect are akin and the result, in the art of Degas, was bound to

292. Edgar Degas: Ballet Rehearsal ('Adagio'), 1874. *Glasgow, Art Gallery and Museum, Burrell Collection*

body, and by it alone. For him, however, the medium of this idea was not the body constructed according to Classicist rules, but the real body observed with uncompromising exactitude. An ideal presented by means of such bodies was

fascinate not only painters, but also writers.[15] Never before had anyone seen the female body in this way, so expressive in its animal beauty and yet so free from any erotic charm. To what extent the apparently different spheres of Ingres

293. Edgar Degas: Ballet Dancers, *c.* 1899. Pastel-drawing. *New York, Museum of Modern Art*

and Degas are in contact can be seen if we look back to Ingres's *Turkish Bath* [24]. Not that Degas's ballet-dancers were the only form in which he expressed his new doctrine. They are merely an extreme instance, and the many scenes of women bathing or after their bath served his purpose just as well, and so did the thoroughbred horses in his racecourse scenes [294]. The stupendous accuracy in the rendering of movement, like all correctness in art, is of only minor importance. Where such rigid naturalism and such fanatical striving after perfection of form met, there was bound to be tension of a special kind. However much Degas tried to confine to the phenomenon itself his determination to be truthful, he could not help producing criticisms of life, and very pessimistic ones they are. In

other words, feeling could not be eliminated, and the result is somewhat reminiscent of the attitude of Maupassant. Not a single picture from Degas's mature years can be styled 'literary', but in his art as a whole a lot is 'told'. This results in, among other things, a resemblance to Menzel. In Degas's early days the anecdotal and genre element is specially marked,[16] and *L'Absinthe* of 1878 in the Musée de l'Impressionnisme, with a portrait of the painter and etcher Marcellin Desboutin (1823–1902),[17] is still a genre-piece from the Paris of the fin-de-siècle.

Degas did not realize his idea of the harmony and regularity of bodies through the figure alone, but also by visualizing the figures as forming a complete unity with space and light. This

294 *(opposite)*. Edgar Degas: Racehorses, 1874. *Boston, Massachusetts, Museum of Fine Arts*

295 *(below)*. Edgar Degas: Comte Lepic with his Children in the Place de la Concorde, *c.* 1873. *Formerly Berlin, O. Gerstenberg*

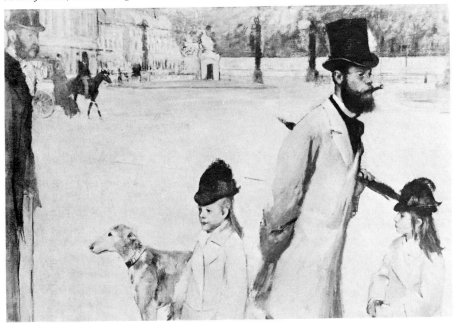

represents a very profound difference between his art and that of the Classicists, and brings it very close to Impressionism. In his early days, however, things were different, for there we find compositions built up in parallel vertical layers, and in some of his later scenes from the theatre there is still a sharp contrast between the large, dark close-ups of the orchestra or the rows of spectators and the light phantoms on the stage (*Ballet from 'Robert the Devil'*, 1872, New York; *Musicians in the Orchestra*, 1872, Frankfurt). Sometimes the dichotomy between the two layers of the picture is glaring; in some of the early pictures of races the figures and the landscape setting, as in some of Manet's pictures (e.g. *The Picnic Lunch* [266]), do not form a whole. Later this dichotomy is avoided com-

pletely. Degas introduced the Japanese form of composition into his art more intensely than any other Impressionist [295], just as intensively as Manet had exploited another element in Japanese art, the power of the flat surface. The significance of the 'casual' passage, a fragment from boundless space, could not possibly be more radically expressed.[18] And even the fascinating corporeal arabesque of the single figure of a woman having a bath is full of space. It is exactly the same with Degas's rendering of light. How often are the ballerinas in his pictures only vague outlines, vanishing, darting shadows. No figures could be more Impressionistic. The fact that Degas painted no landscapes loses all importance, for his landscape setting is the 'foyer de danse' and the bathroom.

From the end of the 1870s Degas hardly ever used any other technique but pastel, and even when he painted in oil the pictures looked like pastels.[19] Artistically speaking, this was the height of colouristic audacity, but it never involved any diminution of the intensity of the draughtsmanship. This is also manifested in the black-and-white of his lithographs and monotypes. The only diminution in these pastels and drawings is in the role played by the details, as we shall also observe in his sculpture (see below, p. 414 ff.; illustrations 330, 331). This coincides with the general development of Impressionism. The final result is an orgy of colour. In these late pastels Degas used a complicated, stratified technique whereby flames and whirling flakes veil the wild and eccentric gestures of the dancers with fiery red, turquoise, and subtle half-tones. Uncanny ecstasy is paradoxically mingled with cold mastery of form.

AUGUSTE RENOIR (1841–1919)

Impressionist painting has often been accused of being too sober and too materialistically objective. Such a statement can only be justified if it expresses no more than a hint of some limitations and dangers. Even then we need only think of a painter like Renoir, and it becomes ridiculous. All the poetry and music associated with Impressionism pervade his art to a supreme degree, more than that of Sisley, because Renoir's work is not limited to landscape. Naturally, one can turn the tables and maintain that, like Manet, Renoir cannot be considered an Impressionist. But this would involve reducing the meaning of the term Impressionism to the method of intensified effects which we have noted in Impressionist landscapes. In this case one would be compelled to regard a painting like Renoir's *The Box* (1874) [296] as *not* being Impressionist – and yet it is one of Renoir's great works, and represents a significant period in his development, the period which lasted until the

beginning of the 1880s. In fact, however, it is Impressionist, in the way that Manet's work is, an Impressionism of form rather than of illusion. Julius Meier-Graefe tells us how Renoir, when asked how one could best learn to be an artist, replied: 'Au musée, parbleu!'[20] Renoir's beginnings, before he started to frequent museums, were in the field of applied art, as a painter of porcelain and fans. The son of a poor tailor in Limoges, he took to work of this kind in Paris when he was only thirteen. This may seem trivial, but it is, as we shall see, symptomatic. In 1861 Renoir entered the atelier of Gleyre, where Monet, Sisley, and Bazille were his fellow-pupils. At that time Corot, Delacroix, and especially Courbet meant a great deal to him. The *Diana* (1867, Washington, on loan from the Chester Dale Collection) or the *Bathers with a little Dog* (1870, Paris, A. Pellerin Collection) are examples of Courbet's influence. In the year 1868 he painted the celebrated *Sisley and his Wife* (Cologne). This is Courbet transformed into Watteau-like softness and tenderness. It has all Courbet's delicacy and deliberate allusion to older masters, without his demonstrative robustness. Yet it already contains the whole of Renoir in two things; the relationship between reality and artistic form, and mood. In the approximately contemporary portrait of a girl entitled *Summer* (West Berlin), the open painterly element is slightly more prominent, while in the portrait of a lady with a sunshade, *Lise* (1867, Essen), the influence of Manet is more evident. Still freer is the pictorial structure in the portrait of Bazille in the Louvre (1868).

The same method, the same precocity, are in fact found in the works of Jean-Frédéric Bazille (1841–70), who came from Montpellier. Bazille was killed during the Franco-Prussian War, and his work is therefore no more than a fragment, but it is a very important fragment. The large group of *The Artist's Family at Montpellier* (1868, two versions [297], of which the second is in the Louvre) and *After the Bath* (1870, Mont-

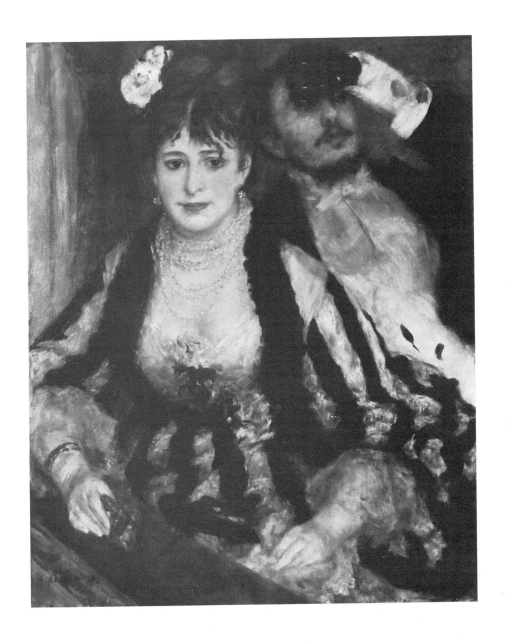

296. Auguste Renoir: The Box, 1874. *London, Courtauld Institute Galleries*

pellier), with their stress on the solidity of the bodies, the subdued rendering of light, and the full colours, are works of the same stage as the contemporary pictures by Renoir, immediately

Paris, Louvre). The affinity persisted until Renoir went to Italy in 1881. He did not incorporate Monet's way of seeing things as completely into his style as Manet did, however, for

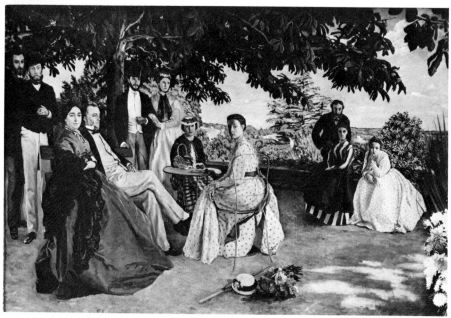

297. Frédéric Bazille: The Artist's Family at Montpellier, 1868-9. Paris, Musée de l'Impressionnisme

before Impressionism and before atmosphere had become all-important. But Renoir's cheerfulness is replaced by a melancholy seriousness, remotely reminiscent of Chassériau. In still-lifes and in his *Studio* (1870, Paris, Louvre) Bazille uses a looser structure.

About this time Renoir was briefly attracted by the systematic Impressionism of Monet's landscapes. A proof of this is his landscape with the landing stage of *La Grenouillère* (1868-9), which Monet also painted at about the same time.[21] Also akin to Monet's Impressionism are Renoir's *Quay on the Banks of the Seine with the Pont des Arts* (1868-70, New York, private collection) and *Barges on the Seine* (*c.* 1869,

he was also painting landscapes which are Impressionistic in a very different sense. The third version of the *Grenouillère*, as compared with the other two (Stockholm, and Winterthur, Oskar Reinhart Collection), is something like an Impressionism seen through the medium of a miraculously resuscitated Baroque. As regards figure pieces, as late as 1872 Renoir was still keeping close to Delacroix's development of Baroque principles when he produced a paraphrase of the *Femmes d'Alger* in his *Parisiennes in Algerian Costume* (in a private collection). Renoir's painting represents the last word in nineteenth-century transformation of the Baroque, and he indeed had much of Baroque

qualities in his nature. Renoir was one of the great ingénus in the art of the nineteenth century – much akin in this to Corot – and his works are such outpourings of enraptured astonish- ment and delight that for him even the pantheism of the pure Impressionist rendering of light and air must have seemed too intellectual. With his colours as iridescent as mother-of-pearl, flowing

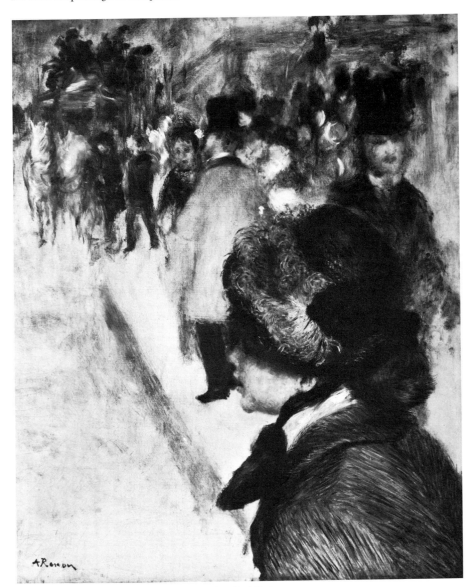

298. Auguste Renoir: Place Clichy, c. 1880. London, Lord Butler

into one another like clouds, yet retaining all the joyous clarity of the music of Haydn, he did not create a dream world remote from nature, but re-created the same nature and the same people that the Impressionists painted. In the pink patches of sunlight in the garden of the *Moulin de la Galette* and round the *Swing* (1876, both Paris, Louvre), and in the glittering light and the haze and the dust of the Paris boulevards (illustrations 298 and 299, *c*. 1880 and 1875), he remained as close to reality as the Impressionists. Nature continued to be the guiding principle both of his and of their painting.

He remained true to nature even when, at the beginning of the 1880s, there was a change in his style. That is why the change does not represent a break. If from the early eighties he makes the nude female figure in a landscape his central theme, and ultimately the personification of an eternally gay and blooming nature overflowing with fertility, this is no more than a simplification of his former style, as also with his later etchings [300]. As regards form, however, so much of the old method of expression is omitted and so much that is new is introduced in the colouring, the monumentality of the body, and the new significance of volume, that this later art of Renoir cannot – as the late works of Degas can – be mentioned in the same breath with Impressionism. Its place is in another context.

299. Auguste Renoir: The 'Grands Boulevards', 1875. *Philadelphia, Henry P. McIlhenny*

300. Auguste Renoir: Woman bathing, 1910. Etching. *Vienna, Albertina*

THE SITUATION ABOUT 1880

In the early 1880s Impressionism had gained a firm foothold. It was beginning to spread, even outside the borders of France. The public was still hostile, and an artist like Sisley had to struggle against poverty because so few people appreciated the magic of his art, despite its essential naturalness. Pissarro did not fare much better. The obstacles to a better appreciation were of many kinds, in particular the demonstrative stress laid by the Impressionists on subjects which were trivial or commonplace, and the overwhelming self-sufficiency of the colouring. The spell was broken when the seductive power of the illusion created by these means gained strength, when it was recognized that the sparkling colours were not simply being played with for their own sake – it was precisely this that had offended the average taste – but were rather an expression of the joy of living; at all events, they were at least appreciated as an astounding *tour de force*. Ultimately, as a result of Impressionist painting, pleasure in the everyday miracles of light and subtle atmospheric variations became common property. Impressionism, from this time on, became a kind of popular philosophy of painting, which in its turn outdid everything else. In a closer study of Impressionism it would be necessary to show in detail how, within the sphere of artistic productivity, the domain of the Impressionist way of seeing grew larger and larger. One would have to discuss that generation of painters whose work as a whole owed allegiance to Impressionism, for example Max Liebermann. The effectiveness of Impressionism could also be demonstrated by the manner in which it penetrated into the later work of individual painters of the older generation, for instance opening up new paths

for Rudolf von Alt in his last years. These things, however, cannot be discussed here, since within the plan of the Pelican History of Art this book must not go beyond 1880. We should, however, say a few words to justify this dividing line.

A dividing line is necessary in the interests of clarity and order, and it must denote the end of something and the beginning of something new. As regards the end, it is easy to see that by the beginning of the 1880s Impressionism had attained fulfilment in its principles and its programme, no matter how original individual achievements may subsequently have been. Round about 1880, at all events in the rendering of landscape, a clearly marked road reaches its end. A lot had happened along this road. At the beginning of the nineteenth century, artists had tended more and more towards expressing the forces of nature in their landscapes, in other words the infinite which exists outside humanity. Nevertheless, human beings at first began to play a very considerable role in their image of the forces of nature. 'Heroic' landscape was the vogue, and heroic landscape is anthropocentric landscape. The Romantics had a very different conception of the task of expressing the forces of nature, and yet they too found room in their landscapes for human beings. Solitude and melancholy are facets of human experience, and the 'universal soul' in the Romantic interpretation of landscape is at the same time the human soul. Towards the end of the century, however, in Impressionism, natural forces became the subject of landscape-painting in a new sense. We have already spoken of this change when discussing the position of Sisley. By his time the individual natural objects, mountains

and streams, trees and clouds, were no longer considered adequate symbols of the forces of nature. The ambition of painters was now to achieve an image of the omnipresent elements in nature, that is light and atmosphere. Such an image of natural forces is an image of the cosmos presented without any pathos. It is unnecessary to stress here how logical this step was as the conclusion to a long development, since we have frequently had occasion to point out the links with what went before, links which exist in the artistic interpretation of nature, as well as in the domain of form, in the language of pictorial expression.

There remains now the second question. What was the new element that appeared about 1880, at the time when Impressionism had achieved fulfilment? It was an element that was already largely implicit in Impressionist painting at the time when it reached its zenith. In its ultimate form the way had been prepared for much of what was to come. To realize this 'double aspect' of Impressionism, one must appreciate that the liberation of the colours and the microcosm of the picture plane, its 'molecular' tissue as it were, ushered in a new pictorial form. This was possible as soon as an integral feature of Impressionism was eliminated – namely the illusionistic element. The way in which this occurred is monumentally demonstrated in a picture exhibited in 1886 at the eighth and last joint exhibition organized by the Impressionists – *Un Dimanche à la 'Grande-Jatte'* (Chicago, Art Institute), by Georges Seurat (1859-91). In this picture the programme of neo-Impressionism was formulated. The reduction of illusionistic effects – the rigidity of the figures which made them look like automatons, the pallid sunlight – must have caused considerable dismay. The essence of the innovation was not the disappearance of Impressionistic vivacity and gaiety, however, but the new power of the construction – though both are closely related to Impressionism.

About the same time there were other signs, in many respects even more significant, of a turning away from Impressionism. They are to be found in the works of the other great founders of modern painting in France, Cézanne, van Gogh, and Gauguin. For all three, Impressionism was more than a mere starting-point. Paul Gauguin (1848-1903) abandoned it shortly before his second journey to Martinique in 1887; van Gogh and Cézanne were never avowed Impressionists. But all three were well aware of how much they owed to Impressionism, and they never attempted to conceal it. In Cézanne's well-known phrase: 'Monet, ce n'est qu'un œil – mais bon Dieu, quel œil', the second half should be kept in mind, but the first half really indicates the attitude of the three great 'post-Impressionists' to Impressionism: for them the aims of Impressionism seemed too limited. They wished to say exactly what the Impressionists had left unsaid. It is all the more remarkable how much Vincent van Gogh (1853-90) retained, not of Impressionism, but of neo-Impressionism. That his world remained all the same utterly different from that of the Impressionists goes without saying. The same is true of the world of Gauguin, whose opposition to Impressionist form was even more pronounced than van Gogh's. What distinguishes them ultimately and fundamentally from their predecessors is that the theme of their art is basically opposed. As against the former theme of life in the processes of natural forces, it was now life in the human sense, or, where not strictly in that sense, at least in relation to man. This is what characterizes the animism of van Gogh and the symbolism of Gauguin.

The relationship between Paul Cézanne (1839-1906) and Impressionism is more complicated. His interests were in many respects the same, but he developed them into depth. For this reason, and also because he reached his ultimate style towards the end of the 1870s, a little earlier than Seurat, van Gogh, and Gau-

guin, it is necessary in this volume to say a few words about his beginnings. These were rather unusual, and have little to do with the subsequent essentials of his art. Cézanne began to paint in 1860, after a brief apprenticeship in the art academy of his native city, Aix-en-Provence. He first visited Paris in 1861, but for only a few months. From 1862 to 1864, however, after he had definitely decided to become a painter, he lived there, working for a time in the Académie Suisse. Outstanding among the works he produced during this early period, which lasted until about 1870, were certain portraits in an incoherent and often barbarous neo-Baroque style, and some dramatic figure-pieces, such as *The Murder* (*c.* 1867-70) [301], a grotesque *Picnic Lunch* dating from the same period (Paris, Lecomte Collection), and *The Elopement* (1867, private collection). Baroque pictures, and soon afterwards pictures by Delacroix and Courbet, provided the inspiration. The wild and fantastic elements are very largely a direct expression of Cézanne's temperament, and only to a smaller degree intended as a revolt against the normal and academic. Certain portraits which were painted during the second half of the 1860s (*The Artist's Father reading 'L'Événement'*,[1] *c.* 1866-8, Paris, Lecomte Collection; and the series of

301. Paul Cézanne: The Murder, *c.* 1867-70.
New York, Wildenstein Galleries

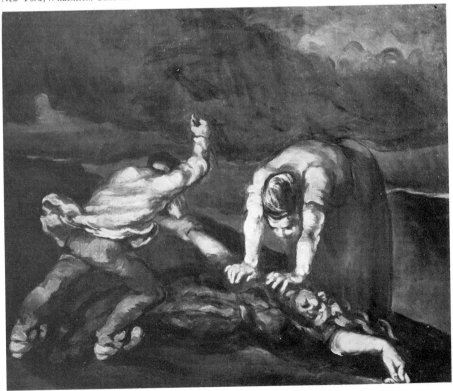

portraits of *Uncle Dominique*, Paris, J.-V. Pellerin Collection; New York, Mr and Mrs Ira Haupt Collection, etc.) are still built up of massive blocks of paint laid on with the palette-knife, but assert themselves as the first signs of a disciplining of the colour guided by Courbet's technique; while others, such as the *Portrait of G. Boyer* (*c.* 1870-1, New York, Metropolitan Museum, H. O. Havemeyer Collection), remind one of the colouring of Manet. The Romanticism of the dark figure-compositions continues until about 1870. At the same time Cézanne produced the *Railway Cutting* [302], which in composition and solidity of volumes is rather like a coarsened Courbet landscape, though its colours have a mysterious originality – like the dawn of a new significance of colour, though still slightly restrained by the sluggish mass of the banks of the cutting. In this curious picture the heavy fullness of Courbet's landscapes [e.g.

185] is transformed into something strangely primeval, but the colour proclaims a manner of 'dematerializing' visible reality hitherto unknown. From this point onwards Cézanne abandons or represses all the fantasy of his early compositions, and concentrates on the image of reality.

Cézanne's contact with Impressionism, and in particular his collaboration with Pissarro at Pontoise and Auvers during the early 1870s, resulted in a greater colouristic differentiation. The landscape shown at the first Impressionist exhibition of 1874 known as '*La Maison du Pendu*' (Paris, Louvre) is the chief work dating from this period. From then until the end of the decade Cézanne developed his definitive style. A picture like the landscape here reproduced [303], painted about 1878-80, shows that by then the goal had been achieved. Dependence on Impressionism is still discernible in every

302. Paul Cézanne: Railway Cutting, *c.* 1870.
Munich, Bayerische Staatsgemäldesammlungen

303. Paul Cézanne: Landscape near Pontoise, *c.* 1878-80. *Paris, private collection*

stroke of the brush, and it is thus easy to understand why Cézanne is so often included among the Impressionists. Yet everything is mysteriously changed. Here is indeed a fundamental reversal of Impressionism. Of Cézanne's painting – and indeed of that of Seurat, though in a different sense – it can be said that the sun of Impressionism has set, but that everything is irradiated with a new clarity, with an unprecedented light. In comparison, the serene spiritualization of Impressionism seems heavy. The magic of the momentary and the actual is transformed into the mystery of the lasting and the eternal, and vibrating, busy life has become a resonant silence. In small, apparently haphazard fragments from nature – but not in the ostentatiously small, as in the works of the Romantics – the boundless, the immeasurable, has been expressed, without Romantic horizons and without the broad expanses of the sky.

Many of these new features had appeared in the earlier painting of the century, but, considered as a whole, it had produced nothing so fundamentally new as this image of the structure of natural things, of bodies and spaces. The magic of this change has its counterpart in the novelty of the conception of the picture as form. In this new relationship between representation and form it is impossible to distinguish what is cause from what is effect. This reciprocal action seems to be the real vital centre of the pictures. From the point of view of such painting general notions such as aestheticism, intellectual art, sentimental art, the sense of drama, idealization on to a plane above reality, and also their contrary – humble satisfaction with the world of everyday objects – all become insignificant. Cézanne's art stands apart from all these things, apart from everything that up to the end of the nineteenth century had determined painting in its sequence and interplay of Classicism, Realism, and Romanticism. Taking all things into account, it was a 'Copernican' turning-point and it ushered in a new age in painting.

PART TWO

SCULPTURE

INTRODUCTION TO CHAPTERS 18-21

During the hundred years between 1780 and 1880, sculpture, as a whole, lagged a considerable way behind painting. The reason for this was that painting could fully express everything that the period had to say and that could be expressed in terms of the visual arts. Not only had sculpture nothing to add, but it even found itself at a disadvantage in everything connected with the principal characteristic of the century, namely the trend towards Naturalism. It is not as though a markedly painterly style in painting automatically makes sculpture impossible – that is disproved by the art of the eighteenth century, when painting and sculpture existed side by side as equals; but when, after the middle of the nineteenth century, sculpture followed the trend towards Naturalism – the enemy of sculpture since it violates its very essence – it surrendered those very qualities that make it a specific art-form. Those are the simple facts, but they do not necessarily help us to understand the causes. The assumption that the Zeitgeist, which governs all branches of art, shapes the individual branches for its own purposes is not always very helpful. There was nothing to stop genuine creative talents for sculptural form from asserting themselves side by side with, or against, the prevailing trend in painting, but in the nineteenth century that did not happen; nor was there any repetition of the situation during the period of great

Dutch realistic painting, when painting was the focal point for all creative forces, so that nothing was left over for sculpture. In the nineteenth century there were many examples of a gift for sculptural form, but no constant stream, no tradition or logical development. There were good sculptors, but not one who expressed a universal spirit in his art, as so many great painters of the period did.

THE SCULPTURE OF THE CLASSICIST PERIOD

Theoretically, Classicism was favourable to the development of sculpture. In a movement which openly declared itself to be idealistic, and in its paintings gave such an important role to the statuesque single figure, sculpturally conceived, one would have thought that sculpture might even have achieved supremacy among the arts. The reasons for the isolated position which it in fact held, particularly later in the century, were twofold: excessive dependence on classical models, and surrender to the temptations of Naturalism, which from an early date became more or less apparent beneath the surface. Lack of originality was a general weakness of figurative art during the Classicist period, and the conflict between concealed Naturalism and openly expressed Idealism was an equally general aesthetic hazard. In painting, however, the burden of classical paradigm did not weigh so heavily as it did on the sister art. The possibilities of painting as a two-dimensional art were far more extensive, and the choice of subjects, among which even landscape was ultimately included, far vaster. As against these advantages of range, sculpture could set economy of effects. A priori, sculptural form could more easily be kept free of literary ideas and illusion. Actually Classicism often did follow this path towards 'pure' sculpture, but the fact that this 'purity' was frequently identical with cold, academic lifelessness and vacuity shows that the real cause of the failure of Classicist sculpture was nothing inevitable or inherent in the age, but merely a lack of strength.

As in the painting of the time, the spirit of the Baroque continued to exert an influence. This can be seen in the work of all the leading sculptors who made their appearance during the last quarter of the eighteenth century, not only – in contrast to what happened in painting – in Central Europe, in France and Germany, but also at the same time in Italy and the Northern European countries. The leading masters were the Frenchman Houdon, the Italian Canova, the German Gottfried Schadow, the Swede Sergel, and the Dane Thorvaldsen.

JEAN-ANTOINE HOUDON (1741–1828)

Of these five Classicist sculptors Houdon was the least Classicist, in the sense that he did not aim at doctrinaire purity of style. In the earlier and longer part of his career he was a Baroque sculptor, and what in his later works can be called Classicist has only a very slight trace of the 'ideological' side of Classicism, the sublime, solemn element of an art of statuary rather than sculpture. His strength lies in the new feeling for naturalness, such as we also find, for example, in the painting of David, as a characteristic of Classicism in France. Even this, however, was nothing strictly new. It was present in Houdon's early works too. He merely discarded the gentle veil of Baroque charm, the arabesque of serenity. Everything becomes a little cooler and more serious, but, what is more important, Houdon yet retained liveliness and naturalness in his portraits [304, 305]. They can be compared in this respect with the best portraits by David [3, 4]. In both artists, this retention of Baroque realism could be reconciled with Classicism in the name of 'truth'. In contrast on the other hand to the Baroque idealization, this closeness to nature seems something new, even before the new Classicist idealization began to make itself felt. In Houdon's portraits, moreover, there is no danger of a decline into a crude, materialistic

naturalism. This is everywhere precluded by his mastery in the organization of the sculptural form, in numberless, individually often unanalysable details, but frequently also in a grandiose curve, or in the majestic sweep of a surface. With the directness and the lifelikeness of his portraits, which were yet everywhere controlled by form, Houdon founded something approaching a tradition. Whenever realistic sculpture in the nineteenth century contrived to maintain itself on an artistic level, it was close to the art of Houdon; this is clearest of all in the works of Carpeaux, and continues in those of Rodin. To this extent what has been said before about a lack of tradition in nineteenth-century sculpture must be modified.

Houdon, the son of a footman in the 'École des Élèves protégés du Roy' in Paris, received his first artistic education from Jean-Baptiste Pigalle (1714-85), Jean-Baptiste Lemoyne (1704-78), and René-Michel (known as Michel-Ange) Slodtz (1705-64). At the age of sixteen he won a prize for the first time. In the course of a stay of several years in Rome (1764-8) he produced the figure of an *Écorché* and two large statues for niches in the church of S. Maria degli Angeli, *St John the Baptist* (this statue, which was made of plaster, fell from its niche in 1894 and was destroyed; only a plaster model has been preserved in the Galleria Borghese at Rome) and *St Bruno*. After his return he began his long sequence of portraits of princes and statesmen (Gustavus III of Sweden, 1785; Louis XVI, 1785; Catherine II of Russia, 1773; the Duke of Saxe-Coburg-Gotha, with whom Houdon stayed twice, in 1771 and 1773, and his family; Napoleon, 1806 [304]; Josephine Beauharnais, 1806; Mirabeau, 1791; Marshal Soult, 1806; Marshal Ney; General Joubert, 1812), and of scholars, artists, poets, and actors (Buffon, 1783; Chénier; Diderot, 1775; Gluck, 1775; La Fontaine, 1783; Rousseau, 1778, after the death-mask; Voltaire, 1778; Joseph Vernet).[1] In 1785 Houdon accompanied Benjamin Frank-

304 *(below)*. Jean-Antoine Houdon: Napoleon, 1806. Terracotta. *Musée de Dijon*

305 *(opposite)*. Jean-Antoine Houdon: George Washington, 1778. Clay. *Mount Vernon*

THE SCULPTURE OF THE CLASSICIST PERIOD · 379

lin, whose portrait he had made in 1778, to the United States, where he made a portrait-bust of George Washington (in the latter's house at Mount Vernon) [305]. A marble statue of Washington – the actual commission he received – was executed between 1788 and 1792 and erected in 1796 in the Capitol at Richmond, Va.

Houdon's monumental full-length statues, with the exception of that of Washington, were executed before the last phase of his career, which chronologically belongs to Classicism. They are the two statues in S. Maria degli Angeli, the *Diana* (1776; bronze casts 1780 and 1790), and the marble statue of the seated Voltaire (1781, Paris, Comédie Française). It is merely a verbal quibble whether we choose to call them the beginnings of Classicism or the last expression of Baroque Classicism. The de-

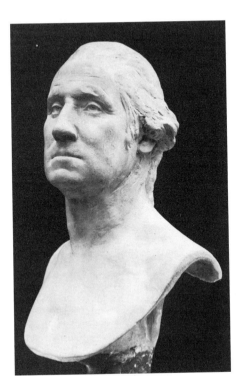

cisive element is the spirit of tranquil harmony, which shuns Baroque agitation, just as the feeling for reality in portraiture shuns Baroque super-reality.

ANTONIO CANOVA (1757–1822)

It was no part of Houdon's aim to represent even the heroes of his time as supermen, and ideas in the sense of doctrines meant little to him. Canova, on the other hand, almost without exception represented heroes and geniuses, and in them personified ultimate values. Some of his portraits show the great dead on their funeral monuments, for example the Popes Clement XIV Ganganelli (1783–7, Rome, SS. Apostoli) and Clement XIII Rezzonico (1787–95, Rome, St Peter's). In the many other cases where he had sitters proper, that is live models, he still portrayed them draped in antique costume, as if no other solution were thinkable, whether they were Letitia Bonaparte, Napoleon's mother, for whose statue (finished 1808, Chatsworth) Canova took as his pattern the statue of Agrippina in the Capitoline Museum; Pauline Borghese, Napoleon's sister, as Venus (1807) [306]; George Washington as a Roman general (1818–20, destroyed as the result of an accident); or Napoleon as the colossal nude figure of an Imperator (1802–10, London, Apsley House, bronze reduction in Milan, courtyard of the Brera). Canova moved exclusively in an ideal world, the only other artist among the Classicists to equal him in this respect being Carstens [26, 27]. The question is whether the forms he chose were really adequate to the greatness of the ideas that he wished to express. On the whole the answer is so plainly negative that the discrepancy between the two can be called a fundamental characteristic of his works. The borrowings from ancient Roman sculpture are numerous, but rare indeed are the attempts to discover even the most elementary laws of sculptural form. In the conception, in the composi-

tion, and in the function of the individual figure, it is always the programme that gains the upper hand. The decisive factor here was the influence of the Scottish painter and archaeologist Gavin Hamilton (1723-98), which dates from shortly after 1779, when Canova, fresh from his first studies at the Academy in Venice had come to Rome, where Hamilton was then working.[2]

There is a charming side in addition to the heroic side in Canova's works. His charm, however, lacks genuineness and naivety, and so the sugary element prevails, as in the group of *Amor and Psyche* (1793, Paris, Louvre; several replicas), which has won immortal popularity as a bric-à-brac figure. But in the portrait of Pauline

art that attracted Prud'hon, and if it existed in his art, this was due to a legacy of the Rococo. Some of Canova's funeral monuments also reveal echoes and transformations of Baroque ideas, not only the two monuments of popes, but also his most important work in this field, the memorial to the Archduchess Maria Christina in the Augustinerkirche in Vienna, finished in 1805 [307].[3] There is much theatricality in the tragic solemnity of this work. The black entrance to the vault, which in the papal monuments is an architectural fact, is here turned into a stage property, and Adolf Hildebrand was right when he found fault with the figures, which he described as 'versteinerte Menschen'

306. Antonio Canova: Pauline Borghese as Venus, 1807. Marble. *Rome, Galleria Borghese*

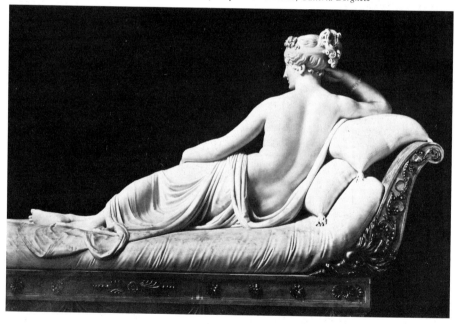

Borghese [306], the sculptural counterpart to David's portrait of Madame Récamier painted a few years earlier, the construction and the gentle flow of the contours result in an ideal of nobility as well as charm. It was this side of Canova's

('petrified human beings'). All in all, however, this picture in stone, this sentimental allegory of piety, is Canova's finest achievement, partly because in it he departed from the classical model to a greater extent than in any other work.

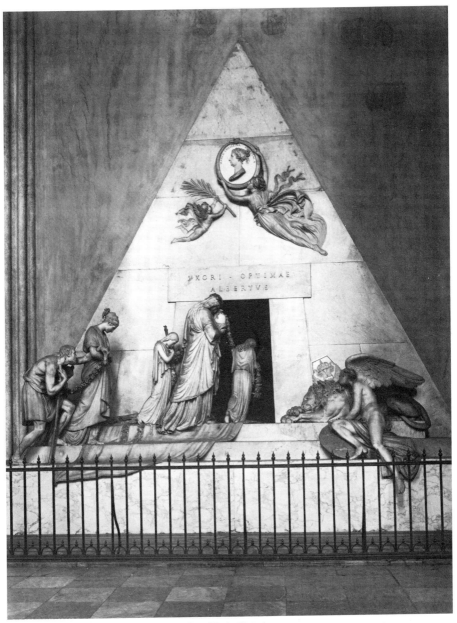

307. Antonio Canova: Tomb of the Archduchess Maria Christina,
finished 1805. Marble. *Vienna, Augustinerkirche*

As a biographer of his said at the end of the last century,[4] 'The great spirit ruling the universe may look upon it [Canova's art] with tolerant irony, when he thinks of the genuine art of Antiquity, the art of a so much more healthy youth of mankind, and an art of whose eternal beauty Canova contrived to capture only a few rays. These rays shed enough light, however, to give life to a new era in art.'

BERTEL THORVALDSEN (1770–1844)

Canova's contemporaries really believed that they could detect the beginning of a new era in his works. They felt the same enthusiasm on beholding those of Thorvaldsen. In fact, however, the eclectic art of Canova and Thorvaldsen led nowhere; the mysterious, timeless grandeur of the Classicism of Ingres was denied them. They had successors, but these were epigones. Both the aims and the achievements of Canova and Thorvaldsen are very similar; indeed, the differences between them are not easy to define.

Thorvaldsen is not quite so theatrical as Canova. His most important advantage probably lies in the fact that in his best moments he contrived to express in his figures slightly more self-contained repose, in the sense in which we find it in the art of Antiquity. For him, contrary to what was customary in his time, 'first-hand' art of Antiquity meant not Roman, but archaic Greek sculpture. Quite apart from any opinion based on style, this is proved by certain items in his own collection of antique sculpture and by his decision in 1816 to restore the recently discovered figures of the Aeginetan pediment for erection in the Munich Glyptothek. That he was influenced in his own production by this archaic, or Early Classical, Greek art is shown by some of his numerous reliefs (*Priam entreating Achilles to deliver the Body of Hector*, 1815 [308]; *Amor and Anacreon*, 1828; parts of the great *Alexander Frieze*, 1812;[5] all Thorvaldsens Museum) and the statue of *Hope* (1817, Thorvaldsens Museum). The emotionless repose of Greek statues is transformed in his figures into a

308. Bertel Thorvaldsen: Priam entreating Achilles to deliver the Body of Hector, 1815. Marble. *Copenhagen, Thorvaldsens Museum*

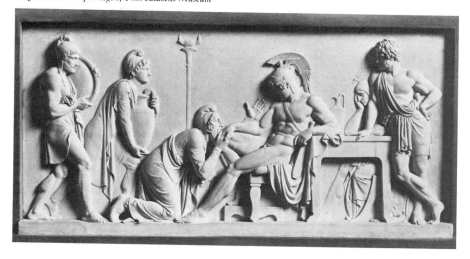

309. Bertel Thorvaldsen:
Hebe, 1806. Marble.
Copenhagen, Thorvaldsens Museum

romantic dreaminess, for example in the *Gany-mede* (1804), and the *Hebe* (1806) [309], and in some of his portraits, such as that of Princess Bariatinsky (1818; all three also in Thorvaldsens Museum).

Most of Thorvaldsen's works were created in Rome. The son of a wood carver from Iceland who had settled in Copenhagen, Thorvaldsen was already attending the academy in 1781, when he was still only a child. There Abilgaard soon began to take an interest in him. In 1797 he went to Rome, where he remained until 1838, except for a short visit to his own country in 1818-19. While there he received the commission for the statues of Christ and the Apostles for the Church of Our Lady in Copenhagen (executed in 1821-7). The art of Carstens, whom he got to know just before the latter's death, made a deep impression upon him.[6]

After the first difficult years in Rome, at last in 1803 the tide turned. In that year the English collector Thomas Hope commissioned him to execute in marble a figure of Jason of which the model was just finished (completed 1828, Thorvaldsens Museum). This is his first deliberately Classicist work, and it already shows the influence of Canova. Soon commissions began to pour in from every part of the world, and Thorvaldsen was able to carry them out only with the assistance of a number of pupils, among them his fellow-countrymen Herman Vilhelm Bissen (1798-1868) and Herman Ernst Freund (1786-1840). The works executed include the equestrian statue of Prince Poniatowski for Warsaw (1826-7), the equestrian monument of the Elector Maximilian of Bavaria for Munich (1833-5), the Byron Monument for London (1829), which eventually found a resting-place in the library of Trinity College, Cambridge, the Gutenberg Monument for Mainz (1833-4, executed by Bissen), the Schiller Monument for Stuttgart (1835), and the 'Lion of Lucerne'.[7] Thorvaldsen's ultimate return from Rome to Copenhagen

was an event in Denmark's history, and Thor-valdsens Museum, erected in 1839-48 by the architect Bindesbøll, in which the sculptor is buried, became his country's memorial to him. This building with its pictorial and sculptural decorations by the painters Jørgen Sonne (see above, p. 92 and illustration 56) and Henrik Christian From (1811-79) and the sculptors Bissen and Freund, is also a Classicist *Gesamt-kunstwerk*, and one of the most interesting.

Thorvaldsen influenced sculpture through-out Europe; in his own country, Denmark, the immediate followers of his style were Freund, Bissen, and Jens Adolf Jerichau (1816-83). In their work the ambition to be monumental grew weaker and weaker and what was left is only an extravagant paraphrase of an ideal of tender and often effeminate grace. The youngest member of this group, Jerichau, introduced a few more life-like touches into his art, and this was enough to bring him into a conflict with the orthodox Classicist school which it is difficult for us to understand today.

JOHAN TOBIAS SERGEL (1740-1814)

The grandeur of the principal ideas of Canova and Thorvaldsen, sublimity, dignity, and per-fect grace – with, in addition, the attractive vision of combining Antiquity and Christianity – achieved world-wide fame for both these sculptors, since theirs were the general ideals of the time. Their technical mastery in the treat-ment of marble was an additional factor. The smoothness and whiteness of their stone figures fascinated everybody because they seemed to be the expression of an unearthly purity. The fact was overlooked that this treatment is by no means exclusively an expression of ethical values in artistic form, but also of a voluptuous use of technical bravura, and of a poverty of real sculptural vitality, in the sense of living rela-tionships between surfaces, curves, and depths.

In the art of the Swedish sculptor Sergel the position is the exact reverse: his fame did not spread beyond the frontiers of his own country, and he did not approach his art with an arma-ment of ideological and symbolical notions. He concerned himself with the solution of sculp-tural problems as they could be combined with the natural and the vital. His attitude to nature is thus the same as that of his contemporary Houdon, and he occupies the same position be-tween Baroque and Classicism, whereas in the development of Thorvaldsen, who was younger by one generation, Baroque was nothing but a temporary phase at the beginning of his career.[8] In his *Resting Faun* [310] Sergel for the first time gave full expression to his character, his nature, and his ability as a sculptor. He made the clay model for it in Rome in 1770 – two versions in marble were completed four years later – and it is astonishing how perfectly the experience of the antique and the art treasures of Rome in general are balanced here by the force of a personality, in spite of the fact that this experience had been so overwhelming as al-most to shatter him, and occasionally to make it impossible for him to do any work. Sergel's *Faun* is a synthesis – to refer only to obvious models – of the dynamics and refinement of Bernini (a model unusual at the time) and of the canon of classical sculpture. After studying in Stockholm under the painter Jacques-Adrien Masreliez (1717-1806) and the sculptor Pierre-Hubert Larchevêque (1721-78) and spending a short time in Paris in 1758, Sergel went to Rome in 1767, where he remained for twelve years. The vigour and originality of the *Faun* are again evident, this time in terms of a dramatic group, in his *Mars and Venus* (1770s, several versions in plaster and terracotta, executed in marble in 1804) [311], which is his chief work, and in the *Dying Otryades* (1779, terracotta model, Stock-holm). If we judge it by the pathos and the over-stressed *contrapposto*, the *Mars and Venus* ought

310. Johan Tobias Sergel: Resting Faun, 1774.
Marble. *Stockholm, Nationalmuseum*

to be described as Baroque. Sergel's principle
- and it was the principle of the most forceful
personalities among the sculptors of early and
mature Classicism - was not to weaken Baro-
que dynamism, but to control it. To achieve
this, one deliberately severe contour was often
enough, like the vibrating, sinewy vertical of the
left side of the body of Mars, against which all
the writhing curves terminate.

Another side of Sergel's work is exemplified
by a series of vivacious portraits, most of them
executed when he was court sculptor to King
Gustav III. He also produced many drawings,
among them numerous masterly designs and
caricatures, and a few sweeping and agitated
landscapes, in which Baroque liveliness is

mingled with the irony of the Age of Reason.
These drawings are basically in the spirit of
Abilgaard, and they also have something of the
demonic element of Blake and Fuseli [312].

There were no lasting after-effects anywhere
of the impression made by Sergel's forceful per-
sonality. He himself, after he had left the city,
spoke of Rome as the 'only true home of art
where an artist ought to be born, live, and die;
for all the other countries of Europe are bar-
baric'; but Rome, in the sense of the Canova-
Thorvaldsen style, became the sole satisfying
doctrine only for those Swedish sculptors who
visited Rome after him, especially Johan Niklas
Byström (1783-1848), who lived there perma-
nently from 1810 on, and Bengt Erland Fogel-

311 *(opposite)*. Johan Tobias Sergel: Mars and Venus, *c*. 1770–80. Clay. *Stockholm, Nationalmuseum*

312 *(above)*. Johan Tobias Sergel: An Abduction, *c*. 1775. Pen-drawing. *Stockholm, Nationalmuseum*

berg (1786–1854). However, the apostles of this
doctrine were active in all other European coun-
tries as well, right down to Spain – where José
Alvarez y Cubero (1768–1827) and Valeriano
Salvatierra y Barriale (*c.* 1790–1836) were the
leading Classicists – and the average production
degenerated more and more into a cliché-ridden
sentimentality. In the end, there was in many
areas nothing but this average production, in
which the boundary, always endangered, be-
tween real monumentality and empty bombast
was more and more frequently overstepped.

GOTTFRIED SCHADOW (1764–1850)

In the foregoing pages two trends of Classicism
in sculpture could be distinguished, the manner
of Canova and Thorvaldsen, dominated by art
theory, and always concerned with a world of
gods and Titans, and the more sensuous manner
of Houdon and Sergel, which devoted its efforts
to the lifelike representation of man. This
second trend, more closely bound to visible
reality, and also to the only indirectly visible,
the psychological, reality, proved to be the
stronger both in sculpture and in painting. No-
where did the doctrinaire trend in sculpture
produce anything new, anything comparable
with the elementary force of the poetry of the
Goethe period in Germany. Classicist sculp-
ture of this particular kind continued to lag
even further behind poetry than did Classicist
painting.

Gottfried Schadow was completely on the
side of Houdon and of Sergel (whom he met
during a journey to Russia, Denmark, and
Sweden in 1791–2). In his case there is less of a
definitely Baroque element than there is in
those of the two older artists. It is true that
Schadow received his first schooling from a
Baroque artist, the Belgian Jean-Pierre-Antoine
Tassaert (1727–88), who is known chiefly for his
portrait busts. He worked as court sculptor in
Berlin from 1775 unil 1788, when he was suc-

313. Gottfried Schadow:
General Joachim Ziethen, 1794. Marble.
(East) Berlin, Staatliche Museen

ceeded by Schadow. From 1785 to 1787 Scha-
dow was in Rome, where he came into contact
with Canova. In his first important work, the
funeral monument of Count Alexander von der
Mark (completed in 1790, Berlin, Dorotheen-
städtische Kirche), the fundamental differences
between his art and that of Canova are clearly
visible. The subject, the poetry of death, was a
favourite subject of their age. In Schadow's
work this poetry is not conveyed with demon-
strative pathos, and the same is true of his
monuments of famous men,[9] such as his chief
work of this kind, the monument of Frederick
the Great at Stettin (completed in 1793; the
original is in the Ständehaus, Stettin).[10] Harsh-
ness and masculine sobriety, the pride of the
middle-class citizen and Prussianness are the
outstanding traits in Schadow's conception of
human beings. In this he resembles Chodo-
wiecki and Graff [30]. Thus, he strove to em-
phasize human simplicity even in his marble
statue of General Ziethen (finished 1794; ori-
ginal in East Berlin) [313] and in his statue of
Field-Marshal Blücher for the city of Rostock
(completed in 1819), despite the antique lion's
skin bestowed upon the latter at the request of
Goethe. For Schadow 'form always remained a
contemporary dress for a super-historical con-
ception of nature' (Karl Scheffler).[11] But in a
work like the group of Crown Princess Luise
and her sister Friederike (1793)[314] the Classi-
cist ideal of repose and harmony is spiritualized
by means of naturalness, especially in the mag-
nificently differentiated abundance of the flow
of the folds.

Schadow's numerous reliefs (Ziethen Monu-
ment; reliefs on Karl Gotthard Langhans's
Brandenburger Tor in Berlin[12]; frieze on the
Mint in Berlin, 1800, after designs by the archi-
tect Friedrich Gilly) possess a Baroque liveli-
ness and agitation and a sense of painterly space,
and his drawings and etchings a Baroque vigour
and a delicacy that are more marked than in the
works he carved in the round.

314. Gottfried Schadow:
The Princesses Luise and Friederike, 1793. Marble.
(East) Berlin, Staatliche Museen

THE SPREAD OF CLASSICISM

The general aspect of Classicist sculpture is so clearly defined in the works of Houdon, Canova, Thorvaldsen, Sergel, and Schadow that few essential traits can be found that do not appear in their work. The overwhelming influence of Canova and Thorvaldsen largely excluded the development of individual characteristics among the minor talents. But some who worked at a distance from spectacular events do show

315. Asmus Jakob Carstens: Atropos, 1794. Plaster. *Frankfurt am Main, Städelsches Kunstinstitut*

original features, especially during the tense period when Classicism was just beginning.

Among the most interesting works is the one accidentally surviving fragment of the sculpture of Asmus Jakob Carstens. This is a plaster figure of one of the Fates, *Atropos* (1794) [315]. All the rest of his sculpture, as well as his designs for a monument of Frederick the Great, have been destroyed (see above, p. 52). In comparison with his drawn figures, the *Atropos* is not a work of Classicism, for the gesture is ecstatic and unrestrained, and the whole figure is expressive of uncontrolled emotion, a thing which Classicist sculpture was very reluctant to allow. The unusual element in the *Atropos* cannot, however, be ascribed to the polarity between Baroque and Classicism; its passionate feeling is not derived from eighteenth-century Baroque, and it could be considered as a rare example of *Sturm und Drang* in sculpture, if it were not so evidently a reflection of Michelangelo's tremendous turbulence.

With this *Atropos* by Carstens begins that series of sculpture by painters which was continued from time to time during the following century and provides an interesting demonstration of the fact that painters can sometimes surpass professional sculptors in their own art. These works – by Carstens, Géricault, Daumier, Degas, Renoir – prove that it was the painters who sought most earnestly to achieve the absolute in sculpture.

At least one sculptor, however, is remarkable because he does not express himself by means of either solemnity or prettiness, or by mere painstaking imitation of external reality. Shortly before Carstens created his *Atropos*, an Austrian sculptor was engaged on his last works, which, in a curiously aloof way, are a most striking example of how sculptors of the late eighteenth century were turning away from the sculptural conception of the Baroque. His name was Franz Xaver Messerschmidt (1736–83), and he had been the most important Baroque sculptor in

Austria during the second half of the eighteenth century. His busts of the Empress Maria Theresia and her husband Francis Stephen of Lorraine (now in the Österreichisches Barockmuseum at Vienna) are brilliant examples of Late Baroque court portraiture, while that of the physician Gerard van Swieten, in the same museum (1769), is something rather more than this, since psychological profundity is added to the polyphonic abundance of Baroque sculptural form which here flares up in all its splendour for

316. Franz Xaver Messerschmidt: A Rascal, c. 1780. Lead. *Vienna, Österreichische Galerie*

the last time. From the beginning of the 1770s, these studies in physiognomy provided him with a long series of subjects – sixty-nine in all – for heads in lead or stone [316]. As representations of types of human character, temperament, and mood they clearly belong to the same period as Lavater's *Physiognomische Fragmente zur Beförderung der Menschenkenntnis und Menschenliebe*[13] (1775-8), but in the sculptural construction of

some of them there is a deliberately radical element which is hardly ever found in other contemporary works. This radical element can be described as the nakedness of cubic form, and it gives them, in comparison with the rest of the sculpture of the time, an almost abstract quality. Classicist sculpture strove to express abstract ideas, but its only achievement was the rather negative one of limiting and simplifying the effect of the corporeal. The powerful directness of the sculptural effect of masses in these character heads by Messerschmidt found no following.

The leading sculptor of Austrian Classicism, Franz Anton von Zauner (1746-1822), could not entirely ignore the increasing interest in the psychologically conceived portrait, and his bust of a famous contemporary, Freiherr Josef von Sonnenfels (1787, Vienna, Akademie der bildenden Künste), shows how successful he was in dealing with it. As a rule, however, it was more in his line to attempt the usual kind of generalization and universal validity in monumental figures. It is true that he revered Georg Raphael Donner (1693-1741), the great Baroque master, but Donner's is the most moderate, the most 'Classic' style among the Baroque sculptors of Austria. In the school of Johann Christian Wilhelm Beyer (1725-96), under whose direction he worked on the stone figures for the park of the castle of Schönbrunn, Zauner was in contact with the dying Baroque of the 1770s. From 1776 to 1781, together with his friend Füger, he lived in Rome, under the direct influence of the sculptor Alexander Trippel of Schaffhausen (1744-93) and in the circle of David, Mengs, and Canova. In the three chief works of his maturity, simplicity and an unpretentiousness remarkable in comparison with the overstressed solemnity of so many of his contemporaries are the main virtues. These three works are the monuments of Field-Marshal Gideon von Laudon (1790-1) at Hadersdorf near Vienna and of the Emperor Leopold II (1793-5, Vienna, Augustinerkirche), and the bronze equestrian

statue of the Emperor Joseph II in the square in front of the National Library (1795-1806) [317].[14] The latter is his finest piece on a large scale, and the highest praise one can give is to acknowledge that it takes careful account of the background of architecture by Fischer von Erlach and succeeds in asserting itself artistically in front of the colossal dimensions of this building. In its composition it continues the long tradition of the equestrian statue of Marcus Aurelius on the Capitol in Rome.

Zauner's nearest artistic relative is Johann Martin Fischer (1741-1820). In his work Classicism became more and more academic. He, too, owed much to that 'Classic' trend in the Baroque which was represented in Austria by Donner. Donner's principal work, the fountain in the Neuer Markt at Vienna (1737-9), he renovated in 1801. Viennese sculptors such as Johann Nepomuk Schaller (1777-1842) and Leopold Kiesling (1770-1827) remained followers of Canova, while in the late works of Josef

317. Franz Anton von Zauner:
The Emperor Joseph II, 1795-1806. Bronze.
Vienna, Josefsplatz

Klieber (1773-1850), whose beginnings were similar, a Biedermeier cosiness takes the place of austere severity. Figure reliefs full of decorative harmony are combined with the sober charm of the pre-1848 architectural style to make an informal unity of buildings and sculpture, for the last time before the mostly unsuccessful attempts in this direction during the subsequent period of historicism. Very often, even during the heyday of Classicism, such endeavours towards a *Gesamtkunstwerk* fell far short of the ideal, whether the work was designed by one master, or, as often the case in the field of monumental sculpture, it was, on the Baroque pattern, due to the collaboration of painters and sculptors.

In Germany during the 'heroic' early stage of Classicist sculpture, the Swabian Johann Heinrich von Dannecker (1758-1841) was the most gifted artist after Schadow. His very popular *Ariadne riding on a Panther* (1803, various other versions down to 1814), the portrait of his friend Schiller (1794, likewise in several versions; colossal marble bust dating from 1810 in the Valhalla near Regensburg), and a self-portrait made in 1797 (Stuttgart) are outstanding examples of German Classicism in sculpture.

A pupil of Schadow and his most notable follower was the North German Christian Rauch (1777-1857). During his stay in Rome from 1804 to 1811, Rauch added the influence of Thorvaldsen to that of Schadow. This influence turned out to be very strong, as Rauch's character was similar to Thorvaldsen's. The characteristic feature of Rauch's art is the trend towards prettifying, towards the smooth and pleasing, and towards a courtly elegance. These qualities make it understandable that he was widely successful and received innumerable commissions for portraits and monuments. Schadow's well-known pun to the effect that his fame was 'in Rauch aufgegangen' (had gone up in smoke) has a sharper edge than perhaps he himself imagined. The monument of Queen Luise at Charlottenburg, one of Rauch's early

works (1810-14), is among the best of its kind, and is a worthy successor to Schadow's monument of Graf von der Mark. But Rauch's later monuments of the same kind reveal a progressive shallowness as they decline towards the naturalistic. In the statue of the Emperor Alexander of Russia (1814-21) [318], and also in the Scharnhorst Monument in Berlin (1819-22), realism and idealization are still in harmony with each other and controlled by a formal idea, above all by a flowing linear composition; but Rauch's

318. Christian Rauch:
The Emperor Alexander of Russia, 1814-21. Plaster.
Formerly Berlin, Rauch Museum

later portrait statues are nothing but an adaptation of nature. His chief work, the monument to Frederick the Great in Berlin (1839–52), belongs to the second category. It is an example of that mass production of public statuary which went on throughout the century, and which may well be said to show an excess of anecdote and symbol and a paucity of all that is essential to sculpture.

The strongest echo of Rauch's manner is to be found in the art of his pupil Ernst Rietschel of Dresden (1804–61). Of his monuments of great Germans – Lessing (1853, Brunswick); Goethe and Schiller (1857, Weimar); the Monument to the Reformation at Worms with its statue of Luther (1858); and Carl Maria von Weber (1860, Dresden) – the last is the most natural. In the sculpture of the mid nineteenth century naturalness became more and more a merit, though a modest one, within the increasingly monotonous and empty academic formality. In most cases, even in the specialized branch of portrait sculpture, naturalness gradually sank into routine imitation far removed from genuine art. Thanks to the long persistence of the nobility of the Rauch tradition, Johann Friedrich Drake (1805–82), one of Rauch's pupils, was to a certain extent preserved from this danger. The numerous allegorical statues and the architectural sculpture of Ernst Julius Hähnel (1811–91) of Dresden, a pupil of Rietschel and Schwanthaler, also remained within the orbit of this tradition. In addition to the Arcadia of statuary, there was also a Valhalla; for the idealistic trend in sculpture showed a preference for colossal patriotic monuments, such as the Niederwald Monument (finished 1883) on the Rhine by Johannes Schilling (1822–1910), the monument to Bavaria in Munich (1837–50) by Ludwig Schwanthaler (1802–48), the leading sculptor of South Germany, the same artist's groups for the pediments[15] of Klenze's Valhalla near Regensburg (completed in 1842), and Ernst von Bandel's (1800–76) monument to Arminius the Cheruscan in the Teutoburger Wald (1830–75).

*

In French Classicist sculpture, in spite of what Houdon had achieved, it was Canova, Napoleon's court sculptor, who set the fashion. Only rarely does one meet works independent of his influence, such as the very individual bust of Napoleon by Charles-Louis Corbet (1758–1808) in the museum at Versailles. This is dated 1802. A faithful reflection of Canova's art, both in the heroic pose of the glorified ruler and in an often mawkishly sentimental gracefulness, is found in the works of Antoine-Denis Chaudet (1763–1810), who was likewise court sculptor. In addition to many portraits of Napoleon, he executed in 1808 the colossal statue of the emperor on the column in the Place Vendôme.[16] Soon afterwards, in 1816, François-Frédéric Lemot (1772–1827) completed his equestrian statue of Henri IV on the Pont Neuf in Paris. This is a later French counterpart to Zauner's monument of Joseph II in Vienna, but compared with the pure Classicism of the latter it appears to be still an imitation of Baroque equestrian statues. The same pompous glorification of a ruler is found in the relief by Jean-Pierre Cortot (1787–1843) depicting the *Triumph of Napoleon in 1809–10*. This is on the Arc de Triomphe (c. 1833), but the ardent epic poetry of Rude's *Marseillaise*, its companion-piece executed at the same time (see p. 399, illustration 320), damns Cortot's relief for ever as an example of arid, mediocre Classicism. The two reliefs on the opposite side of the Arc de Triomphe date from the same years – *The Resistance of the French People in 1814* and *The Peace of 1815*, both by Antoine Etex (1808–88). Like Cortot's relief, these works, finished in 1836, are related to Rude's group only superficially; in spirit they are fundamentally different. The friezes above these huge reliefs, by the sculptors Jean-François-Théodore Gechter (1796–1844), Philippe-Joseph-Henri Lemaire (1798–1880), Bernard-Gabriel Seurre (1795–

1867), Jean-Jacques Feuchère (1807-52), Jean-Étienne Chaponnière (1801-35), and Baron Carlo Marochetti (1805-67) are battle-scenes in bas-relief. During the 1830s, that is during the era of Louis-Philippe, there was also an unusual demand for public monuments. From these years date the colossal allegorical figures of eight French cities on the Place de la Concorde, the best of which (*Strasbourg* and *Lille*) are by James Pradier (1790-1852), while the fountain in the same square, with the personifications of the Rhine and the Rhône, is by Gechter.[17] A beautiful but isolated example of the quieter, more modest tone of arcadian Classicism is provided by *The Farewell* (Paris, Louvre) by Jean-Joseph Perraud (1819-76). Otherwise the cold pomp of academic Classicism persisted for decades in French monumental sculpture. Frédéric-Auguste Bartholdi's (1834-1904) *Statue of Liberty* for New York (1886), a gift of France to the United States, is still in this style.

A sentimental mood and the ingratiating charm of single figures or genre groups within the narrow framework of the academic style or borrowed from famous French Late Baroque models – Pigalle, Falconet, Clodion, Pajou – are the principal features of the work of Pradier, Pierre-François Giraud (1783-1836), François-Joseph Bosio (1769-1845), and Francisque-Joseph Duret (1804-65). In some of their works the desire to express the cheerful and the graceful tempted them into greater freedom, as for example in Duret's *Neapolitan Fisherman dancing* (1833, Louvre); in the same way, in heroic or tragic figures such as Cortot's *Messenger from Marathon* (1834, Louvre), the limits which Canova, in such works as *Hercules and Lychas* (1795, Rome, Palazzo Torlonia) and *Theseus battling with the Centaur* (1805-19, Vienna, Kunsthistorisches Museum) had set for others as well as himself are occasionally overstepped.

Pierre-Jean David (1788-1856), called David d'Angers on account of his birthplace, was another artist who did not remain completely

within the austere and narrow world of stately statuary and tranquil forms. He was trained in the Classicist school, at first under Jacques-Louis David in Paris and later, from 1811 to 1816, in Rome under the influence of Canova and Thorvaldsen, while immediately after his return from Rome in 1816 he studied the Elgin Marbles in London. This was the preparation for two of his monumental works, the frieze on the Odéon (completed in 1827, destroyed by fire) and the group for the pediment of the Panthéon completed in 1837.[18] In addition to these works, single statues like the monument to Condé (finished in 1817, in the courtyard of the Palace of Versailles), the *Philopoemen* (c. 1835, Paris, Louvre), *General Bonchamp* (1824, church of Saint-Florent), *Racine* (1824-7, La Ferté-Milon), *Talma* (1827, Paris, Jardin des Tuileries), the Gutenberg Monument at Strasbourg (1840), etc. all contributed to his fame. But he owes his position in the history of nineteenth-century sculpture still more to his numerous portrait reliefs of famous contemporaries. Among others he portrayed Jacques-Louis David, Charlet, Canova, Gros, Gérard, Ingres,

319. Pierre-Jean David d'Angers: Johann Wolfgang von Goethe, 1831. Plaster. *Angers, Musée de Peinture et de Sculpture*

Victor Hugo, and Chateaubriand. Nor was his work in this field restricted to France. He made journeys abroad, visiting London a second time and portraying his friend Flaxman, and visiting Germany twice. Here he stayed at Weimar,[19] Berlin, Dresden (see above, p. 97), Nuremberg, Cologne, and Munich, and made portraits of Rauch, Ludwig Tieck, Goethe [319], Schiller, Alexander von Humboldt, Schinkel, Chamisso, etc. In two respects these reliefs represent a departure from Classicism, to which in the main he adhered in his monumental works. Painterly elements are often introduced into the relief style which makes them in a certain sense more realistic than the reliefs produced by doctrinaire Classicism. Secondly, however, in many of David d'Angers's portraits of celebrities the physiognomical peculiarities are rhetorically exaggerated, the 'genius' of the sitter being conveyed by overstressing the energy of the profile, the locks of a leonine head, the arching of a forehead, or the jutting forward of a chin. In this interpretation Romantic elements are mixed with Classicist hero-worship and a very definite sense of reality.

In Italy, as was only natural, the influence of Canova was decisive and lasted for several decades. Of his pupils, Pompeo Marchesi (1789–1858) also rose to fame and also worked abroad (monument to the Emperor Francis I in the Hofburg at Vienna, 1846; colossal statue of Goethe in the City Library at Frankfurt am Main, 1838). His best-known work in the field of public statuary in Italy is the monument to Alessandro Volta at Como (1838); among his portraits, the self-portrait of c. 1840 and the portrait bust of Giovanni Bozzotti dating from 1827 (both in the Civiche Raccolte d'Arte at Milan) are outstanding. In them and in a work

such as the portrait bust of the Abbate G. B. Casti (1804, Milan, Civiche Raccolte d'Arte) by Giovanni Battista Comolli (1775-1830), a pupil of Canova, the restrained realism of the early nineteenth century is represented at its best. A counterpart to this is the bust of the painter Giuseppe Bossi (1817, Milan, Brera) by Camillo Pacetti (1758-1826), which, with its sentimental mannerism, is one of the best works of Italian Classicism.

It is understandable that the progress of Realism brought Italian sculpture into contact with the sculpture of the Quattrocento, and the only surprising thing is that this contact was not closer. In one case it proved particularly fruitful – in the monument to Countess Zamoyski in S. Croce at Florence (1837), the *chef d'œuvre* of Lorenzo Bartolini (1777-1850). Apart from this work, Bartolini, one of the most successful Italian sculptors of his time, a pupil of David and Lemot in Paris and one of those employed on the reliefs for the column in the Place Vendôme, followed in the footsteps of Thorvaldsen and Canova. Pietro Tenerani (1798-1869) remained especially faithful to his teacher Thorvaldsen. His monument for Pope Pius VIII in St Peter's (1866) is in every respect on the same lines as Thorvaldsen's monument for Pius VII there (1823-31) and Canova's papal tombs.

When Italian sculpture at last broke away from academism, it went to the other extreme: a distasteful, theatrical *verismo*. Supernatural beings were in most cases replaced by figures from real life, usually rendered with excessive agitation, sentimentality, and gush, but showing little inventiveness or creative power. About the middle of the century in Italy – and not only in Italy – there began a mass production of sculpture which belongs rather to the history of civilization than to the history of art.

SCULPTURE IN THE DAYS OF ROMANTICISM AND REALISM

The terms Romanticism and Realism can hardly be used in a precise sense with reference to nineteenth-century sculpture. There had been Realism in sculpture ever since the end of the Baroque, and the transition to the new kind of Realism was much simpler than it was in painting. Of course, this is true only in a very general sense – it would not apply where there was a strong desire to achieve strictly sculptural form and expression by means of strictly sculptural form – but this desire to resist the temptations of Realism had in most cases not been sufficiently strong since the end of the Baroque.

As regards Romanticism, and fundamentally for the same reason, there was in sculpture no Romanticism in the stricter and deeper sense nor a Romanticism in the sense of an organized spread of a doctrine. Naturally, there was Romanticism in the 'literary' sense, in the choice of subjects. It goes without saying that the Early Romantic, sentimental philosophy of life which found expression throughout the whole of the Classicist period in the idea of the English Garden also expressed itself in the sculpture in these gardens. Similar to that of garden sculpture was the situation of funeral sculpture. Canova's monument to the Archduchess Maria Christina [307] clearly shows a Romantic trend, and Zauner's monument to Laudon – after a design by Füger – with the stone figure of a mourning knight seems, in its sylvan surroundings, like something out of a picture by Friedrich. But this sort of thing does not seriously constitute Romantic sculpture. Yet Romantic sculpture could easily be imagined. Just as the sculpture of Antiquity was studied by the Classicist sculptors, so could that of the Middle Ages have been by sculptors during the Ro-

mantic period, at least to the same extent as medieval painting was studied by the Nazarenes. As a matter of fact, however, this hardly ever happened.

But Romanticism in sculpture could also mean something quite different, something more profound and independent of models of the past, something entirely of its own. Why should the transcendental aspect of Romantic feeling, the idea of boundlessness, not find expression in pure sculptural form, just as it had in painting and the graphic arts in the rhythm of lines and in chiaroscuro? One might have thought such aesthetic adventures would have been possible in sculpture as in the other arts. In particular, one might have thought that sculptors would have been able to invent innumerable interactions between the body and the surrounding space, relationships which Classicist sculpture, in accordance with its programme, had largely ignored. In fact, the path of development did lead to such incursions into new fields of sculptural creation. But during the Romantic period there was not yet any general manifestation of this. Only isolated attempts can be singled out. On the whole, Romanticism in the field of sculpture never ventured outside the sphere of subject-matter, that is of narrative elements and mood. In this sense, David d'Angers can, and François Rude must, be called a Romantic.

Romanticism in sculpture, even within these narrow limits, existed in France alone. It did not – oddly enough – exist in Germany, the country of Romantic poetry, painting, and music. In Germany there is no sculpture other than that of a late Classicism occasionally turning sentimental.

FRANÇOIS RUDE (1784-1855)

In Rude's life and work politics played a part which cannot be disregarded. A supporter of Napoleon, he fled to Brussels after the fall of the Emperor in 1814, and did not return to France until 1827. The work which, above all others, laid the foundations of his fame is the relief on the Arc de Triomphe de l'Étoile in Paris glorifying the French Revolution [320], while another of his chief works is a vision of the resurrection and immortality of Napoleon.

The works Rude produced after he had finished his studies at the École des Beaux-Arts in Paris, and even those produced during his stay in Brussels, are all mediocre, though quite pleasing, and not much more can be said of many of his later works, which enjoy the questionable additional advantage of increased realism. During the intervening period, however, Rude created a few pieces of sculpture which rose above the generally low level of the time. The outstanding examples are the two works we have already mentioned. It is true that the colossal relief on Chalgrin's triumphal arch, *The Departure of the Volunteers in 1792* (1835-6) [320], more generally known as *The Marseillaise*, is made up of a number of conventional details, but that is of minor importance in view of the mighty, compelling impetus of the whole. A comparison with Delacroix's *Liberty on the Barricades*, painted a few years earlier, reveals a close similarity. Rude's group, like Delacroix's painting, is more than just neo-Baroque. It is not an imitation of a past style, but a re-experiencing of the formative methods of the masters of the past. The closest analogy is with Puget's violent style. In Rude we find once

again, after a long interval, a sense of the force-fulness of a mass of stone, and at the same time the power to endow it with dramatic movement. These are forms in rebellion, and in this respect *The Marseillaise* is a notable exception to our generalization that Romanticism in sculpture is confined to narrative and gesture and does not penetrate into sculptural form. The bronze monument of *The Awakening of Napoleon* (1845-7), set in romantic surroundings in a park at Fixin near Dijon,[1] Rude's native city, is a romantically visionary conceit. The emperor is seen rising out of his shroud on a kind of gruesomely improbable rocky catafalque, above a dead eagle. To express this conceit fully in sculptural terms, the mass is broken by mysterious cavities of shadow. Both the bronze statue of the mathematician Gaspard Monge at Beaune (1846-8) and the portrait bust of Jacques-Louis David in the Louvre (1833-8) also show a forceful massiveness beneath a naturalistic surface. On the other hand the magnificent vivacity and fiery silhouette of the bronze statue of Marshal Ney (1852-3, Paris, Place de l'Observatoire) is achieved by sacrificing the strength of the sculptural element.

GÉRICAULT, BARYE, DAUMIER, DANTAN, AND OTHERS

Long before the appearance of Rude's chief works, Géricault had executed a few small pieces of sculpture which, to judge by the only three that have been preserved,[2] cannot be called Romantic in the sense of a stylistic classification, but do express the feeling of the infinite through the medium of sculpture in a way quite foreign to other sculpture of the time. These sculptural works by Géricault not only stand out above the general run of contemporary production, but they are also of special interest in that they do not even express themselves in the same language. The relationship of the *Satyr and Nymph* (c. 1818) [321] to Correggio's *Jupiter and*

320. François Rude:
Departure of the Volunteers in 1792,
1835-6. Stone. *Paris, Arc de Triomphe de l'Étoile*

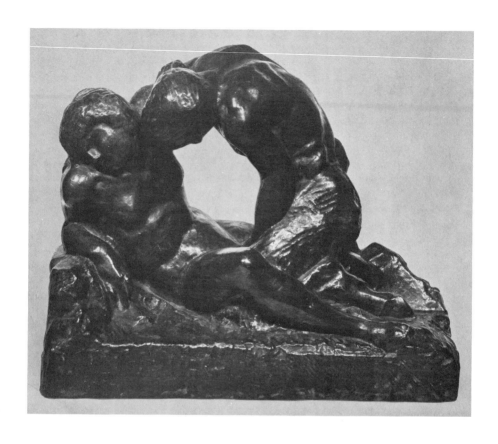

321. Théodore Géricault: Satyr and Nymph, *c.* 1818. Bronze. *Paris, private collection*

Antiope is of less importance than its relationship to Michelangelo. The introspection and the aloof, sombre melancholy are all entirely in the spirit of Michelangelo, and so is the whole conception of sculptural form, seen even in such a detail as the head inclined towards the shoulder in an attitude of tragic resignation. In creating this grandiose piece of sculpture, Géricault must have had in mind Michelangelo's *Captives* in the grotto of the Boboli Gardens (now in the Galleria dell'Accademia at Florence), and perhaps the Rondanini *Pietà* as well.

In the *Satyr and Nymph* the space between the writhing, surging masses of the two bodies has a formal function of its own. Such things played no important role in Classicist sculpture, but naturally became significant in romantically dramatized sculpture. There is now a double meaning in the silhouette, which is related not only to the body itself, but also to the surrounding empty space. This effect is of great importance in the animal sculpture of Antoine-Louis Barye (1796-1875), equally as the expression of

a Romantic tendency in sculpture, and as a feature of naturalism. Barye began as a painter. He drew his inspiration from Gros (whose pupil he had been for a short time), from Géricault, and from Delacroix, and his paintings, watercolours, and drawings, whether early or late, are no less important than his sculptural works. In his sculptural representations of animals [322] there is more naturalism than in his paintings or drawings, and that too is characteristic of the relationship between the two arts in general. One could well imagine a closer similarity, in sculptural terms, to his Romanticism of chiaroscuro and his painterly form altogether, but this is not achieved. In fact little more than the very common Romantic predilection for beasts of prey and the savage spectacle of fighting animals links the two aspects of Barye's art. He produced masterly works, for the most part small bronzes, from the beginning of the 1830s onwards, masterly as regards observation, craftsmanship, and the passionate and spirited manner of sculptural execution.

322. Antoine-Louis Barye:
Jaguar devouring a Crocodile, *c.* 1830/40. Bronze.
Copenhagen, Ny Carlsberg Glyptotek

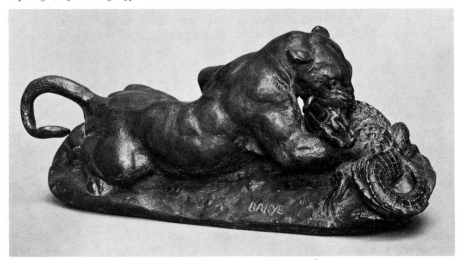

323. Honoré Daumier: Ratapoil, *c.* 1850. Bronze.
Paris, Louvre

324. Jean-Pierre Dantan: Paganini, 1832. Plaster.
Whereabouts unknown

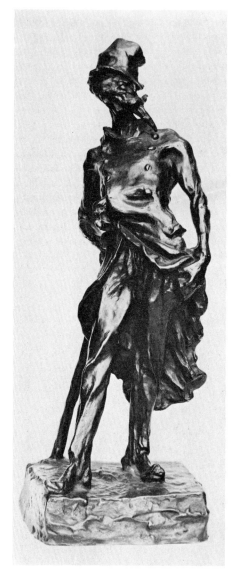

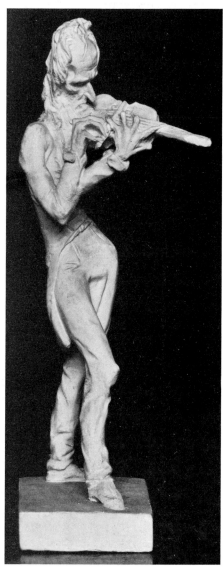

Very different and much closer is the relationship between the drawings and paintings of Daumier and his experiments in sculpture. In the years immediately after 1830 he modelled thirty-six small busts in clay, from which he drew the lithographed bust- and full-length caricatures of the deputies in the Parliament of the 'Roi Citoyen' Louis-Philippe which appeared in *Caricature* in 1832 and 1833.[3] These clay models are sketches, conceived primarily as aids for his work. But they are also something more. The resulting lithographs are clumsy and ponderous and look like reproductions of statues. The effect was deliberate and, moreover, not peculiar to Daumier but a frequent artistic device for political caricature, since the exaggerated massiveness ensured drastic effects. In the portraits of deputies combined in 1834 to form the *Ventre législatif* [197], Daumier achieved a slight reduction and refinement of this massiveness in the individual figures. But he was also already far ahead of his contemporaries in the modelling of the earlier single caricatures. The clay models helped him to achieve this heightened sculptural effect, and in this respect

they are far more than physiognomical studies and caricatures; despite all their technical insouciance and the lack of method, they bear witness to Daumier's close study of sculptural form. Later also, so far as we know, Daumier modelled independent works of sculpture. Of these later pieces for a long time only two were known, the two here illustrated [323, 325], but now some more of Daumier's sculpture has reappeared.[4] The two figures known longest and, in contrast to the others, well documented, are far and away the best of the painter's fragmentarily preserved sculptural *œuvre*. They are the statuette of *Ratapoil*, a symbol of the Bonapartist demagogues (*c.* 1850 [323]; the terracotta original is in the Henry Bing Collection, Paris), and the relief known as *The Fugitives* (*c.* 1870, two versions, plaster casts in the Louvre and in a private collection [325]). Both works, which, artistically, are completely isolated in the mid nineteenth century, show once again how a genius can create his own means in another branch of art. That the experiment was so successful – just as it had previously been with the coarser form of the earlier clay busts – is not

325. Honoré Daumier: Fugitives, *c.* 1870. Plaster.
Private Collection

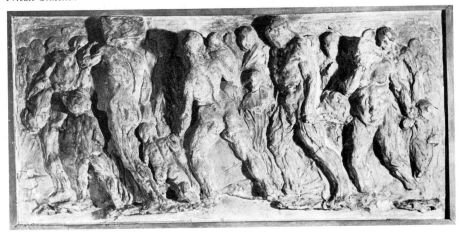

surprising in the case of this 'Michelangelo of draughtsmanship'. Nevertheless, as a sculptor Daumier remains a border-line case, since in all these sculptural works the hand of the born painter is very evident.

In the 1830s sculptural caricatures were also produced by Jean-Pierre Dantan (Dantan jeune; 1800–69), in addition to his 'serious' portrait sculpture. They are terracotta statuettes, witty and pungent caricatures of well-known contemporaries, making use of the method popular at the time of comic exaggeration of bodily shapes and dimensions. Celebrities, artists, and statesmen constitute his 'Dantanorama'.[5] Some

of them are merely amusing puppets (e.g. *The Duke of Gloucester conversing with the Duke of Cumberland*, 1834, *Rossini*, 1831), or reliefs without any particular sculptural ambition (*Liszt at the Piano*), but even in the best pieces of the series, such as the absurd, Satanic figure of Paganini playing the violin (1832) [324], Dantan, in comparison with the sculptor Daumier, is on the same level of caricature as Traviès is with the draughtsman Daumier.

Late Classicist-Naturalist monumental sculpture is a veritable *International* of uniform academic mediocrity, and if any more vigorous

326. Anton Dominik von Fernkorn:
The Lion of Aspern, 1858. Sandstone.
Aspern, Vienna

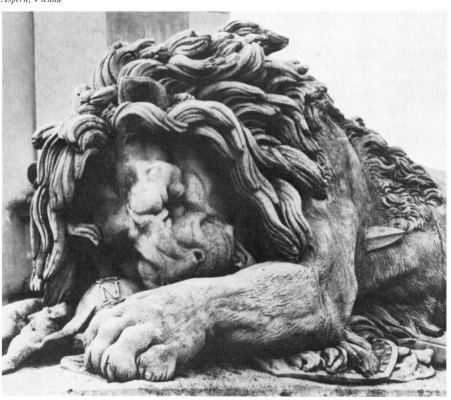

individual talents stand out amidst the mono-
tony, they do so not because they show a closer
approach to the longed-for ideal of a super-
reality on the lines of Classical sculpture, but
because, on the contrary, their vivacious ex-
pressiveness brings about a heightening of the
Romantic and dramatic elements. One example
among the not very many is sufficient here:
Anton Dominik von Fernkorn (1813-78), who
was born in Erfurt, trained under the influence
of Thorvaldsen and Schwanthaler, and worked
from 1840 in Vienna. His *Dying Lion* (com-
pleted 1858) [326], the monument to the fallen
in the cemetery at Aspern near Vienna, where
Napoleon suffered his first defeat in 1809, shows
that Fernkorn possessed a fiery spirit like Rude's
[320] and Rethel's [170, 171]. In its dramatic
forms the huge figure of the animal, with its
almost human face ravaged by grief, is artis-
tically superior to Thorvaldsen's *Lion of Lu-
cerne*. In the two bronze equestrian statues on
the Heldenplatz in Vienna, one of the Archduke
Carl (finished 1860) and the other of Prince
Eugène of Savoy (finished 1865), we have a
variation of the standard type of equestrian
monument with the rearing horse, the type
introduced by Leonardo. Falconet's monument
to Peter the Great in St Petersburg (finished
1782), in particular, and the equestrian portraits
of Velázquez were the models for monuments
of this type during the nineteenth century. The
other type, with the horse moving at a leisured
pace, represented by Schlüter's monument to
the Great Elector in Berlin (finished 1700) and
Bouchardon's statue of Louis XV in Paris
(finished 1762), had its successors in nineteenth-
century equestrian sculpture too. On the whole,
equestrian monuments of the late nineteenth
century were most successful when they re-
mained faithful to Baroque models. A proof of
this is Fernkorn's mighty *Prince Eugène*, one of
the best without doubt of them all.

Other monuments which are of equal artistic
quality are hard to find. They qualify only if

they rise above the anonymity of eclecticism
and lack of imagination by a sense of mass, truly
sculptural and not derived from melodramatic
gesticulation, or by the sensitive curve of a
fluttering mane. The monument to General
Belliard in Brussels (1836) by Willem Geefs
(1805-83) stands out in this way, and so do
individual works by Baron Marochetti, the
'Romantic' among Italian sculptors - for ex-
ample the equestrian statue of Emanuele Fili-
berto of Savoy in Turin (1836) or the statue of
Richard Cœur de Lion in front of the Houses of
Parliament in London (1860). The statue of
Goldoni in Venice (1883) by Antonio Dal Zotto
(1841-1918) is a late example, commendable for
similar reasons. But it was not works of this kind
that determined the general picture. The hosts
of statues made for the squares of every large or
small town, for theatres, public buildings, etc.,
just as they had, in earlier centuries, been made
for churches and palaces, were on the whole
nothing more than official speeches in stone or
metal. They are remote from the real life which
surrounds them, and also remote from the life
of the spirit. In the end nature took them over;
the sun shines on the few good and the many bad
ones, and most of them, their creators forgotten,
have become part of the urban landscape.

SCULPTURE IN THE THIRD QUARTER

OF THE NINETEENTH CENTURY

The title of an account of sculpture from about 1850 to 1880 might be: 'Sculpture in the shadow of fully painterly painting', at least if we think of the more progressive sculpture and of its close connexion with Realism and Impressionism in painting. Such sculpture was painterly from its very foundations. Painterly sculpture had existed before – there was nothing basically new in it – but the painterly effects were now achieved with greater intensity and more consciously. Naturally, when we are confronted with truly powerful individual achievements – and, it may be added, such achievements were not very numerous during this period – all this is almost irrelevant. But from the historical point of view even they lead us to criteria which are primarily those of painting. Hence their role in the art of their time was doomed to be a minor one.

One of the characteristic qualities of 'painterly sculpture' after the middle of the nineteenth century is a new feeling for surface. After the end of Classicism there had been many changes in the treatment of the surface of stone, metal, or clay. For orthodox Classicist sculpture the surface had been something immaterial, possessing a positive value only on account of its unreal, even smoothness. Such, as has already been mentioned, was its moralistic–aesthetic function within the idea of a world of superhuman types. However, the delight in technical perfection, and above all the ostentation which the art of working in marble offered, could add a sense of pleasure in the surface. Such material charm enhanced the ideal spirit of the surface. This material, sensuous charm of the surface

could be of two different kinds. On the one hand it could stress the characteristics of the raw material of which the piece is made. In this way, the sculpture of Michelangelo had achieved the highest synthesis between material and form: the nature of stone and the essence of the form hewn out of the stone are spiritually one. But Classicist sculpture neither knew nor cared about such a synthesis. It is true that it was much concerned with the beauty of the material; but not with its primary, but its secondary beauty, not with the beauty of the stone, but with that of the smooth, softly gleaming surface.

The other, fundamentally different, though also independent and sensuous, value of the surface is its illusionistic possibilities. Here it was not so much a question of extracting the best from the raw material of which the sculpture consisted, whether stone or metal,[1] as of concentrating on the character of the material imitated – flesh, hair, silk, etc. In actual fact, both values invariably co-operate, producing manifold reciprocal relationships. This had already been the case in the illusionistic sculpture of earlier times, during the High and Late Baroque, but now illusionism was exploited to an extreme extent.

In principle, illusionism of the surface has the same double meaning in sculpture as in painting, since both the illusion itself and the artistic play of forms creating the illusion can be appreciated. Despite this, illusionism in the two-dimensional art of painting is not the same thing as illusionism in three dimensions, just as the surface has different meanings in the two arts. In the close texture of innumerable dots

and commas characteristic of painterly painting, the spirit of illusionism can find complete fulfilment. This is shown both by Baroque 'Impressionism' (Hals, Velázquez, Guardi) and by the very different Impressionism of the nineteenth century; in both the glitter of the surface becomes certainly more than just a surface phenomenon. In illusionistic sculpture this possibility exists only to a much smaller degree; for unless specifically sculptural values are added to the illusionism, it retains a certain marginal character and was therefore from the historical point of view destined to be short-lived. However great the charm of an individual work, nothing could change this situation.

The truth of all these considerations can be seen in the art of Carpeaux, the greatest master of painterly sculpture in the nineteenth century.

JEAN-BAPTISTE CARPEAUX (1827-75)

The Louvre possesses a crayon drawing by Carpeaux after the head of the screaming genius of Revolution in Rude's *Marseillaise*. Rude's sharp-edged, spacious carving [320] is transformed in this drawing into an impression of fluttering, scattered strokes and soft hatching. This little sketch sharply stresses the historical position of Carpeaux. The drawing is a tardy homage to Rude, whom the nineteen-year-old Carpeaux, with a sure instinct, had chosen to be his teacher. There followed a brief interlude in the studio of Duret, resulting in the Late Classicist aridity of two reliefs, *The Holy Alliance of the Nations* (1848, plaster cast in the museum at Valenciennes), *Abd-el-Kader surrendering to Napoleon III* (1853, Versailles), and the group of *Hector and Astyanax* (1854, Paris, École des Beaux-Arts). Carpeaux's *Fisher-boy with a Sea-shell*, on the other hand, made during his stay in Rome (1855-9),[2] though later, is again modelled on Rude. The pattern is the *Boy with a Tortoise* (1831, Paris, Louvre). The bronze group of *Ugolino* (1861-3, Paris, Jardin des Tuileries)

marks the transition to sculpture in the round, striving agitatedly outwards on all sides. Shortly afterwards, in a number of portrait busts, Carpeaux achieved the painterly realism of his definitive personal style. It marks the extreme of vivaciousness attained by the sculpture of the century. This must be attributed to methods which enabled Carpeaux to dispense with all the rules of sculptural construction hitherto respected. Time after time he overstepped with the utmost daring limits which are, as a rule, accepted as sacrosanct, and not by dogmatists alone. He modelled in just the same way as he painted and sketched, and his painting was improvisation in a mood of nervous and exuberant excitement (*Ball in the Tuileries*, 1868, Louvre; *The Attempt on the Life of Berezowski*, c. 1867, Louvre). All painterly effects and the illusion in the reproducing of materials down to the texture of the skin were translated into sculpture with playful ease, and sometimes, it must be admitted, even in a routine manner. Yet, in Carpeaux's most important works there remains enough of sculptural structure to ensure that the surface cannot take the upper hand. Despite the liberties he took, Carpeaux knew the value of links with the past, and the essential elements of his forms, especially in his portraiture, are inherited from the art of Houdon. He vied successfully with this great model in the rendering of character and of passing moods, as is proved by many of his masterly portraits, such as the busts of his friend Charles Garnier, the architect of the Paris Opera House (1869, Paris, Musée de l'Opéra; used also in the monument to Garnier erected in 1903 by the side of the Opéra), of the Marquise de la Valette (1863, Paris, Louvre), and of the painter J.-L. Gérôme (1872, Paris, Mme Clémen-Carpeaux Collection). How far his depth of penetration reached is seen in one of his finest works, the sketch of about 1863 for the monument to Watteau at Valenciennes, the painter's birthplace and his own [327]. Here the wonderful

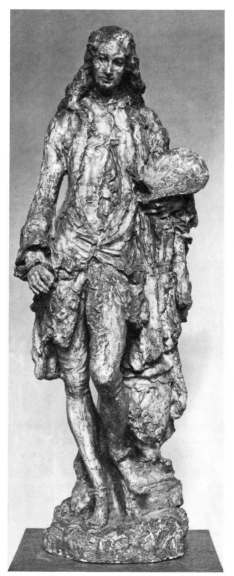

movement of the surface is wholly in the spirit of Watteau's own painting, and yet completely translated into the language of sculpture. The same spirit of fragile tenderness is expressed in the excessively elongated figure and the dreamily pensive face.[3]

It is hardly necessary to say that when sculptors of this kind worked in conjunction with architecture, they did not feel any obligation to comply more than very slightly with the canons of architectural composition or with those of structural relief composition. For this reason Carpeaux's group *The Dance* for the Opera House in Paris (finished 1869) [328] met with

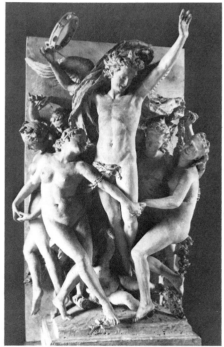

327. Jean-Baptiste Carpeaux:
Design for a Monument to Watteau, *c.* 1863. Clay.
Copenhagen, Ny Carlsberg Glyptotek

328. Jean-Baptiste Carpeaux:
The Dance, 1869. Plaster.
Paris, Louvre

violent criticism in conservative circles. The group, which is an intensification of the slightly earlier sculptural decoration on the Pavillon de Flore in the Louvre (1864–6), is not only Carpeaux's most sensational and celebrated work, but is also something of an apotheosis of his art. This joyous, delicately Bacchanalian dance is the visible expression of the gracefulness of Carpeaux's spirit. Its free yet concise movement and its perfect rhythm endow it with true greatness. The same may be said of the best of Carpeaux's portraits, which, in addition, like the genre-pieces of the French painters and caricaturists, reflect contemporary society – the upper middle class and the aristocracy – of the time. What fascinates us, however, is not only the sparkling gaiety, the whirl of lace, and the flashing of eyes, but something else in Carpeaux's works: for they belong to the few works of sculpture of the nineteenth century that express in a genuine and direct manner the most intense striving of the period, the striving to find a sculptural equivalent for the pulsating life of nature. In this respect, the art of Carpeaux, though not on the same level, can be linked with that of the great realists in painting, from Courbet down to Leibl, Menzel, and Degas, however different it may appear. Moreover there is also a spiritual link between Carpeaux and early Renoir. When confronted with many of Carpeaux's portraits our critical doubts are silenced, even though taken as a whole he represents a branch of sculpture which remained an ancillary of painting. Here the position and the fate of sculpture in the nineteenth century are clearly revealed: the strict postulates of Classicist sculpture, setting the highest ideals and dealing with the fundamental laws of sculptural form, remained for the most part mere theory and unfulfilled promise. Mastery based on sureness of instinct was to be found only in the field of painterly sculpture.

THE SPREAD OF NATURALISM

Sculpture of this kind was bound to prove seductive and to make converts. The attractions of illusionism were certainly of a dangerous kind; but the danger was no longer that of a monotonous stylization, as it had been in Classicist sculpture, but of formlessness and a total absence of style. Only great personal ability could escape this danger, and none of Carpeaux's followers possessed this ability to the same degree as he did. There was, however, another way. Sculptors might entrust themselves to tradition and resort to Late Baroque and Rococo art. When they did so the result was for the most part mere eclecticism, but sometimes a kind of neo-Rococo emerged, which at least in France occasionally looks like the genuine flower of Rococo grace and subtlety. But this happened very rarely. The greater part of sculptural work remained mere routine, the counterpart of what Cabanel and Bouguereau were doing in painting. Genre elements often appear in works of this kind. All these traits can be discerned in the work of Emmanuel Frémiet (1824–1910), a nephew of Rude. The dramatic element in Rude and Barye is carried to an exaggerated pitch in some of his best-known pieces (e.g. *Gorilla carrying off a Woman*, 1887, Nantes), but in the beautiful statue of an elephant (1878) in the gardens of the Trocadéro in Paris it is endowed with scientific realism, while in the equestrian statue of Joan of Arc (1874; present version 1898) in the Place des Pyramides in Paris, the form has benefited to a certain extent from the conceit, which is animal vigour controlled by the fanaticism of the heroine. In addition to this, as is invariably the case in realistic French sculpture, the memory of the tense sharpness of Renaissance bronzes by Donatello, Verrocchio, and their followers exerts an influence. Similarly, in another of the many statues erected about that time to the Maid of Orleans, the equestrian one by Paul Dubois (1829–1905) in

front of the cathedral at Reims (1889–95), the ecstasy of the attack is expressed in the nervously taut, sharply broken outlines of the emaciated heroine. Such examples of an expressiveness influencing form, even if the form was only to a very limited degree strictly sculptural, are exceptions. The general characteristic of the period is that even in large-scale sculpture preciosity takes the place of monumentality; only the dimensions become larger, as, for example, in the huge, certainly imposing, bronze monument to the *Triumph of the Republic* (1889–99) in the Place de la Nation in Paris by Jules Dalou (1838–1902), a pupil of Carpeaux, who also worked for a long time in London. In works of this kind one can see clearly that the followers did not imitate the best works of their models. Barye's centre-pieces made for the dining-table of the Prince of Orleans in the 1830s and Carpeaux's 'Fontaine de l'Observatoire' (*The Four Continents*, finished 1874)[4] found followers far more readily than their more important works. In French sculpture of the period after Carpeaux, the best and least controversial achievements were in the field of portrait sculpture, in which Dalou and Dubois in particular produced notable works.

In other countries, too, the realistic tendency in sculpture failed to attain the high level of the art of Carpeaux. The natural facility and freedom of his works makes them appear to spring from an idea, even though it was not a literary idea – the idea of the joy of living. His followers, however, failed to draw anything more from this than a few clever notions. These, because they form part of the national character, are found on a larger scale in France than elsewhere. From German sculpture they are absent altogether. The situation in Germany is most clearly defined in the *œuvre* of one sculptor: Reinhold Begas (1831–1911). The son of the painter Karl Begas, he began his career at the Berlin academy as a pupil of Rauch. During his first stay in Rome, from 1856 to 1858, he associated with the 'German Romans'. How persistent was the

influence of Böcklin and Lenbach on his work is shown by a number of portraits which he painted in the 1860s and 1870s. In the sculptural works of his Roman years he enchants us with a genuine, moderate neo-Baroque, as in the marble group of *Pan and Psyche* dating from 1857 (Berlin, private collection). In such works the best of his great talents comes to light. Certain works from his later years show to what an extent this style could be intensified; for example the marble of *Mercury and Psyche* dating from 1874 (East Berlin) and the bronze group of *Centaurs* (1881). It is such works that justify the frequently-drawn parallel between Begas and Carpeaux, and a series of delicate sketches full of rhythm and vitality can also be mentioned in the same context. In the monument to Schiller in Berlin (1865–71) Begas succeeded in achieving a compromise between the Rauch tradition, the more robust realism of the new generation, and his own vigorous personality. After the late 1870s, however, his Naturalism became more superficial, and whereas this had earlier on been inspired to a certain extent by the naturalistic yet unfailingly noble portrait busts by Bernini, this inspiration now slackened, and Begas's concern with character became weaker and weaker (bronze bust of Bismarck, 1887, formerly Berlin, Ruhmeshalle; bust of the Crown Prince Friedrich Wilhelm, 1883, formerly Berlin, Zeughaus). The discipline imposed by sculptural form is in inverse proportion to the size of these later monuments. In the Fountain of Neptune in front of the former Royal Palace in Berlin (1886–91), this discipline is almost abandoned, and the national monument to Kaiser Wilhelm I (1892–7) is, however one looks at it, a sad ending.

The sculptors of Begas's circle, such as Rudolf Siemering (1835–1905) and Gustav Eberlein (1847–1926), who worked in his spirit, or rather with his absence of spirit, in so far as they were aware of the dangers of Naturalism, sought a solution in neo-Baroque. But they succeeded only in achieving an unpleasing pseudo-

Baroque. For this return to the Baroque was not based on inner affinity – which the whole spirit of the age made impossible – nor was there any method in their approach to Baroque models. Everywhere they were carried away by unbridled Naturalism, and the results were innumerable aberrations from all standards that could conceivably be called artistic. Extreme Naturalism in sculpture falls short of imitated reality in only one respect – the monochrome nature of the material. And when complete fidelity to nature is achieved in sculpture, the contrast of the unnatural colourlessness becomes a painful contradiction. A piece of sculpture by Carpeaux, sparkling with life, must be contemplated like a chromatically constructed Impressionist landscape. Both capture the bliss of a momentary vision. But the efforts of the minor talents ended up in the Naturalism of waxworks. An occasional moderating factor was the persistence of Late Classicist idealization. This is the redeeming feature in the works of the Norwegian Stefan Sinding (1846–1922). But even this cooler manner leaves us unmoved.

The most vivid reflection of the spirit of Carpeaux's art is found in the best works of Viktor Tilgner (1844–96), especially his portraits, e.g. those of Vereshtchagin the painter (1885, Vienna, Historisches Museum) and Ferstel the architect (1877, Vienna, Österreichisches Museum für angewandte Kunst). Tilgner worked in Vienna, as did also the more conventional Caspar von Zumbusch (1830–1915). One sculptor, Medardo Rosso of Turin (1858–1928), carried sculptural Impressionism to its logical conclusion. He modelled in wax the most fleeting effects of light and materials, for example in the face of a lady behind a veil (1892, Venice, Galleria Internazionale d'Arte Moderna). Here the tenderest chiaroscuro is given sculptural embodiment. The result is astonishing, and not only from the technical point of view. Rosso also found room for delicately nervous psychological sketches, such as the portrait head of Yvette Guilbert (1894, Venice, Galleria Internazionale d'Arte Moderna). But Rosso's is an extreme form; it was not capable of being repeated.

THE RETURN TO FORM

When finally even inspiration derived from Baroque models had exhausted itself, sculpture, still the victim of ever-increasing Naturalism, found itself menaced by anarchy. The regeneration of sculpture as a creative art, which took place about 1880, was twofold. On the one hand there was a radical change of attitude, an openly declared opposition to Realism and Illusionism, a search for 'autonomous' sculpture, the renunciation of dependence on painting. This was the path that was most deliberately followed by the German Adolf Hildebrand, and it led him to a form of Neo-Classicism. On the other hand there was the path followed by Rodin, in which there was nothing of the programmatic reliance on theories. Hildebrand and Rodin are the opposite poles of the common effort to set the art of sculpture new tasks, or to revive the old everlasting tasks of a sculpture which had sunk to the level of mere reproduction of the body, and had done, in what was on the whole a more comfortable way, what photographic Naturalism had done in painting.

ADOLF VON HILDEBRAND (1847–1921)

Hildebrand's principle of a reform of sculpture is comparatively easy to describe because his creative activity was invariably accompanied by intellectual reflection, or, one is tempted to say, because reflection preceded it. Which of these two views is correct can hardly be decided (as indeed in the sphere of creative art it never can). In any case what matters is the result. We know that Hildebrand belonged to the circle of Marées and Konrad Fiedler, and that meditation on art, or, to be more precise, meditation on form, was just as important for him as it was for Marées.

Meditation was part of his personality and his art, and it was expanded into a strict theory in his book *Das Problem der Form* (1893). For vigorous creative personalities, the formulation of an aesthetic theory of art in general as well as of their own is never an obstacle to their creative powers, the best, though admittedly unusual, example of this being Leonardo. Meditation can be a necessary secondary expression of creative power, although, as in the case of Marées, it may then only render the mystery of form more obscure. It can also mean, as it did with Cézanne, something like a helpless consternation as regards the insistent power of one's own creation. With Hildebrand, however, it was not this. He thought very clearly and his own form could be as clear as that of Marées, but it was not so mysterious or so deep. His theoretical considerations remind us in many respects of the theorems of the Classicists, especially his hypothesis of parallel vertical layers and imaginary boundaries of the block of stone. In his doctrine of form there is, in fact, a touch of intellectualism, but in his day this was extremely wholesome, as it implied the rejection of illusionism, and signified a plea to return to the basic laws of three-dimensional creation.

In Hildebrand's first works, something of the better, Classicist side of Siemering,[1] under whom he studied, is still to be seen. An occasional isolated work by Carl Begas (1845–1916), a brother of Reinhold Begas, such as the portrait bust of Hans von Marées (1878, East Berlin), too, is like an anticipation of the art of Hildebrand. The purity, clarity, and nobility of Hildebrand's definitive form are revealed in the bronze statue of the *Water-Carrier* (1878–80, Berlin, private collection), the marble figure of

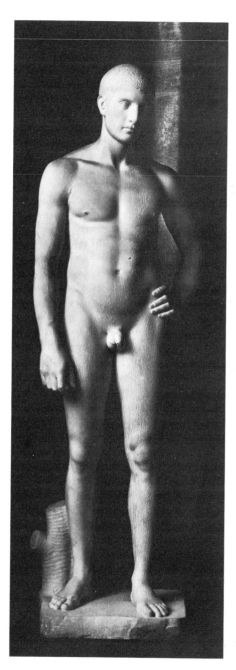

329. Adolf von Hildebrand:
A Youth, 1884. Marble.
(East) Berlin, Staatliche Museen

a *Youth* (1884) [329], and the *Skittles-Player*
(1886, Berlin, private collection). To these must
be added certain reliefs (*Leda*, 1890, Dresden;
Archers, etc.) and a series of portraits such as
the terracotta half-length of Marie Fiedler, the
mother of Konrad Fiedler (1882, Hamburg),
the busts of Konrad Fiedler (1874, East Berlin),
Arnold Böcklin (1898, East Berlin), and Ignaz
Döllinger (formerly Berlin). The affinity of these
works to architecture - Hildebrand, in fact, also
made architectural designs - and their suita-
bility for public monuments are obvious. The
stone Wittelsbach Fountain in Munich (com-
pleted in 1895) and the bronze statue of Bis-
marck at Bremen (1907-10) are his outstanding
creations in this field. Their all-embracing idea
is statuesque dignity, and the representation of
the body as volume at rest.

At the opposite pole stands a painter, Degas,
to whom we must make a brief return. His
sculpture, because he was a painter, belongs
radically to the same category as Rodin's. In
his work there is no question of sculpture de-
monstrating a 'return to form', for he created
his sculpture solely for his own pleasure, un-
known to the public. Yet the sculpture of Degas
achieves a level of formal expression that was
not often attained by sculpture in the whole of
the nineteenth century.

EDGAR DEGAS (1834–1917)

The catalogue of Degas's sculpture lists
seventy-four works,[2] but these are only the

330. Edgar Degas:
Fourteen-year-old Ballet-Dancer, 1881. Bronze.
Rotterdam, Museum Boymans-van Beuningen

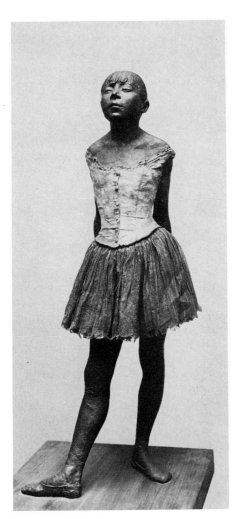

works cast in bronze by Hébrard between 1919 and 1921 after the more or less fragmentary wax figures which were found in the artist's studio after his death. Approximately an equal number were found in fragments, in such a condition that it was impossible to cast them. As Degas had been engaged in modelling since about 1865, these works represent several decades of sculptural activity, and not merely occasional works as in the case of Courbet.[3] They must certainly also imply an even more intensive study of the problems of sculpture than in the case of Daumier. Only once did Degas exhibit one of his sculptural works, at the Impressionist Exhibition of 1881, the work in question being the *Fourteen-year-old Ballet-Dancer*, a wax figure with real hair, a little tulle skirt, and a silk bow [330]. Such blatant realism – which was sharply criticized at the time of the exhibition – is not to be found in any of the other works of sculpture by Degas that have been preserved. They are in the main sketches of movement, and their somewhat impromptu form is partly due to an external reason, Degas's failing eyesight, which finally brought him to the verge of blindness. One might say that the figure of 1881 is simply a translation into sculpture of one of his painted ballet-dancers [292, 293], but in this case 'simply' means that not only has all the penetrating sharpness ·of the realism of the painted ballet-dancers been absorbed by this figure, but also that the carefulness and perfection of form have been translated into the other medium. If in the paintings we admire the way in which movement of the bodies and space are transposed into two dimensions, in the sculpture we admire the discipline of the succession of views following and overlapping each other as we walk round it. This was the aim of Degas in all his sculptural works, and in this sense all of them are outstanding examples of life in terms of sculptural form. Compared with this, the difference between the bold Naturalism in the use of various materials in the *Ballet-Dancer* and the

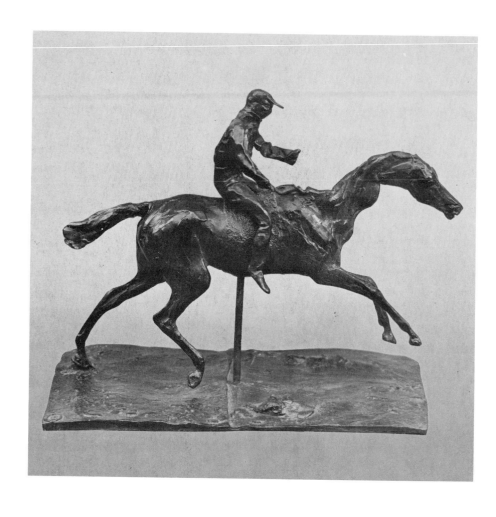

331. Edgar Degas: Jockey on his Horse, *c*. 1880. Bronze. *New York, Metropolitan Museum of Art*

sketchy rapidity of the modelling in the other figures is of no importance. This oscillating, painterly modelling was certainly intended to be attractive in itself, and the study of the movements of ballerinas, and of racehorses [331] and women bathing – which are also among the subjects of his sculpture – afforded opportunities to display it; but the essential thing is that Degas, by a happy stroke of genius, not only fixes a fleeting impression in a three-dimensional work, but also interprets sculptural form fundamentally as 'sculpture from within'. All this happened without the use of any discernible method and apparently without any connexion worth mentioning with what was going on in professional sculpture at the same time; yet, to a greater extent than the works of most professionals, it achieved a synthesis which at the time was everybody's goal.

AUGUSTE RODIN (1840–1917)

We are probably not going too far if we say that everything which lends greatness to Rodin's sculpture is also present in that of Degas. It is easy to name a number of works by Rodin which justify this statement. Common to both of them, apart from the sculptural method, is the persistence of realism, together with the life of the surface in an illusionistic sense. The lesson of Carpeaux is clearly visible in the direction towards which the renewal of sculptural form was tending: not a turning away from the physical object, not the establishment of laws of form – as in the case of Hildebrand; on the contrary, as an endeavour to discover new possibilities for sculpture in the structure of the figure as conceived in painterly terms.

An early work of Rodin, *The Man with the broken Nose* [332],[4] which was rejected by the committee of the 'Salon' in 1864, already reveals all the salient features of his art with a degree of intensity and purity that he could never afterwards surpass and which could only

be developed on a larger scale. This furrowed visage with its protuberances, its lumps and hollows, and the restless flickering lights, shows the way in which Rodin surpassed Carpeaux. The breathing life of the surface is heightened until it reaches a climax of dramatic confusion, and at the same time this confusion of forms is the direct expression of an idea, the idea of suffering mankind. The face is like a tragic mask

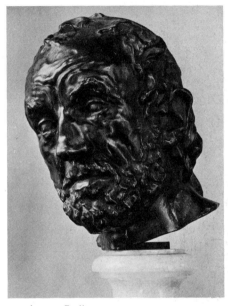

332. Auguste Rodin:
The Man with the broken Nose, 1864. Bronze.
Paris, Louvre

of Michelangelo. In the literary, the poetical, and the Romantic sense, an idea carried to its utmost pitch forms the contrast of all Rodin's works, and is often exaggerated in his many symbolical figures and accumulations of figures (*The Portal of Hell*, 1880–1917, is the most comprehensive of these). In such works Rodin always kept in view the highest artistic aim, that of

expressing the idea as a drama of sculptural forms, but never did he come nearer to this aim than in the head of *The Man with the broken Nose*. It was in this way that Daumier had created his *Ratapoil* [323]. When we are confronted with this head we are reminded of Delacroix, with his attempt to create something new and free from eclecticism out of the great inheritance of the art of the past. In the bronze figure of *John the Baptist* (1878), the method of the *Man with the broken Nose* is developed into a static image of a nude body,[5] while in the *Call to Arms* (1878), a kind of paraphrase of Rude's *Marseillaise*, it is endowed with ecstatic pathos. The large bronze group of *The Burghers of Calais* (1884–6) is Rodin's first narrative work on a monumental scale. It is one of the extreme examples of the autocratic attitude of the sculptor Rodin towards the empty spaces round his sculpture. For him there is no limit imposed by the remembered original shape of the block of stone, such as had been valid for Michelangelo. If, despite this, he allowed uncarved portions of the stone to have a say, it was in the interests of symbolical effect (*La Pensée*, 1886) – for him the only things that matter are the requirements of expression, and thus every daring *contrapposto*, every disregard of the static outline, every opposition between light and shade, is permissible. Combined with a high degree of realism, this can lead occasionally, as it does in the *Burghers of Calais*, to a problematic lack of detachment of the world of art from the world of the spectator. Many artists who were attracted by Rodin's form found this was too bold, for example the Belgian Constantin Meunier (1831–1905), who therefore, both in his paintings and in his sculpture, resorted to a compromise. His figures of workmen are raised to heroic proportions, but without undue exaggeration. They are types of working men and miners which are fairly exact counterparts of Millet's peasants, that is to say the outcome of a Romantic ideal-

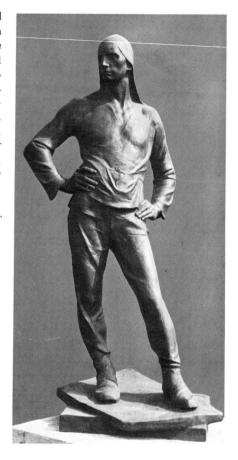

333. Constantin Meunier:
Porter, *c*. 1900. Bronze.
Vienna, Kunsthistorisches Museum

ization, but also inspired by the new aestheticism [333].

Many things, apart from the lack of detachment referred to, are problematic in Rodin's mature style. This was to be expected in such an extreme statement as Rodin's art. The fact that he and Hildebrand were contemporaries caused the old controversy concerning the limits of the arts to flare up again. This controversy need not concern the historian, though it does, incidentally, remind us that it always breaks out more readily in the field of sculpture than it does in that of painting. From the historical point of view it is far more important to establish in what manner and how closely Rodin's excessive sculpture – to use a simple term for a complicated matter – is connected with the fundamental principles of contemporary Impressionism in painting. A fundamental pantheism is common to Rodin's sculpture and the painting of the Impressionists. Both strove to represent the all-pervading power of natural forces and elements. The Impressionists noticed the ever-present element in the phenomena of light, and Rodin, too, made abundant use of light in his sculpture. Much of the discordance and apparent carelessness in his art and many a superficial effect are connected with this, and the obtrusiveness of his symbolism, the preponderance of literary allusions, and a demon-strative, sometimes only pretended demonism are often disconcerting. Despite all these things, however, a definite and revolutionary sculptural principle lies behind the unbridled impetuosity of Rodin's exuberant movement. Something like a primeval plastic law both moulds and threatens the figures. The innumerable wash drawings, a kind of masterly shorthand of the nude body and its movements, are a memorable summing-up of Rodin's knowledge of elementary sculptural form, completely purged of all literary interference.

Rodin's sculpture is as much of an end and a beginning as Impressionist painting. For this reason, further discussion of his art, and also of Hildebrand's sculpture, must be reserved for the volume of the Pelican History of Art devoted to 'modern' art, and the same applies to the painting of Cézanne and Marées. No words need be wasted on the differences between these two painters and the two sculptors, which is a measure of the superiority of painting over sculpture at that time. But there can be no doubt, despite all the evidence of a late phase in the rather too ostentatious ebullience of Rodin's temperament and in Hildebrand's tendency to take refuge in the philosophy of style, that the subsequent development of sculpture is indicated in these two diametrically opposed conceptions of its essence.

NOTES

Bold numbers indicate page reference

PART ONE: PAINTING

CHAPTER 2

25. 1. David's authorship of both 'La Maraîchère' and the portrait of the Gérard family has been questioned – in my view, on insufficient grounds. **26**. 2. There are at Versailles eighty-three small replicas by Gérard of his portraits. One of them represents the Fries family. **44**. 3. A large number of sketches of movements and compositions in the museum at Montauban show, often in a most surprising way, that the first stage in his methods of working consisted of impulsive and cursory sketches. A selection of 129 of these drawings was published by René Longa, *Ingres inconnu* (Paris, 1942). – In contrast to these sketches, there exists another, entirely original type of drawings, the nearly 200 landscapes which he did during his first stay in Rome (1806-20). They too belong to the museum of Montauban, and have only recently been made known to a more general public by means of an exhibition, 'Rome vue par Ingres', at the Kunsthaus in Zürich (see the catalogue by Hans Naef). These drawings, for which Ingres himself cared little, show the spirit of his art as clearly as the difference in feeling from the superficially similar drawings of landscape by the German Classicists and Romantics. 4. 'Il est sans exemple qu'un grand dessinateur n'ait point trouvé exactement la couleur, qui convenait au caractère de son dessin.' 5. 'Au fur et à mesure que l'on peint, on dessine; plus la couleur s'harmonise, plus le dessin se précise.'

CHAPTER 3

49. 1. 'Der Pinsel, den der Künstler führt, soll in Verstand getunket sein.' **52**. 2. 'Seine Seele lebt nur in Götterkriegen, Titanenschlachten, im Hesiodus und Homer. Er wünscht nichts Sehnlicheres als eine Wand, siebenzig Ellen hoch, wie die von Michelangelos jüngstem Gericht, um sich tot daran zu arbeiten und unsterblich zu sein.' **55**. 3. 'Dass ich diese Skizzen radierte, war eine Betrachtung und Liebe für den Carstens, durch

dessen Umgang ich den Staub der akademischen Dummheit abschütteln lernte.' **59**. 4. This, like all Humboldt's portraits by Schick, was destroyed in the Second World War. Cf. H. Th. Musper, *Neues zu Schick; Festschrift für Julius Baum, zum 70. Geburtstag* (Stuttgart, 1952). **61**. 5. Altogether he produced over two thousand single sheets. **63**. 6. In the Landesmuseum Joanneum at Graz; the picture reproduced in this volume is a study for it. 7. Incidentally, in, for example, a female portrait by the Viennese Josef Grassi (1757-1838) in the Österreichische Galerie at Vienna, even Rembrandt's chiaroscuro is subjected to a similar process. **64**. 8. *The Entry of the Emperor Francis I into Vienna after the first Peace of Paris, 1814; Return of the Emperor Francis after the Conclusion of Peace at Pressburg in 1809* [34]; *The Emperor's first Drive after his long Illness in 1826.* 9. Now in the Museum of Army History in Vienna; smaller versions made in 1838 are in the possession of the Kinsky family, Vienna.

CHAPTER 4

67. 1. 'Wie jedes historische Gemälde in seiner Art gut ist, wenn es eine Scene aus der sittlichen Welt vorstellt, die auf eine merklich lebhafte Weise heilsame Empfindungen erwecket, und sittliche Begriffe nachdrücklich in uns veranlasset, oder erneuert: so ist auch die Landschaft in ihrer Art gut, die ähnliche Scenen der leblosen Natur vorstellt; fürnehmlich alsdann, wenn dieselben noch mit übereinstimmenden Gegenständen aus der sittlichen Welt erhöhet werden.' A French counterpart is the following phrase from Jean-Baptiste Deperthes's *Théorie du paysage*, published in Paris in 1818: '... seule la présence des figures pourra vivifier ce désert' ('only the presence of figures can give life to this desert'). **68**. 2. 'Von Osten gegen Westen, so weit das Auge zu reichen vermag, sieht man den ganzen südlichen Dunstkreis wie von tausend glänzenden, oft durch Wolken von der Erde getrennten erhabenen Körpern durchschnitten, deren kronenähnliche Häupter einen Teil des entfernten Himmels zu sein scheinen. Welcher Unbekannte sollte hierunter eine so uner-

messliche Bergkette vermuten. Er würde nur staunen und vergebens raten. Ja es sind unermesslich hoch und weit ausgedehnte Alpen, starrend von ewigem Frost, beladen mit Eismassen, die durch himmeldurchdringende Felsen unterstützt sind. Diese, durch ein Wolkenmeer wie von der Erde getrennt, scheinen dem Himmel zu gebieten.'

3. In addition to the *Reflections* already quoted (see above, p. 55), in particular *Die Rumfordische Suppe oder Das Jahrhundert Winckelmanns* (1812–15) and *Moderne Kunstchronik* (1834).

69. 4. In addition to the version here reproduced, there are two others (1834–5, Basel and Elberfeld).

5. For example, *The Sacrifice of Noah*, in three versions (1803–8, Frankfurt am Main; Copenhagen, Thorvaldsens Museum; Leipzig); *St George* (1807, Nuremberg, Germanisches National-Museum); *Apollo and the Shepherds*, in three versions (1834–7, Innsbruck; Copenhagen, Thorvaldsens Museum; Leipzig, Brockhaus Collection).

6. In addition to the version here reproduced: Innsbruck and Dresden.

70. 7. The second version is in Leipzig.

74. 8. 'Letter concerning landscape painting to Herr Fuesslin', Johann Caspar Füssli the Elder (see below, p. 88), father of the more famous Heinrich Füssli (Fuseli). Gessner's 'letter' is reproduced in the third volume of Johann Caspar Füssli the Elder's *Geschichte und Abbildung der besten Mahler in der Schweiz* (1755 ff.).

75. 9. These are on the same level as the etchings of animals and 'plant studies' of the Berlin artist Carl Wilhelm Kolbe the Elder (1757–1835). Kolbe, who also made etchings from his own and Gessner's landscapes, made graphic renderings of his animal and plant pieces in an intensely plastic manner with a faithfulness to detail derived from Dürer's engravings. Johann Heinrich Menken (1766–1839), who was born in Bremen and worked in that city, had a similarly austere objectivity. His great model was Paul Potter, especially for his etchings, which depict animals amidst the melancholy landscape of Lower Germany.

80. 10. Like his father also, he made a number of etchings.

81. 11. For example, the series of four scenes of hunting in the neighbourhood of Laxenburg, dating from 1758, now in the Österreichisches Barockmuseum at Vienna.

CHAPTER 5

89. 1. Another important work by Abilgaard, on a monumental scale, the murals in the castle of Christiansborg, was almost completely destroyed by fire during the painter's lifetime.

92. 2. This frieze, consisting of coloured plaster composed by means of an unusual technique, has now been removed and replaced by copies.

CHAPTER 6

95. 1. 'Des Künstlers Gefühl ist sein Gesetz.'

2. 'Le sentiment est plus que la raison.'

3. 'naturwidrig prahlerisches Streben nach Reichtum und Fülle'.

97. 4. 'Voilà un homme qui a découvert la tragédie du paysage'; 'Friedrich a l'âme sombre, il a parfaitement compris que l'on peut faire servir le paysage à peindre les grandes crises de la nature.'

99. 5. 'Die individuelle Seele soll mit der Weltseele übereinstimmend werden.'

6. E.g. at Dresden and at Bremen.

101. 7. 'Das Bild liegt mit seinen zwei oder drei geheimnisvollen Gegenständen wie die Apokalypse da, als ob es Youngs Nachtgedanken hätte, und da es, in seiner Einförmigkeit und Uferlosigkeit, nichts als den Rahmen zum Vordergrund hat, so ist es, wenn man es betrachtet, als ob einem die Augenlider weggeschnitten wären.'

8. 'Dein Ich verschwindet, Du bist nichts, Gott ist alles.'

102. 9. 'dunkle Nebelbilder, in Schnee versunkene Kirchhöfe' ... 'um das innerste Geheimnis der Seele von schwerer Trübung zu reinigen'.

104. 10. Hamburg; Mannheim, Städtische Kunsthalle.

106. 11. 'Es drängt sich alles zur Landschaft.'

12. 'Der Morgen ist die gränzenlose Erleuchtung des Universums. Der Tag ist die gränzenlose Gestaltung der Creatur, die das Universum erfüllet. Der Abend ist die gränzenlose Vernichtung der Existenz in den Ursprung des Universums. Die Nacht ist die gränzenlose Tiefe der Erkenntnis von der unvertilgbaren Existenz in Gott. Diese sind die vier Dimensionen des geschaffenen Geistes. Gott aber würket Alles in Allem; wer will gestalten, wie Er den Geschaffenen berührt?'

107. 13. *The Triumph of Cupid*, second version, 1801–2; the early, preparatory versions of the *Phases of the Day*, after 1803; illustrations to Ossian, 1804–5 (all at Hamburg).

108. 14. Dürer's prayer-book was published in 1808 with forty-three lithographical reproductions by Johann Nepomuk Strixner (1782–1855).

111. 15. 'Der Gang, den er nahm, war nicht der seine, sondern des Jahrhunderts, von dessen Strom die Zeitgenossen willig oder unwillig mit fortgerissen werden.'

16. 'Zum Rasendwerden, schön und toll zugleich ... das will alles umfassen und verliert sich darüber immer ins Elementarische, doch noch mit unendlichen

Schönheiten im einzelnen. Da sehen Sie nur, was für Teufelszeug, und hier wieder, was da der Kerl für Anmut und Herrlichkeit hervorgebracht; aber der arme Teufel hats auch nicht ausgehalten, er ist schon hin; es ist nicht anders möglich; wer so auf der Kippe steht, muss sterben oder verrückt werden, da ist keine Gnade.'

112. 17. 'Wenn der Himmel über mir von den unzähligen Sternen wimmelt, der Wind saust durch den weiten Raum, die Woge bricht sich brausend in der weiten Nacht, über dem Walde röthet sich der Äther, und die Sonne erleuchtet die Welt; das Thal dampft und ich werfe mich im Grase unter funkelnden Tautropfen hin, jedes Blatt und jeder Grashalm wimmelt vom Leben, die Erde lebt und regt sich unter mir, alles tönet in einem Accord zusammen, da jauchzet die Seele laut auf, und fliegt umher in dem unermesslichen Raum um mich, es ist kein Unten und kein Oben mehr, keine Zeit, kein Anfang und kein Ende, ich höre und fühle den lebendigen Odem Gottes, der die Welt hält und trägt, in dem alles lebt und würkt: hier ist das Höchste, was wir ahnen – Gott!'

18. The Order had been founded in 1732 by Liguori.

114. 19. 'Am Ende erfinde ich noch eine neue Baukunst, die aber gewiss mehr eine Fortsetzung der Gotischen wie der Griechischen wäre.'

117. 20. 'Alle Schönheit ist Allegorie. Das Höchste kann man, eben weil es unaussprechlich ist, nur allegorisch sagen.'

21. 'Nur eine Art Moos oder Flechtengewächs am grossen Stamme der Kunst.'

22. In 1842 he was summoned to London by Lord Monson in connexion with some projected frescoes which were never executed, and while there he also gave advice on mural paintings for the Houses of Parliament.

23. Finished in 1860 with the collaboration of Eduard Engerth (1818–97) and Leopold Kupelwieser (1796–1862).

120. 24. In 1876 the painter, sculptor, and architect Peter (known in the Order as Desiderius) Lenz (1832–1928) founded a school for religious painting in the Benedictine monastery at Beuron in Württemberg.

122. 25. Cf. H. Geller, *Die Bildnisse der deutschen Künstler in Rom 1800–1830* (Berlin, 1952).

26. There exists a forerunner of these portrait drawings, namely Runge's moving picture of Sophie Sieveking on her sickbed, dating from 1810 (Frankfurt am Main).

123. 27. '... die Natur mit Strenge und plastischem Sinne aufzufassen, wie das die Maler des 15. Jahrhunderts getan haben'.

124. 28. Both pictures are still in their original location.

29. Respectively in a private collection at Dessau;

Berlin, whereabouts unknown; Berlin, private collection.

127. 30. 'In anderen Ländern hat die Natur bei aller Schönheit und Grösse immer nur einen besonderen, einseitigen, gleichsam provinziellen Karakter ... Die italienische Landschaft hingegen trägt den allgemeinen Karakter schöner Natur.'

31. Concerning the part played by Salzburg in the painting of this period, see Heinrich Schwarz, *Salzburg und das Salzkammergut; Die künstlerische Entdeckung der Stadt und der Landschaft im 19. Jahrhundert*, 3rd ed. (Vienna, 1959).

128. 32. It was this influence which resulted in Julius Schnorr becoming a landscape-painter, though only for a short time, during the years they spent together in Vienna and Salzburg.

CHAPTER 7

140. 1. Two versions: Castres, Musée Goya-Musée Taurès, and West Berlin (see Loga, note 232).

CHAPTER 8

149. 1. The study of a nude here reproduced [95], in the Albertina at Vienna, is, according to Clément (no. 119), related to one of the figures in the *Raft of the 'Medusa'*.

154. 2. 'Quand les tons sont justes, les traits se dessinent comme d'eux-mêmes.'

160. 3. 'Ajouter du noir n'est pas ajouter de la demi-teinte, c'est salir le ton dont la demi-teinte véritable se trouve dans le ton opposé ... De là des ombres vertes dans le rouge'; cf. *Le voyage de Eugène Delacroix au Maroc. Fac-similé de l'album du Château de Chantilly; published by Jean Guiffrey* (Paris, 1913).

165. 4. At all events we have pen-drawings by Delacroix after details from Goya's *Caprichos* (Escholier, *Delacroix*, vol. 1, fig. on p. 41).

166. 5. Cf. Meyer Schapiro, 'Fromentin as a Critic', in *Partisan Review* (January 1949).

168. 6. The building was destroyed during the rising of the Commune in 1871; Chassériau's frescoes were later removed in fragments and brought to the Louvre.

7. In Ingres's *Turkish Bath* [24] there would seem to be a reciprocated influence of Chassériau's frescoes.

171. 8. In collaboration with his brother Paul Flandrin (1811–1902), Paul Balze (1815–84), and Louis Lamothe (1822–69).

9. First published in 1828 in *Mélanges et Poésies*.

10. Edited by Charles Nodier, Baron Isidore Taylor, and Alphonse de Cailleux (Paris, 1820–78), 17 vols, arranged according to departments.

172. 11. A list of the works by English landscape-

painters exhibited at the Salon in 1824 is in P. Dorbec, *L'art du paysage en France etc., 78.*

174. 12. Only a few pictures from his early period are known.

13. At Charenton he was one of the patients of Dr Paul Gachet, the psychiatrist and amateur painter whose pseudonym was Paul van Ryssel (1828-1909), and who later befriended van Gogh at Auvers-sur-Oise.

177. 14. 'Toute peinture hollandaise est concave'; *Les maîtres d'autrefois* (Paris, 1876), 183.

178. 15. 'J' entends par composition ce qui est en nous, entrant le plus possible dans la réalité extérieure des choses'; Sensier, *Souvenirs sur Théodore Rousseau* (Paris, 1872), 278.

16. This was also the case in the latter part of the eighteenth century, an example being Jean-Joseph-Xavier Bidault (see p. 84).

180. 17. *The Alps with Mont Blanc, seen from the Col de la Faucille.* This was a theme which had occupied Rousseau from the 1830s onward. Yet he left the picture unfinished in the end. Cf. René Huyghe, *Dialogue avec le visible* (Paris, 1955), 369, and Haavard Rostrup in the catalogue of the Ny Carlsberg Glyptotek (*Danske og franske malerier og tegninger*) (Copenhagen, 1958), 52.

18. Théophile Chauvel (1831-1909) may be mentioned as the most prominent name.

182. 19. Before this Millet, partly in order to earn his daily bread, painted genre pictures in the style of the eighteenth century.

183. 20. Cf. the catalogue of the exhibition *Van Gogh et les peintres d'Auvers-sur-Oise* (Paris, 1954), with contributions by Germain Bazin, Albert Châtelet, and Paul Gachet fils.

184. 21. *Cahiers d'eaux-fortes*, 1851; *Voyage en bateau*, fifteen sheets, 1862. - Cf. Delteil, vol. 21, and the lists of single sheets in Henriet, *op. cit.*

185. 22. Cf. Carlette Engel de Janosi, 'The Forest of Fontainebleau in Painting and Writing', in *The Journal of Aesthetics and Art Criticism*, XI (1953).

187. 23. Cf. David's *View of the Garden of the Luxembourg* [6], and the Italian landscape by Pierre-Henri de Valenciennes (1750-1819), now in the Louvre, reproduced in G. Bazin's monograph on Corot (*op. cit.*, plate 111).

192. 24. So far as we know, museums did not at any time mean much to Corot, not even during his short visits to Holland in 1854 and to England in 1862.

193. 25. Corot's engravings and etchings on glass are listed in Delteil, vol. 5.

CHAPTER 9

195. 1. The origin of the term Biedermeier (originally 'Biedermaier') is uncertain. It was coined, it seems, shortly before the middle of the nineteenth century and achieved popularity by means of the poems of Ludwig Eichrodt in the *Fliegende Blätter*. Cf. *Das Buch Biedermaier/Gedichte von Ludwig Eichrodt und Adolf Kussmaul sowie von ihrem Vorbild, dem 'alten Dorfschulmeister' Samuel Friedrich Sauter.* Gesammelt u. herausgeg. von Ludwig Eichrodt. Neue Ausgabe von Friedrich Eichrodt. Illustriert von Eduard Ille (Stuttgart, 1911); also A. Kennel, *Ludwig Eichrodt/Ein Dichterleben* (Lahr, 1895).

2. Waldmüller published the following treatises: *Das Bedürfnis eines zweckmässigen Unterrichts in der Malerei und plastischen Kunst. Angedeutet nach eigenen Erfahrungen* ('The need for appropriate instruction in painting and sculpture, outlined from personal experience'; Vienna, 1846); *Vorschläge zur Reform der Österreichisch-kaiserlichen Akademie der bildenden Kunst* ('Proposals for the reform of the Imperial Austrian Academy of Art'; Vienna, 1849); *Andeutungen zur Belebung der vaterländischen bildenden Kunst* ('Suggestions for the revival of a national art'; Vienna, 1857); *Imitation, Reminiszenz, Plagiat. Bemerkungen über krankhafte Zustände der bildenden Kunst* ('Imitation, Reminiscence, Plagiarism. Remarks on some morbid states in the arts'; in *Frankfurter Museum*, 1857).

200. 3. On the recommendation of the British Ambassador in Vienna the pictures Waldmüller took with him were shown to Queen Victoria and the Prince Consort at Buckingham Palace and they purchased some of them. The rest were then exhibited in London and were all sold within a week (statement by Waldmüller in his *Andeutungen* etc. of 1857, mentioned above).

202. 4. It is programmatically expounded in the famous preface to his *Bunte Steine* (1852).

204. 5. A volume containing a selection of these sheets, which are all preserved in the Akademie der bildenden Künste in Vienna, has been published by Gilberto Ferrez, *O velho Rio de Janeiro através das gravuras de Thomas Ender*, introduction by Siegfried Freiberg (São Paulo, 1957).

207. 6. Most of Daffinger's water-colours of flowers - 415 sheets - are now in the library of the Akademie der bildenden Künste in Vienna. Twenty-four of them are reproduced in facsimile in the album entitled *Blumen-Aquarelle von M. M. Daffinger (Albertina-Facsimile)* (Vienna, 1948), with articles by Josef Leitgeb, Fritz Novotny, and Lothar Geitler.

211. 7. Cf. *Danske Landskabstegninger af J. Th.*

Lundbye og hans samtid, with introduction by Johannes V. Jensen (Copenhagen, 1950).
216. 8. In addition to *Buntes Berlin*, published between 1837 and 1854 in collaboration with the writer Adolf Glassbrenner, illustrations to works by E. Th. A. Hofmann, Jeremias Gotthelf, etc.
223. 9. 'Blick von den Müggelbergen bei Köpenick gegen Süden. Staffage: Semnonen rüsten sich zum Aufbruch gegen den Andrang der Römer.'

CHAPTER 10

228. 1. The original was then in Frankfurt am Main, whence it must have been sent to Spitzweg on loan.
230. 2. The 'travel pictures' comprise altogether forty works, a considerable number of which were purchased by the Munich patron Adolph Graf Schack.
231. 3. According to tradition painted in the studio of his friend Spitzweg, with remnants of colour from the latter's palette.
234. 4. Before this he had made drawings to illustrate Adelheid von Stolterfoth's *Rheinischer Sagenkreis* (1835) and the Marbach edition of the *Nibelungenlied* (1840), etc. The text of the *Totentanz* is by Robert Reinick.
235. 5. Of the eight frescoes three were ruined in the Second World War. For the history of the frescoes and their restoration see Heinrich Schmidt, *Alfred Rethel (Rheinischer Verein für Denkmalpflege und Heimatschutz, Jhgg. 1958)* (Aachen, 1959).
236. 6. In 1808–16 Hans Albrecht von Derschau, a collector, had published reprints of the wood blocks of German Late Gothic and Renaissance masters which he had collected.
7. After working in Meissen from 1828 to 1835 as teacher of drawing in the porcelain factory, Richter established himself in 1836 at Dresden, where he played a decisive role in the development and diffusion of the woodcut, especially after his son J. H. Richter had started a publishing firm.
8. In his illustrations to fairy-tales and fables (Wilhelm Hey's *Fables*, 1833 and 1837; *Puss in Boots*, 1843; Andersen's fairy-tales, 1845–6; Klaus Groth's *Quickborn*, 1856 [173]), he used every kind of printing technique: woodcut, lithograph, etching, steel-engraving.

CHAPTER 11

240. 1. He lived in Paris from 1832 to 1835 and studied there under Charlet. After this he went to London, and subsequently he made journeys to Vienna, France, and Holland.
242. 2. He published six 'Albums de Caricature':

Histoire de M. Jabot (1833) [177]; *Histoire de M. Crépin* (1837); *Histoire de M. Vieux Bois* (1837); *Monsieur Pencil* (1840); *Le Docteur Festus* (1840); *Histoire d'Albert* by Simon de Nantua (1845); and also an *Essai de Physiognomie* (1845). Between 1832 and 1842 there appeared, under the general title of *Voyages en zigzag*, the descriptions of the journeys which he undertook with his pupils in Switzerland, Italy, and France. In the collected edition of 1844, which incidentally also contains some illustrations after Calame, the original style of Toepffer's autographs has been transformed into the professional manner of wood-engravers.

CHAPTER 12

249. 1. 'Spécialement, l'art en peinture ne saurait consister que dans la représentation des objets visibles et tangibles pour l'artiste. Aucune époque ne saurait être reproduite que par ses propres artistes, je veux dire par les artistes qui ont vécu en elle. Je tiens les artistes d'un siècle pour radicalement incompétents à reproduire les choses d'un siècle précédent ou futur, autrement à peindre le passé ou l'avenir. C'est en ce sens que je nie l'art historique appliqué au passé. L'art historique est par essence contemporain.... Je tiens aussi que la peinture est un art essentiellement *concret* et ne peut consister que dans la représentation des choses *réelles et existantes*. C'est une langue toute physique, qui se compose, pour mots, de tous les objets visibles. Un objet *abstrait*, non visible, non existant, n'est pas du domaine de la peinture' (*Courrier du Dimanche*, 25 December 1861).
250. 2. It is worth noting that as late as 1869, while he was in Munich, he was still making faithful copies of Frans Hals's *Malle Babbe* (Hamburg), a self-portrait of Rembrandt – in reality itself an eighteenth-century copy – and a portrait by Velázquez. According to Courbet's statement, the last-named portrait was supposed to represent Murillo. The picture was formerly in the Durand-Ruel collection, and in 1869, like the *Malle Babbe*, it was shown at the International Art Exhibition in Munich.
254. 3. 'Allégorie réelle, intérieur de mon atelier, déterminant une phase de sept années de ma vie artistique.' – Cf. Meyer Schapiro, 'Courbet and popular Imagery. An Essay on Realism and Naiveté', *Journal of the Warburg and Courtauld Institutes*, IV (1940–1).
255. 4. Two versions, one at Budapest, the other in the Wilstach Collection at Philadelphia.
256. 5. He came from Munkács and called himself after his native town, but his real surname was Lieb.
260. 6. He illustrated a whole series of scenes from

Molière's comedies, especially the *Malade Imaginaire*, and made *Don Quixote* the subject of about thirty paintings and drawings.

7. For a short time he was a pupil of Alexandre Lenoir (1761-1839), he learned the technique of lithography from his friend Charles Ramelet (1805-51), and he occasionally worked in the studio of Eugène Boudin.

263. 8. To mention a few of the books in the illustration of which Daumier had a share, generally in collaboration with other illustrators (Gavarni, Traviès, Grandville, etc.): *Vocabulaire des Enfants* (1839); Paul de Kock and Honoré de Balzac, *La Grande Ville* (1842-3); *Les Français peints par eux-mêmes* (1840-1); the series of *Physiologies*; François Fabre, *La Némésis Médicale* (1840); in addition to the numerous woodcuts that appeared in *Charivari* and in other periodicals.

264. 9. About 1848 he painted for a competition the picture of *The Republic and her Children* (Paris, Louvre), a clear echo of Michelangelo, but at the same time a proof of his already fully-developed originality in painting. We know next to nothing about what he painted before.

268. 10. *Les enfants terribles, Les étudiants de Paris, Fourberies des femmes, La vie de jeune homme, Les Lorettes, Le carnaval à Paris*, etc.

269. 11. The Walters Art Gallery in Baltimore possesses a large collection of these.

12. Other illustrations by Grandville are to, e.g., Swift's *Gulliver's Travels* (1838) and Defoe's *Robinson Crusoe* (1840).

273. 13. Originally the hero of a comedy by Monnier: *Grandeur et décadence de Monsieur Joseph Prudhomme* (1852).

14. A list of nineteenth-century engravers, lithographers, and wood-engravers in the various countries will be found in A. Rümann, *Das illustrierte Buch des XIX. Jahrhunderts*, 376.

274. 15. Gavarni also illustrated Hoffmann's *Contes fantastiques* (1843) [206].

275. 16. Baudelaire in his article on Guys entitled 'Le peintre de la vie moderne', in *Figaro* (1863).

CHAPTER 13

278. 1. In addition to *Künstlers Erdenwallen*, in particular thirty lithographs for Emilie Feige's *Kleiner Gesellschafter* (1836) and sixteen vignettes for Chamisso's *Peter Schlemihl* (1839).

2. 'Graus, Jammer und Stank'. From a letter written by Menzel to the military surgeon Dr Puhlmann on 2 August 1866.

279. 3. After Menzel had made experiments with French and English wood-engravers, which did not

satisfy him, he employed the Germans O. Vogel, A. Vogel, Fr. Unzelmann, E. Kretzschmar, W. Georgy, and J. Ritschl. That he first employed foreign engravers is due to the fact that Kugler's history of the reign of Frederick the Great was originally conceived as a kind of companion volume to the *Histoire de l'Empereur Napoléon* by Laurent de l'Ardèche with wood-engravings by Horace Vernet, published in 1839 [12]. The German edition of this book was published in the same year by J. J. Weber of Leipzig, who had also published the Kugler book. Kugler himself suggested that Menzel should illustrate the book, referring in his letter to the illustrations for *Peter Schlemihl* and the lithographs for the *Denkwürdigkeiten aus der Brandenburgisch-Preussischen Geschichte* published in 1836.

280. 4. 'die grösste Gattung der Malerei ... doch die Historienmalerei', from a letter of Menzel's to C. H. Arnold.

5. Menzel saw works by Constable at the 1839 exhibition in the Hôtel de Rome, Berlin.

287. 6. Lenbach and Marées were in Italy together from 1863 to 1866, copying famous masterpieces for Count Schack.

288. 7. Cologne, private collection; a study for it is in the Kunsthistorisches Museum, Vienna.

291. 8. Because the composition proved unsuccessful, the artist cut up this result of many years' work, as he did with many other pictures of this period, e.g. *Peasant girl with Pink*, 1880 (Vienna, Kunsthistorisches Museum, and Cologne); portrait of J. A. Langbehn (known from the title of his principal book as the 'Rembrandt German'; *c.* 1877, Winterthur, Oskar Reinhart Foundation; hands in a private collection in Germany), etc.

293. 9. '.... die Bedeutung des Tones ist die, dass er den Dingen das Materielle nimmt und nur die ätherische Essenz der Erscheinung festhält'.

10. One of these, known as the *Matteo Still-Life* from the name of an Italian who appears in the picture, is in a private collection at Dresden. The other is at Vienna.

CHAPTER 14

298. 1. 'Ausser Millet gibt es keinen Maler, der so wenig zeichnen und malen konnte wie ich, und dabei so gute Bilder gemacht hat.' Extract from a conversation with Max Liebermann; M. Liebermann, *Jozef Israëls*, 3rd ed. (Berlin, 1909), 6.

304. 2. A good example of this category is *The Water Sprite* (several versions from 1882 on; Stockholm, and Waldemarsudde, Prince Eugen Collection).

310. 3. 'aus seiner niederländischen Haut nicht

heraus'. From a letter written in February 1878 to the author Paul Lindau.

311. 4. Some of the best known are: *Hans Huckebein der Unglücksrabe* (1867), *Die fromme Helene* (1872) [248], *Tobias Knopp* (1875-7), *Balduin Bählamm, der verhinderte Dichter* (1883), *Maler Klecksel* (1884). To these must be added Busch's work for the *Fliegende Blätter* between 1859 and 1871 [247].

312. 5. Now in Thorvaldsens Museum at Copenhagen. Cf. the latest catalogue of the museum, edited by Sigurd Schultz (Copenhagen, 1953).

CHAPTER 15

317. 1. The same term ('Deutsch-Römer') is also used with reference to the early nineteenth-century German artists working in Rome, i.e. Koch, Julius Schnorr von Carolsfeld, etc.

2. To the Medea group of pictures also belong two important works: *Medea with the Dagger* (1872, Mannheim) and *Medea at the Urn* (1873, Vienna, Kunsthistorisches Museum).

318. 3. 'wahrhaft majestätische, abweisende Ruhe'. From a letter to his mother dated 2 November 1855.

320. 4. Julius Meier-Graefe, *Der Fall Böcklin und die Lehre von den Einheiten* (Stuttgart, 1905).

5. 'Ich ersehne nichts mehr als den Moment, wo Vorstellung und Darstellung in Eins zusammenfliessen.'

321. 6. Nos. 139-225 in J. Meier-Graefe's catalogue of the *œuvre*, including all the designs and sketches.

322. 7. Three family groups (*c.* 1867), two Roman landscapes (1868, one at Munich), *Woodland Scene at Evening* (*c.* 1870), etc.

8. Life-size portrait of Fiedler (1869-71), portrait of the artist's father (1869, Munich), double portrait of Hildebrand and Grant (1870).

327. 9. *Le bois sacré cher aux arts et aux muses, Vision antique, Inspiration chrétienne.*

328. 10. From left to right the personages represented are: Scholderer, Manet, Renoir, Astruc, Zola, Maître, Bazille, Monet.

11. Here painting and photography are merely in a relation of proximity, but even this is significant of the essence of Naturalistic painting. More superficial and of no real importance is the occasional use made of photographs as foundations for pictures, a practice followed even by great painters, e.g. Cézanne. A direct relationship between photography and painting exists only in the third case, when knowledge gained from photographs is utilized in painting. This is the case, for example, with the rendering of galloping horses in motion by, e.g., Degas, after the appearance of the first photographs by E. Muybridge (from 1872; pub-

lished in France from 1881). On the problem of the attitude, positive or negative, of painters to photography, and on the evidence we have on the attitude of artists and writers from Ingres, Delacroix, and Baudelaire onwards, see H. Schwarz, 'Art and Photography: Forerunners and Influences', *Magazine of Arts* (November 1949), and 'Daumier, Gill and Nadar', *Gazette des Beaux-Arts* (February 1957). A book by the same author, called *Art and Photography*, is to appear soon.

330. 12. He also studied lithography under Bresdin and Fantin-Latour. Redon's graphic *œuvre* comprises 41 etchings and 181 lithographs.

CHAPTER 16

331. 1. Cf. Werner Weisbach, *Der Impressionismus. Ein Problem der Malerei in der Antike und Neuzeit* (Berlin, 1910-11).

332. 2. The most famous example is the borrowing, in his *Picnic Lunch* (1863) [266], of a group of figures from Marcantonio Raimondi's engraving after Raphael's *Judgement of Paris*. There are other instances of this technique of 'quotation of motifs', e.g. from Rubens. A special role is played by the reminiscences of Velázquez in Manet's Spanish figure pieces, e.g. in the three pictures of beggars known as *Philosophers* (1865, Art Institute of Chicago, private collections in Chicago and New York), and in his *Absinthe Drinker* [276], all of which contain echoes of Velázquez's pictures of Philosophers, etc. Furthermore, there are connexions between Giorgione's *Open-Air Concert* in the Louvre and Manet's *Picnic Lunch*, and between the representations of Venus by Giorgione and Manet's *Olympia*.

3. Cf. the words of Delacroix quoted above (p. 160).

335. 4. In a letter written in 1865 during his journey to Spain (25 September, to Fantin-Latour), Manet calls Velázquez the 'peintre des peintres' and acknowledges that 'j'ai trouvé chez lui la réalisation de mon idéal en peinture'.

5. Zola wrote about Manet for the first time in an article entitled 'Mon Salon' in *L'Événement* of 27 April-20 May 1866 (reprinted in *Mes Haines*, Paris, 1867).

339. 6. In accordance with this is the fact that like, for instance, Marées, Manet dreamt of murals. At the beginning of 1879 he conceived the idea of decorating the council-chamber of the Paris town hall with murals illustrating *The Feeding of Paris*, with references to Zola's *Le ventre de Paris*. In a letter of 1878/9 to his friend Antonin Proust Manet mentioned this idea. He wrote to the Prefect of the Department of the Seine about it, but received no answer.

340. 7. Manet's first series of etchings, *Collection de huit eaux-fortes, sujets divers*, appeared in 1862. Several of his early etchings are copies of famous paintings, especially by Velázquez. Altogether there exist seventy-five etchings by Manet [275].

341. 8. In one of these paintings, the *Races in The Bois de Boulogne* (1872, New York, John H. Whitney Collection), Manet still uses, like Géricault in his *Epsom Derby* of 1821, the traditional motif of the 'flying gallop'.

344. 9. In 1867–8, shortly after the terrible event, Manet painted four versions: the first is now in Boston; another - of which only two fragments exist - is now in London, while a study for the final version is in the Ny Carlsberg Glyptotek at Copenhagen and the definitive version (large like the ones in Boston and London) is at Mannheim. In addition to these Manet made a lithograph in 1868, which for political reasons was not allowed to be printed and did not appear until his death. Cf. Nils Gösta Sandblad's exhaustive study, *Manet, Three Studies in Artistic Conception* (Publications of the New Society of Letters at Lund, no. 46) (Lund, 1954).

350. 10. Cf. especially the programmatic publication by Paul Signac, *D'Eugène Delacroix au Néo-Impressionnisme* (Paris, 1899).

351. 11. Among the twenty-eight painters who took part in this exhibition were Boudin, Degas, Cézanne, Lépine, Berthe Morisot, Bracquemond, Pissarro, Renoir (*The Box*) [296], Sisley, Guillaumin. It was at this time that the word 'Impressionist' was coined. The critic Louis Leroy used it in the title of a satirical article which he wrote about the exhibition: 'L'Exposition des Impressionistes' (*Charivari*, 25 April), with reference to one of Monet's exhibits: *Impression. Soleil levant*, the subject of which was a motif from the harbour of Le Havre (1872, Paris, Donop de Monchy Collection).

354. 12. This refers to the works he executed in Paris. On the other hand a number of pictures and studies have been preserved which were made during Pissarro's journey to Caracas (1853–5) in the company of the Danish painter Fritz Melbye (1826–96); reproductions in John Rewald, 'L'œuvre de jeunesse de Camille Pissarro', *L'Amour de l'Art* (April 1936).

355. 13. Letter from Cézanne to Émile Bernard, written in 1905; Cézanne, *Correspondence*, ed. John Rewald (Paris, 1937), 276. - Pissarro himself recognized the mutual influence between him and Cézanne in a letter of 22 November 1895 to his son Lucien; Camille Pissarro, *Letters to his Son Lucien*, ed. John Rewald (London, 1943), 276.

356. 14. James McNeill Whistler (1834–1903), although American by birth, was, as his prolonged stays in Paris show (1855–9, 1884–96), more or less French by election, and so was Mary Cassatt (1845–1927) of Pittsburgh, whose guiding star was Degas.

358. 15. Paul Valéry, *Degas, Danse, Dessin* (Paris, 1938).

360. 16. In pictures like the *Domestic Scene* (1872, New York), *Interior* (*Le Voil*) (1875, Naugatuck, Connecticut, Whittemore Collection), and also in the *Cotton-Mill in New Orleans* painted during his stay in the United States (1873, Pau).

17. Of this artist, known especially for his portrait etchings, Manet too painted portraits, e.g. the full-length *Marcellin Desboutin with his Pipe* (1875, São Paulo, Museum of Fine Arts).

361. 18. Owing to the often photographic precision of many of his spatial fragments, it has frequently been assumed that Degas, who was very interested in photography and himself took photographs, occasionally used snapshots as a basis for the composition of his pictures.

362. 19. He also used surprising, subtle mixtures of both these techniques; cf. Denis Rouart, *Degas, À la recherche de sa technique* (Paris, 1945), and Douglas Cooper, *Pastels by Edgar Degas* (New York, 1954).

20. Julius Meier-Graefe, *Auguste Renoir* (Munich, 1911), 24.

364. 21. There are three versions.

CHAPTER 17

371. 1. The newspaper which in 1866 published Zola's articles defending the new style. Zola had been a friend of Cézanne's since childhood (see above, Chapter 16, Note 5).

PART TWO: SCULPTURE

CHAPTER 18

378. 1. Houdon's portrait busts, like his statues, are almost without exception preserved in several versions and techniques, in plaster, terracotta, marble, and bronze. For his earlier career see the forthcoming volume in *The Pelican History of Art* by W. Graf Kalnein and M. Levey.

380. 2. Canova was born at Possagno in the province of Treviso. The church of the Holy Trinity there (1819–30) was designed by him; a Classicist *Gesamtkunstwerk*, for which he also made statues and paintings. There is a Canova Museum at Possagno.

3. For this monument, commissioned by Maria Christina's husband, Duke Albert of Sachsen-Teschen, the founder of the Albertina, Canova used a design originally destined to be a monument

to Titian in the church of the Frari in Venice. In the latter church there is a variant of the Christina tomb, erected in 1827 as a funerary monument to Canova himself. The astonishingly free, expressive bozzetti which it embodies reveal a curious byway in his art.
382. 4. Alfred Gotthold Meyer, *Canova* (Knackfuss Monographs, XXXVI) (Bielefeld-Leipzig, 1898), 115: 'mag der Weltgeist freilich nur mit freundlicher Ironie blicken, wenn er hier der wahren Antike gedenkt: seiner eigenen so weit gesunderen Jugend, deren ewiger Schönheit Canova nur wenige Strahlen zu entnehmen wusste, um mit ihnen dennoch ein neues Zeitalter der Kunst zu beleben'.

5. *Alexander the Great entering Babylon*, designed at a time when it was expected that Napoleon would visit Rome, and executed in 1822 in marble by Pietro Galli (1804-77).
383. 6. In Thorvaldsens Museum a few copies by Thorvaldsen after drawings by Carstens have been preserved.

7. Commemorating the Swiss who lost their lives in 1792 in Paris during the Revolution; hewn in the rock in 1821 by Lukas Ahorn of Constance (1789-1856).
384. 8. Most clearly marked in the clay group, dating from 1793, from the Abilgaard Bequest, of a *Woman with two Children* (Thorvaldsens Museum).
389. 9. For example Copernicus, Wieland (both executed in 1807), Kant (after 1801), Klopstock, Leibniz (both dating from 1808), and Nicolai.

10. The first designs for a monument of Frederick were made in Rome in 1786. Schadow also worked on another for the city of Berlin, but the commission was ultimately given to Christian Rauch.

11. 'blieb die Stilform immer ein Zeitgewand für ein übergeschichtliches Naturgefühl'; *Die europäische Kunst im 19. Jahrhundert*, II, 252.

12. Schadow also executed the quadriga crowning the gate (completed 1793, destroyed during the Second World War).
391. 13. English edition: *Physiognomy; or the corresponding analogy between the conformation of the Features and the ruling passions of the Mind*, transl. S. Shaw (London, 1800?). - On the interpretation of Messerschmidt's character heads, see the detailed study by Ernst Kris in *Jahrbuch der Kunsthistorischen Sammlungen in Wien*, N.F. VI (1932), in which some of the extremely bizarre heads in this series are examined from a psycho-analytical standpoint.
392. 14. An experimental cast of the statue in smaller dimensions is in the park at Schönbrunn.
394. 15. The scenes represented are *Germany and the States of the German Confederation* and the *Battle of the Teutoburger Wald*.

16. Destroyed in 1814. Later replaced by another statue of Napoleon (1862-3) by Augustin Dumont (1801-84). The column was torn down in 1871 (see p. 250).
395. 17. The whole arrangement of the Square was designed by Jakob Ignaz Hittorf (1792-1867), court architect of Louis-Philippe, and executed in 1836-46.

18. On the Odéon the great French dramatic poets and leading characters from their dramas and comedies were represented; on the pediment of the Panthéon, the inscription: 'Aux grands hommes la patrie reconnaissante' is illustrated by showing laurel-wreaths being conferred on great scholars, statesmen, and generals.
396. 19. Weimar was the actual goal of the first journey which David d'Angers undertook in order to make a colossal bust of Goethe. The finished marble (1831) was presented by the sculptor to Goethe (now in Weimar, Landesbibliothek).

CHAPTER 19

399. 1. It was presented by one of Rude's friends, Noisot, an enthusiastic admirer of Napoleon and former major in the Imperial Guards; the model for it is in the Louvre.

2. In Clément's catalogue of Géricault's works, six works of sculpture are enumerated (Nos. 1-6); in addition to the work here reproduced (a bronze cast from the original in stone, the latter being in the possession of Madame Thea Sternheim), a group in clay, representing a rape (Clément No. 5; Buffalo, U.S.A., Albright Art Gallery), has been preserved. This is similar in subject and of an equally amazing aesthetic power. There has also recently come to light a statuette of a *Cheval écorché* ('Flayed horse', Clément No. 1), which has been acquired for the Barber Institute of Fine Arts, Birmingham (replica in private possession).
403. 3. The original busts, tinted with colour, are in the Le Garrec Collection, Paris; there are bronze casts of them in several public and private collections.

4. Eduard Fuchs in his book on Daumier as a painter published two statuettes, and since then a self-portrait (c. 1857, Maurice Loncle Collection), two small heads (c. 1840-50, Copenhagen, Ny Carlsberg Glyptothek), and nineteen more statuettes have come out. The latter are published in Maurice Gobin's catalogue of Daumier's sculptural *œuvre*. They mostly represent types familiar from Daumier's lithographs. Their authenticity is not beyond doubt.
404. 5. There is an almost complete collection in the Musée Carnavalet, Paris.

CHAPTER 20

407. 1. Wood as a material plays no role at all during this period; obviously, for the nineteenth century it was too paltry and perishable.

408. 2. The original version, in plaster, is in the Louvre (1857); there are also a bronze version of 1859 and a marble version dated 1861, the latter in the National Gallery, Washington.

409. 3. In the much more conventional execution of the monument (1875), none of this spirit has been preserved.

411. 4. The figures of horses on the base are by Frémiet.

CHAPTER 21

413. 1. This side can be seen in a work such as the monument to the ophthalmologist Albrecht von Graefe in Berlin (1883).

414. 2. Leonard von Matt and John Rewald, *Degas Sculpture. The Complete Works* (London, 1957).

415. 3. Known works by Courbet are a design for a monument, *Le Pêcheur de Chavots* (1861); a medallion portrait in plaster (portrait of Madame Max Buchon, 1864); and a figure, *La Dame à la mouette*.

417. 4. All Rodin's works, in their various versions and casts, can be seen in the Musée Rodin, Paris. The same museum possesses the later, more moderate version of the *Man with the broken Nose*.

418. 5. About 1900 Rodin took up this theme again, in the torso of a *Striding Man*. On dating, see J. A. Schmoll (Eisenwerth), *Der Torso als Symbol und Form (Zur Geschichte des Torso-Motivs im Werk Rodins)* (Baden-Baden, 1954).

BIBLIOGRAPHY

Books and papers on the art of the nineteenth century are innumerable, and no one can blame some authors of general books on the subject who decide to do without a bibliography altogether. On the other hand, it must surely be admitted that for the layman even a brief bibliography is better than no bibliography. The following, though it may seem long, is in fact very brief. Users must be reminded that in the biographical part not all the artists appear who are mentioned in the text. Those not mentioned can be looked up in dictionaries of artists, and especially in the *Allgemeines Lexikon der bildenden Künstler* by Ulrich Thieme and Felix Becker, 37 vols., Leipzig, 1908–50. Another useful general work is the *Art Index*, New York, 1929 ff.

A further selection from the vast material available, amounting to over 200 entries, has been incorporated in 1976.

The material is arranged under the following headings:

I. GENERAL

A. GENERAL WORKS

Antal, F. *Classicism and Romanticism with Other Studies in Art History.* London, 1966.

Argan, G. O. *L'arte moderna 1770–1970.* Florence, 1970.

Beiträge zur Motivkunde des 19. Jahrhunderts (Studien zur Kunst des 19. Jahrhunderts, VI). Munich, 1970.

Berger, K. 'Stilstrukturen des 19. Jahrhunderts', *Zeitschrift für Ästhetik und allgemeine Kunstwissenschaft*, XII (1967), 192–203.

Boyer, F. *Le monde des arts en Italie et la France de la Révolution et de l'Empire. Études et recherches.* Turin, 1970.

Christoffel, U. *Malerei und Poesie: Die symbolistische Kunst des 19. Jahrhunderts.* Vienna, 1948.

Denkmäler im 19. Jahrhundert. Deutung und Kritik (Studien zur Kunst des 19. Jahrhunderts, XX). Munich, 1972.

Hamilton, G. H. *Nineteenth and Twentieth Century Art.* New York, 1970.

Hildebrandt, H. *Die Kunst des XIX. und XX. Jahrhunderts (Handbuch der Kunstwissenschaft).* Wildpark-Potsdam, 1924.

Höck, W. *Kunst als Suche nach Freiheit. Entwürfe einer ästhetischen Gesellschaft von der Romantik bis zur Moderne.* Cologne, 1973.

Hofmann, W. *Das irdische Paradies – Kunst im neunzehnten Jahrhundert.* Munich, 1960.

Holt, E. G. *From the Classicists to the Impressionists, A Documentary History of Art and Architecture in the Nineteenth Century.* London and New York, 1966.

Jones, H. M. *Revolution and Romanticism*. Cambridge, 1974.

Keller, H. *Die Kunst des 18. Jahrhunderts (Propyläen-Kunstgeschichte, X)*. Berlin, 1971.

Lankheit, K. *Revolution und Restauration (Kunst der Welt. Die Kulturen des Abendlandes)*. Baden-Baden, 1965.

Lietzmann, H. *Bibliographie zur Kunstgeschichte des 19. Jahrhunderts. Publikationen der Jahre 1940-1966 (Studien zur Kunstgeschichte des 19. Jahrhunderts, IV)*. Munich, 1968.

Meier-Graefe, J. *Entwicklungsgeschichte der modernen Kunst*. 3 vols. 4th ed. Munich, 1924.

Nochlin, L. *Realism and Tradition in Art 1848-1900*. Englewood Cliffs, N.J., 1966.

Ossian und die Kunst um 1800. Katalog zur Ausstellung in der Hamburger Kunsthalle 1974. Munich, 1974.

Pevsner, N. *Academies of Art, Past and Present*. Cambridge, 1940.

Pevsner, N. 'Art and Architecture 1830-1870', *Cambridge Modern History*, X. Cambridge, 1957.

Richardson, E. P. *The Way of Western Art 1776-1914*. Cambridge, Mass., 1939.

Scheffler, K. *Verwandlungen des Barocks in der Kunst des 19. Jahrhunderts*. Vienna, 1947.

Scheffler, K. *Das Phänomen der Kunst : Grundsätzliche Betrachtungen zum 19. Jahrhundert*. Munich, 1952.

Scheffler, K. *Die europäische Kunst im neunzehnten Jahrhundert*. 2 vols. Berlin, n.d.

Zeitler, R. *Die Kunst des 19. Jahrhunderts (Propyläen-Kunstgeschichte, XI)*. Berlin, 1966.

B. PAINTING

Baumgart, F. *Vom Klassizismus zur Romantik 1750-1832. Die Malerei im Jahrhundert der Aufklärung, Revolution und Restauration*. Cologne, 1974.

Fisher, S. W. *A Dictionary of Watercolour Painters 1750-1900*. London, 1972.

Focillon, H. *La peinture au XIXe siècle. Le retour à l'Antique. Le Romantisme (Manuels d'histoire de l'art)*. Paris, 1927.

Focillon, H. *La peinture aux XIXe et XXe siècles. Du Réalisme à nos jours (Manuels d'histoire de l'art)*. Paris, 1928.

Glaser, C. *Die Graphik der Neuzeit von Anfang des XIX. Jahrhunderts bis zur Gegenwart*. 2nd ed. Berlin, 1923.

Grote, L. *Meister des 19. Jahrhunderts (Europäische Malerei in deutschen Galerien, II)*. Munich, 1967.

Heise, C. G. *Grosse Zeichner des 19. Jahrhunderts*. Berlin, 1960.

Larant, J. (ed.), with Adhémar, J., and Prinet, J. *L'estampe*. 2 vols. Paris, 1959.

Man, F. H. *150 Years of Artist's Lithographs (1803-1953)*. London-Melbourne-Toronto, 1953.

Rümann, A. *Das illustrierte Buch des 19. Jahrhunderts in England, Frankreich und der Schweiz*. Leipzig, 1930.

Valsecchi, M. *Landscape-Painting of the Nineteenth Century*. New York, 1971.

Wind, E. 'The Revolution of History Painting', *Journal of the Warburg and Courtauld Institutes*, II (1938-9).

C. SCULPTURE

Baumgart, F. *Geschichte der abendländischen Plastik*. Cologne, 1956.

Hammacher, A. M. *L'évolution de la sculpture moderne : tradition et innovation*. Paris, 1971.

Kuhn, A. *Die neuere Plastik von 1800 bis zur Gegenwart*. Munich, 1922.

Licht, F. S. *Sculpture - The Nineteenth and Twentieth Centuries*. Greenwich, Conn., 1967.

Osten, G. von der. *Plastik des 19. Jahrhunderts in Deutschland, Österreich und der Schweiz (Die blauen Bücher)*. Königstein im Taunus, 1961.

Rheims, M. *La sculpture au 19e siècle*. Paris, 1972.

Selz, J. *Ursprünge der modernen Plastik*. Munich, 1963.

Tucker, W. *Early Modern Sculpture : Rodin, Degas, Matisse, Brancusi, Picasso, Gonzalez*. New York, 1974.

Tucker, W. *The Language of Sculpture*. London, 1974.

D. MOVEMENTS

Addison, A. *Romanticism and the Gothic Revival*. New York, 1938.

Age of Neo-Classicism, The. Exhibition of the Royal Academy and the Victoria and Albert Museum, London. London, 1972.

Antal, F. *Classicism and Romanticism*. New York, 1967.

Antal, F. 'Reflections on Classicism and Romanticism', *Burlington Magazine*, LXVI (1935), I, LXVIII (1936), I, LXXVII (1940), II, LXXVIII (1941), I.

Arte neoclassica, Atti del Convegno 12-14 ottobre 1957 (Civiltà veneziana, Studi, XVII). Venice and Rome, 1964.

Badt, K. *Wolkenbilder und Wolkengedichte der Romantik*. Berlin, 1960.

Briganti, G. *Pittura fantastica e visionaria dell'ottocento*. Milan, 1967.

Brion, M. *Romantic Art*. London – Munich – Zürich, 1960.

Brion, M. *Art of the Romantic Era (World of Art)*. London and New York, 1966.

Clark, K. *The Romantic Rebellion. Romantic versus Classic Art*. London, 1973.

Cogniat, R. *Le Romantisme (Histoire générale de la peinture)*. Paris, 1966.

Eitner, L. *Neoclassicism and Romanticism 1750-1850 ; Sources and documents*. 2 vols. Englewood, N.J., 1970.

Evers, H. G. *Vom Historismus zum Funktionalismus (Kunst der Welt. Die Kulturen des Abendlandes)*. Baden-Baden, 1967.

Gerstenberg, K. *Die ideale Landschaftsmalerei: Ihre Begründung und Vollendung in Rom*. Halle, 1923.

Gombrich, E. H. 'Imagery and Art in the Romantic Period', *Burlington Magazine*, XCI (1949).

Grundmann, G. *Das Riesengebirge in der Malerei der Romantik*. 2nd ed. Munich, 1958.

Hamann, R. *Impressionismus in Leben und Kunst*. 2nd ed. Marburg, 1923.

Hautecoeur, L. *Rome et la renaissance de l'antiquité à la fin du XVIIIe siècle*. Paris, 1912.

Historismus und bildende Kunst (Studien zur Kunst des 19. Jahrhunderts, 1). Mit Beitr. von Helmut Coing a.o. Munich, 1965.

Hofmann, W. *Grundlagen der modernen Kunst - Eine Einführung in ihre symbolischen Formen*. Stuttgart, 1966.

Honour, H. *Neo-Classicism (Style and Civilization)*. Harmondsworth, 1973.

Knauss, B. *Das Künstlerideal des Klassizismus und der Romantik*. Reutlingen, 1925.

Lankheit, K. *Das Freundschaftsbild der Romantik (Heidelberger kunstgesch. Abh., N.F. 1)*. Heidelberg, 1952.

Levitine, G. 'The "Primitifs" and their Critics in the Year 1800', *Studies in Romanticism*, I/4. Boston, 1962.

Lorck, C. von. *Die Klassik und der Osten Europas: Vom Ursprung und Wesen des Klassizismus*. Oldenburg-Hamburg, 1966.

Martini, A. *L'Impressionismo (Mensili d'arte, V)*. Milan, 1967.

Moore, G. *Modern Painting*. London, 1893.

Neoclassicismo, Londra 1971. Atti del Convegno internazionale promosso dal Comité International d'Histoire de l'Art. Genoa, 1973.

Neumeyer, A. 'Die Erweckung der Gotik in der deutschen Kunst des späten 18. Jahrhunderts. Ein Beitrag zur Vorgeschichte der Romantik', *Repertorium für Kunstwissenschaft*, XLIX (1928).

Neumeyer, A. 'Zum Problem des Manierismus in der bildenden Kunst der Romantik', *Zeitschrift für bildende Kunst* (1928/9).

Nochlin, L. *Realism (Style and Civilization)*. Harmondsworth, 1971.

Pariset, F. G. *L'art néo-classique (Les neuf muses)*. Paris, 1974.

Pauli, G. *Die Kunst des Klassizismus und der Romantik (Propyläen-Kunstgeschichte, XIV)*. Berlin, 1925.

Pichard, J. *Die Malerei der Romantik (Weltgeschichte der Malerei, VI)*. Lausanne, 1966.

Pilo, G. M. (ed.). *Neoclassicismo, romantismo, realismo. Problemi e studi. Omaggio a Michelangelo Grigoletti*. Milan, 1974.

Powell, N. 'Second and Third Rococo and Neo-Rococo. An Attempt at some Stylistic Definitions', *Museion (Festschrift Otto H. Förster)*. Cologne, 1960.

Praz, M. *On Neoclassicism*. London, 1969.

Schmalenbach, F. 'Impressionismus – Versuch einer Systematisierung', in *Wallraf-Richartz-Jahrbuch* (1966).

Venturi, L. 'L'Impressionismo', *L'Arte*, N.S. VI (1935).

Waldmann, E. *Die Kunst des Realismus und des Impressionismus im 19. Jahrhundert (Propyläen-Kunstgeschichte, XV)*. Berlin, 1927.

Wichmann, S. *Realismus und Impressionismus: Bemerkungen zur Freilichtmalerei des 19. und beginnenden 20. Jahrhunderts*. Stuttgart, 1964.

Zeitler, R. *Klassizismus und Utopia: Interpretationen zu Werken von David, Canova, Carstens, Thorvaldsen, Koch (Figura, V; Studies edited by the Institute of Art History, University of Uppsala)*, Stockholm, 1954.

II. INDIVIDUAL COUNTRIES

A. AUSTRIA

Benesch, O. *Kleine Geschichte der Kunst in Österreich (Tagblatt-Bibliothek)*. Vienna, 1950.

Buchowiecki, W. *Geschichte der Malerei in Wien (Geschichte der Stadt Wien, Neue Reihe, VII, 2)*. Vienna, 1955.

Feuchtmüller, R., and Mrazek, W. *Biedermeier in Österreich*. Vienna-Hannover-Bern, 1963.

Feuchtmüller, R., and Mrazek, W. *Kunst in Österreich 1860-1918*. Vienna, 1964.

Fuchs, H. *Die österreichischen Maler des 19. Jahrhunderts*. 4 vols. Vienna, 1972.

Ginhart, K. (ed.). *Die bildende Kunst in Österreich vom Ausgang des 18. Jahrhunderts bis zur Gegenwart*. Vienna-Baden-Brünn, 1943.

Ginhart, K. *Wiener Kunstgeschichte*. Vienna, 1948.

Grimschitz, B. *Die Altwiener Maler*. Vienna, 1961.

Grimschitz, B. *Die österreichische Zeichnung im 19. Jahrhundert*. Zürich-Vienna-Leipzig, 1928.

Grimschitz, B. *Maler der Ostmark im 19. Jahrhundert*. Vienna, 1940.

Grimschitz, B. *Österreichische Maler vom Biedermeier zur Moderne*. Vienna, 1963.

Hevesi, L. *Österreichische Kunst im 19. Jahrhundert*. 2 vols. Leipzig, 1903.

Jahrhundert des Wiener Aquarells, Das, 1780-1880, Albertina-Ausstellung 235. Vienna, 1973.

Jenden, J. C. 'Neue Literatur über das Biedermeier in Österreich', *Kunstchronik*, XVIII (1965), 124-34.

Pötschner, P. *Genesis der Wiener Biedermeierlandschaft*. Vienna, 1964.

Romantik und Realismus in Österreich. Gemälde und Zeichnungen aus der Sammlung Georg Schäfer,

Schweinfurt, Ausstellung Schloß Laxenburg, 1968;
Schweinfurt, 1968.

Schwarz, H. *Salzburg und das Salzkammergut: Die*
künstlerische Entdeckung der Stadt und der Landschaft
im 19. Jahrhundert. 3rd ed. Vienna, 1958.

Tietze, H. *Das vormärzliche Wien in Wort und Bild.*
Vienna, 1925.

Zimmermann, E. H. *Das Alt-Wiener Sittenbild.*
Vienna, 1923.

B. BELGIUM AND HOLLAND

Daalen, P. K. van. *Nederlandse beeldhouwers in de*
negenteinde eeuw. The Hague, 1957.

Fierens, P., and others. *L'art en Belgique.* Brussels,
1938.

Fierens, P. *L'art flamand (Arts, styles et techniques).*
Paris, n.d.

Gelder, H. E. van, and Duverger, J. (eds.). *Kunst-*
geschiedenis der Nederlanden. 2 vols. Utrecht, 1954/5.

Gruyter, J. de. *De Haagse school.* 2 vols. Rotterdam,
1968.

Huebner, F. M. *Die Kunst der niederländischen Ro-*
mantik. Düsseldorf, 1942.

Knoef, J. *Tussen Rococo en Romantiek.* The Hague,
1943.

Knoef, J. *Van Romantiek tot Realisme.* The Hague,
1947.

Knoef, J. 'Een compositie-element in onze midden
19de eeuwsche schilderkunst', *Oud Holland,* LXVIII
(1953).

Lewis, F. *A Dictionary of Dutch and Flemish Flower,*
Fruit and Still-Life Painters, Fifteenth to Nineteenth
Century. Leigh-on-Sea, 1973.

Marius, G. H. *Dutch Painters of the Nineteenth Cen-*
tury. Woodbridge, 1973.

Scheen, P. A. *Honderd jaren Nederlandsche schilderen*
en teekenkunst: de Romantiek met voor- en natijd
(1750–1850). The Hague, 1946.

Vanzype, G. *L'art belge du XIXe siècle.* 2 vols.
Brussels–Paris, 1923.

Wilenski, R. H. *Flemish Painters, 1430–1830.* 2 vols.
London, 1960.

C. FRANCE

1. *General*

Alazard, J. 'L'exotisme dans la peinture française au
XIXe siècle', *Gazette des Beaux-Arts* (1931), II.

Berger, K. 'Poussin's Style and the XIX Century',
Gazette des Beaux-Arts (1955), I.

Boime, A. *The Academy and French Painting in the*
Nineteenth Century. London, 1971.

Bürger-Thoré, W. *Französische Kunst im neunzehnten*
Jahrhundert. 3 vols. Leipzig, 1911.

Christoffel, U. *Von Poussin zu Ingres und Delacroix:*
Betrachtungen über die französische Malerei. Zürich,
1945.

Clark, T. J. *The Absolute Bourgeois: Artists and*
Politics in France, 1848–1851. Greenwich, Conn.,
1973.

De David à Delacroix. La peinture française de 1774 à
1830, Exp. Grand Palais. Paris, 1974.

Dorival, B. *La peinture française (Arts, styles et tech-*
niques). Paris, 1946.

Easton, M. *Artists and Writers in Paris. The Bohemian*
Idea. 1803–1867. London, 1969.

Finke, V. (ed.). *French Nineteenth-Century Painting*
and Literature with Special Reference to the Relevance
of Literary Subject Matter to French Painting (Sym-
posium Manchester 1969). Manchester, 1972.

Fontainas, A., and Vauxcelles, L. *Histoire générale de*
l'art français de la Révolution à nos jours. Paris, 1922.

Fosca, F. *La peinture française au XIXe siècle.* Paris,
1956.

Francastel, P. *La peinture française du Classicisme au*
Cubisme. Paris, 1955.

Fry, R. *Characteristics of French Art.* London, 1932.

Hautecoeur, L., and Jamot, P. *La peinture au Musée du*
Louvre, École française, XIXe siècle. 2 parts. Paris,
n.d.

Herbert, E. W. *The Artist and Social Reform. France*
and Belgium, 1885–1898 (Yale Historical Publications
Miscellany, LXXIX). New Haven, 1961.

Hildebrandt, E. *Malerei und Plastik des 18. Jahrhun-*
derts in Frankreich (Handbuch der Kunstwissenschaft).
Wildpark-Potsdam, 1924.

Leymarie, J. *Französische Malerei – Das neunzehnte*
Jahrhundert. Geneva, 1962.

Leymarie, J. *La peinture française – XIXe siècle.*
Geneva, 1962.

Lindsay, J. *Death of the Hero. French Painting from*
David to Delacroix. London, 1960.

Scheffler, K. *Die grossen französischen Maler des 19.*
Jahrhunderts. Munich, 1942.

Wilenski, H. R. *French Painting.* Boston, 1931.

2. *Special Subjects*

Barilli, R. *Il Simbolismo nella pittura francese dell'otto-*
cento. Milan, 1967.

Berger, K. *French Master Drawings of the Nineteenth*
Century. New York, 1950.

Courboin, F. *Histoire illustrée de la gravure en France,*
III, *XIXe siècle.* Paris, 1926.

Dacier, É. *La gravure française (Arts, styles et tech-*
niques). Paris, n.d.

Daulte, F. *Le dessin français de David à Courbet.*
Lausanne, 1953.

Daulte, F. *Le dessin français de Manet à Cézanne.*
Lausanne, 1954.

Dorbec, P. 'Les paysagistes anglais en France', *Gazette des Beaux-Arts* (1912), II.

Dorbec, P. *L'art du paysage en France: Essai sur son évolution de la fin du XVIIIe siècle à la fin du Second Empire*. Paris, 1925.

Dorbec, P. 'Les influences de la peinture anglaise sur le portrait en France (1750–1850)', *Gazette des Beaux-Arts* (1913), II.

Elles, I. *Das Stilleben in der französischen Malerei des 19. Jahrhunderts (Die Bedeutung für das moderne Weltbild)*. Zürich, 1958.

Gusman, P. *La gravure sur bois en France au XIXe siècle*. Paris, 1925.

Huyghe, R., and Jaccottet, P. *Le dessin français au XIXe siècle*. Lausanne, 1948.

Jalabert, D. *La sculpture française*. Paris, 1931.

Luc-Benoist. *La sculpture française (Arts, styles et techniques)*. Paris, n.d.

Miquel, P. *Le paysage français au XIXe siècle*. Mocurs-la-Jolie, 1975.

Réau, L. *Un siècle d'aquarelle de Géricault à nos jours*. Paris, 1942.

Roger-Marx, C. *La gravure originale en France de Manet à nos jours*. Paris, 1939.

Rostrup, H. *Franske Billedhuggere fra det 19. Aarhundrede*. Copenhagen, 1938.

Sander, M. *Die illustrierten französischen Bücher des 19. Jahrhunderts (Taschenbibliographien für Büchersammler, I)*. Stuttgart, 1924.

3. *Movements*

Balzer, W. *Der französische Impressionismus. Die Hauptmeister in der Malerei*. Dresden, 1958.

Baudelaire, C. *L'art romantique*. Paris, 1869.

Bazin, G. *L'époque impressionniste*. Paris, 1947.

Berger, K. 'Ingrisme et Pre-Raphaelitisme', *Actes du XIXe Congrès International d'Histoire de l'Art*. Paris, 1958.

Bouret, J. *The Barbizon School and Nineteenth-Century French Landscape Painting*. London, 1973.

Brown, M. W. *The Painting of the French Revolution*. New York, 1938.

Centenaire de l'Impressionisme, ed. H. Adhémar and A. M. Clark. Exhibition. Paris, 1974.

Champa, K. S. *Studies in Early Impressionism*. New Haven, 1973.

Chase, E. T. *The Etchings of the French Impressionists*. Paris–New York, 1956.

Clouzot, H. *Le Style Louis-Philippe – Napoléon III (Arts, styles et techniques)*. Paris, 1939.

Cogniat, B., Elgar, F., and Selz, J. *A Dictionary of Impressionism*. London, 1973.

Cogniat, R. *Le siècle des Impressionnistes*. Paris, n.d.

Cooper, D. 'The Painters of Auvers-sur-Oise', *Burlington Magazine*, XCVII (1955).

Dubré, D., and Damigella, A. M. *La scuola di Barbizon*. Milan, 1967.

Duret, T. *Les peintres impressionnistes*. Paris, 1939.

Escholier, R. *La peinture française, XIXe siècle: De David à Géricault*. Paris, 1941.

Francastel, P. *L'Impressionnisme*. Paris, 1974.

Francastel, P. *Le Style Empire (du Directoire à la Restauration) (Arts, styles et techniques)*. Paris, 1944.

Friedlaender, W. *Hauptströmungen der französischen Malerei von David bis Cézanne, I, Von David bis Delacroix*. Bielefeld-Leipzig, 1930. English translation *David to Delacroix*, Cambridge, Mass., 1952.

Gaunt, W. *Impressionism: A Visual History*. New York, 1970.

Hartlaub, G. F. *Impressionists in France*. London, 1956.

Hellebranth, R., and Bayard, J.-P. *Les maîtres de l'école de Barbizon*. In preparation.

Leymarie, J., and Melot, M. *The Graphic Works of the Impressionists: Manet, Pissaro, Renoir, Cézanne, Sisley*. New York, 1972.

Locquin, J. *La peinture d'histoire en France de 1747–1785*. Paris, 1912.

Mathéy, F. *Les Impressionnistes et leur temps*. Paris, 1959.

Mauclair, C. *Les maîtres de l'Impressionnisme: Leur histoire, leur esthétique, leurs œuvres (Bibliothèque d'art)*. Paris, 1923.

Melot, M. *L'estampe impressioniste*. Exhibition. Paris, Bibliothèque Nationale, 1974.

Novotny, F. *Die grossen französischen Impressionisten – Ihre Vorläufer und ihre Nachfolge*. Vienna, 1952.

Rewald, J. *Geschichte des Impressionismus, Werke und Wirkung der Künstler einer bedeutenden Epoche (Das moderne Sachbuch, XLII)*. Stuttgart, 1957, and Cologne, 1965.

Rewald, J. *The History of Impressionism*. New ed. London, 1973.

Roberts, K. *The Impressionists and Post-Impressionists*. London, 1975.

Roskill, M. *Van Gogh, Gauguin and the Impressionist Circle*. London, 1970.

Sérullaz, M. *Les peintres impressionnistes*. Paris, 1959.

Shinoda, Y. *Degas: Der Einzug des japanischen in die französische Malerei*. Dissertation. Cologne, 1957.

Stoll, R. Th. *Die französischen Impressionisten*. Zürich, 1957.

Sutter, J. *The Neo-Impressionists*. London, 1970.

Tabarant, A. *La vie artistique au temps de Baudelaire*. Paris, 1963.

Thomson, D. C. *The Barbizon School of Painters, etc.* London, 1890.

Vaudoyer, J.-L. *Les Impressionnistes de Manet à Cézanne*. Paris, 1948.

Venturi, L. *Les archives de l'Impressionnisme (Lettres de Renoir, Monet, Pissarro, Sisley et autres. Mémoires de Paul Durand-Ruel. Documents).* 2 vols. Paris–New York, 1939.

D. GERMANY

1. *General*

Andresen, A. *Die deutschen Maler-Radirer (Peintres-graveurs) des 19. Jahrhunderts nach ihren Leben und Werken.* Leipzig, 1866–74. Reprinted in 5 vols. Hildesheim–New York, 1971.

Becker, W. *Paris und die deutsche Malerei 1750–1840 (Studien zur Kunst des 19. Jahrhunderts, x).* Munich, 1971.

Ausstellung deutscher Kunst aus der Zeit von 1775–1875 in der Königlichen Nationalgalerie Berlin 1906. Introduction by Hugo von Tschudi. 2 vols. Munich, 1906.

Buchsbaum, M. *Deutsche Malerei im 19. Jahrhundert. Realismus und Naturalismus.* Vienna–Munich, 1967.

Bünemann, H. *Deutsche Malerei des 19. Jahrhunderts. Deutschland, Österreich, Schweiz.* Königstein im Taunus, 1961.

Deutscher Verein für Kunstwissenschaft (ed.). *Schrifttum zur deutschen Kunst,* I–XIX (1933–55). Last vol. 1959.

Eggert, K. 'Die Anfänge der Akademie der bildenden Künste in München', in *Oberbayrisches Archiv,* LXXXV (1962).

Feulner, A. *Skulptur und Malerei des 18. Jahrhunderts in Deutschland (Handbuch der Kunstwissenschaft).* Wildpark-Potsdam, 1929.

Goering, M. *Deutsche Malerei des siebzehnten und achtzehnten Jahrhunderts. Von den Manieristen bis zum Klassizismus.* Berlin, 1940.

Gurlitt, C. *Die deutsche Kunst seit 1800.* 4th ed. Berlin, 1924.

Hamann, R. *Die deutsche Malerei im 19. Jahrhundert.* Leipzig-Berlin, 1914.

Hamann, R. *Die deutsche Malerei vom Rokoko bis zum Expressionismus.* Leipzig-Berlin, 1925.

Hamann, R., and Hermand, J. *Deutsche Kunst und Kultur von der Gründerzeit bis zum Expressionismus,* I: *Gründerjahre.* In preparation.

Justi, L. *Deutsche Malkunst im neunzehnten Jahrhundert: Ein Führer durch die Nationalgalerie Berlin.* Berlin, 1921.

Justi, L. *Von Runge bis Thoma. Deutsche Malkunst im 19. und 20. Jahrhundert. Ein Gang durch die National-Galerie (Berlin).* Berlin, 1932.

Karlinger, H. *München und die deutsche Kunst des XIX. Jahrhunderts.* Munich, 1933.

Noack, F. *Das Deutschtum in Rom.* 2 vols. Stuttgart, 1927.

Oldenbourg, R., and Uhde-Bernays, H. *Die Münchner Malerei im neunzehnten Jahrhundert.* 2 vols. Munich, 1922.

Ost, H. *Einsiedler und Mönche in der deutschen Malerei des 19. Jahrhunderts (Bonner Beiträge zur Kunstwissenschaft,* XI). Düsseldorf, 1971.

Rave, P. O. *Deutsche Malerei des 19. Jahrhunderts.* Berlin, n.d.

2. *Special Subjects*

Bernhard, M. *Deutsche Romantik. Handzeichnungen.* 2 vols. Munich, 1973.

Brieger, P. *Die deutsche Geschichtsmalerei des 19. Jahrhunderts.* Berlin, 1930.

Bülau, E. *Der englische Einfluss auf die deutsche Landschaftsmalerei im frühen 19. Jahrhundert.* Dissertation. Freiburg i. Br., 1955.

Christoffel, U. *Die romantische Zeichnung von Runge bis Schwind.* Munich, 1920.

Dussler, L. *Die Inkunabeln der deutschen Lithographie (1796–1821).* 2nd impression. Heidelberg, 1955.

Geller, H. *Deutsche Künstler in Rom. Von Raphael Mengs bis Hans von Marées (1741–1887). Werke und Erinnerungsstätten.* Rome, 1961.

Hager, W., Imdahl, M., and Fiensch, G. *Die Anfänge des deutschen Landschaftsbildes (Studien zur Kunstform).* Münster-Cologne, 1955.

Höhn, H. *Studien zur Entwicklung der Münchener Landschaftsmalerei vom Ende des 18. und vom Anfang des 19. Jahrhunderts (Studien z. deutschen Kunstgeschichte,* CVIII). Strassburg, 1909.

Höhn, H. 'Vom Wesen der deutschen Handzeichnung in der ersten Hälfte des XIX. Jahrhunderts (Mit Beispielen aus der Graphischen Sammlung des German. Mus.)', *Die Graphischen Künste,* XLIV (1921).

Justi, L. *Deutsche Zeichenkunst im neunzehnten Jahrhundert. Ein Führer zur Sammlung der Handzeichnungen in der Nationalgalerie (Berlin).* Berlin, 1919.

Justi, L., and Weissgärber, H. *Zeichnungen deutscher Meister vom Klassizismus bis zum Impressionismus (Publikation der Berliner Nationalgalerie).* Berlin, 1954.

Rave, P. O. *Deutsche Bildnerkunst von Schadow bis zur Gegenwart.* Berlin, 1929.

Rümann, A. *Die illustrierten deutschen Bücher des 19. Jahrhunderts (Taschenbibliographien für Büchersammler,* IV). Stuttgart, 1926.

Scheyer, E. *Schlesische Malerei der Biedermeierzeit.* Frankfurt, 1965.

Schmidt, P. F. *Die deutsche Landschaftsmalerei von 1750–1830.* Munich, 1922.

Uhde-Bernays, H. *Münchener Landschafter im 19. Jahrhundert.* Munich, 1921.

Weiss, R. *Das Alpenerlebnis in der deutschen Literatur des 18. Jahrhunderts.* Horgen-Zürich-Leipzig, 1933.

Wolf, G. J. *Die Entdeckung der Münchener Landschaft.* Munich, 1921.

3. *Movements*

Andrews, K. *The Nazarenes. A Brotherhood of German Painters in Rome.* London, 1964.

Benz, R., and Schneider, A. von. *Die Kunst der deutschen Romantik.* Munich, 1939.

Biermann, G. *Deutsches Barock und Rokoko Herausgegeben im Anschluss an die Jahrhundert-Ausstellung deutscher Kunst 1650-1800, Darmstadt, 1914.* Leipzig, 1914.

Boehn, M. von. *Biedermeier: Deutschland von 1815-1847.* Berlin, [1911].

Cecchitelli, C. *La pittura dei Nazareni di Villa Massimo.* Rome, 1968.

Deusch, W. R. *Malerei der deutschen Romantiker und ihrer Zeitgenossen.* Berlin, 1937.

Dörries, B. *Zeichnungen der Frühromantik.* Munich, 1950.

Geller, H. *Die Bildnisse der deutschen Künstler in Rom 1800-1830; mit einer Einführung in die Kunst der Deutschrömer von Herbert von Einem.* Berlin, 1952.

Gerstenberg, K., and Rave, P. O. *Die Wandgemälde der deutschen Romantiker im Casino Massimo zu Rom.* Berlin, 1934.

Hütt, W. 'Die Düsseldorfer Kunst und die demokratische Bewegung in der ersten Hälfte des 19. Jahrhunderts', *Wissenschaftliche Zeitschrift der Martin Luther-Universität Halle-Wittenberg* (March 1958).

Hütt, W. *Die Düsseldorfer Malerschule 1819-1869.* Leipzig, 1964.

Klassizismus und Romantik in Deutschland. Gemälde und Zeichnungen aus der Sammlung Georg Schäfer, Schweinfurt, Ausstellung im German. Nat. Museum Nürnberg. Nuremberg, 1966.

Kaiser, K. *Deutsche Malerei um 1800.* Leipzig, 1959.

Landsberger, F. *Die Kunst der Goethezeit.* Leipzig, 1931.

Robson-Scott, W. *The Literary Background of Gothic Revival in Germany. A Chapter in the History of Taste.* Oxford, 1965.

Scheidig, W. *Die Geschichte der Weimarer Malerschule 1860-1900.* Weimar, 1971.

Schellenberg, E. L. *Das Buch der deutschen Romantik.* 2nd ed. Bamberg, 1943.

Schilling, E. *Deutsche Romantiker-Zeichnungen.* Frankfurt, 1935.

Schmidt, P. F. *Biedermeier-Malerei: Zur Geschichte und Geistigkeit der deutschen Malerei in der ersten Hälfte des neunzehnten Jahrhunderts.* Munich, 1922.

Schneider, A. von. *Deutsche Romantiker-Zeichnungen.* Munich, 1942.

Schrade, H. *Deutsche Maler der Romantik.* Cologne, 1967.

Thielen, P. G. 'Zur Historienmalerei der Bismarkzeit', in *Spiegel der Geschichte (Festschrift Max Braubach).* Münster, 1964.

Weiglin, P. *Berliner Biedermeier: Leben, Kunst und Kultur 1815-1848.* Bielefeld, 1942.

Wichmann, S. *Realismus und Impressionismus in Deutschland.* Stuttgart, 1964.

E. ITALY

Belloni, C. *I pittori di Olevano.* Rome, 1970.

Bellonzi, F. *Il Divisionismo nella pittura italiana.* Milan, 1967.

Bellonzi, F. *La pittura di storia dell'ottocento italiano (Mensili d'arte).* Milan, 1967.

Brizio, A. M. *Ottocento; Novecento (Storia universale dell'arte,* VI). Turin, 1939.

Causa, R. *La scuola di Posillipo (Mensili d'arte,* IV). Milan, 1967.

Cazzullo, M. P. *La scuola toscana dei Macchiaioli.* Florence.

Cecchi, E., and Borgiotti, M. *Macchiaioli toscani d'Europa.* Florence, 1963.

Delogu, G. *Pittura italiana dell'ottocento.* 2nd ed. Bergamo, 1962.

Einaudi, G. *Lettere dei Macchiaioli. A cura di Lamberto Vitali.* Milan, 1953.

Forssman, E. *Venedig in der Kunst und im Kunsturteil des 19. Jahrhunderts (Stockholm Studies in History of Art,* XXII). Stockholm, 1971.

Franchi, A. *I Macchiaioli toscani.* Milan, 1945.

Giardelli, M. *I Macchiaioli e l'epoca loro.* 1958.

Grada, R. de. *I Macchiaioli (Mensili d'arte,* I). Milan, 1967.

Griseri, A. *Il paesaggio nella pittura piemontese dell'ottocento.* Milan, 1967.

Guzzi, V. *Il ritratto nella pittura italiana dell'ottocento.* Milan, 1967.

Köhler, I. *Die Florentiner Macchiaioli: Ihre Würdigung in der zeitgenössischen und neueren Kunstliteratur.* Augsburg, 1956.

Lagagnino, E. *L'arte moderna dai Neoclassici ai Contemporanei (Storia dell'arte classica e italiana,* V). 2 vols. Turin, 1956.

Levey, M. *Painting in Eighteenth-Century Venice.* London, 1959.

Maltese, C. 'Il momento unitario della pittura italiana dell'ottocento', *Bollettino d'Arte* (1954).

Maltese, C. *Realismo e verismo nella pittura italiana dell'ottocento.* Milan, 1967.

Maltese, C. *Storia dell'arte in Italia 1785-1943.* Turin, 1960.

Mazzariol, G., and Pignatti, T. *Storia dell'arte italiana,* III. Milan, 1957.

Naujack, A. *Die Florentiner Macchiaioli. Studien zur*

Malerei und Kunsttheorie im 19. Jahrhundert. Tübingen, 1972.
Ottino della Chiesa, A. *Il Neoclassicismo nella pittura italiana*. Milan, 1967.
Pallucchini, R. *Die venezianische Malerei des 18. Jahrhunderts*. Munich, 1961.
Perocco, G. *La pittura veneta dell'ottocento (Mensili d'arte*, II*)*. Milan, 1967.
Pfister, F. 'La scuola di Posillipo', *Bollettino d'Arte* (1925/6).
Predaval, G. *Pittura lombarda dal Romanticismo alla Scapigliatura (Mensili d'arte*, III*)*. Milan, 1967.
Sapori, F. *Scultura italiana moderna*. Rome, 1949.
Schettini, A., and Scuderi, G. *Aspetti dell'ottocento pittorico italiano*. Putignano, 1972.
Somarè, E. *La pittura italiana dell'ottocento*. Novara, 1944.
Tarchiani, N. *La scultura italiana dell'ottocento (Novissima enciclopedia monografica illustrata)*. Florence, 1936.
Vigezzi, S. *La scultura italiana dell'ottocento*. Milan, 1932.
Waterhouse, E. K. 'Painting in Rome in the Eighteenth Century', *Museum Studies*, VI (1971), 7-71.

F. SCANDINAVIA
Aubert, A. *Die norwegische Malerei im XIX. Jahrhundert*. Leipzig, n.d.
Been, C. A. (ed.). *Danmarks Malerkunst: Billeder og Biografier*. 2 vols. Copenhagen, 1902/3.
Bramsen, H. *Landskabsmaleriet i Danmark 1750-1875: Stilhistriske Hovedtraek*. Copenhagen, 1935.
Cornell, H. *Den Svenska Konsten Historia*. 2 vols. Stockholm, 1944-6.
Dänische Maler von Jens Juel bis zur Gegenwart (Die blauen Bücher). Düsseldorf–Leipzig, 1911.
Durham, A. *Painting in Norway*. Stockholm, 1955.
Gauffin, A. 'Les grandes époques de l'art de Suède', *Gazette des Beaux-Arts* (1929), I.
Hintze, C. *Kopenhagen und die deutsche Malerei um 1800*. Würzburg, 1937.
Lindblom, A. *Sveriges Konsthistoria från Forntid til Nutid*. 3 vols. Stockholm, 1944-6.
Nordensvan, G. *Schwedische Kunst des 19. Jahrhunderts*. Leipzig, 1904.
Nordensvan, G. *Svensk Kunsthistoria*. Stockholm, 1913.
Nordensvan, G. *Svensk Konst och Svenska Konstnärer i 19de Århundradet*, I, II. Stockholm, 1925-8.
Okkonen, O. *Die finnische Kunst*. Berlin, 1943.
Schultz, S. *Dansk Genremaleri (Kunst i Danmark)*. Copenhagen, 1928.
Svensskes Konstnärs Lexikon. 2 vols. Malmö, 1952.
Thorlacius-Ussing, V. *Danmarks Billedhuggerkunst fra Oldtid til Nutid*. Copenhagen, 1950.

Zahle, E., and others. *Danmarks Malerkunst fra Middelalder til Untid*. 3rd ed. Copenhagen, 1947.

G. SPAIN AND PORTUGAL
Bozal, V. *Historia del arte en España. Desde Goya hasta nuestras días*. Madrid, 1973.
Gaya Nuño, J. A. *Arte del siglo 19 (Ars Hispaniae*, XIX*)*. Madrid, 1966.
Lambert, É. *L'art en Espagne et au Portugal (Arts, styles et techniques)*. Paris, n.d.
Lipschutz, J. H. *Spanish Painting and the French Romantics*. Cambridge, Mass., 1972.

H. OTHER COUNTRIES

1. *Czechoslovakia*
Neumann, J. *Die tschechische klassische Malerei des 19. Jahrhunderts*. Prague, 1955.
Štepánek, P. 'La pintura checa del siglo 19', *Goya* (1971/2), 290-5.
Volavka, V. *České malířství a sochařství 19. století (Czechoslovakian Painting and Sculpture of the Nineteenth Century)*. Prague, 1968.

2. *Greece*
Lydakis, S. *Geschichte der griechischen Malerei des 19. Jahrhunderts (Materialien zur Kunst des 19. Jahrhunderts*, VII*)*. Munich, 1972.

3. *Hungary*
Balás-Piry, L. von. *Die ungarische Malerei des XIX. und XX. Jahrhunderts*. Berlin, 1940.
Biró, B. *Magyar müvészeti irodalom (Kepzómüvészeti Alap kiadása)* (Bibliography of Hungarian Art History). Budapest, 1954.
Genthon, I. *Az új magyar festérut története*. Budapest, 1933.
Pógány, G. Ö. P. 'L'héritage des peintres de la grande plaine hongroise', *Acta historiae artium Acad. scient. Hungaricae*, VIII (1962).
Pógány, Ö. G. *Die ungarische Malerei des 19. Jahrhunderts*. Budapest, 1955.

4. *Rumania*
Frunzetti, I. 'Etapele evoluției peisajului in pictura romînească pînă la Grigorescu' ('The Development of Rumanian Landscape Painting to Grigorescu'), *Studii și cercetări de istoria artei*, VIII (1961).
Opresco, G. *La peinture roumaine de 1800 à nos jours*. Fribourg, n.d.

5. *Serbia*
Dwa weka srpskoga slikarstwa (Two Centuries [Eighteenth and Nineteenth] of Serbian Painting). Belgrade, 1943.

439

Kolarić, M. *Klasicizam kod Srba, 1790–1848 (Classicism in Serbia)*. Belgrade, 1965.
Medacović, D. 'Die serbische Kunst des 18. und 19. Jahrhunderts', *Südost-Forschungen*, XXIV (1965), 166–85.
Simic-Konstantinović, L. *Istorijskiportret u sipskom slikarstvu 19 veka (The History Portrait in Serbian Painting of the Nineteenth Century)*. Belgrade, 1972.
Stelè, F. *Slovenski impresionisti*. Ljubljana, 1970.

6. Switzerland

Baud-Bovy, D. *Les maîtres de la gravure suisse*. Geneva, 1935.
Frommer-im Obersteg, L. *Die Entwicklung der schweizerischen Landschaftsmalerei im 18. und frühen 19. Jahrhundert (Basler Studien für Kunstgeschichte, III)*. Basel, 1945.
Hugelshofer, W. *Schweizer Kleinmeister*. Zürich, 1943.
Keller, H. *Winterthurer Kleinmeister 1700–1830. 34 Aquarelle und Zeichnungen*. Winterthur, 1947.
Leemann-van Elck, P. *Die zürcherische Buchillustration von den Anfängen bis um 1850*. Zürich, 1952.
Reinle, A. *Kunstgeschichte der Schweiz (Kunst des 19. Jahrhunderts: Architektur, Malerei, Plastik, IV)*. Frauenfeld, 1962.
Zelger, F. *Heldenstreit und Heldentod. Schweizerische Historienmalerei im 19. Jahrhundert*. Zürich, 1973.

III. INDIVIDUAL ARTISTS

ABBATI
Baldaccini, R. *Giuseppe Abbati: Contributi alla pittura italiana dell'Ottocento*. Florence, 1947.

ACHENBACH, O.
Schmidt, J. H. *Oswald Achenbach*. 2nd. ed. Düsseldorf, 1946.

ADAM
Adam, A. *Aus dem Leben eines Schlachtenmalers: Selbstbiographie nebst einem Anhange*. Stuttgart, 1886.

ALT, R.
Hevesi, L. von. *Rudolf Alt: Sein Leben und sein Werk*. Vienna, 1911.
Koschatzky, W. *Rudolf von Alt*. Salzburg, 1975.
Münz, L. *Rudolf von Alt: 24 Aquarelle (Österreichische Aquarellisten, I)*. Vienna, 1954.
Rudolf von Alt. Aquarelle. Wien, Künstlerhaus, 1963.

ALT, T.
Uhde-Bernays, H. 'Ein vergessener Freund Leibls: Theodor Alt', *Cicerone*, V (1913).

AMERLING
Probszt, G. *Friedrich von Amerling. Der Altmeister der Wiener Porträtmalerei*. Zürich-Leipzig-Vienna, 1927.

D'ANCONA
Cecchi, E. 'Vito d'Ancona', *Bollettino d'Arte* (1926/7).

ANKER
Aeberhardt, Werner Ernst. *Notizen und Skizzen von Albert Anker. Ein Taschenkalenderchen des Malers aus dem Jahre 1895*. Solothurn, 1970.
Huggler, Max. *Albert Anker. Katalog der Gemälde und Ölstudien*. Bern, Kunstmuseum, 1962.
Mandach, C. von. *Albert Anker*. Zürich, 1941.

BARYE
Alexandre, A. *A. L. Barye (Les artistes célèbres)*. Paris, n.d. (1889).
Ballu, R. *L'œuvre de Barye*. Paris, 1890.
Dekay, C. *Barye: Life and Works of Antoine Louis Barye, Sculptor*. New York, 1974.
Hamilton, G. H. 'The Origin of Barye's Tiger Hunt', *The Art Bulletin*, XVIII/2 (1936).
Pivar, S. *The Barye Bronzes*. Woodbridge, 1974.

BAZILLE
Daulte, F. *Frédéric Bazille et son temps*. Geneva, 1952.

BISSEN
Frandsen, J. W., and Christensen, C. H. W. *Bissen. Tegniger og modellerede skitser*. Copenhagen, 1972.
Rostrup, H. *H. W. Bissen (I. II) (Kunstforeningen i Köbenhavn)*. Copenhagen.

BLECHEN
Deutscher Verein für Kunstwissenschaft (ed.). *Karl Blechen: Leben. Würdigungen. Werk (Denkmäler deutscher Kunst)*. Berlin, 1940.
Heider, G. *Carl Blechen*. Leipzig, n.d.
Karl Blechen (1798–1840). Exhibition. Berlin, 1973.
Scurla, H., and Ruthenberg, V. *Der Maler Karl Blechen, 1798–1840 (Veröffentlichungen des Museums Cottbus, 1)*. Cottbus, 1963.
Strauss, G. 'Über den Realismus bei Karl Blechen', *Anschauung und Deutung (Festschrift Willy Kurth)*. Berlin, 1964.

BÖCKLIN
Andree, R. *Arnold Böcklin. Beiträge zur Analyse seiner Bildgestaltung* (Dissertation, Freie Universität, Berlin, 1960). Düsseldorf, 1962.
Arnold Böcklin, 1827–1901. Exhibition. London, 1971.
Dollinger, H. (ed.). *Böcklin*. Munich, 1975.

Heise, C. G. 'Arnold Böcklin (1857–1901)', *Der gegenwärtige Ausblick*. Berlin, 1960.

Meier-Graefe, J. *Der Fall Böcklin und die Lehre von den Einheiteu*. Stuttgart, 1911.

Schmid, H. A. *Arnold Böcklin. Eine Auswahl der hervorragendsten Werke des Künstlers*. 4 vols. Munich, 1892–1901.

Schmid, H. A. *Arnold Böcklin*. 2nd ed. Munich, 1922.

Wissmann, J. *Arnold Böcklin und das Nachleben seiner Malerei*. Münster, 1968.

BOILLY

Marmottan, P. *Le peintre Louis Boilly (1761–1845)*. Paris, 1913.

BONHEUR

Klumpke, A. *Rosa Bonheur, sa vie et son œuvre*. Paris, 1908.

BONINGTON

Fry, R. 'Bonington and French Art', *Burlington Magazine* (1927), II.

Shirley, A. *Bonington*. London, 1940.

BOSBOOM

Marius, G. H., and Martin, W. *Johannes Bosboom*. The Hague, 1907.

BOUDIN

Cahen, G. *Eugène Boudin, sa vie et son œuvre*. Paris, 1900.

Cario, L. *Eugène Boudin (Maîtres de l'art moderne)*. Paris, 1928.

Jean-Aubry, G. *Eugène Boudin. La vie et l'œuvre d'après les lettres et documents inédits*. Avec la collaboration de Robert Schmitt. Neuchâtel, Paris, 1968.

Schmitt, R. *Eugène Boudin, 1824–1898*. 3 vols. Paris, 1973.

BRACQUEMOND

Bracquemond, F. *Du dessin et de la couleur*. Paris, 1885.

BRAEKELEER

Album gewijd aan Henri de Braekeleer en zijn werk. Catalogue. Antwerp, 1956.

Haesaerts, P. *Henri de Braekeleer*. Brussels, 1943.

BUCHSER

Wälchli, G. *Frank Buchser: Persönlichkeit, Leben, Kunst (Schweizer Heimatbücher, LXXVII–LXXVIII)*. Bern, 1956.

BUSCH

Behrens, R., and Bohne, F. *Wilhelm Busch. Zauber des Unvollendeten. Das unbekannte malerische Werk*. Stuttgart, 1963.

Bohne, F. '*Was ich ergötzlich fand*'. *Das unbekannte zeichnerische Werk von Wilhelm Busch*. Munich, 1961.

Bohne, F. *Wilhelm Busch: Leben – Werk – Schicksal*. Zürich–Stuttgart, 1958.

Kraus, J. *Wilhelm Busch in Selbstzeugnissen und Bilddokumenten*. Hamburg, 1970.

Nöldeke, O. (ed.). *Wilhelm Busch, Sämtliche Werke*. 8 vols. Munich, 1943.

Novotny, F. *Wilhelm Busch als Zeichner und Maler*. Vienna, 1949.

Teichmann, W. (ed.). *Wilhelm Busch. Werke*. 3 vols. 2: *Eins – zwei – drei im Sauseschritt*. Berlin, 1972.

Vanselow, A. *Die Erstdrucke und Erstausgaben der Werke von Wilhelm Busch*. Leipzig, 1913.

Wilhelm Busch. Sämtliche Werke und eine Auswahl der Skizzen und Gemälde, I. Gütersloh, 1962.

CALAME

Calabi, A., and Schreiber-Favre, A. 'Les eaux-fortes et les lithographies d'Alexandre Calame', *Die Graphischen Künste*, N.F. II (1937).

Rambert, E. *Alexandre Calame: Sa vie et son œuvre d'après les sources originales*. Paris, 1884.

Schreiber-Favre, A. *La lithographie artistique en Suisse au XIX s. Alexandre Calame. Le paysage*. Neuchâtel, 1966.

CANOVA

Argan, G. C. *Antonio Canova*. Rome, 1969.

Bassi, E. *Antonio Canova a Possagno. Catalogo delle opere, guida alla visita della gipsoteca, casa e tempio*. Treviso, 1972.

Malamani, V. *Canova*. Milan, n.d. (1911).

Mostra Canoviana. Catalogue of the exhibition at Treviso; text by Luigi Coletti. Treviso, 1957.

Studi Canoviani. 1. *Le fonti*. 2. *Canova e Venezia (Quaderni sul classico)*. Rome, 1973.

CARPEAUX

Clémen-Carpeaux, L. *La vérité sur l'œuvre et la vie de J.-B. Carpeaux*. Paris, 1934/5.

Jouvenet, N. *Jean Baptiste Carpeaux: 1827–1875*. Valenciennes, 1974.

CARRIÈRE

Morice, C. *Eugène Carrière. L'homme et sa pensée – L'artist et son œuvre, etc.* Paris, 1906.

CARSTENS

Fernow, K. L. *Leben des Künstlers Asmus Jacob Carstens, ein Beitrag zur Kunstgeschichte des 18. Jahr-*

hunderts. Leipzig, 1806. New ed. entitled *Carstens, Leben und Werke*, by Herman Riegel, Hanover, 1867.

Kamphausen, A. *Asmus Jakob Carstens (Studien z. Schleswig-Holsteinschen Kunstgeschichte,* v*)*. Neumünster i. Holstein, 1941.

CARUS

Berglar, P. 'Carl Gustav Carus', *Jahrbuch des Wiener Goethe-Vereins*, LXVII (1963).

Carus, C. G. *Neun Briefe über Landschaftsmalerei*. Leipzig, 1831. New ed. by K. Gerstenberg, 2nd ed., Dresden, 1955.

Carus, C. G. *Zwölf Briefe über das Erdleben*. Stuttgart, 1841. New ed. by C. Bernouilli and H. Kern, Celle, 1926.

Goldschmidt, W. *Die Landschaftsbriefe des Carl Gustav Carus, ihre Bedeutung für die Theorie der romantischen Landschaftsmalerei*. Breslau, 1935.

Jansen, E. (ed.). *Carl Gustav Carus (1798-1840). Lebenserinnerungen und Denkwürdigkeiten*. Weimar, 1966.

Kaiser, K. *Carl Gustav Carus und die zeitgenössische Landschaftsmalerei. Gemälde aus der Sammlung Georg Schäfer*. Schweinfurt, 1970.

Kulm, D. (ed.). *Carus, C. G., Goethe, J. W. von. Briefe über Landschaftsmalerei. Zuvor ein Brief von Goethe als Einleitung*. Heidelberg, 1972.

Prause, M. *Carl Gustav Carus*. Berlin, 1968.

CÉZANNE

Andersen, W. *Cézanne's Portrait Drawings*. Cambridge, Mass., and London, 1970.

Badt, K. *Das Spätwerk Cézannes*. Konstanz, 1971.

Badt, K. *The Art of Cézanne*. Berkeley, Calif., and London, 1965.

Cézanne, Paul. Briefe. Zürich, 1962.

Franz, H. G. 'Cézanne und die Abkehr vom Impressionismus', in *Forschungen und Fortschritte*, 30. Jhg. (1956), Heft II/III.

Fry, R. *Cézanne. A Study of his Development*. London, 1927.

Mack, G. *Paul Cézanne*. New York, 1935.

Novotny, F. *Cézanne und das Ende der wissenschaftlichen Perspektive*. Vienna, 1938.

Rewald, J. *Cézanne et Zola*. Paris, 1936.

Rewald, J. (ed.). *Cézanne, Correspondance*. Paris, 1937.

Rewald, J. *Paul Cézanne, a Biography*. New York, 1968.

Schapiro, M. *Paul Cézanne*. New York, 1952.

Venturi, L. *Cézanne, son art, son œuvre*. 2 vols. Paris, 1936.

Wechsler, J. *Cézanne in Perspective*. Englewood Cliffs, N.J., 1974.

CHARLET

Dayot, A. *Charlet et son œuvre*. Paris, 1893.

De Lacombe, J. F. Le B. *Charlet, sa vie, ses lettres etc.* Paris, 1856.

CHASSÉRIAU

Bénédite, L. *Théodore Chassériau, sa vie et son œuvre*. 2 vols. Paris, 1931.

Sandoz, M. *Théodore Chassériau: 1819-1856, catalogue raisonné des peintures et estampes*. Paris, 1974.

CHODOWIECKI

Engelmann, W. *Daniel Chodowieckis sämtliche Kupferstiche*. Leipzig, 1857.

Engelmann, W. *Nachträge und Berichtigungen*. 2nd ed. Leipzig, 1906.

Journal gehalten auf einer Kunstreyse von Berlin nach Dresden, Halle, Dessau Anno 1789. Introduction by A. Wiecek. Berlin, 1961.

Lichtenberg, G. C., and Branitzer, C. *Handlungen des Lebens. Erklärungen zu 72 Monatskupfern von Daniel Chodowiecki*. Stuttgart, 1971.

Oettingen, W. von. *Daniel Chodowiecki: Ein Berliner Künstlerleben im achtzehnten Jahrhundert*. Berlin, 1895.

Sommer, J. (ed.). *Der Fortgang der Tugend und des Lasters. Daniel Chodowieckis Monatskupfer zum Göttinger Taschenkalender mit Erklärungen Georg Christoph Lichtenbergers 1778-1783*. Berlin, 1974.

CORNELIUS

Einem, H. von. 'Peter Cornelius', *Wallraf-Richartz-Jahrbuch*, XVI (1954).

Kordt, W. 'Die ehemaligen Kuppelbilder im Neusser Münster', *Neusser Jahrbuch für Kunst, Kulturgeschichte und Heimat-Kunde*, IX (1964).

Kuhn, A. *Peter Cornelius und die geistigen Strömungen seiner Zeit*. Berlin, 1921.

COROT

Alpatov, M. 'Corot à Venise (Un tableau du Musée Poushkine à Moscou)', *Art de France* (1961).

Bazin, G. *Corot*. Paris, n.d.

Delteil, L. *Corot (Le peintre-graveur illustré*, v*)*. Paris, 1910.

Figures de Corot. Paris, Musée du Louvre, 1962.

Leymarie, J. *Corot*. Geneva, 1966.

Meier-Graefe, J. *Corot*. Berlin, 1930.

Robaut, A., and Moreau-Nélaton, E. *L'œuvre de Corot. Catalogue raisonné et illustré, précédé de l'histoire de Corot et de son œuvre*. 4 vols. Paris, 1904-6. New ed. Berlin, 1965-6.

Saint-Michel, L. *Corot und seine Welt*. Paris, 1974.

Schoeller, A., and Dieterle, J. *Corot.* Paris, 1948.
Supplement to Moreau-Nélaton's *œuvre* catalogue.

COSTA
Cecchi, E. 'Nino Costa', *Dedalo*, II (1922).

COURBET
Berger, K. 'Courbet in his Century', *Gazette des Beaux-Arts* (1943), II.
Boas, G. *Courbet and the Naturalistic Movement.* Baltimore, 1938.
Clark, T. J. *Image of the People, Gustave Courbet and the 1848 Revolution.* London, 1973.
Durbé, D. *Courbet und der französische Realismus.* Munich, 1974.
Léger, C. *Courbet.* Paris, 1929.
Lindsay, J. *Gustave Courbet: His Life and Art.* Bath, London, 1973.
Meier-Graefe, J. *Courbet.* Munich, 1921.
Mack, G. *Gustave Courbet.* London, 1951.
Mac Orlan, P. *Courbet (Les demi-dieux).* Paris, 1951.
Schapiro, M. 'Courbet and Popular Imagery. An Essay on Realism and Naiveté', *Journey of the Warburg & Courtauld Institutes*, IV (1940-1).
Schug, A. *Gustave Courbet.* Hamburg, Berlin, 1967.

COUTURE
Couture, T. *Méthodes et entretiens d'atelier.* Paris, 1868. English translation, *Conversations on Art Methods*, New York, 1879.
Seznec, J. J. 'The "Romans of the Décadence" and their Historical Significance', *Gazette des Beaux-Arts* (1943), II.

DAFFINGER
Grünstein, L. *Moritz Michael Daffinger und sein Kreis.* Vienna, 1923.

DAHL
Aubert, A. *Professor Dahl.* Kristiania, 1893.
Aubert, A. *Den nordiske Naturfölelse og Professor Dahl.* Kristiania, 1894.
J. C. Dahl og Danmark. Exhibition. Copenhagen and Oslo, 1973.
Johannesen, O. R. *J. C. Dahl.* Oslo, 1965.

DALOU
Dreyfous, M. *Dalou, sa vie et son œuvre.* Paris, 1903.

DANHAUSER
Poch-Kalous, M. 'Josef Danhausers Reiseskizzenbuch in der Albertina: Deutschland, Holland, Belgien', *Albertina-Studien*, IV (1966).
Roessler, A. *Josef Danhauser.* 2nd ed. Vienna, 1946.

DANNECKER
Spemann, A. *Dannecker.* Stuttgart, 1909.

DANTAN
Seligman, J. *Figures of Fun. The Caricature-Statuettes of Jean-Pierre Dantan.* London, 1957.

DAUBIGNY, C.
Bourges, L. *Daubigny: Souvenirs et croquis.* Paris, 1900.
Delteil, L. *Charles Daubigny (Le peintre-graveur illustré*, XIII*).* Paris, 1921.
Henriet, F. *C. Daubigny et son œuvre gravé.* Paris, 1875.

DAUMIER
Adhémar, J. *Honoré Daumier.* Paris, 1954.
Alexandre, A. *Honoré Daumier, l'homme et l'œuvre.* Paris, 1888.
Bouvy, E. *Daumier: L'œuvre gravé du maître.* 2 vols. Paris, 1933.
Cooper, D., and Maison, K.-E. *Honoré Daumier. Catalogue raisonné of the Paintings, Watercolours and Drawings.* London and New York, 1968.
Daumier und die ungelösten Probleme d. bürgerlichen Gesellschaft. Exhibition. Berlin, 1974.
Delteil, L., and Hazard, N. A. *Honoré Daumier (Le peintre-graveur illustré*, XXI-XXIX*).* Paris, 1925-6.
Escholier, R. *Daumier et son monde.* Paris, 1965.
Fuchs, E. *Der Maler Daumier.* 2nd ed. Munich, 1930.
Fuchs, E. *Nachtrag zu 'Der Maler Daumier'.* Munich, 1930.
Fuchs, E. *Honoré Daumier: Holzschnitte: 1833-1870.* Munich, n.d.
Fuchs, E. *Honoré Daumier, Lithographien: 1828-1851; 1852-1860; 1861-1872.* 3 vols. Munich, n.d.
Gobin, M. *Daumier sculpteur.* Geneva, 1953.
Hofmann, W. 'Zu Daumiers graphischer Gestaltungsweise', *Jahrbuch der Kunsthistorischen Sammlungen in Wien*, LII (1956).
Klossowski, E. *Honoré Daumier.* 2nd ed. Munich, 1923.
Maison, K. E. 'Daumier Studies, I: Preparatory Drawings; II: Various types of alleged Daumier Drawing; III: Daumier Studies', *Burlington Magazine*, XCVI (1954).
Maison, K. E. 'Further Daumier Studies, I: The Tracings; II: Preparatory Drawings for Paintings', *Burlington Magazine*, XCVIII (1956).
Maison, K. E. *Honoré Daumier. Catalogue Raisonné of the Paintings, Watercolours and Drawings.* London, 1967.
Mendel, G., and Georgel, P. *Tout l'œuvre peint de Daumier.* Paris, 1972.

Rey, R. *Honoré Daumier.* London, 1966.
Roy, C. *Étude biographique et critique. Daumier.* Geneva and Paris, 1971.
Rümann, A. *Honoré Daumier, sein Holzschnittwerk.* Munich, 1914.
Rümann, A. *Honoré Daumier.* Berlin, 1926.
Wassermann, J. L. *Daumier Sculpture, a Critical and Comparative Study.* Greenwich, Conn., 1969.

DAVID
Adhémar, J., and Cassou, J. *David, naissance du génie d'un peintre.* Paris, 1953.
Berger, K. 'David and the Development of Géricault's Art (The Beginnings of Modern Art)', *Gazette des Beaux-Arts* (1946), II.
Cantinelli, R. *Jacques-Louis David, 1748-1825.* Paris, 1930.
Dowd, D. L. 'Art and the Theatre during the French Revolution: The Role of Louis David', *The Art Quarterly*, XXIII (1960).
Dowd, D. L. *Pageant-Master of the Republic: Jacques-Louis David and the French Revolution.* Lincoln, Nebraska, 1948.
González-Palacios, A. *David e la pittura napoleonica.* Milan, 1967.
Hautecoeur, L. *Louis David.* Paris, 1954.
Maurois, A. *J.-L. David (Les demi-dieux).* Paris, 1948.
Pach, W. 'The Heritage of J.-L. David', *Gazette des Beaux-Arts* (1955), I.
Wildenstein, D. and G. *Documents complémentaires au catalogue de l'œuvre de Louis David.* Paris, 1973.
Wilhelm, J. 'David et ses portraits', *Art de France*, IV (1964).

DAVID D'ANGERS
Jouin, H. *David d'Angers, sa vie, son œuvre, ses écrits et ses contemporains.* 2 vols. Paris, 1878.
Schazmann, P. E. *David d'Angers: profils de l'Europe.* Geneva, 1973.

DECAMPS
Bundorf Canizares, M. *L'œuvre d'Alexandre Gabriel Decamps (1803-1860).* Paris, 1968.
Clément, C. *Decamps (Les artistes célèbres).* Paris, n.d.
Moreau, A. *Decamps et son œuvre.* Paris, 1869.

DEFREGGER
Hammer, H. *Franz von Defregger.* Innsbruck, 1940.

DEGAS
Adhémar, J., Cachin, F., and Rewald, J. *Degas: The Complete Etchings, Lithographs and Monotypes.* New York, 1974.
Browse, L. *Degas Dancers.* London, 1949.

Cabanne, P. *Edgar Degas.* Paris, 1957.
Cooper, D. *Pastels by Edgar Degas.* New York, 1954. German ed. entitled *Pastelle von Edgar Degas,* Basel, 1952.
Guérin, M. (ed.). *Degas Letters.* Oxford, 1947.
Janis, E. P. 'The Role of the Monotype in the Working Method of Degas', *Burlington Magazine,* CIX (1967).
Lemoisne, P. A. *Degas et son œuvre.* 4 vols. Paris, 1946.
Meier-Graefe, J. *Degas, ein Beitrag zur Entwicklungsgeschichte der modernen Malerei.* Munich, 1920.
Minervino, F., and Lassaigne, J. *Tout l'œuvre peint de Degas.* Paris, 1974.
Rewald, J. *Degas. Works in Sculpture.* New York, 1944.
Rewald, J., and von Matt, L. *Degas Sculpture. The Complete Works.* London, 1957.
Rich, D. C. *Edgar-Hilaire-Germain Degas.* New York, 1951.
Werner, A. *Degas Pastels.* New York, 1968.

DELACROIX
Badt, K. *Eugène Delacroix: Drawings.* Oxford, 1946.
Badt, K. *Eugène Delacroix, Werke und Ideale.* Cologne, 1965.
Baudelaire, C. *Delacroix, his Life and Work.* New York.
Busch, G. *Eugène Delacroix. Der Tod der Valentin.* Frankfurt, 1973.
Cassou, J. *Delacroix (Les demi-dieux).* Paris, 1947.
Delacroix, E. *Œuvres littéraires:* I. *Études esthétiques;* II. *Essais sur les artistes célèbres.* Paris, 1923.
Delteil, L. *Eugène Delacroix (Le peintre-graveur illustré,* III). Paris, 1906.
Escholier, R. *Delacroix: Peintre, graveur, écrivain (La vie et l'art romantique).* 3 vols. Paris, 1926-9.
Fischer, U. *Das literarische Bild im Werk Eugène Delacroix (Ein Beitrag zur Ikonographie des 19. Jahrhunderts).* Text and notes. (Dissertation, Bonn, 1961.) Bonn, 1963.
Guiffrey, J. *Le Voyage d'Eugène Delacroix au Maroc.* Paris, 1909.
Hautecoeur, L. 'Delacroix et l'Académie des Beaux-Arts', *Gazette des Beaux-Arts,* 6th per., LXII (1963).
Huyghe, R. *Delacroix ou le combat solitaire.* London, 1963, Paris, 1964, Munich, 1967.
Joubin, A. (ed.). *Correspondance générale d'Eugène Delacroix.* 5 vols. Paris, 1935-8.
Jullian, P. 'Delacroix et le thème de Sardanapale', *Connaissance des Arts* (April 1963).
Jullian, R. 'Delacroix et Baudelaire', *Gazette des Beaux-Arts* (1953), II.
Meier-Graefe, J. *Eugène Delacroix: Beiträge zu einer Analyse.* Munich, n.d.

Robaut, A. *Eugène Delacroix: Facsimilés de dessins et de croquis.* Paris, 1864.

Robaut, A. *L'œuvre complet d'Eugène Delacroix* (with commentary by E. Chesnau). Paris, 1885.

Rossi Bortolatti, L. *L'opera pittorica completa di Delacroix.* Milan, 1972.

Sérullaz, M. *Les peintures murales de Delacroix.* Paris, 1963.

Wellington, H. (ed.). *The Journal of Delacroix. A Selection.* London, 1951.

DIAZ

Hediard, G. *Diaz (Les maîtres de la lithographie).* Châteaudun, n.d.

DILLIS

Lessing, W. *Johann Georg Dillis als Künstler und Museumsmann, 1759-1841.* Munich, 1951.

DORÉ

De Maré, E. *The London Doré Saw: a Victorian Evocation.* London, 1973.

Farner, K. *Gustave Doré, der industrialisierte Romantiker.* Dresden, 1963.

Hartlaub, G. F. *Gustave Doré (Meister der Graphik, XII).* Leipzig, n.d.

Leblanc, H. *Catalogue de l'œuvre complet Gustave Doré.* Paris, 1931.

Pipes, R. (introd.). *The Rare and Extraordinary History of Holy Russia, with over 500 illustrations* (transl. from the French). New York, 1971.

Rose, M. *Gustave Doré.* London, 1946.

Rümann, A. *Gustave Doré: Bibliographie der Erstausgaben.* Munich, 1921.

Stevens, J. *A Doré Treasury; a Collection of the Best Engravings of Gustave Doré.* New York, 1970.

DREBER

Schöne, R. *Heinrich Dreber (Forschungen z. deutschen Kunstgeschichte, XXIV).* Berlin, 1940.

DUPRÉ

Aubrun, M. M. *Jules Dupré, 1811-1889. Catalogue raisonné de l'œuvre peint, dessiné et gravé.* Paris, 1974.

Hediard, G. *Jules Dupré (Les maîtres de la lithographie).* Châteaudun, n.d.

ENDER

Almeida Prado, J. F. de. *Tomas Ender. Pintor austriaco na côrte de D. João VI no Rio de Janeiro.* São Paulo, 1955.

Ferrez, G., and Freiberg, S. *O Velho Rio de Janeiro, através das gravuras de Thomas Ender.* São Paulo, 1957.

ERHARD

Apell, A. *Das Werk von Johann Christoph Erhard, Maler und Radirer.* Dresden, 1866.

FANTIN-LATOUR

Bénédite, L. *Fantin-Latour.* Paris, 1903.

Fantin-Latour. Catalogue complet de l'œuvre de Fantin-Latour. Amsterdam, Israel, New York, 1969.

Fantin-Latour, Madame V. *Catalogue de l'œuvre complet (1849-1904) de Fantin-Latour.* Paris, 1911.

FATTORI

Bianciardi, L., and Della Chiesa, B. *L'opera completa di Fattori.* Milan, 1970.

Disegni di Giovanni Fattori, Galleria nazionale d'arte moderna, Roma, Villa Giulia. Rome, 1970.

Malesci, G. *Catalogazione illustrata della pittura a olio di Giovanni Fattori.* Novara, 1961.

Micheli, M. de. *Giovanni Fattori (I grandi pittori italiani dell'ottocento, IV).* Busto Arsizio, 1961.

Ojetti, U. 'Ritratti dipinti da Giovani Fattori', *Dedalo,* VI (1925-6).

Servolini, L. *177 aqueforti di Giovanni Fattori.* Milan, 1966.

Wilt, A. de. 'Giovanni Fattori acquafortista', *Bollettino d'Arte* (1931).

FAVRETTO

Somaré, E. *Giacomo Favretto.* Milan, n.d.

FEARNLEY

Willoch, S. *Maleren Thomas Fearnley.* Oslo, 1932.

FENDI

Adolph, H. *Peter Fendi.* Dissertation. Vienna, 1951.

Peter Fendi. Exhibition. Vienna, Oberes Belvedere, 1963.

FERNKORN

Aurenhammer, H. *Anton Dominik Fernkorn.* Vienna, 1959.

FEUERBACH

Allgeyer, J. *Anselm Feuerbach.* 2 vols. Berlin-Stuttgart, 1904.

Arndt, M. *Die Zeichnungen Anselm Feuerbachs. Studien zur Bildentwicklung.* Bonn, 1967.

Feuerbach, H. (ed.). *Ein Vermächtnis von Anselm Feuerbach.* Munich, 1926.

Uhde-Bernays, H. *Feuerbach: Beschreibender Katalog seiner sämtlichen Gemälde (Klassiker der Kunst, XXII).* Munich, 1929.

FOHR

Dieffenbach, P. *Das Leben des Malers Karl Fohr,* 1823;

new ed. by R. Schrey and P. F. Schmidt, Frankfurt, 1918.
Fohr, C. P. *Skizzenbuch*. With introduction and catalogue by A. von Schneider. Berlin, 1952.
Jensen, J. C. *Carl Philipp Fohr in Heidelberg und im Neckartal. Landschaften und Bildnisse*. Karlsruhe, 1968.

FRIEDRICH
Aubert, A. *Caspar David Friedrich: 'Gott, Freiheit, Vaterland'*. Berlin, 1915.
Börsch-Supan, H., and Jähnig, K. W. *Caspar David Friedrich*. Munich, 1973.
Eimer, G. 'Caspar David Friedrich und die Gotik', *Baltische Studien*, N.F. XLIX (1962/3).
Einem, H. von. *Caspar David Friedrich*. Berlin, n.d. [*c.* 1940].
Emmerich, I. *Caspar David Friedrich (1774-1840)*. Weimar, 1964.
Friedrich, C. D. *Skizzenbuch aus den Jahren 1806 und 1818*. Introduction by L. Grote. Berlin, 1942.
Geismeier, W. *Caspar David Friedrich*. Vienna and Munich, 1973.
Hinz, S. (ed.). *C. D. Friedrich in Briefen und Bekenntnissen*. 2nd ed. Munich, 1974.
Hofmann, W. *C. D. Friedrich 1774-1840. Hamburger Kunsthalle*. Exhibition. Munich, 1974.
Hofstätter, H. H. *C. D. Friedrich. Das gesamte graphische Werk*. Munich, 1974.
Jensen, J. C. *C. D. Friedrich. Leben und Werk*. Cologne, 1974.
Sumowsky, W. *Caspar David Friedrich-Studien*. Wiesbaden, 1969.
Wolfradt, W. *Caspar David Friedrich und die Landschaft der Romantik*. Berlin, 1924.

FROMENTIN
Fromentin, E. *Les maîtres d'autrefois*. Paris, 1876.
Fromentin, le peintre et l'écrivain, 1820-76. Exhibition. La Rochelle, 1970.
Gonse, L. *Eugène Fromentin, peintre et écrivain*. Paris, 1881.
Schapiro, M. 'Fromentin as a Critic', *Partisan Review* (1949), I, 25.

FÜGER
Bourgoing, J. de. *Miniaturen von Heinrich Füger und anderen Meistern aus der Sammlung Bourgoing*. Zürich-Leipzig-Vienna, 1925.
Stix, A. *H. F. Füger*. Vienna-Leipzig, 1925.

FÜHRICH
Führich, J. R. von. 'Selbstbiographie', *Libussa* (1844).
Führich, J. R. von. *Von der Kunst*. Vienna, 1866.
Wörndle, H. von. *Josef Führich's Werke*. Vienna, 1914.

FUSELI (FÜSSLI)
Schiff, G., and Hofmann, W. *Henry Fuseli, 1741-1825*. Exhibition. London, Tate Gallery, 1975.

GAUERMANN
Feuchtmüller, R. *Friedrich Gauermann, 1807-1862. Der Tier- und Landschaftsmaler des österreichischen Biedermeier*. Vienna, 1962.
Krauland, E. *Das Werk Friedrich Gauermanns unter besonderer Berücksichtigung seiner Studien und Skizzen*. Dissertation. Vienna, 1952.

GAVARNI
Armelhaut, J., and Bocher, E. *L'œuvre de Gavarni, lithographies originales et essais d'eau-forte. Catalogue raisonné*. Paris, 1873.
Goncourt, J. and E. de. *Gavarni, l'homme et l'œuvre*. Paris, 1873.
Pilz, G. (ed.). *Paul Gavarni*. Munich, 1971.

GENELLI, B.
Christoffel, U. (ed.). *Aus dem Leben eines Künstlers. Originalzeichnungen im Kupferstichkabinett des Leipziger Museums*. Berlin, 1922.
Ebert, H. 'Über Bonaventura Genellis Umrisszeichnungen zu Dantes Göttlicher Komödie im Dresdner Kupferstichkabinett', *Staatliche Kunstsammlungen Dresden. Jahrbuch* (1961/2).
Marshall, H. *Bonaventura Genelli*. Leipzig, 1912.

GÉRARD
Gérard, H. *Œuvre du Baron F. Gérard*. 2nd ed. Paris, 1852-7.

GÉRICAULT
Aimé-Azam, D. *La passion de Géricault*. Paris, 1970.
Aimé-Azam, D. *Mazeppa: Géricault et son temps*. Paris, 1956.
Antal, F. 'Géricault: Reflections on Classicism and Romanticism', *Burlington Magazine*, LXXVII-LXXVIII (1940-1).
Berger, K. 'David and the Development of Géricault's Art', *Gazette des Beaux-Arts* (1946), II.
Berger, K. *Géricault: Drawings and Watercolours*. New York, 1946.
Berger, K. *Géricault und sein Werk*. Vienna, 1952.
Busch, G. 'Kopien von Théodore Gericault nach alten Meistern', *Pantheon*, XXV (1967).
Clément, C. *Géricault: Étude biographique et critique avec le catalogue raisonné de l'œuvre du maître*. Paris, 1867.
Delteil, L. *Théodore Géricault (Le peintre-graveur illustré*, XVIII). Paris, 1924.
Lem, F.-H. 'Géricault portraitiste', *L'Arte*, LXII (1963).

447

Miller, M. 'Géricault's Paintings of the Insane', *Journal of the Warburg and Courtauld Institutes*, IV (1940–1).

Schmoll, gen. Eisenwerth, J. A. 'Géricault sculpteur', *Bulletin de la Société de l'histoire de l'art français* (1973), 319–31.

GESSNER

Leeman-Van Elck, P. *Salomon Gessner: Sein Lebensbild mit beschreibenden Verzeichnissen seiner literarischen und künstlerischen Werke (Monographien z. Schweizer Kunst, VI)*. Zürich–Leipzig, 1930.

Wölfflin, H. *Salomon Gessner. Mit ungedruckten Briefen*. Frauenfeld, 1889.

GIGANTE

Ortolani, S. *Giacinto Gigante e la pittura di paesaggio a Napoli e in Italia dal '600 al '800*. Naples, 1970.

GIRODET-TRIOSON

Adhémar, J. 'L'enseignement académique en 1820: Girodet et son atelier', *Bulletin de la Société de l'Histoire de l'Art Français* (1933).

Levitine, G. 'L'Ossian de Girodet et l'actualité politique sous le consulat', *Gazette des Beaux-Arts* (1956), II.

GLEYRE

Clément, C. *Gleyre: Étude biographique et critique avec catalogue raisonné*. Paris, 1886.

GOETHE

Corpus der Goethezeichnungen. Leipzig, 1963 ff.

Femmel, G. (ed.). *Corpus der Goethezeichnungen, III: Italienische Reise 1786–88*. Leipzig, 1965.

Femmel, G. (ed.). *Corpus der Goethezeichnungen, V*. Leipzig, 1967.

Münz, L. *Goethes Zeichnungen und Radierungen*. Vienna, 1949.

Wahl, H. *Goethe als Zeichner der deutschen Landschaft 1776–1786*. 2nd ed. Erfurt, 1961.

GOYA

Achiardi, P. d'. *Les dessins de D. Francisco Goya y Lucientes au Musée du Prado à Madrid*. 3 vols. Rome, 1908.

Adhémar, J. *Goya*. London–Paris, 1948.

Delteil, L. *Francisco de Goya (Le peintre-graveur illustré, XIV)*. Paris, 1922.

Desparmet Fitz-Gerald, X. *L'œuvre peint de Goya*. 4 vols. Paris, 1928–50.

Gantner, J. *Goya. Der Künstler und seine Welt*. Berlin, 1974.

Gassier, P., and Wilson, J. *Goya, His Life and Work*, *with a Catalogue raisonné of his Paintings, Drawings and Engravings*. London, Fribourg, Paris, 1971.

Gassier, P. (ed.). *Goya. Die Skizzenbücher*. Frankfurt, 1973.

Goya Exhibition. Catalogue. Paris, 1935.

Gudiol, J. *Goya*. (Spanish, English, French.) 4 vols. Barcelona, 1969.

Harris, E. *Goya*. London, 1969.

Harris, T. *Goya. Engravings and Lithographs*. I: text and illustrations. II: catalogue raisonné. Oxford, 1964.

Held, J. *Farbe und Licht in Goyas Malerei*. Berlin, 1964.

Held, J. 'Francisco de Goya. Literatur von 1940–1962', *Zeitschrift für Kunstgeschichte*, XXVIII (1965).

Hetzer, T. 'Francisco Goya und die Krise der Kunst um 1800', *Wiener Jahrbuch für Kunstgeschichte*, XIV (1950).

Hofmann, J. *Francisco de Goya: Katalog seines graphischen Werkes*. Vienna, 1907.

Klingender, F. D. *Goya in the Democratic Tradition*. London, 1948; German ed., Berlin, 1954.

Lafuente Ferrari, E. *Goya*. Madrid, 1947.

Lafuente Ferrari, E. *Goya, Complete Etchings, Aquatints and Lithographs*. London, 1962.

Lafuente Ferrari, E., and Stolz, R. *The Frescoes in San Antonio de la Florida*. Geneva, 1955.

Loga, V. von. *Francisco de Goya*. Berlin, 1903.

López-Rey, J. *Goya's Caprichos: Beauty, Reason and Caricature*. 2 vols. Princeton, 1953.

Mayer, A. L. *Goya*. Munich, 1923.

Sanchez Canton, F. J. *The Life and Works of Goya*. Madrid, 1964.

GRAFF

Berckenhagen, E. *Anton Graff*. Berlin, 1967.

Waser, O. *Anton Graff von Winterthur*. Zürich, 1903.

GRANDVILLE

Adhémar, J. 'Grandville le maudit', *Bizarre* (special number for the 150th anniversary of Grandville's birth). Paris, 1953.

Appelbaum, S. *Bizarreries and Fantasies of Grandville*. New York, 1974.

Grandville. Gesamtwerk. 2 vols. Frankfurt, 1970.

Münz, L. 'Über die Bildsprache von Jean Ignace Isidore Gérard, dit Grandville (1803–1847)', *Alte und neue Kunst*, III (1954).

GRIGORESCU

Jianu, J. *Grigorescu*. Bucharest, n.d.

Oprescu, G. *Nicolae Grigorescu*. Bucharest, 1971.

Popescu, M. *Nicolae Grigorescu (Rumänische Künstler)*. Bucharest, 1962.

Varga, V. *Nicolae Grigorescu. Monographie.* Bucharest, 1973.

GROS
Gros, ses amis, ses élèves. Exhibition Catalogue. Paris, 1936.
Lelièvre, P. 'Gros peintre d'histoire', *Gazette des Beaux-Arts* (1936), I.

GUYS
Baudelaire, C. 'Constantin Guys: Le peintre de la vie moderne', *Figaro* (1863).
Hall, C. *Constantin Guys.* London, n.d.
Wicke, H. v. d. (ed.). *Guys: 20 Faksimile nach Aquarellen (Drucke der Marées-Ges.,* XXV*).* Munich, n.d.

HAIDER
Haider, E. *Karl Haider: Leben und Werke eines süddeutschen Malers.* Augsburg, 1926.
Kutschera, G. *Karl Haider. Biographie einer Künstlerfamilie.* Innsbruck, 1962.

HAYEZ
Carodeschi, S., and Castellaneta, C. *L'opera completa di Hayez.* Milan, 1971.
Hayez, F. *Le mie memorie.* Milan, 1890.
Nicodemi, G. *Francesco Hayez.* Milan, 1962.

HEINRICH
Schwarz, H. 'August Heinrich und die geistigen Voraussetzungen seiner Malerei', *Mitteilungen der Österr. Galerie,* Neudruck, IV (1960), nos. 46–8.

HILDEBRAND
Adolf von Hildebrand und seine Welt. Briefe und Erinnerungen. Munich, 1962.
Heilmeyr, A. *Adolf von Hildebrand.* Munich, 1922.
Hildebrand, A. von. *Das Problem der Form.* Strassburg, 1893.
Hildebrand, A. von. *Gesammelte Aufsätze.* Strassburg, 1909.

HILL
Blomberg, E. *Carl Frederik Hill.* Stockholm, 1960.
Gullberg, H. 'Med Blicken Stirrande i Tidens Flod. Till en målning av C. F. Hill', *Studier Tillägnade Ragnar Josephson.* Lund, 1957.

HÖCKERT
Wieselgren, H. *Johan Fredrik Höckert 1826–1866 (Sveriges Allmänen Konstförenings Album,* VIII*).* Stockholm, 1900.

HORNY
Scheidig, W. *Franz Horny: 1798 Weimar – Olevano 1824.* Berlin, 1954.

HOSEMANN
Brieger, L. *Theodor Hosemann: Ein Altmeister Berliner Malerei.* With catalogue by K. Hobrecker. Munich, 1920.
Wirth, I. *Theodor Hosemann, Maler und Illustrator im alten Berlin.* Berlin, 1967.

HOUDON
Arnason, H. H. *The Sculptures of Houdon.* London, 1975.
Réau, L. 'Le premier salon de Houdon', *Gazette des Beaux-Arts* (1923), I.
Réau, L. 'Houdon sous la Révolution et l'Empire', *Gazette des Beaux-Arts* (1924), II.
Rostrup, H. J.-A. *Houdon (1741–1828).* Copenhagen, 1942.
Seymour, C., Jr. 'Houdon's Washington at Mount Vernon Re-examined', *Gazette des Beaux-Arts* (1948), I.

HUET
Hediard, G. *Paul Huet (Les maîtres de la lithographie).* Le Mans, n.d.

HUGO
Escholier, R. *Victor Hugo artiste.* Paris, 1926.
Journet, R., and Guy, R. *Victor Hugo, trois albums.* Paris, 1963.
Massin, J. (ed.). *Victor Hugo. Œuvres complètes.* Paris, 1969.
Picon, G., Cornaille, R., and Herscher, G. *Victor Hugo dessinateur (Le cabinet fantastique,* III*).* Paris, 1963.

HUMMEL
Hummel, G. *Der Maler Johann Erdmann Hummel.* Leipzig, 1954.

INDUNO
Nicodemi, G. *Domenico e Gerolamo Induno.* Milan, 1945.

INGRES
Alain. *Ingres (Les demi-dieux).* Paris, 1949.
Amaury-Duval. *L'atelier d'Ingres (Bibliothèque dionysienne).* Paris, 1878; 6th ed., Paris, 1924.
Angrand, P. *Monsieur Ingres et son époque.* Lausanne, Paris, 1968.
Fröhlich-Bum, L. *Ingres, sein Leben und sein Stil.* Vienna, 1924.

Longa, R. *Ingres inconnu*. Paris, 1942.

Mongan, A., and Naef, H. *Ingres Centennial*. Greenwich and New York, 1967.

Naef, H. *Die Bildniszeichnungen von J.-A.-D. Ingres.* (Dissertation, Zürich, 1962.)

Naef, H. *Ingres*. Rome–Zürich, 1962.

Naef, H. 'Paolo und Francesca: Zum Problem der schöpferischen Nachahmung bei Ingres'. *Zeitschrift für Kunstwissenschaft*, X (1956).

Naef, H. *Rome vue par Ingres*. Lausanne, 1959.

Rosenblum, R. *Ingres*. New York, 1968.

Schwarz, H. 'Ingres graveur', *Gazette des Beaux-Arts* (1959).

Wildenstein, G. *Ingres*. London, 1954.

ISABEY

Basily-Callimaki, Mme de. *J.-B. Isabey: Sa vie et son temps*. Paris, 1909.

Curtis, A. *Catalogue de l'œuvre lithographié de Eugène Isabey*. Paris, 1939.

ISRAËLS

Hubert, H. J. *The Etched Work of Jozef Israëls*. Amsterdam, n.d.

Liebermann, M. *Jozef Israëls*. Berlin, 1901.

ISSEL

Lohmeyer, K. *Aus dem Leben und den Briefen des Landschaftmalers und Hofrats Georg Wilhelm Issel 1785-1870*. Heidelberg, 1929.

JONGKIND

Aquarelles de Jongkind. Exhibition. Paris, Institut néerlandais, 1971.

Bakker-Hefting, V. *J. B. Jongkind*. Amsterdam, 1963.

Signac, P. *Jongkind*. Paris, n.d.

JOSEPHSON

Ernst Josephson. Exhibition. Stockholm, 1972.

Paulsson, G. *Ernst Josephsons Teckningar 1888-1906*. Stockholm, 1918.

Sandblad, N. G. 'En Kluven Pannå', *Studier Tilläg-nade Ragnar Josephson*. Lund, 1957.

KAUFFMANN

Gerard, F. *Angelica Kauffmann*. London, 1892.

Mayer, D. M. *Angelica Kauffmann, R.A., 1741-1807*. Gerrards Cross, 1972.

KELLER, G.

Schaffner, P. *Gottfried Keller als Maler*. Zürich, 1942.

KERSTING

Eberlein, K. K. 'Georg Friedrich Kersting', *Kunst und Künstler*, XVIII (1919-20).

Friesen, G. *Die Innenraumbilder Georg Friedrich Kerstings*. Berlin, 1935.

Gehrig, O. *Georg Friedrich Kersting*. Güstrow, 1931.

KLEIN

Jahn, C. *Das Werk von Johann Adam Klein*. Munich, 1863.

Schwemmer, W. *Johann Adam Klein. Ein Nürnberger Meister des 19. Jahrhunderts*. Nuremberg, 1966.

KNAUS

Pietsch, L. *Ludwig Knaus (Velhagen & Klasings Künstlermonographien, XI)*. Bielefeld–Leipzig, 1896.

KOBELL, F.

Biedermann, H. 'Bäume als Seele der Landschaft, Zu graphischen Arbeiten Ferdinand Kobells', *Weltkunst, Allem.* (1973), 43, no. 15, 1208.

Stengel, É., Baron de. *Catalogue raisonné des estampes de Ferdinand Kobell*. Nuremberg, 1822.

KOBELL, W. VON

Goedl-Roth, M. *Wilhelm von Kobell. Druckgraphik. Studien zur Radierung und Aquatinta mit kritischem Verzeichnis*. Munich, 1974.

Lessing, W. *Wilhelm von Kobell*. Edited and with an introduction by L. Grote. Munich, 1966.

Sternelle, K. *Wilhelm von Kobell*. Hamburg and Berlin, 1965.

KOCH

Frey, D. 'Die Bildkomposition bei Joseph Anton Koch und ihre Beziehung zur Dichtung. Eine Untersuchung über Kochs geistesgeschichtliche Stellung', *Wiener Jahrbuch für Kunstgeschichte*, XIV–XVIII (1950).

Lutterotti, O. R. von. *Joseph Anton Koch 1768-1839 (Denkmäler deutscher Kunst)*. Berlin, 1940.

Schneider, A. von. 'Die Briefe Joseph Anton Kochs an den Freiherrn Karl Friedrich von Uexküll', *Jahrbuch der preussischen Kunstsammlungen*, LIX (1938).

KOLLER

Fischer, M. *Rudolf Koller 1818-1905*. Zürich, 1951.

KRAFFT

Vancsa, E. 'Zu den "Vaterländischen Historien" Peter Kraffts', *Wiener Jahrbuch für Kunstgeschichte*, XXVII (1974), 158-76.

Vasić, P. 'Die Kunst Peter Kraffts', *Österreichische Zeitschrift für Denkmalpflege*, XIV (1960).

KRIEHUBER

Wurzbach, W. von. *Katalog der Porträtlithographien Joseph Kriehubers*. 2nd ed. Vienna, 1955.

KRÜGER
Osborn, M. *Franz Krüger (Velhagen & Klasings Künstlermonographien, CI)*. Bielefeld–Leipzig, 1910.

LAMI
Lami, E., and Monnier, H. *Voyage en Angleterre*. Facsimile ed. with introduction by G. Jedlicka. Zürich, n.d. [1939].
Lemoisne, P.-A. *Eugène Lami 1800–1890*. Paris, 1912.

LEGA
Durbè, D., and Bonagura, C. *Silvestro Lega*. Bologna, 1973.
Giardelli, M. *Silvestro Lega*. Milan, 1965.
Tinti, M. 'Silvestro Lega', *Bollettino d'Arte* (1923/4).

LEIBL
Langner, A., *Wilhelm Leibl*. Leipzig, 1961.
Mayr, J. *Wilhelm Leibl, sein Leben und Schaffen*. 4th ed. Munich, 1935.
Neuhaus, R. *Die Bildnismalerei des Leibl-Kreises (Untersuchungen zur Geschichte und Technik der Malerei der zweiten Hälfte des 19. Jahrhunderts)*. Marburg, 1953.
Petzet, M. *Wilhelm Leibl und sein Kreis. Städt. Galerie im Lenbachhaus München*. Munich, 1974.
Waldmann, E. *Wilhelm Leibl: Eine Darstellung seiner Kunst; Gesamtverzeichnis seiner Gemälde*. Berlin, 1914.
Waldmann, E. *Wilhelm Leibl als Zeichner*. Munich, 1942.

LENBACH
Mehl, S. *Franz von Lenbach 1836–1904. Leben und Werk*. Munich, 1972.
Rosenburg, A. *Franz von Lenbach (Velhagen & Klasings Künstlermonographien, XXIV)*. Bielefeld–Leipzig, 1898.
Wichmann, S. *Franz von Lenbach und seine Zeit*. Cologne, 1973.

LUCAS
Du Gué Trapier, E. *Eugenio Lucas y Padilla*. New York, 1940.

MAKART
Frodl, G. *Hans Makart*. Salzburg, 1974.
Pirchan, E. *Hans Makart*. Leipzig–Vienna, 1942.

MÁNES
Kotalik, J., Seydlová, M., and Kesnerová, G. *Josef Máneš*. Prague, 1971.
Pecírka, J. *Josef Mánes, zivý pramen národní tradice*. Prague, 1940.

MANET
Bazin, G. *Édouard Manet*. Antwerp, 1974.
De Leiris, A. *The Drawings of Édouard Manet*. Berkeley, 1969.
Guérin, M. *L'œuvre gravé de Manet*. Paris, 1944.
Hamilton, G. H. *Manet and his Critics*. New Haven, 1954.
Harris, J. C. *Édouard Manet: Graphic Works; a Definitive Catalogue raisonné*. New York, 1970.
Jamot, P., and Wildenstein, G. *Manet*. 2 vols. Paris, 1932.
Martin, K. *Édouard Manet: Aquarelle – Pastelle (Phoebus-Kunstbücher)*. Stuttgart, 1958.
Rewald, J. *Édouard Manet: Pastels*. Oxford, 1947.
Richardson, J. *Manet*. London, 1967.
Tabarant, A. *Manet et ses œuvres*. 3rd ed. Paris, 1947.
Vaudoyer, J.-L. *Manet (Les demi-dieux)*. Paris, 1955.
Zola, É. *Mon salon. Manet, écrits sur l'art*. Paris, 1970.

MARÉES
Bessenich, W. *Der klassische Marées*. Dissertation. Basel, 1967.
Degenhart, B. *Marées: Zeichnungen*. Berlin, 1953.
Degenhart, B. *Hans von Marées: Die Fresken in Neapel*. Munich, 1959.
Degenhart, B. *Marées Zeichnungen*. 2nd ed. Berlin, 1963.
Einem, H. von. 'Hans von Marées', *Sitzungsber. bayer. Akad. Wiss.* (1967), no. 4, 27 p.
Fiedler, C. *Hans von Marées*. Epilogue by H. Uhde-Bernays. Munich, 1947.
Marées, H. von. *Briefe*. Wuppertal, 1948.
Meier-Graefe, J. *Hans von Marées: Sein Leben und sein Werk*. 3 vols. Munich–Leipzig, 1910.
Neumeyer, A. 'Hans von Marées and the Classical Doctrine in the XIX Century', *The Art Bulletin*, XX (1938).

MARIS
'The Brothers Maris: James – Matthew – William', *The Studio*, special number (Summer 1907).

MARTIN
Frölich, H. *Bröderna Elias och Johan Fredrik Martins gravyrer*. Stockholm, 1939.

MATEJKO
Bogucki, J. *Matejko*. Warsaw, 1956.
Gintel, J. *Jan Matejko. Biografia w wypisach (Biography from the Sources)*. Wyd. 2. Cracow, 1966.
Kolev, B. *Jan Matejko. Monogr. očerk*. Sofia, 1971.

MAUVE
Engel, E. P. *Anton Mauve*. (Dissertation, Utrecht, 1967.) Utrecht, 1967.

Hancke, E. 'Anton Mauve', *Kunst und Künstler*, XIII (1914-15).

MEISSONIER
Gérard, M. D. *Jean-Louis-Ernest Meissonier: Ses souvenirs, ses entretiens, etc.* Paris, 1897.

MENGS
Honisch, D. *Anton Raphael Mengs und die Bildform des Frühklassizismus.* Recklinghausen, 1965.
Mengs, A. R. *Gedanken über die Schönheit und den Geschmak in der Malerey.* Zürich, 1762.
Mengs, A. R. *Sämmtliche hinterlassene Schriften.* Ed. G. Schilling. 2 vols. Bonn, 1843-4.

MENN
Brüschweiler, J. *Barthélemy Menn.* Zürich, 1960.
Lanicca, A. *Barthélemy Menn (Zur Kunstgeschichte des Auslandes, LXXXIX).* Strassburg, 1911.

MENZEL
Adolf Menzel. 1815-1905. Pastelle, Aquarelle und Zeichnungen. Berlin, 1965.
Bock, E. *Adolph Menzel: Verzeichnis seines graphischen Werkes.* Berlin, 1923.
Hütt, W. *Adolph Menzel.* Vienna-Munich, 1965.
Kaiser, K. *Adolph Menzel, der Maler.* Stuttgart, 1965.
Liebermann, M. (intr.). *Adolph Menzel, 50 Zeichnungen, Pastelle und Aquarelle aus dem Besitz der Nationalgalerie.* Berlin, 1921.
Meier-Graefe, J. *Der junge Menzel.* Leipzig, 1906.
Scheffler, K. *Adolf Menzel: Der Mensch - Das Werk.* Berlin, n.d.
Tschudi, H. von. *Adolph von Menzel: Abbildungen seiner Gemälde und Studien.* Munich, 1906.
Waldmann, E. *Der Maler Adolph Menzel.* Vienna, 1941.
Wolff, H. (ed.). *Adolph von Menzels Briefe.* Berlin, 1914.

MERYON
Burty, P. *Charles Meryon: A Memoir and Complete Catalogue of his Works.* London, 1879.
Charles Meryon: officier de marine, peintre-graveur, 1821-1868. 2 vols. Paris, 1968.
Delteil, L. *Charles Meryon (Le peintre-graveur illustré,* II*).* Paris, 1907.
Drost, W. W. R. 'Documents nouveaux sur l'œuvre et la vie de Charles Meryon', *Gazette des Beaux-Arts*, 6th per., LXIII (1964).
Ecke, G. *Charles Meryon (Meister der Graphik,* XI*).* Leipzig, 1923.
Stokes, H. *Etchings of Charles Meryon (The Great Etchers,* III*).* London, n.d.

MESSERSCHMIDT
Kris, E. 'Die Charakterköpfe des Franz Xaver Messerschmidt', *Jahrbuch des Kunsthistorischen Sammlungen in Wien*, N.F. VI (1932).

MEUNIER
Christophe, L. *Constantin Meunier (Monographies de l'art belge).* Antwerp, 1947.

MICHALOWSKI
Dobrowolski, T. *Piotr Michalowski.* Cracow, 1955.
Maslowski, M. *Piotr Michalowski.* Warsaw, 1974.
Sienkiewicz, J. *Piotr Michalowski.* Warsaw, 1959.
Zanoziński, J. *Piotr Michalowski.* Wroclaw, 1965.

MICHEL
Sensier, A. *Étude sur Georges Michel.* Paris, 1873.

MILLET
Ady, J., and Cartwright, M. *Jean-François Millet.* New York, 1971.
Bacon, R. *Millet. One Hundred Drawings.* London, 1975.
Gensel, W. *Millet und Rousseau (Velhagen & Klasings Künstlermonographien,* LVII*).* Bielefeld-Leipzig, 1902.
Herbert, R. L. 'Millet Revisited', *Burlington Magazine*, CIV (1962).
Moreau-Nélaton, É. *Millet, raconté par lui-même.* 3 vols. Paris, 1921.

MONET
Cogniat, R. *Monet and his World.* London, 1966.
Clemenceau, G. *Claude Monet, cinquante ans d'amitié.* Paris-Geneva, 1965.
Geffroy, G. *Claude Monet: Sa vie - son temps - son œuvre.* Paris, 1922.
Rossi Bartolatto, L. *L'opera completa di Claude Monet.* Milan, 1972.
Usener, K. H. 'Claude Monets Seerosen-Wandbilder in der Orangerie', *Wallraf-Richartz-Jahrbuch*, XIV (1952).
Wildenstein, D. *Claude Monet, Biographie et catalogue raisonné,* I, *1840-1881. Peintures.* Paris, 1974.

MOREAU L'AÎNÉ
Wildenstein, G. *Un peintre de paysage au XVIIIe siècle (Moreau l'aîné).* Paris, 1923.

MOREAU LE JEUNE
Bocher, E. *Catalogue raisonné des estampes de Jean-Michel Moreau le jeune.* Paris, 1932.

MORELLI
Levi l'Italico, P. *Domenico Morelli nella vita e nell'arte.* Rome-Paris, 1906.

MUNKÁCSY
Gál György, S. *Munkácsy Mihály élete.* Bratislava, 1969.
Végvári, L. *Katalog der Gemälde und Zeichnungen Mihály Munkácsys.* Budapest, 1959.

NAVEZ
Maret, F. *François-Joseph Navez.* Brussels, 1962.

NAVRÁTIL
Macková, O. 'Das Werk Josef Navrátils' (in Czech, with German résumé), *Umeni,* XIV (1966).
Pecírka, J. *Josef Navrátil.* Prague, 1940.

NEDER
Hareiter, K. *Michael Neder.* Vienna, 1948.

OBERLÄNDER
Esswein, H. *Adolf Oberländer (Moderne Illustratoren,* V). Munich, 1905.

OLIVIER
Grote, L. *Die Brüder Olivier und die deutsche Romantik.* Berlin, 1938.
Lindtke, G. 'Von Nazarenischer Landschaftskunst. Ferdinand Oliviers Salzburger Landschaften', *Der Wagen* (1963).

OVERBECK
Heise, C. G., and Eberlein, K. K. *Overbeck und sein Kreis.* Munich, 1928.
Howitt, M. *Friedrich Overbeck.* I: *1789–1833.* II: *1833–1869.* Bern, 1971.
Jensen, J. C. *Die Zeichnungen Overbecks in der Lübecker Graphiksammlung.* Lübeck, 1969.
Seeliger, S. 'Overbecks 7 Sakramente', *Jahrbuch der Berliner Museen,* VI (1964).

PÁAL
Lázár, B. *Ladislaus de Páal: Un peintre hongrois de l'école de Barbizon.* Paris, 1904.

PETTENKOFEN
Fuchs, H. 'August von Pettenkofen 1822–89', *Weltkunst,* t.39 (1969).
Weixlgärtner, A. *August von Pettenkofen.* Vienna, 1916.

PFORR
Lehr, F. H. *Die Blütezeit romantischer Bildkunst: Franz Pforr, der Meister des Lukasbundes.* Marburg, 1924.

PISSARRO
Coe, R. T. 'Camille Pissarro in Paris. A Study of his Later Development', *Gazette des Beaux-Arts* (1954), I.
Erpel, F. (ed.). *Camille Pissarro. Briefe. Der Maler in seinen Briefen an den Sohn Lucien.* Berlin, 1970.
Künstler, C. *Camille Pissarro.* Antwerp, 1974.
Pissarro, L. R., and Venturi, L. *Camille Pissarro, son art - son œuvre.* Paris, 1939.
Pissarro, C. *Letters to his Son Lucien.* Ed. J. Rewald. 2nd ed. London, 1943.
[Rewald, J.] 'Camille Pissarro as seen by Himself through his Unpublished Letters', *Gazette des Beaux-Arts* (1943), II.
Rewald, J. C. *Pissarro.* Cologne, 1963.

PRUD'HON
Bricon, É. *Prud'hon (Les grands artistes).* Paris, n.d.
Forest, A. *Pierre-Paul Prud'hon: Peintre français.* Paris, 1913.
Goncourt, E. de. *Catalogue raisonné de l'œuvre peint, dessiné et gravé de P. P. Prud'hon.* Paris, 1876. New ed. Amsterdam, 1971.
Guiffrey, J. *L'œuvre de P. P. Prud'hon (Collection de la Société de l'Histoire de l'art française).* Paris, 1924.

PURKYNĚ
Volavka, V. *Karel Purkyně.* Prague, 1942. New ed. 1962.

PUVIS DE CHAVANNES
Jullian, R. 'L'œuvre de jeunesse de Puvis de Chavannes', *Gazette des Beaux-Arts* (1938), II.
Riotor, L. *Puvis de Chavannes.* Paris, n.d.

RAFFET
Bry, A. *Raffet, sa vie et ses œuvres.* Paris, 1874.
Dayot, A. *Les peintres militaires Charlet et Raffet.* Paris, n.d.
Giacomelli, H. *Raffet, son œuvre lithographique et ses eaux-fortes.* Paris, 1862.
Lhomme, F. *Raffet.* Paris, n.d.

RAUCH
Avery, C. 'Neo-classical Portraits by Pistrucci and Rauch', *Apollo* (1975), 102, no. 161, 36–43.
Eggers, F. *Christian Daniel Rauch.* Berlin, 1873–91.
Mackowsky, H. 'Christian Daniel Rauch 1777–1857', *Kunst und Künstler,* XIV (1915/16).

RAYSKI
Grautoff, O. *Ferdinand von Rayski (Grote'sche Sammlung von Monographien zur Kunstgeschichte,* IV). Berlin, 1923.
Marauschlein, W. *Ferdinand von Rayski.* Hamburg and Berlin, 1968.

Walter, M. *Ferdinand von Rayski : Sein Leben und sein Werk.* Bielefeld–Leipzig, 1943.

REDON

Berger, K. *Odilon Redon.* London, 1965.

Cassou, J. *Odilon Redon.* Vevey, 1974.

Mellerio, A. *Odilon Redon, peintre, dessinateur, graveur.* Paris, 1923.

Redon, O. *Œuvre graphique complet.* The Hague, n.d.

Redon, O., Türoff, M., and Mattenklott, G. *Selbstgespräch, Tagebücher und Aufzeichnungen 1867–1915.* Munich, 1971.

Roger-Marx, C., and Hahnloser, H. *Odilon Redon.* Geneva, 1967.

Sandström, S. *Le monde imaginaire d'Odilon Redon : Étude iconologique.* Lund–New York, 1955.

Selz, J. *Odilon Redon.* New York, 1971.

RENOIR

Cabanne, P., Cogniat, R., Daulte, F., and Duret-Robert, F. *Renoir.* Paris, 1970.

Daulte, F., Renoir, J., and Durand-Ruel, C. *Auguste Renoir. Catalogue raisonné de l'œuvre peint,* I : *Figures 1860-90.* Lausanne, n.d.

Drucker, M. *Renoir.* Paris, 1955.

Hausenstein, W. *Renoir : Faksimiles nach Zeichnungen, Aquarellen und Pastellen* (Drucke d. Marées-Ges., 24. Druck). Munich, 1920.

Meier-Graefe, J. *Renoir.* Leipzig, 1929.

Renoir, J. *Renoir.* Paris, 1962.

Rewald, J. *Renoir Drawings.* New York, 1946.

Roger-Marx, C. *Les lithographies de Renoir.* Monte Carlo, 1951.

RETHEL

Einem, H. von. 'Die Tragödie der Karlsfresken Alfred Rethels', *Karl der Grosse,* IV (Düsseldorf, 1967).

Ponten, J. *Alfred Rethel : Des Meisters Werke in 300 Abbildungen (Klassiker der Kunst,* XVII*).* Stuttgart–Leipzig, 1911.

Ponten, J. (ed.). *Alfred Rethels Briefe.* Berlin, 1912.

Schmidt, H. *Alfred Rethel.* Neuss, 1959.

Schmidt, H. J. 'Alfred Rethels Gedanken über seine Kunst', *Jahrbuch für Ästhetik und allgemeine Kunstwissenschaft,* VI (1961).

RIBOT

Fourcaud, T. de. *Ribot : Sa vie et ses œuvres (Maîtres modernes).* Paris, n.d.

RICHTER

Friedrich, K. J. *Die Gemälde Ludwig Richters (Forschungen z. deutschen Kunstgeschichte,* XXIV*).* Berlin, 1937.

Neidhardt, H. J. *Ludwig Richter.* Leipzig, 1969.

Richter, L. *Lebenserinnerungen eines deutschen Malers. Selbstbiographie nebst Tagebuchniederschriften und Briefen.* Leipzig, 1909.

Stubbe Wolf. *Das Ludwig Richter Album. Sämtliche Holzschnitte.* Munich, 1968.

ROBERT, L.

Feuillet de Conches, F. *Léopold Robert, sa vie, ses œuvres et sa correspondance.* Paris, 1854.

Ségal, G. B. *Der Maler Louis Léopold Robert, 1744–1835. Ein Beitrag zur Geschichte der romant. Malerei in der Schweiz.* Dissertation. Basel, 1973.

RODIN

Adams, P. R. *Auguste Rodin.* New York, 1945.

Boeck, W. 'Rodins "Höllenpforte" : ihre kunstgeschichtliche Bedeutung', *Wallraf-Richartz-Jahrbuch,* XVI (1954).

Cassou, J. *Rodin, Sculptures.* Paris, 1970.

Eisenwerth (Schmoll, J. A.). *Der Torso als Symbol und Form (Zur Geschichte des Torso-Motivs im Werk Rodins).* Baden-Baden, 1954.

Elsen, A. E. *Rodin.* London, 1974.

Gantner, J. *Rodin und Michelangelo.* Vienna, 1953.

Goldscheider, C. *Rodin. Sa vie, son œuvre, son héritage.* Paris, 1962.

Jianu, J., and Goldscheider, C. *Rodin.* Paris, 1967.

Story, S. *Auguste Rodin and his Work.* London, 1939.

Tirel, M., and Cladel, J. *The Last Years of Rodin.* New York, 1974.

ROMAKO

Novotny, F. *Der Maler Anton Romako.* Vienna, 1954.

ROSSO

Carlone, M., Brunelli, G., and Antonio, G. *Medardo Rosso.* Catania, 1969.

Papini, G. *Medardo Rosso (Arte moderna italiana,* XXXV*).* Milan, 1940.

ROTTMANN

Decker, H. *Carl Rottmann.* Berlin, 1957.

ROUSSEAU

Sensier, A. *Souvenirs sur Th. Rousseau.* Paris, 1872.

Toussaint, H. *Théodore Rousseau.* Exhibition. Paris, 1968.

RUDE

Bertrand, A. *François Rude sculpteur : Ses œuvres et son temps.* Paris, 1904.

Quarré, P. *La vie et l'œuvre de François Rude.* Introduction to the catalogue of works by Rude in the Musée de Dijon. Dijon, 1947.

RUNGE
Berefelt, P. O. *Runge, zwischen Aufbruch und Opposition, 1777–1802 (Stockholm Studies in History of Art,* VII*).* Uppsala, 1961.
Böttcher, O. *Philipp Otto Runge: Sein Leben, Wirken und Schaffen.* Hamburg, 1937.
Franz, H. G. 'Philipp Otto Runge und die Gedankenwelt der Romantik', *Anschauung und Deutung (Festschrift Willy Kurt).* Berlin, 1964.
Maltzahn, H., Frh. von (ed.). *Philipp Otto Runges Briefwechsel mit Goethe (Schriften der Goethe-Gesellschaft,* LI*).* Weimar, 1940.
Matile, H. *Die Farbenlehre Philipp Otto Runges. Ein Beitrag zur Geschichte der Künstlerfarbenlehre.* Bern, 1973.
Philipp Otto Runge. Hinterlassene Schriften, I–II. Göttingen, 1965.
Runge, P. O. *Farbenkugel oder Construction des Verhältnisses aller Mischungen der Farben zueinander, etc.* Hamburg, 1840/1.
Schmidt, P. F. *Philipp Otto Runge: Sein Leben und sein Werk.* 2nd ed. Wiesbaden, 1956.

SCHADOW
Friedlaender, H. J. *Gottfried Schadow: Aufsätze und Briefe nebst einem Verzeichnis seiner Werke.* 1st ed. 1864. 2nd ed. Stuttgart, 1890.
Mackowsky, H. *Johann Gottfried Schadow: Jugend und Aufstieg 1764–1797.* Berlin, 1927.
Mackowsky, H. *Schadows Graphik (Forschungen zur deutschen Kunstgeschichte,* XIX*).* Berlin, 1936.
Peters, H. 'Wilhelm von Schadow', *Annalen des historischen Vereins für den Niederrhein,* CLXIV (1962).
Schadow, G. *Polyclet oder von den Maassen des Menschen nach dem Geschlechte und Alter.* Berlin, 1834; reprinted 1925.
Schadow, G. *Nationalphysionomien oder Beobachtungen über den Unterschied der Gesichtszüge und die äussere Gestaltung des menschlichen Kopfes.* Berlin, 1835.
Schadow, G. *Kunstwerke und Kunstansichten.* Berlin, 1849.

SCHICK
Simon, K. *Gottlieb Schick. Ein Beitrag zur Geschichte der deutschen Malerei um 1800.* Leipzig, 1914.

SCHINDLER, C.
Haberditzl, F. M., and Schwarz, H. *Carl Schindler: Sein Leben und sein Werk.* Vienna, 1930.

SCHINDLER, E. J.
Moll, C. *Emil Jakob Schindler, 1842–1892.* Vienna, 1930.

SCHINKEL
Brües, E. *Karl Friedrich Schinkel, Lebenswerk,* XII*: Die Rheinlande.* Munich and Berlin, 1968.
Schinkel, K. F. *Briefe, Tagebücher, Gedanken.* Ed. H. Mackowsky. Berlin, 1922.
Schreiner, L. *Karl Friedrich Schinkel, Lebenswerk,* XIII*: Westfalen.* Munich and Berlin, 1969.

SCHNORR VON CAROLSFELD
Metz, H. *Schnorr von Carolsfeld. Die Bibel in Bildern. 240 Darstellungen, erfunden und auf Holz gezeichnet.* Zürich, 1972.
Singer, H. W. *Julius Schnorr v. Carolsfeld (Velhagen & Klasings Künstlermonographien,* CIII*).* Bielefeld, 1911.
Trost, A. *Das römische Porträtbuch Julius Schnorrs v. Carolsfeld.* Leipzig, 1909.

SCHUCH
Hagemeister, K. *Karl Schuch: Sein Leben und seine Werke.* Berlin, 1913.
Migacz, R. *Carl Schuch als Landschaftsmaler.* Dissertation. Vienna, 1973.

SCHWIND
Busch, H. *Moritz von Schwind.* Königstein, 1949.
Halm, P. 'Moritz von Schwind, Jugendgedanken und reifes Werk', *Festschrift für Eberhard Hanfstaengl zum 75. Geburtstag.* Munich, 1961.
Moritz von Schwind und seine Vaterstadt Wien. Catalogue of the exhibition at the Historisches Museum der Stadt Wien, commentary by G. Glück. Vienna, 1954.
Pommeranz-Liedtke, G. *Moritz von Schwind.* Vienna, 1974.
Rath, H. W. (ed.). *Briefwechsel zwischen Eduard Mörike und Moritz v. Schwind.* Stuttgart, n.d. [1919].
Schwind, M. von. *Briefe.* Ed. O. Stoessl. Leipzig, 1924.
Weigmann, O. *Schwind: Des Meisters Werke in 1256 Abbildungen (Klassiker der Kunst,* IX*).* Stuttgart-Leipzig, 1907.

SEQUEIRA
Lord, D. 'Sequeira: A neglected Portuguese Painter', *Burlington Magazine,* LXXIV (1939), I.

SERGEL
Josephson, R. *Sergels fantasi.* 2 vols. Stockholm, 1957.

SISLEY
Daulte, F. *Alfred Sisley.* In preparation.
Reutersvaerd, O. 'Sisley's "Cathedrals": A Study of the "Church at Moret" Series', *Gazette des Beaux-Arts* (1952), I.

SPECKTER, O.
Ehmke, F. H. *Otto Speckter*. Bibliography by K. Hobreke. Berlin, 1920.

SPERL
Diem, E. *Johann Sperl: Ein Maler aus dem Leiblkreis*. Munich, 1955.

SPITZWEG
Carl Spitzweg. Zeichnungen, Aquarelle und Ölbilder. Exhibition. Vienna, 1968.
Dirrigl, M. *Carl Spitzweg, der Münchner Maler-Poet. Werke*. Munich and Vienna, 1969.
Elsen, A. *Carl Spitzweg*. Vienna, 1948.
Hanfstaengl, E. *Bilder von Carl Spitzweg*. Zürich, 1965.
Höhne, E. *Carl Spitzweg*. 2nd ed. Leipzig, 1972.
Kalkschmidt, E. *Carl Spitzweg und seine Welt*. Munich, 1966.
Roennefahrt, G. *Carl Spitzweg*. Munich, 1960.
Roennefahrt, G. *Carl Spitzweg. Beschreibendes Verzeichnis seiner Gemälde, Ölstudien und Aquarelle*. Munich, 1960.
Uhde-Bernays, H. *Carl Spitzweg: Des Meisters Werk und seine Bedeutung in der Geschichte der Münchener Kunst*. Munich, 1913.
Winkler, A. *Carl Spitzweg, Maler, Bild-Erzähler und Poet*. Munich, 1968.

STEINLE
Steinle, A. M. von. *Edward von Steinle: Des Meisters Gesamtwerk in Abbildungen*. Kempten-Munich, 1910.

STEVENS
Vanzype, G. *Les frères Stevens*. Brussels, 1936.

STIFTER
Novotny, F. *Adalbert Stifter als Maler*. 3rd ed. Vienna, 1948.

SZÉKELY
Dobai, J. *Székely Bertalan*. In preparation.

SZINYEI-MERSE
Pataky, D. *Pal Szinyei Merse*. Budapest, 1965.
Rajnai, M. *Szinyei-Merse Pál 1845-1920*. Budapest, 1953.

THOMA
Beringer, J. A. *Hans Thoma: Griffelkunst*. Frankfurt, 1916.
Beringer, J. A. *Hans Thoma: Radierungen*. Munich, 1923.

Thode, H. *Hans Thoma. Des Meisters Gemälde in 874 Bildern (Klassiker der Kunst, xv)*. Stuttgart, 1909.
Thoma, H. *Im Herbste des Lebens: Gesammelte Erinnerungsblätter*. Munich, 1909.
Thoma, H. *Im Winter des Lebens: Aus acht Jahrzehnten gesammelte Erinnerungen*. Jena, 1919.

THORVALDSEN
Rave, P. O. *Thorvaldsen*. Berlin, 1944.
Sass, E. K. *Thorvaldsens portraetbuster*. Copenhagen, 1965.

TISCHBEIN. J. F. A.
Stoll, A. *Der Maler Joh. Friedrich August Tischbein und seine Familie*. Stuttgart, 1923.

TISCHBEIN, J. H. W.
Landsberger, F. *Wilhelm Tischbein: Ein Künstlerleben des 18. Jahrhunderts*. Leipzig, 1908.

TOEPFFER
Maschietto, M. *Catalogue raisonné des œuvres originales de Rodolphe Töpffer dans les collections privées génévoises*. Geneva, 1961.
Schur, E. *Rodolphe Toepffer*. Berlin, 1912.

TROYON
Gensel, W. *Corot und Troyon (Velhagen & Klasings Künstlermonographien, LXXXIII)*. Bielefeld-Leipzig, 1906.
Hustin, A. *Constant Troyon (Les artistes célèbres)*. Paris, n.d.

TRÜBNER
Beringer, J. A. *Wilhelm Trübner (Klassiker der Kunst, xxvi)*. Stuttgart-Berlin, 1917.

VERNET
Dayot, A. *Les Vernet: Joseph - Carle - Horace*. Paris, 1898.

VERNET, C.
Dayot, A. *Carle Vernet*. Paris, 1925.

VERNET, H.
Rees (L. Runtz). *Horace Vernet and Paul Delaroche*. London, 1880.

VIGÉE-LEBRUN
Nolhac, P. de. *Madame Vigée-Lebrun, peintre de Marie-Antoinette*. Paris, 1912.

WALDMÜLLER
Grimschitz, B. *Ferdinand Georg Waldmüller*. Salzburg, 1957.

Keil, N. 'Ein neuentdeckter Waldmüller in der Albertina', *Mitteilungen d. Österr. Galerie*, XVIII (1974), no. 62, 92–6.

Unvergängliches Österreich. Ferdinand Georg Waldmüller und seine Zeit. Essen, 1960.

(For Waldmüller's own publications, see Chapter 9, note 2.)

WALLIS

Baudissin, K., Graf von. *Georg August Wallis: Maler aus Schottland, 1768–1847 (Heidelberger Kunstgeschichtlichte Abhandlungen*, VII). Heidelberg, 1924.

WASMANN

Nathan, P. *Friedrich Wasmann: Sein Leben und sein Werk*. Munich, 1954.

LIST OF ILLUSTRATIONS

Unless otherwise indicated, the medium for paintings is always oil, and copyright in photographs belongs to the gallery or collection given as the location, by whose courtesy the photographs are reproduced. 'Archives Photographiques, Paris' is abbreviated 'A.P.' Metric measurements appear last when derived from exact measurements in inches.

30. Anton Graff: The Painter Daniel Chodowiecki, *c.* 1800. 70 × 57cm: 28 × 22in. *Munich, Bayerische Staatsgemäldesammlungen*
31. Daniel Chodowiecki: Ladies in a Studio, *c.* 1760. Pencil-drawing. 19 × 19cm: 7½ × 7½in. *(West) Berlin, Staatliche Museen, Print Room*
32. Friedrich Heinrich Füger: Count Franz Joseph Saurau, *c.* 1797. 69 × 55 cm: 27 × 22in. *Vienna, Österreichische Galerie* (Verlag Schroll)
33. Johann Baptist von Lampi the Elder: Two Children of Count Thomatis, *c.* 1790. 98 × 80cm: 38½ × 31½in. *Vienna, Österreichische Galerie* (Verlag Schroll)
34. Peter Krafft: Return of the Emperor Francis after the Conclusion of Peace at Pressburg in 1809, 1825-30. Wall-painting. 370 × 598cm: 146 × 235in. *Vienna, Hofburg* (Bildarchiv d. Öst. Nationalbibliothek)
35. Joseph Anton Koch: Macbeth and the Witches, 1835. 81 × 122cm: 32 × 48in. *Innsbruck, Landesmuseum Ferdinandeum*
36. Joseph Anton Koch: The Bernese Oberland, 1815. 70 × 89cm: 27½ × 35in. *Vienna, Österreichische Galerie*
37. Joseph Anton Koch: The Schmadribach Waterfall, 1821-2. 132 × 110cm: 52 × 43in. *Munich, Bayerische Staatsgemäldesammlungen*
38. Jakob Philipp Hackert: Lago d'Averno, 1794. Gouache. 56·5 × 80cm: 22 × 31in. *Munich, Bayerische Staatsgemäldesammlungen*
39. Salomon Gessner: Bathers in a Stream, *c.* 1767-8. Etching. 10 × 16cm: 4 × 6¼in.
40. Johann Christian Reinhart: Italian Landscape with Hunter, 1835. 45·1 × 58·8cm: 18 × 23in. *Copenhagen, Thorvaldsens Museum*
41. Carl Rottmann: Taormina and Etna, 1828. 49 × 73cm: 19 × 29in. *Munich, Bayerische Staatsgemäldesammlungen*
42. Johann Wolfgang von Goethe: Gretchen appearing to Faust and Mephistopheles on the Blocksberg, *c.* 1812. Wash-drawing. 20 × 33cm: 8 × 13in. *Weimar, Goethe-Nationalmuseum*
43. Ferdinand Kobell: View of Goldbach, 1785-7. 80 × 113cm: 31½ × 44½in. *Munich, Bayerische Staatsgemäldesammlungen*
44. Wilhelm von Kobell: The Siege of Kosel, 1808. 207 × 302cm: 81½ × 119in. *Munich, Bayerische Staatsgemäldesammlungen*
45. Johann Christian Brand: The Danube near Vienna, *c.* 1790. 27·5 × 48·5cm: 11 × 19in. *Vienna, Österreichische Galerie*
46. Johann Jakob Biedermann: The Pissevache Waterfall, 1815. 52·5 × 66cm: 11 × 26in. *Winterthur, Kunstmuseum* (Kunstverein, Winterthur)
47. Louis-Gabriel Moreau: The Château de Vincennes, seen from Montreuil, *c.* 1770-80. 46 × 86cm: 18 × 34in. *Paris, Louvre* (A.P.)

48. Théodore Caruelle d'Aligny: Landscape with Prometheus, 1837. 202 × 298cm: 80 × 117in. *Paris, Louvre* (A.P.)
49. Jens Juel: The Little Belt, seen from a height near Middlefart, *c.* 1800. 42·3 × 62·5cm: 17 × 25in. *Copenhagen, Thorvaldsens Museum*
50. Jacques-Laurent Agasse: Westminster Bridge, 1818. 35 × 53·5cm: 14 × 21in. *Winterthur, Oskar Reinhart Foundation*
51. Nicolai Abraham Abilgaard: Scene from Terence's *Andria*, after 1800. 157·5 × 128·5cm: 62 × 50½in. *Copenhagen, Statens Museum for Kunst*
52. Jens Juel: Marcus Pauli Karenus Holst von Schmidten, 1802. 180·5 × 126cm: 71 × 50in. *Copenhagen, Statens Museum for Kunst*
53. Wilhelm Eckersberg: Graf Preben Bille-Brahe and his second Wife, 1817. 61 × 50cm: 24 × 20in. *Copenhagen, Ny Carlsberg Glyptotek*
54. Wilhelm Eckersberg: S. Maria in Aracoeli, Rome, *c.* 1813-16. 32·5 × 36·5cm: 12¾ × 14¼in. *Copenhagen, Statens Museum for Kunst*
55. Wilhelm Eckersberg: View from the Trekroners Batteri towards Copenhagen, 1836. 21·5 × 30·5cm: 8½ × 12in. *Copenhagen, Hirschsprung Collection* (Kunsthistorisk Pladearkiv, Copenhagen)
56. Jørgen Sonne: Unloading Sculpture (detail), *c.* 1846-50. H. *c.* 2·5m: *c.* 8ft. *Copenhagen, Thorvaldsens Museum, frieze* (Dr Bengt M. Holmquist, Lund)
57. Caspar David Friedrich: Landscape in the Harz Mountains, *c.* 1820. 36 × 50cm: 14 × 20in. *Hamburg, Kunsthalle*
58. Caspar David Friedrich: Early Snow, 1813-14. 45 × 35cm: 18 × 14in. *Hamburg, Kunsthalle*
59. Caspar David Friedrich: Moonrise over the Sea, 1823. 55 × 71cm: 22 × 28in. *(West) Berlin, Staatliche Museen*
60. Caspar David Friedrich: Capuchin Friar by the Sea, 1808-9. 108 × 170cm: 42½ × 67in. *(West) Berlin, Staatliche Museen*
61. Caspar David Friedrich: The Abbey Graveyard under Snow, 1819. 121 × 170cm: 48 × 67in. *Formerly Berlin, Staatliche Museen, Nationalgalerie*
62. Johann Christian Clausen Dahl: Study of Clouds, *c.* 1825. 21 × 22cm: 8¼ × 8¾in. *(West) Berlin, Staatliche Museen* (Neues Museum, Wiesbaden)
63. Georg Friedrich Kersting: Man reading by Lamplight, 1814. 47·5 × 37cm: 19 × 14½in. *Winterthur, Oskar Reinhart Foundation*
64. Philipp Otto Runge: Night, 1803. Pen-drawing. 71·5 × 48cm: 28 × 19in. *Hamburg, Kunsthalle*
65. Philipp Otto Runge: Morning, 1808-9. Second version (detail). 171 × 111·5cm: 67 × 44in (entire picture). *Hamburg, Kunsthalle*
66. Phillip Otto Runge: Self-portrait, 1799. Drawing.

106. Eugène Delacroix: Fight between a Lion and a Tiger, 1856. Pen-drawing. $12\frac{1}{4} \times 10\frac{1}{2}$in: 31×27cm. (After Robaut, *Facsimile de dessins* . . . , 1865)

107. Eugène Delacroix: Gretchen and Mephistopheles in the Cathedral (scene from *Faust*), 1827. Lithograph. $26 \cdot 5 \times 22$cm: $10\frac{1}{2} \times 8\frac{3}{4}$in. (From the original in the Albertina, Vienna)

108. Alexandre-Gabriel Decamps: Marius vanquishing the Cimbri, 1833. 130×195cm: 51×77in. *Paris, Louvre* (Giraudon)

109. Adolphe Monticelli: Portrait of Madame René, 1871. $64 \cdot 5 \times 54$cm: 25×21in. *Lyon, Musée des Beaux-Arts*

110. Virgilio Narcisso Diaz: A Group of Girls, *c.* 1845. 33×24cm: $13 \times 9\frac{1}{2}$in. *Paris, Louvre* (A.P.)

111. Théodore Chassériau: The Toilet of Esther, 1842. $45 \cdot 5 \times 35 \cdot 5$cm: 18×14in. *Paris, Louvre* (A.P.)

112. Théodore Chassériau: Peace (detail). Fresco from the Palais d'Orsay, 1844–8. 340×362cm: 134×143in. *Paris, Louvre* (A.P.)

113. Thomas Couture: Romans of the Period of Decline, 1847. 466×775cm: 183×305in. *Paris, Louvre* (A.P.)

114. Richard Parkes Bonington: The Park of Versailles, *c.* 1826. 42×52cm: $16\frac{1}{2} \times 20\frac{1}{2}$in. *Paris, Louvre* (A.P.)

115. Victor Hugo: Morning in Vianden, 1871. Wash-drawing. 25×35cm: $9\frac{3}{4} \times 13\frac{3}{4}$in. *Paris, Maison de Victor Hugo* (After R. Escholier, *Victor Hugo artiste*)

116. Charles Meryon: The Morgue, 1854. Etching. 190×213cm: 75×84in. (From the original in the Albertina, Vienna)

117. Charles Meryon: The Collège Henri IV, 1864. Etching. 22×41cm: $8\frac{1}{2} \times 16$in. (After G. Ecke, *Charles Meryon*, 1924)

118. Théodore Rousseau: The Edge of the Woods, 1854. $31\frac{1}{2} \times 48$in: 80×122cm. *New York, Metropolitan Museum of Art*

119. Théodore Rousseau: The Valley of Saint-Vincent, *c.* 1830. $7\frac{3}{8} \times 12\frac{3}{4}$in: 19×32cm. *London, National Gallery* (Reproduced by permission of the Trustees, the National Gallery, London)

120. Jean-François Millet: Peasants digging, *c.* 1855. Etching. $23 \cdot 8 \times 33 \cdot 5$cm: 9×13in. (From the original in the Albertina, Vienna)

121. Jean-François Millet: The Woodcutter and Death, 1859. $77 \cdot 5 \times 98 \cdot 5$cm: 31×39in. *Copenhagen, Ny Carlsberg Glyptotek*

122. Jean-François Millet: Shepherdess, *c.* 1855. Wood-engraving. 27×22cm: $10\frac{1}{2} \times 8\frac{1}{2}$in. *Vienna, Albertina*

123. Charles-François Daubigny: The Lock at Optevoz, 1859. 48×73cm: 19×28in. *Paris, Louvre* (A.P.)

124. Charles François Daubigny: River Landscape,

c. 1860. Chalk-drawing. $29 \times 44 \cdot 5$cm: $11\frac{1}{2} \times 17\frac{1}{2}$in. *Vienna, Albertina*

125. Camille Corot: The Farnese Garden in Rome, 1826. $9\frac{1}{2} \times 15\frac{3}{4}$in: 24×40cm. *Washington, The Phillips Gallery*

126. Camille Corot: Ville d'Avray, *c.* 1835–8. 28×40cm: 11×16in. *Paris, Louvre* (A.P.)

127. Camille Corot: Morning at Castelgandolfo, 1850. $65 \times 81 \cdot 2$cm: 26×32in. *Paris, Louvre* (A.P.)

128. Camille Corot: The Valley, *c.* 1850–60. 35×54cm: 14×21in. *Paris, Louvre* (A.P.)

129. Camille Corot: Lady in Blue, 1874. $80 \times 50 \cdot 5$cm: 32×20in. *Paris, Louvre* (A.P.)

130. Camille Corot: Portrait of Mme Gambay, *c.* 1870. 80×59cm: 31×23in. *Formerly Marczell von Nemes Collection*

131. Ferdinand Georg Waldmüller: Prater Landscape, 1830. $71 \times 91 \cdot 5$cm: 28×36in. *Formerly Berlin, Nationalgalerie* (Nationalgalerie, East Berlin)

132. Ferdinand Georg Waldmüller: View of the Hallstättersee from the Hütteneckalm, 1838. $45 \cdot 5 \times 57 \cdot 5$cm: 18×23in. *Vienna, Historisches Museum der Stadt Wien*

133. Ferdinand Georg Waldmüller: The Public Auction, 1857. $44 \times 56 \cdot 5$cm: 17×22in. *Stuttgart, Staatsgalerie*

134. Ferdinand Georg Waldmüller: Anna, second Wife of the Artist, 1850. 68×55cm: 27×22in. *Vienna, Österreichische Galerie* (Verlag Schroll)

135. Ferdinand Georg Waldmüller: Window surrounded by Vines, 1841. 39×48cm: 15×19in. *Vienna, Österreichische Galerie* (Verlag Schroll)

136. Matthias Rudolf Toma: Garden of a House on the Cobenzl near Vienna, 1832. 34×43cm: 13×17in. *Formerly Vienna, Josef Siller* (Verlag Schroll)

137. Adalbert Stifter: View of the Beatrixgasse, Vienna, 1839. $23 \cdot 5 \times 30$cm: $9\frac{1}{4} \times 11\frac{3}{4}$in. *Vienna, Adalbert Stifter-Museum* (Adalbert Stifter-Gesellschaft, Vienna)

138. Rudolf von Alt: The Graben, Vienna, 1848. Water-colour. 17×25cm: $6\frac{3}{4} \times 9\frac{3}{4}$in. *Vienna, Albertina*

139. Carl Schindler: The Last Salute to the Flag, *c.* 1838–9. Water-colour. 13×18cm: 5×7in. *Vienna, Albertina*

140. Peter Fendi: Mass by the Outer Burgtor, 1826. 62×125cm: 24×49in. *Vienna, Österreichische Galerie*

141. Freidrich von Amerling: Rudolf von Arthaber and his Children, 1837. 221×155cm: 87×69in. *Vienna, Österreichische Galerie* (Verlag Schroll)

142. Christen Købke: The Castle of Frederiksborg, 1835. 69×101cm: 27×40in. *Copenhagen, Hirschsprung Collection* (Kunsthistorisk Pladearkiv, Copenhagen)

461

180. Wouter Johannes van Troostwijk: The Raampoort in Amsterdam in Winter, 1809. 57×48cm: 22×19in. *Amsterdam, Rijksmuseum*
181. Pieter Rudolph Kleyn: In the Park of Saint-Cloud, 1809. 99×130cm: 39×51in. *Amsterdam, Rijksmuseum*
182. Gustave Courbet: Self-portrait, *c.* 1853. 71·5×59cm: 28×23in. *Copenhagen, Ny Carlsberg Glyptotek*
183. Gustave Courbet: Funeral at Ornans, 1850. 314×663cm: 124×261in. *Paris, Louvre* (A.P.)
184. Gustave Courbet: Woodland Scene at the Puits Noir, *c.* 1865. 92×132cm: 36×52in. *Vienna, Kunsthistorisches Museum* (Verlag Schroll)
185. Gustave Courbet: Rocky Landscape near Ornans, *c.* 1860. 65×81cm: 26×32in. *Vienna, Kunsthistorisches Museum* (Verlag Schroll)
186. Gustave Courbet: Flower-piece, 1855. 84×109 cm: 33×43in. *Hamburg, Kunsthalle*
187. Gustave Courbet: Trout, 1871. 52·5×87cm: 21×34in. *Zürich, Kunsthaus*
188. Gustave Courbet: The Studio, 1855. 361×598 cm: 142×235in. *Paris, Louvre* (A.P.)
189. Michael von Munkácsy: Smoker, *c.* 1874. 92×72 cm: 36×28in. *Budapest, Museum of Fine Arts*
190. Paul von Szinyei Merse: Picnic in May, 1873. 123×161cm: 48×63in. *Budapest, Museum of Fine Arts*
191. Honoré Daumier: In a Third-Class Railway Carriage, *c.* 1860-5. Water-colour. 8×11⅞in: 20·3×29·5cm. *Baltimore, Walters Art Gallery*
192. Honoré Daumier: Blacksmith, *c.* 1855-60. Water-colour. 35×25cm: 13¾×9¾in. *Whereabouts unknown*
193. Honoré Daumier: Wood-engraving from Balzac and Frémy, *Physiologie du Rentier*, 1841. 1½×2⅝in: 3·8×6·7cm.
194. Honoré Daumier: Don Quixote capering in front of Sancho Panza, *c.* 1865-8. Charcoal drawing. 34×25cm: 13×10in. *Winterthur, Dr Oskar Reinhart*
195. Honoré Daumier: Don Quixote and Sancho Panza, *c.* 1865. 100×77 cm: 39×30in. *London, Courtauld Institute Galleries* (Reproduced by permission of the Home House Trustees)
196. Honoré Daumier: Mountebanks on the Move, *c.* 1865. Water-colour. 14¼×11in: 36×28cm. *Hartford, Connecticut, Wadsworth Atheneum*
197. Honoré Daumier: Le Ventre Législatif, 1834. Lithograph. 43·1×28cm: 17×11in. (From the original in the Albertina, Vienna)
198. Honoré Daumier: Rue Transnonain le 15 avril 1834, 1834. Lithograph. 44·5×29cm: 17½×11½in. (From the original in the Albertina, Vienna)
199. Honoré Daumier: The Defence, *c.* 1855. Pen-drawing. 18×27cm: 7×10¾in. *London, Courtauld Institute Galleries* (Reproduced by permission of the Home House Trustees)

200. Honoré Daumier: Ulysses on the Journey. Wood-engraving from *Ulysse ou les porcs vengés*, 1852. 2⅛×2⅛in: 5·3×5·3cm.
201. Honoré Daumier: Singing Couple, *c.* 1855-60. 37×28·5cm: 15×11in. *Amsterdam, Rijksmuseum*
202. Honoré Daumier: The Dream of the Inventor of the Needle-Gun, 1866. Lithograph. 23·3×19·9cm: 9¼×7¾in. (From *Charivari*)
203. Honoré Daumier: During the Interval, *c.* 1855-60. Water-colour. 24·5×33cm: 10×13in. *Winterthur, Dr Oskar Reinhart*
204. Honoré Daumier: Rehearsing a Smile for the Electors, 1869. Lithograph. 23·1×20·4cm: 9¼×8in. (From *Charivari*)
205. Paul Gavarni: Lithograph from *Faits et gestes du propriétaire*, 1846. 20·2×16·2cm: 8×6½in. (From *Charivari*)
206. Paul Gavarni: Wood-engraving from *Contes fantastiques de Hoffmann*, 1843. 3×2½in: 7·6×6·4cm.
207. Paul Gavarni: Congé en partie double. Wood-engraving from *Masques et Visages*, 1852-3. ⅝×1in: 1·6×2·5cm.
208. Paul Gavarni: Lithograph from *Le propos de Thomas Vireloque*, 1852. 19·5×16·7cm: 7¾×6½in.
209. Grandville: An Eclipse of the Sun. Wood-engraving from *Un autre monde*, 1844. 5⅞×4⅝in: 14·9×11·8cm.
210. Gustave Doré: Wood-engraving from *Histoire de la Sainte Russie*, 1854. 1⅜×4⅜in: 3·5×11·1cm.
211. Gustave Doré: Newgate - the Exercise Yard, 1872. Wood-engraving. 23·7×19cm: 9½×7½in. (From Blanchard Jerrold, *London, A Pilgrimage*; photo Hawkley Studio Associates Ltd)
212. Bertall: Wood-engraving from Feuillet, *Vie de Polichinelle*, 1846. 2¼×2¼in: 5·7×5·7cm.
213. Constantin Guys: Two Ladies with Muffs, *c.* 1875-80. Wash-drawing. 7×5½in: 18×14cm. *London, Courtauld Institute Galleries* (Reproduced by permission of the Home House Trustees)
214. Constantin Guys: Woman standing, *c.* 1875-80. Wash-drawing. 31·5×21cm: 12½×8¼in. *Vienna, A.S. Collection*
215. Adolf von Menzel: Departure of Frederick the Great with the Army. Wood-engraving from Kugler, *Geschichte Friedrichs des Grossen*, 1840-2. 1⅞×3½in: 4·8×8·9cm.
216. Adolf von Menzel: Two young Officers in a Military College. Wood-engraving from *Werke Friedrichs des Grossen*, 1844-9. 3¾×4¼in: 9·5×10·8cm.
217. Adolf von Menzel: The Artist's Sister with Candle, 1847. 46×32cm: 18×12½in. *Munich, Bayerische Staatsgemäldesammlungen*
218. Adolf von Menzel: Garden of Prince Albrecht's Palace in Berlin, 1846. 68×86cm: 27×34in. *(East) Berlin, Staatliche Museen*

260. Gustave Moreau: St Sebastian, *c.* 1875. 26¾× 15¼in: 36× 89cm. *Cambridge, Massachusetts, Fogg Art Museum* (Fogg Art Museum, Harvard University, Grenville Lindall Winthrop Collection)

261. Pierre Puvis de Chavannes: The Sacred Grove (detail), 1883-4. 458× 1062cm: 180× 418in. (entire mural). *Lyon, Musée des Beaux-Arts (Palais Saint-Pierre)*

262. Henri Fantin-Latour: A Studio at Batignolles, 1870. 171× 205cm: 67× 81in. *Paris, Musée de l'Impressionnisme* (A.P.)

263. Eugène Carrière: Paul Verlaine, *c.* 1890. 61× 51cm: 24× 20in. *Paris, Louvre* (A.P.)

264. Odilon Redon: Pegasus, after 1890. Lithograph. 19·8× 14·5cm: 7¾× 5¾in. *Vienna, Albertina*

265. Odilon Redon: Caliban's Dream, *c.* 1880-5. 44·5× 39cm: 15½× 17½in. *Paris, Ari Redon* (Bulloz, Paris)

266. Édouard Manet: The Picnic Lunch, 1863. 214× 270cm: 84× 106in. *Paris, Musée de l'Impressionnisme* (A.P.)

267. Édouard Manet: Olympia, 1863. 130× 190cm: 51× 75in. *Paris, Musée de l'Impressionnisme* (A.P.)

268. Édouard Manet: Émile Zola, 1868. 190× 110cm: 75× 43in. *Paris, Musée de l'Impressionnisme* (A.P.)

269. Édouard Manet: Concert in the Tuileries Gardens, 1862. 73× 116cm: 29× 46in. *London, National Gallery* (Reproduced by permission of the Trustees, the National Gallery, London)

270. Édouard Manet: The Roadstead at Boulogne, 1863. 29⅛× 36⅝in: 74× 93cm. *Chicago, Art Institute* (Courtesy of the Art Institute of Chicago, Potter Palmer Collection)

271. Édouard Manet: Chez Père Lathuille, 1879. 92× 112cm: 36× 44in. *Tournai, Musée des Beaux Arts*

272. Édouard Manet: The Bar of the Folies Bergère, 1881-2. 96× 130cm: 38× 51in. *London, Courtauld Institute Galleries* (Reproduced by permission of the Home House Trustees)

273. Édouard Manet: Country House at Rueil, 1882. 73× 92cm: 29× 36in. *(West) Berlin, Staatliche Museen*

274. Édouard Manet: Lady with a Fur, *c.* 1881. Pastel-drawing. 55× 45cm: 22× 18in. *Vienna, Kunsthistorisches Museum* (Österreichische Galerie, Vienna)

275. Édouard Manet: Portrait of Baudelaire, 1862. Etching. 3× 2⅛in: 7·6× 5·3cm.

276. Édouard Manet: The Absinthe Drinker, 1859. 181× 106cm: 71× 42in. *Copenhagen, Ny Carlsberg Glyptotek* (Durand-Ruel, Paris)

277. Édouard Manet: White Lilac in a Glass, 1880. 54× 41cm: 21× 16in. *(West) Berlin, Staatliche Museen*

278. Édouard Manet: The Execution of the Emperor Maximilian of Mexico, 1867. 252× 305cm: 99× 120in. *Mannheim, Städtische Kunsthalle*

279. Barthold Jongkind: The Barrière de Vanves, 1867. 33× 43cm: 13× 17in. *Paris, Alfred Daber*

280. Eugène Boudin: Seashore near Trouville, 1874. 17× 35cm: 7× 14in. *Zürich, private collection* (Zürcher Kunstgesellschaft)

281. Claude Monet: Ladies in a Garden, 1867. 256× 208cm: 101× 82in. *Paris, Musée de l'Impressionnisme*

282. Claude Monet: The Church of Saint-Germain l'Auxerrois, Paris, 1866. 79× 98cm: 31× 39in. *(West) Berlin, Staatliche Museen*

283. Claude Monet: Anglers on the Seine near Poissy, 1882. 60× 82cm: 24× 32in. *Vienna, Kunsthistorisches Museum* (Verlag Schroll)

284. Claude Monet: The Houses of Parliament, London, 1903. *New York, Mrs Vanderbilt Webb*

285. Claude Monet: Water-lilies, Giverny, 1919. 39⅜× 79in: 100× 201cm. *Paris, P. Durand-Ruel Collection*

286. Alfred Sisley: Cornfield, 1873. 50·5× 73·1cm: 20× 29in. *Hamburg, Kunsthalle*

287. Alfred Sisley: Flood at Port Marly, 1876. 60× 81cm: 24× 32in. *Paris, Musée de l'Impressionnisme* (A.P.)

288. Alfred Sisley: Fresh Snow, 1873. 50× 65cm: 20× 26in. *Paris, P. Durand-Ruel Collection*

289. Camille Pissarro: Red Roofs, 1877. 53× 64cm: 21× 25in. *Paris, Musée de l'Impressionnisme* (A.P.)

290. Camille Pissarro: The Railway to Dieppe, 1886. 21¼× 25¾in: 54× 66cm. *Gladwyne, Pennsylvania, Mrs Louis C. Madeira 4th*

291. Camille Pissarro: Evening on the Boulevard Montmartre, 1897. 55× 65cm: 22× 26in. *London, National Gallery* (Reproduced by permission of the Trustees, The National Gallery, London)

292. Edgar Degas: Ballet Rehearsal ('Adagio'), 1874. 23× 33in: 58× 84cm. *Glasgow, Art Gallery and Museum, Burrell Collection*

293. Edgar Degas: Ballet Dancers, *c.* 1899. Pastel-drawing. 37× 31in: 94× 79cm. *New York, Museum of Modern Art* (Gift of William S. Paley)

294. Edgar Degas: Racehorses, 1874. 12× 15¾in: 31× 40cm. *Boston, Massachusetts, Museum of Fine Arts*

295. Edgar Degas: Comte Lepic with his Children in the Place de la Concorde, *c.* 1873. 79× 118cm: 31× 46in. *Formerly Berlin, O. Gerstenberg* (Durand-Ruel)

296. Auguste Renoir: The Box, 1874. 81× 65cm: 32× 26in. *London, Courtauld Institute Galleries* (Reproduced by permission of the Home House Trustees)

INDEX

References to the notes are given to the page on which the note occurs, followed by the number of the chapter and the number of the note. Thus, 429(18)[7] indicates page 429, chapter 18, note 7. The names of artists and places are usually indexed under the final element, particles being ignored. Where names of places or buildings are followed by the name of an artist in brackets, the entry refers to work by that artist in such buildings or places: thus Heidelberg, Kurpfälzisches Museum (Fohr) refers to the portrait of Joseph Sutter by Fohr in the Museum.